In Memory of

JUSTINE FIELDS

Given By

Mrs. Dorsey B. Hardeman

© DEMCO, INC.—Archive Safe

ART FOR HISTORY'S SAKE

Cecilia Steinfeldt

DATE DUE

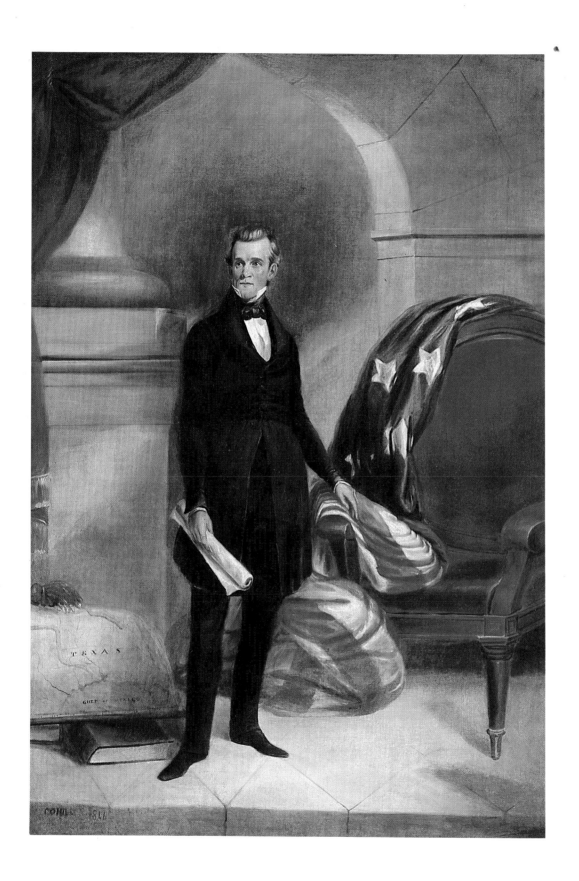

Art for History's Sake:

THE TEXAS COLLECTION OF THE WITTE MUSEUM

Text by CECILIA STEINFELDT
Introduction by WILLIAM H. GOETZMANN

PUBLISHED BY
THE TEXAS STATE HISTORICAL ASSOCIATION
FOR THE WITTE MUSEUM
OF THE SAN ANTONIO MUSEUM ASSOCIATION

Publication of this book has been made possible by
grants from the National Endowment for the Arts, a
federal agency; the Horse Creek Trust of San
Antonio; and Charles Butt and H-E-B of San Antonio.

LIBRARY OF CONGRESS
CATALOGUING IN PUBLICATION DATA

Steinfeldt, Cecilia.
 Art for history's sake: the Texas collection of
the Witte Museum / Steinfeldt, Cecilia;
introduction by William H. Goetzmann.
 p. cm.
 Includes bibliographical references and index.
 ISBN 0-87611-116-9
 1. Art, American—Texas—Catalogs. 2. Texas
in art—Catalogs. 3. San Antonio Museum
Association—Art collections—Catalog. 4. Art—
Private collections—Texas—San Antonio—
Catalogs. 5. Art—Texas—San Antonio—
Catalogs. I. San Antonio Museum
Association. II. Texas State Historical
Association. III. Title.
N6530.T4S74 1993
709'.764'074764351—dc20 93-12535
 CIP

Photographers:
Al Rendon, James Hicks, Bob Chalk, Roger Fry.

Design and typography by George Lenox

FRONTISPIECE
Portrait of President James K. Polk (1844), by George H.
Comegys. This portrait of Polk, whose name is
inextricably linked with Manifest Destiny and the
westward expansion of the United States, symbolizes
the importance of Texas in the middle of the
nineteenth century. With annexation, which was a
principal issue in the 1844 presidential election, Texas
began to develop the distinctive artistic identity
reflected in The Texas Collection of the Witte
Museum of the San Antonio Museum Association.

For ELEANOR ONDERDONK
with admiration for her determination
to preserve Texas heritage
and ELLEN SCHULZ QUILLIN
with appreciation for her recognition
of the importance of Texana

CONTENTS

THE TEXAS COLLECTION: ITS HISTORY AND DEVELOPMENT

The Witte Museum's collections of Texas paintings, decorative arts, folk art, and furniture have grown consistently since the Witte Memorial Museum was founded in 1926. Interest in regional material developed during the tenures of the two women most important in guiding the museum through its formative years: Ellen Schulz Quillin, director, 1926 to 1960, and Eleanor Onderdonk, art curator, 1927 to 1958. These women were not only the heart and soul of the institution, they were its structural supports—the pillars, the posts, the walls, and the concrete. Ellen Quillin was responsible for the construction of the buildings, the establishment of the scientific collections, and the accumulation of historical artifacts. Eleanor Onderdonk was the driving force in building the painting and decorative arts collections, including the material that would become the nucleus of the Witte Museum of the San Antonio Museum Association's Texas Collection.

In the beginning the efforts of Quillin and Onderdonk were supported by four organizations: the San Antonio Museum Association, the San Antonio Art League, the San Antonio Conservation Society, and the San Antonio Scientific Society. The Museum Association and the Art League continued their support throughout the years. The Scientific Society dissolved shortly after the museum opened, and the Conservation Society grew so rapidly that it was forced to broaden its areas of activity, although it has never withdrawn its interest in the institution. By the 1970s the Art League had also outgrown the museum's walls and sought new quarters for its exhibits and offices.

Eleanor Onderdonk, a charter member of the San Antonio Conservation Society, formed in 1924, and an active member of the Yanaguana Society, a group devoted to preserving and perpetuating all aspects of regional history, was always fascinated with Texas history. She enthusiastically gathered for the museum paintings, prints, drawings, and handcrafted artifacts from the state's frontier environment. With her extensive artistic background, fervent devotion to things Texan, and determination to preserve local heritage, she sought to enrich and expand the local art scene in every way possible.

The establishment of the Witte Memorial Museum, the mother institution of the San Antonio Museum Association, was neither quick nor easy. It began in 1922 with the acquisition of the Attwater Collection, mostly scientific specimens, first displayed in vacant classrooms at old Main Avenue High School, adjacent to Ellen D. Schulz's teaching area and under her guidance. It became obvious to city officials and the general public that more efficient and permanent housing was needed for a real "museum." Some of the necessary funds were raised through tag days, bluebonnet seed sales, cake sales, concerts, and theatrical performances. Not until Alfred G. Witte left a $65,000 bequest, however, was adequate funding assured. To this bequest was appended $50,000 already accumulated and $25,000 that Mrs. Henry Drought secured for a second-floor exhibits area for the San Antonio Art League. Ellen Schulz accepted the position of director of the Witte Memorial Museum at an annual salary of one dollar a year while she continued her teaching career.

One of the most important aspects of Witte's bequest was an additional $10,000 endowment, the interest from which was to be used "for the purchase of paintings." Because of the perspicacity of Eleanor Onderdonk, the modest interest realized from this legacy was devoted almost entirely to the acquisition of Texas

paintings, prints, and drawings that would form the basis of the most important collection of Texas works in the state. Many of the Gentilz paintings, the Thomas Allen *Market Plaza*, the Seth Eastmans, and others were acquired at surprisingly moderate sums.

In 1933 Eleanor Onderdonk, with the cooperation of Frederick Chabot and the Yanaguana Society, organized an exhibition entitled Old San Antonio Paintings. She served as art committee chairman for the event, which would become a milestone in the annals of Texas art history. All of the artists represented, including Theodore Gentilz, Hermann Lungkwitz, Mary Van Derlip Chabot, Carl G. von Iwonski, Edward Grenet, Louise Wueste, and Robert Onderdonk, had worked in San Antonio.

In Texas's centennial year, 1936, Eleanor Onderdonk assembled a far more comprehensive exhibit, which she called the Centennial Exposition of Early Texas Paintings. She added new names to the roster of recognized Texas artists, including Tom Brown, Seth Eastman, Thomas Allen, Ida Weisselberg Hadra, and Richard Petri. She borrowed material to add to paintings already owned by the museum and intended for the show to entice visitors from the State Fair Exposition in Dallas to San Antonio, to learn more about Texas history.

The interest engendered by these exhibitions prompted more gifts to supplement the collection. The paintings acquired added to both history displays and to The Texas Collection. For the most part, the paintings related to San Antonio, the cultural center for the arts in Texas until well into the twentieth century.

In 1946 Eleanor Onderdonk assembled yet another show, Early San Antonio Paintings, with many new paintings by artists whose names were now familiar. Other artists were added: W. G. M. Samuel, Charles Herff, José Arpa, John Beckmann, and Mrs. Sam Maverick. An innovative aspect of the exhibition was to include examples of Texas furniture and decorative arts, another area in which the Association pioneered. Miss Schulz, by then Mrs. Quillin, was instrumental in acquiring the early pieces that would become the basis of one of the most important collections in the state.

Eleanor Onderdonk retired in 1958 and was succeeded as art curator by Martha Utterback. The wealth of provincial material she found in The Texas Collection led her in 1964 to organize the most complete display of Texas paintings thus far attempted. Although the core of the exhibition consisted of works that belonged to the Association, she also borrowed new material from other institutions and from individuals. With approximately 200 paintings, the exhibition filled several galleries. It included twenty-eight works by Seth Eastman, sixty-two by Theodore Gentilz, twenty-seven by Robert Onderdonk, three by Thomas Allen, six by Carl G. von Iwonski, fourteen by Hermann Lungkwitz, and thirteen by Richard Petri. Numerous other artists were represented by one or two examples of their work. Loaned materials came from family members and collectors throughout the state and from institutions such as the Peabody Museum at Harvard University, the McNay Art Institute, the Dallas Museum of Fine Arts, St. Mary's University in San Antonio, the San Antonio Art League, the San Antonio Public Library, the Museum of Fine Arts in Houston, and the Boston Museum of Fine Arts.

This popular show, called The Early Scene: San Antonio, was on display during the summer of 1964. Using her research for the exhibit, Martha Utterback compiled a

book on the Association's collection, *Early Texas Art in the Witte Museum*, published in 1968. As a result of the exhibition and the catalogue, more donors were influenced to place their heirlooms in the public domain for the edification of museum visitors and historic researchers. Due largely to her continued interest in enhancing the collection, contributions escalated throughout Utterback's tenure.

In 1971 Utterback collaborated with Jerry Bywaters of Southern Methodist University in Dallas in assembling a show called Texas Painting and Sculpture: The 20th Century. Selections represented the diversity and character of painting and sculpture in Texas from 1900 to 1970, bridging the gap between early Texas art and contemporary work. In addition to its showings at the Pollock Galleries at Southern Methodist University and at the Witte Memorial Museum, the exhibition traveled to the University of Texas at Austin, the Amon Carter Museum of Western Art in Fort Worth, and the Museum of Texas Tech University in Lubbock.

The decade of the 1970s found the Association intensifying its interest in local arts and crafts and using its growing collections for major exhibitions. Director Jack R. McGregor was instrumental in organizing some blockbuster shows. For his initial effort in the field, The Meyer Family: Master Potters of Texas, he enlisted local authorities Georgeanna Greer and Harding Black as guest curators. This show revealed the quality, beauty, and sheer sensitivity of mundane, utilitarian potterywares made in Atascosa County at the edge of San Antonio. In conjunction with the exhibition, Greer and Black wrote a catalogue published in 1971 by Trinity University Press.

The next ambitious show, the Texas Furniture and Decorative Arts exhibition assembled in 1973, catapulted the San Antonio Museum Association into the national spotlight. When Utterback left the Association's staff to become museum projects director for the Texas Commission on the Arts, McGregor assigned the responsibility for the show's organization to Cecilia Steinfeldt, curator of history. Donald L. Stover, who had invaluable knowledge of handcrafted furniture, served as associate curator for the project. The extensive show utilized all changing exhibition galleries in the Witte Memorial Museum as well as the historical houses on the museum grounds. Much of the furniture was borrowed from collectors, including handsome pieces from Mr. and Mrs. Charles L. Bybee, Ted James, Mr. and Mrs. Paul Herder, and Walter Nold Mathis. Decorative arts complemented the furniture: Texas-made quilts, coverlets, silver, pottery, needlework, metalwork, and folk art; Texas paintings, prints, maps, and drawings completed the panorama.

Recognized as a pioneering event in the area of Texas works of art, it was well reviewed throughout the country. The catalogue published by Trinity University Press in conjunction with this exhibition has long since become a collector's item.

Other significant exhibitions followed. In 1974–1975, Theodore Gentilz: A Frenchman's View of Early Texas was a tribute to the book, *Gentilz: Artist of the Old Southwest*, by Dorothy Steinbomer Kendall and Carmen Perry. In 1975 another important show, The Onderdonks: A Family of Texas Painters, was curated by Cecilia Steinfeldt. She also wrote the book of the same title. A particularly appropriate endeavor for the Association to undertake, it included works by Robert and Julian Onderdonk and numerous miniatures by Eleanor Onderdonk.

In 1976 a joint venture with the University of Texas Institute of Texan Cultures at San Antonio resulted in an exhibition, Iwonski in Texas: Painter and

Citizen. James Patrick McGuire of the Institute's staff prepared the catalogue. Cecilia Steinfeldt assisted McGuire in locating and selecting examples of Iwonski's work. In 1977 came Tischlermeister Jahn: A Texas Cabinetmaker, again supervised by the curator of history and accompanied by a comprehensive publication compiled by Donald Stover.

In 1978–1979 a large and innovative exhibition, A Survey of Naive Texas Artists, set a precedent in its field. A book, *Texas Folk Art: One Hundred Fifty Years of the Southwestern Tradition*, published in 1981, was based upon the exhibition. Cecilia Steinfeldt was responsible for the exhibition as well as the publication.

The opening in 1981 of the San Antonio Museum of Art, a large and handsome new facility of the Association, allowed selections from The Texas Collection to be showcased to much greater advantage. Furthermore, The Texas Collection has increased so significantly that special exhibitions can be constituted solely from the Association's holdings, each displaying the depth, maturity, and interpretative meaning of Texas's art.

One such display was organized in 1986 in recognition of Cecilia Steinfeldt's many years of service to the Association and her dedication to furthering interest in the field of Texas arts and crafts. Texas Seen/Texas Made, supervised by John Mahey, director, San Antonio Museum of Art, and supported by the Association's Board of Trustees with Mrs. Gilard Kargl and Gilbert M. Denman, Jr., as chairpersons, concentrated on Texas paintings, augmented with prints, furniture, and decorative arts.

This publication is intended to be a tribute to all of these people who have been so perceptive as to realize the importance of maintaining our rich Texas heritage. But most of all, it is a memorial to Ellen Schulz Quillin and Eleanor Onderdonk, who established the nucleus of The Texas Collection.

Finally, we would like to thank the National Endowment for the Arts, a federal agency; the Horse Creek Trust of San Antonio; and Charles Butt and H-E-B of San Antonio for grants that made the publication of this book possible.

MARK LANE
Director
Witte Memorial Museum

This catalogue has been a long time in preparation and has involved many people. Each has contributed assistance in research, shared his or her knowledge and expertise unselfishly, and provided the encouragement and support so necessary to complete the project. There are so many to thank for their help and patronage that it is difficult to select those of most importance and virtually impossible to remember and acknowledge them all.

In the beginning, the book was the brainchild of Jack R. McGregor, SAMA director from 1970 to 1979. When Helmuth Naumer took over the reins of the Association in 1979, the focus of the museums changed somewhat, and, although the catalogue was not entirely abandoned, other projects took priority. In 1986, when Bradford R. Breuer served as interim director, his fervor for Texana and Texas history prompted him to resurrect the project and approach the Texas State Historical Association with a cooperative concept. TSHA Director Dr. Ron Tyler responded with interest and enthusiasm, and so it was back to the libraries, files, and records with steadfast determination to complete the task. Since that time, Mark Lane, director of the Witte Museum, and Dr. E. Laurence Chalmers, Jr., former president of the Association, have unfailingly lent their support whenever necessary. And John Mahey, then director of the San Antonio Museum of Art, furnished welcome sympathy and understanding.

It seems quite proper at this point to acknowledge Eleanor Onderdonk, art curator at the Witte Memorial Museum for thirty-five years, whose obsession for maintaining files on Texas artists and Texas history made it possible for me to find much information at my very fingertips. In a sense, her spirit seemed with me at every turn, and her devotion to The Texas Collection inspired me continually. Her successor, Martha Utterback, was just as diligent in keeping records that proved invaluable in my research.

Martha continued to provide information in her present role at the DRT Library at the Alamo. Her advice and her recall of events and artists were illuminating and reassuring. Two other colleagues with whom I have worked for years were Dr. William Elton Green, former associate curator of history for SAMA, and James Patrick McGuire of the Institute of Texan Cultures. McGuire was a fountainhead of information concerning not only the nineteenth-century German artists who worked in Texas but also the frontier environment in which they labored. Green, a meticulous researcher, ferreted out facts and incidents never before placed in proper context. These experts perused the manuscript and contributed immeasurably to its accuracy.

The other great source for material proved to be the records kept by Jerry Bywaters, former director of the Dallas Museum of Fine Arts. These documents are now housed at the Hamon Arts Library at SMU. Dr. Sam Ratcliffe and his assistant, Marla Ziegler, were generous to the point of embarrassment with their assistance. They allowed me free access to Bywaters's voluminous files, which filled the gap for information primarily on artists of the early twentieth century. They are to be commended for their conscientious guardianship of these records.

Dr. Don E. Carleton and his talented staff at the Eugene C. Barker Texas History Center at the University of Texas at Austin were equally helpful. They graciously provided worlds of microfilm, old newspapers and magazines, as well

as material from vertical files and ephemeral matter unavailable elsewhere. The Austin History Center is ahead of the computer game with index cards that defy description and added bits of information to the biographies in this catalogue otherwise unattainable.

Other individuals who must be acknowledged are J. C. Martin and Winston Atkins at the San Jacinto Museum of History in Houston. Additonal sources in that city were the Public Library, the Museum of Fine Arts, Michael Brown of the Bayou Bend Collection, Pat Butler, formerly with the Harris County Heritage Society, and Mrs. Frank Freed. Others who helped in various ways were Lynn Denton of the Texas Memorial Museum, the University of Texas at Austin; Violet Sigoloff Flume of Sigoloff Galleries in San Antonio; the librarians at La Retama Library in Corpus Christi and at Trinity University in San Antonio; Dora Guerra and Dr. Michael F. Kelly of the John Peace Library, Special Collections, the University of Texas at San Antonio; Dan Havlick and Jean Carefoot of the Texas State Archives in Austin; Milan R. Hughston of the Amon Carter Museum in Fort Worth; John Hyatt and Lise Darst of the Rosenberg Library in Galveston; and Forrest Keane, Curator, Abilene Museum of Fine Arts.

I would like especially to acknowledge the help of Linda Wooten, who served as special researcher, albeit for too short a time, as she married and moved to Bryan, Texas; and of Dr. William H. Gerdts, professor of art history at the Graduate School of the City University of New York. Dr. Gerdts, an avid art historian, courteously provided little-known but extremely vital bits of information that clarified certain aspects of the more contemporary painters. I salute him not only for his prodigious fund of knowledge, but also for the bulldog tenacity needed to acquire that information.

San Antonio's Carmen Perry was consulted whenever there was a knotty problem with accents or spellings in the Spanish language. Michael R. Grauer, curator of art at the Panhandle-Plains Historical Museum in Canyon, Texas, generously critiqued the Frank Reaugh biography, correcting errors and enriching factual material. And I wish to thank Lois Boyd, Victoria Moreland, and Martin Kohout, who edited the manuscript, for their unfailing grasp of the complexities involved and for their consistent tolerance and patience throughout.

Last, but certainly not least, I acknowledge the assistance and support from members of the SAMA staff. First, I humbly express my gratitude to my very efficient secretary, Karen Branson. Karen translated my illegible scribblings into coherent computer read-out versions, an arduous task, with alacrity and skill, and did it with verve, graciousness, and scrupulous attention to detail. Rebecca Huffstutler, Karen's successor, assisted with these tasks. George Anne Cormier, SAMA's librarian, was able to supply data that was difficult for me to retrieve. Rick Casagrande and Kim Peel, registrars, dug into the innermost depths of SAMA's early records to provide information on exhibitions and publications. Margie Shackelford, development coordinator, initiated the grant with the National Endowment for the Arts, and Judy Gibbs, her successor, coped with grant extensions for more time so that this publication would be worthy of the NEA, the Texas State Historical Association, and SAMA, as well as a significant contribution to American art history. Grants require matching funding, and my gratitude is extended to many generous donors listed elsewhere who helped to match NEA funds.

As work progressed, however, it became evident that the increasing size and scope of the publication would require additional funding. New works of art were being added to SAMA's Texas Collection that required more research material to be appended. The book would not stop growing. It was then that the Horse Creek Trust, through the courtesy of Miss Esther Berry, and H-E-B, through the courtesy of Charles Butt, came to the rescue. Their assistance ensured more color inserts, more sophisticated design techniques, and greater comprehensiveness in the text, making the book a substantial contribution to Texas history.

The enthusiasm expressed by Dr. William H. Goetzmann, who has supplied the superb introduction, further inspired me in my efforts to make the publication worthy of the artists represented and a tribute to those who have helped me along the way. And, as always, I am grateful for the patience and understanding of my husband, Eric, and my family. They spent many long hours in solitude that could have been spent in leisure and recreation while I pursued my own selfish interests in completing this work. To those I have unwittingly omitted, my humblest apologies.

As one who owes so much to so many, may I say I feel I have performed merely as a catalyst in amassing information on Texas artists for future generations.

CECILIA STEINFELDT
Senior Curator
Witte Museum

SAN ANTONIO MUSEUM ASSOCIATION TRUSTEES

CONTRIBUTORS

This book was made possible in part by generous contributions from:

Mrs. Claude B. Aniol, San Antonio, Texas
Anonymous
Mr. and Mrs. Harvey H. Belgin, San Antonio, Texas
Mrs. Arthur S. Bennett, San Antonio, Texas
Miss Esther Berry, San Antonio, Texas
Mr. and Mrs. Albert M. Biedenharn, Jr., San Antonio, Texas
Mr. and Mrs. Louis Bishop, San Antonio, Texas
Mrs. Mary Lee Blackmon, San Antonio, Texas
Dr. and Mrs. George N. Boyd, San Antonio, Texas
Mr. and Mrs. William A. Bristow, San Antonio, Texas
The Brown Foundation, Inc., Houston, Texas
Mrs. Emily B. Browning, San Antonio, Texas
Mr. and Mrs. J. Fred Buenz, San Antonio, Texas
Lt. Col. and Mrs. Harry C. Burkhalter, Jr., San Antonio, Texas
Mrs. Lois Wood Burkhalter, San Antonio, Texas
H. E. Butt Grocery Company, San Antonio, Texas
Ms. Patsy Buys, San Antonio, Texas
Mrs. Charles L. Bybee, Houston, Texas
Miss Helen Campbell, San Antonio, Texas
Mr. Fidel G. Chamberlain, Jr., San Antonio, Texas
Mrs. Dorothy S. Chamberlain, San Antonio, Texas
Miss Joyce Erbe Chamberlain, San Antonio, Texas
Miss Margaret Cousins, San Antonio, Texas
Mrs. B. M. Crenshaw, San Antonio, Texas
Mrs. Cornelia E. Crook, San Antonio, Texas
Mrs. Julia L. Cauthorn, San Antonio, Texas
Mr. Gilbert M. Denman, Jr., San Antonio, Texas
Mrs. Henry B. Dielmann, San Antonio, Texas
Helen and Don Douglas, San Antonio, Texas
Miss Ruby Dugosh, San Antonio, Texas
Duncan Foundation, San Antonio, Texas
Mr. Clyde W. Ellis, San Antonio, Texas
Mrs. E. S. Emerson, San Antonio, Texas
Mrs. Marion L. Evans, San Antonio, Texas
Dr. and Mrs. Donald E. Everett, San Antonio, Texas
Mrs. Rowena G. Fenstermaker, San Antonio, Texas
Col. and Mrs. William P. Francisco, San Antonio, Texas
Mrs. Frank Freed, Houston, Texas
Miss Gloria Galt, San Antonio, Texas
Mr. Gordon N. George, San Antonio, Texas
Mr. Lukin Gilliland, San Antonio, Texas
Miss Mary Vance Green, San Antonio, Texas
Dr. Georgeanna H. Greer, San Antonio, Texas
Mrs. Martin E. Griffin, Jr., San Antonio, Texas
Mrs. Julia G. Groce, San Antonio, Texas
Mr. and Mrs. Henry Guerra, San Antonio, Texas
Mr. and Mrs. J. H. Guillory, San Antonio, Texas
Mr. and Mrs. Hugh Halff, Jr., San Antonio, Texas
Mrs. Fred Hamilton, San Antonio, Texas
Mr. and Mrs. Albert Hausser, San Antonio, Texas
Mr. and Mrs. Otto Hegemann, San Antonio, Texas
Mrs. Karen J. Hixon, San Antonio, Texas
Mr. and Mrs. Reagan Houston III, San Antonio, Texas
Dr. Milton S. Jacobs, San Antonio, Texas

Dr. and Mrs. David Jacobson, San Antonio, Texas
Miss Constance J. Jones, San Antonio, Texas
Mrs. Floy Fontaine Jordan, San Antonio, Texas
Mrs. Gilard Kargl, San Antonio, Texas
Mr. and Mrs. Charles J. Katz, San Antonio, Texas
Mrs. Maurine J. Kincaid, San Antonio, Texas
Mr. and Mrs. S. Peter Lambros, San Antonio, Texas
Mrs. C. Ralph Letteer, San Antonio, Texas
The Lifshutz Fund, Inc., San Antonio, Texas
Lt. Gen. and Mrs. Sam Maddux, Jr., San Antonio, Texas
Lt. Col. and Mrs. Bernard J. Marazzini, Jr., San Antonio, Texas
Mrs. B. B. McGimsey, San Antonio, Texas
Mr. James P. McGuire, San Antonio, Texas
Mrs. William B. McMillan, San Antonio, Texas
Mrs. Laura B. McNeel, San Antonio, Texas
Mr. and Mrs. Octavio Medellin, Bandera, Texas
Mr. and Mrs. Vaughan B. Meyer, San Antonio, Texas
Mrs. L. C. Negley, San Antonio, Texas
Ms. Leslie Nelson Negley, San Antonio, Texas
Miss Margaret M. Nelson, San Antonio, Texas
Mr. Joe W. Nicholson, San Antonio, Texas
Mr. and Mrs. Jerry W. Nicks, San Antonio, Texas
Maj. Gen. and Mrs. Thetus C. Odom, Signal Mountain, Tennessee
Frederic J. and Dorothea Oppenheimer Foundation, San Antonio, Texas
Miss Mary Louise Ovenshine, San Antonio, Texas
Mr. Joseph Polley Paine, San Antonio, Texas
Miss Ladie Jane Paschal, San Antonio, Texas
Miss Carmen Perry, San Antonio, Texas
Dr. and Mrs. James E. Pridgen, San Antonio, Texas
Mrs. Cherry Rainone, Rainone Gallery, Inc., Arlington, Texas
Mrs. Gregg Ring, Houston, Texas
Mrs. Ofelia L. Robbie, Gladstone, New Jersey
Rosenberg Library Association, Galveston, Texas
Mrs. Florence K. Rosengren, San Antonio, Texas
The Estate of Mary N. Rosenthal, San Antonio, Texas
Paul Rossbach Public Relations, San Antonio, Texas
San Antonio Conservation Society, San Antonio, Texas
Mrs. Margaret W. Saunders Block, San Antonio, Texas
Maj. Anna K. Schelper, San Antonio, Texas
Mrs. Dorothy T. Schuchard, San Antonio, Texas
Mrs. Sylvia Schwebke, San Antonio, Texas
Mrs. John W. Seaman, San Antonio, Texas
Mr. and Mrs. Glen Skaggs, San Antonio, Texas
Mrs. Adair R. Sutherland, San Antonio, Texas
Mr. and Mrs. Seth W. Temple, San Antonio, Texas
Mr. and Mrs. R. P. Thomas III
Dr. and Mrs. Don Tobin, Bandera, Texas
Mrs. Elizabeth H. Urschel, San Antonio, Texas
Miss Martha Utterback, San Antonio, Texas
Miss Ann Maria Watson, San Antonio, Texas
Mr. and Mrs. Sidney H. Wiedermann, San Antonio, Texas
Mrs. Murray Winn, San Antonio, Texas
Mrs. Benjamin K. Wyatt, San Antonio, Texas
Mr. and Mrs. William I. Wyatt, Jr., San Antonio, Texas
Mr. Liston Zander, San Antonio, Texas
Mr. Scott Zesch, Mason, Texas
Miss Elizabeth Zogheib, San Antonio, Texas

by William H. Goetzmann

1. William H. Goetzmann and Becky Duval Reese, *Texas Images and Visions* (Austin: Archer M. Huntington Art Gallery, University of Texas, 1983), 16.

2. See Linda Ayres, "William Ranney," in Ron Tyler, Linda Ayres, Warder H. Codbury, Herman J. Viola, and Bernard Reilly, *American Frontier Life: Early Western Painting and Prints*. Introduction by Peter Hassrick. (New York: Abbeville Press, 1987), 79–107.

3. William H. Goetzmann and William N. Goetzmann, *The West of the Imagination* (New York: W. W. Norton & Co., 1986, passim; William Truettner (ed.), *The West as America: Reinterpreting Images of the Frontier, 1820–1920* (Washington, D.C.: Smithsonian Institution Press, 1991), passim.

4. William Truettner, "The West and the Heroic Ideal: Using Images to Interpret History," *The Chronicle of Higher Education* (November 20, 1991), 132

In the summer of 1989, speaking at the Buffalo Bill Historical Center in Cody, Wyoming, James Michener put the question: Why had states like Wyoming, Montana, and Colorado produced significant and beautiful renditions of their environments when Texas had not? In one sense, the answer is clear enough. Texas had no Missouri River, hence no 3,000 miles of scenic panorama for artists to paint from steamboats and keelboats. No picturesque Oregon Trail crossed its terrain. Majestic mountain ranges like the Rockies and the Sierras were mere mirages on the vast emptiness of the Staked Plains. Texas had no Yellowstone or Yosemite, and its Grand Canyon, the Palo Duro, drew only the genius of Georgia O'Keeffe and certainly few tourists, so remote was its location. Thus railroads did not pay photographers and artists to picture Texas as did the Union Pacific, the Denver and Rio Grande, and the Great Northern that crossed the Rockies. The Santa Fe employed great painters like Thomas Moran to work up splendid scenes of the Grand Canyon. It also employed the Taos Society of Artists and the Santa Fe group to paint an endless number of pictures of Pueblo Indian culture. Meanwhile, the Southern Pacific that crossed Texas on the way to California employed artists to tout only its California scenery and mission culture. To the Southern Pacific, the huge Texas missions like those in San Antonio were not important, though today picturesque San Antonio ranks among the top ten tourist cities in America. These are a few of the reasons why Texas failed to attract the attention of many eastern practitioners of the "fine arts."[1]

Texas was not, however, without an interesting art tradition, as Cecilia Steinfeldt, author of this subtle and varied catalogue, *Art for History's Sake*, proves conclusively. People—genre scenes and portraits—rather than geysers and the Rocky Mountains predominate. Without being formal history paintings like Emanuel Leutze's overblown cavalcade of westbound Americans, *Westward the Course of Empire Takes its Way*, the Texas genre paintings reveal a great deal about life on a frontier that was remarkably cosmopolitan. Indeed, even the numerous paintings of ruined San Antonio missions represent evidence of this cosmopolitanism, as do the portraits of substantial German immigrants and the scenes of native Americans. And, as more and more artists came to Texas, not only was this cosmopolitanism enhanced, but nineteenth-century Texas saw the introduction of a variety of Eurpoean art styles that represent a palimpsest of historical mind sets. William Tylee Ranney, a noted Brooklyn artist, rushed to take part in the Texas Revolution and stayed awhile to paint Texas plainsmen, and we must be grateful for those federal government-sponsored artists like Captain Seth Eastman, Arthur Schott, and John Russell Bartlett whose works illustrated Texas in the 1850s.[2]

But in the present author's *The West of the Imagination* (1986) and, subsequently, in William Truettner's *The West as America* catalogue and controversial captions to his Smithsonian exhibition of the same name, we learn that art as history can be deceptive.[3] In Truettner's exhibition we learn that it can be a sinister tool of capitalist and racist interests. Since images of the West do not "mirror history," writes Truettner, "they respond to issues that deeply concern their intended audience." According to some "new" western art historians, currents of aesthetic fashions likewise had nothing to do with artistic production, which was solely a function of caste and class.[4] So where does that leave the present Witte Museum collection of Texas art in the eyes of "new" western historians and "new" art historians?

In many ways it leaves the art represented in the Witte exhibition and catalogue in the very forefront of contemporary "new" western history and "new" western art history. Few collections illustrate images of ethnicity, common people, religious diversity, class structure, and female achievement like the Witte collection. Few assemblies of paintings in one place in the United States represent the cosmopolitanism of the Witte's exhibition, no matter what art style of the day reigned. There were, of course, the immigrant artists, primarily from Europe, who came to central Texas in the wake of Prince Solms Braunfels's colony. Many of these were German or German-Jewish. They bore names like Lungkwitz, von Iwonski, Wueste, Mueller, and Schloss, to name a few. Then there were the French: Gentilz, Frétellière, and Chabot; the Dutch-descended Onderdonks, Robert and Julian; and Spaniards such as José Arpa y Perea, as well as the Galveston-born Hispanic cotton brokers, the Gonzaleses, father and son. It was these largely immigrant or ethnic artists reinforced by the New York Onderdonks who created the first tradition in and around San Antonio, though they followed in the wake of the military-expedition artists like John Mix Stanley or another immigrant, the Haitian-born John James Audubon, who visited Texas in 1837.

Jean Louis Theodore Gentilz, who arrived in San Antonio in 1844, was preeminent as a founder of the immigrant artist tradition. He had studied art, surveying, and map-making in Paris and had been persuaded to come to Texas by Count Henri Castro, a French Jew who was described as a "great capitalist wo wished to establish a colony in Texas" where he had obtained a land grant for settlement along the banks of the Medina River sometime in the early 1840s.[5] To prospective and desirable people, he spread the challenge, "Would you like to earn a million in five years?"[6] The inclusion of cultured, ambitious people like Gentilz in the central Texas immigrant colonies was typical. Indeed, a whole coterie of Kantians founded a Utopian colony in Sisterdale, not far from Fredericksburg, Texas. Gentilz, who never earned a million dollars, nonetheless early on began teaching art in San Antonio. One of his pupils was his wife, Marie Fargeix Gentilz. Another was his niece, Louise Andree Frétellière. Soon he had a significant number of pupils—mostly French and German immigrants.

Gentilz's own paintings set an important example for future artists. He was the first to paint the Alamo, which he did in 1844 just eight years after the battle.[7] But more important, he was fascinated by the Hispanic life of the city. His first house was a Mexican *jacál* made of vertical mesquite logs chinked with clay and roofed with tules, which his friend-roommate Auguste Frétellière declared "served as a refuge for scorpions, spiders, centipedes and other animals whose company no one likes."[8]

Gentilz's paintings included a view of his *jacál*, but also numerous views of the ruined Spanish missions as mute reminders of Spanish glory. More important, however, Gentilz recorded the social life of San Antonio's distinctive Hispanic community in numerous paintings that indicated his fascination with every phase of that culture from cantinas and fandangos to tamale vendors and Mexican milkmen. Thus this French painter brought to the fore a rich social life almost unknown to the Anglo establishment and East Coast-dominated art circles. Had he been better known in his time, Gentilz's numerous paintings of Mexican San Antonio, from its faded mission-period glories to the lively culture of his day, might well have proved fascinating in an

5. Dorothy Kendall, *Gentilz, Artist of the Old Southwest* (Austin: University of Texas Press), 5.
6. Ibid.
7. Ibid., 8.
8. Ibid.

era when regional fiction was a vogue, and an ever-increasing number of tourists were looking West.

Gentilz's painting of peaceful Lipan Apaches and menacing Comanche warriors would certainly have captured East Coast attention. They represented some of his best work. *Camp of the Lipans* (1896) is a pastoral scene with a mother and a child, a man bow fishing, youngsters learning to ride, braves in earnest conversation as they wander from one small tipi to another in a benign tree-studded landscape along the Medina River. In another painting of the same year, however, he depicts Comanches on the warpath with a mountain—perhaps the Sierra Blanca Mountains, 400 miles west of Castroville near the Rio Grande—in the background. They are far from Castroville and not half fierce enough, given the fact that Comanches had raided both San Antonio and Castroville.

Gentilz, who is extensively represented in the Witte's holdings, painted other scenes not included in this catalogue. At least two of these must be noted. *Camel and Rider* (ca. 1856–1857) is a compelling view of a Turk riding a camel at Camp Verde north of San Antonio. This peep at orientalism commemorates Secretary of War Jefferson Davis's famous experiment with camels on what were considered the deserts of Texas. It further signals Gentilz's fondness for the exotic in the regional culture around him. A second painting not in the catalogue *Stick Stock*, or *Surveying in Texas before Annexation to the* U.S., portrays Gentilz at what was perhaps his primary work, surveying—in this case probably laying out the town of Castroville, twenty-five miles west of San Antonio on the edge of the wilderness frontier.[9] Gentilz was a precise draftsman, whereas, as a painter, he was definitely a folk artist whose figures were often expressionless and naive, yet had a certain charm. He was indeed a pioneer painter.

But what "issues of deep concern" did Gentilz's work address, and what was his "intended audience" in William Truettner's "new" western art historical terms? We know from Dorothy Kendall's *Gentilz, Artist of the Old Southwest* that Indian raids still plagued both San Antonio and Castroville in Gentilz's day.[10] We also know that Gentilz was fascinated with Bowie, Fannin, and Seguin's conquest of San Antonio in the Battle of Mission Concepción on October 28, 1835, which is why he took special pains to paint this mission in detail.[11] Thus an innocuous architectural rendering of an Hispanic structure becomes a symbol of heroic Anglo conquest. Further, Gentilz took extensive notes on the Battles of Alazan and Medina in the War for Mexican Independence, and he was especially interested in the siege of the Alamo, which he painted after making dozens of drawings of the people involved, the weapons, even the positions of the sun on that fateful day.[12] He also interviewed numerous eyewitnesses in San Antonio. Alas, his *Battle of the Alamo* painting was destroyed in a fire that ravaged the Mueller art supply store in San Antonio.[13] Other pictures survived, however: *Death of Dickinson*, *Drawing of the Black Beans*, and *Shooting the 17 Decimated Texians at El Salado, Mexico*.[14] In the former we see Dickinson facing Santa Anna and surrounded by Mexican soldiers, pleading for his life, holding his young child up before him— a now discredited scene. In the latter we see Texians from the Mier expedition perishing before a firing squad, while some of those same happy Mexican civilians that later cavort in Gentilz's San Antonio scenes look on. Thus we know that Gentilz was intensely interested in San Antonio's bloody military history, but we also see a basic

9. Ibid. See plates 59 and 13.
10. Ibid., 17.
11. Ibid., 21–22.
12. Ibid., 22.
13. Ibid., 22–23. Also see Plate 20 for a photograph of the painting.
14. Ibid. See plates 18 and 23.

ambiguity in his work as it concerned Mexican culture. Perhaps the resolution of this ambiguity lies in the fact that Santa Anna and his soldiery were villainous, but the Mexican peasants and common folk were not, and in fact were portrayed as flourishing under Texian rule. He also seems to have a made a distinction between the peaceful Lipan Apaches and the warlike Comanche. Does all this interest in things military, including the Camel Corps, stem from Gentilz's studies of Napoleonic military art in Paris? If so, then how account for his neglect of the Mexican-American War of 1846? Did this suggest that Gentilz always regarded himself as a Texian and never really as a citizen of the United States? Did he see Anglo-Americans and the Germanic peoples that he must have noticed all around him in San Antonio, Fredericksburg, and New Braunfels as intruders on the Texian scene? They are conspicuous by their very absence from his work. The "new" art history thus enables one to decode messages long hidden in Gentilz's work—or does it?[15]

Even as Gentilz was demonstrating the cosmopolitanism of San Antonio with a European eye and a subtlety that revealed "issues," William G. M. Samuel, the sheriff at San Antonio, took brush instead of pistol (he was a crack shot) in hand to record the lively life of San Antonio's Main Plaza in 1849. He portrayed in charming folk paintings four sides of the Plaza in systematic fashion. He was recording history, but not a history of violence as we would expect from a gun-toting sheriff. Instead what we see is San Antonio, prosperous with its vaqueros galloping about, horsemen roping runaway steers, all manner of carts, wagon trains, stagecoaches, and most of San Antonio's major buildings recorded for history. Samuel's folk art is a variety of a bustling, dynamic "Peaceable Kingdom." This image is, of course, deceptive since San Antonio has seen plenty of violence, including a fight with Comanches right in the Main Plaza in 1840, while the Alamo will forever stand as a symbol of even greater violence and tragedy in the "Peaceable Kingdom." In Samuel's naive paintings we see a crude realism, but we also see pride in the city's progress and a dream—the dream that overshadows history itself—of a prosperous, peaceful cosmopolitan city on the far frontier of Texas.

This same plaza scene is repeated much later in 1878–1879 by the much-travelled, European-trained Thomas Allen, a member of the National Academy and chairman of the Board of Trustees of the Boston Museum of Fine Arts. His *Market Plaza*, first shown in 1882 in a Paris salon, reflects the same lively cosmopolitanism reached for by Sheriff Samuel and caught by Theodore Gentilz but in far more finished European style. The churches, the *al fresco* dining in the plaza, the chili stands, the ox carts, and the colorfully painted throngs of people in his picture perhaps make this work the key to San Antonio history—a place where many different peoples have always met, beginning with the Lipans and the Comanches and carrying on through the Hispanic peoples to the French, German, and other Anglo communities. San Antonio as a multicultural crossroads of history might well be regarded as the underlying theme of this catalogue.

Another aspect of the art history of Texas that the Witte holdings reveal is the relatively large number of female artists of some prominence in Texas. Twenty women artists are represented in the collection's catalogue. They include the Frenchwomen Marie Fargeix Gentilz, Louise Andree Frétellière, Mary Chabot, and Marie Chambodut, and the German pioneer women painters Louise Heuser Wueste,

15. Ibid. On p. 14 mention is made that Castro "had to settle quarrels between the French and the Germans" But in his journal, he mentions dining regularly under "leafy trees on the banks of the Medina" with "Messes. Goubaurd, Brougeois, Fretelliere, Gentil [*sic*] Huth, Haass and Montel (paid guides) and Dr. Cupples."

Elizabeth Nette, and Ida Weisselberg Hadra, whose paintings of the *St. Mary's Street Bridge* (1883) and *View of the San Antonio River* (ca. 1883) are outstanding renditions of the old river city. Hadra's *View of the San Antonio River* contrasts the tree-shrouded right bank of the river with an almost cubistic rendering of sunlit buildings on the opposite bank. A student of Hermann Lungkwitz, the premier landscape painter in early Texas who is also represented in this catalogue, Ida Weisselberg Hadra painted many scenes that reflect his influence: *River in the Hill Country, The Ridge* (a copy of Lungkwitz's work), studies of rocks and shrubs, and *Mountain View.* She was at her best in city paintings, however. *The Old Iron Foundry on the San Antonio River* (ca. 1884) relates to her masterful San Antonio River scene, *St. Mary's Street Bridge.* All of these paintings owe much to Lungkwitz's tutelage.[16] Her view of Austin from West Seventh Street pictures some of the city's outstanding buildings, including the Texas Military Institute and the African Methodist Episcopal Church. Her decision to adopt a peculiar hillside perpective enabled her to capture developing, prosperous Austin and at the same time the unspoiled wilderness of Mount Bonnell.

Ida Weisselberg Hadra showed the extreme versatility of the art student. She painted landscapes, still lifes, city views, and portraits. The three that she did of her father, Dr. Gustave Friedrich Weisselberg, her sister Emma Weisselberg, and her aunt Emma Buchner reflect the aristocratic self-importance of a number of the German immigrant families. A neurologist who graduated from both the universities of Königsburg and Jena, Dr. Weisselberg, a student activist, had fled to Texas in 1852. By 1872 he had become superintendent of the State Lunatic Asylum—a man of no little consequence.

Louisa Heuser Wueste painted herself—a haunting portrait of a beautiful woman with a slight Mona Lisa smile that is one of the best in the Witte collection.

Eugenie Etienette Aubanel Lavender was probably the most remarkable of the Texas women painters. Born a French aristocrat whose grandfather served as a general under Napoleon in the Russian campaign, Eugenie studied under numerous masters in Paris and with the special patronage of Queen Marie Amelie Therese, the wife of King Louis Philippe who was forced to flee Paris in the Revolution of 1848. Eugenie and Rosa Bonheur, fellow art students, both received medals for their work from King Louis Philippe in 1848, somewhat before his abrupt departure from the throne. In 1846, unaware that the eligible widower George Catlin was wandering about the city, she had married Charles Lavender, a young Englishman who was a professor at the University of Paris before he abruptly decided to move Eugenie and their two children to Texas. Ms. Steinfeldt describes (see p. 152) how Eugenie exchanged her feminine garb for "deerskin trousers and jacket, a large wide-brimmed hat, and kept a pistol and a knife at her side," presumably to fight off alligators, snakes, wild animals, and hostile Indians while having her third child. She also learned to hunt, which explains her picture *Still Life with Game Birds.*

Of the more modern women artists, Mary Anita Bonner stands out for her unique work in aquatints. Raised on a ranch near Uvalde and honored with the Ordre des Palmes Academiques and the silver medal of the salon of the Société des Artistes Français, Mary Bonner made prints that form one of the high points of the exhibition and the Witte Collection. Her *Three Bucking Broncos,* which includes a "cowgirl," her comic *Bucking Steer,* and her masterful *The Cowboy Parade,* done, significantly, in 1929, the

16. For more on Hermann Lungkwitz, see James Patrick McGuire, *Hermann Lungkwitz, Romantic Landscapist on the Texas Frontier* (Austin: University of Texas Press, 1983).

year of the bumbling bankers, are examples of her incredible talent. Her aquatints portray modernistic cowboys, cowgirls, broncos, mules, and even a camel that came to symbolize a new era in Texas history, as well as art fashion. Interestingly, Bonner, in effect, *reverses* the aquatint medium in the spirit of iconoclasm. The aquatint process is an engraving technique that facilitates shading. Bonner's parade pictures eschew shading entirely. The figures in her frieze-like works stand out as cardboard cutout—like figures on a Greek vase or perhaps like the stunning frieze on the cover of Andy Adams's *Log of a Cowboy*, which Bonner must have seen and which she may well be parodying.

Texas women artists, it should be clear from the awards they received abroad, were far less obscure than many of the male Texas artists. One outstanding exception to this was Robert Jenkins Onderdonk. A student of William Merritt Chase, Walter Shirlaw, and James Carroll Beckwith at New York's Art Student' League, Robert Jenkins Onderdonk came to San Antonio in 1879.[17] He became an art teacher and founder of such artistic associations as the Van Dyke Art Club, the Brass Mug Club, and the "Chili Thirteen." Later, in Dallas, he formed the Dallas Art Students' League. Onderdonk was, in a sense, the Texas Johnny Appleseed of the New York art fashions of the later nineteenth century. He managed to create two important art communities in Texas—one in San Antonio and the other in Dallas. He, his son Julian, and his daughter Eleanor were at long last well-known Texas artists in the eastern art establishments. Despite all the wide-ranging views of San Antonio that he produced, Robert Jenkins Onderdonk is probably best remembered for his large dramatic painting, *Fall of the Alamo* (1903). Commissioned by pioneer amateur historian James De Shields, Onderdonk's painting of Davy Crockett swinging his rifle like a club before an advancing horde of swarthy Mexican soldiers became a Texas icon. Using members of his family as models, Onderdonk took a long time to complete his painting, which he declared was intended to portray "battle, murder, and sudden death!"[18] He showed Davy Crockett, in effect, defending the Alamo almost single-handed against an overwhelming force of Mexicans. It was the Texas equivalent of Custer's *Last Stand* and a far better painting than Henry McArdle's lurid *Dawn at the Alamo* (1876–1883). Onderdonk's painting, like a mural or George Caleb Bingham's Missouri masterpieces, was made up of dozens of carefully drawn pencil sketches of figures that could be moved around to strengthen the composition until he got it just right. In this work a comparison with Bingham is inevitable because both men created solid realistic figures controlled and empowered by the use of light, which had long since become fashionable in the Düsseldorf School. Onderdonk's work, via Chase and especially Shirlaw, also owed something to the school of French military art. What was the "issue" to which he addressed his painting? What was the "intent"? To portray the heroism that did not fear "battle, murder and sudden death." Onderdonk set out to create a myth. The myth he created overshadowed all his other work and, in effect, history itself. One of Onderdonk's masterful pencil sketches in preparation for his great Texas and national icon is included in the exhibition.

Julian Onderdonk ushered in a new era as far as Texas was concerned. He was the state's premier Impressionist. Though Impressionism had captivated much of the New York art establishment with a large French show in 1886, few Texas artists had

17. For more information on the Onderdonks, see Cecilia Steinfeldt, *The Onderdonks: A Family of Texas Painters* (San Antonio: Trinity University Press, for the San Antonio Museum Association, 1976).

18. Goetzmann and Goetzmann, op. cit., 86–87, 89. Also see Samuel Ratcliffe, Texas History Painting: An Iconographic Study (Ph.D. diss., University of Texas, Austin, 1985), ch. 11, p. 3.

gone beyond the *plein aire* techniques of the French Barbizon School. His memorable scenes like *Chili Queens at the Alamo, The Family at Cards,* and the pleasing pastoral *Scene Near Sisterdale* reflect the influence of a range of late nineteenth-century artists, including George Inness and Ralph Blakelock, as well as his teacher William Merritt Chase. Julian Onderdonk's splendid Impressionist rendition of a bluebonnet field in 1912 was a new kind of out-of-doors art for Texans. In 1912 bluebonnet painting was relatively new, but Julian Onderdonk's clever, stabbing foreground brushwork in vivid blue, backed by broader brushstrokes in the more distant plane of the painting, made for a stunning rendition of a scene all too often taken for granted by Texans. This painting was matched by Julian Onderdonk's *Cactus Flowers* in the same colorful Impressionist mode. The two paintings gave a new and dramatic meaning to the Texas landscape which many thought dry and barren. Julian Onderdonk's bluebonnet and cactus paintings have long since been debased by a horde of "bluebonnet school" Sunday painters, but it may perhaps be of some significance that this new view of the wildflower Texas landscape has in some ways alerted people like Lady Bird Johnson to repopulate our highway-crossed countryside with the beauties of our wildflower heritage. Art, as in the case of Julian Onderdonk and the wildflower painters' tradition, can condition people to see nature in whole new ways; in the present era of ecological consciousness, such scenes have perhaps alerted Texans to a heritage that might well have been lost to the roadside lawnmower.

At about the same time that Julian Onderdonk was introducing Impressionism to Texas, a strange German American "artist" was ushering in the age of flight from a perch above the Stelzig Saddlery and Harness Shop in Houston. C. A. A. Dellschau, formerly of Sonora and Columbia, California, and a member of the Sonora Aero Club, was painting and pasting startling collage-like views of strange imaginary aircraft on woodpulp paper mounted on cardboard. Most of these bizarre aircraft designs were derived from ideas of the sixty-two-member Sonora Aero Club in the 1850s. The colorful, balloon-striped watercolors include clippings from German and American newspapers. These works forcibly remind us of Jacob Brodbeck of Luckenbach, Texas, who apparently flew a spring powered "airship" over Dr. Ferdinand Herff's meadow outside of Boerne in 1865 and later in Luckenbach in 1874.[19]

Of the ten carefully drawn and colored Dellschau folk art pieces, a number are attributed to the members of the Sonora Aero Club who first dreamed them up. There is the *Long Distance Aero Immer* of 1910, a design attributed to August Immer. Here we have a heavier-than-air craft, with pilot, navigator, and telescope, ready to take off from hydraulic lifts. Here, too, is the *Number Seven Aero Newell,* a passenger craft equipped with a dining area, designed by one George Newell in 1857. *Babymyn* (1912) was the brainchild of Gustave Kolbe in 1858. *Aero Jourdon* (1909) is probably Dellschau's own fantasy. It is his largest work and the most luxurious of the aircraft, complete with dining area and gaming room. *Aero Goosey* (1910) was considered by Dellschau as the most perfect of any of the Aero Club designs. The Goosey was, according to Ms. Steinfeldt and John Obrecht, "designed, built, and flown by Peter Mennis around 1857."[20] One has to ask: why this interest in aircraft design by Germans in California in the 1850s? Could it be that they were seeking faster ways to the gold fields, in the middle of which stood the towns of Sonora and Columbia? Or, were these just miners

19. Anita Tatsch, *Jacob Brodbeck "Readied for the Sky" in Texas* (Fredericksburg, Tex.: Dietal and Son, 1986), 41–42, 45–46. Pages 39–40 represent Brodbeck's description of his "airship" (a name he coined). Also see pp. 66–67 for pictures of a share of stock he issued for his "airship" venture and a drawing by Fernando Cortez of San Antonio of Brodbeck's "airship." Page 68 compares Brodbeck's "airship" with the Wright brothers' "aeroboat."

20. See Steinfeldt catalogue entry (p. 55). Also see John Obrecht, "Fantasy Flight," M3, SAMA Quarterly, in *San Antonio Monthly,* 6 October 1986), 9.

passing the time in Jules Verne fantasies, aided and abetted by the "aeronautical draftsman" C. A. A. Dellschau? These watercolor precision works, studded with newspaper clippings which Dellschau called "press blooms," are among the most interesting items in the exhibition. They cry out for further research, especially since Dellschau appears to have painted them all from memory some fifty or more years after he first saw the designs. How to categorize in art terms this forerunner of Rube Goldberg is no small part of the "great Dellschau mystery." For those interested, the Witte Museum has four scrapbooks of Dellschau's work—some 622 paintings and collages, signed, dated, and numbered.

Dellschau, like Mary Bonner with her art deco works, brings us to the edge of the age of the modern. This exhibition of Texas art has not necessarily, or even obviously, been focused on history paintings. Rather, in a more subtle way, it has chronicled San Antonio and Texas history through different scenes, art styles, and insights into its lively, even fantastic, cosmopolitanism. From Sheriff William G. M. Samuel's ("the bravest man of his day") imitations of the work of the mad St. Louis artist Charles Deas (see Steinfeldt catalogue entry p. 239) through his charming naive folk art renditions of San Antonio's Main Plaza, to the relatively recent work of Otis Dozier, Everett Spruce, and Charles Bowling, one can *see* time, and time passing, which is history. This is perhaps best illustrated by a final comparison.

Take careful note of Sheriff Samuel's haunting folk portrait of the aged, beshawled Sam Houston—no longer the dashing Raven—and then look to Austinite Wayman Adams's portrait of his Russian-born, New York bon vivant friend Morris Gest. Gest, a theatrical producer and son-in-law of the great David Belasco, sits casually gesturing, with a crazy hat insouciantly perched atop his head, inside a room rich with furnishings. He is a modern man of the times. Adams's picture is full of the dash and flair colorism taught by William Merritt Chase. In contrast, Samuel's *Sam Houston* looks very crude and old. Time passes. History moves on. In this catalogue art is our clue to this process and the issues and visions it engenders.

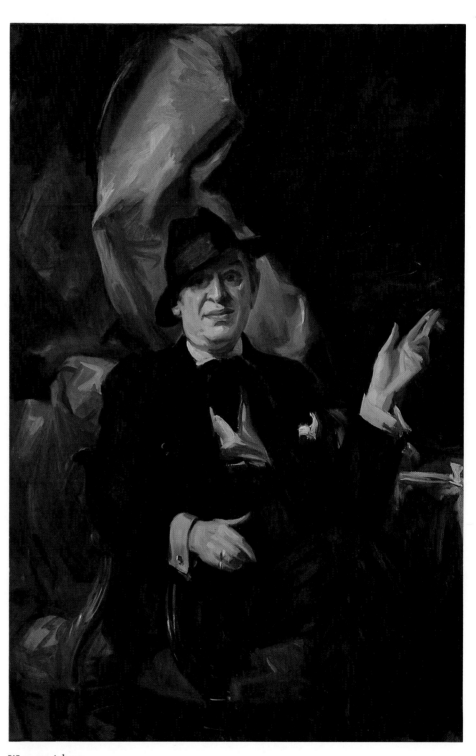

Wayman Adams
PORTRAIT OF MORRIS GEST (N.D.)

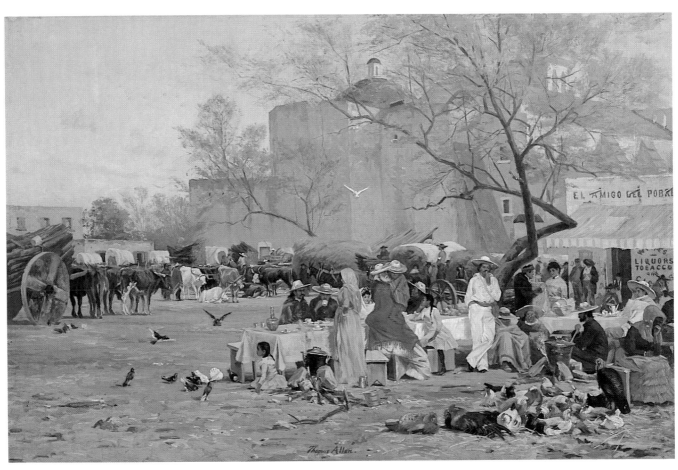

Thomas Allen
MARKET PLAZA (1878–1879)

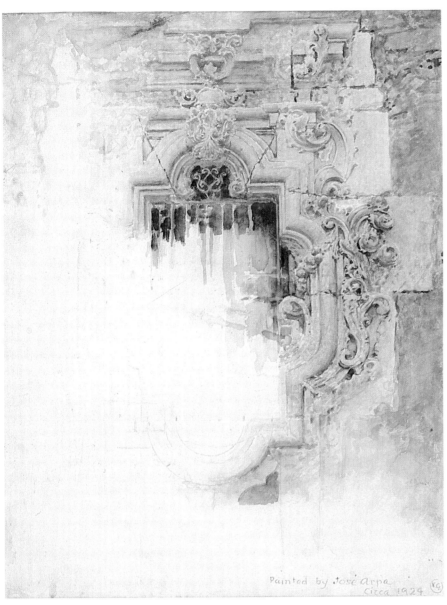

José Arpa y Perea
ROSE WINDOW (CA. 1924)

José Arpa y Perea
PORTRAIT STUDY (N.D.)

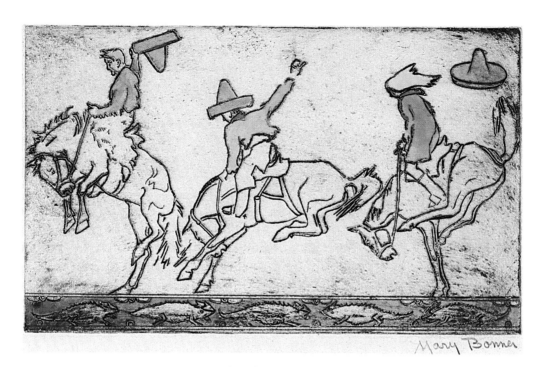

Mary Anita Bonner
THREE BUCKING BRONCOS (N.D.)

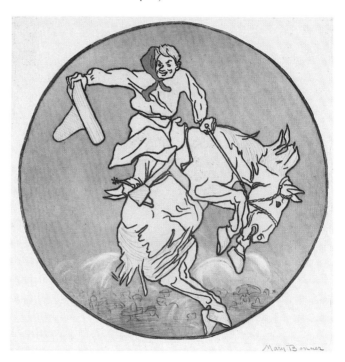

Mary Anita Bonner
CIRCULAR COWBOY (CA. 1929)

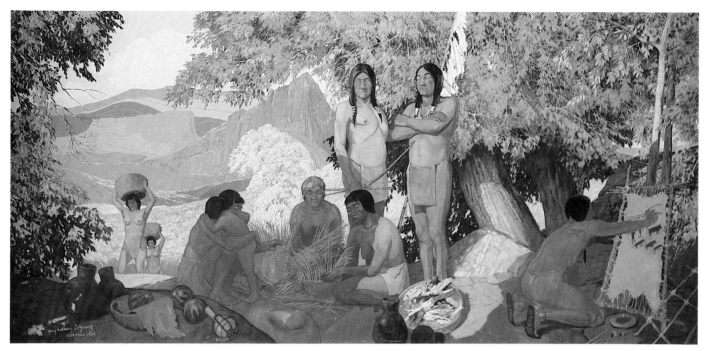

Harry Anthony De Young
TEXAS BASKETMAKER INDIANS (1934)

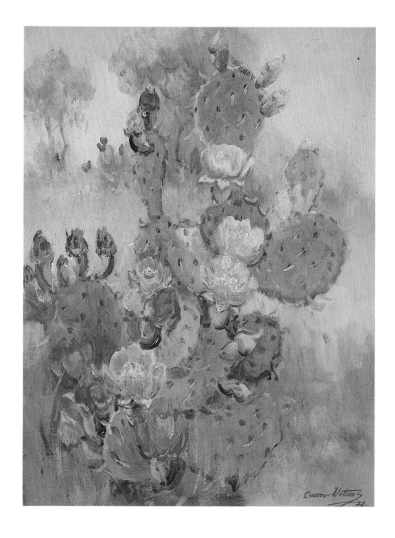

Dawson Dawson-Watson
CACTUS FLOWERS (1929)

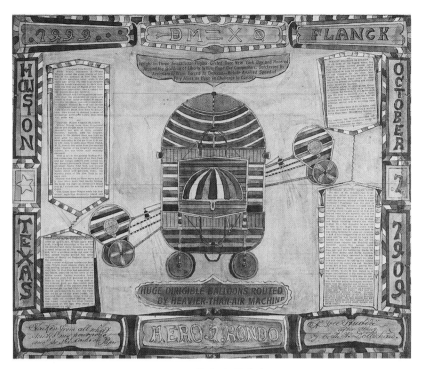

C. A. A. Dellschau
AERO RONDO (1909)

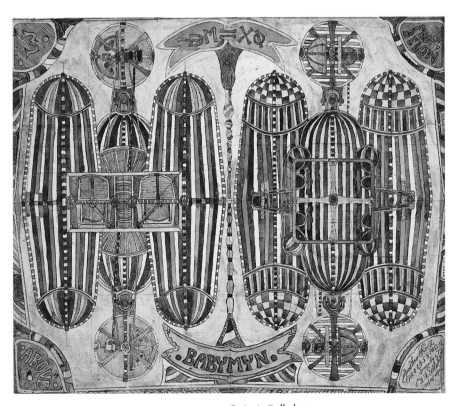

C. A. A. Dellschau
BABYMYN (1912)

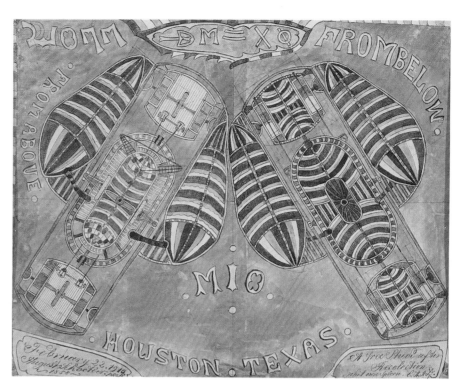

C. A. A. Dellschau
AERO MIO (1910)

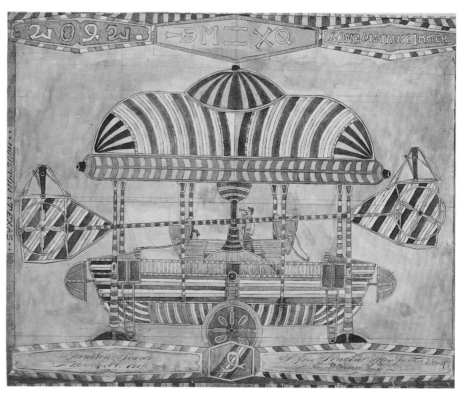

C. A. A. Dellschau
LONG DISTANCE AERO IMMER (1910)

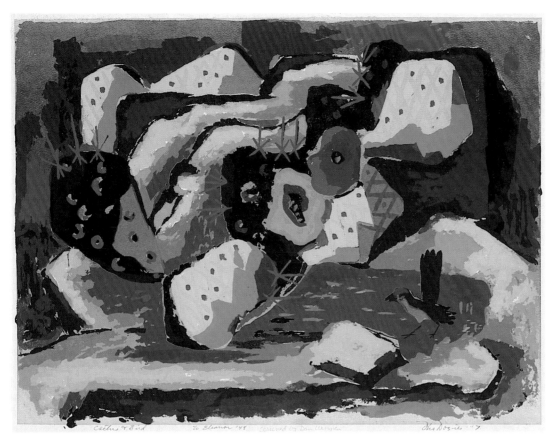

Otis Dozier
CACTUS AND BIRD (1947)

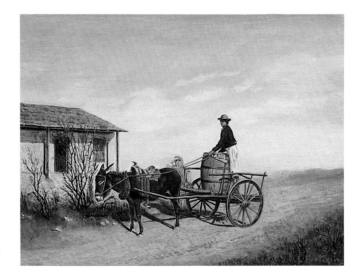

Louis Andrée Frétellière
WATER CART (N.D.)

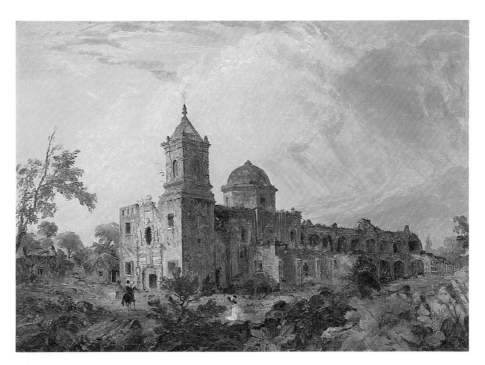

Seth Eastman
MISSION SAN JOSÉ (1848 1849)

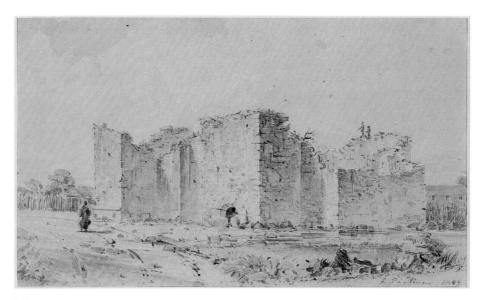

Seth Eastman
THE ALAMO (1849)

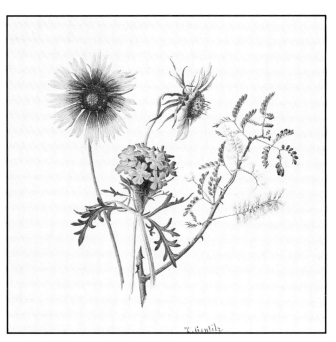

Jean Louis Theodore Gentilz
TEXAS WILDFLOWERS (N.D.)

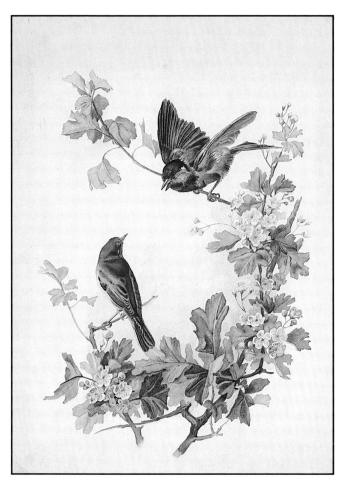

Jean Louis Theodore Gentilz
BIRDS IN FLOWERING BRANCHES (CA. 1892)

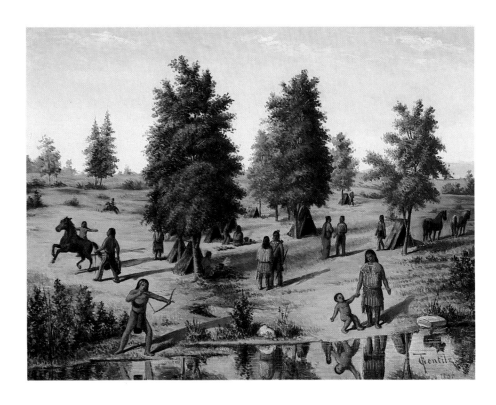

Jean Louis Theodore Gentilz
CAMP OF THE LIPANS (1896)

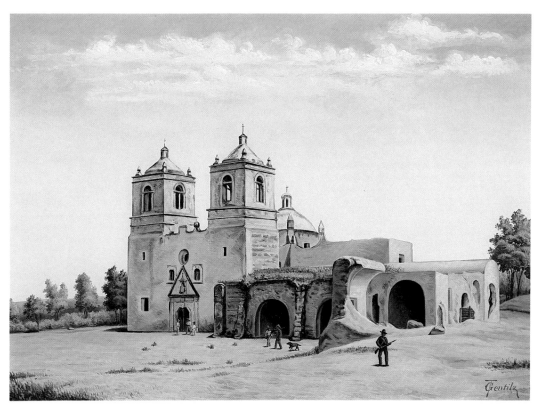

Jean Louis Theodore Gentilz
MISSION NUESTRA SEÑORA DE LA PURÍSIMA CONCEPCIÓN DE ACUÑA (CA. 1900)

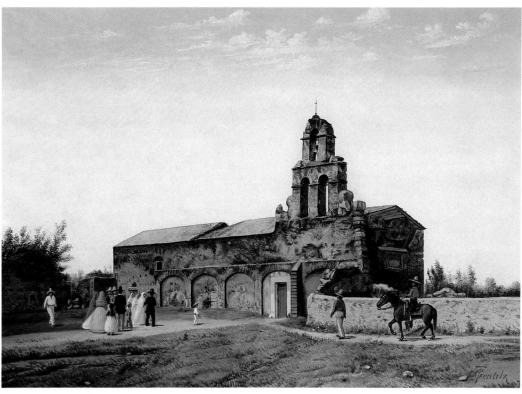

Jean Louis Theodore Gentilz
MISSION SAN JUAN CAPISTRANO (CA. 1900)

Jean Louis Theodore Gentilz
ST. MARY'S COLLEGE (1882)

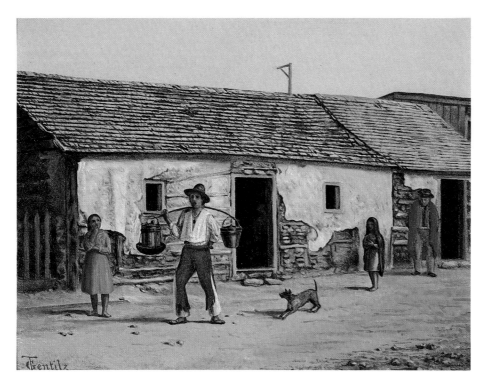

Jean Louis Theodore Gentilz
TAMALE VENDOR, LAREDO STREET,
SAN ANTONIO (N.D.)

Boyer Gonzales, Jr.
STREET SCENE IN SAN ANTONIO
(1938)

Xavier Gonzales
FARM YARD SCENE, WARING, TEXAS
(1915)

Louis Edward Grenet
MELANCHOLISCHES MÄDCHEN (MELANCHOLY MAIDEN) (N.D.)

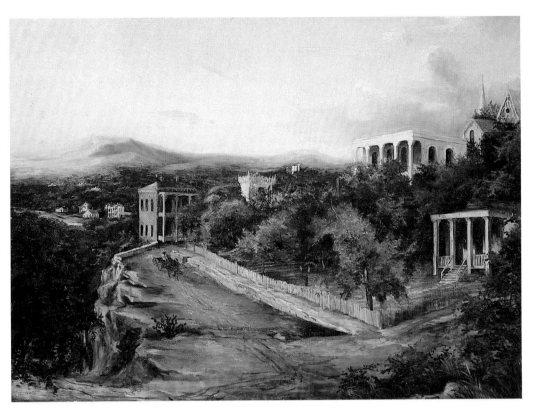

Ida Weisselberg Hadra
VIEW OF AUSTIN (N.D.)

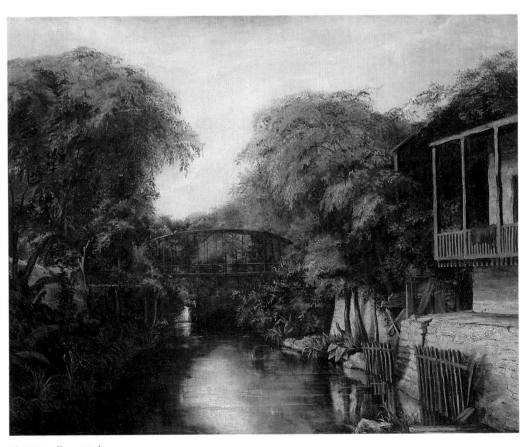

Ida Weisselberg Hadra
SAN ANTONIO RIVER AT ST. MARY'S BRIDGE (CA. 1883)

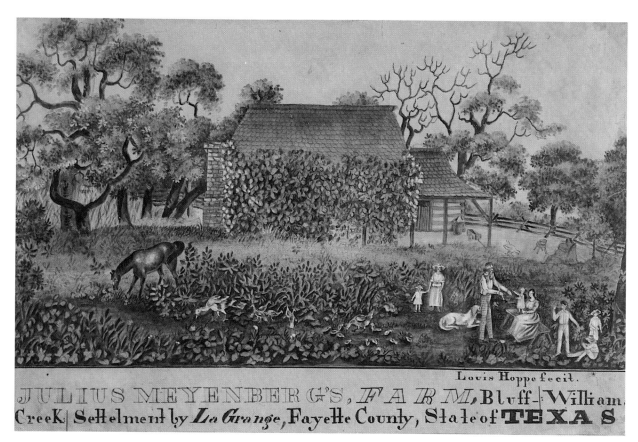

Louis Hoppe
JULIUS MEYENBERG'S FARM (CA. 1864)

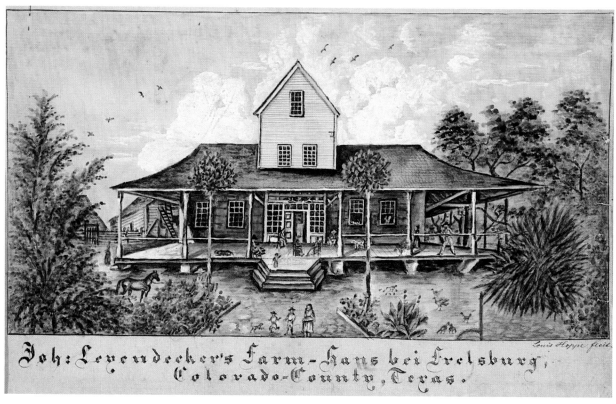

Louis Hoppe
JOH: LEYENDECKER'S FARM-HAUS BEI FRELSBURG (CA. 1863)

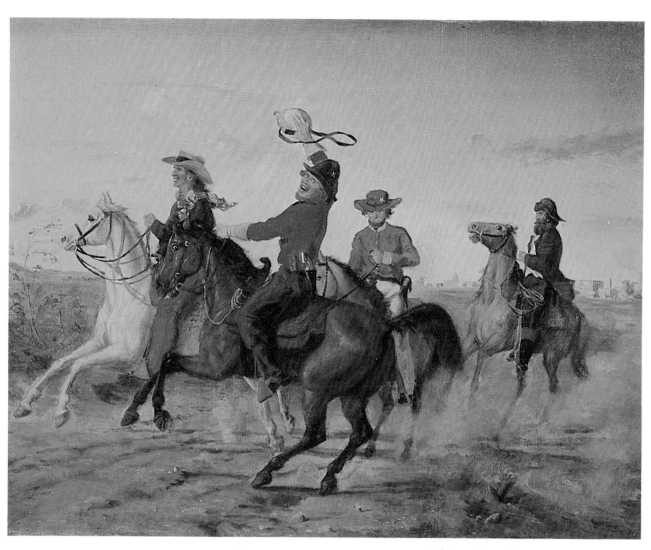

Carl G. von Iwonski
THE TERRY RANGERS (CA. 1862)

Carl G. von Iwonski
PORTRAIT OF MR. EDWARD STEVES (1873)

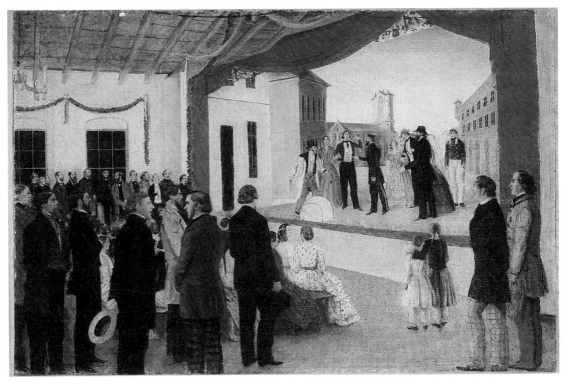

Carl G. von Iwonski
THEATRE AT OLD CASINO CLUB IN SAN ANTONIO (CA. 1858–1860)

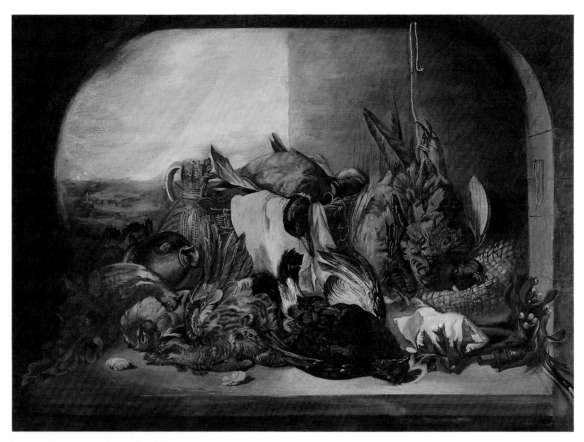

Eugenie Etienette Aubanel Lavender
STILL LIFE WITH GAME BIRDS (1892)

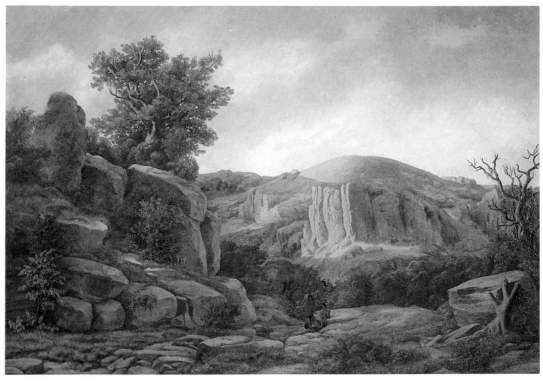

Karl Friedrich Hermann Lungkwitz
ENCHANTED ROCK, FREDERICKSBURG (1856)

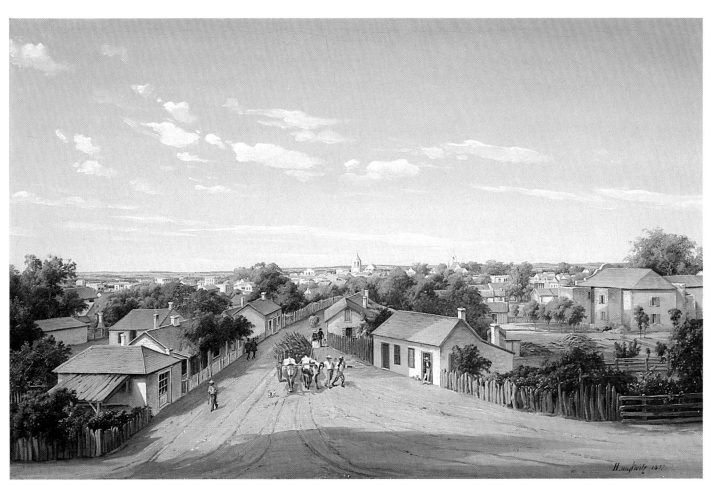

Karl Friedrich Hermann Lungkwitz
CROCKETT STREET LOOKING WEST, SAN ANTONIO DE BEXAR (1857)

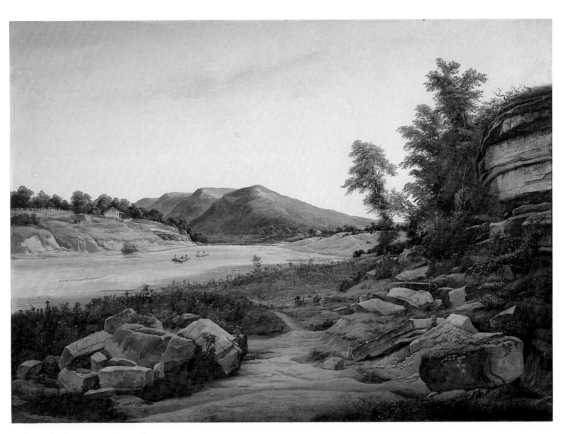

Karl Friedrich Hermann Lungkwitz
MOUNT BONNELL, AUSTIN (1875)

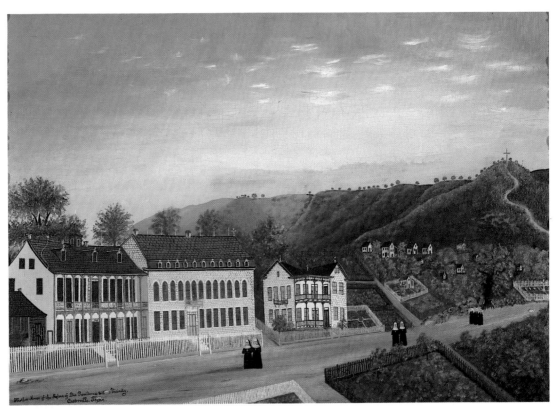

Rudolph Mueller
MOTHER HOUSE OF THE SISTERS OF DIVINE PROVIDENCE AND VICINITY, CASTROVILLE, TEXAS (N.D.)

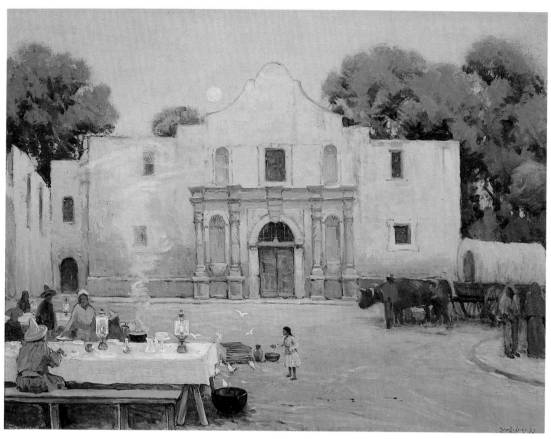

Robert Julian Onderdonk
CHILI QUEENS AT THE ALAMO (N.D.)

Robert Julian Onderdonk
SCENE NEAR SISTERDALE (1909)

Robert Julian Onderdonk
BLUEBONNET FIELD (1912)

Robert Julian Onderdonk
NEAR SAN ANTONIO (N.D.)

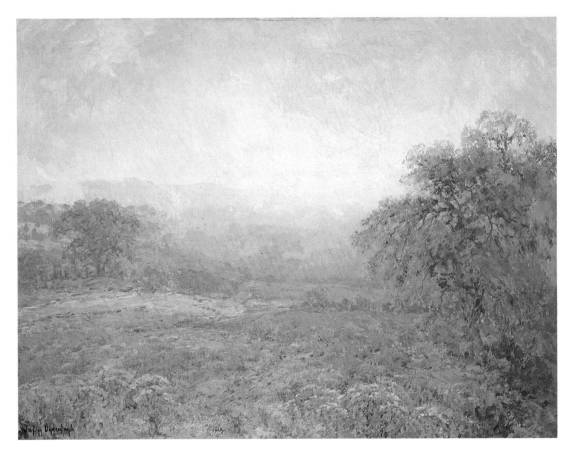

Robert Julian Onderdonk
DAWN IN THE HILLS (1922)

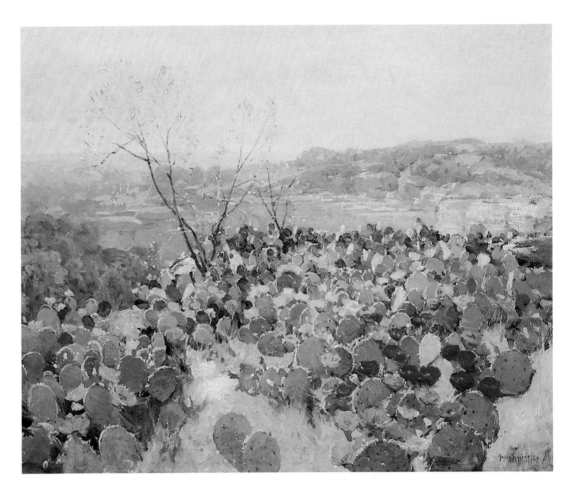

Robert Julian Onderdonk
CACTUS FLOWERS (N.D.)

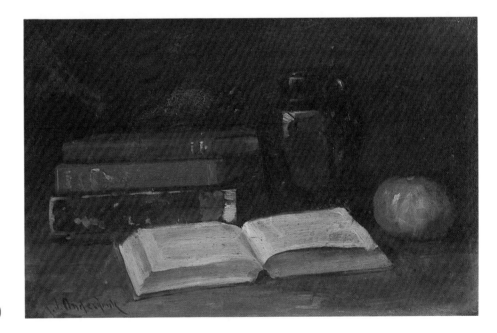

Robert Jenkins Onderdonk
STILL LIFE WITH BOOKS, (N.D.)

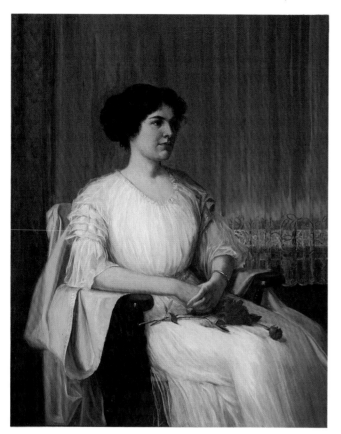

Robert Jenkins Onderdonk
PORTRAIT OF RUTH LIPSCOMB (CA. 1913)

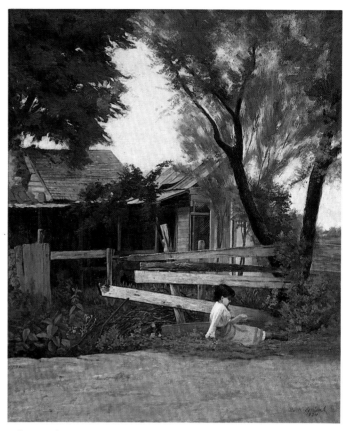

Robert Jenkins Onderdonk
HOUSE AND FIGURE (1884)

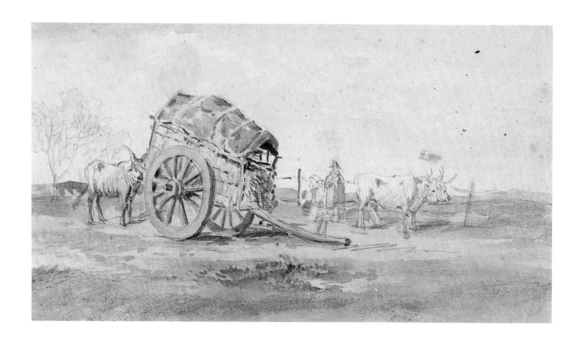

Friedrich Richard Petri
OX CART (N.D.)

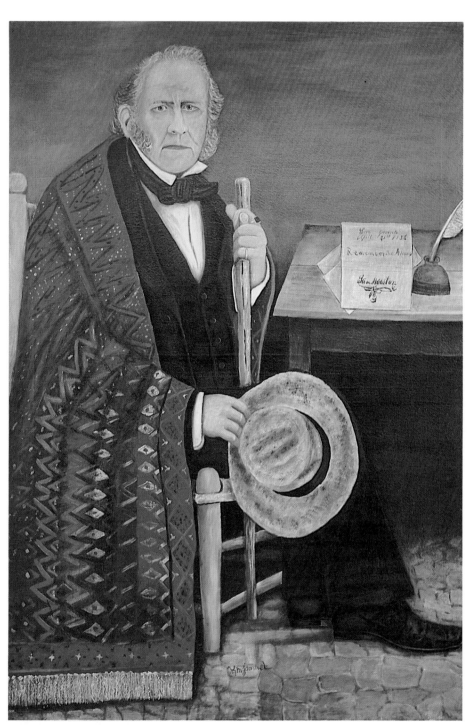

William G. M. Samuel
PORTRAIT OF SAM HOUSTON (N.D.)

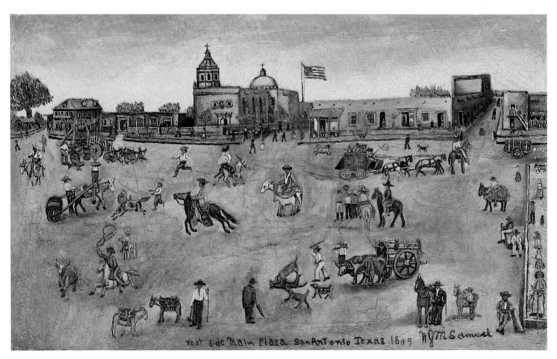

William G. M. Samuel
WEST SIDE MAIN PLAZA, SAN ANTONIO, TEXAS (1849)

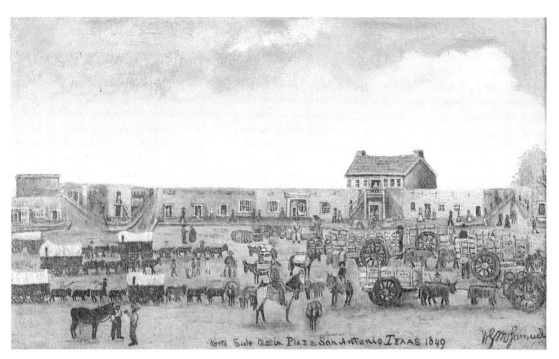

William G. M. Samuel
NORTH SIDE MAIN PLAZA, SAN ANTONIO, TEXAS (1849)

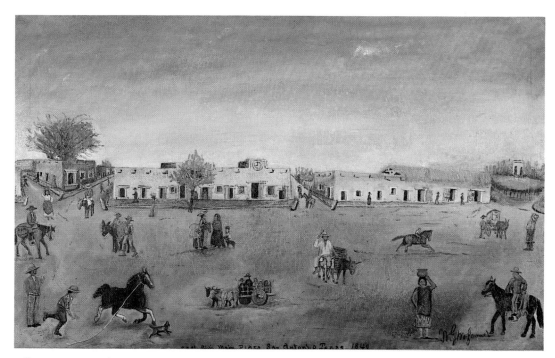

William G. M. Samuel
EAST SIDE MAIN PLAZA, SAN ANTONIO, TEXAS (1849)

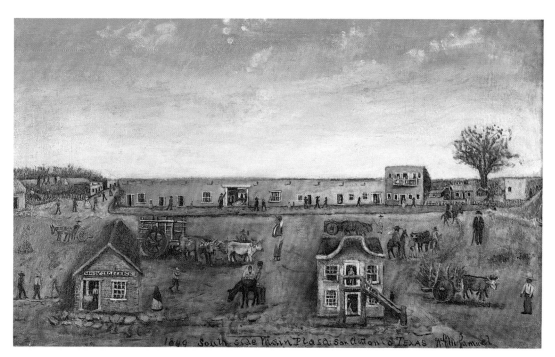

William G. M. Samuel
SOUTH SIDE MAIN PLAZA, SAN ANTONIO, TEXAS (1849)

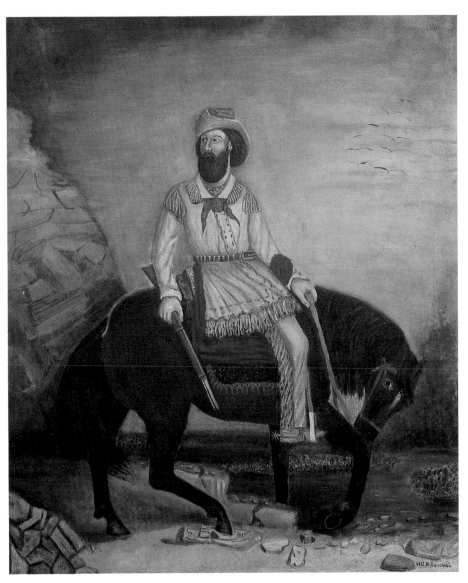

William G. M. Samuel
MAN ON HORSEBACK (N.D.)

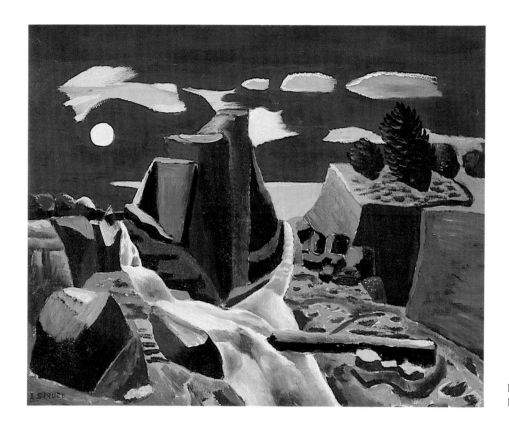

Everett Franklin Spruce
LANDSCAPE (N.D.)

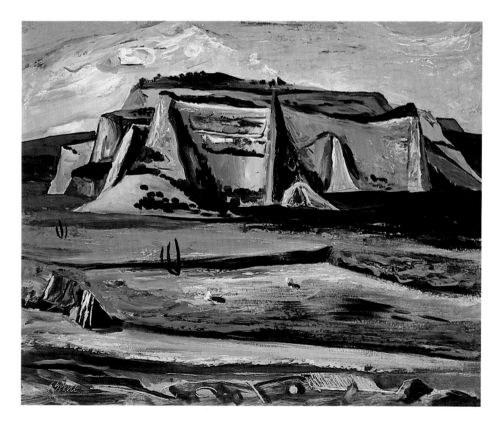

Everett Franklin Spruce
MESA (1944)

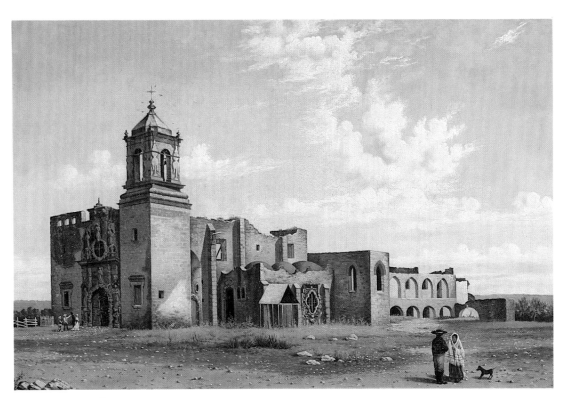

William Aiken Walker
SAN JOSÉ MISSION (1876)

ART FOR HISTORY'S SAKE: THE ARTISTS

ARCHIVES MATERIAL:
Unless otherwise noted all references to letters, clippings, listings, catalogues, and unpublished material may be found in original or photocopied form in the San Antonio Museum Association files.

CITATIONS:
Citations within the text and notes contain shortened references. Full bibliographical information appears in the Bibliography.

DATES AND SPELLINGS:
In cases where an artist's birth and death dates are unavailable, the name will be followed by "(n.d.)." Where spellings of names are uncertain, "(sp. ?)" will follow the name. Where dates are unavailable and the spelling is uncertain, "(?)" will appear.

EXHIBITIONS:
Only special exhibitions in which paintings from The Texas Collection have been used are listed. The paintings from The Texas Collection have been shown on a regular basis in the galleries of the Witte Memorial Museum and the San Antonio Museum of Art.

MEASUREMENTS:
Dimensions of each object are given in inches, height preceding width.

PUBLICATIONS:
Publications in which paintings from The Texas Collection have been illustrated are listed in chronological rather than alphabetical order.

ABBREVIATIONS:

ACMWA/ACM	Amon Carter Museum of Western Art (Fort Worth, Texas). Now known as the Amon Carter Museum.
CWA	Civil Works Administration.
DMFA/DMA	The Dallas Museum of Fine Arts (Dallas, Texas). Now known as the Dallas Museum of Art.
DRT	The Daughters of the Republic of Texas.
ITC	The University of Texas Institute of Texan Cultures at San Antonio (San Antonio, Texas).
NA	Member, National Academy of Design (New York, New York).
SA	San Antonio, Texas.
SAMA	San Antonio Museum Association (San Antonio, Texas).
SAMOA	San Antonio Museum of Art (San Antonio, Texas).
SMU	Southern Methodist University (Dallas, Texas).
WMM	Witte Memorial Museum (San Antonio, Texas). Now known as the Witte Museum.
WPA	Works Progress Administration.

Wayman Adams was born on September 23, 1883, in Muncie, Indiana. He was the son of a Quaker dirt farmer and amateur painter who died when the boy was still in grade school. As a consequence, Wayman's formal education ended with the sixth grade, but he determinedly continued his education on his own.

Adams discovered his potential as an artist when he followed a custom practiced by Indiana farmers and decorated his father's barn with a painting of the family's prized livestock. It has been recorded also that his first portrait commission was a picture of a heifer for which he received five dollars. When he was fourteen he had his first one-man show in Silverburg's Drug Store in Muncie, and the local newspapers referred to him as a "boy wonder."[1]

Later, fired with ambition, Adams borrowed three hundred dollars from his grandmother to go to the John Herron Art Institute in Indianapolis, where he studied with William Forsyth (1854–1935). On a visit to the school, the author Booth Tarkington noticed the young man and was impressed with his ability. He asked what Adams would charge to do a portrait of him, and the artist offered to do it for fifty dollars. Tarkington paid him five hundred dollars with the understanding that Adams would go to New York City to study. He also supplied Adams with letters of introduction to prominent people, which, no doubt, helped launch the young artist. Adams studied at the Grand Central Art School in New York and eventually became a member of the faculty.[2]

After his studies in New York, Adams went abroad and worked with William Merritt Chase (1849–1916) in Italy and Robert Henri (1865–1929) in Spain.[3] He met his future wife, fellow pupil Margaret Burroughs (?-1965), while abroad and they were married in 1918. They had one son, Wayman Adams, Jr., born in 1924.[4]

The Adamses opened an art school in New York City. It was evidently a successful venture, for several years later they established an ambitious school and art colony in Elizabethtown, New York. The school flourished for many years, but by 1949 Adams, then sixty-six years old, became disenchanted with the cold winters and demanding work. The family moved to Mrs. Adams's hometown of Austin, Texas. There they built a handsome and comfortable home, "Encina Linda," which became a mecca for artists and authors and was the scene of many cultural entertainments.[5]

Besides teaching in Elizabethtown, Wayman Adams also taught at the Grand Central Galleries in New York City and at the John Herron Art Institute in Indianapolis; and in 1935 and 1936 he conducted an art school in Taxco, Mexico.[6] During his long and distinguished career Adams painted portraits of virtually every well-known person alive: United States presidents, university regents, authors and artists, society women, actors and actresses, military notables, sports celebrities, musicians, royalty, governors, and even a whimsical self-portrait in full cap-and-gown regalia when he was made honorary Doctor of Arts at Syracuse University in 1943.[7]

Adams also produced small oils and watercolors of places he visited—scenes abroad, in Mexico, or in New Orleans. He was a versatile and prolific painter, often referred to as "brilliant." The list of his awards, memberships in national and international organizations, and the number of his works in important collections and exhibitions is staggering, requiring almost a complete page in the 1954 edition of *Who's Who*. He suffered a heart attack at his home at 2815 San Gabriel in Austin on April 7, 1959. On the previous evening he had attended a concert by the Austin Symphony Orchestra and a post-concert party.[8] Adams's sudden death was as dramatic as his life.

1. Margaret Taylor Dry, "Wayman Adams' Career Filled With Achievement in Art," Austin *American-Statesman*, March 22, 1970. Photocopy, Wayman Adams file, SAMA Texas Artists Records.
2. "His List of Prizes Long and Imposing," Austin *American-Statesman*, n.d. Photocopy, Adams file, SAMA Texas Artists Records.
3. *The Westgate Gallery of Wayman Adams Paintings*, exhibition catalogue (n.p., n.d).
4. Dry, "Wayman Adams' Career."
5. Ibid.
6. *The Westgate Gallery of Wayman Adams Paintings.*
7. Ibid.
8. "Wayman Adams Funeral Rites Set Thursday," Austin *American-Statesman*, April 8, 1959; *Who's Who in America*, Dorothy P. Gilbert, ed. (New York: R. R. Bowker Co., 1956), s.v. "Adams, Wayman."

PORTRAIT OF ERNST RABA
1949 Oil on canvas, 24″ × 20″
Signed center right: Wayman Adams

Wayman Adams was adept at quick character
sketches and was fond of doing demon-
stration pieces for classes and clubs, much in
the manner of his instructor, William Merritt
Chase. Ernst Raba, the subject of this portrait,
was a well-known artist and photographer in
San Antonio.[9] His peppery personality and
piquant features are conveyed with ambience
and keen insight in Adams's sure, bold
brushstrokes that slash across the partially
covered canvas. The color is dark and rich
and reflects the virility of both subject and
artist. It is a significant work, not only
because it is a good example of Adams's
fluent style, but also because it represents one
of San Antonio's most colorful characters of
the early twentieth century.

PROVENANCE:
1949: The quick sketch was done as a demonstration
piece for the Fenwick Club, SA.
1951: Gift to SAMA by the Fenwick Club. Although
the painting is undated, the date, 1949, was supplied
by the Fenwick Club and appears on the Association's
records.
51–65 G

EXHIBITIONS:
1952: Painting of the Month, WMM (January).
1970: Special Texas Exhibition, ITC (March 16 to
October 8).
1986: Texas Seen/Texas Made, SAMOA (September 29
to November 30).

PUBLICATIONS:
"Socially Speaking," San Antonio Light, December 12,
1951.

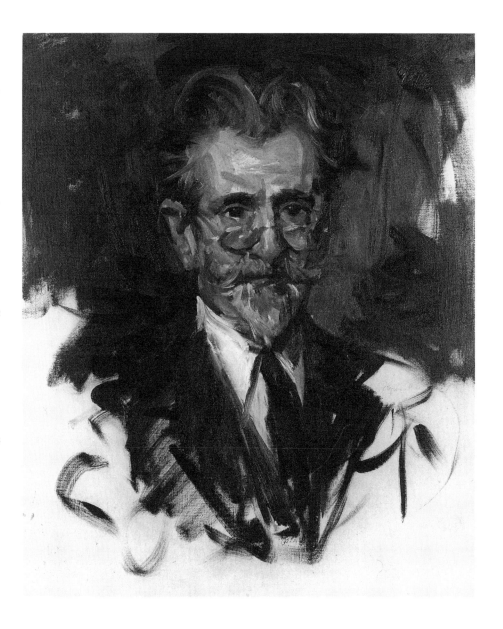

9. Cecilia Steinfeldt, San Antonio Was: Seen Through a
Magic Lantern (San Antonio: San Antonio Museum
Association, 1978), 16.

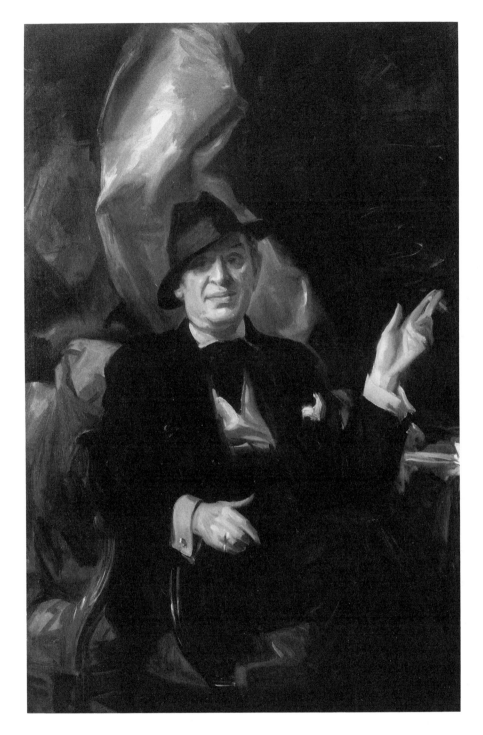

PORTRAIT OF MORRIS GEST
n.d., Oil on canvas, 54″ × 35″
Unsigned

The subject of this painting, Morris Gest, was born in Russia, January 17, 1881, and immigrated to the United States with his parents in 1893. He started his career as an entrepreneur in Boston as a young man and, in 1911, married Victoria Belasco, daughter of the famous Broadway producer David Belasco. Gest became a very successful producer himself, with more than fifty outstanding plays to his credit. He directed the Manhattan Opera House from 1911 until about 1920 as well as the Century Theatre in New York from 1917 to 1920. He was the first impresario to bring the original Russian Ballet to America and introduced Michel Fokine, the renowned ballet master, to this country. During his ensuing years, there were many more "firsts" and a succession of prestigious productions for which he was responsible.[10] His illustrious career ended with his death on May 16, 1942.[11]

Gest was a brilliant and colorful man—a fitting subject for Wayman Adams's flamboyant brush. Adams portrays Gest in a theatrical pose with his sensitive hands captured in a nonchalant gesture. The lush gold and crimson draperies in the background, the luxuriant textures of the fabrics, and the spontaneous attitude of the sitter all heighten the dramatic effect and contribute to the painting's *bon vivant* character.

PROVENANCE:
-1976: Collection of the Adams Family.
1976: Purchased by SAMA from the Austin National Bank, Trustee of the Wayman Adams, Jr., Consolidated Trust, with funds provided by the Sarah Campbell Blaffer Foundation, Houston.
76–186 P

EXHIBITIONS:
ca. 1940: Headliner's Club, Austin.[12]
1947: Exhibition of Character Portraits by Wayman Adams, WMM (December 7 to 30).
1953: Paintings by Wayman Adams, Texas Federation of Women's Clubs, Austin.
1977–1978: Gallery of American Painting, WMM (June 1, 1977 to June 1, 1978).
1984–1985: A Fiesta of Christmas Trees, WMM (December 1, 1984, to January 13, 1985).
1986: Texas Seen/Texas Made, SAMOA (September 29 to November 30).
1989–1990: Special Christmas Exhibition, WMM (December 7, 1989, to April 1, 1990).

10. *Who's Who in America: Biographical Dictionary of Notable Living Men and Women of the United States, 1924-1925*, vol. 13 (Chicago: A. N. Marquis & Company, 1925), s.v. "Gest, Morris."
11. Inez Miller, "Wayman Adams: The Man From Indiana," reprint from *The Texas Artist Now* (n.p., n.d.) Photocopy, Wayman Adams file, Amon Carter Museum, Fort Worth.
12. Gilbert M. Denman, Jr., to author (SA), interview, September 5, 1981.

PUBLICATIONS:
SAMA Bi-Annual Report, 1976–1978, 62.
"The San Antonio Museum Association Exhibits," *San Antonio Monthly*, 5 (September 1986): 19.
SAMA *Calendar of Events* (September 1986): [3].
Cecilia Steinfeldt, "Wayman Adams: Portraitist of High Society," M3, SAMA Quarterly, in *San Antonio Monthly*, 6 (October 1986): 10.
Inez Miller, "Wayman Adams: The Man From Indiana," reprint from *The Texas Artist Now* (n.p., n.d.).

THOMAS ALLEN, NA

Thomas Allen was a distinguished American painter who visited Texas during the winter of 1878–1879. He was born in St. Louis on October 19, 1849, the son of railroad builder and congressman Thomas Allen and Anne (Russell) Allen. He was educated at Washington University in St. Louis. In 1869, when he was twenty years old, he accompanied Professor J. W. Pattison (1844–1915) of Washington University on a sketching trip into the Rocky Mountains west of Denver. This experience stimulated him to seek further instruction in drawing and painting.[1]

In 1871 Allen studied in Paris and from there went to Düsseldorf, where he entered the Royal Academy in the spring of 1872. While in the academy he received instruction from professors Andreas and Karl Müller (1811–1890 and 1818–1893) in basic art classes and from Eugene Dücker (1841–1916) in advanced painting. His vacations were spent traveling and visiting the art centers of the Continent and Great Britain. He graduated from the academy in 1877 and in 1878 moved to Écouen, a suburb of Paris. His first work to be exhibited in New York City was at the National Academy in 1876, a canvas entitled *The Bridge at Lissengen*. From then on he exhibited each year in the academy's exhibition and was elected an associate member in 1884.[2]

During his years abroad Allen continued vacationing in Holland, Belgium, Bavaria, France, and England. His companions in Paris included other notable artists such as Edouard Frère (1837–1894), Luigi Chialiva (1842–1914), August Friedrich Albrecht Schenck (1828–1901), and others.[3]

On a tour through the American West in 1878–1879, the artist lingered long enough in San Antonio to paint his famous *Market Plaza* as well as several other scenes in and around the city.[4] These included several views of Mission San José: a watercolor of the *Portal of the Mission*, now in the collection of the Boston Museum of Fine Arts; a scene of a cockfight outside the walls of the mission; and a skillful rendition of the building's famous rose window. He also painted a view of the ford on San Pedro Creek with a Mexican *carreta* about to cross the stream, a painting now in the collection of the San Antonio Public Library. According to his daughter, he did not confine himself to scenes of San Antonio, painting in addition *Freighters from the Rio Grande* and a *Prairie Scene with Mexican Herdsmen and Cattle*.[5]

Allen returned to this country permanently in 1882 and established a studio in Boston. He served as trustee and later as president of the Board of the Museum of Fine Arts in Boston, chairman of the Council and Faculty of the Museum School, chairman of the Art Commission of the City of Boston, member of the National Jury of the International Board of Judges of Award at the Columbian Exposition in 1893, and president of the International Jury of Award of the St. Louis Exposition in 1904. He was a member of the National Academy of Design, the Society of American Artists, the Boston Society of Water Color Painters, and the Copley Society of Boston. His work is represented in the Museum of Fine Arts, Boston; the City Art Museum, St. Louis; the Berkshire Athenaeum and Museum, Pittsfield, Massachusetts; the San Antonio Museum Association; and the San Antonio Public Library.[6]

Allen was also an astute businessman. He served as president of the MacAllen Company of Boston and was associated with the Wellesley Knitting Mills of Wellesley, Massachusetts.[7] He also was active in the Massachusetts Horticultural Society.[8]

Allen was married twice; first to Eleanor G. Whitney and later to Alice Ranney.[9] He died on August 25, 1924, within a month of his appointment as president of the Trustees of the Boston Museum of Fine Arts.[10]

1. William H. Goetzmann and Joseph C. Porter, with Artists' Biographies by David C. Hunt, *The West as Romantic Horizon* (Omaha: Joslyn Art Museum, 1981), 71; Martha Utterback, *Early Texas Art in the Witte Museum* (San Antonio: Witte Memorial Museum, 1968), 49.
2. Undated biographical typescript, Thomas Allen file, SAMA Texas Artists Records.
3. Eleanor W. Allen (Boston) to Eleanor Onderdonk (SA), February 13, 1936, with attached biographical information.
4. Undated biographical typescript prepared by Minnie B. Cameron, Librarian, SA Public Library, SA Public Library Archives.
5. Eleanor W. Allen (Princeton, Mass.) to Minnie B. Cameron (SA Public Library), October 16, 1935.
6. Utterback, *Early Texas Art*, 49.
7. Goetzmann and Porter, *The West as Romantic Horizon*, 71.
8. *Boston Museum of Fine Arts Bulletin*, 23, no. 7 (n.d., n.p.). Photocopy, Allen file, SAMA Texas Artists Records.
9. Charles H. Hawes (Associate Director, Boston Museum of Fine Arts) to Mattie Austin Hatcher (Archivist, University of Texas, Austin), September 20, 1932.
10. *Boston Museum of Fine Arts Bulletin*, 23, no. 7.

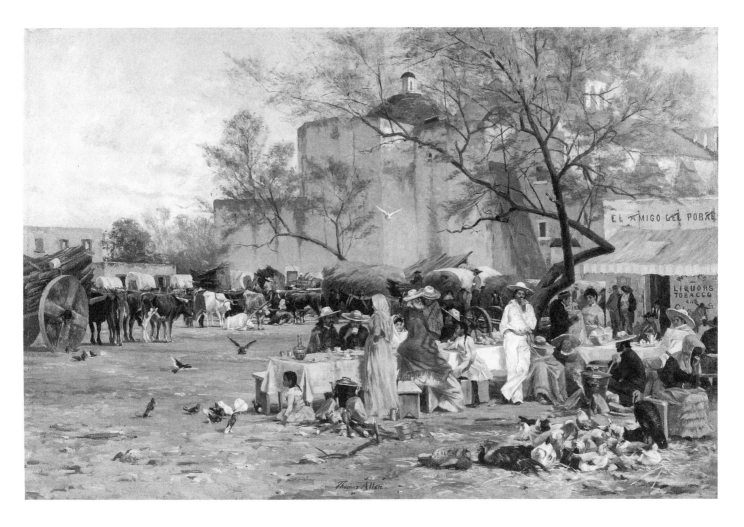

MARKET PLAZA
1878–1879, oil on canvas mounted on panel,
26″ × 39½″
Signed lower center: Thomas Allen

The paintings that Thomas Allen executed during his short stay in Texas have become some of the most important visual documents of local genre scenes of the period. Unfortunately, records show that only two other known Texas paintings besides *Market Plaza* are in public institutions: the *San Pedro Creek* scene, which is on view at the San Antonio Public Library, and the *Portal of San José*, which belongs to the Boston Museum of Fine Arts. Eleanor Allen, his daughter, mentioned a number of other Texas subjects in her correspondence with Eleanor Onderdonk and with Minnie B. Cameron when the purchase of *Market Plaza* was being considered.[11]

Allen's scene of the plaza reflects his interest in San Antonio's picturesque atmosphere. The painting depicts the time-honored practice of dining *al fresco* in the plazas and streets of the colorful Mexican American town. This custom prevailed until the plazas were converted into parks in the early years of the twentieth century.[12] Allen's view of the plaza (actually Military Plaza) provides a survey of the site with typical "chili stands" in the foreground and the staunch stone walls of San Fernando Cathedral and adjacent buildings in the background. Groups of customers and cooks in gaily colored clothing serve as the focal point, and a profusion of oxcarts, hay wagons, and animals complete the composition. The scene vividly portrays the charismatic and casual lifestyle of the old town.

The ease and confident character of Allen's brushstrokes and the clarity of his draftsmanship in the painting are indicative of his European training as well as of his natural ability. A view of *Market Plaza* was first shown in the Paris Salon in 1882.[13] The subject must have been one of Allen's favorites because

11. Photocopied correspondence, Allen file, SAMA Texas Artists Records.
12. Steinfeldt, *San Antonio Was*, 112–113.
13. Utterback, *Early Texas Art*, 49.

there is evidence that he repeated it in similar views. An old journal records that a painting called *Market Place, San Antonio* was owned by a resident of Worcester, Massachusetts, and *Evening on Market Place, San Antonio* belonged to Mr. Newton of Holyoke, Massachusetts.[14]

Another corroborating fact emerged in a letter written in 1935 by Thomas Allen's daughter in which she states: "The original Salon picture of the San Antonio Market Place was sold and we do not know the present owner. My father, however, was so fond of that particular spot that he painted another canvas from his original study, slightly smaller than the first one. It measures 3′3″ × 2′2½″. . . ." This evidently is the canvas in the collection of the San Antonio Museum Association as it was purchased directly from Allen's family and the measurements correspond. The larger painting is mentioned in *Dictionnaire des Peintres* by Bénézit as having been exhibited in the Paris Salon in 1882.[15]

PROVENANCE:
1879–1936: Collection of the Allen Family.
1936: Purchased by SAMA from Eleanor W. Allen with funds procured through subscription and the Witte Picture Fund.
36–6518 P

EXHIBITIONS:
1936: Centennial Exposition of Early Texas Paintings, WMM (June 1 to August 1).
1946: Early San Antonio Paintings, WMM (February 24 to March 12).
1950: American Processional, The Corcoran Gallery of Art, Washington, D.C. (July 1 to December 17).
1958: Mission Summer Festival, Mission Concepción, SA (June 13 to 22).
1960: Go West, Young Man, Marion Koogler McNay Art Institute, SA (January 1 to February 17).
1960: Early Texana Exhibit, in recognition of the premiere festivities of the film, *The Alamo*, WMM (October 1 to 30).
1964: The Early Scene: San Antonio, WMM (June 7 to August 31).
1983: Images of Texas, Archer M. Huntington Art Gallery, College of Fine Arts, The University of Texas at Austin (February 25 to April 10).
1983: Images of Texas, Traveling Exhibition: Art Museum of South Texas, Corpus Christi (July 1 to August 14). Amarillo Art Center (September 3 to October 30).
1984: The Texas Collection, SAMOA (April 13 to August 26).
1986: Texas Seen/Texas Made, SAMOA (September 29 to November 15).
1986: Collecting: A Texas Phenomenon, Marion Koogler McNay Art Museum, SA (November 23 to December 24).
1988: The Art and Craft of Early Texas, WMM (April 30 to December 1).

1988: A Witte Merry Christmas: Tannenbaums to Tumbleweeds, WMM (December 1 to 30).
1990: Looking at the Land: Early Texas Painters, San Angelo Museum of Fine Arts (February 22 to March 25).
1990: Regional American Painting to 1920, Greenville County Museum of Art (November 6 to December 30).

PUBLICATIONS:
"Boston Cherishes Pictures Painted in San Antonio Just 56 Years Ago," San Antonio Express, December 31, 1935.
"Museum Obtains Historic Painting," San Antonio Express, February 13, 1936.
"Old Canvases Depict S.A.," San Antonio Light, February 24, 1946.
"Texas in Pictures," The Magazine Antiques, 53 (June 1948): 458.
Charles Ramsdell, San Antonio: A Historical and Pictorial Guide (1959), 280.
Witte Museum Brochure, San Antonio (1961): [2].
Jerry Lochbaum (ed.), Old San Antonio: History in Pictures (1965), cover.
Bess Carroll Woolford and Ellen Schulz Quillin, The Story of the Witte Memorial Museum: 1922–1960 (San Antonio: San Antonio Museum Association, 1966), 144, 161.
Pauline A. Pinckney, Painting in Texas: The Nineteenth Century (1967), [182]: plate 103.
Martha Utterback, Early Texas Art in the Witte Museum (1968), 50.
Jerry Lochbaum (ed.), Old San Antonio: History in Pictures (rev. ed., 1968), cover.
James V. Reese and Lorrin Kennamer, Texas, Land of Contrast: Its History and Geography (1972), 139.
Cecilia Steinfeldt, The Onderdonks: A Family of Texas Painters (1976), 47.
"Historic San Antonio . . . a pictorial glimpse," San Antonio Express-News, October 16, 1977.
Mary Ann Noonan-Guerra, San Fernando: Heart of San Antonio (1977), centerfold.
James V. Reese and Lorrin Kennamer, Texas, Land of Contrast: Its History and Geography (rev. ed., 1978), 171.
Adrian N. Anderson and Ralph A. Wooster, Texas and Texans (rev. ed., 1978), 88–89.
Frank Trejo, "Controversial Chili Queens' fare a favorite," San Antonio Light, March 1, 1981.
William H. Goetzmann and Becky Duval Reese, Texas Images and Visions (1983), 67.
Jon Holmes, Texas: A Self-Portrait (1983), 170.
Southern Living, The Southern Heritage Company's Coming! Cookbook (1983), 66.
John Palmer Leeper, "The San Antonio Museum of Art," in Collecting: A Texas Phenomenon (1986), 56.
Becky Duval Reese, Susan M. Mayer, and Arthur J. Mayer, Texas (1987), 58.
Gilbert R. Cruz, Let There Be Towns: Spanish Municipal Origins in the American Southwest, 1610–1810 (1988), dust jacket, frontispiece.
Mary Ann Guerra, The History of San Antonio's Market Square (1988), cover.
Robert A. Calvert and Arnoldo De León, The History of Texas (1990), 41.
"Main Plaza as it appeared in the 1800s," San Antonio Express-News, December 16, 1990.
William A. Gerdts, Art Across America: Two Centuries of Regional Painting, 1710–1920, vol. 2 (1990), 118: plate 2.109.

14. Frank T. Robinson, Living New England Artists (facsimile reprint, New York & London: Garland Publishing Co., 1977), 20.
15. Allen to Cameron, October 16, 1935; Emmanuel Bénézit, Dictionnaire Critique et Documentaire des Peintres, Sculpteurs, Dessinateurs et Graveurs, vol. 1 (2nd ed., Paris: Libraire Gründ, 1966), s.v. "Allen, Thomas."

José Arpa was born in Carmona, Spain, in a small village about eighty miles from Seville. He was the son of Antonio Arpa and María de Gracia Perea Arpa. His early painting was influenced by Eduardo Cano de la Peña (?-1807), an artist noted for his historical paintings. Arpa won the Prix de Rome three consecutive times, which entitled him to six years of study in that city. In 1891, when in Rome, he completed a large portrait of Don Miguel de Manarra, founder of the Associated Charities of Seville. This portrait won first prize at an exhibition in Madrid and gained more recognition for Arpa. Throughout the years, while traveling extensively in Europe and evidently touring Africa as well, he exhibited in numerous galleries and museums.[1]

In 1893 the Spanish government sent four of Arpa's paintings to the Columbian Exposition in Chicago as "representative of the best art of Spain." They were: A *Peasant Girl*, *Pompey's Funeral*, *Port of Seville*, and *Landscape*.[2]

The Mexican government invited Arpa to become an instructor in the Academy of Fine Arts in Mexico City. The government even sent a man-of-war to Spain to transport Arpa to Mexico as an honored guest. After inspecting the academy, however, he declined the position.[3] Two of his schoolmates from Spain, Manuel Rivero and Antonio Guijano, nevertheless persuaded him to remain in Mexico.

When Arpa visited Guijano in Puebla he became enchanted with the colorful adobe houses, glittering church towers, picturesque people, and verdant tropical growth. He had developed a reputation as a brilliant colorist, and the atmospheric luminosity of the radiant Mexican countryside struck a responsive chord in his aesthetic consciousness.[4]

Eventually the Guijanos decided to send their children to San Antonio to attend school, and Arpa agreed to accompany them as guardian and advisor.[5] Existing records of the exact date this occurred are vague, but a short article in the San Antonio *Light* places Arpa in the city as early as 1899. On October 24 of that year an announcement appeared in the newspaper stating that "Prof. José Arpa, a talented artist now in the city, has painted a splendid portrait of Master Paul Lovelace, a cash boy for Joske Bros., which is now on exhibition in Joske's display window. The work is much admired by art connoisseurs." In his autobiography, Pompeo Coppini (1870–1957) mentions Arpa as being in San Antonio in 1902.[6] The artist probably traveled back and forth from Mexico and did not take up permanent residence in San Antonio until 1923, when he is first listed in the city directory.

During the early years of the twentieth century Arpa was active as a painter and teacher in San Antonio. He became friends with many local artists and was a member of the Brass Mug Club, an informal and congenial group which met on Sundays. In 1914 he was photographed with his artist friends in Julian Onderdonk's home, with Arpa and Robert Onderdonk prominently situated in the center of the group.[7]

Arpa exhibited a large painting, A *Mexican Funeral*, at one of the San Antonio International Fairs in the early 1900s. The Boston Museum of Fine Arts purchased the work for a reputed $12,000, no small sum in those days. In 1923 Arpa opened a studio and art school in San Antonio; his nephew, the artist Xavier Gonzalez, joined him in 1925.[8] First situated on Oakland Street, the institution moved to more spacious quarters when the artists acquired the old Vance homestead on Nueva Street in 1927.[9] Here they carried on the traditions of teaching, painting, and artistic leadership established by the Onderdonks and other early San Antonio artists.

"The Gang," 1913.
When Julian Onderdonk was in New York in 1913 assembling the art exhibition for the State Fair of Texas, "The Gang" sent him a postal card. It is dated August 5, 1913, and was signed by José Arpa, R. Leo Cotton, Rolla Taylor, and Ernst Raba. SAMA Historical Photographic Archives, gift of an anonymous donor.

1. Frances Battaile Fisk, A *History of Texas Artists and Sculptors* (Abilene, Texas: Privately published, 1928), 29.
2. Esse Forrester-O'Brien, *Art and Artists of Texas* (Dallas: Tardy Publishing Company, 1935), 41–43.
3. Ibid.
4. Fisk, A *History of Texas Artists*, 29.
5. Ibid.
6. Pompeo Coppini, *From Dawn to Sunset* (San Antonio: The Naylor Company, 1949), 85.
7. "San Antonio Scenery Supplies Inspiration For Artists," San Antonio *Express*, December 27, 1936.
8. Fisk, A *History of Texas Artists*, 29.
9. "Open House Today at Arpa's New Studio," San Antonio *Express*, October 9, 1927.

The Brass Mug Club, 1914.
Left to right standing: M. Emig; Julian Onderdonk, artist; Ernst Raba, photographer; Theodore Fletcher; Tom Brown, artist; Robert Leo Cotton, artist; and Joe Braun. Seated: Ernest A. Thomas, violin teacher; Robert Onderdonk, artist; José Arpa, artist; Charles Simmang, Jr., steel engraver and medalist; and Alois Braun, music teacher. SAMA Historical Photographic Archives, gift of an anonymous donor.

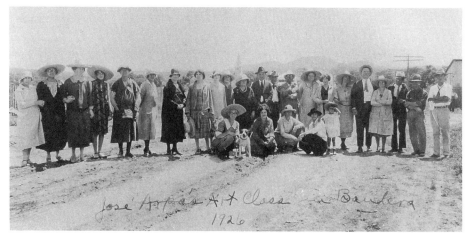

José Arpa's Art Class, 1926.
Arpa's art class frequently headed for the hills around San Antonio to paint. This group was photographed in Bandera. Arpa is standing just to the right of the center wearing a white hat, with cigar in hand. SAMA Historical Photographic Archives, gift of an anonymous donor.

Arpa was a prolific painter and proficient in all mediums. He exhibited extensively throughout Europe, the United States, Mexico, and South America, winning many awards and prizes. The Edgar B. Davis Wildflower Competition, organized in San Antonio in 1926, netted Arpa a $1,000 purchase prize for his painting *Verbena* in 1927. In 1928 he won third prize in this competition for his canvas *Cactus Flower* and in 1929 he won the first prize of $2,000 for *Picking Cotton*.[10] By that time the competitions had broadened to include all kinds of Texas landscapes. Had these contests continued after that year, no doubt Arpa would have received still more prizes for his masterly renditions of the Texas countryside.

José Arpa remained in San Antonio until about 1932, at which time he returned to his native Spain. He died in Seville in 1952 at the age of ninety-four.[11]

10. Forrester-O'Brien, *Art and Artists*, 43.
11. "Spanish Painter, Well Known in S. A. Reported Dead in Seville at 94," San Antonio *Express*, October 17, 1952.

SELF-PORTRAIT
n.d., oil on canvas, 18″ × 24½″
Signed lower left: J. Arpa/San Antonio, Texas

José Arpa was a skilled painter, an excellent draftsman, and an indefatigable worker. When other models were unavailable, he used himself to produce candid self-portraits. His pipe was evidently a constant companion, as it appears in numerous self-portraits. That he brushed the locale, "San Antonio, Texas," below his signature suggests his pride in the city and his awareness of his own importance in its artistic environment.

PROVENANCE:
1947: Purchased by SAMA from the Milam Galleries, SA, with Witte Picture Funds.
48–10 P

EXHIBITIONS:
1966: Ethel Drought Gallery of Contemporary Art, WMM (Summer).

PUBLICATIONS:
Helen Raley, "Texas Wild-Flower Art Exhibit," Holland's, The Magazine of the South, 46 (July 1927): 49.
"Witte Museum Schedules Series of Art Exhibits," San Antonio Express, September 23, 1951.
Woolford and Quillin, The Story of the Witte Memorial Museum (1966), 148.

PORTRAIT STUDY
n.d., oil on canvas, 24″ × 20″
Signed and titled lower right: Portrait Study./J. Arpa

In 1951, when Arpa's nephew Xavier Gonzalez (1898–) considered donating a self-portrait of Arpa to the San Antonio Museum Association, he wrote a letter to art curator Eleanor Onderdonk in which he stated:

Today I sent to the Witte Museum a painting 'Self Portrait' by José Arpa.
Besides its value as a good painting—it seems to me that your museum will welcome this work; because uncle Arpa taught in S. A. for so many years and his very fondest memories are from San Antonio, its people and its landscape.
He is, I know, so beloved by so many people in Texas that they will love to see a self portrait—painted in S. A. . . .

Eleanor was delighted and replied with alacrity: "The Board of Directors of the Witte Museum will be very happy to receive the self portrait of dear Mr. Arpa and wish me to express the appreciation of each one for your generosity and thought of us. . . ."
The painting, a valuable addition to The Texas Collection, arrived in San Antonio in time for the Witte Memorial Museum's twenty-fifth anniversary in October 1951 and was immediately put on display.[12]

PROVENANCE:
ca. 1932–1951: Collection of Xavier Gonzalez.
1951: Gift to SAMA by Xavier Gonzalez.
51–39 G

EXHIBITIONS:
1951: Picture of the Month, WMM (October).
1986: Texas Seen/Texas Made, SAMOA (September 29 to November 30).

PUBLICATIONS:
"Witte Gets Birthday Gift," San Antonio Light, September 9, 1951.
Joe Rosson, "More than Bluebonnets," in Sentinel: Star of the Republic Antique Show, Houston, Texas (December 1984): 27.

12. "Witte Gets Birthday Gift," San Antonio Light, September 9, 1951.

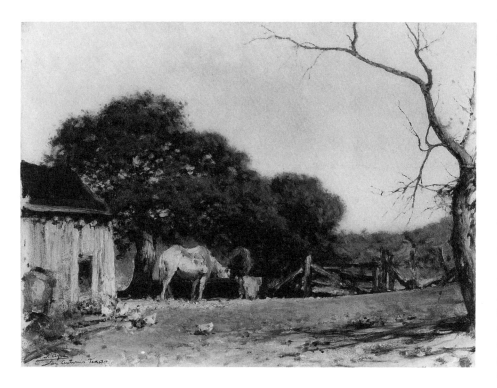

RURAL SCENE IN TEXAS
n.d., oil on wooden panel, 10⅜" × 14"
Signed lower left: J. Arpa/San Antonio, Texas
Inscribed on reverse: Van Raub, Texas

A versatile artist, Arpa handled all types of subject matter and mediums with ease. He found interest and beauty in earthy, ordinary themes. His ability to convert a simple barnyard, rock quarry, or group of Irish Flat huts into handsome and brilliant works of art was contingent upon his facile brushwork, his understanding of dazzling light, and his manipulation of radiant color. His genre paintings of Texas scenes capture the essence of hot sunlight and torpid tranquility with candor and confidence.

"Van Raub, Texas," is written in pencil on the back of the panel in what appears to be Arpa's handwriting. Van Raub was a small community north of San Antonio which has been virtually engulfed by the city.[13] Arpa's Texas landscapes are valuable documents of regional scenery in the early years of the twentieth century.

PROVENANCE:
-1976: Collection of Mr. and Mrs. Gaines Voigt.
1976: Gift to SAMA by Mr. and Mrs. Gaines Voigt.
76–26 G

EXHIBITIONS:
1986: Texas Seen/Texas Made, SAMOA (September 29 to November 30).
1990: Looking at the Land: Early Texas Painters, San Angelo Museum of Fine Arts (February 22 to March 25).

13. Walter Prescott Webb, H. Bailey Carroll, and Eldon Stephen Branda (eds.), *The Handbook of Texas*, 2 (3 vols.; Austin: Texas State Historical Association, 1952, 1976), s.v. "Van Raub, Texas."
14. Xavier Gonzalez (New York) to Martha Utterback (SA), undated (ca. October 1, 1968).
15. Marion A. Habig, O.F.M., *San Antonio's Mission San José: State and National Historic Site, 1720–1968* (San Antonio: The Naylor Company, 1968), 65–66.

THE ROSE WINDOW (*Opposite page*)
ca. 1924, watercolor on paper, 11½" × 9"
Attributed lower right: Painted by José Arpa/circa 1924, XG. The initials, XG, stand for Xavier Gonzalez, nephew of the artist.

This unfinished painting demonstrates Arpa's proficiency as a watercolorist. At some point the artist set the work aside and did not have the opportunity, or possibly the inclination, to complete the work. When Xavier Gonzalez, the donor, offered the painting to the San Antonio Museum Association he wrote: "Without exag[g]eration, it is an exquisite work of art, besides it has historical significance for S. A."[14]

The rose window is an important fenestration in the most famous of San Antonio's missions, San José. The window suffered less damage through the years from erosion and vandalism than did the carvings on the façade of the building. The sturdy stone structures of San José were erected over a period of years in the eighteenth century and were described by Fray Agustín Morfi in his *History of Texas, 1673–1779*. He visited the mission in 1777 and wrote that "San José is, in truth, the first mission in America, not in point of time, but in point of beauty, plan and strength, so that there is not a presidio along the entire frontier line that can compare with it. . . ." He continued, "The whole structure is admirably proportioned and strongly built of stone and mortar, chiefly a sandy limestone that is light and porous when freshly quarried, but in a few days hardens and becomes one with mortar. . . . This stone is obtained from a quarry near the mission of Nuestra Señora de la Concepcion."[15]

Arpa has captured the impression of stalwart stone and dexterous carving although his medium was delicate watercolor. The painting reflects the respect with which the artist regarded the skills of the sculptor and the architects responsible for the handsome building.

PROVENANCE:
ca. 1924–1969: Collection of Xavier Gonzalez.
1969: Gift to SAMA by Xavier Gonzalez.
69–22 G

EXHIBITIONS:
1969: Ethel Drought Gallery of Contemporary Art, WMM (Summer).
1986: Texas Seen/Texas Made, SAMOA (September 29 to November 30).

BLUEBONNET FIELD
n.d., oil on canvas, 24″ × 36″
Signed lower left: José Arpa/San Antonio, Texas

Fields of Texas bluebonnets became very popular subjects for local painters during the early years of this century. To paint a field of bluebonnets is deceptively simple, and the subject was not only overworked but also degraded by many amateur painters. When a masterly craftsman such as José Arpa or Julian Onderdonk produced bluebonnet paintings, the results were stunning symphonies of color and atmosphere. In this rendition Arpa catches the vast distances, the warm ambience, and the glowing light so characteristic of his Texas landscapes.

PROVENANCE:
1966: Gift to SAMA by the George W. Brackenridge High School, SA. An accompanying letter stated it was given "with the understanding that it will be restored and placed on display in the museum facility." The painting was restored in 1974 by Ben Johnson of the Los Angeles County Museum of Art. 66–199 G

EXHIBITIONS:
-1966: George W. Brackenridge High School.
1984: The Texas Collection, SAMOA (April 13 to August 26).
1986: Texas Seen/Texas Made, SAMOA (September 29 to November 30).
1990: Looking at the Land: Early Texas Painters, San Angelo Museum of Fine Arts (February 22 to March 25).

PUBLICATIONS:
Cecilia Steinfeldt, "Blooming Bluebonnets: A Texas Tradition," *Southwest Art*, 14 (April 1985): 63.

WORKS BY JOSÉ ARPA Y PEREA
NOT ILLUSTRATED:

HOUSE ON A HILL
n.d., toned etching on paper, 7″ × 5″
Signed lower right: José Arpa
65–250 G (3)
Gift to SAMA by Thelma Brand.

FISHING BOATS
n.d., toned etching on paper, 4¼″ × 5⅛″
Signed lower right: José Arpa
65–250 G (4)
Gift to SAMA by Thelma Brand.

WOODLAWN LAKE
ca. 1912, toned etching on paper, 8½″ × 11⅛″
Signed lower right: José Arpa
65–250 G (5)
Gift to SAMA by Thelma Brand.

STREET IN ARABIA
n.d., toned etching on paper, 9¾″ × 6½″
Signed lower right: José Arpa
65–250 G (6)
Gift to SAMA by Thelma Brand.

STREET SCENE
n.d., toned etching on paper, 5½″ × 4¼″
Signed lower right: José Arpa
65–250 G (7)
Gift to SAMA by Thelma Brand.

MARY ANITA BONNER (1887–1935)

Mary Bonner is best known as a printmaker, but she has been included in this publication because of her importance in the field of Texas art. In addition to her prints, she produced paintings, drawings, and even sculpture, and many of her etchings were aquatints with coloring sometimes applied manually. During her lifetime, she was recognized as a printmaker internationally as well as regionally.[1]

Mary was born on March 31, 1887, at Bayou Bartholemew Plantation in northern Louisiana, the youngest of three children of Dr. Samuel Lafayette Bonner and Carrie Ann (Hill) Bonner. The family was financially able to provide the children with good educations, a matter they felt of utmost importance, and Mary went to the best schools wherever she lived. Dr. Bonner died in 1891, and six years later Mrs. Bonner and the children moved to San Antonio, presumably because the city's cosmopolitan atmosphere provided greater opportunity for educational advancement and cultural enrichment. The family owned a large ranch near Sabinal in Uvalde County where they spent their summers. It was as a child on this ranch that Mary became acquainted with the life-style and customs of the Texas cowboy, a character she was to immortalize in her cowboy etchings years later. Ranch life also taught her to love the freedom of the great outdoors and the wonders of nature and developed her fondness for animals, particularly horses, cattle, and dogs.[2]

In 1901 Mary was enrolled as a day scholar at the San Antonio Academy, and in 1904 she became a student at the University of Texas in Austin.[3] After two years at the university she was sent to a girls' school in Lausanne, Switzerland. Her carefree spirit found the confining atmosphere of the institution intolerable and, after eighteen months, her older sister Emma withdrew her from the school. There is evidence that she then went to Munich where she studied "charcoal," but when World War I loomed, she returned to the United States and entered Stickney Memorial College in Pasadena, California.[4]

Although Mary Bonner obviously had dabbled in the arts at the various schools she had attended, she herself considered a trip to the Woodstock Art Colony in New York in 1922 as the true beginning of her artistic career. It was there that she saw an exhibition of lithographs that intrigued her. She visited the artist, believed to be Bolton Coit Brown (1865–1936), with the objective of studying lithography with him. The artist advised her to take up etching rather than lithography as the necessary equipment was lighter and easier for a woman to handle. Mary was thus launched upon the career that was to make her a world-renowned printmaker.[5]

In the autumn of 1922, Mary went to Paris to further her studies. After six weeks of searching for a suitable instructor, she chose Édouard-Henri Léon (1873–?). She must have engulfed herself in her work because Édouard Léon contended that she accomplished in two and one-half years what would ordinarily have required fifteen years to achieve.[6]

Mary started to exhibit in the Paris salons and from the beginning was awarded distinguished honors. Although the subjects for her first works were primarily European, it was her large, vigorous cowboy friezes that caught the imagination of the French people and hurled her into the limelight. An article in a Paris newspaper stated: "Had Mlle. Bonner never introduced her native cowboys to Paris, with all their humor and abandon, her other work would mark her as an important artist; but when those inimitable cowboys are regarded, she is, in addition to being a great artist, also the unique Mary Bonner of Texas."[7]

PORTRAIT BUST OF MARY BONNER BY GUTZON BORGLUM

In *Mary Bonner: Impressions of a Printmaker*, Mary Carolyn George indicates that Borglum and Mary Bonner were good friends and attended many cultural soirées at the gracious home of Mrs. Henry P. Drought in San Antonio. And perhaps it was Borglum who encouraged the printmaker to experiment in the field of sculpture. Certainly their relationship was responsible for this striking bust of Mary Bonner, which is inscribed on the back: "Mary Bonner, Gravure, Salon de 1926, Paris, France." Signed "Gutzon Borglum" under the left shoulder, it is made of plaster and toned a bronze green. It was the gift of William F. Bonner, Jr., Mary's brother, to the San Antonio Museum Association in 1957.

Mary Bonner and Édouard Léon in the studio at 6 rue Vercingétorix in Paris, about 1930. SAMA Historical Photographic Archives, gift of William F. Bonner, Jr.

1. "Mary Bonner," San Antonio Express, June 28, 1935.
2. Mary Carolyn Hollers George, Mary Bonner: Impressions of a Printmaker (San Antonio: Trinity University Press, 1982), 3–8.
3. Ibid.
4. Marie Gertrude McCampbell, "Mary Bonner, Artist," San Antonio Express, November 8, 1936.
5. Penelope Borden, "Mary Bonner, Etcher of Texas Cowboys," Holland's, The Magazine of the South, 47 (June 1928): 16–17; George, Mary Bonner, 23.
6. Borden, "Mary Bonner," 17.
7. Ibid.
8. George, Mary Bonner, 57–58.
9. McCampbell, "Mary Bonner."
10. George, Mary Bonner, 58–60.
11. Witte Memorial Museum Art Department Annual Report, 1936. Witte Museum Library.
12. "Witte Features Bonner Etchings," San Antonio Express, June 29, 1952.

In 1929, Miss Bonner won the coveted Ordre des Palmes Académiques and in 1931 received the silver medal at the salon of the Société des Artistes Français.[8] Her work was included in many important exhibitions, and examples may be found in the British Museum, the New York Public Library, the Luxembourg Museum in France, and many other major institutions and private collections.[9]

During her artistic career Mary traveled from Texas to Europe many times but, after 1929, she remained for the most part in San Antonio. She became active in the city's cultural affairs and continued to produce lively and enchanting prints and watercolors. In 1935 she underwent surgery for duodenal ulcers. A week later, on June 26, she died of an embolism, an aftermath of the operation. She was forty-eight years old.[10]

In 1936 Eleanor Onderdonk organized a memorial exhibition of Mary Bonner's work at the Witte Memorial Museum. It opened on September 1 and continued through the month of October. It included forty-eight prints and five watercolors, examples she had produced over a number of years.[11] In 1952 the museum presented another exhibition of her work, and Eleanor Onderdonk hailed the artist as "America's foremost etcher."[12]

In 1982 Trinity University Press published the definitive book on the artist. Written by Mary Carolyn Hollers George, it was entitled Mary Bonner: Impressions of a Printmaker.

CALF ROPING
1924, copperplate etching on toned paper, 6″ × 10″
Signed lower right: Mary Bonner

Mary Bonner's ability to capture motion and
liveliness of action and her innate sense of
design are represented in this amusing print
of cowboys in the act of roping a reluctant
calf. Other versions in this series are tinted,
possibly with color that was hand-applied.[13]

PROVENANCE:
1924–1956: Collection of Emma Bonner.
1956: Purchased from the Estate of Emma Bonner by
Walter Nold Mathis from the Bonner home on
Agarita Street, SA.
1977: Gift to SAMA by Walter Nold Mathis.
77–1004 G

EXHIBITIONS:
1986: Texas Seen/Texas Made, SAMOA (September 29
to November 30).

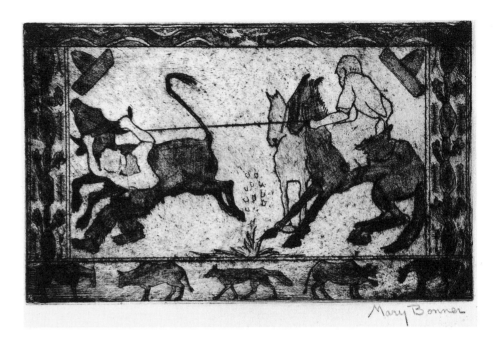

THE WHITE MULE
1928, aquatint, 11″ × 23½″
Signed and dated lower right: Mary Bonner 28

In *The White Mule*, one of Mary Bonner's
most popular and successful prints, the artist
achieved a pleasing arrangement of forms,
much in the manner of Greek vase painting
In her printmaking Mary Bonner explored a
variety of techniques, and in this print she
attained four distinct tones by using the
aquatint process.

PROVENANCE:
-1990: Collection of Mr. and Mrs. Gordon George.
1990: Purchased by SAMA from the Estate of Gordon
George with funds provided by the Lena and Albert
Hirschfeld Endowment.
90–109 P (6)

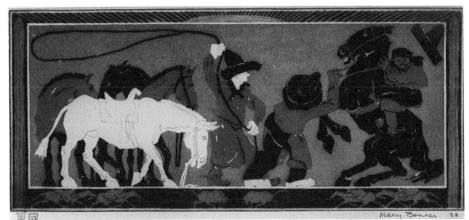

THE WHITE COW
1924, aquatint, 11″ × 23½″
Signed and dated lower right: Mary Bonner 24

Although there is a span of four years in the
dating of these prints, they apparently were
designed as a pair. The sizes coincide; the
arrangement of the figures and the tonal
gradations complement one another; and
the borders are identical in treatment.
Miss Bonner's superiority as a printmaker is
demonstrated in these two examples.

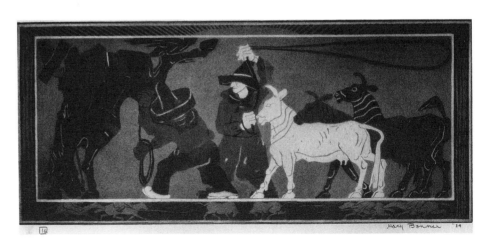

PROVENANCE:
-1990: Collection of Mr. and Mrs. Gordon George.
1990: Purchased by SAMA from the Estate of Gordon
George with funds provided by the Lena and Albert
Hirschfeld Endowment.
90–109 P (7)

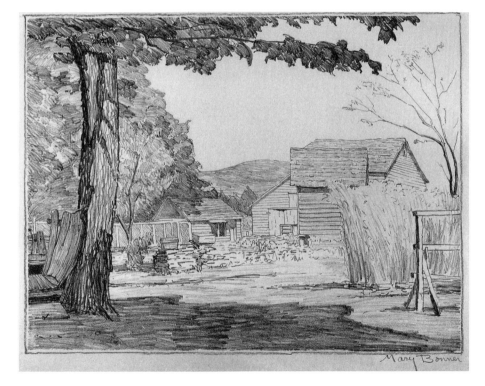

SEASCAPE
1926, watercolor on paper, 13¼″ × 19″
Signed and dated lower right: Mary Bonner '26

Mary Bonner's watercolors seem in direct contrast to her prints. They are sensitive in treatment, delicate in color, and are far less dramatic than her vigorous etchings. Her strokes are deliberate, however, as demonstrated in this seascape. In this example the washes are broad and sure, and she accomplishes the feeling of space and distance by accenting the rocks in the foreground with dark, swift, linear strokes.

PROVENANCE:
-1990: Collection of Mr. and Mrs. Gordon George.
1990: Purchased by SAMA from the Estate of Gordon George with funds provided by the Lena and Albert Hirschfeld Endowment.
90–109 P (1)

HOUSE AND BARN
ca. 1927, lithograph on paper, 10″ × 13¼″
Signed lower right: Mary Bonner

Mary Bonner's artistic virtuosity expanded into the realm of lithography, well illustrated in this print. It has all the attributes of a fine pencil drawing and shows the skill and richness of her mature work. It is believed the original drawing was made when Mary Bonner and the Édouard Léons toured Pennsylvania and Delaware in the spring of 1927.[14]

PROVENANCE:
1977: Purchased by SAMA from King William Antiques with Witte Picture Funds.
77–964 P

EXHIBITIONS:
1986: Texas Seen/Texas Made, SAMOA (September 29 to November 30).

13. George, *Mary Bonner*, 78: plate 5.
14. Ibid., 106: plate 21.

BUCKING BRONCOS
ca. 1924 (?), copperplate etching on paper, 6″ × 9¹³⁄₁₆″
Signed lower right: Mary Bonner

Bucking Broncos was one of three etchings in a
group entitled *Texas* that hung in the French
Salon d'Automne in 1924. The western
theme of these plates was enhanced with the
innovative borders Mary Bonner used to
surround the central motif. These borders
featured rattlesnakes, centipedes, scorpions,
cattle, horses, and a coyote, all indigenous
symbols of Texas.[15]

PROVENANCE:
1924–1952: Collection of Emma Bonner.
1952: Purchased from the Estate of Emma Bonner
by Walter Nold Mathis from the Bonner home on
Agarita Street, SA.
1977: Gift to SAMA by Walter Nold Mathis.
77–1003 G

EXHIBITIONS:
1986: Texas Seen/Texas Made, SAMOA (September 29
to November 30).

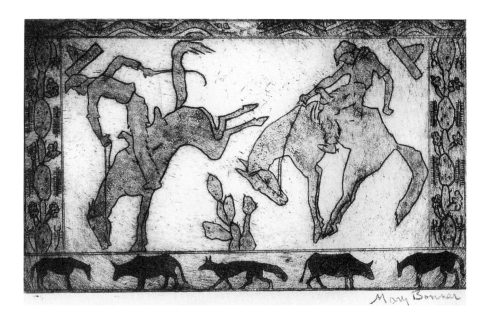

MISSION ESPADA, SAN ANTONIO
1927, etching and drypoint on paper, 7¹⁄₁₆″ × 12″
Signed and dated lower right: Mary Bonner, '27

In 1927, M. and Mme. Léon visited Mary
Bonner in Texas. M. Léon had been sent
to this country for three months as a
representative of the Beaux Arts de Paris. He
lectured on French art, and he and Mary had
joint exhibitions of their work in New York,
Philadelphia, Washington, D.C., Portland,
Wilmington, and other American cities.
When in San Antonio, however, he and Mary
spent their precious time making sketches in
and around the city. It is presumed that the
print of *Mission Espada* by Mary was produced
at this time.[16]

PROVENANCE:
1927–1956: Collection of Emma Bonner.
1956: Purchased from the Estate of Emma Bonner
by Walter Nold Mathis from the Bonner home on
Agarita Street, SA.
1978: Gift to SAMA by Walter Nold Mathis.
78–1185 G

EXHIBITIONS:
1986: Texas Seen/Texas Made, SAMOA (September 29
to November 30).

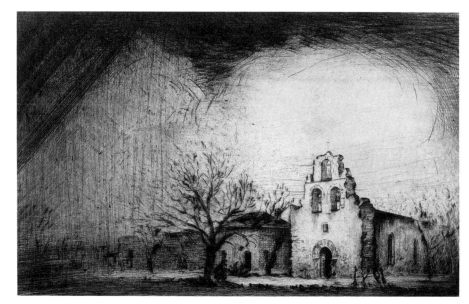

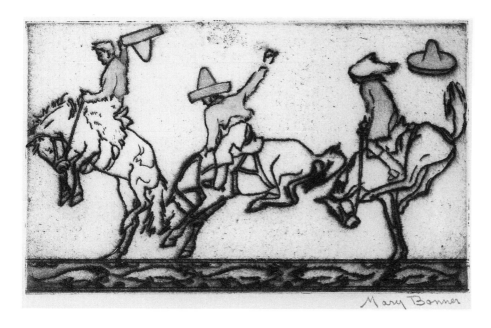

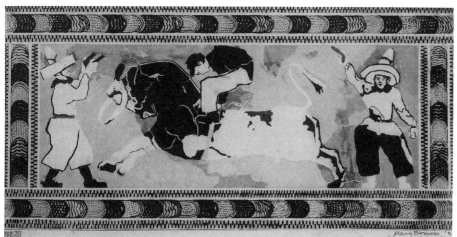

THREE BUCKING BRONCOS
n.d., etching with aquatint on paper, 6″ × 9¼″
Signed lower right: Mary Bonner

Three Bucking Broncos is a typical Bonner print: vital, action-packed, and bold in treatment. It appears that the "cowboy" on the right may actually be a "cowgirl," a deviation that occurs in her three-paneled frieze, *Les Cowboys.* It is difficult to tell whether color was applied to the plate and printed or applied after printing, with a brush.

PROVENANCE:
1977: Purchased by SAMA from King William Antiques with Witte Picture Funds.
77–957 P

EXHIBITIONS:
1986: Texas Seen/Texas Made, SAMOA (September 29 to November 30).

BUCKING STEER
1926, etching with aquatint on paper, 12½″ × 25½″
Signed, dated, and inscribed lower right: Mary Bonner, '26/To Jerry and Judy Drought, March 1928

Mary Bonner often displayed a wry sense of humor, especially in her cowboy prints. It appears that the cowboys, standing on either side, are deliberately discharging their handguns in order to provoke livelier action from the bucking steer—much to the consternation of the hapless rider. The decorative border, one of Mary Bonner's distinctive trademarks, is more abstract than usual, but seems to be a series of overlapping cactus leaves.

PROVENANCE:
1926–1928: Collection of Mary Bonner.
1928: Gift to Jerry and Judy Drought.
1945: Gift to SAMA by the Drought Estate.
45–131 G

EXHIBITIONS:
1952: Mary Bonner Etchings, WMM (September 14 to 28).
1986: Texas Seen/Texas Made, SAMOA (September 29 to November 30).

15. "San Antonio Girl Wins Fame Abroad," San Antonio *Express*, January 25, 1925.
16. Borden, "Mary Bonner," 17.

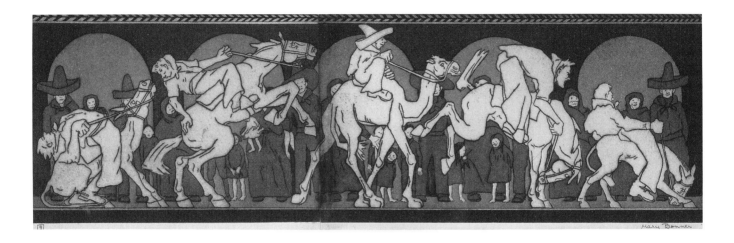

THE COWBOY PARADE
1929, aquatint on paper, 12½" × 40½"
Signed and dated lower right: Mary Bonner '29

Again Mary Bonner uses the complicated
process of aquatint for one of her most
humorous prints of Texas cowboys. The
camel in the center is not a figment of
the artist's imagination but was no doubt
based upon her knowledge of the camels
introduced into Texas in 1856 by the military
to be used as beasts of burden.[17] Her
composition arcs across the extended print
with recalcitrant mules at either end and
bucking broncos flanking the sedate camel
in the center. The parade is being witnessed
by children and adults in the background,
obviously amused by the strange procession
of animals.

PROVENANCE:
-1990: Collection of Mr. and Mrs. Gordon George.
1990: Purchased by SAMA from the Estate of Gordon
George with funds provided by the Lena and Albert
Hirschfeld Endowment.
90–109 P (5)

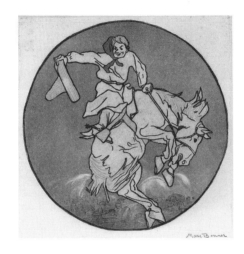

CIRCULAR COWBOY
ca. 1929, etching and aquatint on toned paper,
16½" × 16½"
Signed lower right: Mary Bonner

In choosing a circular shape for her bucking
horse and cowboy, Miss Bonner created a
challenge for herself in composition. The
curved lines of the arched horse lend
themselves admirably to the round area and
are balanced by the cowboy's outflung arm
and large sombrero. The bandanna and
saddlestrap bear touches of color which
appear to have been applied to the plate
and then printed, as in a monotype.

PROVENANCE:
-1990: Collection of Mr. and Mrs. Gordon George.
1990: Purchased by SAMA from the Estate of Gordon
George with funds provided by the Lena and Albert
Hirschfeld Endowment.
90–109 P (4)

17. Webb, Carroll, and Branda (eds.), *The Handbook of
Texas*, 1, s.v. "Camels in Texas."

WORKS BY MARY ANITA BONNER
NOT ILLUSTRATED:

GUITAR PLAYER
n.d., etching on toned paper, 6⁵⁄₁₆″ × 6⅛″
Signed lower right: Mary Bonner
64–251 G (1)
Gift to SAMA by anonymous donor.

BOATS
n.d., etching on toned paper, 6¹³⁄₁₆″ × 5⁹⁄₁₆″
Signed lower right: Mary Bonner
64–251 G (2)
Gift to SAMA by anonymous donor.

SEASIDE HOUSES
1924, hand-colored softground etching on toned
paper, 5⅝″ × 8⁹⁄₁₆″
Signed and dated lower right: Mary Bonner '24
64–251 G (3)
Gift to SAMA by anonymous donor.

HORSES
1912, etching with softground details on toned paper,
4⅛″ × 3⅞″
Signed and dated (on plate) across bottom: Mary
Bonner 1932
74–14 G (4)
Gift to SAMA by anonymous donor.

McNAY MUSEUM (Christmas card)
n.d., drypoint etching on paper mounted on
card, 7″ × 5⅛⁄₁₆″
Signed lower right: Mary Bonner
Signed (on plate) center bottom: Mary Bonner
Inscribed front center bottom: Christmas Greetings
Inscribed (on card) upper right: McNay Museum
Inscribed inside card: Donald and Marion Atkinson/
Sunset Hills/San Antonio, Texas
74–14 G (16)
Gift to SAMA by anonymous donor.

WITTE MUSEUM
ca. 1930, etching on toned paper, 2⁹⁄₁₆″ × 4⁷⁄₁₆″
Signed lower right: Mary Bonner
Titled (on plate) lower left: Witte Museum
Inscribed lower left: To Mrs. Fellows
76–198 G (1)
Gift to SAMA by anonymous donor.

COWBOY ON BUCKING HORSE
(Christmas card)
1930, etching on toned paper, 3½″ × 4¼″
Signed and dated (on plate) across bottom: 1930/Mary
Bonner/145 E. Agarita, San Antonio, Texas
Inscribed (on plate) upper left: Greetings
76–198 G (2)
Gift to SAMA by anonymous donor.

HORSES
1932, etching with softground details on toned paper,
4¼″ × 3⅞″
Signed and dated (on plate) across bottom:
Mary Bonner 1932
76–80 G (8)
Gift to SAMA by Irene E. Wright.

MOUNTED COWBOY WITH LASSO (invitation)
n.d., etching on paper mounted on cardboard,
5⁵⁄₁₆″ × 4¹⁄₁₆″
Initialed (on plate) lower right: M. B.
Etching extends to right with inscription: Mrs. Henry
Drought/invites/you and friends/To a tea showing/of/
Mary Bonner's/Etchings/at her home/1215 N. St.
Mary's St./from 3-6/Friday May 23
82–52 G (125)
Gift to SAMA by Esther Berry in memory of Peggy
and Richard Prassel.

CHRISTMAS CARD
1928, etching on toned paper, 3¼″ × 4¹⁵⁄₁₆″
Signed and inscribed (on plate) lower left: Mary
Bonner/145 E. Agarita/San Antonio
Inscribed and dated (on plate) upper left: Greetings,
1928
82–90 G (1)
Gift to SAMA by William F. Bonner, Jr.

MRS. McNAY'S DOG AND PUP
1930, aquatint on paper, 8⅝″ × 9¼″
Signed lower right: Mary Bonner
Inscribed on back: Fritzie
61–1 G (6d)
Gift to SAMA by the Estate of Mariette DePew.

PATIO OF McNAY RESIDENCE, SAN ANTONIO
ca. 1930, drypoint and line etching on toned paper, 7″
× 5⅛⁄₁₆″
Signed lower left: Mary Bonner
61–1 G (6e)
Gift to SAMA by the Estate of Mariette DePew.

CHILDREN ON HORSEBACK
n.d., hand-colored etching on toned paper, 6″ × 9⅛″
Signed lower right: Mary Bonner
77–957 P
Purchased by SAMA from King William Antiques
with Witte Picture Fund.

LES COWBOYS (left panel)
1925, hand-colored etching with gouache on paper,
9¹⁵⁄₁₆″ × 16½″
Signed lower right: Mary Bonner
77–958 P
Purchased by SAMA from King William Antiques
with Witte Picture Fund.

LES COWBOYS (right panel)
1925, hand-colored etching with gouache on paper,
10″ × 16½″
Signed lower right: Mary Bonner
77–959 P
Purchased by SAMA from King William Antiques
with Witte Picture Fund.

WHITE MULE
1928, aquatint on paper, 10⁵⁄₁₆″ × 23⅛″
Signed and dated lower right: Mary Bonner '28
77–960 P
Purchased by SAMA from King William Antiques
with Witte Picture Fund.

POLO PLAYERS
n.d., etching on paper, 5¹³⁄₁₆″ × 8⁹⁄₁₆″
Signed lower right: Mary Bonner
77–961 P
Purchased by SAMA from King William Antiques
with Witte Picture Fund.

CYPRESS TREE
n.d., softground etching on toned paper,
6⁵⁄₁₆″ × 4¹³⁄₁₆″
Signed lower right: Mary Bonner
77–962 P
Purchased by SAMA from King William Antiques
with Witte Picture Fund.

TWO DOGS
n.d., etching on paper, 5⅛″ × 9″
Signed lower right: Mary Bonner
77–963 P
Purchased by SAMA from King William Antiques
with Witte Picture Fund.

DOG ON CHAIR
n.d., etching on paper, 7¹⁄₁₆″ × 4⅛″
Signed lower left: Mary Bonner
77–965 P
Purchased by SAMA from King William Antiques
with Witte Picture Fund.

SAIL BOATS
1925, etching on paper, 11¹³⁄₁₆″ × 15¹⁵⁄₁₆″
Signed and dated lower right: Mary Bonner '25
77–966 P
Purchased by SAMA from King William Antiques
with Witte Picture Fund.

DOGS
n.d., etching on paper, 5⅛″ × 8¹⁵⁄₁₆″
Signed lower right: Mary Bonner
77–967 P
Purchased by SAMA from King William Antiques
with Witte Picture Fund.

PORTRAIT OF A PRINCESS OF THE HOUSE
OF ESTE, after Pisanello
1926, etching on toned paper, 15¹⁵⁄₁₆″ × 11¼″
Signed and dated lower right: Mary Bonner '26
77–968 P
Purchased by SAMA from King William Antiques
with Witte Picture Fund.

PADDY
1930, etching and drypoint on toned paper,
10⅛″ × 10⁵⁄₁₆″
Signed and dated lower right: Mary Bonner '30
Titled (on plate) upper left: Paddy
77–969 P
Purchased by SAMA from King William Antiques
with Witte Picture Fund.

PONIES
n.d., etching on paper, 9″ × 13⁵⁄₁₆″
Signed lower right: Mary Bonner
Titled on back: Ponies
77–970 P
Purchased by SAMA from King William Antiques
with Witte Picture Fund.

LA BRETAGNE QUELQUES TYPES DE ROSCOFF,
DIX POINTES SECHÉS ORIGINALES GRAVÉES
PAR MARY BONNER
1924, portfolio, containing etchings on toned paper,
12⅛″ × 9⅐/₁₆″
77–971 P
This portfolio contains five of the ten etchings:

LE TOUR DE FETE
[1924], 6⅛″ × 5¹/₁₆″
Signed lower right: Mary Bonner
77–972 P
FISHERMAN
1924, 5″ × 6¹⁵/₁₆″
Signed and dated lower right: Mary Bonner '24
77–973 P
STREET SCENE
[1924], 8½″ × 5½″
Signed lower right: Mary Bonner
77–974 P
LE PINT
[1924], 6¹⁵/₁₆″ × 5¹/₁₆″
Signed lower right: Mary Bonner
77–975 P
LA LAVANDIERE
1924, 5″ × 6¹⁵/₁₆″
Signed and dated lower right: Mary Bonner '24
77–976 P
Purchased by SAMA from King William Antiques
with Witte Picture Fund.

WHITE MULE
1928, aquatint on paper, 10⅜/₁₆″ × 23⅐/₁₆″
Signed and dated lower right: Mary Bonner '28
77–999 G
Gift to SAMA by Walter Nold Mathis.

MESQUITES IN BRACKENRIDGE PARK,
SAN ANTONIO (proof)
n.d., etching and drypoint on paper,
5⅞″ × 9¹⁵/₁₆″
Signed lower right: Mary Bonner
77–1000 G
Gift to SAMA by Walter Nold Mathis.

MISSION ESPADA
1927, etching and drypoint on toned paper,
7½″ × 12″
Signed and dated lower right: Mary Bonner '27
77–1001 G
Gift to SAMA by Walter Nold Mathis.

SAIL BOATS
1925, etching on paper, 11¼″ × 15¹⁵/₁₆″
Signed and dated lower right: Mary Bonner '25
77–1002 G
Gift to SAMA by Walter Nold Mathis.

BUCKING BRONCOS
n.d., copperplate etching on paper, 5⅞″ × 9¹⁵/₁₆″
Signed lower right: Mary Bonner
77–1003 G
Gift to SAMA by Walter Nold Mathis.

BUCKING BRONCO
1927, etching on paper, 7″ × 5½″
Signed and dated lower right: Mary Bonner '27
77–1005 G
Gift to SAMA by Walter Nold Mathis.

CHILDREN ON HORSEBACK
n.d., hand-colored etching on paper, 5¹⁵/₁₆″ × 9⅛″
Signed lower right: Mary Bonner
77–1006 G
Gift to SAMA by Walter Nold Mathis.

LE BRETAGNE QUELQUES TYPES DE ROSCOFF,
DIX POINTES SECHÉS ORIGINALES GRAVÉES
PAR MARY BONNER
1924, portfolio, containing etchings on toned paper,
12⅛″ × 9½″
77–1007 G
This portfolio contains all ten etchings:

LA LAVANDIERE
[1924], 5″ × 6¹⁵/₁₆″
Signed lower right: Mary Bonner
Titled upper right: La Lavandiere
77–1008 G
LA CALFATEUR
1924, 5″ × 6¹⁵/₁₆″
Signed and dated lower right: Mary Bonner '24
Titled upper right: La Calfateur
77–1009 G
LE TOUR DE FETE
1924, 6⅛″ × 5″
Signed and dated lower right: Mary Bonner '24
Titled upper right: Le Tour de Fete
77–1010 G
LE PINT
1924, 6¹⁵/₁₆″ × 5″
Signed and dated lower right: Mary Bonner '24
Titled upper right: Le Pint
77–1011 G
LE REMASSEURS D'OIGNANS
1924, 5¹/₁₆″ × 7″
Signed and dated lower right: Mary Bonner '24
Titled upper right: Le Remasseurs d'Oignans
77–1012 G
LA FAMILLE
1924, 5¹/₁₆″ × 6¹⁵/₁₆″
Signed and dated lower right: Mary Bonner '24
Titled upper right: La Famille
77–1013 G
FISHERMEN
1924, 5″ × 6¹⁵/₁₆″
Signed and dated lower right: Mary Bonner '24
77–1014 G
LA HOUE
1924, 6¹⁵/₁₆″ × 5″
Signed and dated lower right: Mary Bonner '24
Titled upper right: La Houe
77–1015 G
LES POMMES DE TERRE
1924, 7″ × 5¹/₁₆″
Signed and dated lower right: Mary Bonner '24
Titled upper right: Les Pommes de Terre
77–1016 G
BRITTANY WOMEN
1924, 5¹/₁₆″ × 6¹⁵/₁₆″
Signed and dated lower right: Mary Bonner '24
77–1017 G
Gift to SAMA by Walter Nold Mathis.

TWO HUNTING DOGS
1929, etching on toned paper, 15⅝″ × 12⅝/₁₆″
Signed and dated lower right: Mary Bonner '29
78–1186 G
Gift to SAMA by Walter Nold Mathis.

WOMAN RESTRAINING DOGS
1930, etching on toned paper, 21⅛″ × 14⅝/₁₆″
Signed and dated lower right: Mary Bonner 1930
78–1187 G
Gift to SAMA by Walter Nold Mathis.

DANCERS, after Degas
n.d., copperplate etching on toned paper,
21⅞″ × 27⅝/₁₆″
Unsigned
Inscribed (on plate) lower right: Degas
78–1188 G
Gift to SAMA by Walter Nold Mathis.

MAN WEARING DUTCH SHOES
n.d., copper plate, cancelled, 10″ × 8″
Unsigned
80–234 G (1)
Gift to SAMA by Walter Nold Mathis.

SAN JOSÉ MISSION
n.d., copper plate, cancelled, 7″ × 11⅛″
Unsigned
80–234 G (2)
Gift to SAMA by Walter Nold Mathis.

TWO DOGS WITH FIGURE
n.d., copper plate, 21⅛″ × 14⅝″
Unsigned
80–234 G (3)
Gift to SAMA by Walter Nold Mathis.

COSTUMED DANCERS
n.d., copper plate, 22½″ × 27¼″
Unsigned
80–234 G (4)
Gift to SAMA by Walter Nold Mathis.

ARCHITECTURAL SKETCH
n.d., wash drawing on paper, 8¹/₁₆″ × 5⅝/₁₆″
Unsigned
80–235 G (3t)
Gift to SAMA by Walter Nold Mathis.

BUCKING BRONCO
n.d., drypoint and etching on paper, 6⅞″ × 5¹/₁₆″
Signed lower right: Mary Bonner
80–112 G
Gift to SAMA by Mr. and Mrs. Eric Steinfeldt.

PATIO OF McNAY RESIDENCE, SAN ANTONIO
ca. 1930, etching on toned paper, 7″ × 5⅜/₁₆″
Signed (on plate) and on etching lower right:
Mary Bonner
84–54 G
Gift to SAMA by Mr. and Mrs. Eric Steinfeldt.

The child who bore such an impressive name was born in a settlement near Bear Lake on the border between Utah and Idaho on March 26, 1867. He was the son of James Borglum, a Danish woodcarver and doctor, and his young Danish wife, who had immigrated to America in 1864. Biographical accounts do not mention Gutzon's mother's name, but they relate that when Gutzon was a small boy she called him and his younger brother, Solon, into the house from play. She kissed them both, bid them goodbye, walked out the door, and never returned. James Borglum's second wife was Ida (Michelson) Borglum. He received his American degree in medicine in St. Louis and moved to Fremont, Nebraska, where Gutzon spent his boyhood years.[1]

Young Borglum displayed artistic inclination at an early age, but, although encouraged by his teachers, he received little support from his family in his aspirations to become an artist. After he finished high school in St. Mary's, Kansas, he went to work in a machine shop in Omaha, Nebraska, where his family then lived. Determined to be an artist, however, Gutzon decided to go to California when he earned enough money. Dr. Borglum himself was excited by stories of fabulous opportunities in the West, so in the spring of 1884, the entire family moved to Los Angeles.[2]

Gutzon apprenticed himself to a lithographer, with whom he learned printing and engraving. He also worked as a fresco painter, decorating rooms with garlands and angels. He opened his own studio and started painting California landscapes as well as western scenes of Indians, cowboys, and horses. He was nineteen years old, full of energy and enthusiasm, and eager to advance himself in the art field.[3]

Gutzon realized his limitations, however, and decided to further his studies in San Francisco. His mentors there were Virgil Williams (1830–1886) and William Keith (1839–1911).[4] It was at the San Francisco Art Association that he met Elizabeth Putnam, a widow, who became his first wife. Although she was considerably older than he (she was forty, he was twenty-two), the alliance was a happy one for a number of years.[5] They were both artists and shared the same interests and ambitions. Elizabeth, or Lisa, as he called her, was an understanding helpmate until Gutzon's eccentricities caused a gradual separation that resulted in divorce in 1908. Gutzon's increasingly frenzied lifestyle and cavalier disregard for financial matters no doubt were largely responsible for the rift.[6]

During these years Gutzon had turned from painting to the more demanding and challenging pursuit of sculpture. The mediums of clay, bronze, and stone were more suited to his dynamic character and colossal ideas. He went to Paris in 1888 and studied at the Académie Julian and École des Beaux-Arts, and with the sculptor Stephen Sinding (1846–1922).[7] He toured Spain, had studios in London and Paris, and shuttled between the United States and Europe fulfilling commissions.

On May 19, 1909, Gutzon married Mary Montgomery, a woman he had met on shipboard on one of his trips between the continents.[8] Brilliant and well-educated, she proved to be a stabilizing force and a sympathetic companion to the vigorous man who was to become one of the world's most renowned sculptors. As he developed, his work and his conceptions became grander in scale, culminating in the monumental Mount Rushmore Memorial in South Dakota, in which he used a rock mountain for his sculpture and blasted and gouged the likenesses of Jefferson, Washington, Lincoln, and Theodore Roosevelt out of its craggy depths.[9] This mammoth monument

1. Willadene Price, *Gutzon Borglum: Artist and Patriot* (1961), 10 (quotation), 9–11. Most biographies of Borglum state that Ida (Michelson) Borglum was Gutzon's and Solon's mother. Willadene Price, who has done the most thorough biographical research on the sculptor, maintains otherwise. She states: "By the time Gutzon was old enough to want an explanation [about his mother's identity], there was already Ida, a stepmother, and somehow he couldn't bring himself to ask his father any questions. His father insisted that he call his stepmother 'Mama,' but he was a grown man before he did so willingly."
2. Ibid., 12–16.
3. Ibid., 19–21.
4. Caroline Remy, "Biographical Sketches of Fifteen Texas Artists," s.v. "Borglum, John Gutzon de la Mothe." June 1966. Photocopied typescript, SAMA Texas Artists Records.
5. Price, *Gutzon Borglum*, 28.
6. Ibid., 78.
7. Peggy and Harold Samuels, *The Illustrated Biographical Encyclopedia of Artists of the American West*, s.v. "Borglum, John Gutzon de la Mothe."
8. Price, *Gutzon Borglum*, 84.
9. *Mount Rushmore National Memorial* (Chicago: Mount Rushmore National Memorial Commission, 1930), 3–33.

A photograph of Mount Rushmore with work in progress, used as a Christmas card by the Gutzon Borglums. SAMA Historical Photographic Archives, gift of an anonymous donor.

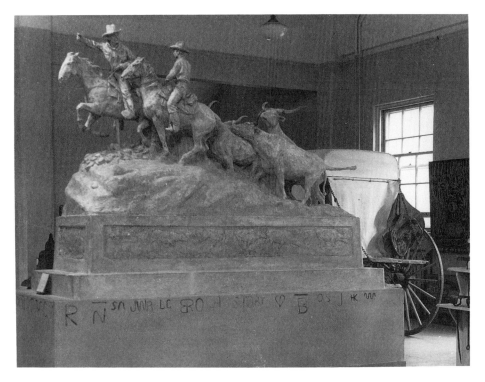

Model of the Trail Drivers Monument by Gutzon Borglum. This photograph shows the plaster cast of the Trail Drivers Monument as it stood in the entrance hall of the Witte Memorial Museum in 1926. It was later cast in bronze and placed in front of the Texas Rangers Museum adjacent to the museum. SAMA Historical Photographic Archives, gift of an anonymous donor.

was formally dedicated by President Calvin Coolidge on August 10, 1927, and was completed after Gutzon's death by his son, Lincoln.[10]

Borglum made San Antonio his intermittent home for about fifteen years, from 1924 until 1939. He came to the city to work on a model for an Old Trail Drivers Monument, using an abandoned pump house in Brackenridge Park as his studio. The monument, as Borglum envisioned it, was to be forty feet high, cost $100,000, and be placed on the plaza in front of the Municipal Auditorium in San Antonio. The necessary funds never were raised to achieve the large sculpture, but a smaller version was cast from his model and now stands in front of the Texas Rangers Museum adjacent to the Witte Memorial Museum in Brackenridge Park.[11]

Gutzon was as adept at speaking his mind as he was at monumental sculpture. During the Texas Centennial in 1936 he wrote numerous scathing letters to government and civic leaders in the state, which found their way into various newspapers, denouncing the quality of sculpture chosen for the celebration and the shoddy planning behind the funding and choices. He also championed liberation movements, hosted Czechoslovak freedom fighters in his home in Connecticut in 1918, and helped write the Czechoslovakian constitution with Jan Masaryk, son of the new country's first president. He was a pioneer in sponsoring roadside beautification in Texas as well.[12]

Besides Gutzon's masterpiece at Mount Rushmore, many other of his works exist in the United States. Some outstanding examples are the colossal head of Lincoln in the capitol in Washington, D.C., and an equestrian statue of General Sheridan, also in Washington. A seated Lincoln is in Newark, New Jersey; a statue of John W. Mackay in Reno, Nevada; the *Mares of Diomedes* in the Metropolitan Museum of Art; and *Three Apostles* in the Cathedral of Saint John the Divine, also in New York.[13]

Gutzon Borglum, the man of heroic ideals and ideas, died on March 6, 1941, leaving his wife, Mary, and two children, Lincoln and Mary Ellis. Gutzon had wished to be buried in California, but his death was such a shock to his family that his body was laid to rest temporarily in a crypt in Chicago. In 1944, arrangements finally were completed to remove Gutzon's body to Forest Lawn Memorial Park in Glendale, California. He was entombed in the Court of Honor as an "immortal" on November 14, in the first service of its kind to be held there, a fitting tribute to a man who produced immortal sculpture. More than 1,200 people reportedly attended the ceremony.[14]

10. Remy, "Biographical Sketches of Fifteen Texas Artists," s.v. "Borglum."
11. "The Borglum Studio." Undated photocopied typescript, Gutzon Borglum file, SAMA Texas Artists Records; Sam Acheson, "Texas Irresistibly Attracted Borglum, and He Exhibited Intense Interest in Its Art," Dallas News, March 7, 1941.
12. John L. Davis, *The Danish Texans* (San Antonio: University of Texas Institute of Texan Cultures at San Antonio, 1979), 96.
13. Remy, "Biographical Sketches of Fifteen Texas Artists," s.v. "Borglum"; Price, *Gutzon Borglum*, 61–82.
14. Price, *Gutzon Borglum*, 211–212; "1,200 See Body of Borglum Entombed," San Antonio Express, November 17, 1944.

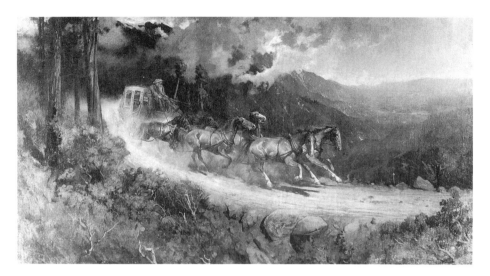

RUNNIN' OUT THE STORM
ca. 1896, oil on canvas, 60" × 108⅛"
Signed and dated lower right: Gutzon Borglum, 189?

Gutzon Borglum's penchant for western themes reflects his early boyhood and his love for horses. The first of many horses that Borglum owned during his lifetime was a young mare that he purchased from a Pawnee Indian in Fremont, Nebraska, for fifty cents.[15] When he made the trip by train from Los Angeles to San Francisco a few years later to pursue his art career, he was overcome by the majestic beauty of the rugged California land and the endless subjects it symbolized. As the train labored up a narrow ledge of mountainside, Gutzon remarked to a fellow traveler, "What a picture it must have been . . . to see a stage coach go thundering along these precipices."[16]

After Gutzon finished his studies in San Francisco and returned to Los Angeles, he began work on a stagecoach picture that probably was inspired by his train journey. It was on an immense canvas that measured five feet by nine feet. Called *Staging in California*, it closely resembles *Runnin' Out the Storm*.[17] Evidently a theme that appealed to the young painter, the smaller version in The Texas Collection shows Borglum's skill with a paintbrush and his familiarity with horses. The sculptural quality of the anatomy of the animals is obvious even in the painting medium. *Runnin' Out the Storm* also captures the ferocity of the elements and the grandeur of California scenery.

Although the painting is signed and dated, the last digit in the numerals is unclear. Perry Huston, the conservator of the painting in 1979, interpreted it as a "6," although it could be a "0" or an "8." The numbers blend into the painted foreground and are difficult to decipher. There is no doubt, however, that it is an early painting, probably executed in California sometime before Borglum transferred his energies to sculpting.

PROVENANCE:
ca. 1896–1977: Collection of the Borglum Family.
1977: Gift to SAMA by Anne Borglum Carter.
77–1101 G

EXHIBITIONS:
1961: Edgar B. Davis Gallery, WMM (June 1 to September 31).
1961–1977: Menger Hotel Lobby, SA.
1977–1986: Edgar B. Davis Gallery, WMM.
1990: Gutzon Borglum (1867–1941): Before Mount Rushmore, Art Museum of South Texas, Corpus Christi (October 12 to December 2).

PUBLICATIONS:
SAMA Bi-Annual Report, 1976–1978 (1978), 31.
[Margaret Gillham], *Gutzon Borglum (1867–1941): Before Mount Rushmore* (1990), 8.

15. Price, *Gutzon Borglum*, 11–12.
16. Ibid., 21.
17. Ibid., 24–27.

WORKS BY
JOHN GUTZON DE LA MOTHE BORGLUM
NOT ILLUSTRATED:

MARY BONNER
n.d. (see section on Mary Bonner), toned plaster, 27" × 18" × 8½"
Signed under left shoulder: Gutzon Borglum
Inscribed on back: Mary Bonner, Salon de 1926, Paris, France
57–174 G
Gift to SAMA by William F. Bonner, Jr.

INGERSOLL
n.d., toned plaster, 14" × 3¼"
Initialed lower right rear of base: "G" within a circle
49–17 G (1)
Gift to SAMA by Mrs. Gutzon Borglum.

COWHAND
n.d., toned plaster, 15" × 9"
Initialed right top base: "GB" within a circle
49–17 G (2)
Gift to SAMA by Mrs. Gutzon Borglum.

INDIANS PURSUED
n.d., bronze, 18" × 9" × 22"
Signed left rear base: Gutzon Borglum
46–111 P
Purchased by SAMA from Mrs. Gutzon Borglum with Witte Picture Fund.

LINCOLN MASK
n.d., wax, 4¼" × 3"
Unsigned (model for Lincoln Memorial, Newark, New Jersey)
44–98 G
Gift to SAMA by the Drought Estate.

SORROW
n.d., white marble, 13" × 5" × 4"
Signed left side and reverse: Gutzon Borglum
78–240 P
Purchased by SAMA from Sotheby Parke Bernet, Inc., with funds provided by The Blaffer Foundation.

CHARLES TAYLOR BOWLING

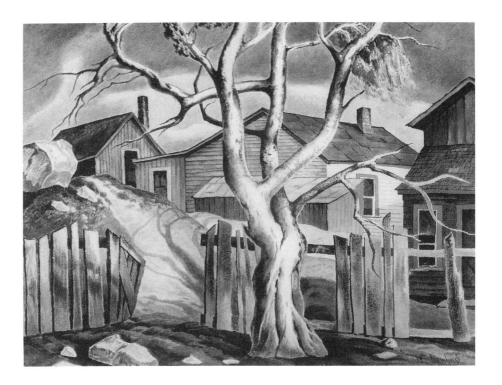

SYCAMORE
n.d., watercolor on paper, 17½" × 23"
Signed lower right: Chas. T. Bowling

Charles Bowling could work competently in several mediums. His *Sycamore* is one of his more successful watercolors and received an award in the Allied Arts Show at the Dallas Museum of Fine Arts in 1937.[6] Bowling found artistic inspiration in the lowliest of urban subjects, and, although the sycamore tree is the focal point in this composition, it is placed against a background of commonplace houses and a makeshift fence. The artist's proficiency as a draftsman, due no doubt to his engineering experience, is evident in the clear crisp lines of the houses. A mood of solitude pervades the painting, suggested by the empty windows, the muted tones of the worn wood, and the steely gray of the windswept sky.

PROVENANCE:
ca. 1937–1986: Collection of the Bowling Family.
1986: Purchased by SAMA from Frances Layne, the artist's daughter, with Witte Picture Fund.
86–84 P (1)

EXHIBITIONS:
1937: Allied Arts Show, DMFA.
1940: Twentieth Annual Exhibition of the Southern States Art League, The Mint Museum of Art, Charlotte, North Carolina (April 4 to 30).
1943: Texas Fine Arts Association Annual Membership Show, Elisabet Ney Museum, Austin (May 5 to 31).
1986: Texas Seen/Texas Made, SAMOA (September 29 to November 30).

1. Rick Stewart, *Lone Star Regionalism: The Dallas Nine and Their Circle, 1928–1945* (Austin: Texas Monthly Press for the Dallas Museum of Art, 1985), 19–39.
2. Ibid., 65.
3. William H. Goetzmann and Becky Duval Reese, *Texas Images and Visions* (Austin: University of Texas Press, 1983), 84.
4. Stewart, *Lone Star Regionalism*, 65.
5. Ibid., 153–154; Forrester-O'Brien, *Art and Artists*, 56.

Charles Bowling was one of a group of Dallas artists who gained prominence during the Great Depression. These artists developed a unique regional style and portrayed the bleakness of the depression as it related to the agricultural environment of the state. Their paintings were stark and realistic, primarily landscapes, strong in color and design, and reflected the austere circumstances in which they lived. These artists, known as the "Dallas Nine," were regionalists in the true sense of the word.[1]

Bowling was the oldest of these artists and, although he had always been interested in art, he did not begin to paint seriously until he was thirty-five. But his work is typical of the regionalist style this group explored and adopted.[2] He was born in Quitman, Wood County, Texas, in 1891 and moved to Dallas in 1901. An engineer by profession, he was head of the drafting department at the Dallas Power and Light Company for many years. During the depression, he employed two fellow artists, Otis Dozier (1904–1984) and William Lester (1910–1991).[3]

When Bowling painted, he chose familiar scenes: the landscape around Dallas, abandoned farmhouses, or the hovels in "Little Mexico," a rambling shantytown on the west side of the city.[4] His paintings have a desolate but poignant realism, characteristics that typified much of the work produced by this group.

Charles Bowling had studied at the Dallas Art Institute with Olin Herman Travis (1888–1975) and, later, with Alexandre Hogue (1898–) and Frank Klepper (1890–1950). He was a charter member of the Lone Star Printmakers and specialized in lithography. He received many honors in his lifetime, and he is represented in numerous public and private collections. Although Bowling lived until 1985, he was forced to abandon his art career in 1965 due to failing eyesight.[5]

WINTER LANDSCAPE
1959, oil on academy board, 16″ × 20⅛″
Signed and dated lower left: Chas. T. Bowling, '59

Although this painting is outside the time
frame selected for this catalogue, it has been
included because Bowling was still painting
in the style he had espoused in the 1930s
and 1940s. When compared with his canvas
entitled *Winter Evening*, painted in 1941,
and some of his lithographs of snow-covered
houses executed in the 1940s, the theme
and his handling of subject matter show little
change.[7] Derelict houses huddling under
snowy blankets seemed to be among his
favorite subjects. He succeeds in conveying a
stealthy quietness in these somber paintings,
with the only signs of life being the thin
plumes of smoke issuing from chimneys
silhouetted against a cold winter sky.

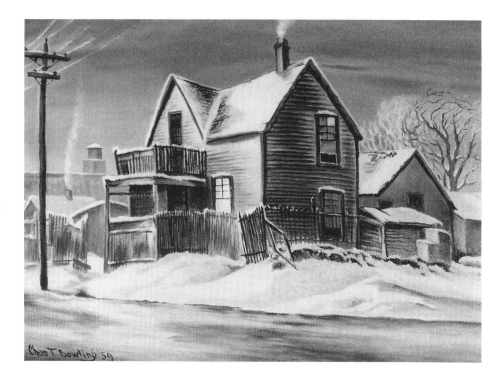

PROVENANCE:
1959–1986: Collection of the Bowling Family.
1986: Purchased by SAMA from Frances Layne with
Witte Picture Fund.
86–84 P (2)

EXHIBITIONS:
1986: Texas Seen/Texas Made, SAMOA (September 29
to November 30).

MEADOW WIND
1941, lithograph on paper, 9⅛″ × 12″
Signed lower right: Chas. T. Bowling
Titled lower left: Meadow Wind, "Ed 25"

Bowling was a charter member of the Lone
Star Printmakers, a Dallas group that formed
in 1938. At that time printmaking was a
feasible medium for artists, since prints could
be sold at affordable prices and were much
less expensive than paintings to crate, ship,
and insure, all factors to be considered
during the lean years of the depression.
Charles Bowling became so captivated with
lithography that he purchased his own press,
a luxury few of these printmakers could
afford.[8] He became exceptionally proficient in
his craft, and his prints seem to convey an
intensity of feeling and mood even more
than his paintings. *Meadow Wind* is dramatic
and forceful with its stormy sky, its
windblown grass and flowers, and its sense of
abject vulnerability to the vagaries of nature.
A watercolor of this same subject won the
Ted Dealey Purchase Prize in the Fourteenth
Annual Dallas Allied Arts Exhibition in 1943.[9]

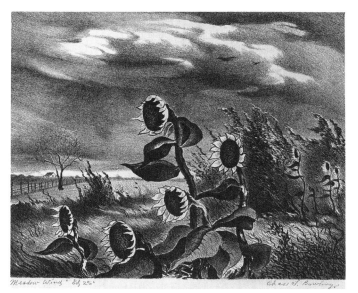

PROVENANCE:
1943–1964: Collection of Eleanor Onderdonk.
1964: Inherited by Ofelia Onderdonk from the Estate
of Eleanor Onderdonk.
1973: Gift to Mr. and Mrs. Eric Steinfeldt by Ofelia
Onderdonk.
1974: Gift to SAMA by Mr. and Mrs. Eric Steinfeldt.
74–135 G

EXHIBITIONS:
1943: Lone Star Printmakers Fifth Circuit of Prints by
Texas Artists, WMM (January 6 to 30).
1986: Texas Seen/Texas Made, SAMOA (September 29
to November 30).

6. Frances Layne (Dallas) to author (SA), June 29,
1986.
7. Stewart, *Lone Star Regionalism*, color plate 9,
lithographs 19–20.
8. Ibid., 93, 113.
9. Ibid., 155.

BETTY TWOHIG CALVERT

Betty Calvert was the niece of Mrs. John Twohig, née Bettie Priscilla Calvert, of Seguin, Texas, wife of a San Antonio merchant, banker, and philanthropist. Twohig came to San Antonio in 1835 and married Bettie Calvert in 1853.[1] When he became a banker, he shared his wealth with the poor by doling out bread every week for the unfortunate. Thus he became known as the "Breadline Banker of St. Mary's Street."[2]

Betty Twohig Calvert married Larkin Smith who, according to the city directory, was working as an assistant cashier in Twohig's bank in 1883. By 1891 he was a full cashier, and by 1895 had established the business of Smith, Devine and Company, bankers in foreign and domestic exchange.

GIRL WITH DOG
n.d., charcoal and chalk on toned paper,
16⅛" × 12¼"
Unsigned

Betty Calvert did this sentimental version of a child with her favorite pet, classic in its Victorian taste, when she was a young girl attending Mount de Chanel Convent in Wheeling, West Virginia.[3] Undoubtedly, it was an exercise in drawing and exemplifies an aspect of the type of education received by nineteenth-century women. For years it hung in the hallway of John Twohig's home on St. Mary's Street in the center of San Antonio. The house, built in 1841 of local limestone, was unusual because it was two-storied. After the deaths of the Twohigs, it changed hands a number of times until, in 1942, it was moved to its present site on the grounds of the Witte Memorial Museum.[4] In 1958, when Betty Calvert's drawing was presented to the museum, it was again placed in the hallway of the gracious old home.

PROVENANCE:
-1958: Collection of the heirs of Mr. and Mrs. Larkin T. Smith.
1958: Gift to SAMA by Fannie S. Tully, Emily A. Smith, Betty G. Wilson, and Gail E. Goodloe.
58–385 G (5)

1. S. W. Pease, "They Came to San Antonio: 1794–1865," s.v. "Twohig, John." Undated photocopied typescript, SAMA Texas History Records.
2. Webb, Carroll, and Branda (eds.), *The Handbook of Texas*, 2, s.v. "Twohig, John." John Twohig also was a Texas patriot who, at the time of the Adrian Woll invasion of San Antonio, in September 1842, blew up his store to keep ammunition and goods from the Mexican enemy. He was taken to Mexico as a prisoner but escaped on July 2, 1843.
3. Information provided by the donors when the drawing was presented. SAMA Registrar's Records.
4. Woolford and Quillin, *The Story of the Witte Memorial Museum: 1922–1960*, 97–103.

MARY VAN DERLIP CHABOT

(1842–1929)

Mary Van Derlip was born in Gonzales, Texas, on December 28, 1842, the daughter of Juliana Adelia (Cook) and David Campbell Van Derlip. She married George Stooks Chabot, an Englishman who worked for the British foreign service in Mexico, on December 3, 1863. The couple spent the first years of their married life in that country, but later moved to San Antonio where Chabot became a commission merchant dealing in cotton, wool, and hides from his business on Main Plaza.[1]

The firm, known as Chabot, Moss & Co., was established in 1880.[2] Stephen Gould devoted a paragraph to the company in his 1882 *Alamo City Guide*, relating the success of the business and its importance to the community.[3] Moss retired from the firm in 1883 to be replaced by Charles C. Cresson and the enterprise became known as Chabot and Cresson.[4]

Mr. and Mrs. Chabot became prominent citizens in the community. By 1876 they had built a handsome home at 403 Madison Street in the King William district and contributed much to the cultural milieu of the city.[5] Mrs. Chabot was a good musician and wrote considerable verse. She was a typical Victorian lady whose upbringing encouraged her to dabble in the arts. She probably never intended to be a serious painter but was taught the rudiments of painting and drawing in her younger days to induce an appreciation of the fine arts. She had attended the Ursuline Convent as a child, and studied as an adult with Robert Onderdonk.

Mrs. Chabot was active in art circles in the city, being a member of the Texas Press Association Art League as well as the Van Dyke Art Club.[6] She participated in many local art exhibitions, and in 1888 served as a judge for the art department of the San Antonio International Fair.[7] Her interests were diverse and philanthropic as well, and she and her sister, Mrs. Charles C. Cresson, established and helped maintain the Protestants Orphans Home of San Antonio. She died in her home on Madison Street on November 6, 1929, having outlived her husband by twenty-four years.[8]

WORKS BY MARY VAN DERLIP CHABOT
NOT ILLUSTRATED:

MEXICAN SCENE WITH FIGURE
n.d., oil on canvas, 11″ × 13″
Signed lower center: M. C. Chabot
80–112 G (4)
Gift to SAMA by Mr. and Mrs. Eric Steinfeldt.

1. Frederick C. Chabot, *With the Makers of San Antonio: Genealogies of the Early Latin, Anglo-American, and German Families With Occasional Biographies, Each Group Being Prefaced With a Brief Historical Sketch and Illustrations* (San Antonio: Artes Gráficas, 1937), 312–313.
2. J. S. Reilly, *San Antonio: Past, Present, and Future* (San Antonio: J. S. Reilly, ca. 1885), 150.
3. Stephen Gould, *The Alamo City Guide: San Antonio, Texas* (New York: McGowan and Slipper, 1882), 64.
4. Chabot, *With the Makers of San Antonio*, 313.
5. Mary V. Burkholder, *The King William Area: A History and Guide to the Houses* (San Antonio: The King William Association, 1973), 91–92.
6. Chabot, *With the Makers of San Antonio*, 312.
7. "Last Day of the Fair," *San Antonio Daily Express*, December 1, 1888.
8. Chabot, *With the Makers of San Antonio*, 312.
9. [Frederick C. Chabot], *Yanaguana Society Catalogue of a Loan Exhibition of Old San Antonio Paintings* (San Antonio: Yanaguana Society, 1933): 9.

PORTRAIT OF A GIRL
1886, oil on pressed board, 12¼″ × 9¼″
Signed and dated lower left: M. C. Chabot/1886

Many of Mary Chabot's subjects were copies of engravings and illustrations of the day, a common practice in which genteel ladies indulged and to which many instructors resorted.[9] Her rendition of a small girl has all the attributes of a copied piece. It is not without charm, however, and displays a modicum of skill in the lacy texture of the dress, the soft skin tones, and the pensive expression of a child in repose.

PROVENANCE:
1886–1937: Collection of the Chabot-Cresson-Kearny Family.
1937: Gift to SAMA by Mrs. C. H. Kearny, Mrs. Chabot's niece.
37–92 G

MARIE CHAMBODUT

Very little information is available on Marie Chambodut except what can be found in San Antonio city directories. She was married to J. C. Chambodut, and, after his death about 1912, she earned a living as a clerk in various department stores in the city. By 1926, when her painting of General Sam Houston was given to the Witte Memorial Museum, she was serving as a housekeeper for the Elks Club. Painting, obviously, was an avocation for Marie Chambodut.

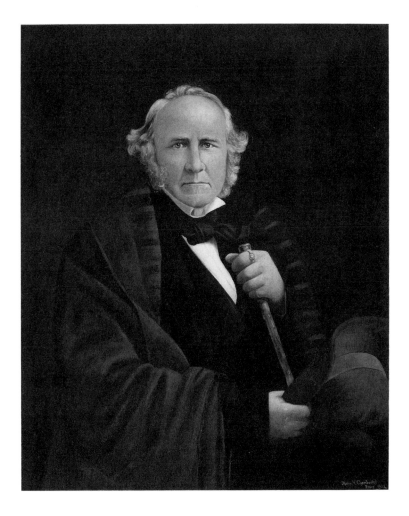

PORTRAIT OF SAM HOUSTON
1902, oil on canvas, 34″ × 28″
Signed and dated lower right: Marie H. Chambodut./
Pinxit. 1902

This portrait of the famous Texan is believed to be the first painting presented to the San Antonio Museum Association. Although Ellen Quillin, founder and director of the Witte Memorial Museum, mentions in her history of the museum that there was a painting of General Sam Houston in the Texas display at the opening of the institution, she does not credit the artist.[1] A photograph of the exhibit in the museum's first annual report shows a different portrait than the one by Marie Chambodut.[2]

A newspaper account of this painting states that it was done at the request of General Houston's youngest daughter, Nettie Houston Bringhurst, and that it won a blue ribbon at one of the annual exhibits of the International Fair in San Antonio.[3]

The likeness was taken from a well-known photograph that was used by numerous artists who painted Houston's portrait.[4] One may compare Marie Chambodut's version with the portrait of Houston done by William G. M. Samuel (see William G. M. Samuel, *Portrait of Sam Houston*), since the same photograph was used for both, but neither painting is a slavish copy. Both artists portrayed Houston as he impressed them; Chambodut's treatment is restrained and dignified, whereas Samuel's version is virile and rugged.

1. Woolford and Quillin, *The Story of the Witte Memorial Museum*, 47.
2. *Witte Memorial Museum: First Annual Report* (San Antonio: Witte Memorial Museum, 1927): opposite 18.
3. "C. D. of A. Present Picture of Sam Houston to Witte," *The Southern Messenger*, October 14, 1926.
4. Marquis James, *The Raven: A Biography of Sam Houston* (New York: Blue Ribbon Books, Inc., 1929), frontispiece.

PROVENANCE:
1926: Gift to SAMA by the Catholic Daughters of America at the formal opening of the Witte Memorial Museum.
37–6891 G

EXHIBITIONS:
Date unknown: San Antonio Annual International Fair.

PUBLICATIONS:
"C. D. of A. Present Picture of Sam Houston to Witte Museum," *The Southern Messenger*, October 14, 1926.

EMMA RICHARDSON CHERRY

Emma Richardson Cherry lived a long, productive, and fascinating life. Her credentials rival those of Wayman Adams (1883–1959), and her portraits of prominent people, including many important Houstonians, are equally impressive.[1] She was born in Aurora, Illinois, in 1859, the daughter of Perkins and Frances Richardson. Her father was an architect, and she used remnants of his drawing papers for her first artistic endeavors. After her marriage to a Texas businessman, Dillon Brooks Cherry, she moved to Houston.[2]

Emma's first formal art training was at the Chicago Art Institute, and she later studied with such distinguished American artists as Rhoda Holmes Nicholls (1854–1938), William Merritt Chase, Walter Shirlaw (1838–1909), Kenyon Cox (1856–1919), Henry McCarter (1886–1942), and Hugh Breckenridge (1870–1937) at the Art Students League in New York. She made numerous trips to Europe and studied at the Académie Julian and other ateliers in Paris. Her European teachers included André Lhote (1885–1962), Vettore Zanetti-Zilla (1864–1964), Vicente Poveda y Juan (1857–?), and possibly Jules Lefebvre.[3]

Emma Cherry was dedicated to her art and was intent on sharing her extensive knowledge with others. She taught at Methodist University in Denver, possibly shortly after her marriage, and is credited with establishing the Denver Art Association.[4] She also is considered one of the founders of the Denver Art Museum.[5]

When Mr. and Mrs. Cherry moved to Houston is uncertain, but it probably was in the late nineteenth century. There Emma Cherry discovered neither an art organization nor art classes in the public schools. Through her efforts the Houston Public Art League, which developed into the Houston Art League, was founded. As early as 1898, Emma Cherry was campaigning for a Museum of Fine Arts and was one of a number of women who were given permission by Levy Brothers to sit in front of their store with tin cups and beg nickels to buy the land upon which the Houston Museum of Fine Arts now stands. She also assisted the San Antonio Art League in its early stages with encouragement and advice.[6]

In 1896 Emma Cherry was the superintendent and the impelling force behind an exhibition for the Texas Coast Fair in Dickinson, Texas, with examples borrowed from all over the United States. Included were a few by Texas artists who later gained recognition: Atlee B. Ayres (1873–1969), E. G. Eisenlohr (1872–1961), Frank Reaugh (1860–1945), Eloise Polk McGill (1868–1939), Minette Stein (n.d.), Julius Stockfleth (1857–1935), Dawson Dawson-Watson (1864–1939), Ellsworth Woodward (1861–1939), and Bernhardt Wall (1872–1956).[7] By today's standards, the exhibition must have presented a strange assortment of art work, but it was unprecedented in Texas.

E. Richardson Cherry with her portrait of her son-in-law, Col. Walter H. Reid. SAMA Historical Photographic Archives, gift of an anonymous donor.

A view of one of the Witte Museum's art galleries, ca. 1938, with E. Richardson Cherry's paintings being installed. SAMA Historical Photographic Archives, staff photograph.

STILL LIFE WITH ZINNIAS AND LARKSPUR
ca. 1930, oil on academy board, 16″ × 20″
Signed lower right: E. Richardson Cherry

Emma Cherry's taste in subject matter was
diverse and cosmopolitan. When she painted
flowers, she was interested in expressing on
canvas their ephemeral, fragile quality as
well as their subtle nuances in color. She
maintained, however, that she preferred to
paint portraits: "People interest me the most.
It's a challenge to capture their personalities.
I like to paint them best."[12]

PROVENANCE:
ca. 1930: The painting was given to Col. and Mrs. E. F.
Harrison, parents of the donor, by E. Richardson
Cherry.
ca. 1930–1980: Collection of Col. and Mrs. E. F.
Harrison.
1980: Gift to SAMA by Marjorie H. Monteith.
80–12 G

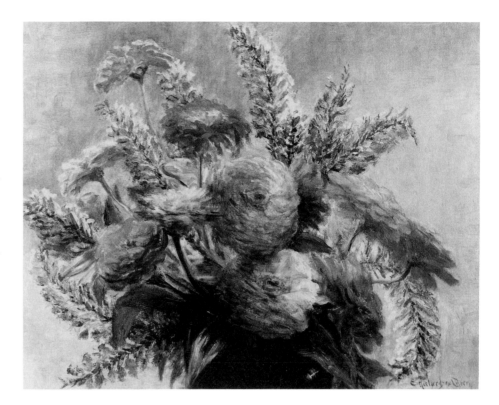

1. Forrester-O'Brien, Art and Artists, 69–70.
2. "Mrs. Cherry, 95, Dies; Art Leader Since 1893,"
 Houston Post, October 31, 1954; Lucy Runnels
 Wright, "A Woman Extraordinary," The Texas
 Outlook, 21 (May 1937): 28–29. Research has not
 disclosed the exact date of Emma Cherry's
 marriage.
3. Wright, "A Woman Extraordinary," 28.
4. Ibid.
5. Mrs. Robert Petteys (Trustee of the Denver Art
 Museum, Sterling, Colorado) to Claudia Eckstein
 (SAMA Registrar), December 5, 1978.
6. Wright, "A Woman Extraordinary," 28.
7. Texas Coast Fair Art Catalogue, 1896, Dickinson,
 Nov. 10 to 14 Inclusive (Dickinson, Texas: Privately
 published, 1896). Harris County Heritage Society
 Archives, Houston.
8. Dorothy Kendall Bracken and Maurine Whorton
 Redway, Early Texas Homes (Dallas: Southern
 Methodist University Press, 1956), 164.
9. "Houston Artist to Exhibit Paintings in Witte
 Museum," San Antonio Express, December 5, 1926.
10. "Dean of City Artists, Mrs. Cherry, Dies at 95,"
 Houston Chronicle, October 30, 1954.
11. Marie Lee Phelps, "Mrs. Cherry and Her House
 Have Left Mark on Houston," Houston Chronicle,
 n.d. Clipping, Harris County Heritage Society
 Archives, Houston.
12. Kathleen Bland, "Mrs. Cherry: Turning 91 Anti-
 Climax," Houston Post, March 5, 1950.

Emma also concerned herself with conservation and preservation of historical
structures and artifacts. In 1894 she and her husband purchased a house with a long
and interesting history. Built in 1850 by Gen. E. B. Nichols, it had the reputation of
being one of the most frequently moved early Texas homes. When it was up for sale,
Mr. and Mrs. Cherry submitted a bid of $25 for the classic front door. Their bid, the
only one tendered, was accepted for the entire house on condition that it be speedily
moved away. The Cherrys moved it to a tract of land south of Houston and lived in it
for many years. After Mrs. Cherry's death the house was given to the Harris County
Heritage Society by her daughter, Dorothy Cherry Reid.[8] It was moved and restored
by the society and now stands in Sam Houston Park in the heart of Houston for all to
enjoy.

Emma Cherry's awards, honors, exhibitions, and commissions are staggering.
She had at least two one-woman shows at the Witte Memorial Museum—one in
1926, the first solo exhibition at the museum, and the other in 1938—and was
included in many regional shows at the museum as well. These were her local
accomplishments, but she also exhibited throughout the United States and Europe.

Only a woman of vigorous character and sprightly determination could have
achieved what Emma Cherry did in her life span of ninety-five years. She did not
become dependent upon her daughter and son-in-law, Col. and Mrs. Walter H. Reid,
until the last year of her life, and was wielding her paintbrush, using a magnifying
glass, three weeks before her death.[9] She was a perennial student as well as an active
artist and shortly before her demise she insisted on going to the Contemporary Arts
Museum in Houston to see what "these modern artists, Rattner and Motherwell, were
up to."[10] One idiosyncrasy persisted throughout her lifetime, however. She disliked
her given name, Emma, and always signed her canvases "E. Richardson Cherry."[11]

GEORGE H. COMEGYS

(ca. 1811–ca. 1852)

Very little is known about the artist. Comegys was primarily a genre painter who specialized in paintings of everyday youths, of delightful rapscallions, not idealized, as in the mode of the period. He was a student of John Neagle (1796–1865), the eminent American portraitist.[1] Comegys died sometime after 1852 in the Pennsylvania Hospital for the Insane.[2]

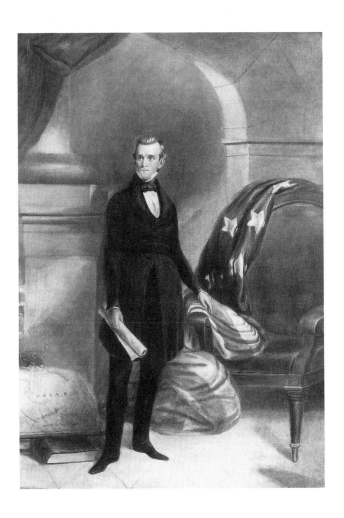

PORTRAIT OF PRESIDENT JAMES KNOX POLK
1844, oil on canvas, 51¼" × 36¼"
Signed and dated lower left: Comegys, 1844

Although George Comegys neither lived nor painted in Texas, his portrait of President James Knox Polk contributes to the history of the state and thus is a fitting frontispiece for this publication. It was painted in 1844, the year Polk was elected president. Polk's position on the annexation of Texas, a major issue in the election, helped win him the presidency over Henry Clay. President Polk evidently considered the event so significant that he had his portrait painted with the map of Texas beside him and probably the terms of annexation held in his hand.

Comegys's portrait is remarkably similar to Neagle's *Portrait of Henry Clay*, which has hung in the United States Capitol, in stance, composition, and painting style.[3]

PROVENANCE:
-1977: H. Shickman Gallery, New York City.
1977: Purchased by SAMA from H. Shickman Gallery with funds provided by The Annual Gift Appeal and The Sarah Campbell Blaffer Foundation, Houston.
77–944 P

PUBLICATIONS:
SAMA *Bi-Annual Report, 1976–1978*, 77.

1. William A. Gerdts (Professor of Art History, The Graduate School and University Center of the City University of New York) to author (SA), February 3, 1987.
2. Mantle Fielding, *Dictionary of American Painters, Sculptors, and Engravers*, s.v. "Comegys, George H."
3. Joan Sayers Brown, "Henry Clay's Silver," *The Magazine Antiques*, 120 (July 1981): 174.

Born in Uvalde, Texas, Paul Cook was the son of a doctor. His father was opposed to an artist's career for the young man and sent him to the University of Texas to study law, although Paul was more interested in playing football and baseball than he was in academic studies or even in becoming an artist. A football hero in high school, his brief collegiate athletic career ended when he injured both knees.[1]

Paul Cook left the university and went to Massachusetts, where he entered the sales department of a leather tanning company. One version of this period in his life maintains that he was so successful financially that he was able to leave work and devote his time to the study of art.[2] Another account states that he developed dengue fever in Massachusetts and was forced to give up his work because of poor health.[3] The latter version seems more plausible, as he evidently moved to San Antonio to recuperate from his illness and to be with his family.[4]

Cook's convalescence demanded that he be out in the open air, and he developed the habit of going to Brackenridge Park in San Antonio. Here he started painting and sketching the trees as he basked in the Texas sunshine. Hugo Pohl (1878–1960), who had a studio in the park, was his first teacher, and suddenly art became Paul's absorbing interest.[5] Pohl was an academician of the old school and evidently a painstaking teacher. He was an excellent draftsman and his influence on Paul's drafting ability is evident in much of the younger man's work.[6]

Thus Paul Rodda Cook was launched upon a very successful art career. He went to Taos, New Mexico, and studied under Walter Ufer (1876–1936) and Leon Gaspard (1882–1964). Later, in Boston, he was a student of H. Dudley Murphy (1867–1915). In Woodstock, New York, his mentors were Henry Lee McFee (1886–1953) and Charles Rosen (1878–1950). Although he no doubt benefited from the instruction of such reputable teachers, he developed his own style and technique and was able to support himself with the sale of his paintings.[7]

Shortly after his marriage to Dorothy Weed in 1928, Cook moved to Boerne, Texas, and became enamored of the Texas Hill Country.[8] He purchased property on the nearby Scenic Loop and designed and helped build his own house there. It was of solid rock construction plastered over in Spanish style, with graceful lines that blended into the landscape. It reflected the personalities of the owners with its simple decor and warm furnishings.[9]

But like many artists Paul Cook was temperamental and not always affable, and the pragmatic Dorothy finally decided to terminate the alliance in the early 1940s.[10] Paul later married Dr. Ina H. Boyd and moved to Houston.[11]

During Paul's years in San Antonio and in the Hill Country, he fulfilled many portrait commissions. He was a consummate draftsman, and his pleasing portraits indicated his fine artistic talent. He had many exhibitions in local galleries and had a one-man show in the Witte Memorial Museum in 1935.[12] In the lean depression days, when artists donated works for fund-raising projects for the museum, Cook provided a very handsome landscape as one of the awards for a card party in December 1932.[13]

As a member of the New York Water Color Society, the Southern States Art League, the College Art Association, and other national organizations, Paul Cook not only exhibited widely but also won a number of awards. One of his first was an honorable mention in the Davis Wildflower Competition at the Witte Memorial Museum in 1928.[14] He won the Montgomery Prize in the Southern States Art League

1. "Paul Rodda Cook," San Antonio Express, May 9, 1948; "Built His Own House, Paints Own Pictures: Or How Paul Cook Came to Be an Artist," San Antonio Light, October 20, 1940.
2. "Paul Rodda Cook."
3. "Built His Own House, Paints Own Pictures."
4. Ibid.
5. Ibid.
6. Remy, "Biographical Sketches of Fifteen Texas Artists," s.v. "Pohl, Hugo D."
7. "Paul Rodda Cook."
8. Mrs. W. B. McMillan to author (SA), interview, May 9, 1985.
9. "Built His Own House, Paints Own Pictures."
10. Elizabeth Conroy Gibson to author (SA), interview, May 14, 1985.
11. "Artist Paul R. Cook Funeral to Be Friday," Houston Chronicle, August 17, 1972.
12. Molly Heilman, "Cook Shows at Witte Gallery," San Antonio Light, November 17, 1935.
13. "Prize at Museum," San Antonio Light, November 27, 1932.
14. "San Antonio Artist Opens Exhibit," San Antonio Express, February 16, 1930.

in 1938 and again in 1942.[15] Among his most prestigious honors was the selection of his work, first in 1936 and again in 1938, to represent Texas for the annual exhibitions of American art under the auspices of the Municipal Art Committee of New York.[16]

Paul Cook died in Mexico City after a short illness in 1972.[17] Although the last years of his life were not as productive as the earlier decades, his contribution to the local art scene from the 1920s through the 1950s was substantial. He represented a transitional period between the "bluebonnet" school and nonobjective painting in Texas. He was considered an "artists's painter," and although he was successful in his field he painted primarily to please himself, a luxury few artists could afford.[18]

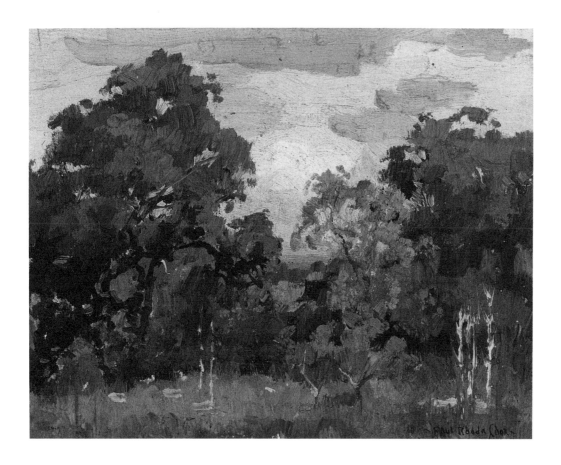

TEXAS LANDSCAPE
n.d., oil on canvas, 7¼″ × 9¼″
Signed lower right: Paul Rodda Cook

This small canvas reveals Paul Cook's ability to capture the atmosphere and character of the Texas Hill Country. It is a quick study and is handled in a much less formal manner than the portrait of his wife, Dorothy. The painting shows Cook's versatility with subject matter and a desire to experiment in the oil medium using softer edges and broader brushstrokes. The rich, warm tones of the foliage contrast agreeably with the cooler hues in the sky and denote the artist's feeling for and appreciation of the Texas landscape.

PROVENANCE:
-1980: Gift to SAMA by W. W. McAllister, Sr.
80–208 G (4)

EXHIBITIONS:
1986: Texas Seen/Texas Made, SAMOA (September 29 to November 30).

PORTRAIT OF DOROTHY COOK
1937, oil on canvas, 30″ × 24″
Signed lower left: Paul Rodda Cook
Titled and dated on reverse: Portrait of Dorothy
Cook, 1937

Paul Cook's wife, Dorothy, evidently was one
of his favorite subjects as there are numerous
references to his portraits of her in
newspaper articles. In these works he was not
compelled to please the sitter, as he was in
his commissioned works, and allowed himself
freer reign in his figure interpretations. This
portrait is indicative of his interest in the
new trends in painting that were developing
within the state. The stylized handling of the
clothing, the obvious absorption in dynamic
design, and the artist's complete control of
draftsmanship and medium are all clear in this
portrait.

Cook said about his philosophy of
painting: "Those art movements that have
come to bear names are associated with
certain basic types of thinking, and the
thinking emanates from the experience of
artists and not from any trends in public
taste. Modern painters base their expressions
on factors out of the past and sift those
factors through their creative personalities
into an art which is contemporary, vital, and
reflects to a great extent the aspirations of
all the people."[19] Paul's portrait of Dorothy
Cook suggests this theory and is a good
transitional example of the change from
purely traditional painting to a more
simplistic style.

One very personal fact emerged when
this painting was researched. It was in its
original frame, which was hand-carved and
silver-leafed by the subject, Dorothy Cook.[20]

PROVENANCE:
1937: Gift from the artist to his wife.
1985: Purchased from Grace Johnson by Mrs. W. B.
McMillan. Grace Johnson was secretary for Mr. and
Mrs. Lynn Ormsby, uncle and aunt of Dorothy Cook.
1985: Gift to SAMA by Mrs. W. B. McMillan.
85–73 G

EXHIBITIONS:
1986: Texas Seen/Texas Made, SAMOA (September 29
to November 30).
1989–1990: Special Christmas Exhibition, WMM
(December 7, 1989, to April 1, 1990).

15. "San Antonio Artist Wins Montgomery Prize,"
San Antonio Express, April 24, 1938; "S. A. Artist
Wins New Orleans Prize," San Antonio Light,
May 1, 1942.
16. "Two San Antonians' Art Recognized," San
Antonio Express, April 26, 1936; "Three San
Antonians Get Art Honors," San Antonio Express,
May 12, 1938.
17. "Artist Paul R. Cook Funeral to Be Friday."
18. "Paul Cook's Paintings Show Artist's Progress
Marked," San Antonio Express, November 10,
1935.
19. "Paul Rodda Cook."
20. Heilman, "Cook Shows at Witte Gallery."

DAWSON DAWSON-WATSON

Dawson Dawson-Watson was born in England on July 21, 1864, the son of John Dawson-Watson, a popular English illustrator whose work appeared regularly in the *English Graphic*, a London weekly. John Dawson-Watson also was the first artist to illustrate *Pilgrim's Progress* and *Robinson Crusoe*, in editions that were published in 1870. The Dawson-Watson family lived in St. John's Wood, London, a fashionable residential district that was the home of many artists, authors, and actors. As a consequence, young Dawson came into constant contact with many famous painters and distinguished men of the literary world.[1]

Dawson's artistic talent was evident at an early age, and he was first tutored by Mark Fisher (1841–1923), an American artist who spent most of his life in England. When Dawson's parents moved from England to Wales, he met Henry Boddington, a wealthy brewer, who became his sponsor and sent him to Paris to further his art career. There, with an allowance of $50 a month, he spent three years in hard work and intense study. He worked under a number of famous artists: Carolus-Duran (1838–1917), the portrait painter; Léon Glaize (1842–1932), the historical painter; Luc Olivier-Merson (1846–1920) and Raphaël Collin (1850–1916), decorators; and Aimé Morot (1850–1913), renowned for his battle scenes.[2] His training made him proficient in many mediums. He worked in oils and watercolors, mezzotint, and engraving, as well as woodcarving. Besides these skills he was a scenic artist and costume and textile designer.[3]

After three years in Paris, the young man met Mary Hoyt Sellar, who was to become Mrs. Dawson-Watson. She was traveling in France with E. Richardson Cherry and, after a whirlwind courtship of six weeks, the couple were married on May 30, 1888. They lived in Giverny, France, for five years. Then an American artist, James Carroll Beckwith (1852–1917), urged them to go to the United States.[4] Dawson-Watson and his wife came to America sometime in 1893. He became director of the Hartford Art Society in Hartford, Connecticut, a position he maintained for four years. He returned to England for a very short time, but, preferring America, he decided to try Canada for a while. In about 1902, Birge Harrison (1855–1929), an American painter, told Dawson-Watson of a new art colony being founded in the Catskill Mountains of New York. Dawson-Watson became a teacher at Byrdcliffe at the Woodstock Art Colony but remained only four months.[5]

In 1904 Dawson-Watson accepted an offer to teach in the St. Louis School of Fine Arts at Washington University. He fulfilled this position for eleven years, spending his winters in St. Louis and his summers in Massachusetts. After resigning from the St. Louis School of Fine Arts in 1915, he began traveling around the country and visited San Antonio. During this period he reportedly divided his time between St. Louis and San Antonio, but he probably was far more active in St. Louis.[6]

Dawson-Watson was author and director of a pageant in 1916 in Brandsville, Missouri. He was art director of the Missouri Centennial and of the St. Louis Industrial Exhibition in 1920. He also acted as art director for the City Homecoming of Soldiers (1918?). His skills as a stage designer came into full play when he acted as art director, designer, and scenic constructor for the St. Louis Junior Players from 1920 to 1923.[7] Despite these activities, in 1918–1919 Dawson-Watson served as director of the San Antonio Art Guild. This was a group limited to practicing artists who had separated from the San Antonio Art League, formed in 1912. The Art League had broadened its membership by accepting persons who were not actually artists but who could be more aptly described as patrons of the arts.[8]

1. "Glory of the Morning," *The Pioneer Magazine*, 7 (April 1927): 5, 12.
2. Ibid.
3. "Dawson-Watson, Painter, Dead," San Antonio *Express*, September 5, 1939.
4. "Glory of the Morning."
5. Ibid.
6. Ibid.; "Dawson-Watson, Painter, Dead."
7. "Dawson Dawson-Watson." Undated biographical typescript, Dawson Dawson-Watson file, SAMA Texas Artists Records.
8. Sister Miriam Garana, "Art Has a Home in S. A.," in *San Antonio: A History for Tomorrow*, ed. Sam Woolford (San Antonio: The Naylor Company, 1963), 62.

Dawson Dawson-Watson in his studio in 1929. Courtesy of the Rainone Galleries, Inc., Arlington, Texas.

The Edgar B. Davis Texas Wildflower Competition eventually lured Dawson-Watson to San Antonio as a permanent resident. He was in Boston when the announcement of the competition was published. Mrs. John Herff and Mrs. Henry Drought wrote him and convinced him to come to Texas and enter the contest. It was a lucrative move for the well-known artist, for he won the $5,000 national award for his painting *Glory of the Morning*. Under the terms of Davis's offer, the $5,000 prize was open to any artist in the United States who held membership in a nationally recognized art organization, while native Texas artists could compete for the $1,000 prize.[9] Although Dawson-Watson was *Hors de Concours* in the 1928 Davis competition, he won first and fifth prizes in the 1929 contest.[10] Davis gave the 1927 prize-winning painting, *Glory of the Morning*, to the Lotus Club in New York, of which he was a member.[11]

Dawson-Watson was a gentleman of the old school in appearance and demeanor. His shock of light hair, his old-fashioned pince-nez glasses, and the Victorian-type cravat he wore high around his throat appear in all of his photographs. He was a compassionate man with a sincere concern not only for the arts but also for cultural institutions. In 1933, when the Witte Memorial Museum was in dire straits because of the depression, he wrote an eloquent letter to the newspaper making a plea to artists for help:

To the Editor:

In Wednesday's paper, Mayor Chambers stated it would be impossible to make any appropriation for the support of the museum for the months of April and May.

Such being the case, I feel it is up to artists, professional and amateur to step forward and show our appreciation of the educational values of the museum. A short while back we stepped forward and gave pictures, which were awarded as prizes, at a bridge party held in the museum, which resulted in a fund which supported the museum for a month. Those winning the prizes got more than their money's worth, and I, for one, am glad they did, so long as the museum was kept going.

So I appeal to my brother artists to step forward and back me up and I will start the ball rolling with a $5 subscription. There are a large number of clubs and other organizations in the city that can well afford to subscribe something no matter how small, to support an institution whose main idea is to teach the appreciation of the beautiful, of which life is so full, and yet has to be demonstrated to bring it home to us in the full meaning of the word.

There isn't an artist here who hasn't benefited directly, or indirectly, through the art appreciation created by the museum.

DAWSON-WATSON [12]

The depression was not the only time Dawson-Watson offered his assistance to troubled San Antonians. In 1921, when a disastrous flood devastated downtown San Antonio, he wrote to Julian Onderdonk and offered one of his pictures to be sold "for any fund that is to be raised."[13]

Dawson-Watson was a popular artist and had many exhibitions in San Antonio, including three one-man shows in the Witte Memorial Museum. The first was in 1928, the second in 1932, and the third in 1935.[14] In 1934 he was one of eight local artists commissioned by the CWA to execute murals in San Antonio. His canvas, *Meditation*, approximately nine feet by ten feet, was placed on the first floor adjoining the lobby at Jefferson Senior School.[15]

9. "Glory of the Morning."
10. "Dawson Dawson-Watson."
11. Forrester-O'Brien, *Art and Artists*, 83.
12. "Artist Starts Museum Fund," San Antonio *Light*, March 5, 1933.
13. Dawson Dawson-Watson (St. Louis) to Julian Onderdonk (SA), September 11, 1921.
14. Exhibition files, SAMA Registrar's Records.
15. "Artists Assigned to CWA Projects," San Antonio *Express*, January 6, 1934.

In addition, he won the silver medal at the Lewis and Clark Exposition in Portland, Oregon, in 1905; silver and gold medals in Sedalia, Missouri; three first prizes and one second in the Illinois State Fair in 1916; an honorable mention in the State Fair in Austin, Texas, in 1926; a special first prize in the Nashville Art Association Exhibition in 1927; and the prize for watercolor in the Southern States Art League in 1931.[16]

Dawson-Watson was a member of numerous American art organizations and exhibited at the Royal Academy in London in 1886; Paris Salon in 1888; Exposition Universelle, Paris in 1889; Royal Cambrian Academy in 1902; and in many important exhibitions in the United States. He is represented in the permanent collections of the City Art Museum in St. Louis; the Springfield Art Association, Illinois; the New Haven Clay and Palette Club, Connecticut; the Lotus Club, New York; the Vanderpoel Memorial Gallery, Chicago; the University of Texas at Austin; and the San Antonio Museum Association; and in many libraries and public schools.[17]

Dawson-Watson died in San Antonio in September 1939, leaving an enviable legacy of artistic accomplishment in the United States and abroad.[18]

Photo of Dawson Dawson-Watson taken about 1935. Courtesy of Mrs. Ganahl Walker, Jr.

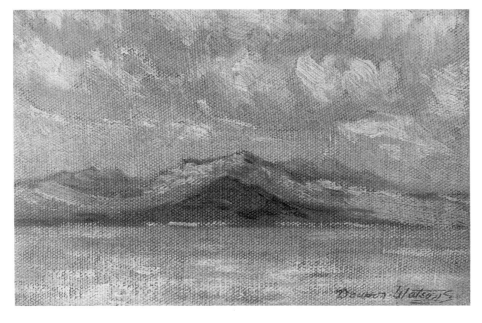

SEASCAPE
n.d., oil on canvas, 5¼" × 8¼"
Signed lower right: Dawson-Watson

Dawson-Watson's small seascape has a very sketchy quality and may have been a study for a larger canvas. Its unfinished character, however, demonstrates the artist's willingness and ability to experiment with new techniques and innovative approaches to his subject matter. Many paintings pertaining to the sea and ships are listed in the catalogues of Dawson-Watson's exhibitions. He found his subjects in Maine and Massachusetts, as well as along the Texas Gulf Coast.

PROVENANCE:
-1980: Collection of W. W. McAllister, Sr.
1980: Gift to SAMA by W. W. McAllister, Sr.
80–208 G (3)

EXHIBITIONS:
-1980: The painting was displayed for a number of years in the offices of the San Antonio Savings Association.
1986: Texas Seen/Texas Made, SAMOA (September 29 to November 30).

16. "Dawson Dawson-Watson."
17. Forrester-O'Brien, Art and Artists, 83.
18. "Dawson-Watson, Painter, Dead."

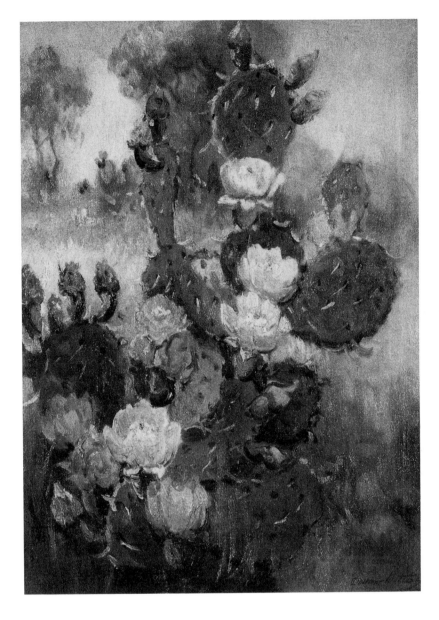

CACTUS FLOWERS
1929, oil on canvas, 21″ × 16″
Signed and dated lower right and on reverse:
Dawson-Watson/'29

Dawson-Watson became as famous for his paintings of cactus as did Julian Onderdonk for his bluebonnets. It was the subject he chose for his award-winning picture in the 1927 Davis Wildflower Competition, and he painted cactus with a zeal unequalled in the annals of Texas art history. It is said that he completed seventy pictures of cactus from May to October of 1926 before he was satisfied enough with one to enter into the Davis contest.[19]

Although Dawson-Watson could not be considered eccentric, his method of landscape painting was unusual. He did not use the customary easel, canvas stool, and umbrella when he went on sketching jaunts; he preferred to sit on the ground, prop his canvas against a tree or rock, and envelope himself with the feel of nature.[20] This legend is graphically illustrated in a newspaper photograph, in which the artist is seated on the ground, his long legs bent in front of him, with his canvas supported by vegetation and within easy reach. Although it was a most unorthodox way of working, he was as usual fastidiously groomed. He is pictured with his flowing white cravat, a soft Panama hat atop his head, and spats on his well-shod feet.[21]

Cactus Flowers is a characteristic Dawson-Watson canvas. It is painted in a high, brilliant key, skillfully conveying the dazzling sunlight and torrid heat of the Texas countryside. His interpretations of nature were influenced by his five-year association with the American art colony in Giverny, France. He is considered one of the earliest of the American painters to become involved with Impressionism in France, and is considered a direct link to that movement.[22] The style suited his talents and personality, and his later lyrical landscapes, such as *Cactus Flowers*, indicate he continued in the impressionistic idiom. His proficiency as a wood-carver also was evidenced in the original hand-carved frame.

PROVENANCE:
1929: Collection of the artist (?).
1945: Wedding gift to Mary Jane Lyles and Reagan Houston III.
1980: Gift to SAMA by Mr. and Mrs. Reagan Houston III.
80–61 G (1)

EXHIBITIONS:
1986: Texas Seen/Texas Made, SAMOA (September 29 to November 30).

PUBLICATIONS:
Rosson, "More than Bluebonnets," in *Sentinel* (December 1984): 26.
Cecilia Steinfeldt, "Lone Star Landscapes: Early Texas Seen through Artists' Eyes," M3, SAMA Quarterly, in *San Antonio Monthly*, 5 (July 1986): 24.

19. "Glory of the Morning."
20. Ibid.
21. "Blooming Cactus Motif of Artists." Undocumented newspaper clipping, Dawson-Watson file, SAMA Texas Artists Records.
22. William H. Gerdts, *American Impressionism* (New York: Abbeville Press, 1984), 252.

PORTRAIT OF MRS. DAWSON-WATSON
1933, oil on canvas, 30″ × 40⅛″
Signed and dated lower right: Dawson-Watson/'33

Dawson-Watson's ability to paint the human figure is demonstrated in the portrait of his wife. In this rendition, the artist has deviated from his usual norm of high-keyed impressionistic painting. Rather, he is following the pattern of popular painting of the period and interpreting his subject in a realistic manner with more clearly defined drawing and in a casual, domestic atmosphere.

The composition is unusual, with the heavy dark sofa and solid figure skillfully balanced with a single circular object, a plate hanging on the wall. The plate serves to draw the viewer's eye to the center, directing it back to the image of Mrs. Dawson-Watson. The pose itself is highly unconventional, rendered as it is in a horizontal rather than a vertical composition. The portrait was featured in the artist's 1935 one-man show in the Witte Memorial Museum, but reproductions of the painting at that time show a light-colored shawl draped across the back of the sofa. When the painting was given to the Association in 1974, the shawl had been removed. Presumably, Dawson-Watson had made the change himself, probably because he felt it detracted from his composition. The painting is in the original frame, hand-carved by the artist.

PROVENANCE:
1933–1935: Collection of the artist.
1974: Gift to SAMA by an anonymous donor.
74–199 G

EXHIBITIONS:
1935: Exhibition of Paintings by Dawson Dawson-Watson, WMM (January 20 to February 3). Lent by the artist.
1986: Texas Seen/Texas Made, SAMOA (September 29 to November 30).
1989–1990: Special Christmas Exhibition, WMM (December 7, 1989, to April 1, 1990).

PUBLICATIONS:
"Shown at Witte Museum," San Antonio Light, January 27, 1935.

HARRY ANTHONY DE YOUNG

Portrait of Harry Anthony De Young, ca. 1940. SAMA Historical Photographic Archives, gift of Anita De Young Ischar.

When Harry Anthony De Young moved to San Antonio in 1928, he already was an established painter and respected teacher in his native Chicago as well as in other areas of the Midwest. He, like many other artists, had been drawn to the Alamo City because of the prizes offered in the Edgar B. Davis Painting Competitions.[1] In 1929, he won an honorable mention award of $100 in this contest.[2]

De Young was a skillful painter in both oils and watercolors and an excellent draftsman. His careful pencil drawings, the most eloquent and sensitive of all the mediums he used, were undoubtedly his favorite mode of expression. Anita Ischar, his daughter, has said: "He was always sketching. . . . He never just sat, without doing anything. He drew. If he went to a banquet, he would draw the whole time and end up with sketches of everybody at his table."[3]

Like José Arpa (1858–1952), De Young could transform the most ordinary things into works of art. This aptitude is graphically expressed in a small volume entitled *Texas Out Back*, published in 1973. This book depicts a series of twenty-two drawings of Texas privies—most unlikely subjects for any artist. His skill with a pencil is illustrated in the various textures he achieves that depict weathered wood, rough sheet metal, disintegrated shingles, rugged stone, tattered shutters, and rusting hinges. During the years of 1929 to 1934, when De Young made these sketches, most of the structures were neglected and unused. They nestle in beds of overgrown weeds, stacks of tin cans, discarded boxes, and precariously decrepit fences. But the delicacy of their perceptive treatment overrides their infirm appearance and humble origin.[4]

De Young had been educated at the University of Illinois, studying art under Professors Edward Lake (1870–1940) and Fabians Kelly (n.d.), and at the Art Institute of Chicago with F. de Forrest Shook (n.d.), John W. Norton (1876–1934), and others. He was an honor student at the Art Institute in 1917 and was awarded second prize in the institute's Art Students League the same year. He won the Fine Arts Building Prize of $500 as well as an honorable mention for landscape at the Art Institute in 1925. In 1927, he won the $200 Member Prize of the Chicago Galleries Association.[5]

After De Young's arrival in San Antonio, the Great Depression curtailed the presentation of monetary prizes and awards in competitions and those dark days unmistakably affected De Young's career, as they did the careers of many others. De Young survived by opening a well-organized art school at 615 Fifth Street. In the summer of 1934, he held painting classes in Monterrey, Mexico. His prospectus for the course detailed his experience as a teacher. From 1914 to 1916 he had been an instructor for children's classes in Chicago's Palmer Park. He served in World War I in 1917 and 1918 and returned to teaching in Chicago in 1921. In 1922 he was an assistant instructor at the Bailey's Harbor Summer School of Painting in Wisconsin. In 1923 and 1924 he was director of the Glenwood School of Landscape Painting in Glenwood, Illinois. From 1925 to 1929 he served as director of the Midwest Summer School of Art in Coloma, Michigan, and the following two years he was an instructor in the National Academy of Art in Chicago.[6]

De Young was a welcome addition to the art community of San Antonio and extended his teaching skills by organizing summer sessions in other areas of the state. His favorite site for these classes was in the Davis Mountains of West Texas. In his 1932 bulletin he counselled: "It is not necessary to bring an extensive wardrobe to Camp. A supply of clothing for dress-up occasions and some old clothes to work in should

1. Leon Hale, *Texas Out Back* (Austin: Madrona Press, 1973), 20.
2. "Harry Anthony De Young Summer Painting Class in Monterrey, Mexico" (1934?). Typescript announcement, Harry Anthony De Young file, SAMA Texas Artists Records.
3. Hale, *Texas Out Back*, 21.
4. Ibid., 24–65, passim.
5. "Harry Anthony De Young Summer Painting Class in Monterrey, Mexico."
6. Ibid.

suffice. Bring your automobile to Fort Davis and enjoy the many side trips in this wonderland of scenic beauty. An extra blanket for the cool evenings will add to one's comfort."[7] He did not neglect to mention recreational features: "Motoring, biking, swimming, horseback riding, mountain climbing, are some of the forms of outdoor exercise that Fort Davis has to offer her summer visitors. During the period of the Camp there will be numerous campfire parties, weenie and steak roasts, treasure hunts on foot and on horseback for camp members. Of course there will be Bridge for bridge enthusiasts."[8] Obviously, Harry Anthony De Young was a shrewd judge of human nature as well as a great admirer of Mother Nature.

In San Antonio, De Young's association with the Witte Museum and art curator Eleanor Onderdonk was a mutually rewarding one. He had one-man shows at the museum in 1932 and in 1934. Both exhibitions were large and consisted of oils, watercolors, and his finely executed pencil drawings. Newspaper accounts, especially of the 1934 exhibition, were glowing:

There are none of the landscapes that seem to have come out of the mold in this exhibition. One walks beneath fantastic but real peaks and walks dizzily on heights carpeted with clouds, where few white men have been, as scenes from the wilds of Mexico and from secluded spots in Texas unfold their secrets, many for the first time. De Young is a bold, masculine painter, and his new work shows some departure from details in favor of color and pattern, yet loses none of its conventional grace of treatment.[9]

In appreciation, De Young lectured frequently in the museum galleries, assisted in art programs, acted as juror for special exhibitions, and supported the institution in every way he could. His work was popular and also was shown in many San Antonio galleries and other museums throughout the state. He was active in local art organizations as well. Among his commissioned works were covers for the invitations for the annual pilgrimage to the Alamo. They included portraits of Davy Crockett, James Bonham, Dr. Amos Pollard, and Susanna Dickinson, all of which were hung in the Alamo Museum.[10] One of his pencil sketches of the San José Mission doorway decorated the cover of a San Antonio guidebook published in 1938.[11] Besides institutions in San Antonio, his work is represented in schools, museums, and hospitals throughout Texas and the United States, as well as in numerous private collections.[12]

In 1942 this active and talented artist suffered a stroke that resulted in paralysis of his right side. De Young was hospitalized in the Veteran's Hospital in Waco, Texas, where, showing true Texas grit, he taught himself to paint with his left hand. Few of these paintings sold, however, and he and his family were reduced to existing on a meager veteran's pension.[13]

During this period the Alamo Museum had reproduced his *Davy Crockett* painting and sold hundreds of the reproductions. De Young realized none of the royalties from these sales, as he had waived all reproduction rights to the painting when he sold it in 1937. A poignant editorial appeared in the San Antonio *Express* in 1955 that lamented this ironic fact. The editorial was entitled, "The Forgotten Man."[14]

When De Young died in January 1956, his obituary was short and concise and listed very few of his achievements.[15] Although he has been "forgotten" for years, he lives on in his paintings, his sensitive drawings, and the extension of the artistic philosophy he instilled in his many students.

7. "Second Annual Davis Mountain Summer Painting Camp" (1932). Typescript announcement, De Young file, SAMA Texas Artists Records.
8. Ibid.
9. Bess Carroll, "De Young Art Shown at Witte," San Antonio *Light*, April 8, 1934.
10. "Forgotten Man," San Antonio *Express*, June 19, 1955.
11. "Guide Reveals 100 Odd Facts of San Antonio," San Antonio *Express*, April 10, 1938.
12. "Harry Anthony De Young Summer Painting Class in Monterrey, Mexico."
13. "Forgotten Man."
14. Ibid.
15. "S. A. Artist Dies in Waco," San Antonio *Express*, January 18, 1956.
16. "Artists Assigned to CWA Projects," San Antonio *Express*, January 6, 1934.
17. "Indian Mural Hung in Museum," San Antonio *Express*, March 7, 1934.
18. Woolford and Quillin, *The Story of the Witte Memorial Museum*, 192–214.
19. Ibid.
20. Roberta McGregor and Fred Valdez, Jr., "The Lower Pecos River Indian Art," *Heritage: A Publication of the Texas Historical Foundation*, 3 (Spring 1986): 30–31.
21. Roberta McGregor (SAMA Associate Curator of Anthropology) to author (SA), interview, March 21, 1986.
22. Ibid.

TEXAS BASKETMAKER INDIANS
1934, oil on canvas, 96″ × 200″
Signed and dated lower left: Harry Anthony De
Young/San Antonio, 1934

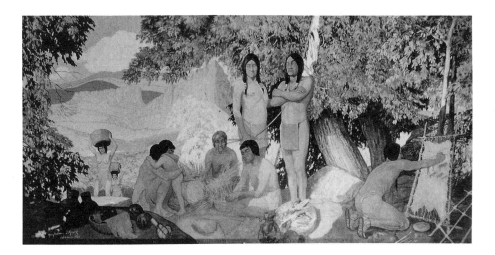

In 1934 the Civil Works Administration commissioned eight San Antonio artists to paint murals for public buildings in San Antonio. It selected Harry Anthony De Young to paint a mural for the Witte Memorial Museum depicting prehistoric peoples called, at that time, "Basketmakers."[16] De Young's mural depicted a scene in the lives of the Basketmakers as he envisioned it using research material available at the time. It was the focal point of the entrance hall of the museum.[17] These early inhabitants, who dwelled in the Lower Pecos area of Southwest Texas, were called Basketmakers because they used sotol, agave, and other fibers in weaving clothing, cooking utensils, devices to ensnare game, carrying baskets, and other ordinary implements.[18]

Since the Witte Museum had pioneered archaeological expeditions into the Lower Pecos region of the state, locating sites where these ancient peoples had lived and collecting artifacts which they had used, the subject matter of the mural was deliberate and appropriate. The museum conducted preliminary investigations in 1928, 1931, and 1933. Besides professional museum personnel, the investigators included an artist, a newspaper reporter, science teachers, Texas Rangers, and local guides. These specialists found complete burials with mummies covered with woven plant fibers, food remains, weapons, mysterious painted pebbles, stone tools, fire-making equipment—everything that sustained a culture some 4,000 years old. They also found vivid pictographs painted on the stone walls of the caves in which these ancient peoples lived. The pictographs shed further light on their life-style and living habits.[19]

The artist chose to paint the scenes from the viewpoint of a cave interior looking over a domestic tableau with the rugged West Texas countryside in the background. It is a highly romanticized version with robust individuals in a carefree and casual atmosphere. In reality, these ancient peoples were anything but indolent. Their diet produced slighter and leaner individuals.[20] They were not agrarians and corn was unknown to them. And there is no evidence that they painted their pictographs on hides. They did use the *atlatl* (a spearthrower shown in the mural), the main weapon of the Archaic period.[21] The inaccuracies in characterization in De Young's mural were the result of incomplete knowledge of the Basketmakers' life-style. Since those early digs, many expeditions have produced more specific information.[22]

PROVENANCE:
1934: Commissioned by the Civil Works Administration for the Witte Memorial Museum. 86–49 G (Delayed Accession)

EXHIBITIONS:
1934–1970: Entrance Hall of the Witte Memorial Museum. The mural was removed when the galleries were renovated and was in storage until 1983.
1983–1985: The Witte Museum: Past, Present and Future, WMM (October 23, 1983, to November 1, 1985).
1986: Edgar B. Davis Gallery, WMM (January 1 to November 19).

PUBLICATIONS:
"Finishing Mural for Museum," San Antonio *Light*, February 18, 1934.
"Indian Mural Hung in Museum," San Antonio *Express*, March 7, 1934.
"Brrr! Basket-Weaving Braves Brave Cold," San Antonio *Evening News*, November 11, 1945.
"So You Think You Know San Antonio," San Antonio *Express*, July 11, 1948.
"So You Think You Know San Antonio," San Antonio *Express*, January 29, 1950.
"So You Think You Know San Antonio," San Antonio *Express*, April 22, 1951.
Woolford and Quillin, *The Story of the Witte Memorial Museum*, (1966), 217.
John Obrecht, "The SAMA Saga: Six Decades with the San Antonio Museum Association," M3, SAMA Quarterly, in *San Antonio Monthly*, 5 (July 1986): 13.

This photo shows the entrance hall of the Witte Memorial Museum as it appeared in the 1940s. De Young's mural is prominently displayed with much of the museum's Indian collection. SAMA Historical Photographic Archives, staff photograph.

LOVER'S LEAP, EARLY SPRING, JUNCTION,
TEXAS
n.d., oil on canvas board, 12″ × 16″
Signed lower right: Harry Anthony De Young
Titled and signed on reverse: Lover's Leap, Early
Spring, Junction, Texas, Harry Anthony De Young

The bare trees in this West Texas landscape
suggest that De Young visited the area in
winter or early spring. The somber grays and
browns in the stark trees are silhouetted
against the warm pink of the butte in the
background. The harshness and ruggedness of
the area are evident not only in the craggy
outcroppings of the rocky cliffs but also
in the gnarled and twisted trees in the
foreground which are depicted with bold
and positive brushstrokes.

PROVENANCE:
-1989: Collection of the Freeborn Family.
1989: Purchased by SAMA from Moran Estate
Liquidators, agents for the Freeborn Family, with
funds provided by the Minnie Stevens Piper
Foundation.
89–25 G (2)

EXHIBITIONS:
1990: Looking at the Land: Early Texas Painters,
San Angelo Museum of Fine Arts (February 22 to
March 25).

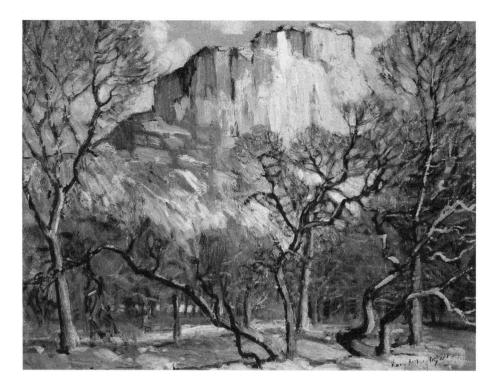

SUNLIGHT THROUGH THE TREES
n.d., oil on canvas, 20″ × 24″
Signed lower right: Harry Anthony De Young

Although the site of this landscape is
undetermined, it probably was done in the
Big Bend area of West Texas because of the
towering peak in the background. It is a
lively canvas with shimmering light cascading
through the brilliant young yellow-green
leaves of the trees. The treatment of
sparkling light and dusky shadows gives the
canvas movement and vivacity characteristic
of a brisk spring morning in the mountains.

PROVENANCE:
-1989: Collection of the Freeborn Family.
1989: Purchased by SAMA from Moran Estate
Liquidators, agents for the Freeborn Family, with
funds provided by the Minnie Stevens Piper
Foundation.
89–25 G (1)

CASTLE ROCK, DAVIS MOUNTAINS OF TEXAS
1932, pencil on paper, 10″ × 8″
Signed and dated lower right: Harry Anthony De
Young/1932
Titled lower left: Castle Rock—Davis Mts.—Texas

This small sketch typifies the artist's favorite
and most successful medium: pencil. It
illustrates De Young's masterful control of an
ordinary marking implement, using delicate
shades and nuances to achieve light, shadow,
depth, and in this instance, space as well.
Only a person sensitive to nature could
have expressed so much with such tactile
perception in such a limited space.

In accounts of De Young's exhibitions
and in descriptions of his work, his drawings
are always lauded. Probably one of his
proudest accomplishments was having five
pencil sketches of the missions in San Antonio
shown at the Century of Progress Exposition
in Chicago in 1933.[23]

PROVENANCE:
1932–1934: Collection of the artist.
1934: Wedding gift to Bess Carroll and Sam Woolford.
The original backing had the title, *Castle Rock, Davis
Mountains of Texas* inscribed in pencil as well as the
message, "To the Sam Woolfords/Wishing you a long
and most happy married life. San Antonio—1934/
Harry Anthony De Young."
1980: Gift to SAMA by Mr. and Mrs. Eric Steinfeldt.
Purchased by the donors from the Estate of Sam
Woolford, Boerne, Texas. Woolford, former editor
of the San Antonio *Light*, was also a noted writer and
historian.
80–121 G (5)

EXHIBITIONS:
1986: Texas Seen/Texas Made, SAMOA (September 29
to November 30).

23. "Artists Will Exhibit Paintings," San Antonio
Light, March 29, 1936.

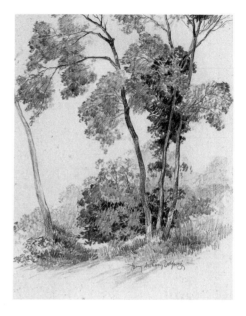

ROADSIDE TREE
n.d., pencil on paper, 5″ × 4″
Signed lower right: De Young
Titled on reverse: Roadside Tree

De Young's dexterity with a pencil is obvious in all of his sketches, large or small. In this example he used heavy strokes to simulate the rough bark on the gnarled tree trunk, short broad dashes for the windblown leaves, dots and dashes in foreground vegetation and soft circular scrawls for the distant mountains. He achieved different textures merely by turning and twisting his pencil.

PROVENANCE:
-1989: Collection of the Freeborn Family.
1989: Purchased by SAMA from Moran Estate Liquidators, agents for the Freeborn Family, with funds provided by the Minnie Stevens Piper Foundation.
89–25 G (5)

PRICKLY PEAR
n.d., pencil on paper, 5″ × 4″
Signed lower right: De Young
Titled on reverse: Prickly Pear

De Young used the technique of *chiaroscuro* to great advantage in his small rendition of a prickly pear cactus. The dark, light, and halftone areas create a vigorous composition with the white blossom a focal point silhouetted against the darker areas. The sharp thorns are delineated with positive strokes in the light spaces and are in relief against the dark tones. The boldness of the treatment again proves the artist's capability with his medium.

PROVENANCE:
-1989: Collection of the Freeborn Family.
1989: Purchased by SAMA from Moran Estate Liquidators, agents for the Freeborn Family, with funds provided by the Minnie Stevens Piper Foundation.
89–25 G (4)

YOUNG TREES
n.d., pencil on paper, 10″ × 8″
Signed lower right: Harry Anthony De Young

De Young's ability to capture the essence of his subject matter in his sensitive drawings is remarkable. The slenderness of the trunks of the trees, the delicate treatment of the leaves and shrubs, and the play of light and shadow in the foliage all convey a sense of early growth. Again a variety of strokes creates the textures of grass, bark, leaves, and fragile branches.

PROVENANCE:
-1989: Collection of the Freeborn Family.
1989: Purchased by SAMA from Moran Estate Liquidators, agents for the Freeborn Family, with funds provided by the Minnie Stevens Piper Foundation.
89–25 G (3)

C. A. A. DELLSCHAU

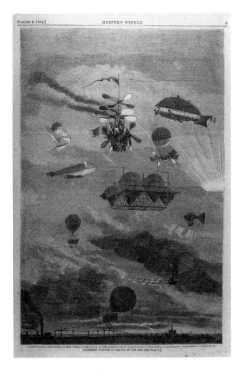

Interest in flying and flying machines was prevalent throughout the nineteenth century. This illustration from *Harper's Weekly* magazine of 1864 shows a variety of airships similar to those designed by Dellschau. Courtesy of the author.

C. A. A. Dellschau is one of the most enigmatic painters in Texas art history. He probably considered himself not an artist but rather an aeronautical draftsman. He was an inventor, dreamer, and scientist who, during the last few years of his life, painted thousands of pictures of imaginary aircraft.

Dellschau was reputedly born in Germany on June 4, 1830, and came to the United States sometime during the 1850s.[1] According to available research sources, he spent his first years in America in the company of scientists, most of them German, who were living in Sonora and Columbia, California. There he became a member of the Sonora Aero Club, a group of about sixty-two men dedicated to designing and constructing navigable aircraft. Researchers believe that Dellschau served as their chief draftsman and was closely involved in designing their unique and innovative airships.[2]

By about 1886, Dellschau was working in Houston as a salesman for Anton Stelzig, who owned the Stelzig Saddlery and Harness Shop. Stelzig also provided Dellschau with living quarters above his shop, rooms which Dellschau continued to occupy after his retirement in 1900 at the age of seventy.[3] It was probably then that he started his phenomenal series of drawings of fanciful airships.

Dellschau pasted his drawings in numerous scrapbooks. He executed the sketches on inexpensive paper resembling newsprint which he pasted onto heavier cardboard or paper and organized into books. Each plate was numbered, dated, and documented, sometimes in German, at other times in English, and sometimes in a combination of the two. The books were sewn together with heavy thread and the binding usually held together with shoe laces.[4]

For nearly half a century these scrapbooks remained undiscovered until, one day in the late 1960s, some of them were found by art students from the University of St. Thomas in a Washington Avenue antique store in Houston. In 1969 they were displayed in an exhibition at that school. Several of the scrapbooks were acquired by the Menil Foundation, also in Houston, and were shown at the Rice University Museum in 1977 in an exhibition called The I at Play.[5]

Dellschau's provocative and intriguing work inspired P. G. Navarro and James Ward of Houston to research and document the artist's life and to learn more about his clandestine activities. They have written a series of articles concerning not only Dellschau's life, but also little-known facts about the Sonora Aero Club, early experiments with aircraft, and the interest in unidentified flying objects at the turn of the century.[6] Although much of their study is based upon speculation, it suggests the fascination in all forms of aviation during the early years of the twentieth century. This interest doubtless influenced Dellschau's numerous renditions of fantastic airships, for Dellschau incorporated many contemporary newspaper and magazine clippings into his amazing creations. He called these collages "press blooms."[7]

The Menil Foundation of Houston owns a number of Dellschau's scrapbooks, the San Antonio Museum Association acquired four in 1979, and a few are in private hands, but Ward and Navarro believe there are eighteen to twenty books unaccounted for.[8] Whether the missing volumes would shed more light on the cryptic Dellschau is a matter of conjecture.

Dellschau is buried in a Houston cemetery not far from another abstruse man, Howard Hughes. Even the artist's gravestone and burial records are ambiguous. His

1. Kathryn Davidson and Elizabeth Glassman, "C. A. A. Dellschau, A Visual Journal." Typescript, Menil Foundation Archives, Houston, 1977.
2. P. G. Navarro, "Dellschau's Aeros," manuscript, 1979. Property of the author.
3. Ibid.
4. James Ward and P. G. Navarro, "The Riddle of Dellschau and His Esoteric Books." Undated photocopied typescript, C. A. A. Dellschau file, SAMA Texas Artists Records.
5. Charlotte Moser, "Dellschau drawings spark Rice show," Houston *Chronicle*, October 12, 1977.
6. Ward and Navarro. Undated photocopied typescripts and manuscript, Dellschau file.
7. Ward and Navarro, "The Riddle of Dellschau."
8. Ibid.

name is misspelled "Dellschaw" on the headstone and there are no public records of his burial, although all other family members are listed.[9] Mysterious man that Dellschau was, he left a legacy of inventive renditions of imaginary flying ships that are delightful in treatment, thought-provoking, and creative.

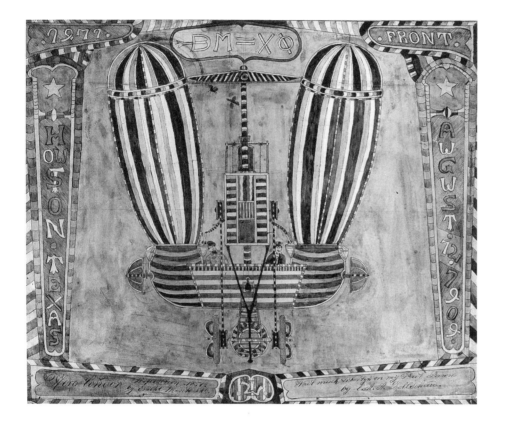

AERO CONDOR
1909, watercolor and ink on wood pulp paper
mounted on cardboard, 15⅝" × 19⅛"
Signed and documented lower right: Whit much
Libertys on my Part Drawn/by C. A. A. Dellschau
Titled and attributed lower left: Aero Condor,
Proposition. 1857/by Emihl Mente S A C
Dated right side: August 12, 1909

Dellschau was meticulous about attribution and usually credited the scientist whose work he used. In this instance, he also frankly admitted that he had taken liberties with the original design. He obviously was an intelligent man, but his spelling of English words appears to be based upon his knowledge of the German language.

PROVENANCE:
1909–ca. 1960: Collection of the Dellschau Family (?).
ca. 1960–1979: Collection of P. G. Navarro.
1979: Purchased by SAMA from P. G. Navarro with funds provided by The Annual Gift Appeal.
79–20 P (32)V

EXHIBITIONS:
1984: C. A. A. Dellschau, SAMOA (August 1 to November 1).
1986: Texas Seen/Texas Made, SAMOA (September 29 to November 30).

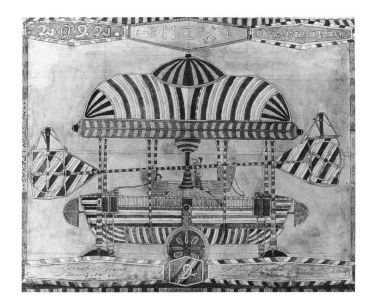

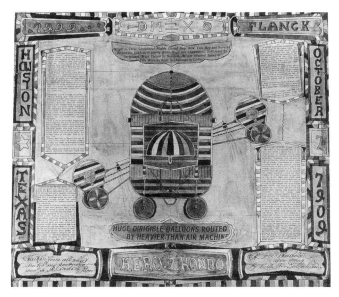

LONG DISTANCE AERO IMMER
1910, watercolor and ink on wood pulp paper
mounted on cardboard, 15¾″ × 19¼″
Signed lower center: C. A. A. Dellschau
Titled upper right: Long Distance Immer
Documented lower right: A free Studia after
foreward Work/August Immer, Senior
Dated and located lower left: May 14, 1910/Houston,
Texas

The inscription on this piece indicates
that August Immer must have made the
preliminary designs for the *Long Distance Aero
Immer*. Dellschau's memory evidently enabled
him to reconstruct the original concept. The
long distance *Immer* appears ready to take
off. The pilot is in position, a navigator with
telescope is plotting direction, and what
appear to be hydraulic lifts are ready to
move. The artist's fertile imagination and his
knowledge of engineering are obvious in this
rendition.

PROVENANCE:
1910–ca. 1960: Collection of the Dellschau Family (?).
ca. 1960–1979: Collection of P. G. Navarro.
1979: Purchased by SAMA from P. G. Navarro with
funds provided by The Annual Gift Appeal.
79–20 P (88)R

EXHIBITIONS:
1984: C. A. A. Dellschau, SAMOA (August 1 to
November 1).
1986: Texas Seen/Texas Made, SAMOA (September 29
to November 30).

PUBLICATIONS:
Taylor, "Images," *Vision*, 3 (March 1980): 18.

AERO RONDO
1909, watercolor and ink on wood pulp paper
mounted on cardboard, 15½″ × 18⅝″
Signed and documented lower right: A Free Studia/
after Others/C. A. A. Dellschau
Titled lower center: Aero Rondo
Documented lower left: Tacken from what suited my
pourpose/and so she came on Paper
Dated right side: October 1, 1909

When Dellschau incorporated current
newspaper or magazine clippings into his
work, he called these collages "press blooms."
He painstakingly outlined these clippings with
colorful and elaborate borders that matched
the illustrated airship. In *Aero Rondo*, the flying
machine seems to represent the printed
matter. He evidently contrived a "heavier-
than-air machine" that, in his imagination,
could route the "huge dirigible balloons."[10]

PROVENANCE:
1909–ca. 1960: Collection of the Dellschau Family (?).
ca. 1960–1979: Collection of P. G. Navarro.
1979: Purchased by SAMA from P. G. Navarro with
funds provided by The Annual Gift Appeal.
79–20 P (45)R

EXHIBITIONS:
1984: C. A. A. Dellschau, SAMOA (August 1 to
November 1).
1986: Texas Seen/Texas Made, SAMOA (September 29
to November 30).

PUBLICATIONS:
Steinfeldt, "Simple Self-Expression," *Southwest Art*, 10
(September 1980): 63.
Steinfeldt, *Texas Folk Art* (1981), 134.

9. James Ward in collaboration with P. G. Navarro,
"Dellschau: The Enigmatic Man." Undated
photocopied typescript, Dellschau file, SAMA
Texas Artists Records.
10. Ward and Navarro, "The Riddle of Dellschau";
see illustration of *Aero Rondo*.

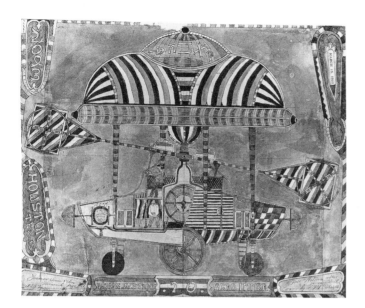

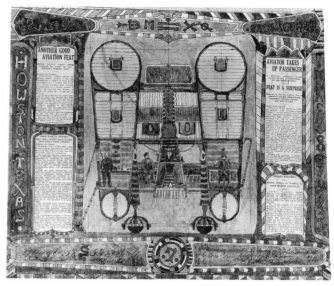

LONG DISTANCE AERO IMMER
1910, watercolor and ink on wood pulp paper
mounted on cardboard, 15¼″ × 19¼″
Signed and documented lower right: A free Studia
after/forward Worck/drawn by C. A. A. Dellschau
Titled lower center: Long Distance Aero Immer
Attributed lower left: Immer Senior & Son/Heinrich
Prop/1857
Dated upper right: March 15, 1910

In many instances Dellschau would make a
series of drawings of a single airship to show
different views and various aspects of its
construction. Apparently a penurious person,
he glued drawings to both sides of the
cardboard inserts in his scrapbooks. This
sequential view of the *Aero Immer* was applied
to the opposite side of the preceding plate.
Dellschau shows the interior of the airship
body with another aviator or passenger
seated on a bunk in a sleeping compartment.
The ship is not quite airborne, but the
hydraulic lifts have been activated and the
aircraft seems ready for departure.

PROVENANCE:
1910–ca. 1960: Collection of the Dellschau Family (?).
ca. 1960–1979: Collection of P. G. Navarro.
1979: Purchased by SAMA from P. G. Navarro with
funds provided by The Annual Gift Appeal.
79–20 P (88)V

EXHIBITIONS:
1984: C. A. A. Dellschau, SAMOA (August 1 to
November 1).
1986: Texas Seen/Texas Made, SAMOA (September 29
to November 30).

AERO NEWELL
1912, watercolor and ink on wood pulp paper
mounted on cardboard, 16″ × 19¼″
Signed and documented lower right: If George was
living would he not/open his peepersss/C. A. A.
Dellschau
Attributed lower left: George 1857 Newell/Propser
Dated right side: March 8, 1912

The *Aero Newell* is another flying machine that
Dellschau felt to be important enough to
portray in a succession of drawings. This is
number seven in the *Aero Newell* sequence
and is one of the more complex of the
illustrations. It is an interior or cross-section
view of the airship and clearly demonstrates
that the *Aero Newell* could accommodate a
number of people and, in this particular
instance, a cat as well. The ship was even
equipped with a dining area, represented by
the man seated at the table on the right.

PROVENANCE:
1912–ca. 1960: Collection of the Dellschau Family (?).
ca. 1960–1979: Collection of P. G. Navarro.
1979: Purchased by SAMA from P. G. Navarro with
funds provided by The Annual Gift Appeal.
79–20 P (136)R

EXHIBITIONS:
1984: C. A. A. Dellschau, SAMOA (August 1 to
November 1).
1986: Texas Seen/Texas Made, SAMOA (September 29
to November 30).

PUBLICATIONS:
Steinfeldt, *Texas Folk Art* (1981), 135.
Rosson, "More than Bluebonnets," *Sentinel* (December
1984): 27.

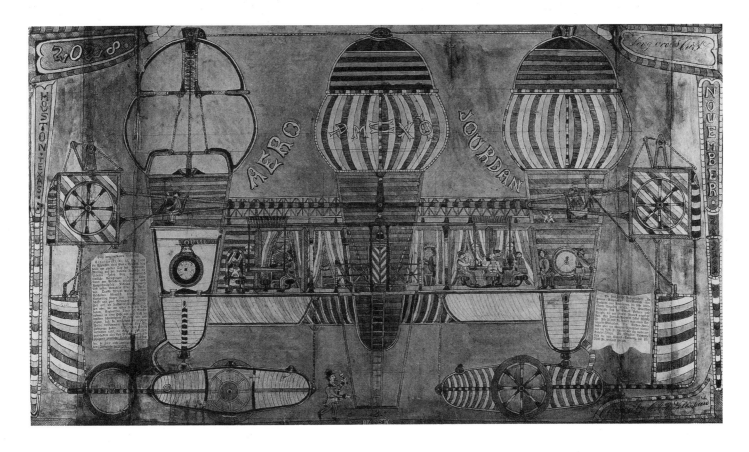

AERO JOURDAN
1909, watercolor and ink on wood pulp paper
mounted on cardboard, 15½″ × 27¼″
Signed lower right: Drawn by C. A. A. Dellschau
Titled upper center: Aero Jourdan
Dated right side: November 28, 1909

As Dellschau did not attribute *Aero Jourdan* to another designer, as was his habit, this may be considered an original drawing. It is an ambitious concept that required paper larger than the size of the scrapbooks. Dellschau extended his drawing with added paper and folded it over at the sides in order to have an enlarged area on which to work. In *Aero Jourdan*, the papers attached to either end were of better quality, resulting in more brilliant and sharper images in these areas. The *Aero Jourdan* is spacious enough to house a dining area, what appears to be a gaming room, and special stations for the crew. This view is the eighth in the series depicting this particular craft and is termed the "Long Cross Cutt" at upper right.

PROVENANCE:
1909–ca. 1960: Collection of the Dellschau Family (?).
ca. 1960–1979: Collection of P. G. Navarro.
1979: Purchased by SAMA from P. G. Navarro with funds provided by The Annual Gift Appeal.
79–20 P (58)R

EXHIBITIONS:
1984: C. A. A. Dellschau, SAMOA (August 1 to November 1).
1986: Texas Seen/Texas Made, SAMOA (September 29 to November 30).

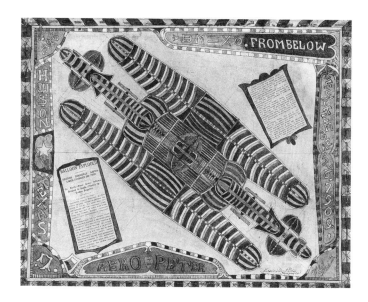

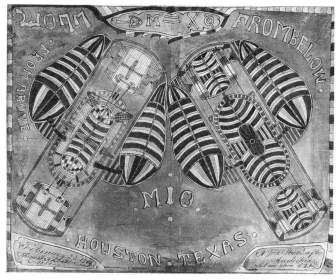

AERO PETER
1909, watercolor and ink on wood pulp paper
mounted on cardboard, 15¼" × 19½"
Signed and attributed lower right: Maximilian Heiss/
Proposer/by C. A. A. Dellschau
Titled lower left: Aero Peter
Dated right side: September 26, 1909

All of Dellschau's paintings of imaginary
aircraft are reminiscent of gaily colored,
striped Victorian hot-air balloons. The
intricate banding, the repetition in color, and
the obsession with outlining and decorating
each shape and form on his paper results in a
tedious similarity in his renditions. But closer
examination of his thousands of drawings
reveals a rich variety in engineering design.
His sources of inspiration were in the realm of
fantasy, and Aero Peter is suggestively an erotic
concept.

PROVENANCE:
1909–ca. 1960: Collection of the Dellschau Family (?).
ca. 1960–1979: Collection of P. G. Navarro.
1979: Purchased by SAMA from P. G. Navarro with
funds provided by The Annual Gift Appeal.
79–20 P (43)R

EXHIBITIONS:
1984: C. A. A. Dellschau, SAMOA (August 1 to
November 1).
1986: Texas Seen/Texas Made, SAMOA (September 29
to November 30).

AERO MIO
1910, watercolor and ink on heavy paper,
15¼" × 19"
Signed and documented lower right: A free Stude
after/Recolection/whit own Spleen, C. A. A. D.
Titled lower center: Mio
Dated and attributed lower left: February 22, 1910/
August Schoetler. Prop. 1858

These views of the Aero Mio are richer in
color and sharper in detail than most of
Dellschau's work because he used a heavier
paper of quality, rather than his usual
inexpensive wood pulp paper. Evidently
August Schoetler, the "proposer" of Aero Mio,
was responsible for the original concept in
1858. He probably was a member of the
Sonora Aero Club. The ship seems to
resemble more closely a hot air balloon with
a flight deck than most of the other plans.

PROVENANCE:
1910–ca. 1960: Collection of the Dellschau Family (?).
ca. 1960–1979: Collection of P. G. Navarro.
1979: Purchased by SAMA from P. G. Navarro with
funds provided by The Annual Gift Appeal.
79–20 P (80)V

EXHIBITIONS:
1984: C. A. A. Dellschau, SAMOA (August 1 to
November 1).
1986: Texas Seen/Texas Made, SAMOA (September 29
to November 30).

PUBLICATIONS:
SAMA Calendar of Events (February 1979): [2].

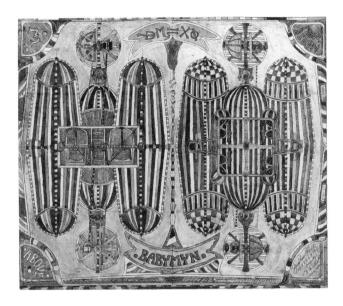

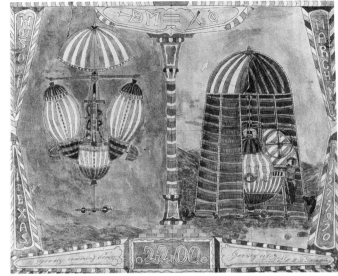

WORKS BY C. A. A. DELLSCHAU
NOT ILLUSTRATED:

Four scrapbooks of watercolors and collages by C. A. A. Dellschau containing 622 paintings. Each is signed, dated, and numbered.

1979: Purchased by SAMA from P. G. Navarro with funds provided by The Annual Gift Appeal.
79–20 P (1–311)

BABYMYN

1912, watercolor and ink on wood pulp paper mounted on cardboard, 16" × 19"
Signed and attributed lower right: Gustav Kolbe/PRO 1858 POSER/drawn by/C. A. A. Dellschau
Titled lower center: Babymyn
Dated right side: March 15, 1912

The emblem "←D M = X ɘ" appears on all of Dellschau's paintings and reputedly was the secret symbol of the Sonora Aero Club.[11] Sometimes painted directly on the airship, more often it is represented on a ribbon-like banner or cartouche placed at the top center of the painting. This rendition of Babymyn shows the craft from two perspectives, above and below, and is only one of numerous drawings in which Dellschau depicted it from many angles. Gustav Kolbe, the "proposer" of this particular aircraft in 1858, presumably was another member of the Sonora Aero Club.

PROVENANCE:
1912–ca. 1960: Collection of the Dellschau Family (?).
ca. 1960–1979: Collection of P. G. Navarro.
1979: Purchased by SAMA from P. G. Navarro with funds provided by The Annual Gift Appeal.
79–20 P (137)V

EXHIBITIONS:
1984: C. A. A. Dellschau, SAMOA (August 1 to November 1).
1986: Texas Seen/Texas Made, SAMOA (September 29 to November 30).

PUBLICATIONS:
Steinfeldt, *Texas Folk Art* (1981), 132.
"Texas Furniture and Decorative Arts Exhibit at Museum of Art Focuses on Native Artists," *Paseo del Rio Showboat* (SA), August 1984.

AERO GOOSEY

1910, watercolor and ink on wood pulp paper mounted on cardboard, 15½" × 19"
Signed and documented lower right: Goosey at Rest/ drawn by C. A. A. Dellschau
Dated right side: March 27, 1910
Documented lower left: Goosey coming down

Plate number 2,200 from Dellschau's scrapbooks includes two views of the airship *Goosey*. According to researchers, the artist considered this *Aero* the most perfect of any designed by members of the Sonora Aero Club. The *Goosey* was also referred to as the *Gander* and reputedly was designed, built, and flown by Peter Mennis around 1857.[12] An anti-gravity gas was used to keep the ship airborne, and hydraulic mechanisms were employed to raise and lower the craft. The *Goosey* evidently had its own tentlike hangar, as is shown on the right in the illustration.

PROVENANCE:
1910–ca. 1960: Collection of the Dellschau Family (?).
ca. 1960–1979: Collection of P. G. Navarro.
1979: Purchased by SAMA from P. G. Navarro with funds provided by The Annual Gift Appeal.
79–20 P (311)V

EXHIBITIONS:
1984: C. A. A. Dellschau, SAMOA (August 1 to November 1).
1986: Texas Seen/Texas Made, SAMOA (September 29 to November 30).

PUBLICATIONS:
Steinfeldt, *Texas Folk Art* (1981), 133.
John Obrecht, "Fantasy Flight," M3, SAMA Quarterly, in *San Antonio Monthly*, 6 (October 1986): 9.

11. Ward and Navarro, "The Riddle of Dellschau."
12. Davidson and Glassman, "C. A. A. Dellschau."

Otis Dozier, like Everett Spruce (1908–), was a member of the "Dallas Nine" who won national and international acclaim. Like Spruce, he was reared on a farm and as a youth had little access to cultural activities. Born in Forney, Texas, in 1904, he moved shortly thereafter to Mesquite, Texas, both sites near Dallas. He grew up outdoors and developed an interest in animals—jackrabbits, road runners, owls, horses, and bulls—subjects which frequently appeared in his canvases.[1]

Dozier received his first art instruction at Forest Avenue High School in Dallas under Cora Edge. She was certain that Dozier had promise as an artist and encouraged him to become a painter.[2] He then attended the Aunspaugh School, founded by Vivian Aunspaugh (1870–1960), and became a charter member of the Dallas Artists League. He also began teaching at the newly founded Dallas School of Creative Arts and started exhibiting his work.[3] He won the Kiest Purchase Prize in the Dallas Allied Arts Show in 1932 for his painting of horses, On the Lot.[4]

During the depression Dozier painted a number of murals under the Public Works of Art Project: two at Forest High School, two at Texas A&M University, and one for the Treasury Department at the post office in Giddings.[5] In 1937 he received a scholarship to study at the Colorado Springs Fine Arts Center, and two years later he began teaching there with Boardman Robinson (1876–1952), remaining until 1945.[6] While in Colorado he roamed the hills and mountains, producing over 3,000 sketches of their craggy heights and depths—sketches he later used for paintings.[7] He also produced many fine prints during this period and participated in every circuit of the Lone Star Printmakers group.[8]

In 1940 Dozier married Velma Davis (n.d.), also an artist, and when he returned to Texas in 1945 began teaching at Southern Methodist University in Dallas, where he remained until 1948, and at the Dallas Museum of Fine Arts School, where he taught until 1970.[9]

During Dozier's notable career he exhibited at the Museum of Modern Art, the Whitney Museum of American Art, the Des Moines Art Center, the Metropolitan Museum of Art, the University of Illinois, and in many other major museums throughout the country. Solo exhibitions were held in numerous galleries and museums. The Dallas Museum of Fine Arts had a show in 1944 and a retrospective exhibition in 1956, which merited a glowing review in the December 17, 1956, issue of Time magazine. The Witte Memorial Museum honored Otis Dozier and Edward Schiwetz (1898–1984) with a joint exhibition in 1948, which also elicited much favorable comment.[10]

Like that of Everett Spruce, Dozier's painting style matured and ripened throughout his many working years. This was evident in the 1956 retrospective that covered twenty-five years of the artist's work. In the exhibition catalogue, Jerry Bywaters wrote:

Otis Dozier is one of the fortunate American artists who have gone through a lengthy and self-compelled procedure of disciplined drawing, painting and experimenting, searching and maturing. Of course, hard work and sincerity have never been enough to make a good painter, but throughout his durance the artist has always maintained an affectionate understanding of and insatiable curiosity for the subjects and ideas which he paints—and this has resulted unmistakably in a quality of spiritual depth. Dozier has not become purely abstract or nonobjective, but he has taken advantage of all technical

1. Elizabeth Crocker, "Farm Boy Paints Texiana," Dallas Morning News, July 17, 1938.
2. "Otis Dozier: Art Teacher Learns Her Pupil Made Good," Dallas Morning News, February 12, 1960.
3. Stewart, Lone Star Regionalism, 164.
4. "Freshness and Assurance Mark Dallas Show," The Art Digest, 6 (May 1, 1932). Clipping, Otis Dozier file, SAMA Texas Artists Records.
5. Crocker, "Farm Boy."
6. Stewart, Lone Star Regionalism, 164.
7. Jerry Bywaters, Otis Dozier: Growth and Maturity of a Texas Artist (Dallas: Dallas Museum of Fine Arts, 1956), [8].
8. Stewart, Lone Star Regionalism, 164.
9. Francine Carraro, "Painters of the Southwest Landscape: Otis Dozier, William Lester, Everett Spruce" (M.F.A. thesis, Southern Methodist University, Dallas, 1976), 23.
10. Catalogues and listings, Dozier file, SAMA Texas Artists Records, and Jerry Bywaters Collection, SMU.
11. Bywaters, Otis Dozier, [1].
12. Ibid.
13. "Otis Dozier."
14. Catalogues and listings, Dozier file, SAMA Texas Artists Records, and Jerry Bywaters Collection, SMU.
15. "Southwest Painter," Time, 68 (December 17, 1956): 82.
16. "Otis Dozier's art shown in San Antonio," San Antonio Light, July 30, 1987.
17. Crocker, "Farm Boy."

TOWN IN THE MOUNTAINS
1945, lithograph on paper, 10⅛″ × 14⅛″
Signed and dated lower right: Otis Dozier, '45
Inscribed lower center: to Eleanor
Titled lower left: Town in the Mountains

Dozier learned the art of lithography during his years at the Colorado Fine Arts Center. Ranging over the Colorado mountains, he enjoyed exploring mining sites and ghost towns.[17] *Town in the Mountains* appears to be the result of one of these excursions, and, although it is a small print, he has captured the loftiness of the craggy peaks, the blustery windswept sky, and the loneliness of a small town huddled in the valley. He presented it to Eleanor Onderdonk, probably as a token of appreciation.

PROVENANCE:
1945–1964: Collection of Eleanor Onderdonk.
1964: Gift to SAMA by Eleanor Onderdonk.
64–295 G (3)

EXHIBITIONS:
1968: Prints from the Permanent Collection, WMM (January 14 to February 4).
1986: Texas Seen/Texas Made, SAMOA (September 29 to November 30).

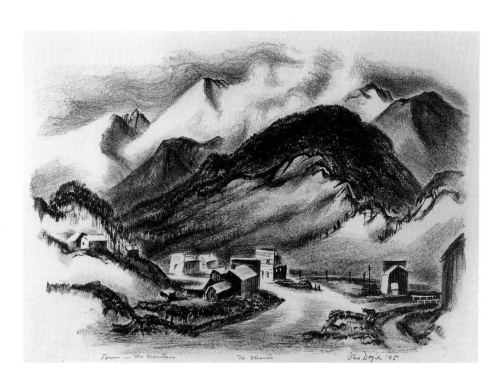

advances and his paintings are powerfully composed with the color always richly organized and used with great sensitivity to symbolize a subject.[11]

Although Dozier was based in Dallas he made frequent treks to the Big Bend area of Texas, as well as to New Mexico and Colorado. He also found inspiration along the Gulf Coast and in the swampy bayous of Louisiana.[12] In the winter of 1958–1959 he visited India and the Far East, making numerous sketches of exotic sites. Paintings developed from these sketches were displayed at the Nye Galleries in Dallas in 1960.[13]

In 1960 Dozier was the second Texas artist chosen for the Blaffer Series of Southwestern Art published by the University of Texas Press, and he was represented in *Pecos to the Rio Grande: Interpretations of Far West Texas by Eighteen Artists*, published by Texas A&M University Press in 1983.

Dozier's work may be found in the permanent collections of the Metropolitan Museum of Art and the Whitney Museum of American Art in New York; the Wadsworth Athenaeum in Hartford, Connecticut; the Newark Museum of Art; the Denver Museum of Art; and many other national and local institutions as well as private collections.[14]

The work of Otis Dozier helped transport Texas art into the mainstream of American art. In his later work he consciously aimed to break the bonds of regionalism and said: "You've got to start from where you are and hope to get to the universal."[15]

Dozier died of heart failure on July 28, 1987. At the time of his death, he had completed four of a series of six color lithographs for Peregrine Press of Dallas.[16]

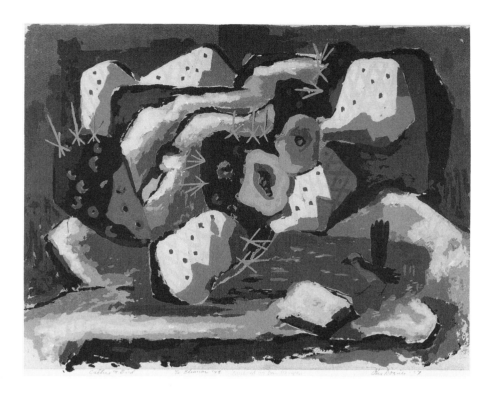

CACTUS AND BIRD
1947, serigraph on toned paper, 12¼″ × 15⅛″
Signed and dated lower right: Otis Dozier, '47
Inscribed lower center: to Eleanor, '48. Screened by
Dan Wingren
Titled lower left: Cactus and Bird

Otis Dozier once stated: "I would like to
do for cactus plants what Van Gogh did for
sunflowers and cypress trees." [18] And probably
no one has succeeded as well as Dozier in
this objective. Dawson-Watson and Julian
Onderdonk appreciated the spiny specimens
as well, but their versions were more realistic
and less dynamic in design. Dozier did many
paintings with cacti as subjects, virile, highly
stylized, and exploding with color. This print
evidently was based upon a canvas with
the same date and title, shown at Dozier's
retrospective exhibition at the Dallas Museum
of Fine Arts in 1956. Silk-screened by Dan
Wingren (1923–), a student of Dozier's and a
fine painter and printmaker in his own right,
it was a gift to Eleanor Onderdonk in 1948.
It was a welcome addition to the Texas
Collection when Eleanor donated it in 1964.

PROVENANCE:
1948–1964: Collection of Eleanor Onderdonk.
1964: Gift to SAMA by Eleanor Onderdonk.
64–295 G (2)

EXHIBITIONS:
1968: Prints from the Permanent Collection, WMM
(January 14 to February 4).
1986: Texas Seen/Texas Made, SAMOA (September 29
to November 30).
1988: The McNay and the Texas Artists, McNay Art
Museum, SA (July 1 to 31).
1990: Looking at the Land: Early Texas Painters,
San Angelo Museum of Fine Arts (February 22 to
March 25).

18. Ralph M. Pearson, *The Modern Renaissance in the
U.S.A.: Critical Appreciation Course* II (Nyack, N.Y.:
Ralph M. Pearson's Design Workshop Courses by
Mail, 1950), 63.

Seth Eastman exemplifies how an outstanding nineteenth-century artist became an indispensable ally to the historian. The sketches and paintings he made as a soldier-artist are among the most valuable pictorial records of early settlements along the Mississippi, in Texas, and of the American Indian. Although he is best known for his studies of native Americans, his early views of the structures and genre scenes of mid-nineteenth-century Texas made his contributions very important to the state's art history.

The artist was born in Brunswick, Maine, on January 24, 1808, the eldest son of Robert and Sarah (Lee) Eastman. Appointed to the United States Military Academy on July 1, 1824, Eastman was graduated and made a second lieutenant on July 1, 1829. At the academy he studied drawing with Thomas Gimbrede (1781–1832), a French miniaturist and engraver. According to William Dunlap (1766–1839), a contemporary artist and president of the National Academy of Design, Gimbrede was not a good teacher; Dunlap attributes Eastman's achievements to natural talent.[1]

Eastman's military record for his first twenty years of service is preserved in the Adjutant General's Office in Washington, D.C. It reads:

On duty at Fort Crawford, Wisconsin, with regiment, 1829–30, and at Fort Snelling, Minnesota, 1830–31; on topographical duty 1831 to January 9, 1833; Assistant Teacher of Drawing, United States Military Academy, to January 22, 1840; in the Florida War, 1840–41; with regiment at Fort Snelling, Minnesota, from 1841 to 1846; on recruiting service in 1846; at Fort Snelling, with regiment, 1846 to 1848; on march through Texas to San Antonio, Fredericksburg and the Neuces [Nueces] River, 1848–1849.[2]

When Eastman was on the faculty at the academy as assistant teacher of drawing, he taught military draftsmanship. Robert W. Weir (1803–1889) had been appointed to the post of teacher of drawing, and Eastman evidently benefited greatly from the association. He became more serious about his painting and by 1836 had progressed sufficiently to have a canvas exhibited at the National Academy of Design in New York. Eight of his pictures had been accepted by 1838, and in 1839 Eastman was elected an "honorary member amateur."[3]

In 1848, the War Department sent Eastman to Texas. He left Fort Snelling in September and started down the Mississippi with sketchbook in hand. According to Lois Burkhalter's introduction to A Seth Eastman Sketchbook, 1848–1849, "Eastman possessed the skill of drawing in the smallest possible space and a trained eye for the minutest detail, qualifications needed in the type of delineation developed at West Point for topographical engineers who were to give the world the first authentic views of the unknown West."[4] Seventy-nine of his miniature watercolors of the Mississippi River are illustrated in a notebook-size volume entitled Seth Eastman's Mississippi: A Lost Portfolio Recovered.[5]

Eastman entered Texas at Indian Point (Indianola) in November 1848, and several days later was on the march to San Antonio. Sketching along the way, he made several important drawings and paintings in and around San Antonio. By December he began travel to a frontier post near Fredericksburg known as Camp Houston. Later the post was named Fort Martin Scott in honor of an officer by that name who was killed in the war between the United States and Mexico.[6]

Eastman kept a journal of his travels in Texas as well as a sketchbook and described San Antonio as "a Mexican town but rapidly becoming yankeeized. . . . "

1. John Francis McDermott, The Art of Seth Eastman: A Traveling Exhibition of Paintings and Drawings (Washington, D.C.: Smithsonian Institution, 1959), 1–2.
2. David I. Bushnell, Jr., Seth Eastman: The Master Painter of the North American Indian, Smithsonian Miscellaneous Collections, 87 (April 11, 1932): 1.
3. McDermott, The Art of Seth Eastman, 2–3.
4. Lois Burkhalter, A Seth Eastman Sketchbook, 1848–1849 (Austin: University of Texas Press for the Marion Koogler McNay Art Institute, San Antonio, 1961), xv.
5. John Francis McDermott, Seth Eastman's Mississippi: A Lost Portfolio Recovered (Urbana: University of Illinois Press, 1973), passim.
6. Burkhalter, A Seth Eastman Sketchbook, xvii.

The missions around the town and the ruins of the Alamo interested him, but the hardships, particularly rattlesnakes encountered on his marches, concerned him greatly. He must have been relieved when he was granted a leave of absence to return to Washington in September 1849.[7] In Washington he was awarded the assignment he wanted, that of illustrating Henry Rowe Schoolcraft's six-volume study of the Indian tribes of the United States.[8]

In 1835 Seth Eastman married Mary Henderson, the seventeen-year-old daughter of Thomas Henderson, army surgeon for Virginia. The couple had five children. Mary shared her husband's interest in native Americans and studied and wrote about them, including a series of volumes of Indian lore, all illustrated by her husband.[9]

Eastman continued his service in the United States Army and was brevetted brigadier general in 1866. After his retirement Congress restored him to active duty to paint oils of native American scenes and United States forts. Still on assignment when he died in 1875, he had completed twenty-six of the commissioned paintings, which now hang in the United States Capitol.[10]

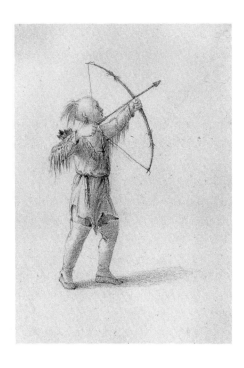

AMERICAN INDIAN WITH BOW
AND ARROW
n.d., pencil on paper, 5″ × 3½″
Unsigned

Although this small sketch bears no signature, it is logical to attribute it to Seth Eastman, who was famous for his paintings and studies of native Americans. It probably was done on one of his tours of duty in the United States Army. He made many such sketches which he later used as the basis of paintings.

PROVENANCE:
ca. 1950: The drawing was purchased by Gilbert M. Denman, Jr., at Goodspeed's Book Store in Boston, Massachusetts.
1974: Gift to SAMA by Gilbert M. Denman, Jr.
74–189 G

EXHIBITIONS:
1978: Native American Display, WMM (April 15 to November 1).
1986: Texas Seen/Texas Made, SAMOA (September 29 to November 30).

7. Ibid., xxii.
8. Utterback, Early Texas Art, 34.
9. McDermott, The Art of Seth Eastman, passim.
10. Burkhalter, A Seth Eastman Sketchbook, xxvi.
11. Ibid., xvii, 47. The drawing reproduced in Lois Burkhalter's book from the sketchbook (now owned by the McNay Art Museum in San Antonio) is very similar to the painting with slight variations in detail.
12. McDermott, The Art of Seth Eastman, 30.
13. Bushnell, Seth Eastman, 11.
14. Burkhalter, A Seth Eastman Sketchbook, xxii.
15. "Museum Adds To City's Lore With Paintings," San Antonio Express, August 5, 1934.

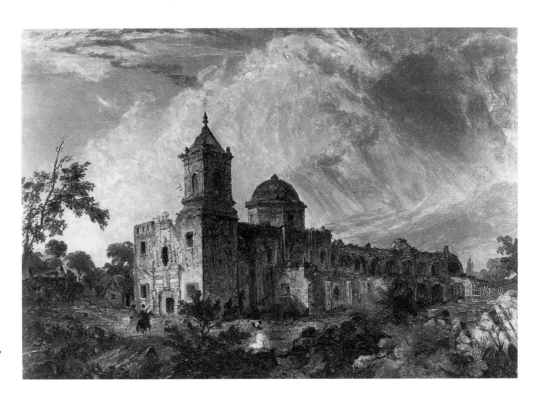

MISSION SAN JOSÉ
1848–1849, oil on canvas mounted on panel,
15½" × 22"
Unsigned

After Captain Seth Eastman embarked at Indianola in 1848, he and his regiment marched westward to San Antonio. He started his assortment of San Antonio drawings at Mission San José in late November of that year. The mission, as he sketched it at that time, is shown with its original façade, carved doors, statuary, dome, and tower.[11] He also did a small watercolor of the mission that he might have used for reference to complete the oil painting at a later date.[12] Ample evidence exists that the artist used his small sketches for finished paintings after he returned to Washington.[13]

In 1849, on his way back through San Antonio, Eastman kept a journal in which he mentions that he made more sketches of the mission and also provides sage observations concerning the structure:

> . . . went to the Mission San Jose. . . . and there encamped—Made several sketches during the day—This old Mission was built about 1800 or a little later—very finely constructed with much sculptur [sic] in from around and over the Door—It has been deserted for years—a few Mexican families now reside around it and in that portion of the church formerly occupied by the Priests—These old Missions were constructed by the Jesuits for the purpose of civilizing the Indians—and a great part of the rough work of building them was done by the Indians—They are all built of Lime stone—They are now going to ruins. . . .[14]

Whether Eastman painted the mission on the spot or in a studio is immaterial, because the painting has all the vitality and spontaneity of a work executed directly from life, the criterion of a true artist.

The acquisition by the San Antonio Museum Association of the painting and the watercolors of *The Alamo* and of *The View in Texas* in 1934 was widely recognized by the local press. Headlines pronounced: "Museum Adds To City's Lore With Paintings." The newspaper article cited the rendition of San José Mission as being the most important from an historical point of view and stated that the painting was "rich in color and free in technique. . . . "[15]

PROVENANCE:
ca. 1849–1934: Collection of the Eastman Family.
1934: Purchased by SAMA from Benjamin K. Smith, agent for Harry Eastman, grandson of Seth Eastman, with Witte Picture Funds.
34–6186 P

EXHIBITIONS:
1936: Centennial Exposition of Early Texas Paintings, WMM (June 1 to August 1).
1946: Early San Antonio Paintings, WMM (February 24 to March 12).
1960: Go West, Young Man, Marion Koogler McNay Art Institute, SA (January 1 to February 17).
1960: Early Texana Exhibit in recognition of the premiere festivities of the film, *The Alamo*, WMM (October 1 to 30).

1964: The Early Scene: San Antonio, WMM (June 7 to August 31).
1986: Texas Seen/Texas Made, SAMOA (September 29 to November 30).
1988: The Art and Craft of Early Texas, WMM (April 30 to December 1).
1990: Looking at the Land: Early Texas Painters, San Angelo Museum of Fine Arts (February 22 to March 25).

PUBLICATIONS:
"Museum Adds To City's Lore With Paintings," San Antonio *Express*, August 5, 1934.
"One of the Most Valuable Acquisitions by Witte Memorial Museum," San Antonio *Express*, September 5, 1934.
"San Antonio Gets Four Eastman Paintings," *The Art Digest*, 8 (September 1, 1934): 17.
John Francis McDermott, *Seth Eastman: Pictorial Historian of the Indian* (1961), plate 69.
Woolford and Quillin, *The Story of the Witte Memorial Museum* (1966), 161.
Utterback, *Early Texas Art* (1968), frontispiece.
Reese and Kennamer, *Texas, Land of Contrast* (1972), 95.
Reese and Kennamer, *Texas, Land of Contrast*, rev. ed. (1978), 124.
Mary Ann Guerra, *The Missions of San Antonio* (1982), cover.
"Antique Show," *Houston Downtown Magazine* (November 26, 1984): 5.
Sesquicentennial Almanac, calendar, *Texas: Under Six Flags, 1836–1986* (1986): 12 [under June 1836].
Steinfeldt, "Lone Star Landscapes," M3, SAMA Quarterly, in *San Antonio Monthly*, 5 (July 1986): 21.

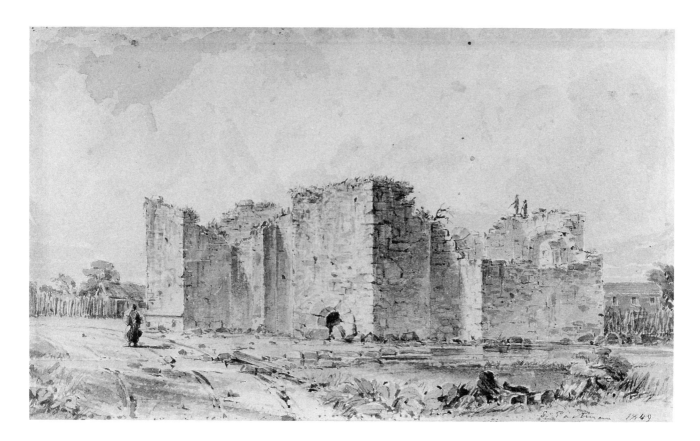

THE ALAMO
1849, watercolor on paper, 5⅛″ × 9¼″
Signed and dated lower right: S. Eastman, 1849

When Seth Eastman painted his small view of the back of the Alamo, he, like Gentilz, saw the destruction caused by Mexican troops in 1836 during the siege of the Alamo. In 1848, Eastman had made a watercolor of the front of the structure, now in the collection of the McNay Art Museum, which also shows the edifice ravaged and despoiled.

Shortly after Eastman did his watercolors, the United States Army leased the Alamo property from the Catholic Church for a quartermaster depot. William Corner, in *San Antonio de Bexar: A Guide and History*, describes some of the problems involved in the conversion:

"Much work was necessary to put the place into anything like the shape necessary for offices and depot houses, and sheds. . . . The next work done was the repairing of the front. To restore the upper part of it to its original form was impracticable. . . . So the top was finished off in its present modest shape [designed by architect John Fries], the rest of the walls were raised to an equal height, a roof was added, and to assist in bearing up this roof, two stone pillars were built inside. . . ."[16]

The façade and buildings as reconstructed by the Quartermaster Corps are the images familiar today.

Few artists depicted the Alamo before its famous face-lift. Arthur Tracy Lee (1814–1879), another soldier-artist, did a small watercolor of the back of the Alamo similar to Eastman's, also just months before renovation began. Theodore Gentilz made a few sketches showing the structure in ruins as well. And Mary Adams Maverick (1818–1898), one of the earliest Anglo settlers in San Antonio who came shortly after the siege, made a very crude sketch, probably the first made after the battle. Eastman's renditions, however, are the most sensitive and detailed, warranting the accolade in a newspaper article in 1934 that the Alamo watercolor was "of special value to San Antonio. . . ."[17]

PROVENANCE:
ca. 1849–1934: Collection of the Eastman Family.
1934: Purchased by SAMA from Benjamin K. Smith, agent for Harry Eastman, grandson of Seth Eastman, with Witte Picture Fund.
34–6184 P

EXHIBITIONS:
1936: Centennial Exposition of Early Texas Paintings, WMM (June 1 to August 1).
1946: Early San Antonio Paintings, WMM (February 24 to March 12).
1958: Mission Summer Festival, Mission Concepción, SA (June 13 to 22).
1960: Go West, Young Man, Marion Koogler McNay Art Institute, SA (January 1 to February 17).
1960: Early Texana Exhibit, in recognition of the premiere festivities of the film, *The Alamo*, WMM (October 1 to 30).
1964: The Early Scene: San Antonio, WMM (June 7 to August 31).
1986: Remembering the Alamo: The Development of a Texas Symbol, 1836–1986, WMM (February 23 to October 31).

PUBLICATIONS:
"Ancient: This painting of a rear view of the Alamo," San Antonio *Express*, August 4, 1934.
C. Ramsdell, *San Antonio* (1959), 63.
Walter Lord, "Myths and Realities of the Alamo," *The American West*, 5 (May 1968): 23.
Walter Lord, "Myths and Realities of the Alamo," *The Republic of Texas* (1968), 23.
Utterback, *Early Texas Art* (1968), 35.

VIEW IN TEXAS ABOUT 65 MILES NORTH
OF SAN ANTONIO
1848–1849, watercolor on paper, 4¹⁵⁄₁₆″ × 7⁵⁄₁₆″
Signed lower left: Capt. S. Eastman U.S.A.
Inscribed on reverse: Mary H. Eastman from her
husband

The sketchbooks and materials that
Seth Eastman carried during his military
assignments necessarily were limited in size
and scope. Nevertheless, he frequently
conveyed the broad vistas of the sweeping
Texas landscape with few colors within a
diminutive space. Such is the case with *View
in Texas*, undoubtedly made near the military
base of Camp Houston. The tiny figures
struggling along the face of a cliffside on the
right emphasize the vast emptiness of Texas
in the mid-nineteenth century. Eastman must
have sent the small watercolor to his wife
to illustrate not only the untamed character
of the land but also to impart his personal
loneliness.

EXHIBITIONS:
1936: Centennial Exposition of Early Texas Paintings,
WMM (June 1 to August 1).
1946: Early San Antonio Paintings, WMM (February 24
to March 12).
1960: Go West, Young Man, Marion Koogler McNay
Art Institute, SA (January 1 to February 17).
1960: Early Texana Exhibit, in recognition of the
premiere festivities of the film, *The Alamo*, WMM
(October 1 to 30).
1964: The Early Scene: San Antonio, WMM (June 7 to
August 31).
1986: Texas Seen/Texas Made, SAMOA (September 29
to November 30).

PUBLICATIONS:
McDermott, *Seth Eastman* (1961), plate 63.
Utterback, *Early Texas Art* (1968), 35.

16. William Corner (comp. and ed.), *San Antonio de
Bexar: A Guide and History* (San Antonio: Bainbridge
and Corner, 1890), 11; Charles Ramsdell, *San
Antonio: A Historical and Pictorial Guide* (1959; rev.
ed., Austin: University of Texas Press, 1976), 86.
17. "Museum Adds To City's Lore With Paintings."

PROVENANCE:
ca. 1849–1934: Collection of the Eastman Family.
1934: Purchased by SAMA from Benjamin K. Smith,
agent for Harry Eastman, grandson of Seth Eastman,
with Witte Picture Fund.
34–6185 P

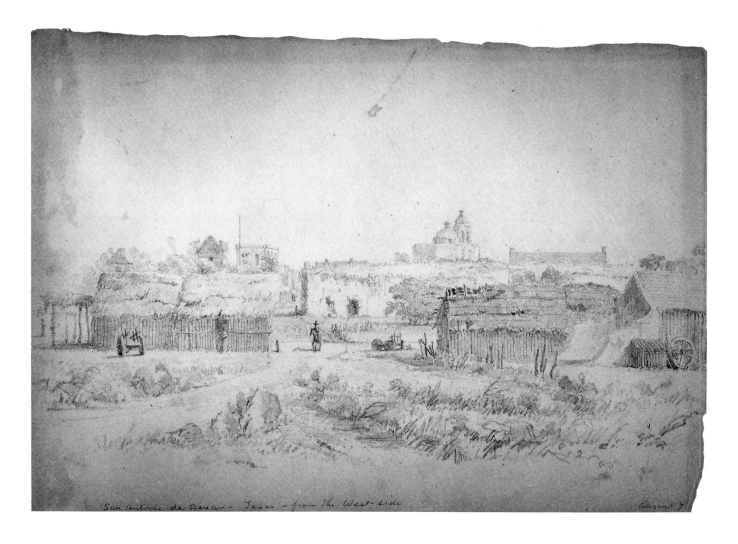

SAN ANTONIO DE BEXAR—TEXAS—FROM
THE WEST SIDE
1849, pencil on paper, 6¼″ × 9″
Unsigned
Inscribed lower left: San Antonio de
Bexar—Texas—from the West Side
Dated lower right: August 7

The date 1849 has been applied to this sketch, as Seth Eastman was encamped in the San Antonio area with his company at the time. He recorded in his Texas journal that he remained in San Antonio from August 5 to August 10, 1849, prior to his departure from the state.[18] A typical Eastman sketch, it shows Mexican *jacales* in the foreground with buildings on Military Plaza in the background. The rear view of San Fernando Cathedral in the distance is clearly identifiable. The drawing is crisply delineated, rich with detail, and keenly documents the rustic character of the small settlement in the mid-nineteenth century.

PROVENANCE:
1849–ca. 1965: Collection of the artist and his descendants.
1965: Collection of Pamela Miller, the artist's great-great-great-granddaughter.
ca. 1975: Acquired by Bartfield Books, New York City.
ca. 1976: Acquired by W. Graham Arader III.
1992: Purchased by SAMA from W. Graham Arader III with Witte Picture Funds.
92–45 P

18. Burkhalter, A *Seth Eastman Sketchbook*, xxi.

Portrait of Emily Edwards taken in about 1965.
Courtesy of Mrs. Floy Fontaine Jordan.

Of all the artists that San Antonio has produced, Emily Edwards is one of the most remarkable. Besides being an artist, she was a competent writer, a dedicated conservationist, an enthusiastic teacher, and an innovative theatrical entrepreneur. Her many accomplishments spanned a long life and, even in her declining years, she kept active and creative. Her last manuscript, *F. Giraud and San Antonio*, was completed shortly before her death in 1980, and she had just started on her memoirs when her life ended.[1]

Emily Edwards was born on October 7, 1888, at the family's Culebra Ranch, eighteen miles west of San Antonio.[2] She lived there for her first six years until a year of devastating drought motivated her father, Frank, to sell the ranch and move to San Antonio. Emily's mother died the following spring after the birth of her fifth child, Lillian. For two years the family was kept together by Emily's father, her grandmother, and a servant. It was finally decided, for the advantage of all, that the four girls should attend the Ursuline Academy, a boarding school for young ladies in San Antonio.[3]

The sisters' school days at the Ursuline began in 1898 when Emily was ten years old.[4] Emily received thorough instruction in all the essentials of reading, writing, and arithmetic, but by 1900 her studies expanded to include art classes.[5] These early days at the academy nurtured Emily's interest in all academic fields and established the basis for her diverse pursuits later in life.

When Emily left the Ursuline in 1902, she transferred to a public school. She also continued her art studies under Pompeo Coppini when he had his studio in the Twohig House, located in the center of town. She later attended Main Avenue High School and San Antonio Female College. At the age of seventeen she went to Chicago to live with her aunt and uncle, Mr. and Mrs. Frederick Deknatel, at the now world-famous Hull House, a pioneer social settlement.[6]

Emily entered the Art Institute of Chicago and studied drawing with John H. Vanderpoel (1857–1911). Her instruction, although academic and conventional, gave her a well-rounded basic education in the visual arts.[7] After her first year at the institute, she earned her tuition by working in the costume department as well as teaching a Saturday class for children. This lasted for two years until she was required to return to San Antonio to care for her father and sisters, replacing her older sister, Floy, who had just married.[8]

After another year Floy returned home because of her husband's death, and Emily returned to Chicago to resume study at the Art Institute. She also assumed teaching assignments at Hull House at the request of Jane Addams, founder of the institution. After graduation from the Art Institute, Emily taught at the University School for Girls and the Frances W. Parker School, also in Chicago.[9]

Beginning in the fall of 1917, when Emily returned to San Antonio, she taught art classes at Brackenridge High School for two years. She sponsored a club at the school that combined all the arts. She and her students helped stage plays in collaboration with the Drama and Sewing Departments. In 1919 she resigned her position as art instructor at Brackenridge and went to New York. There she got a job as a stage designer, which lasted exactly two weeks. Undismayed, the young radical transferred her activities to Provincetown, Massachusetts. She joined a colony of artists and writers who also sponsored an experimental theater. Emily began making puppets and presenting puppet shows, a creative activity that she put to good use

1. Mary Elizabeth Droste, "About the Author," in Emily Edwards, *F. Giraud and San Antonio* (San Antonio: Southwest Craft Center, 1985), 114.
2. Ibid., 106.
3. Ibid.; Mary Fenstermaker, "A Conversation with Emily Edwards," *San Antonio Conservation Society Newsletter*, 17 (February/March 1980): 4.
4. Emily Edwards, *Stones, Bells, Lighted Candles: Personal Memories of the Old Ursuline Academy in San Antonio at the Turn of the Century* (San Antonio: The Daughters of the Republic of Texas Library, 1981), 7.
5. Ibid., 50.
6. Droste, "About the Author," 107–108.
7. Fenstermaker, a continuation of "A Conversation with Emily Edwards," *San Antonio Conservation Society Newsletter*, 17 (April 1980): 4.
8. Ibid.; Droste, "About the Author," 108.
9. Droste, "About the Author," 108.

when she later returned to San Antonio. It was in Provincetown that she became a member of the Provincetown Woodblock Printers.[10]

When Emily returned to San Antonio in 1923, she developed a concern for the preservation of the city's unusual character and was a driving force in establishing the San Antonio Conservation Society, serving as the society's first president from 1924 to 1926. The group's first objective was to save the old Market House on Market Street. Although this mission failed, the small group of dedicated people succeeded in saving the downtown San Antonio River from being "paved over" by ambitious city commissioners who were considering draining the river as a flood control measure.[11]

It was then that Emily Edwards put her theatrical talents and interest in puppetry to practical use. For a presentation to city officials, she designed puppets to represent Mayor Tobin and the commissioners and wrote a script, in verse, about "The Goose that Lays the Golden Eggs," the "Goose" being the San Antonio River. The commissioners were so impressed with the presentation that they voted favorably, and the downtown river bend was saved.[12]

Emily spent the summers of 1925 and 1926 in Mexico with Sybil Browne. She attended classes on art analysis given by Diego Rivera (1886–1957), which evidently developed in her a profound respect for all the Mexican arts and crafts. For the next ten years she spent much of her time in Mexico and gathered material for her monumental book, *The Painted Walls of Mexico*. Emily wrote the text and Manuel Alvarez Bravo (1902–), one of Mexico's outstanding photographers, provided the illustrations. This work actually took more than forty years to complete and was published in 1966 by the University of Texas Press.[13]

During her extended stay in Mexico she married Librado Cantabrano, a master weaver. Although the union lasted only three years, Emily learned much about Mexican village life, and, after the marriage was terminated, the couple remained good friends.[14]

In 1938 Emily Edwards became director of the Hull House Art School and in 1955 participated in a pilot program on gerontology at Cold Springs, New York. She returned to San Antonio in 1958 and again became involved with the San Antonio Conservation Society. She helped to save the Ursuline Convent and Academy and to convert it into the Southwest Craft Center.[15]

Fortunately, Emily Edwards was recognized for many of her accomplishments during her lifetime. The San Antonio Conservation Society gave her a Special Honor Award in 1963 and the Southwest Craft Center had an event in her behalf at which she was presented with a Citation of Appreciation. In 1976 she received an award from the Texas Society of Architects for her contributions to the quality of life in Texas. She also was named one of the thirteen "Founding Mothers of San Antonio" in 1980. In 1983 the art gallery and lecture room at the Southwest Craft Center was dedicated to her memory.[16]

Emily Edwards's impact on San Antonio cannot be overestimated. Obviously, she was an inspiration and a stimulating influence in her many fields of interest, although she considered herself to be "just an agitator."[17]

10. Ibid., 108–109.
11. "Edwards Rites are Set," San Antonio Light, February 17, 1980.
12. Droste, "About the Author," 110.
13. Ibid., 111; Robert Ford, "Mexican Wall Art Traced in History," Dallas Times Herald, February 5, 1967.
14. Droste, "About the Author," 111–112; "Life in Mexico Described by Artist," San Antonio Light, July 17, 1927.
15. Droste, "About the Author," 112–113.
16. Ibid., 113; "River Area Patron Lauded," San Antonio Express, November 4, 1976.
17. "Catching up on river history finds heroine's 90th birthday," San Antonio Express, October 12, 1978.
18. Floy Fontaine Jordan to author (SA), interview, December 22, 1986. Jordan supplied the information that the painting was given to Dr. Smith in about 1924.
19. Mrs. Henry Drought was the patroness of the arts in San Antonio for many years. Her "Sunday Salons" included all outstanding visiting artists and musicians as well as budding local talents, and frequently Mrs. Drought was given works by grateful artists. Presumably Emily Edwards presented this print to her friend, Mrs. Drought, as a token of gratitude.

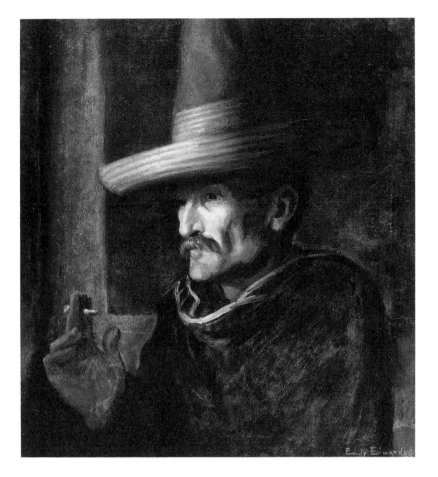

PORTRAIT OF A MEXICAN
n.d., oil on canvas, 14⅛″ × 22¼″
Signed lower right: Emily Edwards

Emily's portrait of a gentleman in Mexican attire is an early work, presumed to have been done when she was a student at the Art Institute of Chicago. The features of the model do not seem to be Hispanic, and Emily Edwards's flare for the dramatic may have prompted her to use clothing from the costume department to dress a professional model. Just exactly when she painted *Portrait of a Mexican* is uncertain, but a faded label on the back of the canvas bears the title and a dim inscription in ink, "Art Institute."

PROVENANCE:
ca. 1910: Collection of Mrs. Jules W. Fontaine, the donor's mother.
ca. 1924: The painting was a gift to Dr. B. W. Smith from Mrs. Jules W. Fontaine.[18]
1924–1981: Collection of Dr. B. W. Smith.
1981: Gift to Floy Fontaine Jordan from a niece of Dr. Smith from his estate.
1986: Gift to SAMA by Floy Fontaine Jordan.
86–92 G (2)

EXHIBITIONS:
1986: Texas Seen/Texas Made, SAMOA (September 29 to November 30).

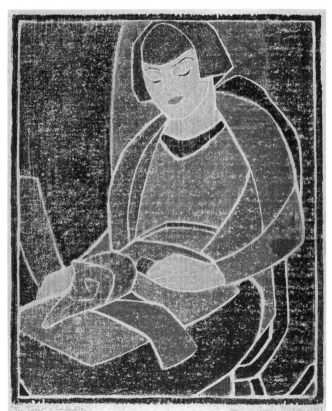

THE TOILET OF CINDERELLA
1921, color block print on paper, 14″ × 11½″
Signed and dated lower right: Emily Edwards—1921
Titled lower left: "The Toilet of Cinderella"

This color block print obviously was made when Emily Edwards was a member of the Provincetown Woodblock Printers. It illustrates her quick acceptance of a more contemporary style of work that was beginning to penetrate all art fields. In comparison with her earlier, more academic and conventional efforts, it shows a strong sense of design, a simplification of form, and a decided flair for color organization. The subject, a girl grooming her cat, is handled in a very positive and straightforward manner. It also indicates Emily's unbiased and receptive attitude toward the changing art scene.

PROVENANCE:
ca. 1924–1945: Collection of Mrs. Henry P. Drought.[19]
1945: Gift to SAMA by the Drought Estate.
45–131 G (13)

EXHIBITIONS:
1986: Texas Seen/Texas Made, SAMOA (September 29 to November 30).

FRANK MUDGE EDWARDS

Frank Mudge Edwards, the father of the artist Emily Edwards (see Emily Edwards), was no less remarkable than his famous daughter. As an artist, he was self-taught and did not take up painting until he was eighty years old.[1] A native San Antonian, he was born in 1855, the son of Benjamin Elisha Edwards and Susan (Mudge) Edwards.[2]

As a boy, Frank Edwards moved with his family to New Orleans, but the Civil War forced them to return to Texas, where Frank and his brother Willis lived on a ranch. When Frank was twelve and Willis was ten, they were sent to Missouri to stay with their grandparents on a farm near Kirkwood. They attended school in St. Louis, where Frank studied engineering.[3]

Frank returned to Texas when he was twenty years old and opened a shoe store on Commerce Street in San Antonio. Evidently he found the work too confining and decided to take over the management of the Culebra Ranch, which he had inherited from his father. He was one of the first ranchers in Texas to fence his property and made several cattle drives up the Kansas trail. Drought and hard times compelled him to move back to San Antonio.[4] He worked in the city assessor's office for many years. Later he prospected in Mexico and sold real estate.[5]

In 1936, in his eighty-first year, Edwards moved to Pleasure Hill near Ingram, Texas. He built a house virtually unaided, using rocks from the area. When the house was finished, he adorned the walls with murals depicting the ranch life and western themes with which he was so familiar.[6] When the murals were finished he turned to easel painting. These paintings also reflected his knowledge of the outdoors, pioneer life, and animals in the Texas Hill Country.[7]

At the age of ninety-four Edwards was still able to chin himself on the rafters in his home. For years he got up every morning and swam across the Guadalupe River, which ran in front of his little rock house.[8] A staunch Texan, each day he raised the Lone Star flag on a twenty-five-foot mast in front of his domain and hunted and fished until he was nearly one hundred years old.[9]

Besides Emily, Edwards had four other children. His wife died after the birth of Lillian, their fifth child, leaving him a widower for half a century. His painting, his athletic activities, and his spirited zest for living kept him alert and sprightly until his death in 1956 at the age of 101 years and four months.[10]

One of the highlights of Edwards's painting career was a two-man show with J. J. King, another "untrained" painter. It was organized by Eleanor Onderdonk and shown in the Witte Memorial Museum in 1946.[11]

Frank Edwards in his little rock house with the murals of western scenes he painted on the walls. SAMA Historical Photographic Archives, gift of an anonymous donor.

1. "Witte to Show Work of Self-Taught Men Painters Who Excelled in Art After a Late Start," *San Antonio Light*, November 24, 1946.
2. Fenstermaker, "A Conversation with Emily Edwards" (February/March 1980): 1.
3. Ibid., 4.
4. Sidney C. Bulla, "Too Young to Retire," Houston *Chronicle*, May 18, 1947; Betty Scheibl, "Hale, Hearty S. A. Pioneer Celebrates on 99th Birthday," San Antonio *Light*, August 22, 1954.
5. Floy Fontaine Jordan (Cotulla) to author (SA), December 6, 1978.
6. Bulla, "Too Young to Retire."
7. Ibid.
8. Ibid.; Scheibl, "Hale, Hearty S. A. Pioneer."
9. "He Uses 100 Years' Experience," Austin *American-Stateman*, September 23, 1955; "Still Going Strong at 100," Uvalde *Leader News*, January 19, 1956.
10. "F. M. Edwards, 101-Year-Old Texan, Dies," Dallas *News*, December 18, 1956.
11. "The Texas Arts: Oldsters' Art," *Texas Week*, 1 (December 14, 1946), 18.
12. Jordan to author, December 6, 1978.

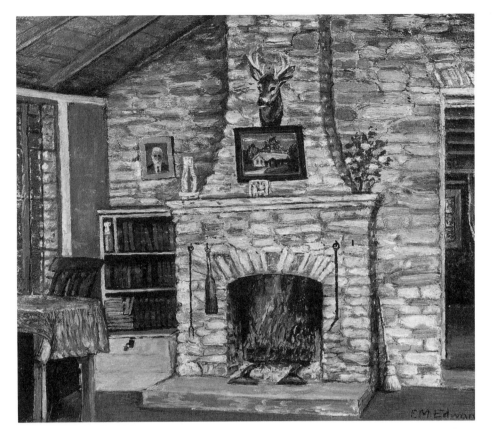

LITTLE ROCK HOUSE INTERIOR
n.d., oil on academy board, 10¼″ × 12⅛″
Signed lower right: F. M. Edwards

The "Little Rock House" that Edwards built was one of his favorite painting themes. He did interior as well as exterior views and, in this instance, shows the cozy fireplace with the mantel adorned with one of his paintings and a deer trophy of which he also was proud. A self-portrait hangs to the left over a well-stocked bookcase, reading being another one of his pastimes.[12] The painting reveals much of the man's character. A fireplace is an object of warmth and friendliness, and Edwards's intimate rendition reflects pride in his own accomplishments as well as the peace and tranquility enjoyed by the venerable gentleman.

PROVENANCE:
ca. 1945–1986: Collection of the Edwards Family.
1986: Gift to SAMA by Floy Fontaine Jordan, Edwards's granddaughter.
86–105 G (1)

EXHIBITIONS:
1978–1979: A Survey of Naive Texas Artists, WMM (December 17, 1978, to March 1, 1979).

PUBLICATIONS:
Steinfeldt, "Texas Folk Art," *Antique Review*, 14 (September 1988): 28.

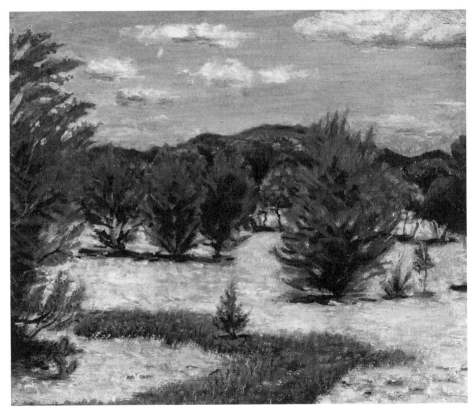

HILL COUNTRY LANDSCAPE
n.d., oil on academy board, 10¼″ × 12¼″
Unsigned

This simple oil sketch may have been one of the artist's earlier efforts. The brushstrokes are less meticulous than in most of Edwards's work, but he has achieved the feeling of the Texas Hill Country in his interpretation of familiar cedar trees, scrub oak, and rocky soil. For this painting, he enhanced the unpretentious character of his subject matter by constructing a plain, but appropriate, frame of cedar limbs.

PROVENANCE:
ca. 1940–1986: Collection of the Edwards Family.
1986: Gift to SAMA by Floy Fontaine Jordan.
86–105 G (2)

ALBERT FAHRENBERG, SR.

Albert Fahrenberg, Sr., was an obscure artist who lived and worked in San Antonio from about 1870 to 1881. An advertisement in the San Antonio *Daily Herald* of February 19, 1871, reads:

> New Photographic Gallery,
> Albert Fahrenberg, Portrait
> Painter AND Photographer
> Market St. opposite Braden Hotel.

It was not unusual for artists then to combine painting and photography and Fahrenberg obviously frequently relied upon photographs for his painted portraits.

The notices in the newspapers of the artist's work lead one to think that Fahrenberg himself wrote them. As an example:

> We were shown this morning a most excellent portrait of Prof. Plagge, from the easel of Mr. Fahrenberg. For life-like expression and artistic finish it is equal to any oil painting we have ever seen. It will be on exhibition at the bazaar of Pentenrider [sic] and Co.'s Successor. We hope our citizens will examine the picture, and if any of them wish to impress posterity favorably with the good looks and lofty bearing of the present generation of San Antonians, we suggest that they allow Prof. Fahrenberg the privilege of doing so, as he is a *bona fide* artist and does not throw so much expression into a picture that the only place where it belongs is in the Sheriff's office.[1]

A few weeks later another glowing account of Fahrenberg's portraits included the provocative statement, "It is surprising that anybody should send abroad, and pay high prices for some miserable charicature [sic], when a genuine work of art can be procured here at our own doors."[2] An advertisement in the same newspaper credited Fahrenberg with being a student of the Düsseldorf School of Painting.[3]

Only one brief biography of Fahrenberg has been located to date. In it, he is listed as a native of Cologne, Germany, who came to New York in about 1850 and worked there as an artist and cigar maker until about 1858. By 1859 he was in Louisville, Kentucky, and a year later in New Orleans where, in the 1860 census, he was registered as a portrait painter, age thirty-five, with personal property valued at $600. Living with him were his wife, Emma, and their three children, Oscar, Lena, and Albert.[4]

Between the time Fahrenberg left New Orleans and his arrival in Texas, he spent some time in Monterrey, Mexico. While the Fahrenbergs lived in Mexico two more children had been born to them, María and Otto.[5] There are photographs in the San Antonio Museum Association's Historical Photographic Archives of Monterrey that bear the caption on the back, "Alberto Fahrenberg/Artista y Fotografo/Monterey [sic], Mexico." A San Antonio newspaper account in 1876 stated that "Prof. Fahrenberg has painted a picture of the city of Monterey, Mexico, which can now be seen at Pentenreider's Successor on Commerce street, where it is on exhibition. The Prof. has lived for nearly ten years in Monterey, and had taken photographic views of all the principal points and scenes. . . . The picture is very beautiful and will be a great addition to any family picture gallery. The public would do well to call and see it."[6] Just two weeks later it was raffled off at Karber's Saloon in San Antonio.[7]

1. "In and About Town," San Antonio *Daily Herald*, May 22, 1875.
2. "In and About Town," San Antonio *Daily Herald*, July 17, 1875.
3. Ibid.
4. George C. Groce and David H. Wallace, *New-York Historical Society's Dictionary of Artists in America, 1564–1860* (New Haven: Yale University Press, 1957), 218.
5. *1870 Texas Census*, microfilm roll #1575, Bexar County Archives, San Antonio.
6. "City News," San Antonio *Daily Express*, February 12, 1876.
7. "City News," San Antonio *Daily Express*, February 26, 1876.
8. "City News," San Antonio *Daily Express*, August 9, 1876; "Local News and Gossip," San Antonio *Daily Express*, August 2, 1878.
9. William Elton Green (SAMA Associate Curator of History, SA) to George L. McKenna (Registrar, William Rockhill Nelson Gallery and Atkins Museum of Fine Arts, Kansas City, Missouri), June 6, 1983.
10. The Alfred G. Witte Bequest, June 6, A. D. 1921. Typescript, SAMA Registrar's Records. Witte died September 25, 1925.
11. Woolford and Quillin, *The Story of the Witte Memorial Museum*, 40–45.
12. "Mrs. Witte, One of Pioneers, is Dead," San Antonio *Express*, January 30, 1917.

DOROTHEA SOPHIA KOCH KLEINE
ca. 1880, pastel on paper, 21″ × 16″
Signed lower right: Fahrenberg

The portraits of Mr. and Mrs. Johann
Friedrich Kleine are of special significance to
the San Antonio Museum Association. They
are likenesses of the maternal grandparents
of Alfred George Witte, who in 1921
bequeathed the sum of $65,000 "to build a
building to be used as a Museum of Art,
Science, and Natural History provided
that the city of San Antonio, Texas, will
allot a parcel of land in Brackenridge
Park, sufficiently large enough for this
purpose. . . ."[10] This building, the Witte
Memorial Museum, opened in October
1926.[11]

The pastel painting of Mrs. Kleine
is a characteristic late nineteenth-century
portrait done in a no-nonsense, direct style.
It is believed to have been done from a
photograph and shows the severe hairstyle,
dainty black bonnet, and dark clothing
characteristic of an elderly gentlewoman
of the period.

PROVENANCE:
ca. 1880–1965: Collection of the Witte Family.
1965: Gift to SAMA by Mrs. George Witte,
descendant of Mr. and Mrs. Kleine.
65–39 G (1)

EXHIBITIONS:
1983–1985: Witte Museum: Past, Present & Future,
WMM (October 23, 1983, to November 1, 1985).

JOHANN FRIEDRICH KLEINE
ca. 1880, pastel on paper, 21″ × 16″
Unsigned (attributed)

Although the portrait of Kleine is not signed
nor as skillfully executed as that of his wife, it
is logical to attribute it to Albert Fahrenberg
as it appears to be a companion piece. Mr.
and Mrs. Kleine were early pioneers to Texas
who came to San Antonio in 1843 from the
village of Burge, in Magdeburg, in eastern
Germany.[12] In 1869 Kleine returned to
Germany for medical treatment but died at
sea in 1870 on his return voyage to Texas,
according to information on a memorial
stone adjacent to his wife's grave in City
Cemetery Number 1.

The stiffer attitude apparent in Kleine's
portrait suggests the likeness was taken
from an early daguerreotype or ambrotype,
rather than a photograph. The fact that his
family had the portrait painted, no doubt
posthumously, indicates their esteem and
respect.

PROVENANCE:
ca. 1880–1965: Collection of the Witte Family.
1965: Gift to SAMA by Mrs. George Witte,
descendant of Mr. and Mrs. Kleine.
65–39 G (2)

EXHIBITIONS:
1983–1985: Witte Museum: Past, Present & Future,
WMM (October 23, 1983, to November 1, 1985).

Several other paintings executed by the artist are mentioned in the San
Antonio newspapers. Fahrenberg painted a portrait of Judge Hugo Klocke, admittedly
taken from a photograph, and also a painting of the "second mission," San José.[8]

By 1881, Fahrenberg evidently decided to move on, for an article in the San
Antonio Daily Express of September 20, 1881, announced that the artist had "departed
for Kansas city to make that place his future home."

Attempts to trace Fahrenberg's movements after 1881 have produced no
results, nor is his death date known.[9] Nevertheless, the paintings he did in San
Antonio contribute another fragment to the city's history.

JOHN C. FILIPPONE

John C. Filippone was born Ginanni Battista Filippone in Brackettville, Texas, in 1882. Wanderlust and a desire to become an artist prompted him to forsake his Texas home and travel. Apparently he first went to St. Louis where he studied art with Charles Swansen [Charles C. Svendsen?]. He also went to New York to study, but with whom is unknown. He traveled through Italy, France, South America, Cuba, and Mexico before he returned to Texas to join his family in San Antonio.[1]

Evidently Filippone was unable to support himself through his artworks alone. The San Antonio city directories from 1908 to 1936 list him as a painter, decorator, sign painter, and architect. He must have spent most of his spare time, however, in producing works of art, and he was active in all of the art organizations in the city. He was one of the founders, and for a number of years a member of the Board of Directors, of the Artists Guild of San Antonio.[2] This was a group of active artists who had dissociated themselves from the San Antonio Art League when it became too social for their interests.[3]

In 1928 Filippone was studying with José Arpa and exhibited at the Witte Memorial Museum with Arpa's outstanding students.[4] He and Gilbert Neumann (1906–?) had a two-man show of their work at the San Pedro Playhouse in 1932.[5] Newspaper articles consistently list him among the exhibitors in Local Artists Exhibitions held annually at the Witte Memorial Museum. In 1936 he became a charter member of the "Villita Artists," a group of enthusiastic local painters who banded together and opened their own gallery.[6] This gallery was located in a picturesque house in La Villita, originally the home of Colonel Jeremiah Y. Dashiell and once used by Louise Wueste (1805–1874) as a studio. The house has been restored and today is occupied by the San Antonio Conservation Society.[7]

Filippone won numerous honors in his lifetime and became well-known for his drypoint etchings. Probably his most admired illustrations in this medium are in *The Rubáiyát of Omar Khayyám*, a version translated by George Roe of San Antonio and published in 1931.[8] An etching of the rose window of San José Mission was selected for the prestigious Texas Centennial Exposition held in the Dallas Museum of Fine Arts in 1936.[9]

After 1936 Filippone's name no longer appeared in local artists' listings. Since an obituary has not been found, we can only surmise that Filippone's love of travel impelled him to move onward.

1. Forrester-O'Brien, *Art and Artists*, 306–307.
2. Ibid.
3. Garana, "Art Has a Home in S. A.," 62.
4. "Arpa Students Exhibit Work," San Antonio *Express*, March 4, 1928.
5. "Exhibit at Playhouse Gallery," San Antonio *Light*, May 22, 1932.
6. "Artists Plan New Gallery for S. A.," San Antonio *Light*, May 1, 1936.
7. Steinfeldt, *San Antonio Was*, 152–155.
8. Forrester-O'Brien, *Art and Artists*, 307.
9. *Catalogue of the Exhibition of Paintings, Sculptures, Graphic Arts*, Centennial Exposition Department of Fine Arts (Dallas: Dallas Museum of Fine Arts, June 6–November 29, 1936): 89.
10. Susanna R. Katz and Anne A. Fox, *Archaeological and Historical Assessment of Brackenridge Park, City of San Antonio, Texas*, Archaeological Survey Report, No. 33 (San Antonio: Center for Archaeological Research, University of Texas at San Antonio, 1979), 16.
11. Stewart King, "Little Known Facts About Our Parks." Paper delivered at the President's Council by Stewart King, Superintendent of Parks, San Antonio, February 6, 1950. Photocopied typescript, John C. Filippone file, SAMA Texas Artists Records.
12. Katz and Fox, *Archaeological and Historical Assessment*, 16.
13. C. Ramsdell, *San Antonio* (rev. ed.), 181–184.
14. Roger Allen Cook, "Sunken Garden Art Colony," *The Southern Artist*, 2 (June 1955): 11–14.
15. C. Ramsdell, *San Antonio* (rev. ed.), 181.

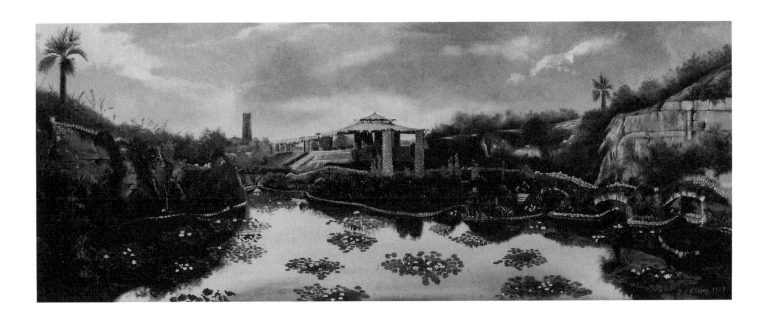

THE SUNKEN GARDEN, BRACKENRIDGE PARK
1920, oil on canvas, 18″ × 44″
Signed and dated lower right: J. C. Filippone, 1920

J. C. Filippone painted the Sunken Garden, one of San Antonio's main tourist attractions. This picturesque spot was once a rock quarry from which huge limestone blocks were mined and used to build some of the city's earliest structures. The limestone was found to be a natural cement rock, and the Alamo Portland and Roman Cement Plant, the first of its kind west of the Mississippi, was established on the site in 1880.[10] The cement manufactured was used in the construction of the Texas State Capitol from 1885 to 1888.[11]

In 1908 the cement plant was moved, and the quarries abandoned.[12] The natural depression in the solid rock was converted into a Japanese Sunken Garden. Walls and rock bridges meandered over and around lily ponds and pools aglow with colorful aquatic and semitropical plants.[13] A teahouse also was constructed, possibly by prison labor, to serve guests visiting the facility. The original lime kiln chimney and the small houses once occupied by cement plant workers remain on the south side of the quarry. After World War II these buildings were converted into

art studios that became a lively center of cultural activity known as the Sunken Garden Art Colony.[14] Structurally the garden has changed little but during World War II it became known as the Chinese Garden. After the war it simply was called the Oriental Garden, obviously a compromise.[15]

Filippone painted the site in 1920, shortly after its conversion. Although his depiction is accurate visually, it is flat and lifeless. The pigment is applied with care and the perspective is precise, suggesting he may have used a photograph as his source. No doubt the painting was done before he studied with José Arpa (1858–1952), who would have encouraged him to imbue the painting with more luminosity and create more texture with his brushstrokes. Nevertheless, the painting is a visual document of historical San Antonio.

PROVENANCE:
1969: Gift to SAMA by an anonymous donor.
69-194 G

FRANK FREED

Frank Freed was essentially a self-taught artist. Painting in a simple, direct manner, he has been called a "sophisticated primitive" because he depicted people and the human comedy in his own intellectual terms and in his distinctive idiomatic style.[1] He considered himself a writer who decided to express himself graphically rather than in words.[2]

In many ways, Frank Freed was unusual. Born in San Antonio on February 6, 1906, he moved with his family in 1913 to Houston, the city he called home for the rest of his life. There he attended Rice University, where as a freshman he drew humorous cartoons for *The Rice Owl*. He transferred to Harvard University in 1924 and received his bachelor's degree in English literature in 1927. After graduation he earned his living as an insurance salesman. He was an avid reader who could absorb and retain information, a quality he would put to good use in his paintings. He also wrote articles for various magazines.[3]

Freed enlisted in the United States Army early in 1942 and served with the Corps of Engineers in Normandy from 1944 through 1946. Always interested in art, he had visited virtually all of the major museums in the United States. During his years in the army and later, in visits abroad, he haunted European museums, immersing himself in the work of artists like Hogarth (1697–1764), Daumier (1808–1897), George Grosz (1893–1959), Peter Brueghel (1528–1569), Oskar Kokoschka (1886–1980), and Edvard Munch (1863–1944). He also admired Edward Hopper (1882–1967) and Ben Shahn (1898–1969).[4]

In 1948, after his tour of duty in France, Frank Freed started to paint. He studied briefly with Robert Preusser (1919–), a Houston artist, but evidently felt that he could best develop his idiosyncratic satirical style on his own.[5] He depicted people and places from his travels, local settings, and current events.[6]

Frank's psychological interpretation of the problems encountered in contemporary life-styles is evident in much of his work. His literal outlook on the world and its people frequently was dramatic, and his paintings often were statements of the perplexities of daily life. But he could infuse his work with a wry sense of humor by incorporating something of the cartoon element.

Frank Freed once wrote about himself:

Each of us would like to feel unique, but when others seek to lump me in a classification I generally find myself included in the group of painters variously described as self-taught, auto-didactic, primitive, or naive. While I have no objection to being placed in this distinguished company (many of whose works I vastly admire and all of whom it seems to me are imbued with the utmost seriousness), my own idea of a naive painter is one who expects to make a living at it.[7]

Freed's paintings have something in common with the "naive" school: strong in design, intense in color, and always idea-oriented. His draftsmanship was somewhat unorthodox and was often strengthened with a linear black outline to create and emphasize vigorous patterns.[8]

In 1973 Freed underwent exploratory surgery that revealed advanced metastasized cancer. He was expected to live only a few weeks to a few months, but he survived another two and one-half years and during that time he added another dimension to his accomplishments. He made videotapes for the University of Texas System Cancer Center, M. D. Anderson Hospital and Tumor Institute, giving personal

Frank Freed, the "sophisticated primitive." Courtesy of Eleanor Freed.

1. Eleanor Freed, "Frank Freed's Visual Reflections on the Human Comedy," *Forum*, 2 (Spring 1973): 25.
2. Ibid., 22.
3. Emily L. Todd, *Frank Freed: People and Places* (Houston: Contemporary Arts Museum, 1983): n.p.; Eleanor Freed, "Frank Freed," undated biographical resumé. Photocopied typescript, Frank Freed file, SAMA Texas Artists Records.
4. E. Freed, "Frank Freed's Visual Reflections," 23.
5. E. Freed, "Frank Freed."
6. Todd, *Frank Freed*.
7. Frank Freed, "Artist on Art," *Southwest Art*, 2 (March 1972): 34. Reprint, Freed file, SAMA Texas Artists Records.
8. E. Freed, "Frank Freed's Visual Reflections," 23–25.
9. E. Freed, "Frank Freed."
10. For listings of Frank Freed's work see Todd, *Frank Freed*.
11. E. Freed, "Frank Freed's Visual Reflections," 22–32.
12. Eleanor Freed (Houston) to author (SA), interview, September 16, 1986.
13. Todd, *Frank Freed*.
14. Alfred Frankenstein, "Freed and Freud: One letter's difference," Houston *Post*, February 24, 1972.

PHRENOLOGY
ca. 1950, oil on panel, 19½″ × 25½″
Signed lower right: Freed

Phrenology was done during Frank Freed's
early painting career, and already his unique
style of satirical commentary was well
established.[12] He pictures a lonely analyst
awaiting her next customer in surroundings
that could have been typical of any back
street of America. This painting, however, has
a Texas setting, as it shows the phrenologist
poised for business on Washington Avenue in
Houston.[13] Alfred Frankenstein, art critic for
the *San Francisco Chronicle*, once observed that
there was but one letter's difference between
Freed and Freud, and *Phrenology* illustrates this
observation literally and figuratively.[14]

PROVENANCE:
ca. 1950–1986: Collection of Eleanor Freed.
1986: Gift to SAMA by Eleanor Freed in honor of
Cecilia Steinfeldt.
86–89 G

EXHIBITIONS:
1978–1979: A Survey of Naive Texas Artists, WMM
(December 17, 1978, to March 1, 1979).
1979–1980: A Survey of Naive Texas Artists, Traveling
Exhibition: The Museum of Fine Arts, Houston (April
11 to May 27, 1979). Laguna Gloria Art Museum,
Austin (June 9 to July 23, 1979). Tyler Museum of Art
(July 31 to September 9, 1979). Lufkin Historical and
Creative Arts Center (September 24 to November 15,
1979). The Art Center, Waco (April 15 to May 30,
1980).
1983: Frank Freed: People and Places, Contemporary
Arts Museum, Houston (August 13 to September 18).
1986: Texas Seen/Texas Made, SAMOA (September 29
to November 30).

PUBLICATIONS:
Taylor, "Images," *Vision*, 3 (March 1980): 19.
Steinfeldt, "Simple Self-Expression," *Southwest Art*, 10
(September 1980): 64.
Steinfeldt, *Texas Folk Art* (1981), 117.
Steinfeldt, "Texas Folk Art," *Antique Review*, 14
(September 1988): 29.

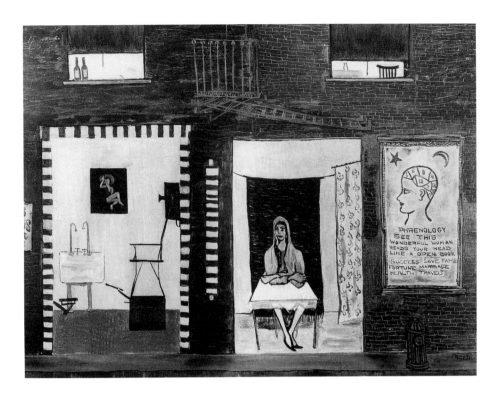

impressions of the psychology of the waiting room. The Rice University Center
also made a videotape entitled "Death and Dying" about Frank Freed. He died on
December 23, 1975, and willed his body to the M. D. Anderson Hospital for cancer
research.[9]

This artist had a number of solo exhibitions during his lifetime and some
expedited after his death in 1975. His work has been included in numerous group
exhibitions throughout the years and continues to be shown.[10] He is also represented
in a number of private collections.

Frank married Eleanor Kempner of Memphis, Tennessee, in 1950. They
complemented each other, both being interested in all phases of art and literature.
Eleanor served as art critic for the Houston *Post* for eight years, from November 1965
through midyear of 1973. During that time, because of an agreement between the
couple, she never wrote about Frank's work or promoted him in any way. Since his
death she has made every effort to share Frank's paintings and to educate the public
about his many remarkable qualities. The world is richer because of her concern.[11]

HENRY C. FREELAND

Henry C. Freeland was a sign painter by profession, but he produced a number of easel paintings as well. These paintings, which have a very personal quality, suggest that the artist painted them more for his own pleasure and satisfaction than for monetary gain. Since they have a naive character, one assumes that his art training was limited. Mystical and imaginative, they indicate that he was a visionary who put his perceptive reveries into tangible form with paint on canvas.

Freeland also used his artistic talents to support himself by making signs. Only two have been located: a "Flag and Banner Painting," which advertised his own business, and a small sign that advertised a local brewery.[1] Both are handled in the same sensitive manner as his personal canvases. In a frontier society shopkeepers and craftsmen used advertising signs to publicize their wares and, when they wished to appeal to strangers or, sometimes, illiterates, they displayed a sign that visually depicted their businesses. Consequently, the banners or boards of tinsmiths, blacksmiths, and innkeepers conveyed images of the type of trade offered by their establishments.

Freeland was a native of New York who worked in Galveston before he came to San Antonio. He is listed in the 1874 Galveston city directory with a residence at 206 East Postoffice. The 1875 and 1876 directories find him at the same address with the same business partner, listed under "Painters—House and Sign." By 1880–1881, however, only Freeland's name appears as a "Painter."[2]

The artist moved to San Antonio, where he married a widow, Augusta Vollrath, in about 1882. They began construction of a two-story house at 712 South Alamo Street. The first floor was intended for a bakery, and the second floor was partitioned for living quarters for the couple and her small children.[3] In the 1889–1890 San Antonio city directory, Freeland is listed not only as a sign painter but also as a grocer, implying that he used the "bakery" portion of his home to sell groceries and possibly baked goods, to supplement his income as a painter of signboards.

Freeland died in 1903 at age eighty-two and his obituary stated that he left "a widow, formerly Mrs. Vollrath, and a number of stepchildren."[4]

One of Freeland's step-grandchildren, Laura Vollrath Washichek, saved his few personal canvases from the abandoned house on South Alamo Street.[5] The house was demolished sometime before 1974.[6]

Obituary announcement of Henry C. Freeland. SAMA Historical Photographic Archives, gift of Laura Vollrath Washichek in memory of H. C. Freeland and Vollrath Blacksmith Shop.

1. The "Flag and Banner Painting" is owned by Mrs. W. B. McMillan of San Antonio, and the brewery sign (in very poor condition) belongs to the Lone Star Brewing Company, also of San Antonio.
2. *Galveston City Directories* are available on microfilm at the Rosenberg Library, Galveston, Texas.
3. Paul Goeldner (comp.), *Texas Catalog: Historic American Buildings Survey* (TEX-3152) (San Antonio: Trinity University Press, 1975); Lillie May Hagner, *Alluring San Antonio: Through the Eyes of an Artist* (San Antonio: Privately published, 1947), 34–35.
4. "Henry C. Freeland," San Antonio *Daily Express*, June 12, 1903.
5. Laura Vollrath Washichek to author (SA), interview, May 24, 1978.
6. Goeldner (comp.), *Texas Catalog* (TEX-3152).
7. Sara Kerr (SAMA Associate Curator of Natural Science) to author (SA), interview, February 2, 1987.
8. John dos Passos, "Builders for a Golden Age," *American Heritage*, 10 (August 1959): 67; Richard M. Ketchum, "The Case of the Missing Portrait," *American Heritage*, 9 (April 1958): 85.
9. Steinfeldt, *Texas Folk Art*, 62.

ISLAND SCENE WITH PALMS
n.d., oil on canvas mounted on Masonite,
11¼″ × 16¼″
Initialed lower right: H. C. F.

Freeland painted several scenes of ships,
whaling scenes, and seascapes. Some appear
to have been done from nature, but others
seem to be inspired by prints. The artist was
undoubtedly interested in travel and history,
but his infatuation with nautical subjects
probably came from his sojourn in the
seaport of Galveston. The *Island Scene with
Palms* was not painted on Galveston Island,
however, because the palms, typical of a
more southerly latitude, are not indigenous
to the area. The canvas could have been
painted nearer Brownsville, at the southern
tip of Texas.[7] But whether Freeland was
inspired by nature, a print, or imagination, his
painting has the ethereal, haunting, dreamlike
quality typical of much of his work.

PROVENANCE:
-1978: Collection of the Freeland-Vollrath-Washichek
Family.
1978: Acquired by Mrs. W. B. McMillan from Laura
Vollrath Washichek.
1983: Gift to SAMA by Mrs. W. B. McMillan.
83–36 G (1)

EXHIBITIONS:
1978–1979: A Survey of Naive Texas Artists, WMM
(December 17, 1978, to March 1, 1979).

PUBLICATIONS:
Steinfeldt, *Texas Folk Art* (1981), 63.

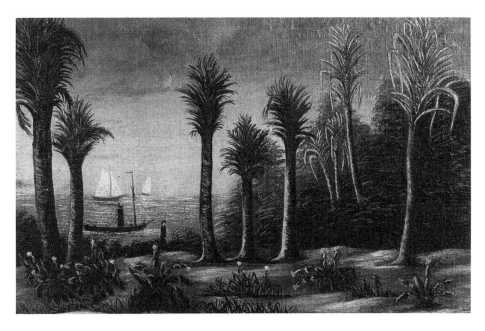

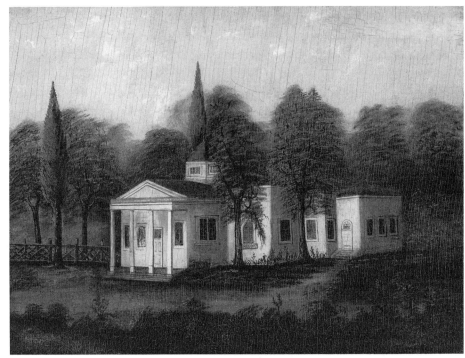

HOUSE WITH TURRET
n.d., oil on wooden panel, 13½″ × 18″
Initialed lower right: H. C. F.

Since Freeland seldom titled his paintings,
the name *House with Turret* has been applied
arbitrarily to this canvas. The classical lines
of the house and the strange cupola bear a
superficial resemblance to Thomas Jefferson's
Monticello. Comparisons with engravings of
Jefferson's house indicate that prints may have
inspired Freeland to attempt a painting of the
famous residence.[8]

Although less complicated, the
placement of doors, windows, and stairs is
very like that of Monticello, and even the
trees surrounding the house are suggestive
of the setting. The artist's rendition shows a
simplified structure, probably due to his
inability to cope with the complexity of the

Palladian architecture. Freeland also did a
simplified version of George Washington's
home, Mount Vernon.[9]

PROVENANCE:
-1983: Collection of the Freeland-Vollrath-Washichek
Family.
1983: Gift to SAMA by Laura Vollrath Washichek in
memory of H. C. Freeland.
83–30 G (1)

WORKS BY HENRY C. FREELAND
NOT ILLUSTRATED:

SHIP SCENE
n.d., oil on cardboard, 12¼″ × 18½″
Initialed lower right: H. C. F.
83–30 G (2)
Gift to SAMA by Laura Vollrath Washichek.

LOUISE ANDRÉE FRÉTELLIÈRE (1856–1940)

Louise Frétellière was the niece and devoted student of Theodore Gentilz. She was considered one of his ablest students, and his influence is readily apparent in her work. She evidently received her academic training at the Ursuline Academy in San Antonio, based on the notice in one of the local newspapers of 1876 that she participated in the closing exercises of that year.[1] According to the San Antonio city directories, she taught art classes at 318 North Flores Street, as did Gentilz. She is listed in the 1909 directory as also being a French teacher. In the 1919–1920 directory she is entered as a teacher of languages with her residence changed to 817 North Palmetto Avenue. These entries continue through 1937, shortly before her death in 1940. Theodore Gentilz, who was childless, bequeathed his entire estate to his two nieces, Mathilde and Louise, as a token of his esteem.[2]

FIRST PRESBYTERIAN CHURCH
187?, pencil and charcoal on toned paper,
16″ × 11¹⁵⁄₁₆″
Signed lower left: L. Frétellière
Partial date lower right: 187? (remainder torn off)

The cornerstone of the First Presbyterian Church in San Antonio was laid on February 29, 1860. The building, erected on the northeast corner of West Houston and North Flores streets, remained unfinished for years. Fund-raising activities to complete the structure included plays, spelling matches, strawberry feasts, and ice cream socials until the church building was finally dedicated on November 30, 1879. It was used until 1910, when the congregation moved into a much larger, more elaborate building at North Alamo and Fourth streets.[3] Louise's delicate drawing must have been done about the time the church on North Flores was completed. Her fastidiousness for detail prompted her to include the adjacent houses, a nice addition that provides another view of nineteenth-century San Antonio architecture.

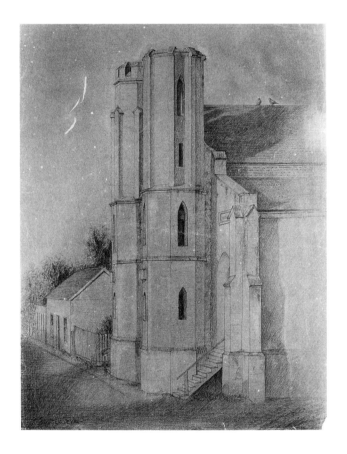

PROVENANCE:
-1943: Collection of Mrs. Terrell Bartlett.
1943: Gift to SAMA by Mrs. Terrell Bartlett.
43–72 G

EXHIBITIONS:
1946: Early San Antonio Paintings, WMM (February 24 to March 12).
1964: The Early Scene: San Antonio, WMM (June 7 to August 31).
1986: Texas Seen/Texas Made, WMM (September 29 to November 30).

PUBLICATIONS:
Utterback, Early Texas Art (1968), 27.
Mary Ann Guerra, The San Antonio River (1st rev. ed.; 1987), 59.

1. Donald E. Everett, San Antonio: The Flavor of Its Past, 1845–1898 (San Antonio: Trinity University Press, 1975), 106.
2. Chabot, With the Makers of San Antonio, 262.
3. Frederick C. Chabot, "Presbyterians First to Unfurl Protestant Banner in San Antonio," San Antonio Express, March 31, 1935.
4. Dorothy Steinbomer Kendall and Carmen Perry, Gentilz: Artist of the Old Southwest (Austin: University of Texas Press, 1974), 39.

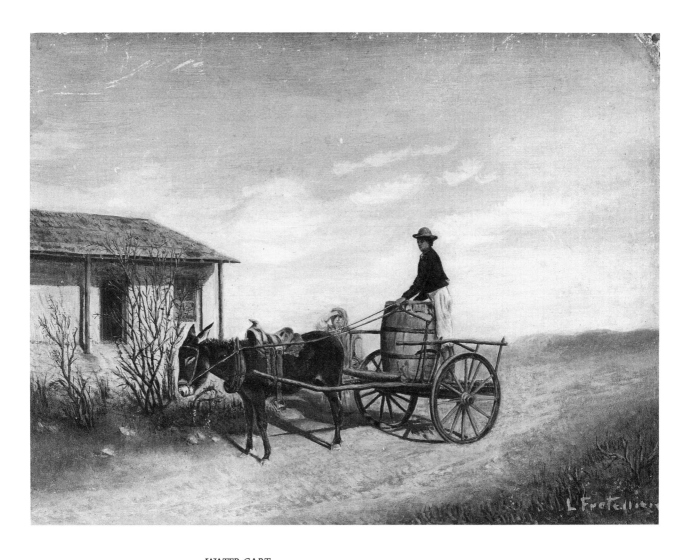

WATER CART
n.d., oil on canvas board, 9″ × 12″
Signed lower right: L. Frétellière

WORKS BY LOUISE ANDRÉE FRÉTELLIÈRE
NOT ILLUSTRATED:

PINK DAISIES
n.d., watercolor on paper, 5″ × 4¼″
Unsigned (attributed)
77–1020 G
Gift to SAMA by Walter Nold Mathis.

UNFINISHED FLOWER SKETCHES
n.d., watercolor on paper, 4⅛″ × 10⅛″
Unsigned (attributed)
77–1021 G
Gift to SAMA by Walter Nold Mathis.

Louise Frétellière's painting of *Water Cart* obviously was derivative of her uncle's version of the same subject, entitled *El Aguador* (see Jean Louis Theodore Gentilz). Having these two paintings in the same collection helps us note the differences and the similarities between them. Gentilz's background is far more complex, with a larger building and several houses as well as another cart and figure to the right. Louise, possibly bored with imitation, simplified the setting and left out the houses on the right side. She also turned her driver's head toward the left and placed a shawled figure on the opposite side of the cart. Although Louise is credited with surpassing Theodore in figurative painting, she was not successful in this instance.[4]

PROVENANCE:
-1937: Collection of the Gentilz-Frétellière Family.
1937: Purchased by SAMA from Louise Frétellière with Witte Picture Fund.
37–6792 P (3)

EXHIBITIONS:
1946: Early San Antonio Paintings, WMM (February 24 to March 12).
1964: The Early Scene: San Antonio, WMM (June 7 to August 31).
1986: Capitol Historical Art Loan Program, State Capitol, Austin (January 30 to September 15).
1986: Texas Seen/Texas Made, SAMOA (September 29 to November 30). Returned to Capitol for exhibition to December 19, 1988.

PUBLICATIONS:
Utterback, *Early Texas Art* (1968), 26.
Caroline Remy, "Hispanic-Mexican San Antonio: 1836–1861," *Southwestern Historical Quarterly*, 71 (April 1968): plate 6.

JEAN LOUIS THEODORE GENTILZ (1819–1906)

Among the painters who worked in nineteenth-century Texas, Theodore Gentilz might be considered the most important. Such an evaluation is based more on his depiction of intimate scenes of native life and activities in the land he chose for his home in 1843 than on the quality of his painting. The wealth of information contained in his small jewel-like vignettes of scenes in and around San Antonio, Castroville, western Texas, and northern Mexico is priceless. Indeed, no other artist has contributed so much to the visual interpretation of customs, life-styles, costumes, and historical events in Texas.[1]

Theodore Gentilz was born in France on May 1, 1819.[2] The son of a successful Parisian merchant who made custom-built carriages for European royalty and wealthy continental citizens, Theodore probably could have entered the family business, but instead chose to become an artist. He studied at L'Ecole Impériale [Nationale] de Mathématique et de Dessin in Paris.[3]

What prompted a twenty-four-year-old aspiring artist to agree to accompany French colonists to Texas—a wild and rugged, but promising, land—is a matter of conjecture. Dorothy Kendall, in her biography of Gentilz, suggests that Count Henri Castro, the entrepreneur who founded Castroville, urged Gentilz to serve as his engineer and surveyor, as well as artist.[4]

Castro, a prominent French Jew with important Portuguese and Spanish forebears, had been awarded a contract by the Republic of Texas to settle 600 families on two extensive tracts of land in the newly formed Republic. The initial group of 114 colonists left the port of Le Havre on November 5, 1842, and arrived in Galveston on January 9, 1843. They proceeded to San Antonio, where they were allowed provisional lands until they were able to continue their journey. On September 1, 1844, Castro finally led his first contingent of twenty-seven colonists plus several Mexicans and twenty of Jack Hays's Texas Rangers to land on the Medina River. They arrived on September 3 and on September 12 named the colony "Castro-Ville."[5]

Gentilz had not been among the first of the immigrants to arrive. His ship, the *Heinrich*, which sailed from Strasbourg and Kehle in November 1843, carried the second group of settlers who joined those already assembled in San Antonio.[6] There he became friends with another young Frenchman, Auguste Frétellière, who later was to become his brother-in-law.[7] Frétellière, as competent with a pen as Gentilz was with a brush, described a *fandango* they attended at the Spanish Governor's Palace:

> As to the pastime and amusements of some of the population, the favorite was the *fandango* (dancing). Often a one-roofed building was used, lit up with candles, and to the tunes of the musicians, whose instruments consisted of a violin or guitar, the couples danced their favorite waltz and *contradonza*. One of the musicians of these dances was named Paulo. He was blind and, therefore, played by ear, and in remarkably good time. We met Dona Andrea Candelaria, a person of darkish features, very energetic and of extraordinary activity.[8]

Gentilz's small painting of the scene is a charming canvas with people garbed in gaily colored Mexican costumes. The painting, in the collection of the Daughters of the Republic of Texas Library at the Alamo in San Antonio, has been published many times.[9]

When Gentilz and Frétellière arrived in Castroville they chose adjoining lots on the right bank of the Medina River. Gentilz was one of the surveyors of the

colony, but, because he could also write well in both English and French, his duties were expanded to include writing "articles" for Castro.[10] As a consequence, Castro built a small house for Gentilz, and Frétellière moved in with him for a short time.[11] Like all colonists in the new Republic, the two Frenchmen had difficulty in coping with the problems of farming, the rigorous living conditions, and the Indian depredations. In 1845 Frétellière left the small settlement to return to France, but Gentilz remained, continuing his duties as surveyor and making forays into San Antonio, frequently on foot.[12] Although the length of Gentilz's stay in Castroville is not clear, he apparently moved to San Antonio after about two years.[13]

Just prior to Texas's admission to the United States in 1846, Castro sent Gentilz back to France to conduct another group of farmers to the Texas colony.[14] Gentilz returned in 1847 with twenty-nine families who settled on the Río Seco (Dry River), where they established a small village named D'Hanis.[15]

In 1849 Gentilz returned to Paris and married Marie Fargeix (1830–1898). She and his sixteen-year-old sister, Henriette Adelaide, returned to Texas with him. The 1850 Bexar County census registers Gentilz as a merchant, thirty-one years old, and lists Henriette as living with him and his wife.[16] Auguste Frétellière also decided to return to San Antonio, and, on February 7, 1852, married Henriette. Although Theodore and Marie had no children, Auguste and Henriette provided the Gentilzes with two nieces and two nephews: Marie Jeanne Matilde, Louise Andrée, Auguste Emanuel Honoré, and Henri Theodore.[17]

After Gentilz settled in San Antonio, he began to teach art. During the Civil War, or shortly thereafter, he taught at St. Mary's College (now St. Mary's University), a school for boys that had been founded in 1852. Escalating enrollment during the war years required additional instructors, and Gentilz was considered a "fortunate acquisition."[18] He retained this position until 1894. His home on North Flores Street also served as his studio and a place where he gave lessons in drawing, sepia, aquarelle, the principles of geometry, and linear and aerial perspective, as well as painting and modeling, charging three dollars a month.

Theodore's talented wife, Marie, also an artist and an accomplished musician, added to the family coffers by giving music lessons.[19] In 1898, after forty-nine years of marriage, Marie preceded Theodore in death. Theodore died on January 4, 1906, at the age of eighty-six.[20] He willed his estate to his two nieces.[21] Although the artist obviously had sold some of his paintings during his lifetime, many remained in this close-knit family. It was during the early years of the San Antonio Museum Association that the nucleus of its Gentilz collection was acquired, primarily from the remaining members of the Frétellière family.

Dorothy Kendall, in her biography, has aptly summed up Gentilz's accomplishments:

His objectivity and dedication as historian and his personal devotion to theme and characters more than compensate for his limited aesthetic capabilities. In the past decade alone, innumerable specialists in a wide range of fields have had reason to be grateful for the body of work that constitutes our Gentilz heritage. His paintings are cherished by those who own them and avidly sought by would-be owners. His contribution to regional history, and therefore to the larger spectrum of American history, is destined to increase in value as the years slip by and the gap widens between yesterday and today.[22]

1. "The Vanished Texas of Theodore Gentilz," American Heritage, 25 (October 1974): 18–27.
2. Utterback, Early Texas Art, 7.
3. Kendall and Perry, Gentilz, 3; Original cover design for Gentilz's Méthode Électique de la Perspective du Dessinateur et du Peintre Ouvrage Élémentaire Complet Contenand plus [?] 600 Figures Par T. Gentilz Lauréat de l'Ecole Nationale de Mathématique et de Dessin, de Paris, undated, Archives of the DRT Library at the Alamo, SA.
4. Kendall and Perry, Gentilz, 3–4.
5. Utterback, Early Texas Art, 7; Julia Nott Waugh, Castro-Ville and Henry Castro, Empresario (San Antonio: Standard Printing Company, 1934): 9–21.
6. Pauline A. Pinckney, Painting in Texas: The Nineteenth Century (Austin: Published for the Amon Carter Museum of Western Art, Fort Worth, by the University of Texas Press, 1967), 99.
7. Utterback, Early Texas Art, 7–8.
8. H. T. Frétellière, "San Antonio de Bexar, Half a Century Ago: The Reminiscence of a Castro Colonist," The Texas Magazine, 5 (March 1912): 58–59.
9. Kendall and Perry, Gentilz, 59: plate 9.
10. Pinckney, Painting in Texas, 101.
11. Kendall and Perry, Gentilz, 13.
12. Ibid., 13–14.
13. Utterback, Early Texas Art, 8.
14. Allan O. Kownslar, The Texans: Their Land and History (New York: American Heritage Publishing, Co., Inc., 1972), 217.
15. Kendall and Perry, Gentilz, 15.
16. Mrs. V. K. Carpenter, Seventh Census of the United States: 1850 Census, Bexar County, Texas (Fort Worth: American Reference Publishers, 1969): 135.
17. Chabot, With the Makers of San Antonio, 263
18. Joseph W. Schmitz, "The Beginnings of the Society of Mary in Texas, 1852–1866." Reprint from Mid America, 25. New Series, 14 (n.d.): 19.
19. Utterback, Early Texas Art, 8.
20. Kendall and Perry, Gentilz, 46–47.
21. Utterback, Early Texas Art, 8.
22. Kendall and Perry, Gentilz, 49.

A hand-drawn plat map of Castroville, believed to have been executed by Theodore Gentilz. SAMA Map Collection, gift of Louis Huth in 1928.

Theodore Gentilz with a group of students on the porch of St. Mary's College. Professor Gentilz is standing at the extreme right. SAMA Historical Photographic Archives, gift of the Elizabeth Sullivan Clem Estate.

Theodore Gentilz teaching an art class at St. Mary's College in San Antonio. SAMA Historical Photographic Archives, gift of the Elizabeth Sullivan Clem Estate.

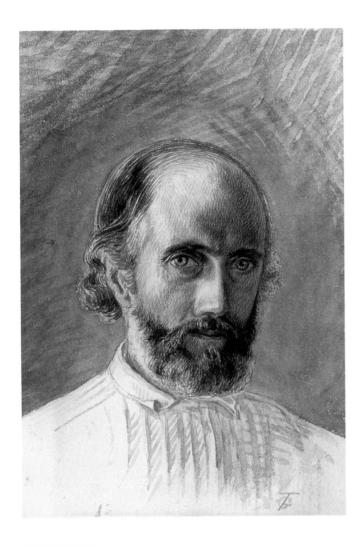

SELF-PORTRAIT
1864, watercolor on paper, 7″ × 5″
Monogrammed lower right: T. G.
Dated on reverse: 15 July 1864

Theodore Gentilz painted this portrait of himself after residing in Texas for twenty years. He was forty-five years old and had established himself as a successful artist and teacher in the growing community of San Antonio. His command of the watercolor medium is apparent with its short deft brushstrokes and careful attention to detail. Not only is the handling of the medium sensitive, the portrait evokes an image of a perceptive, kindly, and intellectual gentleman.

PROVENANCE:
1864–ca. 1945: Collection of the Gentilz-Frétellière Family.
1945: Purchased by SAMA from V. J. Rose with Witte Picture Funds. Rose acquired the painting from the artist's nephew.
45–87 P (14)

EXHIBITIONS:
1946: Early San Antonio Paintings, WMM (February 24 to March 12).
1964: The Early Scene: San Antonio, WMM (June 7 to August 31).
1970: Special Texas Exhibition, ITC (March 16 to October 8).
1974–1975: Theodore Gentilz: A Frenchman's View of Early Texas, WMM (November 25, 1974, to March 1, 1975).
1986: Texas Seen/Texas Made, SAMOA (September 29 to November 30).

PUBLICATIONS:
"Texas in Pictures," *The Magazine Antiques*, 53 (June 1948): 454.
Utterback, *Early Texas Art* (1968), 11.
"Art Traces S. A. Growth," *San Antonio Light*, October 27, 1974.
Marvin D. Schwartz, "Early Texas Art Depicts Era's Action," *Antique Monthly*, 8 (November 1974): 8A.
SAMA *Calendar of Events* (December 1974): centerfold.

THE WINDMILL
n.d., watercolor on paper, 10⁵⁄₁₆″ × 7½″
Monogrammed lower right: T. G.

Presumably Gentilz painted this small watercolor before he came to Texas. Without a date on the painting, and since his style changed so little during his long career, dating it is difficult. Such a windmill is not characteristic of the state during the mid-nineteenth century, although the house could have been in Castroville. The spirited horsemen in the foreground seem out of scale with the tall fence and house in the background, which indicates a degree of inexperience, and thus it might have been a student work.

PROVENANCE:
ca. 1840–ca.1945: Collection of the Gentilz-Frétellière Family.
1945: Purchased by SAMA from V. J. Rose with Witte Picture Funds. Rose acquired the painting from the artist's nephew.
45–87 P (3)

EXHIBITIONS:
1946: Early San Antonio Paintings, WMM (February 24 to March 12).
1964: The Early Scene: San Antonio, WMM (June 7 to August 31).
1966: Echoes of Texas, Museum of the Southwest, Midland (March 1 to April 20).
1974–1975: Theodore Gentilz: A Frenchman's View of Early Texas, WMM (November 25, 1974, to March 1, 1975).

PUBLICATIONS:
Utterback, *Early Texas Art* (1968), 16.

CAMP OF THE LIPANS
1896, oil on canvas, 9" × 12"
Signed and dated lower right: T. Gentilz, 1896

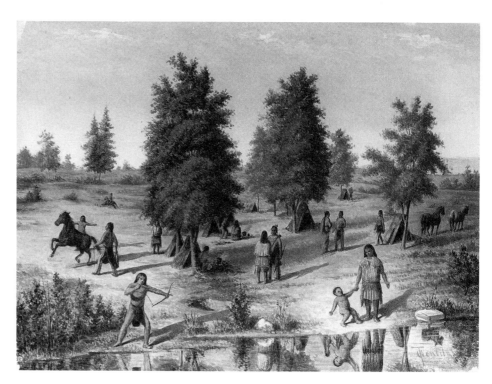

In 1896 Theodore Gentilz copied this painting
from one of his very early works, done in
about 1848. This information appears on
museum records, and a notation in Esse
Forrester-O'Brien's *Art and Artists of Texas*
indicates that Gentilz duplicated a number
of his early works because of the precarious
condition of canvases on which the inferior
paint he had used on his original paintings
was flaking badly.[23] Superior paint from New
Orleans was used for the later versions.[24]

 When Gentilz lived in Castroville, he
was known to walk the twenty-five miles
from that village to San Antonio. During
these early years he first made contact with
the Indian tribes that inhabited Texas and
probably sketched or painted the *Camp of the
Lipans* on one of these walks, or possibly on
one of his surveying expeditions.[25] Although
the Lipan Apaches were notorious hunters
and warriors, Gentilz won their friendship
and produced this intimate view of their
nomadic life-style.

PROVENANCE:
1896–1937: Collection of the Gentilz-Frételière Family.
1937: Purchased by SAMA from the artist's nephew
with Witte Picture Funds.
37–6790 P (1)

EXHIBITIONS:
1933: Yanaguana Society Exhibition, Old San Antonio
Paintings, WMM (December 1 to 3, extended to 8).
Lent by Miss Frételière.
1936: Centennial Exposition of Early Texas Paintings,
WMM (June 1 to August 1). Lent by the Frételière
Family.
1946: Early San Antonio Paintings, WMM (February 24
to March 12).
1964: The Early Scene: San Antonio, WMM (June 7 to
August 31).
1967: Painting in Texas: The Nineteenth Century,
ACMWA, Fort Worth (October 5 to November 26).
1967–1968: Painting in Texas: The Nineteenth Century,
The Academic Center, University of Texas at Austin
(December 9, 1967, to January 31, 1968).
1974–1975: Theodore Gentilz: A Frenchman's View of
Early Texas, WMM (November 25, 1974, to March 1,
1975).
1976: American Landscape Paintings: 1850–1900,
Laguna Gloria Art Museum, Austin (September 8 to
October 17).
1986: Texas Seen/Texas Made, SAMOA (September 29
to November 30).
1988: The Art and Craft of Early Texas, WMM
(April 30 to December 1).
1990: Looking at the Land: Early Texas Painters,
San Angelo Museum of Fine Arts (February 22 to
March 25).

PUBLICATIONS:
[Frederick C. Chabot], *Yanaguana Society Catalogue of a
Loan Exhibition of Old San Antonio Paintings* (1933): 6.
"Paintings by Early S.A. Artists," *San Antonio Light*,
November 26, 1933.
"Texas in Pictures," *The Magazine Antiques*, 53 (June
1948): 455.
Pinckney, *Painting in Texas* (1967), 115: plate 58.
Utterback, *Early Texas Art* (1968), 15.
Allan O. Kownslar, *The Texans: Their Land and History*
(1972), 18.
Reese and Kennamer, *Texas, Land of Contrast* (1972), 126.
Dorothy Steinbomer Kendall and Carmen Perry,
Gentilz: Artist of the Old Southwest (1974), dust jacket; 63:
plate 13.
"The Vanished Texas of Theodore Gentilz," *American
Heritage*, 25 (October 1974): 25.
Story of the Great American West (1977), 117.
Reese and Kennamer, *Texas, Land of Contrast* (rev. ed.,
1978), 148.
Mary Ann Noonan-Guerra, *The Story of the San Antonio
River* (1978), 4.
Anderson and Wooster, *Texas and Texans* (rev. ed.,
1978), 41.
Jim B. Pearson, Ben H. Procter, and William B.
Conroy, *Texas: The Land and Its People* (2nd ed., 1978), 65.
Holmes, *Texas: A Self-Portrait* (1983), 18.
Del Weniger, *The Explorers' Texas: The Lands and Waters*
(1st ed., 1984), after xi.
Steinfeldt, "Lone Star Landscapes," M3, SAMA
Quarterly, in *San Antonio Monthly*, 5 (July 1986): 21.
Reese, Mayer, and Mayer, *Texas* (1987), 20.
Mary Ann Guerra, *The San Antonio River* (1st rev. ed.,
1987), cover, 6.

Jim B. Pearson, Ben H. Procter, and William B.
Conroy, *Texas: The Land and Its People* (3rd ed., 1987), 330.
Bryce Milligan, "Books provide wealth of San
Antonio and Texas trivia," *San Antonio Light*,
August 30, 1987.
Larry Willoughby, *Texas, Our Texas* (1987), 62.

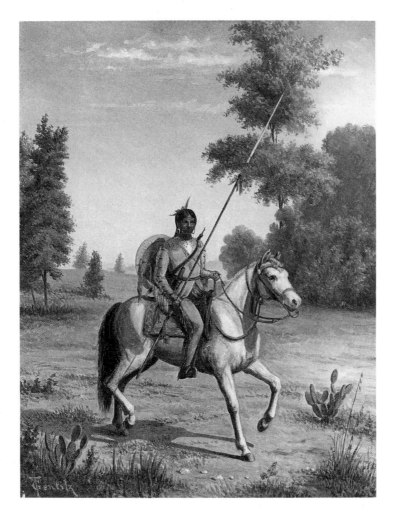

COMANCHE CHIEF
n.d., oil on canvas, 12″ × 9″
Signed lower left: T. Gentilz

Throughout most of the nineteenth century, the Comanche Indians constantly threatened the early settlers in Texas. A proud and fearless people who resented the white man's intrusion on their territory, they were superb horsemen, which gave them mobility to harass and maraud the more sedentary citizens of the land.[26] Gentilz's portrait of a Comanche chief pictures him astride his mount, spear in hand, with a sturdy leather shield decorated with trophy scalps on his back. The chief is attired in typical deerskin clothing. That Gentilz was able to make friends with such a fierce warrior is unusual. Legend maintains he achieved this feat by presenting the chief with a sketch and a bit of tobacco.[27]

PROVENANCE:
-1937: Collection of the Gentilz-Frételliere Family.
1937: Purchased by SAMA from the artist's nephew with Witte Picture Funds.
37–6790 P (2)

EXHIBITIONS:
1933: Yanaguana Society Exhibition, Old San Antonio Paintings, WMM (December 1 to 3, extended to 8). Lent by Miss Frételliere.
1936: Centennial Exposition of Early Texas Paintings, WMM (June 1 to August 1). Lent by the Frételliere Family.
1946: Early San Antonio Paintings, WMM (February 24 to March 12).
1964: The Early Scene: San Antonio, WMM (June 7 to August 31).
1967: Painting in Texas: The Nineteenth Century, ACMWA (October 5 to November 26).
1967–1968: Painting in Texas: The Nineteenth Century, The Academic Center, University of Texas at Austin (December 9, 1967, to January 31, 1968).
1974–1975: Theodore Gentilz: A Frenchman's View of Early Texas, WMM (November 25, 1974, to March 1, 1975).
1983: Images of Texas, Archer M. Huntington Art Gallery, College of Fine Arts, University of Texas at Austin (February 25 to April 10).
1983: Images of Texas, Traveling Exhibition: Art Museum of South Texas, Corpus Christi (July 1 to August 14). Amarillo Art Center (September 3 to October 30).
1984: The Texas Collection, SAMOA (April 13 to August 26).
1986: "Au Texas": The Art of Theodore Gentilz, Star of the Republic Museum, Washington, Texas (June 15 to September 14).
1986: Texas Seen/Texas Made, SAMOA (September 29 to November 30).
1988: The Art and Craft of Early Texas, WMM (April 30 to December 1).

PUBLICATIONS:
"Texas in Pictures," The Magazine Antiques, 53 (June 1948): 455.
Pinckney, Painting in Texas (1967), [114]: plate 57.
Utterback, Early Texas Art (1968), 19.
Kendall and Perry, Gentilz (1974), frontispiece.
"Western Art," San Antonio Light, September 1, 1974.
Schwartz, "Early Texas Art Depicts Era's Action," Antique Monthly, 8 (November 1974): 8A.
SAMA Calendar of Events (December 1974): cover.
Pearson et al., Texas: The Land and Its People (2nd ed., 1978), 499.
Anderson and Wooster, Texas and Texans (rev. ed., 1978), 45.
Richard E. Ahlborn, Man Made Mobile: Early Saddles of Western North America (1980), 83.
Goetzmann and Reese, Texas Images and Visions (1983), 57.
Rosson, "More than Bluebonnets," in Sentinel (December 1984): 26.
[Ellen N. Murry], "'Au Texas': The Art of Theodore Gentilz," Star of The Republic Museum Notes, 10 (Summer 1986): 2.
The Daughters of the Republic of Texas, The Alamo Long Barrack Museum (1986), 6.
Pearson et al., Texas: The Land and Its People (3rd ed., 1987), 412.
Willoughby, Texas, Our Texas (1987), 58.

23. Forrester-O'Brien, Art and Artists, 15.
24. Pinckney, Painting in Texas, 110.
25. Ibid., 116.
26. Webb, Carroll, and Branda (eds.), The Handbook of Texas, 2, s.v. "Comanche Indians."
27. Pinckney, Painting in Texas, 116.

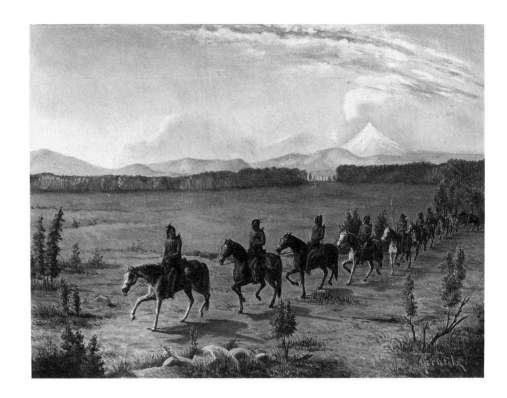

COMANCHES ON THE WAR PATH
1896, oil on canvas, 9″ × 12″
Signed and dated lower right: T. Gentilz/1896
Titled and inscribed on reverse: Comanches on the
war path—View of White Monts (Sierra Blanca)
Texas

Although Theodore Gentilz titled this
painting *Comanches on the War Path*, the Indians
do not appear to be particularly warlike.
Perhaps they were on their way to a
rendezvous that could have terminated in
battle. Again, because this canvas is dated
1896, it is believed that it was copied from an
earlier version or sketch. The Sierra Blanca
Mountains are in the Trans-Pecos region of
West Texas, some four hundred miles west of
Castroville, with peaks varying in elevation
from less than five thousand to more than
seven thousand feet.[28] Gentilz might have
produced his original rendition on one of his
surveying expeditions.

PROVENANCE:
1896–1937: Collection of the Gentilz-Frétellière Family.
1937: Purchased by SAMA from the artist's nephew
with Witte Picture Funds.
37–6790 P (3)

EXHIBITIONS:
1946: Early San Antonio Paintings, WMM (February 24
to March 12).
1964: The Early Scene: San Antonio, WMM (June 7 to
August 31).
1967: Painting in Texas: The Nineteenth Century,
ACMWA (October 5 to November 26).
1967–1968: Painting in Texas: The Nineteenth Century,
The Academic Center, University of Texas at Austin
(December 9, 1967, to January 31, 1968).

1974–1975: Theodore Gentilz: A Frenchman's View of
Early Texas, WMM (November 25, 1974, to March 1,
1975).
1984: The Texas Collection, SAMOA (April 13 to
August 26).
1986: "Au Texas": The Art of Theodore Gentilz, Star
of the Republic Museum, Washington, Texas (June 15
to September 14).
1986: Texas Seen/Texas Made, SAMOA (September 29
to November 30).
1988: The Art and Craft of Early Texas, WMM
(April 30 to December 1).

PUBLICATIONS:
"Texas in Pictures," *The Magazine Antiques*. 53 (June
1948): 458.
Don Ward, *Cowboys and Cattle Country* (1961), 25.
Pinckney, *Painting in Texas* (1967), 116: plate 59.
Utterback, *Early Texas Art* (1968), 15.
Kownslar, *The Texans* (1972), 226.
Reese and Kennamer, *Texas, Land of Contrast* (1972), 102.
"The Vanished Texas of Theodore Gentilz," *American
Heritage*, 25 (October 1974): 25.
Kendall and Perry, *Gentilz* (1974), 65: plate 15.
K. Pardue Newton, "The Gentilz paintings provide a
portable first," *North San Antonio Times*, December 12,
1974.
Editors of Time-Life Books, *The Spanish West* (1976), 102.
Reese and Kennamer, *Texas, Land of Contrast* (rev. ed.,
1978), 133.
Weniger, *The Explorers' Texas* (1st ed., 1984), opposite 6.
Willoughby, *Texas, Our Texas* (1987), 286.
Willard H. Rollings, *The Comanche* (1989), 58.

28. Webb, Carroll, and Branda (eds.), *The Handbook of
 Texas*, 2, s.v. "Sierra Blanca Range."
29. Ibid., s.v. "Comanche Indians."
30. Kendall and Perry, *Gentilz*, 43.
31. Pinckney, *Painting in Texas*, 31.
32. Webb, Carroll, and Branda (eds.), *The Handbook of
 Texas*, 2, s.v. "Wichita County."
33. Ibid., s.v. "Wichita Indians."

INDIAN MAN (OTTER BELT), QUAHADI CHIEF
n.d., black-and-white chalk drawing on toned paper,
9″ × 6⅛″
Unsigned
Inscribed lower left: Otter Belt/Quahadi Chief (later
addition ?)

The Quahadi Indians were a branch of the
Comanche tribe. The Quahadis, or Antelope
People, hunted on the Llano Estacado in the
Plains area of Texas.[29] Dorothy Kendall's
biography of Gentilz suggests that he made
the portrait from a photograph taken from
A. B. Stephenson's *Album of Indians*, published
in 1876.[30] Pauline Pinckney also believes that
the portrait was done from a photograph.[31]
In any event, it is a well-executed drawing,
with fine textures and nice modeling.

PROVENANCE:
-1945: Collection of the Gentilz-Frétellière Family.
1945: Purchased by SAMA from V. J. Rose with Witte
Picture Funds. Rose acquired the drawing from the
artist's nephew.
45–87 P (10)

EXHIBITIONS:
1946: Early San Antonio Paintings, WMM (February 24
to March 12).
1964: The Early Scene: San Antonio, WMM (June 7 to
August 31).
1967: Painting in Texas: The Nineteenth Century,
ACMWA (October 5 to November 26).
1967–1968: Painting in Texas: The Nineteenth Century,
The Academic Center, University of Texas at Austin
(December 9, 1967, to January 31, 1968).
1974–1975: Theodore Gentilz: A Frenchman's View of
Early Texas, WMM (November 25, 1974, to March 1,
1975).

PUBLICATIONS:
Pinckney, *Painting in Texas* (1967), 117: plate 60.
Utterback, *Early Texas Art* (1968), 21.
Kendall and Perry, *Gentilz* (1974), 102: plate 52.

INDIAN WOMAN, WICHITA SQUAW
n.d., black-and-white chalk drawing on toned paper,
9⅛″ × 6⅛″
Unsigned
Inscribed lower left: Wichita Squaw (later addition ?)

The Wichita Indians, of Caddoan stock, were
driven into Texas territory by other tribes in
the early eighteenth century.[32] Their lives
centered on permanent settlements of grass
huts, and their economy depended jointly
upon agriculture and hunting.[33] The
consensus holds that this drawing was from
a photograph, as was *Indian Man*. Gentilz
captures the woman's sturdy features in
a sympathetic manner, however, which
underlines his abiding interest in and
respect for native Americans.

PROVENANCE:
-1945: Collection of the Gentilz-Frétellière Family.
1945: Purchased by SAMA from V. J. Rose with Witte
Picture Funds. Rose acquired the drawing from the
artist's nephew.
45–87 P (9)

EXHIBITIONS:
1946: Early San Antonio Paintings, WMM (February 24
to March 12).
1964: The Early Scene: San Antonio, WMM (June 7 to
August 31).
1974–1975: Theodore Gentilz: A Frenchman's View of
Early Texas, WMM (November 25, 1974, to March 1,
1975).

PUBLICATIONS:
Utterback, *Early Texas Art* (1968), 21.

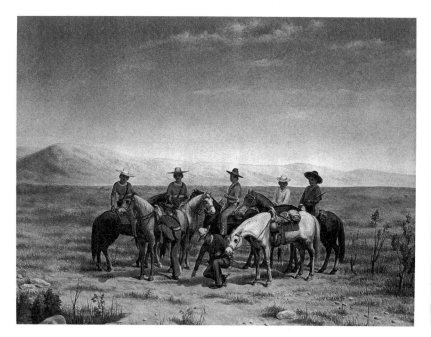

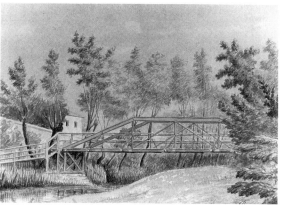

ON THE TRAIL
n.d., oil on canvas, 9″ × 12″
Signed lower left: T. Gentilz
Titled on reverse: Sobre la Huella

This small canvas is inscribed *Sobre la Huella* on the reverse, Spanish for "On the Trail." Gentilz titled his works using French or Spanish more often than English, an indication of his linguistic abilities. The scene, so carefully depicted in this rendition, is probably related to his surveying expeditions. Some have questioned if its locale is northern Mexico or southwestern Texas. A roster of paintings compiled by the artist in 1888 lists *La Huella* as being in Mexico but the size of the canvas listed—10″ × 7½″—differs from this one.[34] Since Gentilz repeated his subjects, however, the site for this painting also may have been in Mexico.

The *rancheros* have stopped to examine tracks in the soil—wild game, untamed mustangs, wandering cattle, or the greatest threat of all, marauding Indians. An interesting feature of this work is the style of clothing worn by the men; the snug-fitting *charro* outfits, the broadbrimmed hats, and the jangling spurs represent range attire in northern Mexico and southwestern Texas.

PROVENANCE:
-1937: Collection of the Gentilz-Frétellière Family.
1937: Purchased by SAMA from Louise Frétellière with Witte Picture Funds.
37–6792 P (2)

EXHIBITIONS:
1936: Centennial Exposition of Early Texas Paintings, WMM (June 1 to August 1). Lent by the Frétellière Family.
1946: Early San Antonio Paintings, WMM (February 24 to March 12).
1964: The Early Scene: San Antonio, WMM (June 7 to August 31).
1974–1975: Theodore Gentilz: A Frenchman's View of Early Texas, WMM (November 25, 1974, to March 1, 1975).
1976: American Landscape Paintings: 1850–1900, Laguna Gloria Art Museum, Austin (September 8 to October 17).
1986: Texas Seen/Texas Made, SAMOA (September 29 to November 30).
1988: The Art and Craft of Early Texas, WMM (April 30 to December 1).
1990: Looking at the Land: Early Texas Painters, San Angelo Museum of Fine Arts (February 22 to March 25).

PUBLICATIONS:
Utterback, *Early Texas Art* (1968), 23.
Kownslar, *The Texans* (1972), 388.
Reese and Kennamer, *Texas, Land of Contrast* (1972), 265.
Kendall and Perry, *Gentilz* (1974), 60: plate 10.
Editors of Time-Life Books, *The Spanish West* (1976), 88–89.
Story of the Great American West (1977), 272.
Reese and Kennamer, *Texas, Land of Contrast* (rev. ed., 1978), 326.
Willoughby, *Texas, Our Texas* (1987), 394.
San Angelo Preview Reception Invitation for the exhibition, Looking at the Land: Early Texas Painters (1990): cover.

BRIDGE OVER THE SAN ANTONIO RIVER
1878, watercolor on paper, 7¼″ × 10″
Monogrammed lower right: T. G.
Dated on reverse: April, 1878

Local artists frequently used the bridges over the San Antonio River as subject matter. Upon acquisition by the San Antonio Museum Association, this view was listed as the *San Antonio Mission Bridge*, a bridge that spanned the stream between the first and second missions.[35] The artist employed short, delicate, but sure brushstrokes and clear, cool color, reminiscent of his early work as a student.

PROVENANCE:
1878–ca. 1945: Collection of the Gentilz-Frétellière Family.
1945: Purchased by SAMA from V. J. Rose with Witte Picture Funds. Rose acquired the watercolor from the artist's nephew.
45–87 P (1)

EXHIBITIONS:
1946: Early San Antonio Paintings, WMM (February 24 to March 12).
1964: The Early Scene: San Antonio, WMM (June 7 to August 31).
1974–1975: Theodore Gentilz: A Frenchman's View of Early Texas, WMM (November 25, 1974, to March 1, 1975).

PUBLICATIONS:
Utterback, *Early Texas Art* (1968), 12.

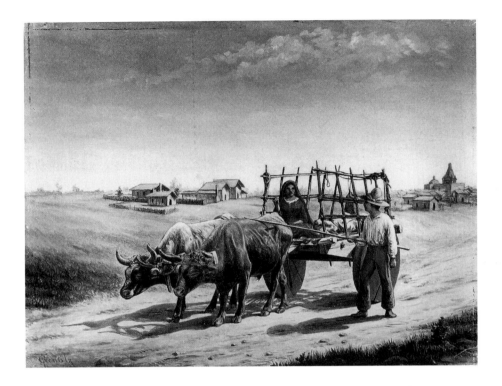

OX CART RETURNING FROM TOWN
1887, oil on canvas, 9″ × 12″
Signed lower left: T. Gentilz
Copyrighted lower right: 1887

Theodore Gentilz staunchly advocated using photographs as an aid in his painting. His *Ox Cart Returning from Town* is based upon a well-known photograph of the period which shows three Hispanic men with a typical cart drawn by two weary oxen. Gentilz, exercising imagination as well as artistic license, converted the figures into a young Mexican couple. He attired them in picturesque and colorful clothing.[36]

PROVENANCE:
1887–1936: Collection of the Gentilz-Frétellière Family.
1936: Purchased by Frederick C. Chabot from Louise Frétellière (contract in the DRT Library at the Alamo, SA).
1937: Purchased by SAMA from Frederick C. Chabot with Witte Picture Funds.
37–6791 P (1)

EXHIBITIONS:
1946: Early San Antonio Paintings, WMM (February 24 to March 12).
1958: Mission Summer Festival, Mission Concepción, SA (June 13 to 22).
1964: The Early Scene: San Antonio, WMM (June 7 to August 31).
1966: Echoes of Texas, Museum of the Southwest, Midland, (March 1 to April 20).
1974–1975: Theodore Gentilz: A Frenchman's View of Early Texas, WMM (November 25, 1974, to March 1, 1975).
1984: The Texas Collection, SAMOA (April 13 to August 26).
1986: "Au Texas": The Art of Theodore Gentilz, Star of the Republic Museum, Washington, Texas (June 15 to September 14).
1986: Texas Seen/Texas Made, SAMOA (September 29 to November 30).
1988: The Art and Craft of Early Texas, WMM (April 30 to December 1).
1988: A Witte Merry Christmas: Tannenbaums to Tumbleweeds, WMM (December 1 to 30).

PUBLICATIONS:
Ralph W. Steen and Frances Donecker, *Texas: Our Heritage* (1962), 103.
David Lavender, *The American Heritage History of the Great West* (1965), 145.
Utterback, *Early Texas Art* (1968), 23.
Reese and Kennamer, *Texas, Land of Contrast* (1972), 136.
Steinfeldt, *The Onderdonks* (1976), 210.
Reese and Kennamer, *Texas, Land of Contrast* (rev. ed., 1978), 151.

Gentilz referred to a copy of this photograph when he painted *Ox Cart Returning from Town*. SAMA Historical Photographic Archives, gift of Eleanor Onderdonk.

34. Pinckney, *Painting in Texas*, 110.
35. Original Bill of Sale, July 16, 1945, signed by V. J. Rose, SAMA Registrar's Records; Frederick C. Chabot Photographic Album #2, SAMA Historical Photographic Archives.
36. Steinfeldt, *The Onderdonks*, 209–210.

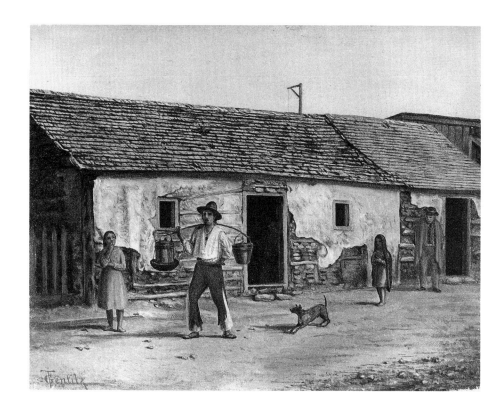

TAMALE VENDOR, LAREDO STREET,
SAN ANTONIO
n.d., oil on canvas, 7″ × 9″
Signed lower left: T. Gentilz

Tamale vendors, or *tamaleros*, sold their wares
from door to door. Such strolling vendors,
who sold all manner of goods, were a
common sight in San Antonio and Gentilz
delighted in showing this distinctly Mexican
custom in several of his canvases. In this small
view, the artist also depicts the construction
of the house and the clothing worn by the
figures. He shows the plastered white walls of
the houses peeling away to reveal the adobe
bricks or soft limestone rubble underneath.
The people wear simple garments; the
women with short skirts, bare feet, and
one with a *rebozo* over her head, the tamale
vendor in a loose shirt, split trousers, and
sandals.

This visual documentation substantiates
Frederick Law Olmsted's descriptions of early
San Antonio: "They [Mexican houses] are all
low, of adobe or stone, washed blue and
yellow, with flat roofs close down upon their
single story. Windows have been knocked in
their blank walls, letting the sun into their
dismal vaults. . . ."[37]

PROVENANCE:
·1936: Collection of the Gentilz-Frételière Family.
1936: Purchased by Frederick C. Chabot from Louise
Frételière (contract in the DRT Library at the Alamo,
SA).

1937: Purchased by SAMA from Frederick C. Chabot
with Witte Picture Funds.
37–6791 P (2)

EXHIBITIONS:
1946: Early San Antonio Paintings, WMM (February 24
to March 12).
1958: Mission Summer Festival, Mission Concepción,
SA (June 13 to 22).
1964: The Early Scene: San Antonio, WMM (June 7 to
August 31).
1974–1975: Theodore Gentilz: A Frenchman's View of
Early Texas, WMM (November 25, 1974, to March 1,
1975).
1986: Texas Seen/Texas Made, SAMOA (September 29
to November 30).
1988: The Art and Craft of Early Texas, WMM
(April 30 to December 1).
1988: A Witte Merry Christmas: Tannenbaums to
Tumbleweeds, WMM (December 1 to 30).

PUBLICATIONS:
"Texas in Pictures," *The Magazine Antiques*, 53 (June
1948): 454.
C. Ramsdell, *San Antonio* (1959), 282.
Martha Utterback, "Gentilz Note Paper," *Witte
Quarterly*, 5 (1967): 17.
Utterback, *Early Texas Art* (1968), 22.
Remy, "Hispanic-Mexican San Antonio," *Southwestern
Historical Quarterly*, 71 (April 1968): plate 10.
Kendall and Perry, *Gentilz* (1974), 89: plate 39.
"Early S.A. painter shown," *San Antonio Express*,
November 25, 1974.
"December Scene at Witte," *San Antonio Scene*
(December 1974).

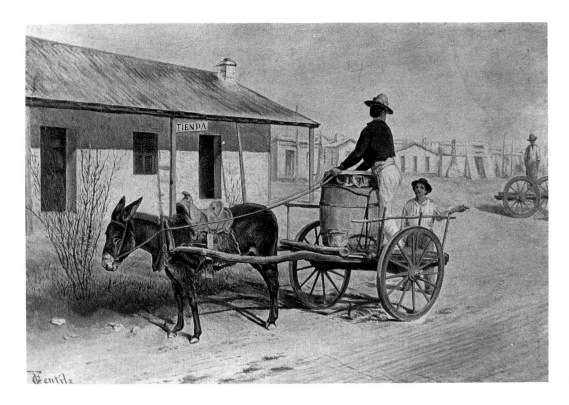

EL AGUADOR
n.d., oil on canvas, 7″ × 10″
Signed lower left: T. Gentilz

This photograph, by H. A. Doerr, appears to be the inspiration for Gentilz's *El Aguador*. SAMA Historical Photographic Archives, gift of Eleanor Onderdonk.

For centuries the San Antonio River served as the community's principal water source for drinking, bathing, laundering, and irrigation. It was described as "a deep, bluish current flowing in a narrow but picturesque channel between bold and rugged banks. . . ."[38] The earliest settlers built their homes as near to the river as possible in order to secure water. Others purchased their water from vendors. Gentilz depicts such a vendor hauling a barrel of the precious liquid in a small *carreta* drawn by a burro. Again, it is believed Gentilz based his rendition on a photograph but used artistic license for the buildings in the background.[39]

PROVENANCE:
−ca. 1939: Collection of the Gentilz-Frétellière Family.
ca. 1939−1974: Collection of Henry B. Dielmann.
1974: Gift to SAMA by Mrs. Henry B. Dielmann.
74−197 G

EXHIBITIONS:
1974−1975: Theodore Gentilz: A Frenchman's View of Early Texas, WMM (November 25, 1974, to March 1, 1975).
1986: Texas Seen/Texas Made, SAMOA (September 29 to November 30).
1988: The Art and Craft of Early Texas, WMM (April 30 to December 1).
1988: A Witte Merry Christmas: Tannenbaums to Tumbleweeds, WMM (December 1 to 30).

PUBLICATIONS:
"The Arts Column," San Antonio *Express*, December 19, 1974.
"Theodore Gentilz: A Frenchman's View of Early Texas," San Antonio *Light*, December 29, 1974.
SAMA *Calendar of Events* (May 1975): [4].
SAMA *Annual Report*, 1974−1975, 8.
"Exhibit honoring Texas artist opens Sunday," *North San Antonio Times*, September 25, 1986.
"Texas Seen-Texas Made," *Current Events*, September 25, 1986.
"SAMA exhibit 'made in Texas'," San Antonio *Express-News*, October 5, 1986.
"'Texas Seen-Texas Made' opens," San Antonio *Light*, October 5, 1986.
"Show Focuses on Texas: Art Reflects Texas Eras," *Paseo del Rio Showboat* (SA), October 1986.

37. Olmsted, A *Journey Through Texas*, 150.
38. [Edward King], "Glimpses of Texas—1: A Visit to San Antonio," *Scribner's Monthly, An Illustrated Magazine for the People* 7 (January 1874): 318.
39. Steinfeldt, *San Antonio Was*, 78: plate 76.

THE ALAMO, MISSION SAN ANTONIO
DE VALERO
1844, oil on canvas, 28″ × 31¼″
Signed and inscribed lower left: T. Gentilz,
copyrighted 12-7-1900
Dated lower center: 1844

Gentilz, who came to San Antonio in 1844,
was one of the few resident or visiting artists
to see the Alamo shortly after its destruction
by Mexican forces. He made numerous on-
the-spot sketches and small watercolors of the
mission in its dilapidated state. His painting,
done in 1900 from these early sketches, shows
the structure as it appeared in 1844, five years
before the United States Army reconstructed
it and used it as a quartermaster depot.[40] This
painting, and the artist's large renditions of
the other four missions, are believed to have
been special commissions executed for Daniel
Sullivan, a prominent San Antonio banker.

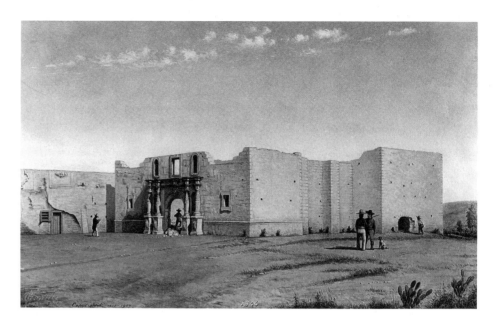

PROVENANCE:
1900–1963: Collection of the Sullivan Family.
1963: Gift to St. Mary's University, SA, by John Cotter
Sullivan.
1977: Extended Loan to SAMA by St. Mary's
University.
77–26 L (1)

EXHIBITIONS:
1936: Centennial Exposition of Early Texas Paintings,
WMM (June 1 to August 1). Lent by John C. Sullivan.
1963: Main Foyer, Administration Building, St. Mary's
University (August).
1964: The Early Scene: San Antonio, WMM (June 7 to
August 31).
1974–1975: Theodore Gentilz: A Frenchman's View of
Early Texas, WMM (November 25, 1974, to March 1,
1975).
1984: The Texas Collection, SAMOA (April 13 to
August 26).
1986: Remembering the Alamo: The Development of
a Texas Symbol, 1836–1986, WMM (February 23 to
September 15).
1986: Texas Seen/Texas Made, SAMOA (September 29
to November 30).
1988: The Art and Craft of Early Texas, WMM
(April 30 to December 1).

PUBLICATIONS:
Noonan-Guerra, The Story of the San Antonio River (1978), 8.
Mary Ann Noonan-Guerra, An Alamo Album (new rev.
ed., 1979), [14].
"San Antonio Museum of Art: The Grand Opening,"
North San Antonio Times Supplement, February 19, 1981.

BACK OF THE ALAMO
1878, watercolor on paper, 7¼″ × 10″
Monogrammed lower right: T. G.
Inscribed and dated on reverse: d'apres un croquis/
Avril, 1878

This small watercolor shows the Alamo as it
looked in 1844, but Gentilz recorded on the
back that it was done after a sketch ("d'apres
un croquis") and dated it 1878. It affords a
glimpse not only of the famous structure, but
also of the simple houses that surrounded the
Alamo at the time. The similarity to Seth
Eastman's rendition of the same site (see Seth
Eastman, The Alamo) is striking even though
the artists' techniques are so different.
Another analogous interpretation may be
found in Captain Arthur T. Lee's view, done
when he was serving with the Eighth U.S.
Infantry on assignment in Texas.[41]

PROVENANCE:
1878–ca. 1945: Collection of the Gentilz-Frétellière
Family.
1945: Purchased by SAMA from V. J. Rose with Witte
Picture Funds. Rose acquired the watercolor from
the artist's nephew.
45–87 P (2)

EXHIBITIONS:
1946: Early San Antonio Paintings, WMM (February 24
to March 12).
1964: The Early Scene: San Antonio, WMM (June 7 to
August 31).
1974–1975: Theodore Gentilz: A Frenchman's View of
Early Texas, WMM (November 25, 1974, to March 1,
1975).
1986: Remembering the Alamo: The Development of
a Texas Symbol, 1836–1986, WMM (February 23 to
October 31).

PUBLICATIONS:
Utterback, Early Texas Art (1968), 12.

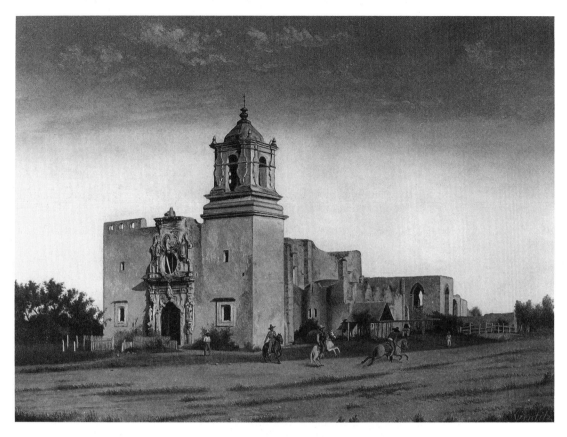

MISSION SAN JOSÉ DE AGUAYO
ca. 1900, oil on canvas, 20″ × 28″
Signed lower right: T. Gentilz

San José de Aguayo, queen of the missions in San Antonio, was a sturdy stone building that had been erected over a period of years during the eighteenth century. Fray Agustín Morfi visited the mission in 1777 and wrote that "San José is, in truth, the first mission in America, not in point of time, but in point of beauty, plan and strength, so that there is not a presidio along the entire frontier line that can compare with it. . . ." He continued, "The whole structure is admirably proportioned and strongly built of stone and mortar, chiefly a sandy limestone that is light and porous when freshly quarried, but in a few days hardens and becomes one with the mortar. . . . This stone is obtained from a quarry near the mission of Nuestra Señora de la Concepción. . . ."[42] When Gentilz painted it in the late nineteenth century, the mission had suffered the vicissitudes of time and vandalism; nevertheless it was still an imposing and magnificent structure.

PROVENANCE:
1900–1963: Collection of the Sullivan Family.
1963: Gift to St. Mary's University, SA, by John Cotter Sullivan.
1977: Extended Loan to SAMA by St. Mary's University.
77–26 L (3)

EXHIBITIONS:
1936: Centennial Exposition of Early Texas Paintings, WMM (June 1 to August 1). Lent by John C. Sullivan.
1963: Main Foyer, Administration Building, St. Mary's University (August).
1964: The Early Scene: San Antonio, WMM (June 7 to August 31).
1974–1975: Theodore Gentilz: A Frenchman's View of Early Texas, WMM (November 25, 1974, to March 1, 1975).
1984: The Texas Collection, SAMOA (April 13 to August 26).
1986: Texas Seen/Texas Made, SAMOA (September 29 to November 30).
1988: The Art and Craft of Early Texas, WMM (April 30 to December 1).
1990: Looking at the Land: Early Texas Painters, San Angelo Museum of Fine Arts (February 22 to March 25).

PUBLICATIONS:
"St. Mary's to Display 'New' Paintings of Old Artist," San Antonio Light, August 10, 1963.
Pinckney, Painting in Texas (1967), 107: plate 50.
Urban Texas Tomorrow: Report of the Texas Assembly on the State and Urban Crisis with Historical Illustrations (1970), 5.
The Spanish Texans (1972), 25.
SAMA Calendar of Events (November 1978): [2].
Noonan-Guerra, The Story of the San Antonio River (1978), 9.
The Daughters of the Republic of Texas, The Alamo Long Barrack Museum (1986), 7.

40. Corner (comp. and ed.), San Antonio de Bexar, 10–11.
41. W. Stephen Thomas, Fort Davis and the Texas Frontier: Paintings by Captain Arthur T. Lee, Eighth U.S. Infantry (College Station: Published for the Amon Carter Museum of Western Art, Fort Worth, by Texas A&M University Press, 1976), 43.
42. Quoted in Habig, San Antonio's Mission San José, 65–66.

MISSION SAN JOSÉ
1882, watercolor on toned paper, 9¹⁄₁₆″ × 7¹⁄₁₆″
Monogrammed lower right: T. G.
Dated on reverse: 15 March 1882

This view of the back of Mission San José
shows the devastation after the north wall
and the dome of the building collapsed. A
part of the wall of the church was destroyed
in a storm on December 10, 1868. The dome
and a portion of the roof remained virtually
unsupported until, during another storm in
the early morning hours of December 25,
1873, they too crashed to the ground.[43]
Although Gentilz based his version upon a
well-known stereograph of the period, it is
beautifully painted, and the quality of the
watercolor suggests that he worked from life
as well as from a photograph. The original
stereograph was made by A. V. Latourette,
who photographed numerous scenes in and
around San Antonio.[44]

PROVENANCE:
1882–ca. 1945: Collection of the Gentilz-Frételliere
Family.
1945: Purchased by SAMA from V. J. Rose with Witte
Picture Funds. Rose acquired the watercolor from
the artist's nephew.
45–87 P (7)

EXHIBITIONS:
1946: Early San Antonio Paintings, WMM (February 24
to March 12).
1964: The Early Scene: San Antonio, WMM (June 7 to
August 31).
1974–1975: Theodore Gentilz: A Frenchman's View of
Early Texas, WMM (November 25, 1974, to March 1,
1975).
1986: Texas Seen/Texas Made, SAMOA (September 29
to November 30).

PUBLICATIONS:
Utterback, Early Texas Art (1968), 17.
Kendall and Perry, Gentilz (1974), 62: plate 12.
Glenn Tucker, "Art Scene," San Antonio Light,
December 1, 1974.
"Comprehensive Exhibit: Works Recall Early Texas,"
Paseo del Rio Showboat (SA), December 1974.

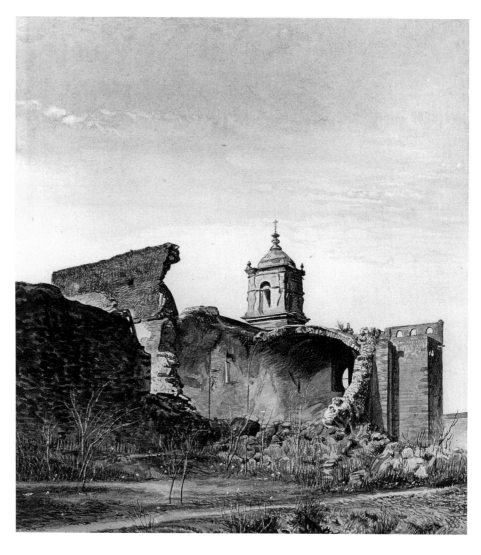

Stereograph view of the back of Mission San José
probably used by Gentilz for his watercolor. SAMA
Historical Photographic Archives, purchased from
James A. Davis.

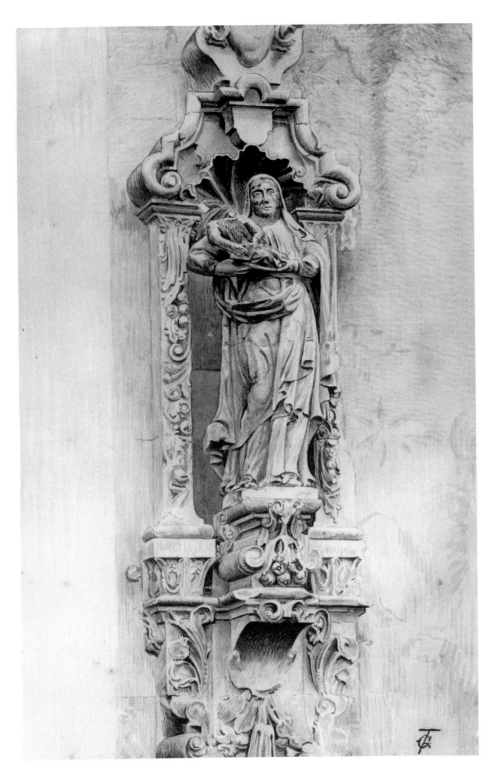

CARVING, SAN JOSÉ
1882, gray wash drawing on paper, 8¾" × 5⅛"
Monogrammed lower right: T. G.
Dated on reverse: 18 March 1882

The figure of Saint Anne originally graced the right side of the portal of Mission San José, but both this sculpture and the one of Saint Joachim on the left side suffered greatly from weather, erosion, and vandalism throughout the years. As early as 1850, John R. Bartlett, surveyor, observed: " . . . the work of ruin has been assisted by the numerous military companies near here, who, finding in the hands and features of the statues convenient marks for rifle and pistol shots, did not fail to improve the opportunity for showing at the same time their skill in arms."[45] This devastation is apparent in Gentilz's rendition of the carving of the Saint with its battered features and headless infant. His careful rendering and meticulous detail suggest that he might have used a photograph. In fact, Doerr and Jacobson, local photographers, had issued a stereograph of the figure in about 1873 that is remarkably like the painting.[46] By 1890 the sculpture of Saint Anne had completely disappeared and much of the left-side figure was gone also.[47] After the turn of the century concerted efforts were made to restore the entire mission, and a Houston sculptor, E. Lenarduzzi, replaced the mutilated statues on the façade in 1948.[48]

PROVENANCE:
1882–ca. 1945: Collection of the Gentilz-Frétellière Family.
1945: Purchased by SAMA from V. J. Rose with Witte Picture Funds. Rose acquired the painting from the artist's nephew.
45–87 P (6)

EXHIBITIONS:
1946: Early San Antonio Paintings, WMM (February 24 to March 12).
1964: The Early Scene: San Antonio, WMM (June 7 to August 31).
1974–1975: Theodore Gentilz: A Frenchman's View of Early Texas, WMM (November 25, 1974, to March 1, 1975).
1986: Texas Seen/Texas Made, SAMOA (September 29 to November 30).

PUBLICATIONS:
Utterback, Early Texas Art (1968), 17.
Kendall and Perry, Gentilz (1974), 64: plate 14.
"Comprehensive Exhibit," Paseo del Rio Showboat (SA), December 1974.

43. Ibid., 146–149; Goeldner (comp.), Texas Catalog (TEX-333).
44. Original stereograph in SAMA Historical Photographic Archives.
45. John Russell Bartlett, Personal Narrative of Explorations and Incidents in Texas, New Mexico, California, Sonora and Chihuahua: Connected with the United States and Mexican Boundary Commission During the Years 1850, '51, '52 and '53 (2 vols.; New York: D. Appleton and Company, 1854; reprint Chicago: The Rio Grande Press, Inc., 1965), 1: 43.
46. An original stereograph is in the collection of T. K. Treadwell of Bryan, Texas.
47. Corner, San Antonio de Bexar, 20.
48. Habig, San Antonio's Mission San José, 180.

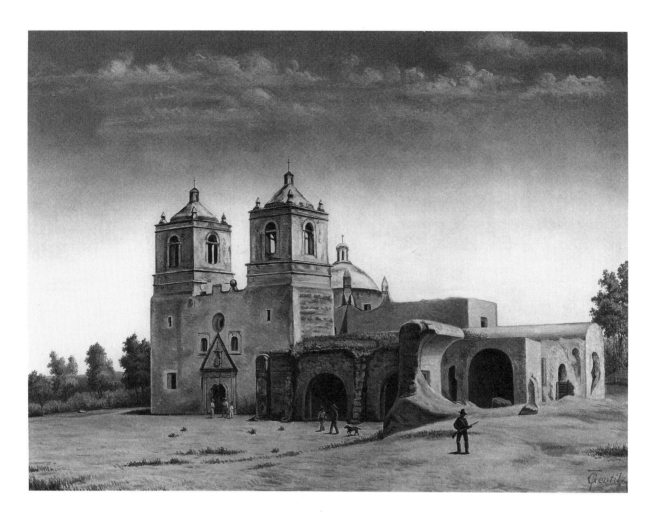

MISSION NUESTRA SEÑORA DE LA PURÍSIMA
CONCEPCIÓN DE ACUÑA
ca. 1900, oil on canvas, 19¼″ × 27½″
Signed lower right: T. Gentilz

Mission Concepción is the best preserved of the San Antonio missions. As a church it ranked next to San José in importance, in successful completion of its religious objectives, and in richness of decorations and of furnishings.[49] As this painting is one of a set of five that Gentilz presumably executed for Dan Sullivan, an arbitrary date of around 1900 has been attributed. In *San Antonio de Bexar: A Guide and History*, William Corner's thorough and exacting account of Concepción in 1890 describes the fading frescoes that once adorned the exterior walls. He mentions, however, that "this frescoing is rapidly disappearing, and from but a little distance the front looks to be merely gray and undecorated stone."[50] No frescoing appears in Gentilz's painting, although he must have seen the structure in the mid-nineteenth century, when the colors would still have been visible.

PROVENANCE:
ca. 1900–1963: Collection of the Sullivan Family.
1963: Gift to St. Mary's University, SA, by John Cotter Sullivan.
1977: Extended Loan to SAMA by St. Mary's University.
77–26 L (2)

EXHIBITIONS:
1936: Centennial Exposition of Early Texas Paintings, WMM (June 1 to August 1). Lent by John C. Sullivan.
1963: Main Foyer, Administration Building, St. Mary's University (August).
1964: The Early Scene: San Antonio, WMM (June 7 to August 31).
1974–1975: Theodore Gentilz: A Frenchman's View of Early Texas, WMM (November 25, 1974, to March 1, 1975).
1984: The Texas Collection, SAMOA (April 13 to August 26).
1986: Texas Seen/Texas Made, SAMOA (September 29 to November 30).
1988: The Art and Craft of Early Texas, WMM (April 30 to December 1).

PUBLICATIONS:
Noonan-Guerra, *The Story of the San Antonio River* (1978), 12.

49. Joseph W. Schmitz, *Mission Concepción*. Reprint from *Six Missions of Texas* (Waco: Texian Press, 1965): 7.
50. Corner, *San Antonio de Bexar*, 16 (quotation), 14–17.
51. Ibid., 16.
52. Ibid., 20.

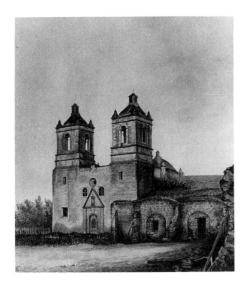

MISSION NUESTRA SEÑORA DE LA PURÍSIMA CONCEPCIÓN DE ACUÑA
n.d., watercolor on toned paper, 12¼" × 11⅛"
Monogrammed lower left: T. G.

Although this small watercolor is similar to Gentilz's large oil of the mission, it presents a more intimate view of the structure. The carved detailing on the pillars flanking the portal corresponds with William Corner's description of "carved relief pillars at the sides ornamented with carved lozenges. . . ." Also evident are the stained glass windows that Corner mentions: "The only stained glass in all the Missions is the panes of two little windows each side of the upper part of the façade. . . ."[51] A fence is visible on the left side of the building, and the arches and the roofline seem to vary somewhat, indicating an earlier date than attributed to the oil painting of Gentilz's Concepción Mission.

PROVENANCE:
-1945: Collection of the Gentilz-Frétellière Family.
1945: Purchased by SAMA from V. J. Rose with Witte Picture Funds. Rose acquired the painting from the artist's nephew.
45–87 P (11)

EXHIBITIONS:
1946: Early San Antonio Paintings, WMM (February 24 to March 12).
1964: The Early Scene: San Antonio, WMM (June 7 to August 31).
1974–1975: Theodore Gentilz: A Frenchman's View of Early Texas, WMM (November 25, 1974, to March 1, 1975).

PUBLICATIONS:
Utterback, *Early Texas Art* (1968), 20.
Ron White, "Onderdonk exhibit at the Witte transcends regionalism," San Antonio *Express-News*, February 16, 1975.

MISSION SAN JUAN CAPISTRANO
ca. 1900, oil on canvas, 19½" × 27½"
Signed lower right: T. Gentilz

San Juan Capistrano, although in disrepair, was still the center of religious and social life for the surrounding area when Gentilz painted this canvas. He enlivened the scene with figures of a Mexican wedding party approaching the mission, the young couple to be married within the chapel walls. The painting probably was done from an earlier sketch or possibly a photograph. It shows the graceful pierced belfry designed to hold three bells, although only one remained in the upper alcove at the time. San Juan was the third mission outside the community of San Antonio and was situated on the east bank of the San Antonio River.[52]

PROVENANCE:
ca. 1900–1963: Collection of the Sullivan Family.
1963: Gift to St. Mary's University, SA, by John Cotter Sullivan.
1977: Extended Loan to SAMA by St. Mary's University.
77–26 L (5)

EXHIBITIONS:
1936: Centennial Exposition of Early Texas Paintings, WMM (June 1 to August 1). Lent by John C. Sullivan.
1963: Main Foyer, Administration Building, St. Mary's University (August).
1964: The Early Scene: San Antonio, WMM (June 7 to August 31).
1974–1975: Theodore Gentilz: A Frenchman's View of Early Texas, WMM (November 25, 1974, to March 1, 1975).
1984: The Texas Collection, SAMOA (April 13 to August 26).
1986: Texas Seen/Texas Made, SAMOA (September 29 to November 30).
1988: The Art and Craft of Early Texas, WMM (April 30 to December 1).
1990: Looking at the Land: Early Texas Painters, San Angelo Museum of Fine Arts (February 22 to March 25).

PUBLICATIONS:
Kownslar, *The Texans* (1972), 255.

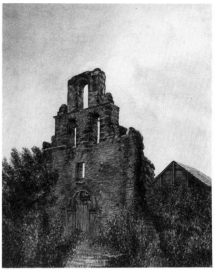

MISSION SAN FRANCISCO DE LA ESPADA
ca. 1900, oil on canvas, 19½" × 27½"
Signed lower right: T. Gentilz

Gentilz's records indicate that he often repeated favorite subjects, sometimes duplicating every detail of a painting. He rendered each of the San Antonio missions in varying sizes and in several media. This version of San Francisco de la Espada, and the other four missions that make up this set, are the largest paintings done by the artist. Gentilz depicts the mission in fairly good repair, which, no doubt, was due to the efforts of a dedicated Franciscan friar, the Reverend Father Bouchu, who worked for a number of years to save the buildings and who used them primarily as classrooms for neighborhood children.[53] The figure of a priest seen in the doorway of the small church may possibly be Father Bouchu himself.

PROVENANCE:
ca. 1900–1963: Collection of the Sullivan Family.
1963: Gift to St. Mary's University, SA, by John Cotter Sullivan.
1977: Extended Loan to SAMA by St. Mary's University.
77–26 L (4)

EXHIBITIONS:
1936: Centennial Exposition of Early Texas Paintings, WMM (June 1 to August 1). Lent by John C. Sullivan.
1963: Main Foyer, Administration Building, St. Mary's University (August).
1964: The Early Scene: San Antonio, WMM (June 7 to August 31).
1974–1975: Theodore Gentilz: A Frenchman's View of Early Texas, WMM (November 25, 1974, to March 1, 1975).
1984: The Texas Collection, SAMOA (April 13 to August 26).
1986: Texas Seen/Texas Made, SAMOA (September 29 to November 30).
1988: The Art and Craft of Early Texas, WMM (April 30 to December 1).

PUBLICATIONS:
SAMA Bi-Annual Report, 1976–1978, 34.
Noonan-Guerra, The Story of the San Antonio River (1978), 11.
Glenn Tucker, "Art Scene," San Antonio Light, November 26, 1978.

ESPADA MISSION
n.d., brown wash drawing on paper, 12½" × 10"
Unsigned

Mission Espada appears in a much more distressed condition in this small painting than it does in the artist's larger canvas. Missing its bells and cross, the structure is almost engulfed in vegetation. This suggests that the watercolor was executed at an early date, before Father Bouchu administered his restorative skills. Both paintings illustrate the changes in the mission throughout the years.

PROVENANCE:
–ca. 1945: Collection of the Gentilz-Frétellière Family.
1945: Purchased by SAMA from V. J. Rose with Witte Picture Fund. Rose acquired the painting from the artist's nephew.
45–87 P (4)

EXHIBITIONS:
1946: Early San Antonio Paintings, WMM (February 24 to March 12).
1964: The Early Scene: San Antonio, WMM (June 7 to August 31).
1974–1975: Theodore Gentilz: A Frenchman's View of Early Texas, WMM (November 25, 1974, to March 1, 1975).

PUBLICATIONS:
Utterback, Early Texas Art (1968), 20.

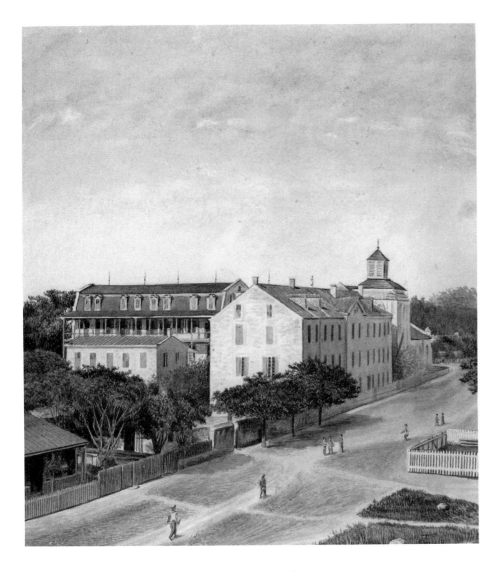

ST. MARY'S COLLEGE
1882, watercolor on paper, 8¼" × 6⅛"
Monogrammed lower right: T. G.
Inscribed and dated on reverse: College Ste. Marie,
5 May 1882

Gentilz spent much of his adult life teaching young men the fine arts of painting and drawing at St. Mary's College in San Antonio. His watercolor of the school is a precise and accurate rendition of the edifice. Although small, it affords an intimate view of San Antonio's simple character in the early 1880s. The street was unpaved, shade trees abounded, and fences were of wooden posts or pickets. The school, however, was an imposing structure built of limestone and distinctly French in design. François Giraud was the architect who is also credited with designing the adjoining St. Mary's Church.[54]

 The small house at the far left of the painting was the home of Eugene Marucheau, a local merchant. There are two small cottages nestled beneath the trees between the Marucheau home and the college. One of these houses belonged to Mr. and Mrs. George Witte, parents of Alfred G. Witte, for whom the Witte Museum was named; the other was the home of Alfred Witte's grandparents, Mr. and Mrs. Johann Friedrich Kleine.[55] In the late 1960s the St. Mary's College buildings were converted into La Mansion Motor Hotel.[56]

PROVENANCE:
1882–1969: Collection of the Gentilz-Frétellière Family.
1969: Gift to Carmen Perry from the Gentilz-Frétellière Family.
1991: Purchased by SAMA from Carmen Perry with Witte Picture Fund.
91–10 P (2)

EXHIBITIONS:
1974–1975: Theodore Gentilz: A Frenchman's View of Early Texas, WMM (November 25, 1974, to March 1, 1975).

PUBLICATIONS:
Kendall and Perry, *Gentilz* (1974), 97: plate 47.
Ernest A. Raba, J.D., LL.D., *The St. Mary's University School of Law: A Personal History* [1981, 3].

53. Ibid., 21–22.
54. Kendall and Perry, *Gentilz*, 36.
55. William Elton Green to author (SA), interview, March 2, 1991. Green did extensive research on the Witte family history in preparation for his exhibit, "Witte Museum: Past, Present, and Future," October 23, 1983, to November 1, 1985.
56. C. Ramsdell, *San Antonio* (rev. ed.), 216.

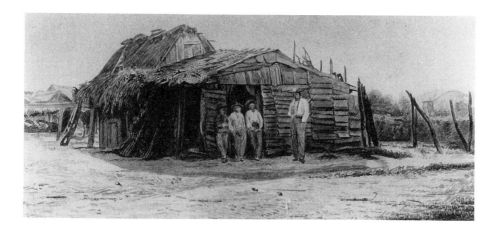

CERCA MATAMOROS, MEXICO
n.d., watercolor on paper, 4¹⁵⁄₁₆″ × 7⁹⁄₁₆″
Monogrammed lower left: T. G.
Titled on reverse: Cerca Matamoros, Mexico

During his numerous surveying expeditions into northern Mexico Gentilz produced many small sketches and watercolors of genre subjects.[57] *Cerca Matamoros*, a picture of a Mexican *jacál*, shows the Mexican influence on the same type of humble abode found in San Antonio at the time. Most of the artist's small paintings were in a monochromatic brown, but this view has vestiges of color in the men's apparel and in the foreground.

PROVENANCE:
-1964: Collection of Mrs. Terrell Bartlett.
1964: Gift to SAMA by Mrs. Terrell Bartlett. Mrs. Bartlett was the daughter-in-law of General George T. Bartlett. It is believed that several Gentilz paintings that she donated once were the property of the general.
64–19 G (5)

EXHIBITIONS:
1964: The Early Scene: San Antonio, WMM (June 7 to August 31).
1974–1975: Theodore Gentilz: A Frenchman's View of Early Texas, WMM (November 25, 1974, to March 1, 1975).
1986: Texas Seen/Texas Made, SAMOA (September 29 to November 30).

PUBLICATIONS:
Utterback, *Early Texas Art* (1968), 18.

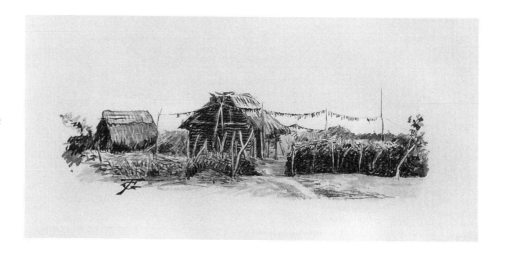

CERCA MATAMOROS
n.d., brown wash drawing, 3¹⁵⁄₁₆″ × 7¹⁄₁₆″
Monogrammed lower left: T. G.
Titled on reverse: Cerca Matamoros

That Gentilz produced so many diminutive washes and watercolors implies that the painting equipment he carried on his journeys was limited in size and variety. Small though these works may be, each is executed with the artist's typical precision and graphic skill. They also provide glimpses into the past of Mexico's bordertowns.

PROVENANCE:
-1964: Collection of Mrs. Terrell Bartlett.
1964: Gift to SAMA by Mrs. Terrell Bartlett.
64–19 G (1)

EXHIBITIONS:
1964: The Early Scene: San Antonio, WMM (June 7 to August 31).
1974–1975: Theodore Gentilz: A Frenchman's View of Early Texas, WMM (November 25, 1974, to March 1, 1975).
1986: Texas Seen/Texas Made, SAMOA (September 29 to November 30).

PUBLICATIONS:
Martha Utterback, "Additions to the Early Texas Collection," *Witte Quarterly*, 3 (1965): 11.
Utterback, *Early Texas Art* (1968), cover.

57. Kendall and Perry, *Gentilz*, 18.
58. Webb, Carroll, and Branda (eds.), *The Handbook of Texas*, 2, s.v. "El Paso, Texas."

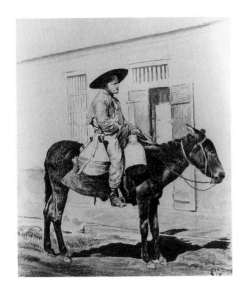

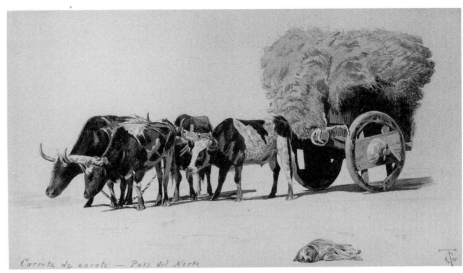

Carreta de zacate — Paso del Norte

LECHERO (MATAMOROS)
n.d., brown wash drawing on paper, 5½" × 5¼"
Monogrammed lower right: T. G.
Titled on reverse: Lechero (Matamoros)

This carefully rendered wash drawing of a Mexican *lechero*, or milk vendor, supplies another insight into nineteenth-century life-styles prevalent in the border area. The milk vendor on his mule could have been seen on the streets of San Antonio as well as in northern Mexico. Gentilz, by depicting genre scenes of this nature, bequeathed a rich pictorial legacy that portrayed everyday activities in Texas and Mexico of the period.

PROVENANCE:
-1964: Collection of Mrs. Terrell Bartlett.
1964: Gift to SAMA by Mrs. Terrell Bartlett.
64–19 G (3)

EXHIBITIONS:
1964: The Early Scene: San Antonio, WMM (June 7 to August 31).
1974–1975: Theodore Gentilz: A Frenchman's View of Early Texas, WMM (November 25, 1974, to March 1, 1975).
1986: Texas Seen/Texas Made, SAMOA (September 29 to November 30).

PUBLICATIONS:
Utterback, "Additions to the Early Texas Collection," *Witte Quarterly*, 3 (1965): 13.
Utterback, *Early Texas Art* (1968), 14.
Kendall and Perry, *Gentilz* (1974), 94: plate 44.

WORKS BY JEAN LOUIS THEODORE GENTILZ
NOT ILLUSTRATED:

BLUE MORNING GLORY
n.d., watercolor on paper, 6½" × 9"
Unsigned (attributed)
77–1022 G
Gift to SAMA by Walter Nold Mathis.

LEAVES AND FLOWERS
n.d., watercolor on paper, 9" × 6¼"
Unsigned (attributed)
77–1023 G
Gift to SAMA by Walter Nold Mathis.

CARRETA DE ZACATE—PASO DEL NORTE
n.d., brown wash drawing on paper, 7" × 12"
Monogrammed lower right: T. G.
Titled lower left: Carreta de Zacate—Paso del Norte

El Paso del Norte, now shortened to El Paso, has long been an important crossroad between Mexico and the United States.[58] Its name, Pass of the North, aptly implies a natural passageway through wild and rugged country. Conveyances such as the oxcart with its load of *zacate*, or hay, apparently were familiar sights in Gentilz's time, and the artist in his small painting catches the mood of the weary oxen indulging in a bit of much-needed rest. The complacent aura of the sketch is further enhanced by a sleeping dog lying in the foreground.

PROVENANCE:
-1964: Collection of Mrs. Terrell Bartlett.
1964: Gift to SAMA by Mrs. Terrell Bartlett.
64–19 G (4)

EXHIBITIONS:
1964: The Early Scene: San Antonio, WMM (June 7 to August 31).
1974–1975: Theodore Gentilz: A Frenchman's View of Early Texas, WMM (November 25, 1974, to March 1, 1975).
1986: Texas Seen/Texas Made, SAMOA (September 29 to November 30).

PUBLICATIONS:
Utterback, "Additions to the Early Texas Collection," *Witte Quarterly*, 3 (1965): 14.
Utterback, *Early Texas Art* (1968), 16.

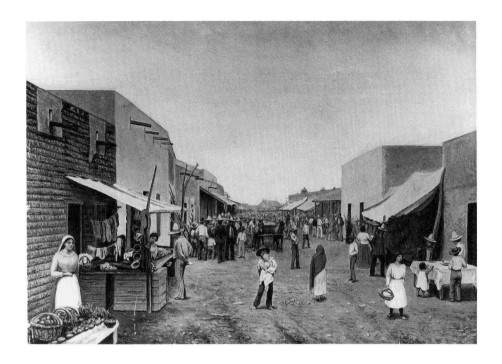

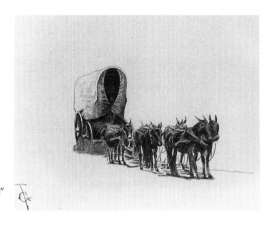

BROWNSVILLE, TEXAS
n.d., brown wash drawing on paper, 4½" × 5⅛"
Monogrammed lower left: T. G.
Titled on reverse: Brownsville, Texas

Brownsville, at the southeastern tip of Texas across from Matamoros, Mexico, is at the opposite end of the state from El Paso. Standard means of transportation along the border between Brownsville and El Paso included mule trains, oxcarts, and covered wagons. These conveyances, with their slow-moving animals, transported goods from seaport towns to San Antonio, then westward to army garrisons, and frequently into Mexico. On a return trip, their cargo often was silver from the mines in Mexico.[59] When Gentilz painted typical Mexican oxcarts or trains of mules pulling Conestoga wagons, he did not realize that he was recording a vanishing era in Texas history.

PROVENANCE:
-1964: Collection of Mrs. Terrell Bartlett.
1964: Gift to SAMA by Mrs. Terrell Bartlett.
64–19 G (2)

EXHIBITIONS:
1964: The Early Scene: San Antonio, WMM (June 7 to August 31).
1974–1975: Theodore Gentilz: A Frenchman's View of Early Texas, WMM (November 25, 1974, to March 1, 1975).
1986: Texas Seen/Texas Made, SAMOA (September 29 to November 30).

PUBLICATIONS:
Utterback, "Additions to the Early Texas Collection," *Witte Quarterly*, 3 (1965): 12.
Utterback, *Early Texas Art* (1968), 14.
Kownslar, *The Texans* (1972), 212.
"Western Display," San Antonio *Light*, September 8, 1974.

MEXICAN MARKET, PAY DAY, COAL MINERS, SAN FELIPE, COAHUILA, MEXICO
n.d., oil on canvas, 10" × 14"
Signed lower right: T. Gentilz
Inscribed on reverse: Pay Day, Coal Miners, San Felipe, Coahuila, Mexico

Gentilz's graphic and meticulous composition poignantly conveys the bustling activity of a Mexican market on payday. The canvas is ambitious in its complexity. The children appear to be indulging in *dulces* (sweets) and the men in a bit of *tequila*. Some of the women sell pottery, vegetables, and clothing from makeshift booths. This is a scene of camaraderie, in which people are not only spending their hard-earned pesos but also are exchanging pleasantries, gossip, and the latest news, as well as merchandise. Although the figures are somewhat stiff and laboriously drawn, the artist imparts an atmosphere of gaiety and festivity.

PROVENANCE:
-1937: Collection of the Gentilz-Frétellière Family.
1937: Purchased by SAMA from the artist's nephew with Witte Picture Funds.
37–6792 P (1)

EXHIBITIONS:
1946: Early San Antonio Paintings, WMM (February 24 to March 12).
1960: Go West, Young Man, Marion Koogler McNay Art Institute, SA (January 1 to February 17).
1964: The Early Scene: San Antonio, WMM (June 7 to August 31).
1974–1975: Theodore Gentilz: A Frenchman's View of Early Texas, WMM (November 25, 1974, to March 1, 1975).
1984: The Texas Collection, SAMOA (April 13 to August 26).
1986: "Au Texas": The Art of Theodore Gentilz, Star of The Republic Museum, Washington, Texas (June 15 to September 14).
1986: Texas Seen/Texas Made, SAMOA (September 29 to November 30).

PUBLICATIONS:
Utterback, *Early Texas Art* (1968), 22.
Kendall and Perry, *Gentilz* (1974), 105: plate 55.
"The Vanished Texas of Theodore Gentilz," *American Heritage*, 25 (October 1974): 24.
"Historic San Antonio . . . a pictorial glimpse," San Antonio *Express-News*, October 16, 1977.
HRW [Holt, Rinehart and Winston] *Time Line* (1989): plate 46.

59. "Pioneer Freighters, in 1877, Organized First Union in Texas," San Antonio *Express*, August 18, 1935.

TEXAS WILDFLOWERS
n.d., watercolor on paper, 8″ × 8″
Signed lower right: T. Gentilz
Inscribed on reverse:
Gaillardia Compositae yellow, red, brown
Verbena Verbonnaceae lilac
Huisache Mimoseae white-yellowish

Gentilz's numerous paintings of Texas
wildflowers are an indication of his interest in
botany. In this painting he has selected three
of the most prevalent species, flowers with
which we are all familiar: the Gaillardia, or
firewheel, with its strong red, brown, and
yellow colors; the Verbena, painted in
luscious lavender tones; and the Huisache or
mesquite with its feathery blossoms and
tapering leaves. Like many artists of the
period, he found beauty in the most
commonplace subjects.

PROVENANCE:
1882–1969: Collection of the Gentilz-Frétellière Family.
1969: Gift to Carmen Perry from the Gentilz-
Frétellière Family.
1991: Purchased by SAMA from Carmen Perry with
Witte Picture Funds.
91–10 P (1)

BIRDS IN FLOWERING BRANCHES
ca. 1892, watercolor on paper, 18⅛₆″ × 13½″
Unsigned

Although Theodore Gentilz usually was
careful to sign or at least initial his work,
this lovely watercolor bears no signature.
Nevertheless, the excellence of the painting,
the delicate handling of the textures, and
the accuracy of the drawing leaves little
doubt that it was done by the master. The
watermark on the heavy paper is dated 1892,
which implies that it was painted in the latter
years of his life, when Gentilz was able to
obtain finer-quality materials.

PROVENANCE:
ca. 1892–ca. 1945: Collection of the Gentilz-Frétellière
Family.
1945: Purchased by SAMA from V. J. Rose with Witte
Picture Fund. Rose acquired the painting from the
artist's nephew.
45–87 P (12)

EXHIBITIONS:
1946: Early San Antonio Paintings, WMM (February 24
to March 12).
1964: The Early Scene: San Antonio, WMM (June 7 to
August 31).
1970: Special Texas Exhibition, ITC (March 16 to
October 8).
1974–1975: Theodore Gentilz: A Frenchman's View of
Early Texas, WMM (November 25, 1974, to March 1,
1975).
1986: Texas Seen/Texas Made, SAMOA (September 29
to November 30).

PUBLICATIONS:
Utterback, *Early Texas Art* (1968), 13.

MARIE FARGEIX GENTILZ

Marie Fargeix and Theodore Gentilz were married in France in 1849 on one of his return journeys to his native land.[1] Marie was well-educated and talented, a singer and musician and evidently a poetess as well, for she is credited with writing the lyrics to a musical composition dedicated to their friend Bishop Claude Dubuis.[2] Theodore made a charming pencil sketch of her as a young woman seated at a square piano, hair stylishly coiled upon her head, her distinguished profile accented with dangling earrings.[3] He also painted her later in life when her hair was white and her features still serene and engaging.[4] As an artist, Marie's style and techniques were so akin to her husband's that unsigned works could be attributed to either. Marie Gentilz died in 1898.[5]

INDIAN MAN, APACHE
n.d., watercolor on toned paper, 8⁷⁄₁₆″ × 5¹¹⁄₁₆″
Signed lower right: M. Gentilz

Marie Gentilz's version of *Indian Man, Apache* is virtually identical to Theodore's *Kiowa Big Tree*, a watercolor in the collection of the Daughters of the Republic of Texas Library at the Alamo.[6] Both renditions appear to have been painted from a photograph in A. B. Stephenson's *Album of Indians* (1876).[7] Why both artists chose to paint such portraits is unknown. Perhaps it was due to the notoriety Kiowa Big Tree acquired from his involvement in a raiding party that resulted in the death of seven men and became known as the Salt Creek Massacre.[8]

PROVENANCE:
–ca. 1945: Collection of the Gentilz-Frétellière Family.
1945: Purchased by SAMA from V. J. Rose with Witte Picture Funds. Rose acquired the painting from the artist's nephew.
45–87 P (8)

EXHIBITIONS:
1946: Early San Antonio Paintings, WMM (February 24 to March 12).
1964: The Early Scene: San Antonio, WMM (June 7 to August 31).
1970: Special Texas Exhibition, ITC (March 16 to October 8).
1986: Texas Seen/Texas Made, SAMOA (September 29 to November 30).

PUBLICATIONS:
Utterback, *Early Texas Art* (1968), 25.

BUTTERFLY (PAPILIO MACHAON)
n.d., watercolor on paper, 6¼″ × 6″
Monogrammed lower right: M. G.
Inscribed top center: *Papilio Machaon*

Marie Gentilz's interest in natural history subjects extended to insects as well as to flowers. This watercolor of a swallowtail butterfly does not appear to be of a native species. It may have been copied from a scientific book or print, or she may have elaborated on a local variety and added exotic coloring to the lower wings. In any event, she produced an exquisite study of one of nature's most beautiful insects.

PROVENANCE:
-1969: Collection of the Gentilz-Frétellière Family.
1969: Gift to Carmen Perry by the Gentilz-Frétellière Family.
1991: Gift to SAMA by Carmen Perry.
91-9 G (2)

FLOWER STUDY
n.d., watercolor on paper, 5¼″ × 4″
Signed lower right: M. Gentilz

Marie Gentilz's studies of flowers are as meticulous as her husband's. When she painted this dainty pink flower, she imbued it with a delicacy that imparts its fragile ephemeral quality. Although many of her works are unsigned, she evidently cared enough for this watercolor to add her signature, a fortunate occurrence for the collector or researcher.

PROVENANCE:
-1969: Collection of the Gentilz-Frétellière Family.
1969: Gift to Carmen Perry by the Gentilz-Frétellière Family.
1991: Gift to SAMA by Carmen Perry.
91-9 G (1)

1. Utterback, *Early Texas Art*, 8.
2. Kendall and Perry, *Gentilz*, 35.
3. Ibid., 78, plate 28.
4. Ibid., 100, plate 50.
5. Ibid., 46.
6. Ibid., 107.
7. Ibid., 43.
8. Webb, Carroll, and Branda (eds.), *The Handbook of Texas*, 2, s.v. "Kiowa Indians."

BOYER GONZALES, JR.

(1909–1987)

Boyer Gonzales, Jr., born on February 11, 1909, in Galveston, Texas, was the only child of Boyer Gonzales, Sr., and Eleanor (Hertford) Gonzales. His father, a cotton broker, became interested in painting as he traveled extensively through the United States and Europe on business and, finally, gave up this occupation to become a professional painter.[1] So Boyer Jr.'s youth was spent in surroundings that stimulated his interest in the arts, and at the age of six he exhibited a pencil sketch of a full-rigged ship at sea in a Galveston show.[2]

Boyer's early education was sporadic. He attended various elementary schools in Texas and New York and was tutored by his parents. In 1924 Gonzales was enrolled in the Mercersberg Academy, a private school for boys in Pennsylvania. By 1927 he was attending the University of Virginia, where he majored in architecture, receiving his B.S. in 1931. His summers were spent in the Woodstock Art Colony in New York where his father had built a studio in 1919. He worked with his father and became associated with many outstanding American artists who further influenced his artistic career.[3]

Gonzales expressed fond memories of these years. He remembered Birge Harrison, the painter; George Bellows (1882–1925), painter, sportsman, and Boyer's baseball coach; Robert Henri, a frequent Woodstock visitor; and Bolton Brown, the lithographer.[4] After his graduation from the University of Virginia, Boyer moved to the family home and studio in Woodstock and seriously began his painting career. His mentors were Henry Lee McFee and Yasuo Kuniyoshi (1893–1953), but Eugene Speicher (1883–1962) and Charles Rosen also were his advisors and good friends. By 1934, Boyer was assisting McFee in his Woodstock classes, and he became a teacher as well as a painter.[5]

McFee moved to San Antonio in 1937 and established a painting school in the old Borglum Studio in Brackenridge Park. Boyer Gonzales, Jr., was his assistant. The school was under the auspices of the Witte Memorial Museum and was known as the Museum School of Art. Boyer left the school in 1939 to join the faculty of the University of Texas at Austin Department of Art, which had been established the year before by Dean E. William Doty, Ward Lockwood (1894–1963), and Loren Mozley (1905–1989). McFee left the school in 1940 to accept a position in the Chouinard School of Art in Los Angeles and was replaced by Charles Rosen, who served as director and instructor through 1941. When World War II intervened, the Museum School was transferred to the spacious grounds owned by Marion Koogler McNay and became the San Antonio Art Institute.[6] In 1942 Boyer received a direct commission as a second lieutenant in the U.S. Army Air Corps and served at bases in Texas, Ohio, Florida, and California. In the summer of 1945 he went to the Philippines and Japan, returning to the States in 1946. On his voyage home he met his future wife, Elizabeth Cullyford Bole, who had been in Japan with the Red Cross. They were married on December 28, 1946, in Los Angeles.[7]

Boyer returned to the University of Texas as assistant professor and chairman of the Department of Art, his first university administrative position and one which he held for two years. He also resumed his painting career, greatly stimulated by the summers he spent at his family home in Woodstock during this time. In 1954 he moved to Seattle, Washington, as director of the School of Art and professor of art at

1. *Boyer Gonzales, The Painter: A Retrospective Exhibition, 1930 to the Present*, Index of Art in the Pacific Northwest, 13 (Seattle: Henry Art Gallery, University of Washington, 1979), 9.
2. "Exhibit of Works of Art under the auspices of the Galveston Art League," Galveston *Tribune*, January 18, 1916.
3. *Boyer Gonzales, The Painter*, 10.
4. "Transcription of a Tape-recorded Interview with Boyer Gonzales [Jr.], at the Artist's Home in Seattle, Washington, November 26, 1984, Barbara Johns, Interviewer." Photocopied typescript, Boyer Gonzales, Sr., file, SAMA Texas Artists Records.
5. *Boyer Gonzales, The Painter*, 11–13.
6. Woolford and Quillin, *The Story of the Witte Memorial Museum*, 121–122.
7. *Boyer Gonzales, The Painter*, 14.
8. Ibid., 14–16.
9. Ibid., 15.
10. Bettie Gonzales (Seattle) to author (SA), July 28, 1987.
11. Catalogues and listings, Gonzales, Jr., file, SAMA Texas Artists Records.

STREET SCENE IN SAN ANTONIO
1938, oil on canvas, 16″ × 20″
Signed lower left: Boyer Gonzales, Jr.

This *Street Scene in San Antonio* is an important
example of the new trends in painting that
were being introduced into the local art
scene in the 1930s. Visually recognizable as a
group of buildings, it nevertheless has an
abstract quality with its flat surfaces broken
into patterns, its well-organized design in
the arrangement of the structures, and the
juxtaposition of pleasing colors. It won the
first prize in the 1938 Annual Local Artists
Exhibition in San Antonio and was given by
the artist to Eleanor Onderdonk as a token of
his respect and esteem for her support and
encouragement in the local art field.

PROVENANCE:
1939–1964: Collection of Eleanor Onderdonk.
1964: Inherited by Ofelia Onderdonk from the Estate
of Eleanor Onderdonk.
1976: Gift to Mr. and Mrs. Eric Steinfeldt by Ofelia
Onderdonk.
1977: Gift to SAMA by Mr. and Mrs. Eric Steinfeldt.
77–62 G

EXHIBITIONS:
1938–1939: Eighth Annual Local Artists Exhibition,
WMM (December 18, 1938, to January 21, 1939).
1986: Texas Seen/Texas Made, SAMOA (September 29
to November 30).
1990: Looking at the Land: Early Texas Painters,
San Angelo Museum of Fine Arts (February 22 to
March 25).

PUBLICATIONS:
Molly Heilman, "Local Artists Show at Witte
Museum," San Antonio *Light*, December 18, 1938.

WORKS BY BOYER GONZALES, JR.,
NOT ILLUSTRATED:

PATOS #2
1962, crayon on paper, 13⅛″ × 16⅛″
Signed, titled, and dated lower right: Boyer Gonzales/
Patos #2 '62
63–240 P
Purchased by SAMA from the artist with Witte
Picture Fund.

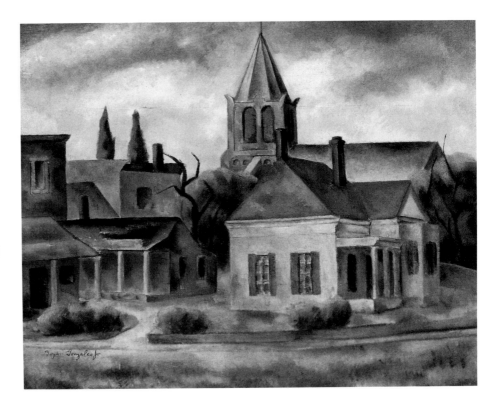

the University of Washington. By 1966 he resigned the directorship of the School of
Art to return to full-time teaching and to devote more time to painting. At the age
of seventy Boyer decided to retire from academic life to continue his private pursuit
of painting.[8]

Gonzales's painting style developed from visual realism to semi-abstract
interpretation to total abstraction. His close association with McFee in the early years
exposed him to the principles of pictorial structure based upon Cézanne's (1839–1906)
method of breaking space and form into planes. Gonzales carried these themes
forward into a semi-abstract idiom and later to paintings translated into patterns
of color.

He once said:

Although I look at nature very carefully and lovingly, in no sense do I try to
make facsimiles of what I see. I am greatly interested in local color; the effects of light on
color; for example, the fact that some of the green on a tree is warm and some of it is
cool. I use local color as a point of departure, and sometimes it will be fairly faithfully
translated. However, I do not hesitate to make a red that I see into a green in the
painting, or to make a blue into an orange if it seems appropriate according to my feeling
at the moment and my feeling for the total canvas.[9]

Boyer Gonzales, Jr., died on July 27, 1987.[10] Only time will tell whether or
not his work will survive in importance. His influence, however, cannot be ignored.
Through his teaching, his many exhibitions, and his impressive awards, he helped to
carry Texas painting forward in the twentieth century.[11]

BOYER GONZALES, SR.

(1867–1934)

Boyer Gonzales was born into a very distinguished family. His early years were spent as a cotton broker, following in the footsteps of his father Thomas, who bought and sold cotton in Galveston after the Civil War.[1]

Thomas Gonzales and Edith Boyer married in New Orleans on August 28, 1850, and moved to Texas shortly thereafter. They had six children. Family accounts maintain that Boyer Gonzales was born in Houston in 1867 but grew up on Galveston Island.[2]

For the young boy, living on the island in the nineteenth century must have been an exhilarating experience, with the waves wildly crashing against the sandy beach or softly murmuring under a moonlit sky. The myriad birds flying overhead and the tall ships gliding in and out of the harbor shaped his destiny. Boyer's youth was spent hunting and fishing on the island's golden shores and sailing in the blue waters of the bay.[3]

In 1892, at the age of twenty-five, Boyer made his first business trip as a cotton broker to Europe on the S. S. Britannia. His diary of the journey clearly illustrates his sensitivity to his surroundings and his assessment of the people he met or saw.[4] According to Gonzales's son, he spent as much time in museums developing his interest in art as he did in selling cotton.[5] He gradually started to paint and by 1912 had left the cotton business entirely "to become an artist."[6]

Gonzales had begun to take his art seriously by 1894, and his first mentor was William J. Whittemore (1860–1955), with whom he studied at the art colony in Annisquam, Massachusetts. During the summer of 1900 he worked with Walter F. Lansil (1846–1925) in Boston. Lansil, a marine painter, was a student of Hendrick Willem Mesdag (1831–1915), and Mesdag's influence, although indirect, is readily apparent in some of Gonzales's earlier work.[7]

But one of the greatest influences in Gonzales's life was his association with Winslow Homer (1836–1910), whom he probably met at an early age through Arthur Homer, a Galveston cotton broker who was the brother of Winslow and a colleague of Thomas Gonzales. Winslow Homer and Boyer Gonzales spent many a summer in Prout's Neck, Maine, sailing, fishing, and painting. Homer was never Gonzales's teacher, but inspired him and encouraged him to become an artist.[8]

This alliance lasted until Gonzales married Eleanor Hertford on September 21, 1907, in The Little Church Around the Corner in New York. They spent their honeymoon in Woodstock, New York, where Gonzales studied with Birge Harrison. The couple took a second extended honeymoon in 1908 and traveled throughout Europe for a year.[9] While in Italy, Gonzales studied watercolor with Giuliani (?) in Florence. The couple had one child, Boyer, Jr., who also became a painter.[10]

By the time of his marriage, Gonzales had begun to acquire recognition for his work. He accepted an invitation to exhibit in the Texas Pavilion at the 1904 St. Louis World's Fair. The letter of request was a flattering one: "It is not the aim of the art department to collect a large exhibit, but to show a few of the best works of each of the leading artists of Texas. Such a collection would of course be notably incomplete without something from your gifted brush."[11]

After Gonzales left the cotton business in 1912 he became a successful full-time painter, exhibiting in galleries and museums throughout the country. In 1919 he built a studio in Woodstock, New York, where he spent his summers, and lived

1. *Galveston City Directories*, 1866–1886, Rosenberg Library, Galveston, Texas.
2. John Henry Brown, "Thomas Gonzales, Galveston," in John Henry Brown, *Indian Wars and Pioneer of Texas* (Austin: L. E. Daniell, n.d.), 297–298.
3. Boyer Gonzales, Jr., to author (Seattle, Washington), interview, August 20, 1984.
4. Diary of Boyer Gonzales, Sr., 1892. Typescript, Rosenberg Library, Galveston.
5. "Transcription of a Tape-recorded Interview with Boyer Gonzales [Jr.]."
6. Photocopied handwritten note by Boyer Gonzales, Sr., 1912. Boyer Gonzales, Sr., file, SAMA Texas Artists Records.
7. Edward T. Simmen (Galveston) to author (SA), November 21, 1991. Dr. Simmen is a professor in the Department of Languages at the University of the Americas, Cholula, Mexico. Dr. Simmen has been working on the Gonzales family history and recently has found new and illuminating information.
8. Ibid.
9. Ibid.
10. Undated biographical typescript supplied by Boyer Gonzales, Jr. Boyer Gonzales, Sr., file, SAMA Texas Artists Records.
11. Simmen to author, November 21, 1991.

VIEW OF MISSION CONCEPCIÓN
n.d., watercolor on paper, 5″ × 5⅛″
Signed lower right: Boyer Gonzales

When the Gonzaleses spent their winters in
San Antonio, the artist painted some of the
local historical sites. His watercolor of *Mission
Concepción* is handled freely with luxuriant
flowing color. There is no sign of inhibition in
his quick strokes of clear paint, a technique
he employed to great advantage when
working with his favorite theme of the sea
and ships.

PROVENANCE:
ca. 1930–1984: Collection of the Gonzales Family.
1984: Gift to SAMA by Boyer Gonzales, Jr.
84–73 G (1)

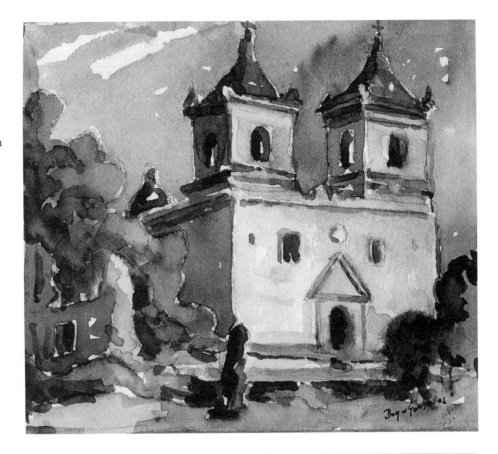

Gonzales painted the San José Tower from
an unusual angle and embellished the
foreground with trees in warm gold and
green tones. Small as the sketch is, the artist
conveys the sturdiness of the stone structure
in strong colors that contrast with the
feathery technique used in the trees.

PROVENANCE:
ca. 1930–1984: Collection of the Gonzales Family.
1984: Gift to SAMA by Boyer Gonzales, Jr.
84–73 G (2)

MISSION SAN JOSÉ TOWER
n.d., watercolor on paper, 7⅛″ × 5⅛″
Unsigned

Boyer Gonzales, Sr., seated on the right, with Gilard
Kargl, taken in 1933. Courtesy of Mrs. Gilard Kargl.

during the winters in Galveston and San Antonio. He became involved in Texas art organizations and exhibited in all major Texas exhibitions, including the Texas State Fair shows, winning many prizes and medals, and selling much of his work.[12]

Gonzales was elected to three prestigious New York clubs: the New York Watercolor Club, the National Arts Club, and the Salmagundi Club. He also was a member of the Washington Watercolor Club, the Mississippi Art Association, the Texas Fine Arts Association, and the American Federation of Arts.[13] He had a one-man show at the Witte Memorial Museum in 1927 and, after his death on February 14, 1934, a Memorial Exhibition was held in the museum in April 1936 and circulated to several other museums in the state.[14]

A gentle man, Gonzales's love for nature, especially bird life, led him to become an avid conservationist. He was also known as a writer, and most of the articles he composed were devoted to poetic accounts of birds.[15] He is a prime example of an artist who was widely known, generally acknowledged, and universally respected during his lifetime, but who has dropped into obscurity since his death.

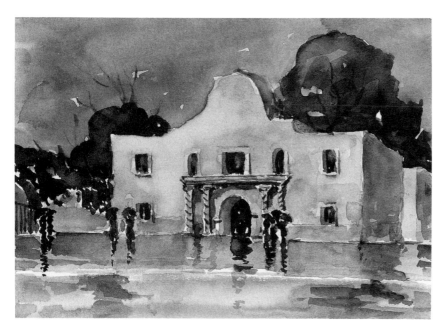

ALAMO LONG BARRACK WALL
n.d., watercolor on paper, 5″ × 7″
Signed lower left: Boyer Gonzales

Winslow Homer's influence on Gonzales is most evident in his watercolors. The ease with which the brushstrokes are made, the control of the strong masses of color, and the freedom of the flowing lines all indicate Gonzales's mastery of the craft.

PROVENANCE:
ca. 1930–1984: Collection of the Gonzales Family.
1984: Gift to SAMA by Boyer Gonzales, Jr.
84–73 G (4)

THE ALAMO
n.d., watercolor on paper, 5″ × 7″
Unsigned

Gonzalez depicts the Alamo in a sudden shower with figures grasping umbrellas clustered in the foreground. The streets glisten with moisture, and the building is clean and uncluttered in its freshness. The watercolor medium lent itself naturally to his interpretation of the scene.

PROVENANCE:
ca. 1930–1984: Collection of the Gonzales Family.
1984: Gift to SAMA by Boyer Gonzales, Jr.
84–73 G (3)

12. Fisk, A History of Texas Artists, 48–50.
13. Forrester-O'Brien, Art and Artists, 109.
14. Catalogues and listings, Gonzales, Sr., file, SAMA Texas Artists Records.
15. Boyer Gonzales [Sr.], "The Rhythm of Wings," Christian Science Monitor, November 13, 1926.

XAVIER GONZALEZ

José Arpa's nephew Xavier Gonzalez was born in Almería, Andalusia, Spain, on February 15, 1898. Gonzalez's personal inheritance was a rich and unusual mixture of artistry from his mother's family and an empirical mentality from his father, a farmer with a particularly inquiring and inventive mind. Although untrained, his father became an expert agricultural engineer, and often was invited to Spanish-American countries to teach correct methods of agriculture. Because the family sometimes accompanied him on his longer trips, Xavier Gonzalez left school at age thirteen. When he was about eighteen, he decided to stay in Mexico to become a mechanical engineer in a gold mine.[1]

In 1922 Gonzalez traveled to the United States and took a job with a railroad in Iowa. He was adept at mechanical drafting, and his job was to make quick and accurate drawings of the defective parts on the rail line as soon as possible after a train had broken down. These sketches provided repair shops with the necessary details for replacements. Later he went to Chicago where he sustained himself by working in an automat, pressing pants, sweeping railbeds, designing window displays, and lettering show cards. Meanwhile he studied at night at the Art Institute of Chicago.[2]

Gonzalez returned to Mexico for a short time and taught art in the public schools, along with Rufino Tamayo (1899–1991) and Miguel Covarrubias (1904–1957). In about 1925 he decided to join his uncle, José Arpa, in San Antonio, where he assisted him in the Arpa School of Painting.[3] Gonzalez introduced an innovative teaching program for talented local pupils. Young people were selected from junior and senior high schools on a merit basis and were not charged for tuition or supplies. Shortly after the Witte Memorial Museum opened its doors in 1926, these classes, still under Gonzalez's guidance, were held in the new facility.[4]

In 1931 Xavier Gonzalez accepted a teaching position at Sophie Newcomb College in New Orleans, and his duties as instructor in the Saturday children's art classes in San Antonio were assumed by one of his former students, Mallory Page Warren (1900–1986).[5] While at Newcomb College, Gonzalez met and married one of his students, Ethel Edwards, who became a distinguished artist in her own right.[6]

Throughout the years Xavier Gonzalez continued his association with the Witte Memorial Museum and San Antonio. He had one-man shows in the museum in 1928, 1947, 1951, 1955, and 1968. From October 14 through November 2, 1951, he was also guest instructor at the San Antonio Art Institute.[7]

In 1968 Gonzalez was selected by the San Antonio Art League to help celebrate the 250th birthday of San Antonio with an exhibition in the Witte Memorial Museum. It was the league's contribution to HemisFair '68, and their objective was to choose an internationally known artist with some relationship to Texas who could serve as a symbol for this gala occasion. Amy Freeman Lee wrote:

When we faced the selection of the particular artist who could serve as our symbol, our thoughts turned immediately to an exciting choice in the person of a Spaniard who has lived in the United States almost all of his life and whose work is known and admired all over the world—Xavier Gonzalez. Since he lived and taught in San Antonio and since a part of his early career development took part in our own Witte Museum, we claim him as our very own. He and his uncle, José Arpa, have left indelible influences on the art of Texas and the Southwest which are still evident in the work pouring from the brushes of many artists of this region.[8]

1. Amy Freeman Lee, *Xavier Gonzalez: A Gift of Compassion to the Confluence of Cultures* (San Antonio: Witte Memorial Museum, 1968), [3].
2. Martha Utterback, "Xavier Gonzalez Biography." Undated typescript, Xavier Gonzalez file, SAMA Texas Artists Records.
3. Ibid.
4. "Battered Fate Develops His Talent, Now Lends Others a Helping Hand," San Antonio *Express*, January 8, 1928.
5. "Teacher Named for Art Course," San Antonio *Express*, September 27, 1931.
6. Lee, *Xavier Gonzalez*, [3].
7. Listings and catalogues, Xavier Gonzalez file, SAMA Texas Artists Records.
8. Lee, *Xavier Gonzalez*, [3].

FARM YARD SCENE, WARING, TEXAS
1915, oil on canvas, 20″ × 24½″
Signed and dated lower right: Xavier Gonzalez/
Waring, Texas, 1915

Xavier Gonzalez was seventeen years old when he painted this scene in Waring, Texas, a small rural community near San Antonio. As he had not yet taken up residency in San Antonio, he probably did the painting while visiting his uncle. When Gonzalez selected a simple barnyard as his subject, he was emulating his distinguished uncle. The daring, resolute brushstrokes, the vivid color, and the courageous choice of subject matter indicate an early mastery of his craft.

PROVENANCE:
·1976: Collection of James Rieves Anderson and
J. D. H. Anderson.
1976: Purchased by SAMA from the National Bank of
Commerce of San Antonio, Executors for the Estate
of James Rieves Anderson and J. D. H. Anderson,
with Endowment Funds.
76–83 P

EXHIBITIONS:
1986: Texas Seen/Texas Made, SAMOA (September 29
to November 30).

PUBLICATIONS:
SAMA *Calendar of Events* (October 1986): [2].
"The San Antonio Museum Association Exhibits,"
San Antonio Monthly, 6 (October 1986): 38.

Xavier Gonzalez was a natural and undisputed choice for this accolade. He was world-renowned for his work and, besides having developed into a painter with a distinctly expressionistic style, he created imaginative sculpture in bronze, clay, paper, fiberglass, and cast concrete, and became famous for his immense and moving murals. He has been called a "Renaissance Man," an apt description of his talents.[9]

Gonzalez's accomplishments may be predicated upon his boundless energy, his dynamic personality, and his long and productive life, as well as his prodigious talents. During World War II he was an artist in the U.S. Army and Navy Education Information Department. Following this assignment, he lectured at the Metropolitan Museum of Art in New York and taught at the Brooklyn Museum.[10] His honors, medals, and awards are too lengthy to list completely but include a grant from the American Academy of Arts and Letters, a Guggenheim Fellowship, and the National Art Club Gold Medal for 1978. He is represented in museum collections and exhibitions at the Metropolitan Museum of Art, the Whitney Museum of American Art, the Brooklyn Museum, the Museum of Modern Art, the Carnegie International at the Carnegie-Mellon, the Corcoran Gallery of Art in Washington, D.C., and the Seattle Art Museum; museums in Texas, Oklahoma, Florida, California, and other states; and also in Paris, Venice, Brussels, Tokyo, Spain, and Italy, as well as in private collections.[11]

Probably the first murals he ever attempted were for the Municipal Auditorium in San Antonio in 1933. Gonzalez painted the murals under the Civil Works Administration program, assisted by Rudolf Staffel (1911–) and John Griffith. Two years after these murals were installed, public complaints maintained that "they bore insignia and symbols of a sinister nature," namely an upraised fist and a palm with a bleeding wound. The murals were ordered removed by Mayor C. K. Quin in 1935 and were returned to the government.[12]

This must have been the artist's one disappointment in his painting career, for he produced at least seventeen important murals for major cities throughout the country in following years.[13] He even served as president of the National Association of Mural Painters in 1968.[14]

Texas can indeed be proud of Xavier Gonzalez, who started his career in San Antonio.

WORKS BY XAVIER GONZALEZ
NOT ILLUSTRATED:

STREET SCENE IN SAN ANTONIO
1927, oil on canvas, 18¼″ × 24¼″
Signed and dated lower right: Xavier Gonzalez/'27
90–16 P
Purchased by SAMA from Mr. and Mrs. Conrad
Gonzales with Witte Picture Funds.

9. Ralph Fabri, "Xavier Gonzalez: Artist of Many Talents," *Today's Art*, 14 (August 1966): 7.
10. Ibid.
11. Listing of awards, commissions, etc. Undated photocopied typescript, Xavier Gonzalez file, SAMA Texas Artists Records.
12. "Quin Orders CWA Murals Removed," San Antonio *Express*, August 28, 1935.
13. Undated listing of awards.
14. *Who's Who in American Art: 16th Edition*, s.v. "Gonzalez, Xavier."

LOUIS EDWARD GRENET

MELANCHOLISCHES MÄDCHEN
(MELANCHOLY MAIDEN)
n.d., mixed media on paper mounted on mat board,
14″ × 9½″
Signed lower left: Edw. Grenet
Titled lower left on mount: Melancholisches
Mädchen

The fact that this painting is signed in
German suggests that Grenet traveled to
other European countries while living in Paris.
His technique in this work is somewhat
atypical. It is a mixture of a number of
mediums and appears to be transparent
watercolor applied over graphite and charcoal
or possibly chalk. It may have been an
experimental effort and the result is pleasing
and somewhat exotic. The linear strokes
enhance rather than detract from the three-
dimensional quality. It would be interesting
to find other paintings in which he used this
unusual and inventive method.

PROVENANCE:
-1984: Galerie und Kunstantiquariat, Frankfurt,
Germany.
1984: Purchased by SAMA from Joseph Fach, Galerie
und Kunstantiquariat, Frankfurt, Germany, with
Witte Picture Fund.
84–45 P

EXHIBITIONS:
1986: Texas Seen/Texas Made, SAMOA (September 29
to November 30).

Edward Grenet was one of the first native Texans to make good in the
international art world. He was born in San Antonio on November 22, 1856, the eldest
of five children of Augustine Honoré and Magdalena (Coll) Grenet. Grenet's father had
emigrated to San Antonio from France in 1851 and established a successful mercantile
business in the city. His first shop, which was also his home, was located at the
northeast corner of Crockett and Nacogdoches streets in back of the Alamo.[1]

Honoré later moved into the long barrack and convent buildings on the
Alamo grounds when they were vacated by the United States Army Quartermaster
Corps in 1878. He leased these buildings from the Catholic Church and proceeded to
erect a simulated fortress that had a crenelated roofline and bristled with mock
cannon atop the stone edifices. This tribute to the Alamo's martial history became
known as "Grenet's Castle."[2] Grenet's stores brought an aura of cosmopolitan
sophistication to the frontier town, for his connections in France enabled him
to import many luxury items.[3]

Although Edward Grenet was keenly interested in art and had produced
many drawings and paintings in and around San Antonio, his father was not convinced
that he possessed enough natural talent to pursue art as a career. Honoré expected
Edward to take over his business. But Edward, in collusion with a neighbor, John
Conrad Beckmann, decided to demonstrate his talent by painting Beckmann's
portrait.[4]

The old gentleman proved to be a splendid subject. He had a flowing white
beard and a thick shock of silvery white hair, sparkling blue eyes, and strong ruddy
features. When the portrait was finished, Honoré Grenet was invited to view it, not
knowing who had painted it. He pronounced it an excellent likeness and a fine piece
of art work and asked, "Who painted that?" When told it was his son's work he
reconsidered his earlier assessment of Edward's abilities and made it possible for the
young Grenet to pursue his art studies.[5]

Grenet's ultimate goal was to study in Paris, but he first went to New York,
where he enrolled in the Art Students League, probably in James Carroll Beckwith's
class. One of his fellow students in 1878 was Robert Onderdonk.[6] Grenet apparently
studied at the National Academy of Design also, but when and with whom is not
clear.[7]

Edward Grenet returned to San Antonio in 1879.[8] On December 18 of that
year he married Eugenie Guilbeau, the daughter of François Guilbeau, Jr., the French
consular agent in San Antonio, and his wife, María del Rosario Ramón. It was a double
wedding ceremony, the other couple being François Guilbeau III and Caterina
Callaghan. The witnesses were the Count of Keroman, Edward Guilbeau, Mary
Lacoste, and María del Rosario Guilbeau.[9]

Edward Grenet and his wife remained in San Antonio for several years.
Edward first had a studio in room 5 of the Danenhauer Building at 276 West
Commerce Street. In 1881 he and his wife were living at the northwest corner of El
Paso and Pecos streets. By 1883, he and Robert Onderdonk each maintained studios in
one of the Maverick Buildings at 402 Houston Street at Losoya, and the Grenets had
moved into a home at 213 Crockett Street. In 1885 Grenet listed a studio in the
Kampmann Building but his residence address had changed to 217 Boulevard Pereire
in Paris.[10]

Whether Edward Grenet had ever been in France or studied in Paris before is unknown. In 1885, however, William Adolphe Bouguereau (1825–1905) and Tony Robert-Fleury (1837–1912) were among his instructors. He became quite a successful painter, exhibiting his work in the Paris Salon and throughout France and receiving numerous honors. He also won medals for his work in London.[11]

Grenet's greatest achievements were in the field of portraiture. In 1909 his painting of a lovely lady called *Mariola* won the first prize in the Paris Salon. His cousin Henry Marucheau sent a postcard of the painting to a friend in San Antonio and wrote: "This is the picture that my cousin won the first prize with in this year's Salon exhibition. Had the pleasure of eating dinner with the model."[12] Another San Antonian, John M. Steinfeldt, had accompanied Marucheau on his trip to France and also mentioned a visit to Grenet: "We went to hunt Ed Grenet [and] found him . . . amongst his pictures way up the top of a building."[13]

Grenet also painted General John J. Pershing while the American commander was in Paris during or after World War I.[14]

The Grenets never returned to San Antonio permanently and little is known of their life abroad. They had three children, Marguerite, Rosaria, and Constance, all apparently born in France.[15]

Louis Edward Grenet died in his adopted city of Paris on March 22, 1922. His obituary noted that he "was one of the few Americans who obtained recognition of his work in the Gran Salon at Paris."[16]

PORTRAIT OF A SMALL GIRL
n.d., oil on canvas mounted on panel, 11″ × 9″
Signed lower left: E. Grenet

Although this painting is neither dated nor identified, it is presumed to have been done in San Antonio, as it was acquired from the Callaghan family. It may be a portrait of Anita, the daughter of François Guilbeau III and Caterina Callaghan, the couple who were married in the double ceremony that also united the artist and his wife, Eugenie Guilbeau.[17] Whoever the child may be, the artist treated his subject with sensitivity and tenderness and a skill that foreshadowed his overwhelming success as a portrait painter after he settled in France.

PROVENANCE:
-1966: Collection of the Callaghan Family.
1966: Purchased by SAMA from Mrs. Alfred Callaghan with Witte Picture Funds. Mrs. Callaghan's husband, who served as mayor of San Antonio from June 1, 1947, until May 31, 1949, was the artist's nephew.
66–9 P

EXHIBITIONS:
1961–1962: Texas Painting Gallery, WMM (May 6, 1961, to June 1, 1962). Lent by Mrs. Alfred Callaghan.
1964: The Early Scene: San Antonio, WMM (June 7 to August 31). Lent by Mrs. Alfred Callaghan.
1986: Texas Seen/Texas Made, SAMOA (September 29 to November 30).

PUBLICATIONS:
Utterback, *Early Texas Art* (1968), 60.

1. Utterback, *Early Texas Art*, 58.
2. Steinfeldt, *San Antonio Was*, 28–30.
3. Chabot, *With the Makers of San Antonio*, 263. Augustine Honoré Grenet stocked the best French wines and liqueurs, canned delicacies, delectable sweets, and fine cigars. His business also expanded to include dry goods, boots and shoes, china, crockery, clothing, glassware, and fancy goods. He even introduced art objects from the French firm of Rousseau, Olivier, and Cie., among them oil paintings, according to some sources.
4. "Death Claims One of City's Aged Pioneers," *San Antonio Daily Express*, April 13, 1907.
5. Ibid.
6. Steinfeldt, *The Onderdonks*, 13.
7. Photocopied newspaper clipping, undocumented, Louis Edward Grenet file, SAMA Texas Artists Records.
8. Everett, *San Antonio*, 69. In November of that year, Edward Grenet participated in what was reported to be the first football game ever played in the city. And again, Robert Onderdonk, his colleague, was one of the players, but on the opposite team.
9. Chabot, *With the Makers of San Antonio*, 263–264.
10. Utterback, *Early Texas Art*, 58–59.
11. Ibid., 59.
12. Postcard from Henry Marucheau (Paris) to Erna Schelper (SA), May 8, 1909. The painting is illustrated in Charles Merritt Barnes, *Combats and Conquests of Immortal Heroes: Sung in Song and Told in Story* (San Antonio: Guezzaz and Ferlet Company, 1910), 162.
13. John M. Steinfeldt (Paris) to Mrs. John M. Steinfeldt (SA), July 6, 1909.
14. "Edward Grenet is Dead," *San Antonio Express*, April 8, 1922.
15. Utterback, *Early Texas Art*, 59.
16. "Edward Grenet is Dead."
17. Chabot, *With the Makers of San Antonio*, 264.
18. "Peter Gallagher," 11. Undated photocopied biographical typescript provided by the donor when the portrait was donated to SAMA.
19. "Peter Gallagher," *San Antonio Light*, October 26, 1969.
20. "Peter Gallagher," 2 (typescript); Webb, Carroll, and Branda (eds.), *The Handbook of Texas*, 1, s.v. "Gallagher, Peter."
21. "Homestead by Alamo to be Razed," *San Antonio Light*, December 16, 1936.
22. "Peter Gallagher," 3 (typescript).
23. George Cormack, "One Great Ranch: Three Great Tales," *San Antonio Express-News*, December 15, 1973.
24. "Peter Gallagher," 3 (typescript).
25. Ibid.; Webb, Carroll, and Branda (eds.), *The Handbook of Texas*, 1, s.v. "Gallagher, Peter."
26. "Peter Gallagher," 2 (typescript).

PORTRAIT OF MR. PETER GALLAGHER
ca. 1883, oil on canvas, 30″ × 24″
Unsigned (attributed)

PORTRAIT OF MRS. PETER GALLAGHER
1883, oil on canvas, 30″ × 24″
Signed and dated lower right: E. Grenet '83

Peter Gallagher was born in Westmeath County, Ireland, in 1812 and emigrated to America, landing in New Orleans in 1829. There he learned the trade of stonemasonry from John Mitchell, a prominent contractor. In 1837 he located in San Antonio and practiced his trade until 1841, when he joined the Santa Fe Expedition.[18]

Gallagher kept a diary of the trek, capture, and imprisonment of the ill-fated group that set out to establish Texas's sovereignty over Mexico's claim to eastern New Mexico.[19] Released from a Mexican prison on June 13, 1842, Gallagher returned to San Antonio and entered the mercantile business with Edward Dwyer. They conducted this enterprise not only in San Antonio but also along the Río Grande and in northern Mexico. At the outbreak of the war between the United States and Mexico, Gallagher joined the Texas Rangers under John Coffee (Jack) Hays and fought in several engagements against the Mexican troops. After the war he resumed his mercantile trade with Dwyer until about 1850, when he returned to Ireland for a visit. There he married Eliza Conran; the couple came to Texas and settled in Brownsville. In 1851 he and his wife moved to San Antonio and built a large home in back of the Alamo.[20] This house was razed in 1936 and the land used to make a park around the Alamo.[21]

During the early 1850s Gallagher established a vast ranch on San Geronimo Creek in Bexar and Medina counties, near San Antonio. He raised cattle, sheep, and horses, and his wife retained the ranch after his death in 1878. Mrs. Gallagher finally sold the ranch in 1884.[22] It was first used as a health resort but in 1926 became Texas's first "dude" ranch.[23] Gallagher, in conjunction with John James, also acquired several thousand acres of land near Fort Stockton in Pecos County, Texas, which he developed into irrigated farmland.[24]

Peter Gallagher was a self-made man. With only rudimentary education he taught himself literature, science, and history and served as chief justice of Bexar County from 1861 to 1864. He took an extensive interest in public affairs until his death on October 29, 1878.[25]

Although Grenet's portrait of Gallagher is undated, it presumably was done from a photograph in 1883 as a companion piece to the portrait of Mrs. Gallagher. The artist, however, managed to capture the character of his subject, with his twinkling blue eyes and strong features.

PROVENANCE:
ca. 1883–1991: Collection of the Gallagher Family.
1991: Gift to SAMA by Elizabeth Conroy Gibson and Alicia Conroy Howard.
91–39 G (1)

Mrs. Gallagher's portrait is livelier and less rigid than that of her husband. This no doubt is because it was painted from life rather than from a photograph. Her features convey a pleasant, even mischievous personality, with sparkling brown eyes with laughter wrinkles at their corners. A gold brooch and earrings accent the somber tones of her dark dress. Mrs. Gallagher, née Eliza Conran, outlived her husband by sixteen years, dying at her San Antonio home in 1904.[26]

PROVENANCE:
1883–1991: Collection of the Gallagher Family.
1991: Gift to SAMA by Elizabeth Conroy Gibson and Alicia Conroy Howard.
91–39 G (2)

115

IDA WEISSELBERG HADRA (1861–1885)

Ida Weisselberg was born in Castroville, Texas, on January 4, 1861. She was the eldest daughter of Dr. Gustave Friedrich Weisselberg and Marie Anna (von Gross) Weisselberg. Her sister, Emma, was born on November 4, 1862, in San Antonio.[1] Their father was a prominent physician, a nerve specialist, who had graduated in general medicine and neurology from the University of Königsberg in East Prussia and the University of Jena, Saxe-Weimer, Germany. Like many other young students, he had been involved in revolutionary activities in his native land and immigrated to Texas as a refugee in 1852.[2]

Dr. Weisselberg became influential in medical affairs in San Antonio, being a charter member of the Bexar County Medical Society and a constituent of the Board of Health, and served the city in a number of positions. In 1872 he moved with his family to Austin, Texas, where he became superintendent of the State Lunatic Asylum.[3]

As teenagers, Ida and Emma were enrolled in the German-American Ladies' College in Austin, a private seminary of high scholastic standards founded by Natalia von Schenck and Alicia L. Nohl. Emma and Ida acquired modest reputations writing poetry, encouraged by their mother, who was herself a poetess. It was discovered at the school that Ida also had an aptitude for painting and drawing, and she devoted much of her time to perfecting this talent.[4] She became a student of Hermann Lungkwitz (1813–1891), who greatly influenced her landscape studies.[5] At the Capitol State Fair held in Austin in 1876, fifteen-year-old Ida Weisselberg won the blue ribbon for a pencil drawing.[6]

Ida graduated with the highest honors from the German-American Ladies' College in 1877, the year the school was formally closed to be converted to the Texas German and English Academy for Boys and Young Men.[7] She was class valedictorian, for which she received a medal.[8] She continued painting and studying, evidently still under the guidance of Hermann Lungkwitz.

A local newspaper lauded Ida's artistic achievements in 1876:

> Miss Weisselberg, a student of Hermann Lungkwitz, is the earnest, patient, toiling young art student. It is no mere accomplishment that she seeks, but finished, profitable excellence, such as the world of art will recognize. Miss W. is said to be patient, painstaking, and faithful to truth and nature as her famous preceptor. She has devoted four or five years to the study and practice of the rules and philosophy of painting and will reflect credit on the people she represents.[9]

When Ella Moss Duval (1843–1911), also a very capable teacher and painter, moved to Austin in about 1880, Ida became one of her pupils. Reporting on an art exhibition held in Austin in 1882, a local newspaper devoted a paragraph to Weisselberg's work: "Two sketches, one of vegetables and the other a landscape, by Miss Eda [sic] Weisselberg of Austin, a pupil of Mrs. B. G. Duval, exhibit painstaking fidelity and give promise of excellence in the future."[10]

Ida's contemplative life of study in art, drama, and music was interrupted when she fell in love with Dr. Berthold Ernest Hadra, a colleague of her father's. Hadra was a widower with three children, and almost twenty years her senior. Her sister disapproved of this alliance, as she thought Ida too talented to marry so young and too immature to take on the responsibility of such a large household.[11]

Portrait photograph of Emma and Ida Weisselberg as children by H. B. Hillyer of Austin. Ida is standing on the right. SAMA Historical Photographic Archives, gift of Mary Josephine Vines.

1. "Descendants of Anna Maria Naffz, Daughter of Heinrich, and Sister of Carl Heinrich Naffz of Mainberheim, Bavaria." Undated photocopied biographical typescript, Ida Weisselberg Hadra file, SAMA Texas Artists Records.
2. Ibid., 6; "Diary of Adeline Wueste Staffel" (translated by Mrs. Heino Staffel in San Antonio, Texas, 1852). Photocopied typescript, Louise Wueste file, SAMA Texas Artists Records.
3. Pat Ireland Nixon, M.D., *A Century of Medicine in San Antonio: The Story of Medicine in Bexar County, Texas* (San Antonio: Privately published, 1936), 91–98.
4. Ida Hadra Vines, "Two Sisters in Early Texas." Undated typescript, Hadra file, SAMA Texas Artists Records.
5. James Patrick McGuire, *Hermann Lungkwitz: Romantic Landscapist on the Texas Frontier* (Austin: Published by the University of Texas Press for the University of Texas Institute of Texan Cultures at San Antonio, 1983), 206 n.5.
6. "Capitol State Fair—Fourth Day," Austin *Daily Democratic Stateman*, November 18, 1876.
7. I. H. Vines, "Two Sisters"; McGuire, *Hermann Lungkwitz*, 36.
8. The medal is in the Weisselberg-Hadra Collection at SAMA, Accession Number 69-102 G (30).
9. "Personal and Local Dots," Austin *Daily Democratic Stateman*, November 18, 1876.
10. "The Art Exchange," Austin *Daily Democratic Statesman*, April 26, 1882.
11. I. H. Vines, "Two Sisters."
12. "Descendants of Anna Maria Naffz."
13. Ibid.
14. L. E. Daniell, *Types of Successful Men of Texas* (Austin: Privately published, 1890), s.v. "Dr. B. E. Hadra," 303–304. Photocopy, Ida Hadra Vines file, SAMA Texas Artists Records.
15. I. H. Vines, "Two Sisters."

Portrait of Ida Weisselberg Hadra taken in Austin about the time of her marriage. SAMA Historical Photographic Archives, gift of Mary Josephine Vines.

Nevertheless, Ida and Dr. Hadra were married on September 18, 1882, in Austin.[12] They moved to San Antonio, where it is believed she continued her studies with Ella Moss Duval, who also had changed her residence to that city. On November 8, 1884, a son, James Marion, was born to the Hadras, and less than a year later, on October 25, 1885, Mrs. Hadra gave birth to a daughter, also named Ida. Ida Weisselberg Hadra died nine days later as a result of that birth.[13] It must have been a devastating experience for her physician-husband, whose specialties were gynecology and surgery.[14]

Fortunately, Emma Weisselberg and her parents assumed the responsibility of caring for the infant children. About five years later, Emma and Dr. Hadra married, and Emma became the children's stepmother as well as their aunt. Possibly it was a marriage of convenience, but Emma nevertheless proved to be a devoted mother. Emma became the family breadwinner as well following an 1898 accident in which Dr. Hadra fell from a horse. She gave German lessons and took in boarders to augment the family income. She was largely responsible for sending the children through college. Young Ida inherited her mother's artistic aptitude and became an artist in a modest way as well.[15]

Although most of the few paintings that Ida Weisselberg Hadra produced during her short lifetime are somewhat immature in execution, they reveal a burgeoning talent. Her greatest contributions to the Texas art scene are her views of San Antonio, which are of particular value historically if not of great aesthetic quality. Practically all of her work has been donated to the San Antonio Museum Association's Texas Collection by her granddaughters, adding another dimension to the history of art in Texas.

ALPINE SCENE
n.d., oil on paper mounted on panel, 7¼" × 9½"
Unsigned

Unfortunately, most of Ida Weisselberg Hadra's paintings are unsigned and undated. There is no doubt of their authenticity because of the source of the donations. A chronology can be established only by their quality and their subject matter. They all provide an insight into a talent that would doubtless have matured if the artist had lived longer. *Alpine Scene* appears to be an early effort, under the tutelage of Hermann Lungkwitz, and copied from one of his paintings.

PROVENANCE:
-1969: Collection of the Hadra-Vines Family.
1969: Gift to SAMA by Mary Josephine Vines, the artist's granddaughter.
69–102 G (13)

RIVER IN THE HILL COUNTRY
n.d., oil on cardboard, 9¼″ × 12½″
Unsigned

This small canvas seems to be a study from nature. The rough rock outcroppings, the dense foliage, and the quiet streambed are all suggestive of subjects inspired by Hermann Lungkwitz. Although the technique is labored and the composition uncontrolled, it has a subdued charm and a definite feeling of a Texas countryside.

PROVENANCE:
-1969: Collection of the Hadra-Vines Family.
1969: Gift to SAMA by Mary Josephine Vines.
69–102 G (11)

THE RIDGE
n.d., oil on cardboard, 5¼″ × 8″
Unsigned

This small painting is a copy of a study of Bear Mountain near Fredericksburg by Lungkwitz.[16] Nevertheless, it has the feeling of a landscape done from nature with its windswept sky and scrubby bushes struggling for a foothold on an unfriendly rocky surface. Muted tones of browns and gray-greens enhance the feeling of an untamed wilderness.

PROVENANCE:
-1969: Collection of the Hadra-Vines Family.
1969: Gift to SAMA by Mary Josephine Vines.
69–102 G (10)

EXHIBITIONS:
1990: Looking at the Land: Early Texas Painters, San Angelo Museum of Fine Arts (February 22 to March 25).

ROCKS AND SHRUB
n.d., oil on cardboard, 10″ × 14″
Unsigned

Lungkwitz undoubtedly encouraged his
students to copy from his own paintings,
a common nineteenth-century teaching
practice. This view is almost identical with
Split Rock on Shoal Creek by Lungkwitz.[17]
There are variations in the rock formations,
however, indicating Ida employed her own
imagination.

PROVENANCE:
-1969: Collection of the Hadra-Vines Family.
1969: Gift to SAMA by Mary Josephine Vines.
69–102 G (12)

EXHIBITIONS:
1984: The Texas Collection, SAMOA (April 13 to
August 26).

ROCKY LAND
n.d., oil on cardboard, 9″ × 12″
Unsigned

Hermann Lungkwitz not only had his
students reproduce his Texas landscapes,
but also some of his European studies.[18] The
similarity in the massive boulders, tall trees,
and rocky streambeds of Germany to Texas
views is striking. Replicating Lungkwitz's
paintings helped Ida in her interpretation
of her own landscape paintings.

PROVENANCE:
-1969: Collection of the Hadra-Vines Family.
1969: Gift to SAMA by Mary Josephine Vines.
69–102 G (14)

EXHIBITIONS:
1984: The Texas Collection, SAMOA (April 13 to
August 26).

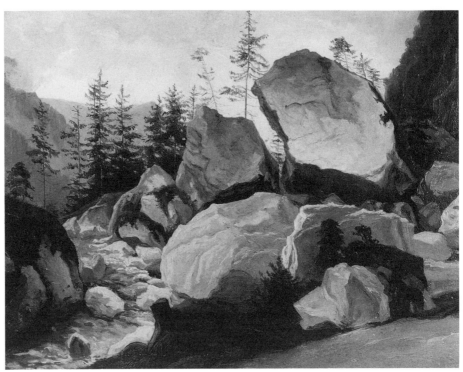

16. James Patrick McGuire to author (SA), interview,
 April 15, 1988.
17. McGuire, *Hermann Lungkwitz*, 165, plate 325.
18. McGuire to author, interview, April 15, 1988.

BURROS AND WOOD WAGON
n.d., oil on canvas, 21″ × 30″
Unsigned

This rustic scene was probably painted by Ida
in San Antonio. Small *carretas*, or carts, drawn
by Mexican burros, commonplace sights
in the community, and were used to haul
all sorts of goods, in this case wood. The
brownish tones and the leaden sky suggest
the inclemency of a winter's day in South
Texas.

PROVENANCE:
-1969: Collection of the Hadra-Vines Family.
1969: Gift to SAMA by Mary Josephine Vines.
69–102 G (2)

EXHIBITIONS:
1986: Texas Seen/Texas Made, SAMOA (September 29
to November 30).

VIEW OF AUSTIN
n.d., oil on canvas, 22″ × 30″
Unsigned

Ida's *View of Austin* has a mystical, eerie
quality, with its somber tones and capricious
perspective. Whether it was done under the
direction of either of her tutors or whether it
was her own effort is a matter of conjecture.
It is a view of West Seventh Street, formerly
called Bois d'Arc, with Guadalupe Street in
the foreground. The churches in the upper
right corner have been identified as the
Swedish Lutheran and the African Methodist
Episcopal, with the North Evans chateau in
front of them. The building in the far distant
center is the Texas Military Institute on
Brazos and Twelfth streets, east of Lamar
Boulevard. Mount Bonnell appears at the
upper far left.[19] It is an interesting version of
Austin in the early 1880s, with pretentious
buildings, unpaved roads, and virgin
countryside in the distance.

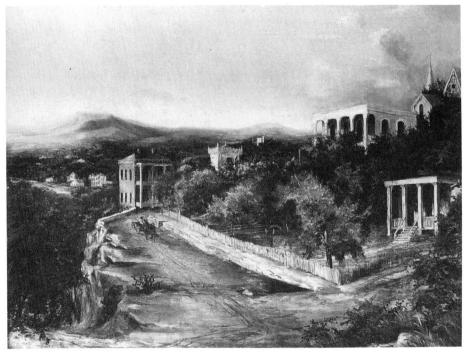

PROVENANCE:
-1969: Collection of the Hadra-Vines-Hopkinson Family.
1969: Gift to SAMA by Phyllis Hadra Hopkinson, the
artist's granddaughter.
69–103 G (3)

EXHIBITIONS:
1960: Special Fiesta Exhibition, WMM (April 1 to
August 15). Lent by Phyllis Hadra Hopkinson.
1970: Special Texas Exhibition, ITC (March 16 to
October 8).

1986: Capitol Historical Art Loan Program, State
Capitol, Austin (January 30 to September 15).
1986: Texas Seen/Texas Made, SAMOA (September 29
to November 30). Returned to Capitol for exhibition
to December 19, 1988.
1990: Looking at the Land: Early Texas Painters,
San Angelo Museum of Fine Arts (February 22 to
March 25).

PUBLICATIONS:
Pinckney, *Painting in Texas* (1967), [180]: plate 101.
"San Antonio loans paintings to capitol," San Antonio
Express-News, May 27, 1988.

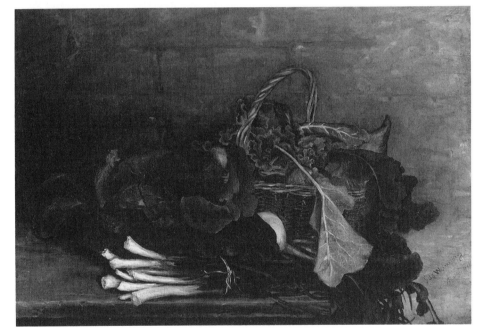

MOUNTAIN VIEW
n.d., oil on paper mounted on panel, 8″ × 11″
Unsigned

The serene quality and quiet tones of this small landscape make it one of Ida's most successful scenic efforts. Probably done near Austin, the canvas has a more pastoral and gentle character than most of her rocky, rugged vistas of the Texas Hill Country. It also suggests the vast distances and clear atmosphere so characteristic of nineteenth-century Texas. She enhanced this feeling by placing small structures at the base of the hill in the center, which intensifies the sensation of space and remoteness and creates a focal point in her composition.

PROVENANCE:
-1969: Collection of the Hadra-Vines-Hopkinson Family.
1969: Gift to SAMA by Phyllis Hadra Hopkinson.
69–103 G (5)

EXHIBITIONS:
1960: Special Fiesta Exhibition, WMM (April 1 to August 15). Lent by Phyllis Hadra Hopkinson.
1986: Texas Seen/Texas Made, SAMOA (September 29 to November 30).
1990: Looking at the Land: Early Texas Painters, San Angelo Museum of Fine Arts (February 22 to March 25).

STILL LIFE WITH VEGETABLES
1881, Oil on canvas, 18″ × 26⅛″
Signed and dated lower right: Ida Weisselberg/Austin, 1881

This still life is presumed to be one of the first paintings the young artist attempted under the direction of Ella Moss Duval. For a teacher, a still life was a good point at which to start a student, for the subject matter was inert and not subject to the vagaries of weather in landscape painting, nor to the mobility of a person sitting for a portrait. Nevertheless, this effort is naive in execution and indicates a timidity on the part of the artist. Since Duval's forte was portraiture, she also was not as adept in handling this type of theme. It appears, however, that this was the painting that won Ida some acclaim in a newspaper in 1882.[20]

PROVENANCE:
1881–1969: Collection of the Hadra-Vines-Hopkinson Family.
1969: Gift to SAMA by Phyllis Hadra Hopkinson.
69–103 G (1)

19. Research done by William Elton Green, Capitol Historian, Austin. The African Methodist Episcopal Church burned in 1883.
20. "The Art Exchange."

EXHIBITIONS:
1960: Special Fiesta Exhibition, WMM (April 1 to August 15) Lent by Phyllis Hadra Hopkinson.

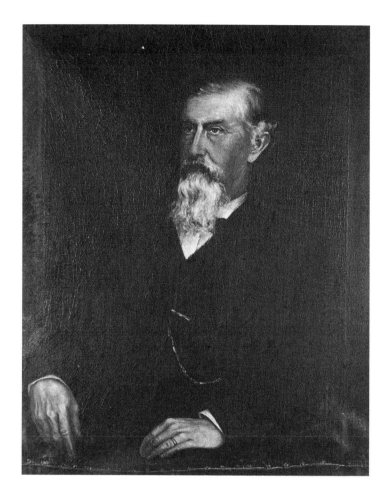

PORTRAIT OF DR. GUSTAVE FRIEDRICH WEISSELBERG
n.d., Oil on canvas, 35½″ × 30¼″
Unsigned

SLEEPING DOG'S HEAD
n.d., Oil on cardboard, 11″ × 11″
Unsigned

The size of this portrait denotes the respect Ida accorded her father as a scholar and an important physician in mid-nineteenth-century Texas.

Dr. Weisselberg was one of the organizers of the Bexar County Medical Society in 1853 and a signer of the original charter. To quote Dr. Pat Ireland Nixon: "No greater honor could come to a San Antonio physician on that day or this day or any day than to have his name on this significant document."[21] Dr. Weisselberg also served as city physician in 1863 and 1864 and again in 1868 and 1869.[22] During the Civil War, he advertised in a local newspaper that he would vaccinate from the "hours of 7 to 9 A.M. and from 3 to 4 P.M." in his offices at August Nette's Drug Store.[23]

Dr. Weisselberg had studied at the University of Königsberg in East Prussia, but it was after the Civil War and before he moved

to Austin in 1872 to become superintendent of the State Lunatic Asylum that he returned to Germany for special study at the University of Jena.[24] Dr. Weisselberg died in Galveston sometime in 1891.[25]

Unfortunately Ida did not date the portrait of her father, but she probably painted it under Mrs. Duval's direction in the early 1880s. Although immature in execution it conveys the doctor's distinguished features and stern mien.

PROVENANCE:
-1969: Collection of the Hadra-Vines Family.
1969: Gift to SAMA by Mary Josephine Vines.
69–102 G (4)

EXHIBITIONS:
1969–1972: Medicine in San Antonio and Texas, WMM (August 1, 1969, to February 30, 1972).

PUBLICATIONS:
Pinckney, Painting in Texas (1967), [178]: plate 99.

Ida's portrait of a sleeping dog shows that she was not afraid to attempt new subject matter. It also indicates a much freer technique with bolder brushstrokes and a feeling for texture in the handling of the dog's silky fur. This may have been a painting the artist accomplished on her own, without guidance from her instructors. It is a quick sketch done with sympathy and sincerity and is representative of a budding talent.

PROVENANCE:
-1969: Collection of the Hadra-Vines Family.
1969: Gift to SAMA by Mary Josephine Vines.
69–102 G (5)

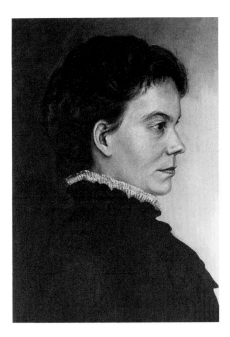

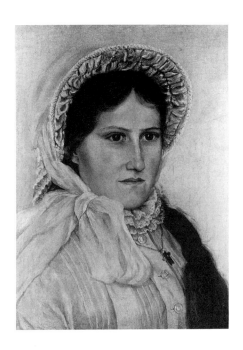

PORTRAIT OF EMMA BUCHNER
n.d., Oil on canvas, 19½″ × 13½″
Unsigned

Emma Buchner was Ida Weisselberg Hadra's aunt. Emma Buchner, born on June 29, 1847, in Bavaria, had immigrated to Texas in about 1860. She never married and lived with the Weisselbergs and later with the Hadras until her death in 1905.[26] She was a handsome woman with rich dark brown hair and strong features. When Ida painted this portrait she captured the reserved character of her subject. A simple dark dress, relieved only with white pleated ruffling at the neck, enhanced this concept. Dark red flowers tucked in Emma's hair offset the austere nature of the painting and lent a touch of warmth to the portrait.

PROVENANCE:
-1969: Collection of the Hadra-Vines Family.
1969: Gift to SAMA by Mary Josephine Vines.
69–102 G (8)

EXHIBITIONS:
1986: Texas Seen/Texas Made, SAMOA (September 29 to November 30).
1990: Special Christmas Exhibition, WMM (December 7, 1989, to April 1, 1990).

PORTRAIT OF EMMA WEISSELBERG
n.d., Oil on canvas, 19⅝″ × 14⅝″
Unsigned

Ida's painting of her sister, Emma, is a sentimental and carefully rendered portrait of a young girl attired in her Sunday best. The two girls were only a year apart in age and shared many interests and activities. They looked very much alike as well, judging from family photographs. Although Emma was considered the less talented of the two, her dark brown eyes are keen and intelligent and her features show much of her father's character. In this instance the artist was quite successful in achieving pleasing flesh tones and the lustrous textures of ruffled bonnet and hair.

PROVENANCE:
-1969: Collection of the Hadra-Vines Family.
1969: Gift to SAMA by Mary Josephine Vines.
69–102 G (7)

EXHIBITIONS:
1986: Texas Seen/Texas Made, SAMOA (September 29 to November 30).
1990: Special Christmas Exhibition, WMM (December 7, 1989, to April 1, 1990).

21. Nixon, A Century of Medicine, 91–92.
22. Ibid., 98, 119.
23. Advertisement, San Antonio Semi-Weekly News, May 21, 1863.
24. Mary Jo Vines, "A Pioneer Poet of Texas," The American-German Review, 14 (June 1948): 28.
25. "Descendants of Anna Maria Naffz."
26. Ibid.

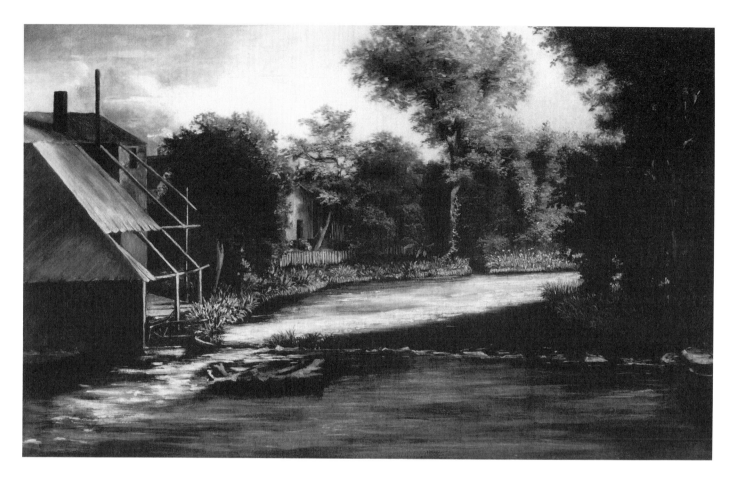

THE OLD IRON FOUNDRY ON
THE SAN ANTONIO RIVER
ca. 1884, Oil on canvas, 18″ × 30¼″
Unsigned

When this canvas was presented to the San Antonio Museum Association, it bore the title *Near the Head of the River at San Antonio*. This doubtless was a mistake on the part of the artist's descendants, as the headwaters of the river were located in what is now Brackenridge Park just below the site of Incarnate Word College.[27] In the early 1880s this area was still virtually undeveloped and probably had few structures near the riverbanks.

A comparison with photographs of the period makes it almost certain that this is a view of the old iron foundry, or Alamo Iron Works, situated on the southeast corner of Market and Presa streets in the city.[28] In Hadra's painting the foundry seems abandoned, which is plausible since the plant moved to a new site in 1884.[29] The old buildings probably remained until a public library was built at the location in 1902.[30]

Ida Hadra's painting shows not only the foundry building but a house nestled among trees and verdant foliage along the river's edge, a nostalgic glimpse into San Antonio's past.

PROVENANCE:
ca. 1884–1969: Collection of the Hadra-Vines Family.
1969: Gift to SAMA by Mary Josephine Vines.
69–102 G (1)

EXHIBITIONS:
1936: Centennial Exposition of Early Texas Paintings, WMM (June 1 to August 1). Lent by Mrs. P. C. Vines.
1960: Special Fiesta Exhibition, WMM (April 1 to August 15). Lent by Mary Josephine Vines.
1986: Texas Seen/Texas Made, SAMOA (September 29 to November 30).
1988: The Art and Craft of Early Texas, WMM (April 30 to December 1). 1988: A Witte Merry Christmas: Tannenbaums to Tumbleweeds, WMM (December 1 to 30).

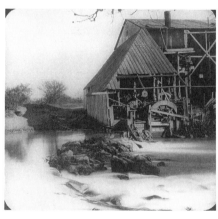

The Old Iron Foundry on the San Antonio River. Photograph from the slide collection of Albert Steves, Sr. SAMA Historical Photographic Archives, gift of Albert Steves IV.

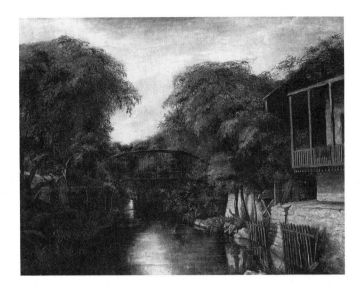

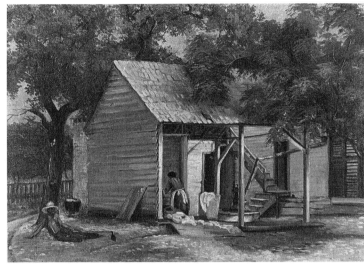

THE SAN ANTONIO RIVER AT ST. MARY'S
STREET BRIDGE
ca. 1883, Oil on canvas, 24″ × 30″
Unsigned

OLD WASHHOUSE IN SAN ANTONIO
n.d., Oil on canvas, 9½″ × 13½″
Unsigned

San Antonio has been called the "City of
Bridges" with good reason. The serpentine
course of the river through the heart of
the city has always necessitated numerous
viaducts to span the flowing stream to
accommodate the commerce and travel of
the community.[31] Artists found the river
irresistible, with its stately trees, charming
houses nestled along its edge, and numerous
bridges. Ida Weisselberg Hadra was no
exception.

When Ida painted the river, her years
of work with Hermann Lungkwitz became
evident in her handling of foliage and
perspective. But her own personality and
techniques began to shine through the
influences her teachers had upon her work.

The view of St. Mary's Street Bridge was
a favorite one with many artists, among them
Robert Onderdonk, who painted the same
scene in oil and watercolor. Ida's rendition
compares favorably with others done by
nineteenth-century Texas painters.

Ida Hadra's genre depiction of an old
"washhouse" in San Antonio provides an
insight into a life-style that disappeared long
ago. When houses were large and rambling,
separate structures for everyday chores
such as cooking and washing were often
connected to a main residence. This one-story
structure seems to be joined to a larger
house, although most of the main building
is hidden by the large tree to the right. The
artist's handling of her subject matter and
the fact that she was not averse to picturing
commonplace activities suggests a maturing
in her artistic conceptions and endeavors.

27. Mary Ann Noonan-Guerra, The Story of the San
Antonio River (San Antonio: The San Antonio River
Authority, 1978), 55.
28. Steinfeldt, San Antonio Was, 86–88.
29. "75 Years for the 'Iron Outfit'," San Antonio
Express, May 24, 1953. As the foundry was located
in the center of town the noise engendered
by the successful enterprise created a serious
problem for the adjacent businessess and
residents. They felt compelled to complain to
the city fathers about the racket of groaning
lathes, screeching water wheels, and constant
hammering. The foundry was considered a
"public nuisance," and the "iron outfit" was
requested to relocate. They moved to a site
bounded by Walnut, Santa Clara, and Montana
streets, "out in the country."
30. Edward W. Heusinger, F.R.G.S., A Chronology of
Events in San Antonio: Being a Concise History of the City
Year by Year From the Beginning of Its Establishment
to the End of the First Half of the Twentieth Century
(San Antonio: Standard Printing Co., 1951), 55.
31. Everett, San Antonio, 55–56.

PROVENANCE:
ca. 1883–1969: Collection of the Hadra-Vines Family.
1969: Gift to SAMA by Mary Josephine Vines.
69–102 G (3)

EXHIBITIONS:
1936: Centennial Exposition of Early Texas Paintings,
WMM (June 1 to August 1). Lent by Mrs. P. C. Vines.
1986: Capitol Historical Art Loan Program, State
Capitol, Austin (January 30 to September 15).
1986: Texas Seen/Texas Made, SAMOA (September 29
to November 30). Returned to Capitol for exhibition
to December 19, 1988.

PUBLICATIONS:
Pinckney, Painting in Texas (1967), [181]: plate 102.

PROVENANCE:
-1969: Collection of the Hadra-Vines-Hopkinson Family.
1969: Gift to SAMA by Phyllis Hadra Hopkinson.
69–103 G (2)

EXHIBITIONS:
1960: Special Fiesta Exhibition, WMM (April 1 to
August 15). Lent by Phyllis Hadra Hopkinson.
1986: Texas Seen/Texas Made, SAMOA (September 29
to November 30).
1988: The Art and Craft of Early Texas, WMM
(April 30 to December 1).

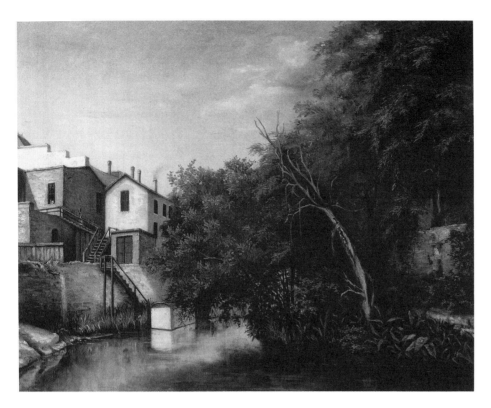

VIEW OF THE SAN ANTONIO RIVER
ca. 1883, Oil on canvas, 24" × 30"
Unsigned

Family legend maintains that this view of the San Antonio River was commissioned by the Casino Club, a local organization that sponsored musical and theatrical events and had a lively interest in all the arts. Also that this painting was done from a boat anchored beneath the St. Mary's Street Bridge.[32] It is an excellent visual record of a site along the river, with stairways leading to the river's edge and a typical canvas bathhouse that provided bathers with a modicum of privacy during ablutions.

Whether these bathhouses were unique to San Antonio is uncertain. Undoubtedly they were popular. An article in the San Antonio *Express* of August 15, 1895, recounts some of their history. "Sammy" Hall is credited with erecting a public bathhouse in 1852 at the old mill ford. It extended across the river and soon was being used by many of the locals for a leisurely dip on a hot Texas afternoon. The idea quickly caught on and soon private bathhouses sprang up along the river's edge. The article states: "Bath houses dotted the river on both sides for nearly a mile. Some of the more pretentious families had private bathing grounds screened from public view, and it was a very popular form of entertainment to give bathing parties."[33]

Family correspondence reveals that Hadra did another painting for the Casino Club, but which one it might be is uncertain. After her death, the organization returned two paintings to Dr. Hadra.[34]

PROVENANCE:
ca. 1883–1969: Collection of the Hadra-Vines-Hopkinson Family.
1969: Gift to SAMA by Phyllis Hadra Hopkinson.
69–103 G (4)

EXHIBITIONS:
1936: Centennial Exposition of Early Texas Paintings, WMM (June 1 to August 1). Lent by J. M. Hadra.
1960: Special Fiesta Exhibition, WMM (April 1 to August 15). Lent by Phyllis Hadra Hopkinson.
1961: A Century of Art and Life in Texas, DMFA (April 9 to May 7). Lent by Phyllis Hadra Hopkinson.
1970: Special Texas Exhibition, ITC (March 16 to October 8).
1986: Texas Seen/Texas Made, SAMOA (September 29 to November 30).
1988: The Art and Craft of Early Texas, WMM (April 30 to December 1).

32. J. M. Hadra (Dallas) to Eleanor Onderdonk (SA), June 2, 1936.
33. Everett, *San Antonio*, 57. See also McGuire, *Hermann Lungkwitz*, "Lewis Grist Mill," 70: plate 224, and "Old San Antonio," 122: plate 225, which appear to show "Sammy's" bathhouse.
34. J. M. Hadra (Dallas) to Eleanor Onderdonk (SA), June 10, 1936.

MINNIE HOLLIS HALTOM

CHRYSANTHEMUMS
ca. 1925, oil on canvas, 12″ × 15½″
Signed lower left: Hollis Haltom

Hollis Haltom's painting of *Chrysanthemums* glows with rich red and gold tones. Her brushstrokes are vigorous and the color is strong and pure. Her style borders on the Impressionistic, but without a true sense of light, atmosphere, and delicacy of vision. Her work, however, is indicative of the trend, even in Texas, away from traditional, academic painting.

PROVENANCE:
1987: Gift to SAMA by Jann and Fred Kline in honor of Cecilia Steinfeldt.
87–41 G

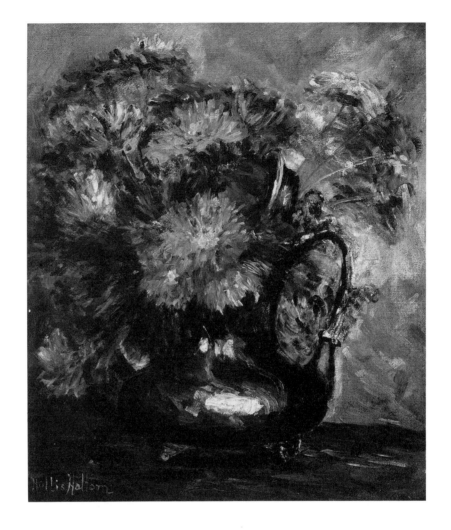

1. Fisk, A *History of Texas Artists*, 25.
2. Ibid.
3. Listings and catalogues, Minnie Hollis Haltom file, SAMA Texas Artists Records.
4. "S. A. Artist Invited to Display Painting in New York Gallery," *San Antonio Evening News*, February 17, 1928.
5. Peter Hastings Falk (ed.), *Who was Who in American Art*. Compiled from the Original Thirty-four Vols. of American Art Annual: Who's Who in Art. Biographies of American Artists Active from 1898–1947 (Madison, Connecticut: Sound View Press, 1985), s.v. "Haltom, (Minnie) Hollis"; Fisk, A *History of Texas Artists*, 28.

Minnie Hollis Haltom was born in Belton, Texas, on November 4, 1889. Her parents, J. U. and Ida (Shelton) Thornbury, were Texas pioneers. She was reared in Colorado City, Colorado, and after finishing high school there turned her attention to art.[1]

After Hollis's marriage to Charles Haltom she moved to San Antonio, where she studied with Rolla Taylor (1872–1970), José Arpa, and Eloise Polk McGill. She also received advice and encouragement from Julian Onderdonk and went to New York, where she attended the Metropolitan Art School. Xavier Gonzalez was also one of her instructors, but she must have studied with him in San Antonio.[2]

In 1929, Hollis Haltom was listed in the San Antonio city directory as a teacher with her home and studio at 315 East Theo Avenue. During the 1920s and 1930s she participated in local and regional exhibitions and acquired a modest fame primarily for her paintings of flowers.[3]

Hollis Haltom was invited to exhibit a painting in the Anderson Gallery in New York City in 1928. This was a signal honor, as selection was based upon nomination by a member of the American Salon.[4] She was a member of the San Antonio Art League, the Texas Fine Arts Association, the Palette and Chisel Club, the American Artists Professional League, the Southern States Art League, and the Women Painters and Sculptors Association of America.[5] The date of her death is unknown.

PETER LANZ HOHNSTEDT

(1872–1957)

Peter Hohnstedt was born in Urbana, Ohio, and grew up in Cincinnati. His first art lessons were under the tutelage of a "nice old lady" and later he studied briefly with Casenelli (1867/68–1961) and Frank Duveneck (1848–1916). By his own admission, however, he was largely self-taught.[1] Before he came to Texas, he lived in Memphis, New Orleans, Los Angeles, and Seattle.[2]

In the beginning, Hohnstedt was a "Sunday" painter and earned his living by pearling in the rivers of Arkansas, finishing floors in Memphis, and working various other sundry jobs. He went to New Orleans around 1917 and submitted two pictures, both of which were hung, to the spring exhibition at the Delgado Museum (now the New Orleans Museum of Art). He also placed four paintings in a local art dealer's window, where they were seen by Sim Weiss, a wealthy New Orleans broker. Weiss engaged the artist to come aboard his yacht and paint the swamps of his plantations. This resulted in a one-man show for Hohnstedt at the Delgado Museum. Some time later Hohnstedt went to Los Angeles, where he spent four years, then moved to Seattle. He had four paintings selected in a competitive exhibition held by the University of Washington. All were reproduced in color in the university annual.[3]

The Davis Competition lured the artist to San Antonio in 1929. It was a propitious move, for he was the winner of two prizes that year: $750 for *Evening Shades* and $1,500 for *Sunshine and Shadow*.[4] Texas seemed to suit Peter Hohnstedt, and he decided to stay. He first set up residence in Leon Springs, near San Antonio, where he joined an art colony. Later he moved to the Jefferson Hotel in San Antonio, but found it was too noisy and not suited to his quiet temperament. He then moved to Comfort, Texas, where he lived alone for many years, doing his own cooking, carrying his own wood, caring for his lawn and garden, and always painting the Texas countryside.[5]

This tranquil, understated man contributed a great deal to the Texas art scene during his lifetime. In 1933 and again in 1936 Hohnstedt had one-man shows featuring his Texas landscapes at the Witte Memorial Museum.[6] He was a consistent exhibitor in local shows, as well as a supporter of all regional art organizations. In 1935 his oil painting of the Alamo was used on invitations to San Antonio's Fiesta celebration.[7] In 1939 eleven of Hohnstedt's paintings, done in the Big Bend area of Texas, were purchased to enhance the "Basketmaker Indian Hall" in the Witte Memorial Museum.[8]

During the latter years of the artist's life he fought cancer and underwent numerous operations for the disease. But as soon as he was able to sit up in bed he would paint, sometimes giving the canvases to the nurses who cared for him.[9] Hohnstedt once said, "An artist never stops learning, and during my lifetime I have learned that success is ninety-five percent hard work and five percent gift."[10]

Peter Hohnstedt died in Comfort at age eighty-five of a coronary occlusion.[11] He had been a member of the San Antonio Art League, the Arts and Crafts Club of New Orleans, Charter Member of the Southern States Art League, the New Orleans Art Association, the Southern National Academy, and a life member of the Little Rock Art Association.[12]

1. Sam Woolford, "Artist Pushing 85, Brush Too," San Antonio *Light*, June 24, 1956.
2. "Peter L. Hohnstedt." Undated biographical typescript, Peter Lanz Hohnstedt file, SAMA Texas Artists Records.
3. Ibid.
4. "Wins 2 Prizes," San Antonio *Express*, February 24, 1929.
5. Woolford, "Artist Pushing 85."
6. "San Antonio Artist in One-Man Show," San Antonio *Express*, January 15, 1933; Catalogues and listings, Hohnstedt file, SAMA Texas Artists Records.
7. "Paints Shrine," San Antonio *Light*, February 1, 1935.
8. "Museum Acquires Big Bend Oils," San Antonio *Express*, July 22, 1939. The paintings, which were made by Hohnstedt near Langtry and Dryden and in the Chisos Mountains of the Big Bend area, were painted while the artist accompanied members of the Southwest Archaeological Society and Witte Memorial Museum expeditions to the Big Bend area of Texas.
9. Woolford, "Artist Pushing 85."
10. Guido Ransleben, A *Hundred Years of Comfort in Texas: A Centennial History* (San Antonio: The Naylor Company, 1954), 220.
11. "Rites Pending for S. A. Painter, 85," San Antonio *Light*, January 1, 1957.
12. "Peter L. Hohnstedt."
13. "Museum Acquires Big Bend Oils."
14. "Among Our Local Artists: Hohnstedt, the Artist and the Man," *San Antonio Home and Club*, 3 (September 1932): [11].

BOQUILLAS CANYON
1933, oil on canvas, 30″ × 36″
Signed lower right: P. L. Hohnstedt

Peter Hohnstedt became one of the first
Texas artists to capture the grandeur of
West Texas scenery on canvas when he
accompanied members of the Southwest
Archaeological Society and the Witte
Memorial Museum expeditions to investigate
the cave dwellings of native Americans in the
Big Bend area of Texas.[13] His view of Boquillas
Canyon shows the majestic mountains
towering over the sweep of the Río Grande.

PROVENANCE:
1933–1939: Collection of the artist.
1939: Purchased by SAMA from the artist with funds
provided by Mrs. J. K. Beretta.
39–97 P (1)

EXHIBITIONS:
1933: Southwest Texas Scenes, WMM (January 1 to
30). Lent by the artist.
1990: Legacies of Native America and Spain in
Texas and the Southeast, WMM (August 25 to
November 4).

CHISOS MOUNTAIN SCENE
1933, oil on canvas, 30″ × 38″
Signed lower right: P. L. Hohnstedt

When Hohnstedt painted his landscapes he
made every effort to achieve "vibration
and atmosphere."[14] He was successful in his
rendition of this Chisos Mountain scene,
with a foreground of clear-cut indigenous
vegetation, and the mountains in the distance
rendered in pearly opalescent tones. The
effect of space and airiness in the background
is enhanced by the solidity of rocks and
foliage in the forefront of the canvas.

PROVENANCE:
1933–1939: Collection of the artist.
1939: Purchased by SAMA from the artist with funds
provided by Mrs. J. K. Beretta.
39–97 P (2)

EXHIBITIONS:
1933: Southwest Texas Scenes, WMM (January 1 to
30). Lent by the artist.
1970: Special Texas Exhibition, ITC (March 16 to
October 8).
1986: Texas Seen/Texas Made, SAMOA (September 29
to November 30).
1990: Looking at the Land: Early Texas Painters,
San Angelo Museum of Fine Arts (February 22 to
March 25).
1990: Legacies of Native America and Spain in
Texas and the Southeast, WMM (August 25 to
November 4).

PUBLICATIONS:
Steinfeldt, "Lone Star Landscapes," M3, SAMA
Quarterly, in *San Antonio Monthly*, 5 (July 1986): 24.

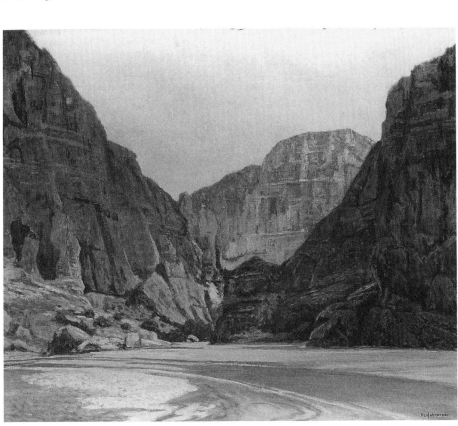

Peter Hohnstedt chose to paint the Chisos Mountains on a grand scale. In this large canvas, there is a feeling of vast distance enhanced by the imposing mountains and his treatment of the foreground and background. The snowy clouds intensify the brilliant colors in the craggy peaks, silhouetted against the clear blue sky. The artist once stated: "I cannot too strongly praise this marvelous country. In all of my travels I have never found the rugged beauty, the marvelous coloring which makes such striking pictures." [15]

PROVENANCE:
1933–1937: Collection of the artist.
1939: Purchased by SAMA from the artist with Witte Picture Funds.
37–6821 P

EXHIBITIONS:
1933: Southwest Texas Scenes, WMM (January 1 to 30). Lent by the artist.
1970: Special Texas Exhibition, ITC (March 16 to October 8).
1990: Legacies of Native America and Spain in Texas and the Southeast, WMM (August 25 to November 4).

THE CHISOS MOUNTAINS
1933, oil on canvas, 45" × 72"
Signed lower right: P. L. Hohnstedt

TEXAS HILL COUNTRY LANDSCAPE
n.d., oil on canvas, 25¼" × 30¼"
Signed lower right: P. L. Hohnstedt

Peter Hohnstedt settled in an isolated farmhouse near Comfort and found satisfaction in painting the rolling terrain, gentle streams, and varied vegetation of the Texas Hill Country. This landscape shows a definite maturity in style and an acceptance of impressionistic technique, with freer handling of his pigment and more fluidity of tone than in his earlier work.

PROVENANCE:
ca. 1930: Collection of Mrs. George Lyles.
1980: Inherited by Mr. and Mrs. Reagan Houston III from Mrs. George Lyles, Mrs. Houston's mother.
1980: Gift to SAMA by Mr. and Mrs. Reagan Houston III.
80–61 G (2)

EXHIBITIONS:
1982: A Birthday Celebration: Recent Gifts and Acquisitions, SAMOA (March 1 to May 16).
1986: Texas Seen/Texas Made, SAMOA (September 29 to November 30).
1990: Looking at the Land: Early Texas Painters, San Angelo Museum of Fine Arts (February 22 to March 25).

15. "Peter L. Hohnstedt's Paintings of Western Texas May Be Seen on First Floor of Witte Museum," San Antonio *Express*, October 15, 1933.

FLORAL CLUSTER
ca. 1863, watercolor on paper, 8¼" × 7"
Unsigned

As in *Zur Erinnerung*, the flowers in this
small bouquet might have been from
Leyendecker's nursery or yard. These blooms,
however, are of a more exotic variety than
those in Hoppe's other flower painting. There
are pansies, lilies of the valley, tulips, forget-
me-nots, rare roses, and what appears to be a
columbine. Louis Hoppe painted them with
the same meticulous tender care as those
he plucked from Leyendecker's garden,
presumably for his employer's pleasure.

PROVENANCE:
ca. 1863–1976: Collection of the Leyendecker-Brune
Family.
1976: Gift to SAMA by the Heirs of the Laura
Leyendecker Brune and Emil J. Brune Estate.
76–163 G (2b)

EXHIBITIONS:
1978–1979: A Survey of Naive Texas Artists, WMM
(December 17, 1978, to March 1, 1979).
1979–1980: A Survey of Naive Texas Artists, Traveling
Exhibition: The Museum of Fine Arts, Houston (April
11 to May 27, 1979). Laguna Gloria Art Museum,
Austin (June 9 to July 23, 1979). Tyler Museum of Art
(July 31 to September 9, 1979). Lufkin Historical and
Creative Arts Center (September 24 to November 15,
1979). The Art Center, Waco (April 15 to May 30,
1980).
1986: Texas Seen/Texas Made, SAMOA (September 29
to November 30).

PUBLICATIONS:
SAMA *Bi-Annual Report*, 1976–1978, 67.
Steinfeldt, "The Folk Art of Frontier Texas," *The
Magazine Antiques*, 114 (December 1978): 1282.
Steinfeldt, *Texas Folk Art* (1981), 37.
Rubin (ed.), *Southern Folk Art* (1985), 79.

Only four paintings by Louis Hoppe have been discovered since interest in
early Texas art has evolved. Two of his paintings are among the most important in the
collection of the San Antonio Museum Association because they provide visual
documentation of mid-nineteenth-century life in the rural area of East Texas. The four
paintings illustrated are somewhat naive in character, suggesting that the artist had
little or no training. Their diminutive proportions and the character of the paper
indicate that his sources for material were extremely limited. All four watercolors are
significant, however, in contributing information concerning Texas's past.

Virtually nothing is known of the artist himself. It is believed he was an
itinerant laborer employed by Johann Leyendecker and Julius Meyenberg on their
farms in the La Grange area. The lists of immigrants on early ships include numerous
Hoppes, but none can be definitely identified as Louis Hoppe. Since some of the
given names are missing on these lists, one could conceivably be the artist, but the
information is too vague to be certain. Members of the Hoppe family maintain that
Carl Hoppe, an artist who worked in the San Antonio area in the early twentieth
century, is a direct descendant.[1]

1. Lillian E. Britton to author (SA), April 23, 1982.

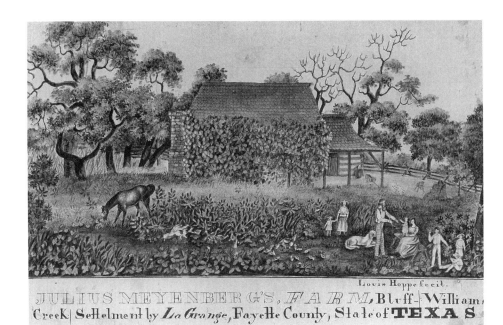

JULIUS MEYENBERG'S FARM
ca. 1864, opaque and transparent watercolor on
toned paper, 8¼″ × 11¼″
Signed lower right: Louis Hoppe, fecit
Titled across bottom: Julius Meyenberg's Farm,
Bluff-/:Williams/Creek:/Settelment by La Grange,
Fayette County, State of Texas

When Hoppe painted this rural scene in East
Texas, he furnished ample documentation
in his title beneath the watercolor. Julius
Meyenberg, the owner of the farm, was born
in Hannover in 1819. He immigrated in 1844,
arriving in Fayette County in 1845.[2] In 1850 he
bought a farm on a high bluff in the county
and married Kunigunde Oske. Six of their
eight children, all born on the farm, appear
in the painting.[3] Small and unimpressive as
this watercolor seems, it is one of the most
important paintings in The Texas Collection.
It has been reproduced numerous times to
illustrate a typical Texas farm during the
state's frontier period. It was purchased by
the San Antonio Museum Association in
1931 from the August Heintze Museum in
La Grange, Texas.[4]

PROVENANCE:
-1931: Collection of August Heintze.
1931: Purchased by SAMA from the August Heintze
Museum with Witte Picture Fund.
31-5360 P

EXHIBITIONS:
1946: Early San Antonio Paintings, WMM (February 24
to March 12).
1964: The Early Scene: San Antonio, WMM (June 7 to
August 31).
1967: Painting in Texas: The Nineteenth Century,
ACMWA (October 5 to November 26).

1967–1968: Painting in Texas: The Nineteenth Century,
The Academic Center, University of Texas at Austin
(December 9, 1967, to January 31, 1968).
1970: Special Texas Exhibition, ITC (March 16 to
October 8).
1978–1979: A Survey of Naive Texas Artists, WMM
(December 17, 1978, to March 1, 1979).
1979–1980: A Survey of Naive Texas Artists, Traveling
Exhibition: The Museum of Fine Arts, Houston (April
11 to May 27, 1979). Laguna Gloria Art Museum,
Austin (June 9 to July 23, 1979). Tyler Museum of Art
(July 31 to September 9, 1979). Lufkin Historical and
Creative Arts Center (September 24 to November 15,
1979). The Art Center, Waco (April 15 to May 30,
1980).
1986: Texas Seen/Texas Made, SAMOA (September 29
to November 30).
1988: The Art and Craft of Early Texas, WMM
(April 30 to December 1).

PUBLICATIONS:
Ward, *Cowboys and Cattle Country* (1961), 46–47.
Pinckney, *Painting in Texas* (1967), 154: plate 84.
Utterback, *Early Texas Art* (1968), 48.
Review of Pauline A. Pinckney, *Painting in Texas: The
Nineteenth Century*, in *Southwestern Art*, 2 (March 1968):
58–61.
Kownslar, *The Texans* (1972), 276–77.
June Rayfield Welch, *Texas: New Perspectives* (1972), 155.
Pearson et al., *Texas: The Land and Its People* (2nd ed.,
1978), 414.
Steinfeldt, "The Folk Art of Frontier Texas," *The
Magazine Antiques*, 114 (December 1978): 1282.
Steinfeldt, "Simple Self-Expression," *Southwest Art*, 10
(September 1980): 59.
Steinfeldt, *Texas Folk Art* (1981), 39.

Pearson et al., *Texas: The Land and Its People* (3rd ed.,
1987), 353.
Willoughby, *Texas, Our Texas* (1987), 149.
Steinfeldt, "Texas Folk Art," *Antique Review*, 14
(September 1988): cover.

2. Utterback, *Early Texas Art*, 48: Chester W. and
 Ethel H. Geue (eds. and comps.), *A New Land
 Beckoned: German Immigration in Texas, 1844–1847*
 (2nd rev. ed.: Waco: Texian Press, 1972), 21.
3. Utterback, *Early Texas Art*, 48.
4. August Heintze, a businessman in La Grange,
 Fayette County, Texas, had established a small
 museum with a great deal of early Texas
 material. After his death, most of the artifacts
 were sold. Ellen Quillin acquired more than
 200 items. If museum records are accurate,
 she paid the staggering sum of fifty cents for
 this painting. SAMA Registrar's Records.
5. Mary Anne Brune Pickens, "The Obituary Of A
 Home—Zimmerscheidt-Leyendecker," *The Eagle
 Lake Headlight*, May 28, 1981.
6. Ibid.; Lonn Taylor and David B. Warren, *Texas
 Furniture: The Cabinetmakers and Their Work: 1840–
 1880* (Austin: University of Texas Press, 1975), 297.
7. Pickens, "The Obituary Of A Home."
8. Ibid.
9. Ibid.

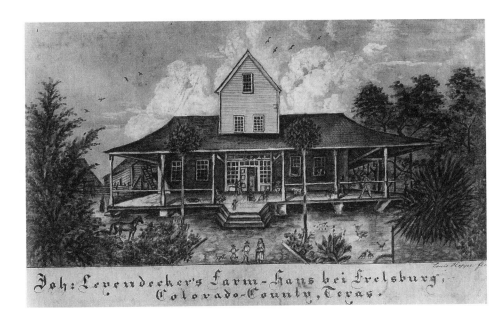

JOH: LEYENDECKER'S FARM-HAUS BEI
FRELSBURG
ca. 1863, opaque and transparent watercolor on lined
notepaper, 7″ × 11½″
Signed lower right: Louis Hoppe, fecit
Titled across bottom: Joh: Leyendecker's Farm-Haus
bei Frelsburg,/Colorado-County, Texas

Hoppe's genre painting of the Leyendecker-Brune home near Frelsburg is virtually all that remains of this unique early Texas house. The "farmhouse" stood for over a century, well-loved and well-cared for by its occupants, in an isolated wooded thicket between Columbus and Frelsburg. On May 20, 1981, it was burned to the ground by an arsonist.[5]

The house combined three types of architecture. The oldest room, about 1843, was a double-dovetailed log cabin of huge oak logs with doors and windows of solid walnut. A perpetual calendar using the German names for the days of the week was painted over the door, which had hand-forged iron hinges. Walnut beams supported the loft above, and a large wine cellar, lined with rocks and straw, was built underneath. It is believed this portion of the house was constructed by Albert Dietrich Heitman, a German cabinetmaker.[6]

About ten years later an addition was made in traditional *fachwerk* style. A hand-hewn timber framework was fitted together with square pegs and braced with diagonal crosspieces. Sandstone rocks from Redgate Creek were used to fill the spaces within the framework, and the entire surface was plastered over. Sometime before 1860 an upstairs room of shiplap siding was added

and a large shady porch wrapped around the front and part of the east portion, as it appears in the painting.[7]

The house was occupied by Johann Leyendecker and his wife, Josephine (Zimmerscheidt) Leyendecker, and their eight children. One of these children, John Frederick Leyendecker, inherited the home from his father. The last occupants of the house were Laura Leyendecker, one of John's children, and her husband, Emil Brune.[8]

The home was placed on the National Register of Historic Places in 1979 as a result of an historical and architectural study by the University of Texas Winedale Institute at Round Top, Texas. Detailed architectural drawings were made of the house at that time. In 1963 the Daughters of the American Colonists placed a commemorative marker on the property.[9] Fortunately, Hoppe's small but very accurate painting had been presented to the San Antonio Museum Association prior to the fire.

PROVENANCE:
ca. 1863–1976: Collection of the Leyendecker-Brune Family.
1976: Gift to SAMA by the Heirs of the Laura Leyendecker Brune and Emil J. Brune Estate.
76–163 G (1)

EXHIBITIONS:
1978–1979: A Survey of Naive Texas Artists, WMM (December 17, 1978, to March 1, 1979).
1979–1980: A Survey of Naive Texas Artists, Traveling Exhibition: The Museum of Fine Arts, Houston (April 11 to May 27, 1979). Laguna Gloria Art Museum, Austin (June 9 to July 23, 1979). Tyler Museum of Art (July 31 to September 9, 1979). Lufkin Historical and Creative Arts Center (September 24 to November 15, 1979). The Art Center, Waco (April 15 to May 30, 1980).
1986: Texas Seen/Texas Made, SAMOA (September 29 to November 30).
1988: The Art and Craft of Early Texas, WMM (April 30 to December 1).

PUBLICATIONS:
SAMA Bi-Annual Report, 1976–1978, 25.
Steinfeldt, "The Folk Art of Frontier Texas," *The Magazine Antiques*, 114 (December 1978): 1282.
Nancy Cook, "19th Century Frontier Art: Texas as Seen through the Eyes of Untrained Artisans," *San Antonio Magazine*, 13 (January 1979): 30.
Steinfeldt, *Texas Folk Art* (1981), 34.
LeRoy Johnson, Jr. (ed.), *Proceedings, Texana I: The Frontier*, The Proceedings of a Humanities Forum Held at Round Top, Texas, May 1–3, 1980 (1983), frontispiece.
Willoughby, *Texas, Our Texas* (1987), 149.
Steinfeldt, "Texas Folk Art," *Antique Review*, 14 (September 1988): 29.

ZUR ERINNERUNG
1863, watercolor on lined notepaper, 10⅛" × 7⅛"
Titled, signed and dated across bottom: Zur
Erinnerung/von Louis Hoppe, October, 1863

When this painting was presented to
the San Antonio Museum Association, an
attached note read: "Flowers taken from
the Leyendecker yard and painted by Louis
Hoppe, a hired hand of the family, 1863." The
blossoms in *Zur Erinnerung* appear to be native
species: morning glories, cypress vine, phlox,
verbenas, and roses, familiar types found in
early Texas gardens.

John Frederick Leyendecker, for
whom Louis Hoppe worked, attended Baylor
University at Independence, Texas, in 1855;
served in the Civil War in the Seventeenth
Texas Volunteer Infantry (1863–1865); was
tax assessor-collector of Colorado County in
1866; served Colorado and Lavaca counties as
representative to the Thirteenth legislature in
1873; and was a county commissioner, justice
of the peace, and notary public for many
years in Colorado County.[10]

Although involved in civic affairs, his
most outstanding accomplishment was in
the field of horticulture.[11] He owned and
operated the Pearfield Nursery, situated on
the road between Frelsburg and Columbus.
He originated and exhibited LeConte, Smith,
and Kieffer pears at the Louisiana Purchase
Exposition in St. Louis in 1904. He was one of
the first to bud pecans, and his son-in-law,
Emil Brune, became an expert in this field.
Leyendecker was president of the South
Texas Horticultural Society in 1890 and
chairman of the standing committee on
entomology of the Texas State Horticultural
Society in 1892. He won numerous prizes for
his contributions to Texas horticulture and
wrote scholarly articles for horticultural
journals.[12]

PROVENANCE:
1863–1976: Collection of the Leyendecker-Brune
Family.
1976: Gift to SAMA by the Heirs of the Laura
Leyendecker Brune and Emil J. Brune Estate.
76–163 G (2a)

EXHIBITIONS:
1978–1979: A Survey of Naive Texas Artists, WMM
(December 17, 1978, to March 1, 1979).
1979–1980: A Survey of Naive Texas Artists, Traveling
Exhibition: The Museum of Fine Arts, Houston (April
11 to May 27, 1979). Laguna Gloria Art Museum,
Austin (June 9 to July 23, 1979). Tyler Museum of Art
(July 31 to September 9, 1979). Lufkin Historical and

Creative Arts Center (September 24 to November 15,
1979). The Art Center, Waco (April 15 to May 30,
1980).
1986: Texas Seen/Texas Made, SAMOA (September 29
to November 30).

PUBLICATIONS:
SAMA *Bi-Annual Report*, 1976–1978, 66.
Steinfeldt, "The Folk Art of Frontier Texas," *The
Magazine Antiques*, 114 (December 1978): 1282.
SAMA *Calendar of Events* (February 1979): [2].
Steinfeldt, *Texas Folk Art* (1981), 38.
Cynthia Elyce Rubin (ed.), *Southern Folk Art* (1985), 78.

10. "A Thumbnail Sketch of the Zimmerscheidt,
 Leyendecker and Brune Family." Undated
 photocopied typescript, Louis Hoppe file, SAMA
 Texas Artists Records.
11. Ibid.
12. Samuel Wood Geiser, *Horticulture and Horticulturists
 in Early Texas* (Dallas: Southern Methodist
 University, 1945), 59–60.

1. James Patrick McGuire, *Iwonski in Texas: Painter and Citizen* (San Antonio: Published by the San Antonio Museum Association with the cooperation of the University of Texas at San Antonio Institute of Texan Cultures, 1976), 11.

2. James Patrick McGuire to author (SA), interview, September 2, 1987.

3. McGuire, *Iwonski in Texas*, 11–12.

4. Ibid., 12. The ship's list included Leopold von Iwonski, his wife, Marie, and their two sons, Carl and Adolph.

5. Utterback, *Early Texas Art*, 28. New Braunfels had been established by Prince Carl of Solms-Braunfels in 1845. He was the first commissioner-general of the *Adelsverein*, a company of noblemen whose purpose was the colonization of a section of Central Texas between 1844 and 1847.

6. McGuire, *Iwonski in Texas*, 14; Webb, Carroll, and Branda (eds.), *The Handbook of Texas*, 2, s.v. "Neighborville."

7. McGuire, *Iwonski in Texas*, 14.

8. Ibid., 16.

9. Ibid.

10. Frank Wagner, "Wm. DeRyee of Corpus Christi: A Biographical Sketch," 16. Undated photocopied typescript, William DeRyee file, SAMA Texas Artists Records. The process of homeography has never been completely analyzed nor explained. The image evidently was first sketched with a pencil or pen from a *camera lucida*, or drawn freehand by an artist. Then, by means of a chemical process, multiple copies could be printed.

11. Ibid., 16–17.

12. Advertisement, San Antonio *Daily Herald*, February 9, 1859. "We are requested by Mr. DeRyee, the artist, to say to the friends of art in our city that he will be glad to have them call at his rooms, on this day between 10 and 2 o'clock, and take a view of a picture just completed by the joint labors of himself and Mr. C. G. Iwanski [*sic*], a young German artist of much promise in our city. The picture consists of two figures in pastile, the little daughters of John C. and Capt. French. We regard the picture as highly beautiful, and alike creditable to both artists."

13. McGuire, *Iwonski in Texas*, 17–20.

14. Ibid., 20; Wagner, "Wm. DeRyee of Corpus Christi," 21.

Of all the painters who worked in nineteenth-century Texas, Carl G. von Iwonski was among the most gifted, although there is little evidence that he received much formal training. He may have acquired elementary instruction in art in his schooling in Breslau, Germany.[1] He may also have been tutored briefly by Richard Petri (1824–1857) and Lungkwitz after his arrival in New Braunfels, Texas.[2]

Iwonski was born at Hildersdorf, Silesia, Germany, on April 23, 1830. His parents, Leopold and Marie (Kalinowska-Tschirski) von Iwonski, were descended from distinguished Polish-Silesian gentry. Carl's father attended a military school and eventually rose to the rank of lieutenant in the Prussian army but left the service for undetermined reasons sometime prior to 1845. He owned estates at Rückers and Dürr Arnsdorff in Silesia but, like many Germans of the period, became disenchanted with the political unrest and economic instability of his native land.[3] In 1845, after selling their estates in Silesia, the Iwonski family immigrated to the Republic of Texas. They sailed from Bremen on the brig *Johann Dethardt* and arrived in Galveston in December 1845.[4]

After an undetermined stay in the coastal town of Indianola, the family traveled overland to New Braunfels, arriving sometime in 1846.[5] The Iwonskis remained in New Braunfels during 1846 but moved the next year to Hortontown, across the Guadalupe River.[6] They cleared the land, built fences, and constructed a sturdy log cabin. Situated as it was on the road between San Antonio and Austin at the Guadalupe River ford, it soon became a convenient stop for travelers and served as a stagecoach inn, saloon, and recreation center.[7]

Although Carl assisted his family, he pursued an artistic career as well. Undoubtedly he was acquainted with other immigrant artists: Hermann Lungkwitz, Richard Petri, and possibly Carl Rohrdorf (1800–1847).[8] During Iwonski's early years in New Braunfels he produced numerous sketches of the vicinity and the activities of the people, among them seventeen known sketches of plays produced by the New Braunfels Amateur Theatre.[9]

Two others whom Iwonski surely knew in New Braunfels were William DeRyee (1825–1903) and William [Wilhelm] C. A. Thielepape (1814–1904). DeRyee (originally spelled Düry) was a chemist, artist, and photographer who had come to Texas in 1856 and settled in the new colony. He boarded with the Thielepapes. William Thielepape was an inventor with some artistic ability but, by his own admission, he was a *Technologer*, a handyman skilled in the construction of mechanical and optical devices. He owned some photographic equipment, and he and DeRyee experimented with different photographic schemes and developed a system of reproduction that they called "Homeography."[10]

Iwonski moved to San Antonio in 1857, possibly in search of a more fertile field for his artistic talents. By 1858, DeRyee also had relocated and set up a studio in San Antonio.[11] In 1859 a notice appeared in the San Antonio *Daily Herald* announcing a partnership of the two men.[12] Carl Iwonski, like many other artists of the time, combined the new craft of photography with his artistic ability. His parents followed him in 1858 to San Antonio, where his father became a retail liquor and tobacco merchant. Iwonski and DeRyee's enterprise was so successful that they hired assistants.[13]

By 1861, however, with the Civil War looming, DeRyee left San Antonio for Austin to assist in the manufacture of gunpowder and explosives.[14] As some of his

The German-English School, San Antonio, after 1870.
SAMA Historical Photographic Archives, gift of
Julius Tengg.

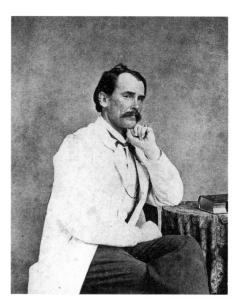

Carl G. von Iwonski in his San Antonio photographic
studio, ca. 1866. Courtesy of James Patrick McGuire.

work indicates, Iwonski became a Union sympathizer. He did some free-lance work
for *Harper's Weekly* before the magazine organized special staff artists to cover the
war.[15] During the war Iwonski's activities in photography lapsed because supplies were
virtually unobtainable.[16]

One year earlier, on August 2, 1860, Iwonski had accepted the post of drawing
master at the newly founded German-English School in San Antonio, a position he
held for the next decade. By the summer of 1864, war-related shortages, worthless
currency, and limited teaching personnel extended the artist's duties to include
instructing students in geography, German reading, essays, and diction. He finally left
the school in 1871.[17]

In 1866 Iwonski resumed his photographic business, this time with his friend
and fellow artist Hermann Lungkwitz. For three years their studio was in the Masonic
Building in San Antonio before they moved into a room with a skylight over Bell
Brothers' Jewelry Store on Main Street. In May 1869 they took in a third partner,
Franz Hanzal (1830–1906). Artists as well as photographers, they advertised that "all
kinds of photographs and paintings will be done. . . ."[18]

Iwonski and his father were active politically and socially in San Antonio.
Leopold von Iwonski had been appointed Bexar County treasurer by General J. J.
Reynolds of the military government of Texas in 1867. General Reynolds appointed
Carl Iwonski city tax collector the same year. When Leopold fell ill in 1872, Carl acted
as his unofficial assistant treasurer.[19]

Carl Iwonski was also a very active member of the city's Casino Club and
helped paint stage scenery for some of its theatrical productions. He undertook a
sculptured bust of Baron Alexander von Humboldt for a celebration held at the
club. On January 23, 1871, San Antonio's German colony celebrated the German
capture of Paris during the Franco-Prussian War. They had parades, fireworks, and
a program at the Casino Hall. Iwonski painted a large canvas to be raffled for the

15. Utterback, *Early Texas Art*, 28–29.
16. McGuire, *Iwonski in Texas*, 20.
17. Ibid., 26–28.
18. McGuire, *Hermann Lungkwitz*, 29 (quotation), 29–35.
19. McGuire, *Iwonski in Texas*, 23–26.
20. Ibid., 28–31.
21. Ibid., 31–32.
22. Utterback, *Early Texas Art*, 30. Elise Haseloff had
 been born in Berlin in 1848, the daughter of
 Hermann and Bertha (Eigendorf) Haseloff, with
 whom she came to Texas. Elise was twelve years
 old when both her parents died, and she, with
 her grandmother, a sister, and two brothers,
 moved to San Antonio, where Elise was adopted
 by the Iwonski family. In 1869, Carl painted
 her portrait, which he gave her, perhaps as a
 wedding gift, when she married Charles Hugo.
 It is a lovely, emotional painting of a beautiful
 young Elise at the age of twenty-one.
23. Rudolph Leopold Biesele, *The History of the
 German Settlements in Texas: 1831–1861* (Austin:
 Von Boeckmann-Jones, 1930), 226.
24. C. W. and E. H. Geue (eds. and comps.), *A New
 Land Beckoned*, 90.
25. Information provided by the donors, SAMA
 Registrar's Records.

occasion. It depicted life-size figures of the king of Prussia and the German general staff in a camp tent planning the capture of the French capital.[20]

Carl Iwonski traveled to Germany in March 1871 to study painting and sculpture in Berlin and to tour Europe, returning to San Antonio in February 1872. The paintings he executed in Texas in 1872 and 1873, his last years in the state, show greater maturity and a marked improvement in technique. Leopold von Iwonski died in October 1872, and sometime in 1873 Carl and his mother decided to return to their homeland, probably prompted by his prospects for a more lucrative artistic career there. In Germany the artist participated in exhibitions and sustained himself with commissions and by painting for churches and casinos. Iwonski died on April 4, 1912, in Breslau at the age of eighty-two.[21]

Carl Iwonski never married, probably because his one great love spurned his affections. She was Elise Haseloff, the adoptive daughter of the Iwonskis.[22]

Iwonski's faithful and sensitive portraits of local citizens add considerably to the Texas art scene. More unique, perhaps, are his drawings of the cultural events in the amateur German theatres in New Braunfels and San Antonio, which provide historians with a perspective on this facet of our frontier society. As artist and photographer Iwonski has enriched our knowledge and appreciation of the state's historical past.

PORTRAIT OF MARIA EIMKE
1855, opaque and transparent watercolor on toned paper, 13″ × 8¼″
Signed and dated lower right: C. G. Iwonski, 1855

In 1930, Rudolph Biesele, a noted Texas historian, wrote: "In Hortontown, northeast of New Braunfels, lived Carl G. von Iwonski, a painter, who engaged mostly in portrait painting. As far as I have been able to determine his first painting was done in 1855. It was a water color portrait of a sixteen-year-old girl."[23] Although more recent research has disclosed that Iwonski produced several works prior to 1855 and a number during that year, Biesele's reference seems to describe this portrait.

Maria Eimke immigrated to Texas from Germany in 1845 with her parents, Heinrich and Sophie (Berends) Eimke, and her two sisters, Louise and Johanna.[24] According to her descendants, however, she was seventeen rather than sixteen when Iwonski painted her likeness. She married Robert Julius Bodemann of New Braunfels, and they had eight children—four boys and four girls.[25]

Maria Eimke's portrait reflects the lifestyle of a frontier society. Her coiffure and dress are characteristic of fashions of a decade earlier, either because of a timelag in style or because of the frugality essential in a borderland culture.

PROVENANCE:
1855–1979: Collection of the Eimke-Brinkmann Family.
1979: Gift to SAMA by Hertha Brinkmann Graham in memory of her brother, Martin Brinkmann.
79–159 G

EXHIBITIONS:
1986: Texas Seen/Texas Made, SAMOA (September 29 to November 30).

GERMANIA GESANGVEREIN,
NEU BRAUNFELS, TEXAS
1857, toned lithograph on paper, 14″ × 17⅛″
Signed and dated lower right: Gez. v. C. G. Iwonski/
Ap. 1857
Titled lower center: Germania Gesangverein,
Neu Braunfels, Texas./Gruender des Texanisches
Saengerbundes

Carl Iwonski's lithograph depicts the men who formed Germania, the first formal German singing society of New Braunfels, organized on Texas Independence Day, March 2, 1850. On October 15 and 16, 1853, the Germania Singing Society sponsored the initial Texas State German Singing Societies Festival in the *Saengerhalle* in New Braunfels.[26] Vocalists from San Antonio, Austin, and many of the German villages and settlements in southwest Texas enjoyed not only the singing but also enthusiastically frequented the beer gardens and taverns.[27] As a matter of fact, the local singers had already made a practice of celebrating the Fourth of July in much the same manner, with parades, martial music, fireworks, and, later, concerts, parties, and dances.[28]

So the group was experienced and well organized for the celebration in October 1853. Rehearsals and band concerts were held at the picnic grounds during the daylight hours and at 5:30, for an admission of fifty cents, the *Saengerhalle* was opened for the grand *Saengerfest*. On Sunday, more music and singing on the picnic grounds preceded a gala ball. For this event the men paid a fee of one dollar.[29]

The location of Iwonski's original sketch for the *Germania Gesangverein*, presumably done in 1853, is unknown. A reproduction of a drawing similar to Iwonski's lithograph, which

may have been the original drawing or possibly a copy, appeared in the Galveston *Daily News* on July 22, 1903. The lithograph, printed in 1857, is much more refined, however, and pictures the scene in greater detail. There are more beer mugs on the table, clearer delineation in the men's features, and greater emphasis on the architectural aspects of the room than appear in the newspaper reproduction.

PROVENANCE:
-1975: Purchased by James Patrick McGuire in an antique shop in San Antonio.
1975: Gift to SAMA by James Patrick McGuire.
75–95 G

EXHIBITIONS:
1976: Iwonski in Texas: Painter and Citizen, WMM (August 1 to September 30).
1986: Texas Lithographs, ACM (March 14 to May 18).
1986: Texas Lithographs, Traveling Exhibition: San Jacinto Museum of History, Houston (June 5 to July 20). University of Texas Institute of Texan Cultures at San Antonio (August 7 to September 17).
1986: Texas Seen/Texas Made, SAMOA (September 29 to November 30).

PUBLICATIONS:
"Witte Gathering to Honor Iwonski Works Writer," New Braunfels *Herald*, September 9, 1976.
James Patrick McGuire, *Iwonski in Texas: Painter and Citizen* (1976), 74.

26. Oscar Haas, *History of New Braunfels and Comal County, Texas: 1844–1946* (Austin: The Steck Company, 1968), 106.
27. "Singers of Long Ago," Galveston *Daily News*, July 22, 1903.
28. Theodore John Albrecht, "German Singing Societies in Texas" (Ph.D. diss., North Texas State University, Denton, 1975), 19–45.
29. "Singers of Long Ago." As no fee for ladies was mentioned, it is presumed they were not required to pay admission. The dancing was lively, however, with round dances, square dances, and polkas.
30. McGuire, *Iwonski in Texas*, 61 n. 38.
31. James Patrick McGuire to author (SA), interview, August 21, 1987.
32. S. W. Pease, "They Came to San Antonio: 1794–1865," s.v. "Dosch, Capt. Ern[e]st A." Undated photocopied typescript, SAMA Texas History Records.
33. C. W. and E. H. Geue (eds. and comps.), *A New Land Beckoned* (2nd rev. ed.), 18.
34 Webb, Carroll, and Branda (eds.), *The Handbook of Texas*, 2, s.v. "Roemer, Ferdinand von."
35. Ibid., s.v. "Lindheimer, Ferdinand Jacob."
36. Ibid., s.v. "Bracht, Viktor Friedrich."
37. McGuire, *Iwonski in Texas*, 71

NEU BRAUNFELS, DEUTSCHE COLONIE IN
WEST TEXAS
1857, toned lithograph on paper, 7¼″ × 13⅛″
Titled lower center: Neu-Braunfels./Deutsche Colonie
in West Texas
Printed lower left: Gez. v. C. G. Iwonsky
Printed lower right: Lith. Anst. v. J. G. Bach, Leipzig

Iwonski's pencil rendition of this view was
acquired by Duke Paul Württemberg during
his brief visit to New Braunfels, Texas, in 1855.
Duke Paul took the sketch back with him on
his return to Germany and may have been
responsible for having the lithograph made.
Unfortunately, the original sketch and some
other Iwonski drawings were destroyed by
bombing in World War II.[30]

When the lithograph was made, three
figures were added to the panoramic view.
The print in The Texas Collection identifies
these persons, in pencil script below the
picture, as Ernst Dosch, Dr. [Ferdinand von]
Roemer, and Ferd[inand Jacob] Lindheimer.
An identical print in the Sophienberg
Museum in New Braunfels lists them as
Ernst Dosch, Dr. Wilhelm Remer, and
Viktor Bracht.[31]

All of the above persons were
important in the early years of Texas history.
Ernst Dosch was one of the first of the
German immigrants who settled in the New
Braunfels area. He was a crack shot, an Indian
fighter, and a renowned hunter. At the age
of eighty, shortly before his death in 1906, he
still had a reputation as an excellent shot.[32]
Iwonski pictured him in his natural element,
astride a horse, with his rifle slung over his
shoulder.

The man on horseback at the right
could be either Dr. Remer or Dr. Roemer. Dr.

Wilhelm Remer was a physician who served
the community of New Braunfels.[33] Ferdinand
von Roemer was a geologist who explored
Texas from 1845 to 1847, studying the fauna,
flora, and geology of the country as far west
as Fredericksburg and New Braunfels.[34]
Ferdinand Lindheimer was a noted botanist
who settled in New Braunfels and organized
the flora of Texas into a system.[35] Viktor
Bracht is best-known for his book *Texas in
1848*, which gives historians a vivid overview
of life in the state in the mid-nineteenth
century.[36]

Iwonski's panorama of New Braunfels is
particularly important as a graphic document
of the site. It has been widely reproduced in
Texas literature.[37]

PROVENANCE:
1950-1975: Collection of the Burkhalter Family.
1975: Gift to SAMA by Lois Wood Burkhalter.
75–72 G

EXHIBITIONS:
1960: Go West, Young Man, Marion Koogler McNay
Art Institute, SA (January 1 to February 17). Lent by
Lois Wood Burkhalter.
1976: Iwonski in Texas: Painter and Citizen, WMM
(August 1 to September 30).
1986: Texas Lithographs, ACM (March 14 to May 18).
1986: Texas Lithographs, Traveling Exhibition:
San Jacinto Museum of History, Houston (June 5 to
July 20). University of Texas Institute of Texan
Cultures at San Antonio (August 7 to September 17).

1986: Texas Seen/Texas Made, SAMOA (September 29
to November 30).
1988: The Art and Craft of Early Texas, WMM (April
30 to December 1).

PUBLICATIONS:
"Museum Receives Gift," San Antonio *Light*, April 27,
1975.
SAMA *Calendar of Events* (May 1975): [4].
"Early Texas Art Given to Witte," New Braunfels
Herald, May 14, 1975.
SAMA *Annual Report*, 1974–1975, 23.
McGuire, *Iwonski in Texas* (1976), 73.
Glen E. Lich and Dona B. Reeves (eds.), *German Culture
in Texas: A Free Earth; Essays from the 1978 Southwest
Symposium* (1980), 126.

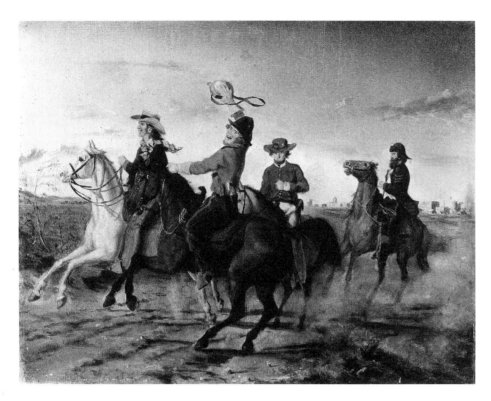

THE TERRY RANGERS
ca. 1862, oil on canvas, 11½" × 15"
Unsigned

The Terry Rangers is one of Iwonski's most widely published paintings. The subject is a group from the Eighth Texas Cavalry, C.S.A., named for Benjamin Franklin Terry, a sugar planter who went to Virginia in 1861 and served as a scout in the First Battle of Manassas. The War Department of the Confederacy gave Terry and Thomas S. Lubbock authority to recruit a mounted regiment in Texas to take part in the fighting in Virginia. Ten companies of young men were formed within a month in Houston. Terry was killed in their first battle, but his Rangers retained his name and went on to fight in Kentucky, Tennessee, Alabama, Georgia, and North and South Carolina.[38]

Sam Maverick, son of Samuel Augustus Maverick, joined the Rangers in 1862 at the age of twenty-five and served with them until the end of the Civil War. He distinguished himself in particular by setting fire to a Federal steamboat in the middle of the Cumberland River. Iwonski captured young Maverick's devil-may-care attitude by picturing him in a bright red tunic, waving his canteen aloft, galloping off to war. He later rose to the rank of lieutenant and survived the war to become a San Antonio banker and businessman. When Maverick died at the age of ninety-eight he was the last survivor of the Terry Rangers.[39]

PROVENANCE:
-1931: Collection of Ernst Muenzenberger.
1931: Gift to SAMA by Ernst Muenzenberger.
31–4801 G

EXHIBITIONS:
1933: Yanaguana Society Exhibition, Old San Antonio Paintings, WMM (December 1 to 3, extended to 8).
1936: Centennial Exposition of Early Texas Paintings, WMM (June 1 to August 1).
1946: Early San Antonio Paintings, WMM (February 24 to March 12).
1950: American Processional, The Corcoran Gallery of Art, Washington, D.C. (July 1 to December 17).
1954: Picture of the Month, WMM (June).
1957: Horse and Rider, Fort Worth Art Center (January 7 to March 3).
1958: Mission Summer Festival, Mission Concepción, SA (June 13 to 22).
1960: Early Texana Exhibit, in recognition of the premiere festivities of the film, *The Alamo*, WMM (October 1 to 30).
1964: The Early Scene: San Antonio, WMM (June 7 to August 31).
1967: Painting in Texas: The Nineteenth Century, ACMWA (October 5 to November 26).

1967–1968: Painting in Texas: The Nineteenth Century, The Academic Center, University of Texas at Austin (December 9, 1967, to January 31, 1968).
1976: Iwonski in Texas: Painter and Citizen, WMM (August 1 to September 30).
1984: The Texas Collection, SAMOA (April 13 to August 26).
1986: Texas Seen/Texas Made, SAMOA (September 29 to November 30).
1990: Looking at the Land: Early Texas Painters, San Angelo Museum of Fine Arts (February 22 to March 25).
1990: Regional American Painting to 1920, Greenville County Museum of Art (November 6 to December 30).

PUBLICATIONS:
"Texas in Pictures," *The Magazine Antiques*, 53 (June 1948): 458.
"War and Peace," *Horse and Rider* (1957), 8.
Ward, *Cowboys and Cattle Country* (1961), 36–37.
Pinckney, *Painting in Texas* (1967), [132]: plate 72.
Utterback, *Early Texas Art* (1968), 31.
Reese and Kennamer, *Texas, Land of Contrast* (1972), 292.
Kownslar, *The Texans* (1972), 336–337.
Jim B. Pearson, Ben H. Proctor, and William B. Conroy, *Texas: The Land and Its People* (1st ed., 1972), 368.
"Iwonski Show is Milestone," *Paseo del Rio Showboat* (SA), August 1976.
McGuire, *Iwonski in Texas* (1976), 44.
Story of the Great American West (1977), 218.
Publications of the San Antonio Museum Association (1978): cover.
Reese and Kennamer, *Texas, Land of Contrast* (rev. ed., 1978), 374.
Pearson et al., *Texas: The Land and Its People* (2nd ed., 1978), 459.
Ahlborn, *Man Made Mobile* (1980), 64.
Celebrating the Republic of Texas, Arby's Restaurant advertisement (December 1980): poster.
"San Antonio Museum of Art: The Grand Opening," *North San Antonio Times* Supplement, February 19, 1981.
Goetzmann and Reese, *Texas Images and Visions* (1983), 62.
Gary Wiggins, *Dance & Brothers: Texas Gunmakers of the Confederacy* (1986), 23.
Pearson et al., *Texas: The Land and Its People* (3rd ed., 1987), 383.
Willoughby, *Texas, Our Texas* (1987), 338.
Paula Mitchell Marks, *Turn Your Eyes Toward Texas: Pioneers Sam and Mary Maverick* (1989), 228.
Gerdts, *Art Across America*, vol. 2 (1990), 115: plate 2.106.
Southwestern Historical Quarterly, 94 (January 1991): cover.

38. Ibid., 44; Utterback, *Early Texas Art*, 30.
39. McGuire, *Iwonski in Texas*, 44.
40. Ibid., 28–32.
41. Ibid., 76.

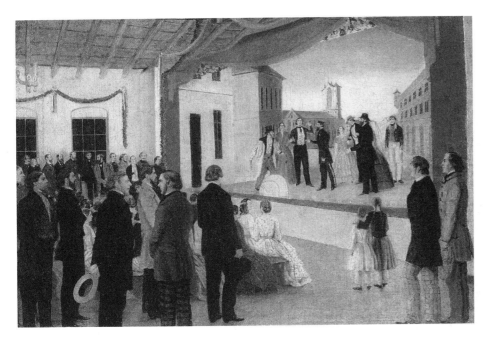

YOUNG STIEREN
1863, pencil on paper, 10″ × 8″
Signed and dated lower right: C. G. Iwonski fert, 1863

THEATRE AT OLD CASINO CLUB
IN SAN ANTONIO
ca. 1858–1860, oil on canvas, 9½″ × 14″
Unsigned

Although this canvas is not signed, there is little doubt as to its authenticity because of its documentation through the von Griesenbeck and Watlington families. According to Mr. Watlington, the donor, the third actor from the left is his grandfather, Carl Friederich von Griesenbeck, a native of Schlesswig-Holstein, who came to Texas in 1849 and settled in San Antonio. The first seated female in the audience is identified as Mrs. Emilie Elmendorf, who came to Texas from Germany in 1848. The other figures in Iwonski's painting are undoubtedly other German pioneers in San Antonio.

According to James Patrick McGuire's *Iwonski in Texas: Painter and Citizen*, the Casino Club was German San Antonio's social and cultural center. The club was organized in 1854 and first conducted meetings in rented quarters. By 1858 the group had constructed its own Casino Hall on Market Street, which included a theatre that seated four hundred. When Iwonski moved to San Antonio from New Braunfels in 1857, he immediately became involved in the club's activities and was one of six artists who painted stage scenery for its productions. Iwonski's visual records of events in the amateur German theatre in New Braunfels and San Antonio are among his most vital contributions to the Texas art scene. This representation of an early theatrical production in San Antonio provides a unique and intimate view of entertainment in mid-nineteenth-century Texas.[40]

PROVENANCE:
ca. 1858–1991: Collection of the von Griesenbeck-Watlington Family.
1991: Gift to SAMA by H. Stirling Watlington.
91–67 G (1)

PUBLICATIONS:
Pinckney, *Painting in Texas* (1967), [125]: plate 65.
McGuire, *Iwonski in Texas* (1976), 41.

Iwonski's drawing of *Young Stieren* illustrates the artist's remarkable ability to capture a person's character. In this instance he portrays a young boy with sensitive and handsome features and an alert and lively look in his dark eyes. Although the name "Stieren" appears on early ships' lists, his first name has not been determined. A person named C. A. Stieren was first listed in the San Antonio city directory of 1892–1893. He was a real estate agent who lived at 503 Guenther. According to the 1908 city directory, he lived with his wife, Hedwig, at 312 Adams Street. Nola Hertzberg Feiler, from whom the drawing was acquired, purchased it at a sale on Adams Street.[41] Certainly if it is not of C. A. Stieren, it must be of a member of his family, as he and Hedwig had seven children.

PROVENANCE:
-1976: Collection of Nola Hertzberg Feiler.
1976: Purchased by SAMA from Nola Hertzberg Feiler with Witte Picture Funds.
76–173 P

EXHIBITIONS:
1976: Iwonski in Texas: Painter and Citizen, WMM (August 1 to September 30).
1986: Texas Seen/Texas Made, SAMOA (September 29 to November 30).

PUBLICATIONS:
McGuire, *Iwonski in Texas* (1976), 80.

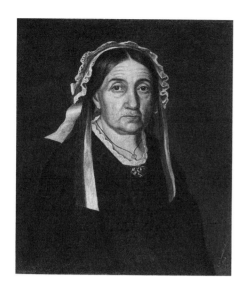

PORTRAIT OF JOHANNA RICHTER
1863, oil on canvas mounted on panel, 14″ × 12″
Signed and dated lower right: C. G. v. Iwonski/1863

THE SCHENCK SISTERS
1870, pencil and wash on paper, 14⅝″ × 11¼″
Signed and dated lower left: C. Iwonski fert/1870

Johanna Richter was born in Glasthahl, Germany, in 1807 and immigrated to Texas in the 1840s. Although few biographical details are available, she apparently died during the cholera epidemic in San Antonio in the summer of 1866.[42]

This is one of two portraits that Carl G. von Iwonski painted of Johanna Richter, the only pair of oil portraits of the same subject he is known to have done. The other, similar in character but somewhat larger, was done a year earlier. They both picture her in frilly lace caps, fashionable accessories of the period, and in both she wears a handsome gold brooch, reputedly made by her father, August Arend.[43] In both versions Iwonski portrayed her stern features, depicting a woman of strong personality and striking individuality.

Iwonski prepared this careful preliminary drawing of the Schenck sisters, Johanna and Lena (Caroline), in 1870 for a large double oil portrait that he painted the same year. The sketch depicts the girls opening Valentine letters while wearing pretty dresses, possibly for a Valentine party.[44] The skillful and sensitive drawing conveys the lovely textures of silken tresses and delicate lace trim on the sheer fabric of the clothing, as well as the crisp paper of the Valentine messages. The life-size painting (32″ × 31″) based on the drawing won much praise in the local press when it was first exhibited at the San Antonio Fair held at San Pedro Springs in 1870.[45]

PROVENANCE:
-1971: Collection of Norma Marriott Bixler.
1971: Purchased by SAMA from Norma Marriott Bixler through Edward J. Finn, dealer, with Witte Picture Fund.
71–84 P

EXHIBITIONS:
1976: Iwonski in Texas: Painter and Citizen, WMM (August 1 to September 30).
1986: Texas Seen/Texas Made, SAMOA (September 29 to November 30).

PUBLICATIONS:
"Iwonski Paintings, Data Sought," San Antonio Light, April 14, 1974.
McGuire, Iwonski in Texas (1976), 46.

PROVENANCE:
1870–1974: Collection of the Schenck-von Wyschetski-Hertzberg Family. 1974: Purchased by SAMA from Nola Hertzberg Feiler with Witte Picture Fund.
74–206 P

EXHIBITIONS:
1936: Centennial Exposition of Early Texas Paintings, WMM (June 1 to August 1). Lent by Sophia Schenck von Wyschetski.
1976: Iwonski in Texas: Painter and Citizen, WMM (August 1 to September 30).
1986: Texas Seen/Texas Made, SAMOA (September 29 to November 30).

PUBLICATIONS:
McGuire, Iwonski in Texas (1976), 83.
Publications of the San Antonio Museum Association (1978): [3].

42. Ibid., 46.
43. Ibid.
44. Pinckney, Painting in Texas, 129.
45. McGuire, Iwonski in Texas, 48. Lena married Edward G. Huppertz in 1876 and Johanna married Ernst Hallman (date unknown).
46. Ellis A. Davis and Edwin A. Grobe (eds. and comps.), The New Encyclopedia of Texas, 3 (Dallas: Texas Development Bureau, ca. 1928), s.v. "Ed Steves," 1588; Ethel Hander Geue, New Homes in a New Land: German Immigration to Texas, 1847–1861 (Waco: Texian Press, 1970), 91.
47. Chabot, With the Makers of San Antonio, 399; McGuire, Iwonski in Texas, 52.
48. McGuire, Iwonski in Texas, 52. The Steves Homestead on King William Street was given to the San Antonio Conservation Society in 1953.

PORTRAIT OF MRS. EDWARD STEVES
1872, oil on canvas, 33¼" × 25½"
Signed and dated lower right: C. Iwonski, fert/1872

The two portraits that follow, of Mr. and
Mrs. Edward Steves, are believed to be among
Iwonski's first commissioned works after he
returned to Texas from his year's study abroad
in 1871. Mrs. Steves was Johanne [Johanna]
Kloepper before she married Edward Steves on
December 25, 1857, in New Braunfels. She was
born in Adenstedt, Hannover, on October 24,
1839, and came to Texas with her family in
1847. The young couple lived in Cypress Creek
near Comfort, Texas, until they moved to San
Antonio in 1866. They had three sons, Albert,
Ernest, and Edward, Jr.[46]

Mrs. Steves is stylishly coiffed and
sedately attired, befitting her station as
the wife of one of San Antonio's leading
businessmen. The delicate lace collar, the silky
rich green of the jabot, and the carefully
detailed jewelry attest to Iwonski's painting
skills. Although these two canvases show
the same interpretation of personality and
character as his earlier portraits, Iwonski's
painting technique is more masterly and his
professional ability more evident.

PROVENANCE:
1872–1979: Collection of the Steves Family.
1979–1992: Extended Loan to SAMA by Elisabeth
Vaughan Bishop.
1992: Gift to SAMA by Curtis Torrey Vaughan, Jr.
92–30 G (1)

EXHIBITIONS:
1933: Yanaguana Society Exhibition, Old San Antonio
Paintings, WMM (December 1 to 3, extended to 8).
Lent by Albert Steves.
1964: The Early Scene: San Antonio, WMM (June 7 to
August 31). Lent by Mrs. Curtis Vaughan.
1976: Iwonski in Texas: Painter and Citizen, WMM
(August 1 to September 30). Lent by Mrs. Curtis
Vaughan.
1986: Texas Seen/Texas Made, SAMOA (September 29
to November 30).
1990–1991: Magic Lanterns: From Victoria to the
Flappers, WMM (December 7, 1990, to February 28,
1991).

PUBLICATIONS:
Frederick C. Chabot, With the Makers of San Antonio:
Genealogies of the Early Latin, Anglo-American, and German
Families With Occasional Biographies, Each Group Being
Prefaced With a Brief Historical Sketch and Illustrations (1937),
opposite 406.
Pinckney, Painting in Texas (1967), [126]: plate 67.
Cecilia Steinfeldt and Donald Lewis Stover, Early Texas
Furniture and Decorative Arts (1973), 251.
McGuire, Iwonski in Texas (1976), 52.

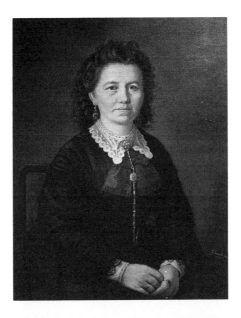

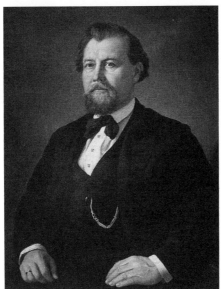

PORTRAIT OF MR. EDWARD STEVES
1873, oil on canvas, 33¼" × 25½"
Signed and dated lower right: C. Iwonski, fert/1873

Edward Steves was a native of Barmen,
Prussia, born on December 14, 1829, who
came to Texas in 1849 on the ship Neptune
with his family. They settled in New
Braunfels, where Edward worked as a farmer,
carpenter, and cabinetmaker. When he
married and moved to Cypress Creek, he
became interested in the lumber business
and, upon moving to San Antonio in 1866, he
established the Steves Lumber Yard. Steves
became one of the city's most successful
merchants and civic leaders and built an
impressive home on King William Street.[47]

Carl Iwonski's portrait of Steves depicts
him as a prosperous San Antonio businessman,
fashionably dressed with flowing tie, neatly
trimmed beard, and glistening gold watch
chain. His features show astuteness and
intelligence, qualities the artist portrays with
dexterity. The portraits of Mr. and Mrs.
Steves hung in the Steves's Homestead on
King William Street for many years.[48]

PROVENANCE:
1873–1979: Collection of the Steves Family.
1979–1992: Extended Loan to SAMA by Elisabeth
Vaughan Bishop.
1992: Gift to SAMA by Elisabeth Vaughan Bishop in
memory of her grandfather, Albert Steves.
92–30 G (2)

EXHIBITIONS:
1933: Yanaguana Society Exhibition, Old San Antonio
Paintings, WMM (December 1 to 3, extended to 8).
Lent by Albert Steves.
1964: The Early Scene: San Antonio, WMM (June 7 to
August 31). Lent by Mrs. Curtis Vaughan.
1976: Iwonski in Texas: Painter and Citizen, WMM
(August 1 to September 30). Lent by Mrs. Curtis
Vaughan.
1986: Texas Seen/Texas Made, SAMOA (September 29
to November 30).
1990–1991: Magic Lanterns: From Victoria to the
Flappers, WMM (December 7, 1990, to February 28,
1991).

PUBLICATIONS:
Chabot, With the Makers of San Antonio (1937),
opposite 406.
Pinckney, Painting in Texas (1967), [127]: plate 68.
Steinfeldt and Stover, Early Texas Furniture and Decorative
Arts (1973), 251.
"Witte Issues New Books," San Antonio Express-News,
September 19, 1976.
McGuire, Iwonski in Texas (1976), 53.
Glen E. Lich, The German Texans (1981), 154.

PORTRAIT OF SAMUEL AUGUSTUS
MAVERICK
1873, oil on canvas, 26″ × 20″
Signed and dated lower left: C. Iwonski, 1873

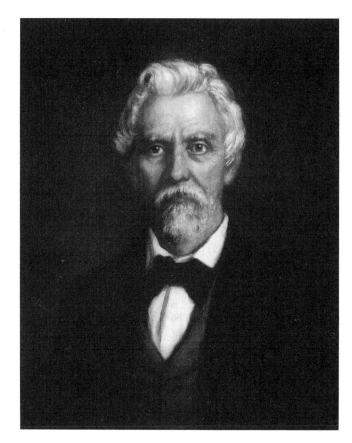

This portrait, which Iwonski painted
posthumously from a photograph, is of Sam
Maverick, one of the most influential of
the pioneers to shape the history of Texas.
Samuel Augustus Maverick was born in South
Carolina in 1803, came to Texas before the
Texas Revolution, fought in the war, and
was a signer of the Texas Declaration of
Independence. His was the first American
family to settle in San Antonio, and he served
the republic, the state, and the city in many
capacities. Maverick was mayor of San
Antonio (1839–1840), a representative to the
Texas Congress (1843–1844, 1844–1847), and a
member of the Texas legislature (1853–1862).
He was one of the Texan commissioners who
accepted the surrender of Federal forces and
property at San Antonio in 1861. Maverick
died in San Antonio on September 2, 1870.[49]

Records show that the Maverick family
commissioned the portrait because they
were impressed with Iwonski's artistic skills,
especially in political illustration.[50] Although
Iwonski usually painted from life, he did
a creditable job on Maverick's likeness,
effectively using his knowledge of flesh
tones, textures, and anatomy.

PROVENANCE:
1873–1979: Collection of the Maverick Family.
1979: Gift to SAMA by Maury Maverick, Jr.
79–72 G

EXHIBITIONS:
1964: The Early Scene: San Antonio, WMM (June 7 to
August 31). Lent by Maury Maverick, Jr.
1976: Iwonski in Texas: Painter and Citizen, WMM
(August 1 to September 30). Lent by Maury Maverick,
Jr.
1986: Remembering the Alamo: The Development of
a Texas Symbol, 1836–1986, WMM (February 23 to
October 31).

PUBLICATIONS:
Rena Maverick Green (ed.), Samuel Maverick, Texan:
1803–1870 (1952), frontispiece.
"The Amazing Mavericks," San Antonio Express,
March 1, 1953.
McGuire, Iwonski in Texas (1976), 55.
T. R. Fehrenbach, The San Antonio Story (1978), 68.
SAMA Calendar of Events (June 1979): [2].
The Daughters of the Republic of Texas, The Alamo
Long Barrack Museum (1986), 16.
Willoughby, Texas, Our Texas (1987), 300.
Marks, Turn Your Eyes Toward Texas (1989), 262.

49. Webb, Carroll, and Branda (eds.), The Handbook of
Texas, 2, s.v. "Maverick, Samuel Augustus."
50. McGuire, Iwonski in Texas, 55.

MARY AUBREY KEATING

Mary Aubrey Keating was a vital, dynamic, and energetic woman whose talents enriched the city and the state in many ways. She was educated in San Antonio public schools and later at Monticello, Illinois, and Notre Dame College, Baltimore, Maryland. Before becoming an artist she studied singing with Madame Ernestine Schumann-Heinck and, as a contralto, performed as soloist with the Philadelphia and San Carlos opera companies as well as with numerous symphonies.[1]

Mary's father, Judge William Aubrey, was born in Mobile, Alabama, and moved to San Antonio in 1882. He married Eugenia Deering Speer on August 25, 1892, and they became the parents of three children. Judge Aubrey was the dean of the San Antonio Law School in 1928 and a director of the *Texas Law Review*. He served as president of the San Antonio Bar Association and the State Bar of Texas. He was a charter member of the historical Yanaguana Society in San Antonio and became one of its first presidents.[2] Mary's mother also was active in civic affairs and served with the Red Cross and the Symphony Society.[3] Mary was justifiably proud of her family name and always used Mary Aubrey Keating as her signature.

Mary married a physician, Peter McCall Keating, on June 1, 1921, and they became the parents of four children, Peter, Jr., Aubrey, Jean, and William. Mary gave up her promising career as an opera singer to devote time to the family, but her creative urge was strong, and she took up painting as a hobby.[4] Mary was unashamed that she was self-taught and found her greatest inspiration in colorful Hispanic subjects in San Antonio and in Mexico, Guatemala, Honduras, and Panama. When she painted a large mural with a Mexican theme for the USO (United Services Organization) Travelers Aid Station in San Antonio, she stated: "If you take away the Mexican element from San Antonio, you lose the thing that makes it special. I am painting a Mexican subject because I want to emphasize for the boys from faraway places the thing we have here that is picturesque and unique."[5]

Mary painted other murals in the city, always with historical or local themes: for the San Antonio Public Library, the Gunter Hotel, the Kelly Air Force Base Aviation Cadet Hospital, and the Junior League Bright Shawl Tea Room. These murals usually were in watercolors or oil washes, which meant she had to work rapidly and decisively in order to complete them.[6]

The artist was not only an energetic painter, she was also a driving force in the community's art activities. She was organizer and chairman of the first Open Air Art Exhibit in San Antonio, held in Travis Park in December 1933. She acted as chairman for the Artists Ball, a gala affair in the Municipal Auditorium on May 31, 1939, which was organized to raise funds to establish the Museum School of Art in the city, and she was one of the school's first co-chairmen. She had been a founder of the Villita Art Gallery in 1939 and was instrumental in organizing the Contemporary Art Group in 1951.[7]

Mary consistently exhibited in local and regional shows and had her first solo exhibition at the Witte Memorial Museum in 1934. Another, booked through the American Federation of Arts, was displayed at the museum on October 15–30, 1943. In April 1944 the murals she had painted for Kelly Field were on special exhibition in the museum for four days.[8]

In 1933 twenty of Mary's watercolors were shown in the Horticultural Hall at the Chicago World's Fair.[9] By 1941 she could boast of having sixteen one-woman

1. "Civic Leader's Funeral Rites Slated Monday," San Antonio *Express*, December 13, 1953.
2. Webb, Carroll, and Branda (eds.), *The Handbook of Texas*, 2, s.v. "Aubrey, William."
3. Marin B. Fenwick (ed.), *Who's Who Among the Women of San Antonio and Southwest Texas: A Blue Book and Directory and Year Book of the Women's Organizations* (San Antonio: Marin B. Fenwick, 1917), s.v. "Aubrey, Eugenia Speer." The three children born to the Aubreys were Jean Dearney, Mary Gayle, and William.
4. "Prominent S. A. Woman Dies As She Leaves Memorial Concert," San Antonio *Evening News*, December 12, 1953.
5. Josephine Ramsdell, "Artist Making Unique Contribution to America's Victory." Undocumented newspaper clipping, Mary Aubrey Keating file, SAMA Texas Artists Records.
6. Catalogues and listings, Keating file, SAMA Texas Artists Records.
7. Ibid.
8. Ibid.

shows, with some in New York, Santa Fe, and Philadelphia.[10] She also had exhibitions in the Denver Art Museum, the Laguna Beach Museum of Art, the Los Angeles County Museum of Art, the Sacramento Public Library, the Museum of Fine Arts, Houston, and art galleries in Oklahoma City, to name a few. Many news releases reported that Mary often sang or lectured at the openings of her exhibitions as well.[11]

In addition to all Mary Aubrey Keating's activities as artist, singer, mother, and organizer, she also managed to write. In 1935 she published a book titled *San Antonio: Interesting Places in San Antonio and Where to Find Them*. It contained forty-three of her well-executed block prints of scenes in and around San Antonio.[12]

Because of her interest in the city and its history, Mary was an ardent conservationist and was president of the King William Area Conservation Society. In 1953, she wrote an impassioned letter to the editor of a local newspaper in which she deplored the destruction of local historical sights. Although very long, it was printed in its entirety. It began: "There are many of us in San Antonio who are uneasily pondering on the ready use of the word 'progress.' It is being heard on all sides, not like the proverbial voice of the turtle throughout the land, but like the voice of steam shovel and crane which are on the march." And it ended, "We still must defend it [our heritage]. To arms, citizens, against shovel and crane used destructively in the name of progress."[13]

Mary Aubrey Keating died much as she had lived, quickly and dramatically. She had attended a Symphony Society Concert at the Municipal Auditorium, a memorial to the late conductor Max Reiter, on December 11, 1953. She collapsed on the steps as she was leaving, and was pronounced dead of a heart attack after being rushed to the Baptist Memorial Hospital.[14]

On March 23, 1954, a special exhibition of Mary's works and a memorial service were held in the War Memorial Auditorium at the Witte Memorial Museum, the Reverend Harold Gosnell officiating. The paintings later were sent to Austin for an exhibition in her memory sponsored by the Texas Fine Arts Association at the Elisabet Ney Museum.[15] In 1955 a retrospective exhibition of her work, which included work from 1928 to 1953, was held in the Davis Galleries in the Witte Memorial Museum.[16]

(*Left*) The first Open Air Art Exhibit in San Antonio, Travis Park, 1933. Left to right: Helen Vance, Mary Aubrey Keating, Guy Holloman, Cecilia Steinfeldt, and Mary Wheeler Cooney. Courtesy of the author.

(*Above*) Photograph of Mary Aubrey Keating at the presentation of the collection of Mary Bonner etchings to the San Antonio Art League by the Emma Bonner Estate in 1952. Mrs. Keating stands at the left of the easel with Mrs. Blanche Bell and Mrs. Betty Urschel at the right. SAMA Historical Photographic Archives, staff photograph.

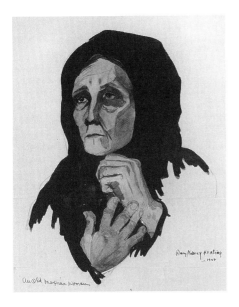

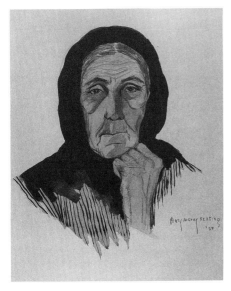

AN OLD MEXICAN WOMAN
1928, watercolor on toned paper, 20″ × 17½″
Signed and dated lower right: Mary Aubrey
Keating/1928
Titled lower left: An Old Mexican Woman

Mary Aubrey Keating could not be accused
of painting "pretty" pictures. But she found
interest and beauty in commonplace subjects,
such as an elderly Hispanic woman with
rugged features and work-worn hands
clutching a black *rebozo* around her head.

PROVENANCE:
1928–1955: Collection of the Keating Family.
1955: Purchased from the retrospective exhibition by
H. Houghton Phillips.
1955: Gift to SAMA by H. Houghton Phillips in
memory of H. Giesecke.
55–20 G (1)

EXHIBITIONS:
1955: Mary Aubrey Keating Retrospective Exhibition,
WMM (May 24 to June 1).

MEXICAN WOMAN
1928, watercolor on toned paper, 19″ × 16″
Signed and dated lower right: Mary Aubrey
Keating/'28

Mary Aubrey Keating captured the pathos,
the character, and the stoicism of the people
she painted using a few simple lines and areas
of color. It is evident that this Hispanic
woman has experienced much in her
lifetime, even though the artist's treatment
of the subject was quickly done. Probably
among Keating's first efforts, it foretells the
strong and vigorous style she developed in
her painting.

PROVENANCE:
1928–1955: Collection of the Keating Family.
1955: Purchased from the retrospective exhibition by
H. Houghton Phillips.
1955: Gift to SAMA by H. Houghton Phillips in
memory of H. Giesecke.
55–20 G (2)

EXHIBITIONS:
1955: Mary Aubrey Keating Retrospective Exhibition,
WMM (May 24 to June 1).

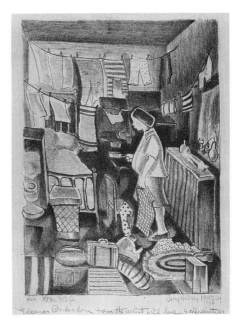

WAR WIFE
1945, lithograph on paper, 15½″ × 11⅛″
Signed and dated lower right: Mary Aubrey Keating/
1945
Titled lower left: War Wife
Inscribed across bottom: Eleanor Onderdonk from
the artist with love and affection

Mary Aubrey Keating was completely
uninhibited in her choice of subject matter.
When she chose to portray a war wife,
she did so showing the difficulties often
encountered by a pregnant young woman
coping with a crowded apartment,
inadequate facilities, and a small child.
The drawing is somewhat crude, but the
composition is strong and the interplay of
dark and light values is robust and forceful.

PROVENANCE:
1945: Gift to Eleanor Onderdonk from the artist.
1945–1964: Collection of Eleanor Onderdonk.
1964: Gift to SAMA by Eleanor Onderdonk.
64–295 G (6)

9. "S. A. Painter Shows at Fair," San Antonio *Light*,
December 17, 1933.
10. J. Ramsdell, "Artist Making Unique
Contribution."
11. Catalogues and listings, Keating file, SAMA Texas
Artists Records.
12. "Book Details City Legends," San Antonio *Light*,
May 23, 1935.
13. "Readers' Round Table," San Antonio *Evening
News*, May 28, 1953.
14. "Prominent S. A. Woman Artist Dies."
15. "Witte Memorial Museum Art Department
Annual Report," 1953–1954. Witte Museum
Library.
16. "Memorial Exhibit Due," San Antonio *Light*,
May 24, 1955.

Born on December 31, 1888, in Pforzheim, Germany, Edmund Kinzinger received his first formal art training at the State Academies of Munich and Stuttgart in his native country. He also studied at the Académie Moderne in Paris before World War I.[1]

In listing a chronology of his painting styles, Kinzinger related that he first was influenced by German and French Impressionism, but in 1913, while in Paris, he became fascinated with Cubism. During World War I he did little work because of his military service and when he returned to painting in 1918 his work became completely abstract. In 1922, however, his pendulum was swinging back to a more naturalistic style, prompted by a year's study in Italy, where he was exposed to the early Renaissance masters and "discovered" Piero della Francesca (1420–1492).[2] He said, "It is in the character of our age that artists change their style from time to time, inclining more to abstract form one moment and leaning more to representation at another."[3]

Although the date of Kinzinger's sojourn in Italy is somewhat vague, it must have been about 1926. A young American girl, Alice Fish (1894–1968), had been attending his classes in Munich. She accompanied Kinzinger's group to Capri, where she and the artist fell in love. Alice brought him to the United States to meet her family, and the couple was married here.[4] From 1927 to 1930 Kinzinger taught in Minneapolis. He, his wife, and their small daughter Didi then returned to Germany, where he maintained a studio.[5]

In Europe, Kinzinger and Hans Hofmann (1880–1966) had been close friends during the early twenties, and when Hofmann came to the United States in 1930 to teach at the University of California, Kinzinger conducted the Hans Hofmann School of Fine Arts in Munich for the next three years. He then spent a year painting in France and Spain, a period in which he produced what he considered to be his strongest work.[6]

When the artist returned to the United States in 1935 he became chairman of the Department of Art at Baylor University in Waco, Texas, a position he held for almost fifteen years. While in Texas, Kinzinger was involved in all art activities and organizations and won numerous prizes and awards both locally and nationally. He earned a Ph.D. from the University of Iowa in 1942.[7]

In the summers of 1936 and 1937, Kinzinger conducted courses in painting in Taxco, Mexico.[8] The Witte Memorial Museum honored the artist with one-man shows in 1938 and 1944, exhibitions that also traveled to Houston and Dallas. The 1938 exhibition was a retrospective and included what the artist termed "Metal Plastics." The 1944 show was composed of twenty-eight paintings and twenty-three prints, both lithographs and serigraphs.[9]

Sometime in the 1940s the Kinzingers purchased a home in Taos, New Mexico. In order to help pay for it, the artist had to sell many of his valuable antiques, but he was enthusiastic that he would have "a real studio and hope that it will improve my painting."[10] He also purchased a sculpture, *Budding Girl*, by Archipenko (1887–1964).[11] These expenditures not only put a burden on his finances but also strained his marital relationship. He was divorced from his wife, Alice, on September 16, 1947.[12]

These worries caused the artist to have a nervous breakdown in 1948, and he was compelled to live with his son and daughter-in-law near the small town of

1. Catalogues and listings, Edmund Daniel Kinzinger file, SAMA Texas Artists Records, and Jerry Bywaters Collection, SMU.
2. Edmund Kinzinger (Delevan, Wisconsin) to Jerry Bywaters (Dallas), March 25, 1958.
3. *Paintings and Prints by Edmund Daniel Kinzinger* (San Antonio: Witte Memorial Museum, October 8–31, 1944), [7].
4. Helen Baldwin, "The Personal Touch," Waco *Tribune-Herald*, January 13, 1963.
5. Kinzinger to Bywaters, March 25, 1958.
6. Ibid.
7. Catalogues and listings, Kinzinger file, SAMA Texas Artists Records.
8. Kinzinger [Edmund Daniel], *Landscape Course Catalogues, 1936 and 1937*, Jerry Bywaters Collection, SMU.
9. Catalogues and listings, Kinzinger file, SAMA Texas Artists Records.
10. Kinzinger (Waco) to Bywaters (Dallas), October 10, 1946.
11. Kinzinger (Waco) to Bywaters (Dallas), September 23, 1947.
12. Kinzinger (Waco) to Bywaters (Dallas), September 24, 1947.
13. Mary Kinzinger (Larboro, North Carolina) to Dr. Richard Gasser (Fort Worth), May 23, 1973.
14. Baldwin, "The Personal Touch."
15. Kinzinger to Bywaters, March 25, 1958. Kinzinger provided Bywaters with listings of his exhibitions abroad and in the United States: one-man shows were at Kunstgebäude, Stuttgart, Germany; Gallerie Pierre in Paris; Gallery Bloomsbury, London; Roullier Gallery, Chicago; at the Universities of Iowa, Minnesota, and Oklahoma; and at the Detroit Institute of Arts. He also exhibited in Milwaukee, Dallas, Houston, and San Antonio. He was included in exhibitions at the Art Institute of Chicago, the New York World's Fair, the Golden Gate Exposition in San Francisco, the Texas Panorama (sent on national circuit by the American Federation of Arts), the International Watercolor Society in Chicago, the Glaspalast in München [Munich], Germany, and the Freiesecession in Berlin. During Kinzinger's sojourn in Texas he belonged to all important state and local organizations and served as vice-president of the Texas Fine Arts Association and as director of the College Arts Association. He exhibited consistently in all these organizations and won awards in 1938 and 1939 at the annual exhibits of Artists of Southeast Texas; 1939 and 1940 at the West Texas Show in Fort Worth; 1941 at the Southern States Art League; 1943 and 1944 at the Texas Fine Arts Membership Show and the Texas General Exhibition; and at the 1947 Texas General Exhibition he won the first prize with a special commendation of the jury for a triptych entitled *Mexican People*. This listing, impressive as it is, probably is not complete.
16. M. Kinzinger to Gasser, May 23, 1973.
17. *Paintings and Prints by Edmund Daniel Kinzinger*, [7].

TWO MEXICAN CHILDREN
1938, oil on canvas, 32″ × 26″
Initialed and dated lower right: EDK/38

The work of Edmund Kinzinger adds an
invigorating dimension to the San Antonio
Museum Association's Texas Collection. The
artist has stated that he was a "follower of
the intellectual principles of Cubism. . . .
Being of a rather romantic nature, however,
and very much bound to direct impressions,
my development reveals many conflicts." [17]
His painting philosophy is reflected in *Two
Mexican Children*. The canvas gains quiet
strength through forcefully modeled
forms and has an intellectual rather than a
sentimental emphasis. It is an example of a
modified phase of abstract painting in which
the artist takes his subject from nature but
gives it formalized treatment.

PROVENANCE:
1938–1944: Collection of the artist.
1944: Purchased by the Houston Museum of Fine Arts
with funds provided by the Houston Friends of Art.
1944–1973: Collection of the Houston Museum of
Fine Arts.
1973: Deaccessioned by the Houston Museum of
Fine Arts and purchased by Edward J. Denari and
Company, Fort Worth.
1973: Purchased from Edward J. Denari and Company
by Dr. Richard Gasser, Fort Worth.
1973–1982: Collection of Dr. and Mrs. Richard Gasser.
1982: Gift to SAMA by Dr. and Mrs. Richard Gasser.
82–72 G

EXHIBITIONS:
1938: Oils and Metal Plastics by Edmund Kinzinger,
WMM (January 1 to 26).
1941: The Second Texas-Oklahoma General Exhibition,
DMFA (February 2 to 15).
1941: The Second Texas-Oklahoma General Exhibition,
Traveling Exhibition: Houston Museum of Fine Arts
(February 23 to March 9). Witte Memorial Museum
(March 16 to 30). Philbrook Art Museum, Tulsa (April
4 to 30).
1986: Texas Seen/Texas Made, SAMOA (September 29
to November 30).

PUBLICATIONS:
The Bulletin of the Museum of Fine Arts of Houston, Texas, 6
(Winter 1944): [6].

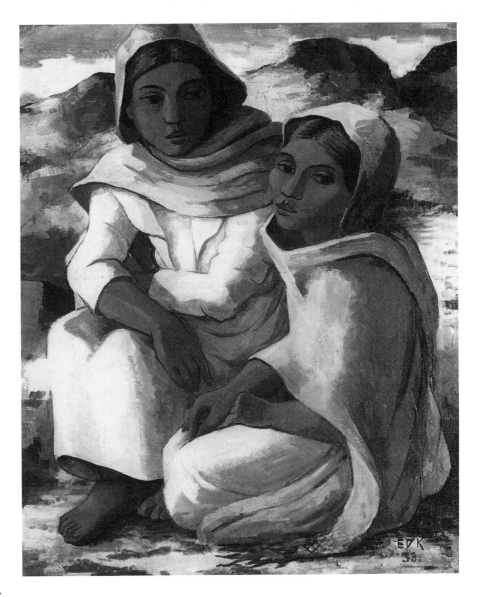

Delevan, Wisconsin.[13] This son was by Kinzinger's first wife, who had been killed in
an accident before the artist and Alice Fish ever met.[14] The artist became extremely
embittered and found life in Wisconsin "tedious." The peaceful Delevan countryside
did not suit his dynamic temperament, and he wrote nostalgically that he "had not
even a place to paint."[15]

In 1960, the Kinzingers moved to Larboro, North Carolina. Mary Kinzinger
wrote: "My father-in-law lived with us until his death in 1963. . . . Our home was in
Wisconsin and we moved to North Carolina in 1960. Edmund was diagnosed as a
manic-depressive in his mid-fifties and was in an almost constant state of deep
depression. His death, however, followed a stroke."[16]

For a man whose life had been so cosmopolitan and who had exhibited and
been so closely associated with such artists as Hans Hofmann, Karl Zerbe (1903–1972),
Oskar Schlemmer (1888–1943), and Josef Albers (1888–1976), Kinzinger's last years must
have been demoralizing. Productive as he was during his painting career, he almost
became an obscure footnote in the scheme of Texas painting.

WOMEN
1944, lithograph on paper, 11¼″ × 9″
Signed and dated lower right: Edmund Kinzinger, '44

Mexican themes were among Kinzinger's favorite subjects when he worked in Mexico and Texas. The simple garb of Mexican peasant women especially appealed to him. He used the flowing lines of *rebozos* and the clean shapes of the costumes to great advantage in his strong and vigorous translations of realistic forms into dynamic design. These traits are evident in his prints as well as in his paintings and are indicative of the artist's robust and energetic personality.[18]

PROVENANCE:
1944–1964: Collection of Eleanor Onderdonk.
1964: Gift to SAMA by Eleanor Onderdonk.
64–295 G (7)

EXHIBITIONS:
1944: Paintings and Prints by Edmund Daniel Kinzinger, WMM (October 8 to 31).
1986: Texas Seen/Texas Made, SAMOA (September 29 to November 30).

18. The composition of the lithograph is almost identical to *Mexican People*, the left panel of the triptych, which won Kinzinger the first prize in the Texas General Exhibition in 1947.

EUGENIE ETIENETTE AUBANEL LAVENDER

Eugenie Lavender's life story reads like a romantic historical novel. Born on Christmas Day, 1817, in Bordeaux, France, shortly after Bonaparte's downfall, Eugenie was the eldest child of Etienne Aubanel and Juliette Antoinette (Fortin) Aubanel, ardent supporters of Napoleon. Her grandfather served under the general in the Moscow campaign. She had a sister, Matilde, and a brother, Ernst. The family moved to Paris when Eugenie was about three months old.[1]

Shortly after Ernst's birth, Juliette Aubanel became seriously ill, and her dying request was that her husband marry her sister. After a year the two were indeed married and, from all accounts, the children had a happy life, being reared in a cultured and cloistered atmosphere.[2] Eugenie and her sister were particularly close, and thus when Matilde became the wife of the Count de la Rouviere, Eugenie fell into a state of melancholy at the separation. The family physician advised a change of scene and occupation. As Eugenie had shown an interest in painting, she was sent to the École de Beaux Arts, then under the special patronage of Queen Marie Amelie Therese, the wife of Louis Philippe.[3]

Eugenie overcame her depression and became a most efficient art student. Her instructors were Ary Scheffer (1795–1858), Henry Scheffer (1798–1862), and Paul Delaroche (1797–1856), all popular painters of large historical subjects, portraits, and genre scenes in the romantic realist tradition.[4] Their influence on Eugenie's painting was evident throughout her long career. Rosa Bonheur (1822–1899) was one of her fellow students, possibly working under the same instructors. Both women received medals from Louis Philippe in 1848, Rosa Bonheur for *Ploughing in the Nivernais* and Eugenie Aubanel for *The Greek*.[5]

Under Ary Scheffer's guidance Eugenie painted two allegorical scenes based on Goethe's *Faust*. Her studies at the École de Beaux Arts included painting from living models; historical pictures; portraits, mainly of family members; and copying famous paintings in the Louvre. Through Horace Vernet (1789–1863), director of the French Academy and an intimate friend of the Aubanel family, she was granted the privilege of duplicating the Old Masters. Among her copies was Correggio's *Madonna and Child*, a painting she brought with her when she came to Texas. She also did some restoration work in the museum.[6]

By this time Eugenie was at the age suitable for marriage. According to the custom of the period, her parents had selected a wealthy French nobleman as a suitor, but Eugenie had other ideas. She had met a young Englishman, Charles Lavender, the son of a London lithographer, who was an Oxford graduate and, at the time, a professor at the University of Paris. They were married on February 14, 1846.[7]

Evidently Charles Lavender had an adventurous nature, for he soon became interested in Texas. Eugenie Lavender's granddaughter, Sister Borromeo, described their move:

Accordingly in 1852 with their two children, Emilie and Matilde, in spite of the protests of their parents, Eugenie and Charles Lavender crossed the Ocean and arrived at New Orleans. In New Orleans they bought a prairie schooner and, having supplied themselves with other necessities, set forth. I cannot trace their route very definitely for the diary that Mr. Lavender kept during this interesting period has unfortunately been lost. They, however, passed through Houston, camped a few days in the environs of Cameron, and finally halted at a point within the limits of Waco, and remained there more than a year. While in Waco, they lived next door to the Ross family, and the two

1. Sister Borromeo, "Biography of Mrs. Charles Lavender, Artist," [1928], 1. Typescript, La Retama Public Library Archives, Corpus Christi, Texas.
2. Ibid.
3. "Grandma Lavender is the Pride of Corpus Christi," *St. Louis Republic*, February 28, 1897. Photocopied typescript, Eugene C. Barker Texas History Center, University of Texas at Austin.
4. Ibid.
5. Borromeo, "Biography," 3–4.
6. Borromeo, "Biography," 5–6; "Grandma Lavender."
7. Pinckney, *Painting in Texas*, 97–98.

little girls played frequently with the little son, Lawrence Sullivan, who later rescued Cynthia Ann [Parker] from the Comanches, and who after fighting bravely as a Confederate soldier, in the Civil War, became Governor of our State.[8]

The Lavenders' exploits during their early years in Texas, related in an article published in a St. Louis newspaper in 1897, included nearly every imaginable peril that neophyte travelers could encounter: swollen rivers; hostile Indians; devastating prairie fires; vicious alligators; snakes and poisonous insects, as well as wild animals; and the birth of Eugenie's third child, Charles Lavender, Jr., delivered in the wilderness without medical aid.[9]

Although these hazards were completely foreign to the young couple's sheltered upbringing, they managed to cope. Eugenie learned to use a rifle and to hunt. She exchanged her feminine garb for deerskin trousers and jacket and a large wide-brimmed hat, and kept a pistol and a knife at her side.[10]

According to one account, the family continued their wanderings through Texas:

The Lavenders found many beauty spots. The moss-covered oaks reached their expectations, and they were delighted with the number and variety of wild flowers. The vastness of the Texas prairies, the wildness of their surroundings, and the novelty of it all satisfied to a certain extent their romantic longing. The fields of bluebonnets, the patches of paintbrush and Indian blanket, the purple mountain laurel—all delighted them, and Mrs. Lavender made pictures of the flowers from the juices of the plants.[11]

Finally the Lavenders decided the hazards outweighed the advantages of this new country and in about 1854 they moved from Waco to New Orleans, where they found conditions far more favorable. Charles Lavender established a school, Audubon College, sometimes called the "Lavender School," on Rampart Street. The family survived the Civil War in the city, although they lost their young son sometime during the early 1860s. Toward the end of the 1870s Charles Lavender died and was buried beside his son in the family vault in New Orleans.[12]

Eugenie Lavender then moved to Corpus Christi to live with her daughter, Emilie, who had married Francis Edward Macmanus shortly after the Civil War. With a small inheritance from her mother, who died in the early 1880s, Eugenie built a small cottage for herself in which she placed valuable paintings, antiques, china, and cut glass from her mother's estate in Paris, thus establishing a veritable art gallery. Eugenie gave art lessons to her grandchildren and others. She resumed her own art career and painted almost daily.[13]

At eighty years of age she attempted her most ambitious painting, a large 5' × 10' canvas of St. Patrick. Sister Borromeo believed the effort necessary to complete such an enormous work hastened her grandmother's demise. Eugenie Lavender died on September 2, 1898, and was buried in Corpus Christi.[14]

Many of Eugenie's final paintings had religious themes and were hung in St. Patrick's Cathedral in Corpus Christi. After her death an exhibition of her work and her collection of famous paintings brought from France was held at the St. Agnes Academy in Corpus Christi.[15] A listing in Corpus Christi's La Retama Public Library of the works shown is disappointing, as few of the artist's Texas paintings remained. This was no doubt because she gave most of her work away to friends during her lifetime.[16]

8. Borromeo, "Biography," 6.
9. "Grandma Lavender."
10. Ibid.
11. Borromeo, "Biography," 7.
12. Ibid., 8–10.
13. Ibid., 11.
14. Pinckney, *Painting in Texas*, 99; Borromeo, "Biography," 12–13.
15. Forrester-O'Brien, *Art and Artists*, 25.
16. Ibid.

STILL LIFE WITH GAME BIRDS
1892, oil on canvas, 18″ × 25″
Signed and dated lower right: Eugenie Lavender, 1892

Most of Eugenie Lavender's work had a distinctive idealistic flair, as romantic as her euphonious name. When she chose to do this still life she selected exotic game birds with sleek and shining feathers cushioned amid soft drapery and crisp foliage, all framed within an arched aperture showing a fanciful landscape in the distance. She was seventy-five years old at the time it was painted, and her rendition unmistakably hearkens back to her early training at the École and the Louvre.

PROVENANCE:
1892–1979: Collection of the Lavender-Welch Family.
1979: Gift to SAMA by Mark Welch, the artist's grandson.
79–116 G

EXHIBITIONS:
1986: Texas Seen/Texas Made, SAMOA (September 29 to November 30).
1988: A Witte Merry Christmas: Tannenbaums to Tumbleweeds, WMM (December 1 to 30).

KARL FRIEDRICH HERMANN LUNGKWITZ

As a young man Hermann Lungkwitz received thorough academic training in the arts at the Royal Academy of Fine Arts in Dresden. Exposed to the best in classical painting there, he was profoundly influenced by the romanticism of Adrian Ludwig Richter (1803–1884). Richter was a protégé of Caspar David Friedrich (1774–1840), known as Germany's greatest romantic painter.[1] When Lungkwitz painted his pastoral views of the Texas countryside he fused this romanticism with natural realism and, as Jerry Bywaters has pointed out, made the first solid contribution to landscape painting in Texas.[2]

Karl Friedrich Hermann Lungkwitz was born on March 14, 1813, in Halle an der Saale, Prussian Saxony, in Germany, to Johann Gottfried and Friederike Wilhelmine (Hecht) Lungkwitz. He was the second of the couple's five children.[3] Hermann's father was a successful hosiery manufacturer and evidently expected young Hermann to carry on the family business. Hermann probably worked for his father during his early adulthood but, according to family records, he decided to study art upon receiving an inheritance from a Hecht uncle. He enrolled in the Royal Academy in 1840, actively participating in drawing and painting classes until the fall of 1843. During these years he also went on sketching jaunts in Bohemia and Austrian Salzkammergut and Tirol.[4]

Photograph of Hermann Lungkwitz made in the Iwonski-Lungkwitz Studio in San Antonio, ca. 1866. Courtesy of the Van der Stucken Family.

Richard Petri, another talented young man, was a fellow student at the academy. They became good friends and eventually brothers-in-law. Political events were to have a profound impact on both of their careers. In 1849 both Lungkwitz and Petri engaged in street fighting that was part of the German uprising against an oppressive government.[5] Retaliation against the leaders and participants resulted in considerable emigration to America. Petri, Lungkwitz, and their families became part of this exodus.[6]

Before leaving Dresden in August 1850, Lungkwitz married Elisabet (Elise) Petri, Richard's sister, on July 2, 1850. Soon after, they began their journey to America, accompanied by his sixty-nine-year-old widowed mother Friederike, his sister Therese, his brother-in-law Richard Petri, and Richard's sister Marie.[7] His brother Adolph, a tinsmith and silversmith, was in Sweden when the party left Dresden but later joined them in America.[8]

The Lungkwitz-Petri family group did not come directly to Texas, as many immigrants did. They arrived in New York on September 23, 1850, and departed two days later for Wheeling, Virginia, where they remained for six months, supporting themselves by selling artwork and giving art lessons.[9]

The cold winter months in Wheeling affected both Elisabet and Richard, who were in delicate health. This no doubt influenced their decision to move to Texas. They left Wheeling in April 1851 and traveled by steamboat down the Ohio and Mississippi rivers to New Orleans. From there they sailed to Galveston and on to Indianola on the Texas coast. After a trip inland by ox-drawn wagons, the group finally arrived in New Braunfels in July where they remained for the next six months.[10]

From this base Lungkwitz and Petri traveled to San Antonio and Fredericksburg, where they made sketches and attempted to sell their work.[11] The Lungkwitzes' first child, Paul, was born in New Braunfels, but survived only three weeks and was buried in a local cemetery.[12]

By 1852 Adolph Lungkwitz had joined them and in the spring of that year the family moved to Fredericksburg. The higher and drier atmosphere of the Hill Country

evidently attracted them, and the scenic beauty of the Pedernales Valley with its surrounding hills must have appealed to Lungkwitz. The family first lived in rented quarters, but on July 14, 1852, Hermann and Adolph Lungkwitz and Richard Petri paid John Twohig four hundred dollars for a 320-acre farm on the Pedernales River a few miles southwest of Fredericksburg. It was to be their home for the next twelve years.[13]

Although ill-equipped to farm, the family purchased livestock, improved the complex of buildings, and worked the fields. The artists devoted part of their time to sketching and painting, some of which they sent to their relatives in Germany. Another son, Max, was born to the Lungkwitzes on October 4, 1853, and was joined by a sister on February 22, 1855. Adolph married Elise Heuser on October 14, 1855, and Friederike Lungkwitz died the same year. Marie Petri married Jacob Kuechler on May 31, 1856, and Richard Petri accidentally drowned in the Pedernales River late in 1857.[14]

The next few years found Lungkwitz spending more and more time in San Antonio. A protracted drought had made the farm unprofitable, so Lungkwitz used his artistic talents to augment the family income. He painted scenery for the Casino Hall in San Antonio, sold lithographs of his *Friedrichsburg* view, and learned the new art of photography from his friends William DeRyee, Wilhelm Thielepape, and Carl G. von Iwonski. They produced a magic lantern show and gave performances with a "Mammoth Agioscope." In about 1860, they took the show on tour to towns along the Mississippi and Ohio rivers.[15]

Shortly after Lungkwitz returned from the magic lantern show circuit, the Civil War made life even more difficult for the family. The artist himself assumed a neutral attitude in the conflict, although other members of the family were Unionists. With German settlements in Texas experiencing difficulties because of differences of opinion concerning the war, Lungkwitz and his wife decided to lease their farm and move to San Antonio, where they felt they would be safer. They moved in mid-April 1864, and from then on Lungkwitz depended on painting, teaching, and photography to earn a living.[16]

During the last years of the war and in the year that followed, economic conditions in San Antonio deteriorated, and Lungkwitz sold very few paintings. He established a drawing and drafting school in 1865 with ten students, each paying five dollars a month. This supported the family until conditions improved. By 1866 Lungkwitz and Iwonski had opened their photographic studio in the old Masonic Building, where they remained for three years before moving to a room over Bell Brothers' Jewelry Store on Main Street. When Franz Hanzal joined the business in 1869 they took a studio opposite Kampmann's Building, also on Main Street. The Lungkwitz children went to the German-English School, and the family's social life centered on the German community in the city.[17]

In 1870 Jacob Kuechler, Lungkwitz's brother-in-law, was state land commissioner, and Lungkwitz became a draftsman and photographer in the General Land Office in Austin, a position he retained for four years. The family moved to Austin shortly thereafter, and when Lungkwitz's term ended he returned to painting and teaching in that city. In 1875 he joined the faculty of Jacob Bickler's German-American Select School for Boys, later known as the Texas German and English Academy for Boys and Young Men. He also conducted private art classes and became associated with a young artist, William Henry Huddle (1847–1902), with whom he

1. Goetzmann and Reese, *Texas Images and Visions*, 22.
2. Pinckney, *Painting in Texas*, xix.
3. McGuire, *Hermann Lungkwitz*, 1.
4. Ibid., 1–4. McGuire gives a very thorough chronology of Lungkwitz's activities and known works during this period.
5. For details of the history of the political revolt in Dresden see William W. Newcomb, Jr., with Mary S. Carnahan, *German Artist on the Texas Frontier: Friedrich Richard Petri* (Austin: University of Texas Press with Texas Memorial Museum, 1978), 13–15; McGuire, *Hermann Lungkwitz*, 6–7.
6. Newcomb with Carnahan, *German Artist*, 15.
7. Ibid., 19; Utterback, *Early Texas Art*, 36.
8. McGuire, *Hermann Lungkwitz*, 8.
9. Ibid., 9–10.
10. Ibid., 10–11.
11. Utterback, *Early Texas Art*, 36.
12. McGuire, *Hermann Lungkwitz*, 12.
13. Ibid., 12–13.
14. Ibid., 14–19.
15. Ibid., 20–21.
16. Ibid., 23–26.
17. Ibid., 27–31.

ELBHAUS BEI DESSAU (STORK NEST)
1846, oil on paper, 11″ × 9″
Unsigned
Titled and dated lower right: Elbhaus bei Dessau/
d. 10h. Jul. 1846

Stork Nest represents Lungkwitz's earliest work in the collection of the San Antonio Museum Association. Although the painting is not signed, it bears a notation on the reverse that credits it to H. Lungkwitz. There is little doubt about the attribution when the painting is compared to his other work of the period. The artist's treatment of the huge, gnarled, half-dead tree foreshadows the windswept, crooked oaks and cypresses in his Texas landscapes. In European countries storks were omens of good luck and often were encouraged to build their bulky platforms of sticks near or on homes to bring good fortune.[24] Perhaps Lungkwitz painted this landscape for good luck.

PROVENANCE:
1846–1982: Collection of the Lungkwitz-von Rosenberg-Ulrich Family.
1982: Gift to SAMA by Mr. and Mrs. Dan E. Ulrich. Ulrich is a great-grandson of Hermann Lungkwitz, and the painting remained in the family until donated to SAMA.
82–165 G (3)

EXHIBITIONS:
1983–1984: Hermann Lungkwitz: German Romantic Landscapist on the Texas Frontier, University of Texas Institute of Texan Cultures at San Antonio (November 25, 1983, to January 8, 1984).
1984: Hermann Lungkwitz: German Romantic Landscapist on the Texas Frontier, Traveling Exhibition: Sarah Campbell Blaffer Gallery, University of Houston (January 14 to February 26). Texas Memorial Museum, University of Texas at Austin (May 6 to June 10).
1986: Capitol Historical Art Loan Program, State Capitol, Austin (January 30 to September 15).
1986: Texas Seen/Texas Made, SAMOA (September 29 to November 30). Returned to Capitol for exhibition to December 19, 1988.

shared a studio for a time in the old (temporary) state capitol.[18] Lungkwitz also taught at the Texas Female Institute in Austin during 1877 and 1878.[19]

Elise Lungkwitz died on February 10, 1880. Her funeral was held at the German and English Academy and she was buried in Austin's Oakwood Cemetery.[20] Hermann and Elise Lungkwitz had seven children: Paul, who died in infancy; Max, Alice, and Guido, all unmarried; Martha, who married Jacob Bickler; and Helene Clara, Alice's twin sister, who married Ernst Johann von Rosenberg.[21]

After Elise's death, Lungkwitz devoted a good deal of time to his children and grandchildren. He also painted and went on sketching jaunts. The artist used his leisure to indulge in another of his interests, singing in German *Saengerfests*. He spent some time in Galveston after 1887 with Martha and Jacob Bickler. There he became acquainted with Julius Stockfleth, a marine artist, to whom he referred as a "fellow painter." When in Austin, he went to his beloved Hill Country, always with painting gear in hand. On the night of February 10, 1891, one month short of his seventy-eighth birthday, Hermann Lungkwitz died of influenza.[22]

Lungkwitz and Petri were among the most important of the nineteenth-century Texas painters. Lungkwitz painted the Texas Hill Country he knew and loved so well, interpreting it in the German romantic style learned in his youth. He was among the first of these early Texas painters to be "discovered." In 1918, Samuel Gideon (1875–1945), professor of architecture at the University of Texas, wrote an article titled "Two Pioneer Artists in Texas" for *The American Magazine of Art*. His assessment of Lungkwitz's painting was simple and straightforward: "The work showed the man to be a faithful student and lover of nature, a careful draftsman with a wonderful sense of color and the gift to select simple but beautiful compositions."[23] Since that time Lungkwitz has become a familiar and respected name in the Texas arts and, as more of his paintings emerge, his contributions to the state's cultural heritage grow in importance and stature.

ENCHANTED ROCK, FREDERICKSBURG
1856, oil on canvas, 23½" × 35"
Unsigned

Hermann Lungkwitz did several paintings of the "enchanted" rock near Fredericksburg. The rock is a large, oval-shaped granite mountain that was considered by the Comanches to have supernatural powers because of the strange noises it emitted, especially at night. These crackings and poppings were caused by contractions that occurred after dusk when the granite cooled after a hot day. The Comanches believed the mountain was inhabited by spirits who made the weird sounds.[25] Lungkwitz probably was intrigued by the legend and in this version included at the base a group of native Americans who often frequented the site because of their reverence for the rock.

At the time this painting was donated to The Texas Collection, records indicated that it had been acquired by Matilde Guenther (Mrs. Hermann Schuchard) from Lungkwitz. For her book on Texas artists, Pauline Pinckney interviewed Mrs. Schuchard's son, Ernst Schuchard, who added the information that the painting had been won in a raffle in New Braunfels.[26] Evidently its easy acquisition caused the painting to be treated in a cavalier manner, for Ernst Schuchard found it abandoned in the family barn. Fortunately he recognized the painting's significance and rescued it. He attached a note to the back that stated: "Painted by Lungkwitz in 1856/ Patched and overpainted by José Arpa, 1925/Restored by E. Schuchard, 1943." Since

the painting's donation, the museum has undertaken further restoration.

PROVENANCE:
ca. 1856–1980: Collection of the Schuchard Family.
1980: Gift to SAMA by Mrs. Ernst Schuchard in memory of Ernst Schuchard.
80–62 G

EXHIBITIONS:
1960: Go West, Young Man, Marion Koogler McNay Art Institute, SA (January 1 to February 17). Lent by Mr. and Mrs. Ernst Schuchard.
1982: A Birthday Celebration: Recent Gifts and Acquisitions, SAMOA (March 1 to May 16).
1983–1984: Hermann Lungkwitz: German Romantic Landscapist on the Texas Frontier, University of Texas Institute of Texan Cultures at San Antonio (November 25, 1983, to January 8, 1984).
1984: Hermann Lungkwitz: German Romantic Landscapist on the Texas Frontier, Traveling Exhibition: Sarah Campbell Blaffer Gallery, University of Houston (January 14 to February 26). Texas Memorial Museum, University of Texas at Austin (May 6 to June 10).
1986: Texas Seen/Texas Made, SAMOA (September 29 to November 30).
1990: Looking at the Land: Early Texas Painters, San Angelo Museum of Fine Arts (February 22 to March 25).

PUBLICATIONS:
"Texas in Pictures," The Magazine Antiques, 53 (June 1948): 456.
James Patrick McGuire, Hermann Lungkwitz: Romantic Landscapist on the Texas Frontier (1983), 128.
Steinfeldt, "Lone Star Landscapes," M3, SAMA Quarterly, in San Antonio Monthly, 5 (July 1986): 22.
Gerdts, Art Across America, vol. 2 (1990), 116: plate 2.107.

18. Utterback, Early Texas Art, 37.
19. McGuire, Hermann Lungkwitz, 36.
20. Ibid., 38.
21. Utterback, Early Texas Art, 37.
22. McGuire, Hermann Lungkwitz, 43–47, 48 (quotation), 49–50.
23. Samuel E. Gideon, "Two Pioneer Artists in Texas," The American Magazine of Art (September 1918): 1. Typescript, Karl Friedrich Hermann Lungkwitz file, SAMA Texas Artists Records.
24. Encyclopaedia Britannica (1959), s.v. "Storks."
25. Webb, Carroll, and Branda (eds.), The Handbook of Texas, 2, s.v. "Enchanted Rock, Legends of."
26. Pinckney, Painting in Texas, 89.

ENCHANTED ROCK (SCENE NEAR
FREDERICKSBURG)
1864, oil on canvas mounted on panel, 14″ × 20″
Signed and dated lower left: H. Lungkwitz/1864

In this smaller version of *Enchanted Rock*,
Lungkwitz portrayed a wider view of the
landscape with sturdy trees, other stony
outcroppings, and a streambed in the
foreground. He captures the essence of the
midday sun on the glistening rock formation
in the background. The broad mica plates
reflected the sun's or moon's rays with
exceptional brilliance, contributing to the
legend of its magical powers. Seth Eastman
is said to have named the mystical hill
"Enchanted Rock" in his travels through
the area.[27]

PROVENANCE:
-1952: Collection of Naoma K. Vickery.
1952: Purchased by SAMA from Naoma K. Vickery
with Witte Picture Funds.
52–35 P

EXHIBITIONS:
1960: Early Texana Exhibit, in recognition of the
premiere festivities of the film, *The Alamo*, WMM
(October 1 to 30).
1964: The Early Scene: San Antonio, WMM (June 7 to
August 31).

1983–1984: Hermann Lungkwitz: German Romantic
Landscapist on the Texas Frontier, University of Texas
Institute of Texan Cultures at San Antonio
(November 25, 1983, to January 8, 1984).
1984: Hermann Lungkwitz: German Romantic
Landscapist on the Texas Frontier, Traveling
Exhibition: Sarah Campbell Blaffer Gallery, University
of Houston (January 14 to February 26). Texas
Memorial Museum, University of Texas at Austin
(May 6 to June 10).
1986: Texas Seen/Texas Made, SAMOA (September 29
to November 30).
1988: The Art and Craft of Early Texas, WMM (April 30
to December 1).
1990: Regional American Painting to 1920, Greenville
County Museum of Art, Greenville, South Carolina
(November 6 to December 30).

PUBLICATIONS:
Utterback, *Early Texas Art* (1968), 41.
McGuire, *Hermann Lungkwitz* (1983), 76.
Willoughby, *Texas, Our Texas* (1987), 258.

FRIEDRICHSBURG, TEXAS
ca. 1856, lithograph on paper, 15⅛" × 21⅟₁₆"
Titled lower center: Friedrichsburg./[Texas]
Printed lower left: N.d. Nat. v.H. Lungkwitz
Printed lower right: Lith. Anst. v. Rau & Sohn,
Dresden

Lungkwitz's pastoral view of Fredericksburg, idyllic and romantic in interpretation, clearly shows the influence of the artist's early training in Dresden. Indolent shepherd boys in the foreground with their placid sheep grazing in the Pedernales Valley heighten the sense of peace and tranquility. The farming village of Fredericksburg is in the distance. Lungkwitz sent drawings to Germany to be converted into lithographs, which he hoped to sell. They were advertised in German newspapers in Central Texas and displayed in the larger cities during the late 1850s. Evidently not many copies of this lithograph exist. One family legend maintains that the ship returning with the finished lithographs was caught in a storm and many of the prints were damaged. Another tale alleges that Lungkwitz was not pleased with the final print, feeling that it did not do justice to his original sketches.[28]

PROVENANCE:
-1940: Collection of Mrs. W. K. Haralson.
1940: Gift to SAMA by Mrs. W. K. Haralson.
40–49 G

EXHIBITIONS:
1964: The Early Scene: San Antonio, WMM (June 7 to August 31).
1973: Early Texas Furniture and Decorative Arts, WMM (June 16 to December 31).
1976: American Landscape Paintings: 1850–1900, Laguna Gloria Art Museum, Austin (September 8 to October 17).
1986: Texas Seen/Texas Made, SAMOA (September 29 to November 30).
1988: The Art and Craft of Early Texas, WMM (April 30 to December 1).

PUBLICATIONS:
Utterback, *Early Texas Art* (1968), 40.

27. Ibid.
28. McGuire, *Hermann Lungkwitz*, 183, 201 n. 63.

GARDEN STREET, OLD MILL BRIDGE,
SAN ANTONIO
ca. 1856, pencil on paper, 10″ × 14½″
Unsigned
Titled lower right: Garden St./Old Mill Bridge/
San Antonio

Garden Street was one of Lungkwitz's early
sketches that he later used in at least two
finished paintings.[29] The sensitive drawing
shows the old Lewis Grist Mill on the
right along with imposing buildings
and San Fernando Cathedral in the
background. It also conveys an impression
of the importance of the San Antonio
River in the nineteenth century, during
which no fewer than ten mills were
established along its banks. In 1845
William Small built one of the first of
these, known as the Lewis Mill after
Nathaniel Lewis acquired it in 1849. The
Lewis family managed the mill until it was
shut down in 1869. It was reopened by
August Bayer in 1880 and finally was
dismantled in 1890. The old millstone
eventually was presented to the Alamo
for preservation.[30]

PROVENANCE:
ca. 1856–1982: Collection of the Lungkwitz-von
Rosenberg-Ulrich Family.
1982: Gift to SAMA by Mr. and Mrs. Dan E. Ulrich.
82–165 G (5)

EXHIBITIONS:
1964: The Early Scene: San Antonio, WMM (June 7
to August 31). Lent by Mrs. Heinz Ulrich.
1983–1984: Hermann Lungkwitz: German Romantic
Landscapist on the Texas Frontier, University of Texas
Institute of Texan Cultures at San Antonio
(November 25, 1983, to January 8, 1984).
1984: Hermann Lungkwitz: German Romantic
Landscapist on the Texas Frontier, Traveling
Exhibition: Sarah Campbell Blaffer Gallery, University
of Houston (January 14 to February 26). Texas
Memorial Museum, University of Texas at Austin
(May 6 to June 10).
1986: Texas Seen/Texas Made, SAMOA (September 29
to November 30).

PUBLICATIONS:
McGuire, *Hermann Lungkwitz* (1983), 121.

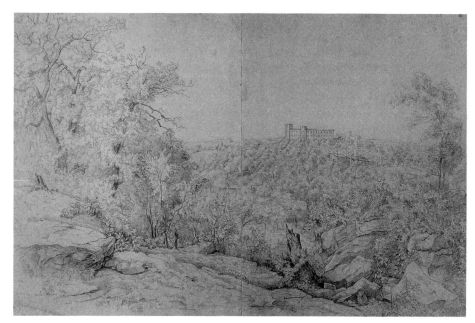

LANDSCAPE SCENE IN AUSTIN
WITH TEXAS MILITARY INSTITUTE
n.d., pencil on paper, 11¼″ × 17½″
Unsigned (attributed)

The Texas Military Institute, located high on
a bluff overlooking Shoal Creek in Austin, was
one of Lungkwitz's favorite subjects.[31] It was
an imposing castle-like structure towering
over a verdant tree-covered hillside. This
drawing was among the Ida Weisselberg
Hadra material when donated to the museum
and was first thought to be her work. But the
drawing is so masterly in technique it finally
has been attributed to Lungkwitz.[32]

PROVENANCE:
-1969: Collection of the Hadra-Vines Family.
1969: Gift to SAMA by Mary Josephine Vines.
69–102 G (20)

EXHIBITIONS:
1986: Texas Seen/Texas Made, SAMOA (September 29
to November 30).
1990: Looking at the Land: Early Texas Painters,
San Angelo Museum of Fine Arts (February 22 to
March 25).

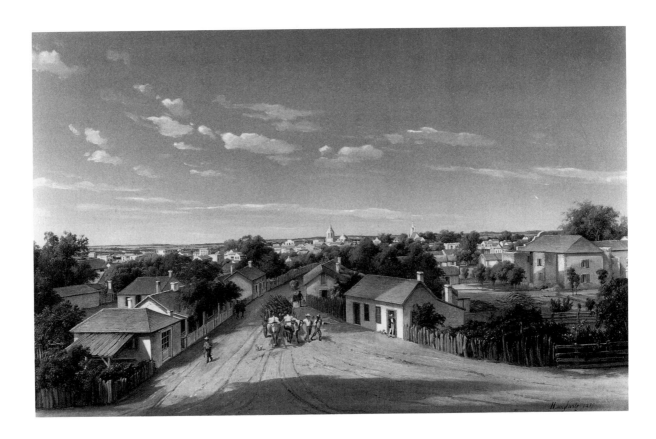

CROCKETT STREET LOOKING WEST,
SAN ANTONIO DE BEXAR
1857, oil on canvas mounted on panel, 13″ × 20″
Signed and dated lower right: H. Lungkwitz, 1857

In *Crockett Street Looking West* Lungkwitz deviated somewhat from his usual romantic style. Instead he rendered this panoramic view in a meticulous, clearly delineated manner, using true, sharp colors. As a result it is accepted as the most valid and historically accurate existing mid-nineteenth-century visual document of the site.

Also interesting is the history of its acquisition. It was discovered in Germany in 1960 by some of the artist's descendants. Martha Utterback learned this when she was organizing her exhibition, The Early Scene: San Antonio in 1964, and in 1969, the Association was informed that the painting was still available at the firm of Aloys Menges and Sohne in Hannover. Albert Hirschfeld, then president of the Board of Trustees of the San Antonio Museum Association, purchased the painting and placed it in the Witte Museum on loan. Upon his death in 1972, the Association acquired the painting from his estate.[33]

PROVENANCE:
1969–1972: Collection of Albert Hirschfeld.
1973: Purchased by SAMA from the Estate of Albert Hirschfeld with Hearst Foundation Funds.
73–68 P

EXHIBITIONS:
1973: Early Texas Furniture and Decorative Arts, WMM (June 16 to December 31).
1983–1984: Hermann Lungkwitz: German Romantic Landscapist on the Texas Frontier, University of Texas Institute of Texan Cultures at San Antonio (November 25, 1983, to January 8, 1984).
1984: Hermann Lungkwitz: German Romantic Landscapist on the Texas Frontier, Traveling Exhibition: Sarah Campbell Blaffer Gallery, University of Houston (January 14 to February 26). Texas Memorial Museum, University of Texas at Austin (May 6 to June 10).
1986: Remembering the Alamo: The Development of a Texas Symbol, 1836–1986, WMM (February 23 to September 15).
1986: Texas Seen/Texas Made, SAMOA (September 29 to November 30).
1988: The Art and Craft of Early Texas, WMM (April 30 to December 1).
1988: A Witte Merry Christmas: Tannenbaums to Tumbleweeds, WMM (December 1 to 30).

PUBLICATIONS:
Utterback, "Additions to the Early Texas Collection," *Witte Quarterly*, 3 (1965): 6.
Urban Texas Tomorrow (1970), 5.
"Painting Comes Home for Witte Display," San Antonio *Light*, May 5, 1973.
Schwartz, "Early Texas Art Depicts Era's Action," *Antique Monthly*, 8 (November 1974): 8A.
McGuire, *Hermann Lungkwitz* (1983), 73.
Mary M. Fisher, "Legacy of drawings left by early-day Texas artist," Book Reviews, *North San Antonio Times*, December 22, 1983.

29. Ibid., 183.
30. Catherine McDowell, "San Antonio's River." Paper delivered for the San Antonio Conservation Society, October 23, 1974. Photocopied typescript, San Antonio River file (under Mills), SAMA Texas History Records.
31. McGuire, *Hermann Lungkwitz*, 187.
32. McGuire to author, interview, April 15, 1988. McGuire determined the drawing was done by Hermann Lungkwitz.
33. "Painting Comes Home for Witte Display," San Antonio *Light*, May 5, 1973.

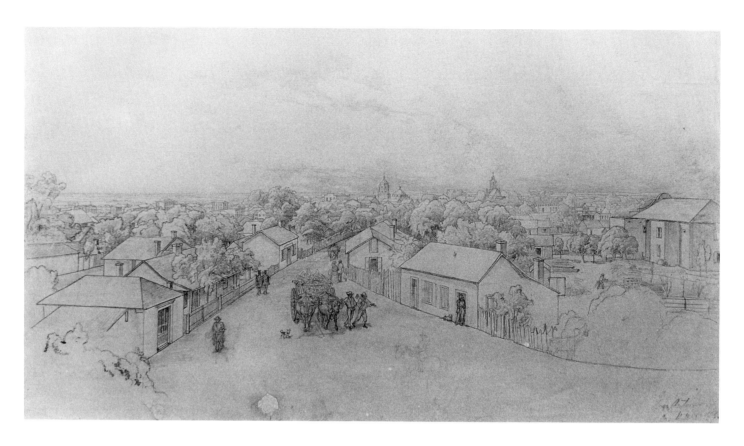

CROCKETT STREET, SAN ANTONIO
1852, pencil on paper, 9¼" × 17¼"
Unsigned
Titled and dated lower right: San Antonio/Crockett
St., 1852

The exhibition The Early Scene: San Antonio,
shown during the summer months of 1964,
encouraged the contribution of a number of
significant early Texas works of art to The
Texas Collection, including this sketch of
Crockett Street. Martha Utterback wrote:
"One of our recent accessions is a pencil
drawing of Crockett Street in San Antonio
(looking west on Crockett from the Bonham
Street corner) made in 1852 by Hermann
Lungkwitz. . . . The artist's grandson, Mr.
Ernest J. von Rosenberg of Austin, with Mrs.
von Rosenberg, gave the drawing to the
museum following its showing here as part
of the summer exhibition."[34] The drawing
was the preliminary sketch for the artist's
painting, as well as the lithograph, of the
same site.

Lungkwitz's carefully rendered drawing
shows neat houses in the German settlement
on the south side of the Alamo with San
Fernando Cathedral in the background.
Richard Petri is credited with adding both
the figures and the Mexican *carreta* loaded
with wood to the sketch.[35]

PROVENANCE:
1852–1964: Collection of the Lungkwitz-von
Rosenberg Family.

1964: Gift to SAMA by Mr. and Mrs. Ernest J. von
Rosenberg.
64–203 G

EXHIBITIONS:
1964: The Early Scene: San Antonio, WMM (June 7 to
August 31). Lent by Mr. and Mrs. Ernest J. von
Rosenberg.
1973: Early Texas Furniture and Decorative Arts,
WMM (June 16 to December 31).
1983–1984: Hermann Lungkwitz: German Romantic
Landscapist on the Texas Frontier, University of Texas
Institute of Texan Cultures at San Antonio
(November 25, 1983, to January 8, 1984).
1984: Hermann Lungkwitz: German Romantic
Landscapist on the Texas Frontier, Traveling
Exhibition: Sarah Campbell Blaffer Gallery, University
of Houston (January 14 to February 26). Texas
Memorial Museum, University of Texas at Austin
(May 6 to June 10).
1986: Remembering the Alamo: The Development of
a Texas Symbol, 1836–1986, WMM (February 23 to
September 15).
1986: Texas Seen/Texas Made, SAMOA (September 29
to November 30).

PUBLICATIONS:
Utterback, "Additions to the Early Texas Collection,"
Witte Quarterly, 3 (1965): 4.
Utterback, *Early Texas Art* (1968), 39.
McGuire, *Hermann Lungkwitz* (1983), 126.

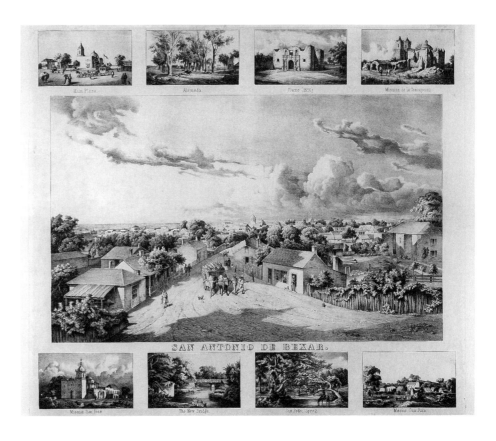

SAN ANTONIO DE BEXAR
ca. 1867, lithograph on paper, 18⅛″ × 20⅛″
Titled beneath center view: San Antonio de Bexar
Printed lower left: Taken from Nature by H. Lungkwitz
Printed lower right: Rau & Son Lith., Dresden

Lungkwitz sent a painting of this scene to Germany to be lithographed, probably intending both to sell the prints in Texas and to advertise San Antonio in Germany. He added eight other views of the city, which form the borders at top and bottom. Lungkwitz duplicated at least three of these scenes in paintings which are owned by the San Antonio Public Library: *Mission San José, Mission San Juan Capistrano,* and *The Alameda.*[36] Whether he did paintings of the other five scenes is not known, but they all are familiar views of early San Antonio. Some of the figures in the center panel have been tentatively identified. The man in the doorway to the right is presumed to be Mayor W. C. A. Thielepape, as that was his home. The figure to the left, walking with saw in hand, reputedly is Wenzel Friedrich, who lived opposite Thielepape and was a carpenter, cabinetmaker, and manufacturer of horn furniture.[37]

PROVENANCE:
-1926: Collection of Charles Grossman.
1926: Gift to SAMA by Charles Grossman.
26–1372 G

EXHIBITIONS:
1964: The Early Scene: San Antonio, WMM (June 7 to August 31).
1973: Early Texas Furniture and Decorative Arts, WMM (June 16 to December 31).
1976: American Landscape Paintings: 1850–1900, Laguna Gloria Art Museum, Austin (September 8 to October 17).
1986: Remembering the Alamo: The Development of a Texas Symbol, 1836–1986, WMM (February 23 to September 15).
1986: Texas Seen/Texas Made, SAMOA (September 29 to November 30).

PUBLICATIONS:
Utterback, "Additions to the Early Texas Collection," *Witte Quarterly*, 3 (1965): 7.
Utterback, *Early Texas Art* (1968), 39.

34. Martha Utterback, "Additions to the Early Texas Collection," *Witte Quarterly*, 3 (1965): 4.
35. McGuire, *Hermann Lungkwitz*, 185.
36. Utterback, "Additions to the Early Texas Collection," 5.
37. McGuire, *Hermann Lungkwitz*, 187; Cecilia Steinfeldt and Donald Lewis Stover, *Early Texas Furniture and Decorative Arts* (San Antonio: Trinity University Press for the San Antonio Museum Association, 1973), 136–141.

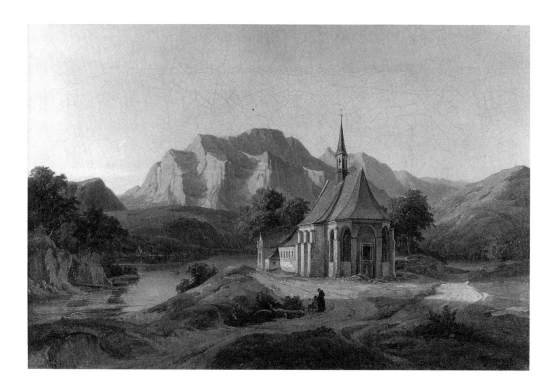

CHURCH ON AN ALPINE LAKE
1864, oil on canvas, 11⅛" × 17¼"
Signed and dated lower right: H. Lungkwitz/1864

When Lungkwitz painted this Alpine scene
in 1864, he had been a resident of Texas for
almost fourteen years. He based the painting
upon a sketch he had made of a church in
Billin, Saxony, in 1842.[38] It may have been a
commissioned piece done for a friend in
Fredericksburg or perhaps it was a nostalgic
exercise. When acquired by the San Antonio
Museum Association in 1975, the name Edna
Kempton was inscribed in ink on the back of
the stretcher strip.

PROVENANCE:
-1975: Collection of the Eisfeld Family.
1975: Purchased by SAMA from William Eisfeld with
funds provided by Mrs. R. C. Nelson in memory of
Ellen Schulz Quillin.
75–162 P

EXHIBITIONS:
1983–1984: Hermann Lungkwitz: German Romantic
Landscapist on the Texas Frontier, University of Texas
Institute of Texan Cultures at San Antonio
(November 25, 1983, to January 8, 1984).
1984: Hermann Lungkwitz: German Romantic
Landscapist on the Texas Frontier, Traveling
Exhibition: Sarah Campbell Blaffer Gallery, University
of Houston (January 14 to February 26). Texas
Memorial Museum, University of Texas at Austin
(May 6 to June 10).
1986: Texas Seen/Texas Made, SAMOA (September 29
to November 30).

WORKS BY
KARL FRIEDRICH HERMANN LUNGKWITZ
NOT ILLUSTRATED:

LANDSCAPE STUDY AT WALDBACH STRUB,
GERMANY
n.d., oil on paper, 9⅛" × 14"
Signed on reverse: H. Lungkwitz
Titled on reverse: Waldbach Strub/Germany
82–165 G (1)
Gift to SAMA by Mr. and Mrs. Dan E. Ulrich.

LANDSCAPE AT PLAUENSCHEN GRUND, DRESDEN,
GERMANY
n.d., pencil on paper, 5½" × 8¼"
Unsigned
Inscribed lower left: Pl. Grund d 7h. Septbr.
82–165 G (2)
Gift to SAMA by Mr. and Mrs. Dan E. Ulrich.

UNTITLED GERMAN LANDSCAPE
n.d., oil on paper mounted on board, 13⅛" × 12⅛"
Unsigned
82–165 G (4)
Gift to SAMA by Mr. and Mrs. Dan E. Ulrich.

ALPINE SCENE
n.d., oil on academy board, 12" × 18¼"
Unsigned
82–165 G (6)
Gift to SAMA by Mr. and Mrs. Dan E. Ulrich.

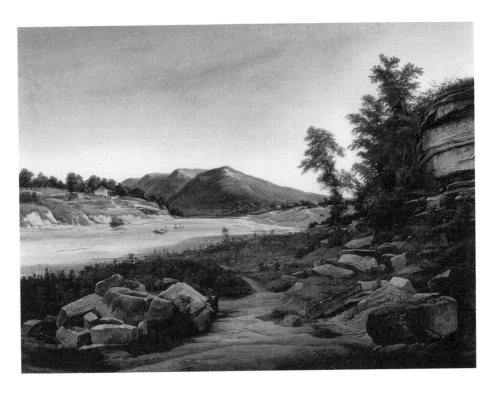

MOUNT BONNELL, AUSTIN
1875, oil on canvas, 26″ × 36″
Signed and dated lower left: H. Lungkwitz, 1875

When the Association first acquired this painting it was called *River Scene near Fredericksburg*. Further research disclosed it to be Mount Bonnell, on the east bank of the Colorado River near Austin. Lungkwitz painted it during his most productive years, when he resumed his art career after leaving the post of photographer at the General Land Office in Austin. His enduring fascination for the Texas countryside is evident in this work with its rugged trees, jagged rock formations, and swiftly flowing rivers. He painted his bucolic, romantic landscapes until his death in 1891.

PROVENANCE:
-1965: Collection of the Clegg Family.
1965: Gift to SAMA by William C. Clegg in memory of Mrs. L. B. Clegg.
65–220 G

EXHIBITIONS:
1964: The Early Scene: San Antonio, WMM (June 7 to August 31). Lent by William C. Clegg.
1967: Painting in Texas: The Nineteenth Century, ACMWA (October 5 to November 26).
1967–1968: Painting in Texas: The Nineteenth Century, The Academic Center, University of Texas at Austin (December 9, 1967, to January 31, 1968).
1983–1984: Hermann Lungkwitz: German Romantic Landscapist on the Texas Frontier, University of Texas Institute of Texan Cultures at San Antonio (November 25, 1983, to January 8, 1984).

1984: Hermann Lungkwitz: German Romantic Landscapist on the Texas Frontier, Traveling Exhibition: Sarah Campbell Blaffer Gallery, University of Houston (January 14 to February 26). Texas Memorial Museum, University of Texas at Austin (May 6 to June 10).
1984: The Waters of America: 19th-Century American Paintings of Rivers, Streams, Lakes, and Waterfalls, New Orleans Museum of Art (May 6 to November 18).
1986: Capitol Historical Art Loan Program, State Capitol, Austin (January 30 to September 15).
1986: Texas Seen/Texas Made, SAMOA (September 29 to November 30).
1988: The Art and Craft of Early Texas, WMM (April 30 to December 1).
1990: Looking at the Land: Early Texas Painters, San Angelo Museum of Fine Arts (February 22 to March 25).

PUBLICATIONS:
Pinckney, *Painting in Texas* (1967), 93: plate c-7.
Utterback, *Early Texas Art* (1968), 41.
"Early Texas Paintings on Permanent Display," San Antonio *Express-News*, September 12, 1971.
Welch, *Texas: New Perspectives* (1972), 105.
"Early Texas Art," San Antonio *Express-News*, October 19, 1974.
McGuire, *Hermann Lungkwitz* (1983), 134.
John Wilmerding, *The Waters of America: 19th-Century American Paintings of Rivers, Streams, Lakes, and Waterfalls* (1984), 93.
Marquis James, *The Raven* (1929; reprint, 1990), following 198.

38. McGuire, *Hermann Lungkwitz*, 24.

ELOISE POLK McGILL

Eloise Polk McGill was born in Independence, Texas, in 1868. She was proud of her Texas heritage and her American background, being a direct descendant of President James Knox Polk and a grandniece of Judge R. E. B. Baylor, the founder of Baylor University in Waco.[1]

Eloise's family came to San Antonio when she was quite young, residing on King William Street. She studied art at Main Avenue High School and was valedictorian of her graduating class.[2] She started displaying her works in 1888 in the San Antonio International Fair and at the Van Dyke Art Club.[3]

Eloise took lessons from Robert Onderdonk in San Antonio and studied at the Art Students League in New York with William Merritt Chase. She spent some time in Paris under the tutelage of Robert Reid (1862–1929) and a painter named Chirdly (?).[4] She learned miniature painting from Rhoda Holmes Nicholls, probably while she was in New York.[5]

Eloise is listed as Mrs. George McGill in the San Antonio city directory of 1897–1898, but when she married, or how long she remained married, has not been determined. During her long and active artistic career, she was known as Eloise Polk McGill.

Eloise established a studio in Alamo Heights in San Antonio where she conducted classes known as the "Edgar B. Davis School of Wildflower Painting."[6] Her work had been included in the Davis Wildflower competitions, although she never was a prizewinner. Nevertheless, the Texas landscape with its carpets of wildflowers was always one of her favorite subjects. She was a prolific painter and a participant in all current exhibitions and competitions.[7] She also helped support the Witte Memorial Museum during the depression by contributing a painting as a prize for a benefit card party.[8]

Eloise was a member of the San Antonio Art League, the Southern States Art League, the Texas Fine Arts Association, and the Historical Association of American Women.[9] Her most prestigious achievements were the *Madonna of Mercy*, painted for St. Anselms's Priory, Washington, D.C.; a copy of the *Sacred Heart* after Acevedo Bernal (n.d.) to go over the altar in the Sacred Heart Church in Del Rio, Texas; and her portrait of John Nance Garner, which was shown in Dallas during the Centennial and Pan-American expositions.[10]

Eloise was a minor painter in the tapestry of Texas painting, but her persistence and involvement in the Texas art scene is one of the strong threads that has kept Texas painting viable.

Eloise was buried at Mission Burial Park in San Antonio on May 23, 1939.[11]

PORTRAIT OF DANIEL SULLIVAN
n.d., watercolor on ivory, 3½" × 2¼"
Signed lower right: E. P. McGill

Eloise's portrait of Daniel Sullivan successfully portrays his stern but amiable features. He was seven years old in 1850, when he immigrated to Texas from Ireland with an uncle. He fought in the Civil War and after hostilities joined his uncle in Indianola.[12]

Sullivan married Annie Cotter in 1867, and they became the parents of seven children. The Sullivans were among the few survivors of the devastating storm at Indianola in 1875. In 1882 he and his family moved to San Antonio where he became a prosperous banker. Noted for his generosity and philanthropy during his lifetime, he was still a very wealthy man at the time of his death on November 30, 1931.[13]

Although the artist may have used a photograph to assist her, the miniature was painted many years before Sullivan's death. The background appears to be a view of the garden at his home at 404 Broadway.

PROVENANCE:
-1968: Collection of the Sullivan Family.
1968: Gift to SAMA by the Estate of Elizabeth Sullivan Clem.
68–213 G (6)

EXHIBITIONS:
1986: Texas Seen/Texas Made, SAMOA (September 29 to November 30).

Photograph of Elizabeth Sullivan (Clem) by David P. Barr of San Antonio. SAMA Historical Photographic Archives, gift of the Estate of Elizabeth Sullivan Clem.

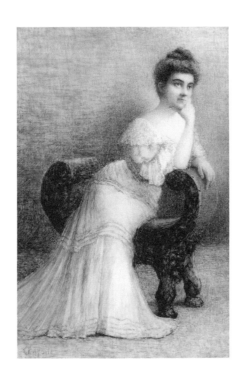

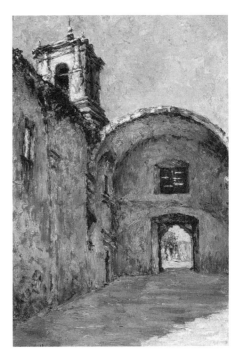

1. Forrester-O'Brien, Art and Artists, 153.
2. "Portrait Painter Succumbs Here," San Antonio Express, May 21, 1939.
3. "Out at the Fair," San Antonio Daily Express, November 16, 1888; "Second Annual Exhibition of the Van Dyke Art Club," San Antonio Daily Express, April 9, 1888.
4. Forrester-O'Brien, Art and Artists, 153.
5. "Portrait Painter Succumbs Here."
6. "Home captures spirit of tropics," North San Antonio Times, November 6, 1986.
7. Catalogues and listings, Eloise Polk McGill file, SAMA Texas Artists Records.
8. "Store to Display Gifts to Benefit Museum Card Party," San Antonio Express, November 30, 1932.
9. Catalogues and listings, McGill file, SAMA Texas Artists Records.
10. Ibid.
11. "Portrait Painter Succumbs Here."
12. "Daniel Sullivan," reprint from National Cyclopaedia of American Biography (New York: James T. White & Co., 1935), n.p.
13. Ibid.
14. Photograph in SAMA Historical Photographic Archives.
15. Webb, Carroll, and Branda (eds.), The Handbook of Texas, 2, s.v. "Clem, John Lincoln."

PORTRAIT OF ELIZABETH SULLIVAN CLEM
n.d., watercolor on ivory, 7¼″ × 4¼″
Signed lower left: E. P. McGill

Eloise's miniature of Elizabeth Sullivan is based upon a photograph by San Antonio photographer David P. Barr.[14] The photograph and the miniature were likely made about the time of Elizabeth's marriage to Major General John Lincoln Clem in 1903.[15] The hairstyle and fashionable dress suggest a time period of the early 1900s. The artist succeeded not only in achieving a good likeness of the lady but also in catching the shimmering silk of the dress and the frothiness of billowing lace at the neckline.

PROVENANCE:
-1968: Collection of the Sullivan Family.
1968: Gift to SAMA by the Estate of Elizabeth Sullivan Clem.
68–213 G (7)

EXHIBITIONS:
1986: Texas Seen/Texas Made, SAMOA (September 29 to November 30).

MISSION SAN JOSÉ BELL TOWER
n.d., oil on academy board, 11½″ × 8½″
Signed lower left: E. P. McGill

When Eloise portrayed Mission San José she chose an unusual angle at the rear of the building. Obviously painted before extensive restoration was accomplished during the 1930s, it depicts the archway and the bell tower in dilapidated condition. Although the canvas lacks skilled draftsmanship, it has a nice plastic painting quality and pleasing colors in the warm tones of the stone walls in brilliant sunlight.

PROVENANCE:
ca. 1968–1979: Collection of Robert K. Winn.
1979–1985: Robert K. Winn Folk Art Collection, The San Antonio Folk Art Museum.
1985: Gift to SAMA by the Robert K. Winn Folk Art Collection.
85–1 G (3885)

EXHIBITIONS:
1930: Local Artist's Exhibition, WMM (August 1 to 30).
1990: Looking at the Land: Early Texas Painters, San Angelo Museum of Fine Arts (February 22 to March 25).

PAUL MERIENNO

(dates unknown)

Paul Merienno is another elusive artist who resided in San Antonio, possibly for only a few years. He is listed as a photographer with his business and residence on the north side of Main Plaza in the first city directory of 1877–1878. Presumably he supplemented his photography business by painting likenesses of local citizens, although the three portraits in the San Antonio Museum Association's Texas Collection are his only known works. As these portraits are dated 1880, it places the artist in the locality for at least three years, from 1877 to 1880.

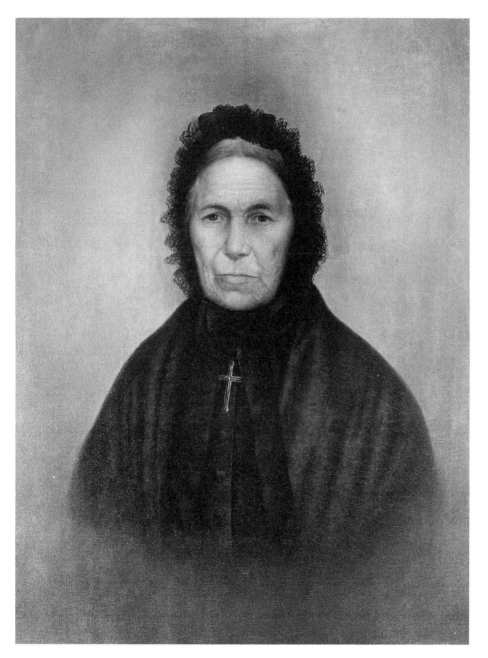

PORTRAIT OF MARGUERITE MONIER
ca. 1880, oil on canvas, 27″ × 21″
Unsigned (attributed)

Although this portrait is not signed, there is little doubt that it is the work of Paul Merienno, signified by the delicate technique, the matching size, and the family connection. Marguerite Monier, from LaChapelle, France, was among the early colonists to settle in Castroville, Texas.[1] Jacobus Monnier and Margaritha Tihs are listed in the 1854 Census of Roman Catholics in Castroville as the parents of eleven children.[2]

John Claude Monier, one of these eleven children, probably had his mother's portrait painted at the time that he had his and his wife's done. Marguerite Monier was painted in a frilly black lace bonnet and simple and subdued clothing, with a large gold cross around her neck.

PROVENANCE:
ca. 1880–1969: Collection of the Monier Family.
1969: Gift to SAMA by John R. Monier.
69–231 G

EXHIBITIONS:
1986: Texas Seen/Texas Made, SAMOA (September 29 to November 30).
1989–1990: Special Christmas Exhibition, WMM (December 7, 1989, to April 1, 1990).

PORTRAIT OF KATHERINE MAY MONIER
1880, oil on canvas, 27″ × 21″
Signed and dated lower left: P. Merienno, 1880

According to family records Katherine
Monier, née Katherine Schwendemann, was
born in Castroville, where her parents were
among the early colonists. She married John
Claude Monier in 1867, after he had become
a successful businessman. By then he had
established himself in San Antonio, and in
1869 he built a gracious home at 231 West
Salinas Street, not too far from Main Plaza,
where Merienno had his studio.[3] The artist's
version of Katherine Monier depicts her as a
refined and thoughtful lady with soft brown
hair and bright blue eyes.

PROVENANCE:
1880–1969: Collection of the Monier Family.
1969: Gift to SAMA by John R. Monier.
69–170 G (2)

EXHIBITIONS:
1986: Texas Seen/Texas Made, SAMOA (September 29
to November 30).
1989–1990: Special Christmas Exhibition, WMM
(December 7, 1989, to April 1, 1990).

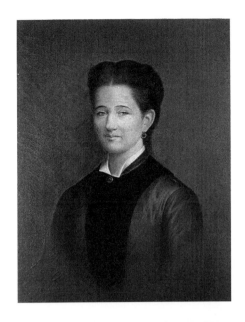

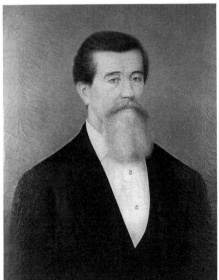

PORTRAIT OF JOHN CLAUDE MONIER
1880, oil on canvas, 27″ × 21″
Signed and dated lower right: P. Merienno./1880

John Claude Monier was born in France on
June 24, 1833, the son of Jacob Monier, who
came to Texas with Henry Castro's colonists
in 1844. The family settled on the Medina
River in 1845, and John Claude was raised on
his father's ranch. In 1856 he became a wagon
freighter, working for others for about three
years until he went into the freighting
business for himself. It proved to be a
lucrative move, especially during the Civil
War, when he was employed by the
Confederacy to transport cotton and other
goods, while he was at the same time
working for H. Meyer and Company in San
Antonio.[4] Monier is credited with being the
first Texan to use mules instead of oxen to
pull the large freighting wagons, a stratagem
that was a boon to the freighting business.[5]
When this pursuit became obsolete because
of the emergence of railroads, Monier
became a stockman, raising both cattle and
horses on a ranch near Fort Stockton.[6]

By 1880 Monier was able financially
to have family portraits painted by Paul
Merienno. The artist portrayed John Claude
Monier as a dignified gentleman with a
fashionable beard and decorous clothing.

PROVENANCE:
1880–1969: Collection of the Monier Family.
1969: Gift to SAMA by John R. Monier.
69–170 G (1)

EXHIBITIONS:
1986: Texas Seen/Texas Made, SAMOA (September 29
to November 30).
1989–1990: Special Christmas Exhibition, WMM
(December 7, 1989, to April 1, 1990).

1. Information supplied by the donor when the
 portrait was presented to the Association.
 SAMA Registrar's Records.
2. Ted Gittinger, Connie Rihn, Roberta Haby, and
 Charlene Snavely (authors and comps.), St. Louis
 Church, Castroville: A History of the Catholic Church in
 Castroville, Texas (Castroville: St. Louis Catholic
 Church, 1973), 127.
3. Ibid.
4. "John C. Monier." Undated biographical
 typescript provided by the Monier Family when
 the portraits were presented to SAMA. John
 Monier file, SAMA Texas History Records.
5. "Pioneer Freighters," San Antonio Express, August
 18, 1935. See August Santleben, A Texas Pioneer:
 Early Staging and Overland Freighting on the Frontiers of
 Texas and Mexico, ed. I. D. Afleck (1910; facsimile
 reprint, Waco; M. M. Morrison, 1967), for an
 extensive account of freighting in Texas.
6. "John C. Monier."

RUDOLPH MUELLER

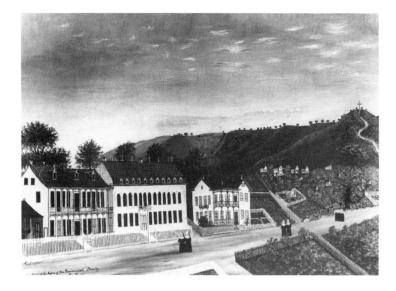

MOTHER HOUSE OF THE SISTERS OF DIVINE
PROVIDENCE AND VICINITY, CASTROVILLE,
TEXAS
n.d., oil on canvas, 25″ × 36″
Unsigned (attributed)
Titled lower left: Mother House of the Sisters of Div.
Providence & Vicinity,/Castroville, Texas.

Rudolph Mueller used his untutored skills when he painted the *Mother House* and produced a charming though naive canvas that depicts the convent as it appeared when first built.

Castroville's settlers, predominantly Roman Catholic, struggled to build proper churches, schools, and religious houses for their members. In 1868 two Sisters of the Congregation of Divine Providence from Alsace-Lorraine arrived and established a school in the settlement. By 1872 their ranks had grown, and they petitioned for a convent. Bishop Claude Dubuis donated the land and part of the money for the cloister, and dedicated parishioners banded together to build an impressive structure, using local limestone and cypress timbers. It was described in the September 13, 1873, New York *Freeman's Journal*: "They have put up and nearly finished a fine building, to which they give the modest title of schoolhouse, and which, elsewhere, would be called an academy or Collegiate institute. It is built of stone, two stories high with galleries and verandahs, and constructed with a view to our Texas climate, open to the breeze from the South in summer and closed to the 'Norther' in the winter. It is an ornament to the town."[7]

Mueller must have painted the town's new "ornament" shortly after its construction. Although the perspective of the buildings is somewhat askew, it is a faithful rendition of the site with the exception of the background. "Mt. Gentilz," with its distinctive cross, was arbitrarily placed to the right of the convent rather than behind it, probably to enhance the spiritual atmosphere. The convent still stands, virtually unchanged, and is one of the main buildings of the Moye Formation Center.[8]

A number of Castroville's older residents remember Rudolph Mueller as a versatile and intelligent person who produced his few paintings as a young man because his eyesight failed as he grew older. Although there is no evidence that Rudolph Mueller ever received formal training in the arts, the canvases attributed to him show a natural talent and a distinct flair for design.

Mueller was born in Saxony, Germany, in 1859 and immigrated to Texas at an early age. Skillful with his hands, he became Castroville's boot and shoemaker, although there is evidence that he also was a cabinetmaker.[1]

Eugen Huesser, who became a shoemaker's apprentice to Mueller in 1895, recalled his first impression of him: "Seated at his bench, the cobbler appeared no different from other men, but when he arose and stretched to his full height, he presented a grotesque figure. The man stood, a swarthy dwarf, with thickset stubby legs supporting an unbelievably robust and powerfully muscled torso. His massive shaggy head topped a sinewy short neck above bulging shoulders and his rare smile revealed large white teeth."[2]

Huesser described a trick that the shoemaker performed to demonstrate his strength. Mueller would clench the edge of a heavy homemade table in his teeth, carry it around the room with arms outstretched, and replace it without using his hands. He then would comment, "People look on me with pity and scorn at times for my deformity, but I can perform feats of strength that big men can not do."[3]

Although an eccentric, Mueller also was something of a mechanical genius. Many Castrovillians recollect his Noah's Ark, which was motivated by heat from a lamp causing the animals to march up the gangplank into the ark. Generous to a fault, he apparently gave the ark away.[4] Another account says he made an apostle's clock as well that also had moving figures propelled by heat and that he carved slingshots to give to children.[5]

With impaired vision, this unusual man fashioned animals out of clay, made likewise as presents for children. Unfortunately all of these creations have disappeared and only Mueller's few paintings remain to remind us of an untrained but remarkably talented man. He was found dead of a heart attack in his shop on April 15, 1929.[6]

PROVENANCE:
-1976: Collection of the Sisters of Divine Providence,
Our Lady of the Lake Convent, SA.
1976: Purchased by SAMA from the Sisters of Divine
Providence, Our Lady of the Lake Convent, with
Witte Picture Fund.
76–167 P

EXHIBITIONS:
1978–1979: A Survey of Naive Texas Artists, WMM (December 17, 1978, to March 1, 1979).
1979–1980: A Survey of Naive Texas Artists, Traveling Exhibition: The Museum of Fine Arts, Houston (April 11 to May 27, 1979). Laguna Gloria Art Museum, Austin (June 9 to July 23, 1979). Tyler Museum of Art (July 31 to September 9, 1979). Lufkin Historical and Creative Arts Center (September 24 to November 15, 1979). The Art Center, Waco (April 15 to May 30, 1980).
1986: Texas Seen/Texas Made, SAMOA (September 29 to November 30).
1988: The Art and Craft of Early Texas, WMM (April 30 to December 1).

PUBLICATIONS:
"A Charming Primitive Oil Painting," *People*, University of Texas Institute of Texan Cultures at San Antonio, 4 (September-October 1974): 8.
SAMA Bi-Annual Report, 1976–1978, 19.
Steinfeldt, "The Folk Art of Frontier Texas," *The Magazine Antiques*, 114 (December 1978): 1280.
SAMA's Annual Christmas Party Invitation (1978): cover.
The 4-County News Bulletin (Castroville), January 1, 1979.
Charlotte Moser, "Cultural Potpourri: 'Naive artists' show reflects the spirit of early Texas," Houston *Chronicle*, April 15, 1979.
"Ethnic Background shows in Texas Exhibit," *Citizen Marquee* (June 15, 1979): 4.
Steinfeldt, "Simple Self-Expression," *Southwest Art*, 10 (September 1980): 58.
Steinfeldt, *Texas Folk Art* (1981), 47.
Rubin (ed.), *Southern Folk Art* (1985), 60–61.
Willoughby, *Texas, Our Texas* (1987), 274.
Steinfeldt, "Texas Folk Art," *Antique Review*, 14 (September 1988): 26.

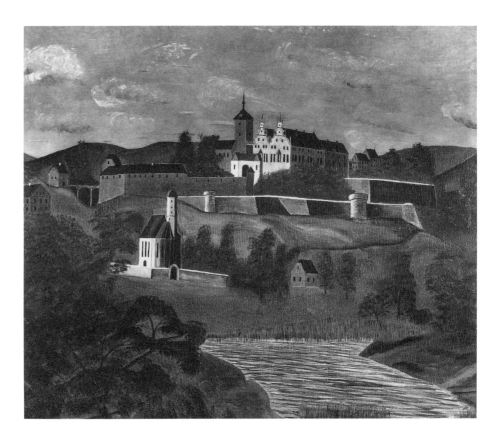

THE CASTLE
n.d., oil on canvas mounted on Masonite, 30″ × 36″
Unsigned (attributed)

Rudolph Mueller's painting style was strong and virile, with robust colors. In this instance his sense of design is evident in the powerful linear pattern and the vigorous contrasting tones. He probably used a postcard or printed source for his inspiration and the canvas may have been an exercise in nostalgia, reminding him of his homeland. At one time this painting hung in the Rihn Saloon in Castroville, one of the artist's habitual haunts. He may even have painted *The Castle* in payment for services rendered in the establishment.[9]

PROVENANCE:
·1941: Collection of the Rihn Saloon.
1941–1977: Collection of Ruth Curry Lawler.
1977: Purchased by SAMA from Ruth Curry Lawler with Witte Picture Funds.
77–44 P

EXHIBITIONS:
1978–1979: A Survey of Naive Texas Artists, WMM (December 17, 1978, to March 1, 1979).
1979–1980: A Survey of Naive Texas Artists, Traveling Exhibition: The Museum of Fine Arts, Houston (April 11 to May 27, 1979). Laguna Gloria Art Museum, Austin (June 9 to July 23, 1979). Tyler Museum of Art (July 31 to September 9, 1979). Lufkin Historical and Creative Arts Center (September 24 to November 15, 1979). The Art Center, Waco (April 15 to May 30, 1980).

PUBLICATIONS:
Steinfeldt, *Texas Folk Art* (1981), 46.

1. Ruth Curry Lawler (Castroville) to author (SA), April 20, 1978; Bernard Fitzsimon (Castroville) to author (SA), interview, June 2, 1978.
2. "Eugen Huesser Retires First of Year to Fish," Hondo *Anvil Herald*, December 18, 1953.
3. Ibid.
4. Ibid.
5. Fitzsimon to author, interview, June 2, 1978.
6. Lawler to author, April 20, 1978.
7. Gittinger et al., *St. Louis Church*, 29–30, 31 (quotation), 32.
8. Ibid., 32.
9. Fitzsimon to author, interview, June 2, 1978. Fitzsimon recalled that Mueller had a reputation for indulgence in alcoholic spirits.

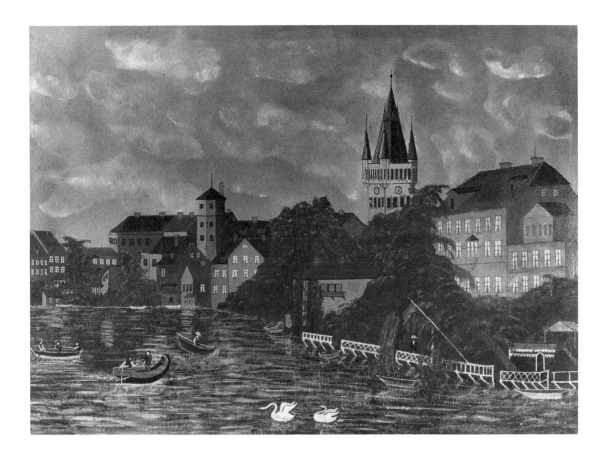

THE CASTLE OF THE ORDER OF TEUTONIC
KNIGHTS, KÖNIGSBERG, PRUSSIA
n.d., oil on canvas, 32″ × 44″
Unsigned (attributed)

This painting of a castle with surrounding buildings and adjacent lake illustrates the artist's remarkable intuitive perception of pattern and design. Although the painting had lost its original paper label with title that was attached to a corner, it has been identified as the castle in Königsberg, Prussia.[10] The view certainly fits the description to be found in the *Encyclopaedia Britannica*: ". . . among the more interesting buildings are the Schloss [castle], a long rectangle begun in 1255 and added to later, with a Gothic tower 277 ft. high and a chapel built in 1592. . . . The Schloss was originally the residence of the Grand Masters of the Teutonic Order and later of the dukes of Prussia. . . . To the east is the Schlossteich, a long ornamental lake covering 12 acres."[11]

Mueller probably copied from a postcard or print, but his version is stamped with his personality. The castle still stands in what is now known as Kaliningrad, capital of the Kaliningrad region of the former USSR.[12]

PROVENANCE:
-1978: Collection of J. Lawton Stone.
1978: Purchased by Joe White Nicholson from Horse of a Different Color Antiques, agents for J. Lawton Stone.
1978: Gift to SAMA by Joe White Nicholson.
78–365 G

EXHIBITIONS:
1978–1979: A Survey of Naive Texas Artists, WMM (December 17, 1978, to March 1, 1979).
1979–1980: A Survey of Naive Texas Artists, Traveling Exhibition: The Museum of Fine Arts, Houston (April 11 to May 27, 1979). Laguna Gloria Art Museum, Austin (June 9 to July 23, 1979). Tyler Museum of Art (July 31 to September 9, 1979). Lufkin Historical and Creative Arts Center (September 24 to November 15, 1979). The Art Center, Waco (April 15 to May 30, 1980).

PUBLICATIONS:
Steinfeldt, "The Folk Art of Frontier Texas," *The Magazine Antiques*, 114 (December 1978): 1288.
Crossley, "Folk Art of the Frontier," Houston *Post*, December 15, 1978.
Crossley, "Folk Art of the Frontier," *The Magazine of San Antonio*, 2 (January 1979): 29.
Steinfeldt, *Texas Folk Art* (1981), 48.

10. Postcard from Robert Hiller (Stuttgart, Germany) to editor, *The Magazine Antiques*, January 27, 1979.
11. *Encyclopaedia Britannica* (1959), s.v. "Königsberg."
12. Ibid.

ELIZABETH NETTE

Elizabeth Nette, daughter of August and Elizabeth (Messer) Nette, was born in Texas on January 5, 1858. Elizabeth's father was a pioneer apothecary who emigrated from Germany in 1840. He first settled in New Braunfels but soon moved to San Antonio, where he established a home and successful business on Commerce Street. As a druggist he often concocted his own remedies from available herbs and plants and, like many early pharmacists, served as a practicing physician as well.[1] Active in civic affairs, Nette became a member of the first board of trustees of the German-English School in 1860.[2]

As a child Elizabeth attended the German-English School but later studied in a fashionable and famous academy for young ladies in Frankfurt, Germany. She married Julius Remer in 1878 and the couple had two children, Hedwig and Julius. Some years after the death of her first husband Elizabeth married William Lorenzen. Three children, William, Lucile, and Edward, were born to this union. William Lorenzen died in 1927; Elizabeth died in 1942.[3]

GIRL WITH BUTTERFLY
1872, charcoal and chalk on paper, 15¼″ × 11″
Signed lower right: Elise Nette/fecit

Elizabeth Nette was fourteen years old when she made this drawing at the German-English School in San Antonio.[4] Probably it was copied from a print or reproduction but nevertheless shows a degree of competency and skill in the rendering. Charming and attractive, it is typical of a young lady's tutelage in the Victorian era and is an interesting example of the work produced in the school in San Antonio. Elizabeth Nette preferred to sign her name as "Elise" rather than Elizabeth, perhaps to avoid confusion with her mother's name, or perhaps because she thought the diminutive "Elise" had a more romantic flair.

PROVENANCE:
1872–1939: Collection of the Nette-Storbeck Family.
1939: Gift to SAMA by Lucile Storbeck, the artist's daughter.
39-41 G

1. Pease, *They Came to San Antonio*, s.v. "Nette, Dr. August, Sr."; Edward W. Heusinger, F.R.G.S., *The Heusinger Family in Texas* (San Antonio: Standard Printing Co., 1945), 9.
2. Mary Mathis El-Beheri and Susan Clayton, "High School Students Research History of German-English School in San Antonio," *Die Unterrichspraxis*, 8 (Fall 1975): 64.
3. Davis and Grobe (eds. and comps.), *The New Encyclopedia of Texas*, s.v. "William Lorenzen," 1734.
4. Information supplied by donor, SAMA Registrar's Records. Lucille Storbeck, donor, was the daughter of Elizabeth Nette Lorenzen.

ELEANOR ROGERS ONDERDONK (1884–1964)

Eleanor Onderdonk, the second child of Robert and Emily Onderdonk, was born on October 25, 1884, in the family home, "Bella Vista," in San Antonio. Her mother referred to her as a "cunning little lady" and remarked how much she resembled her grandmother, Mrs. Gould.[1]

Eleanor, like her brother Julian, grew up in an atmosphere of love and devotion, which developed her warm and friendly personality. Her schooling was sporadic, with her parents and grandparents largely responsible for her early education. She spent the first years of her childhood in Dallas, where her family had moved in 1889 so that Robert Onderdonk might pursue his art career. Upon the death of her grandfather, Nathan Gould, in 1895 the family returned to San Antonio.[2]

Eleanor's teenage years were carefree and filled with simple diversions typical of young San Antonio belles. She went to the World's Fair in St. Louis in 1904 and visited relatives in New York in 1906. In 1909 and 1910 she journeyed to Mexico, staying with friends on their ranch. She kept diaries of these trips, but there is no indication in them that she was interested in becoming an artist.[3]

As she grew older, however, Eleanor recognized that she had artistic ability and a substantial art background. By July 1913 she decided to go to New York to study.[4] She enrolled in the Art Students League and chose miniature painting as her specialty. Her father felt "she had a good eye and a steady hand," both requisites of the meticulous and demanding nature of the art.[5] Eleanor's instructors in miniature painting included Alice Beckington (1868–1942), Lucia Fairchild Fuller (1872–1924), and Helen Savier DuMond (Mrs. Frank Vincent DuMond, 1872–1951). She also studied life drawing with George Bridgman (1864–1943) and portraiture with John C. Johansen (1876–1966) at the Art Students League.[6]

By 1915 Eleanor had returned to San Antonio, painting miniatures of local friends and celebrities, and when her father died in 1917 she assumed his position as teacher in the community.[7] In the summer of 1923 she attended the Woodstock School of Landscape Painting with John F. Carlson (1875–1945) as her instructor.[8] When she returned to San Antonio she continued to teach at home, at Bonn Avon School, and at Saint Mary's Hall until she was offered the position of curator of art at the Witte Memorial Museum in 1927. She replaced Sybil Browne who had served in this capacity for the first year of the museum's existence.[9]

Eleanor had found her niche. She was knowledgeable in the local art field, and her extensive training in the East made her well qualified nationally. Her friendly disposition and her insatiable capacity for study and work, along with the respect she commanded in the community, were invaluable in establishing an art department in the young institution.

Eleanor's first assignment in 1927 was a challenge: the organization and display of the second Texas Wildflower Competitive Exhibition. This competition was the brainchild of Edgar B. Davis, a wealthy oilman in Luling, Texas. Originally from Massachusetts, Davis became enraptured with the beauty of Texas wildflowers, conceived the idea of encouraging artists to paint them, and offered prizes for the results.[10] These competitions lasted through 1929 with expanded categories and larger awards and were open to artists throughout the United States. The interest they engendered catapulted the city, the museum, and the San Antonio Art League into

Eleanor Onderdonk in 1905, a photograph taken by David P. Barr in San Antonio. SAMA Historical Photographic Archives, gift of Ofelia O. Robbie.

1. Entry in Emily Onderdonk's ledger, "Baby Days, 1884." Gould-Onderdonk papers. Private collection.
2. Steinfeldt, *The Onderdonks*, 172–173.
3. Diaries and correspondence written by Eleanor Onderdonk from 1904 through 1910. Gould-Onderdonk papers. Private collection.
4. Diary of Emily Onderdonk, July 15, 1913. Gould-Onderdonk papers. Private collection.
5. Robert Onderdonk (St. Louis) to Emily Onderdonk (SA), January 29, 1899.
6. Fisk, *A History of Texas Artists*, 23.
7. Steinfeldt, *The Onderdonks*, 176–177.
8. Ibid., 177.
9. Woolford and Quillin, *The Story of the Witte Memorial Museum*, 128.
10. "Dawson-Watson Wins Art Prize," *San Antonio Express*, February 20, 1927.
11. "Select Prize Paintings," *San Antonio Light*, February 22, 1929.

Eleanor Onderdonk in 1908, photographer unknown. SAMA Historical Photographic Archives, gift of Ofelia O. Robbie.

12. Eleanor Onderdonk (SA) to Sarah Scott McKeller (Mexico), November 23, 1927.
13. Steinfeldt, *The Onderdonks*, passim.
14. Ibid.
15. "Witte Memorial Museum Art Department Annual Report," 1942. Witte Museum Library.
16. Erretta G. Becker, "A Miniature History of the San Antonio Art League, 1942." Photocopied typescript, San Antonio Art League file, SAMA Texas Artists Records.
17. Eleanor Onderdonk (SA) to Genevieve Hitt (Front Royal, Virginia), October 23, 1952.
18. Joseph Polley Paine to Eleanor Onderdonk (SA), May 10, 1953.
19. Eleanor Onderdonk (SA) to Marion Gibbs Caphton (Harrisburg, Pennsylvania), January 4, 1962.
20. "Stroke Fatal to Ex-Curator," San Antonio *Light*, November 12, 1964.

the national limelight. Alpheus Cole (1876?–), a judge in 1929, stated: " . . . not only did San Antonio offer the largest prizes for pictures of any city in the United States, but more prizes than all the other exhibitions put together, through the generosity of Mr. Davis."[11]

The Davis competitions were discontinued after 1929, but Eleanor was kept busy with a staggering agenda of art exhibitions as well as the care and display of historical collections. She once wrote: "This job keeps me pretty busy. I am working from morning till night, and when I get through I don't seem to have accomplished much. There is more to do here than one would think . . . you have to be hostess, and general information bureau, answer the phone a million times a day and write letters which is slow work for me as I don't seem to acquire much speed on the typewriter."[12]

Eleanor organized many spectacular exhibitions, feeling an obligation to present to local artists, art students, and the general public the best in contemporary painting and sculpture, along with traditional art and the work of the old masters. She also concentrated on building the collection of paintings by Texas artists that is the basis of The Texas Collection.[13]

When the depression curtailed the museum's art activities, Eleanor turned more to local artists and collectors for material. By this time she had become adviser, friend, and confidante to young artists and encouraged many in their art careers— a role she continued the rest of her life.[14]

Eleanor faced other problems during World War II. Attendance at the museum became overwhelming as military personnel and their families studied the displays, pored over art magazines, listened to the concerts, and attended art classes. When the city administrators suggested that art programs be limited because of the war, Eleanor replied, "But that is what we are fighting for—our culture."[15]

People from other museums with whom she had worked attested to Eleanor's contributions to the Texas art scene and her influence in the community. In 1942 James Chillman, director of the Houston Museum of Fine Arts, wrote: "I do hope Miss Onderdonk is fully appreciated in San Antonio. She ranks foremost as an authority on art and does have pronounced influence on all good art in Texas."[16] In 1952 museum officials from across the state presented her with a silver cup in Dallas.[17]

Eleanor won many awards and accolades during her lifetime and in 1953 was made an honorary member of the Men of Art Guild. The secretary wrote: "You have been our friend, our counsel, our standard bearer and at times our courage. We love and respect you for your devotion and sacrifices to our cause."[18]

Eleanor Onderdonk retired in 1958 but returned frequently to the museum to visit. She wrote to a friend, "It's funny how well they get along without me over there!"[19] On November 11, 1964, she was found in the backyard of her home, dead from natural causes.[20]

While Eleanor lived she was the heart of the art center in San Antonio, and her influence radiated from this core to all other art activities in the state. Because of her position in a public institution, she contributed even more to the art scene than either her father or her brother. She was the right person in the right place at the right time.

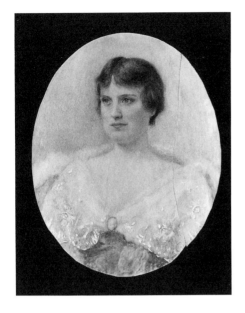

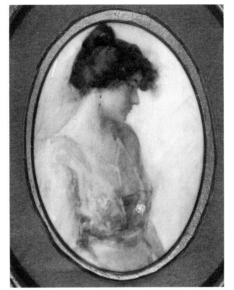

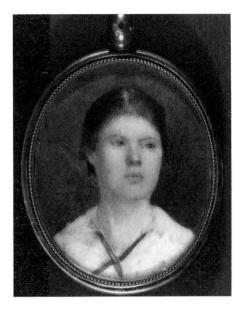

PORTRAIT OF JOSEPHINE WOODHULL
1916, watercolor on ivory, 3⅞" × 3"
Signed lower right: E. Onderdonk

The Onderdonks and the Woodhulls were neighbors and close friends. Josephine Woodhull, one of San Antonio's loveliest young women, must have been a stimulating inspiration for Eleanor's dexterous brush. The miniature was done from life as well as a photograph, for Josephine Woodhull would merely walk across the street to pose for Eleanor.

PROVENANCE:
1916–1976: Collection of Josephine Woodhull Crittenberger.
1976: Gift to SAMA by Josephine Woodhull Crittenberger.
76–51 G

EXHIBITIONS:
1975: The Onderdonks: A Family of Texas Painters, WMM (January 16 to July 31).
1986: Texas Seen/Texas Made, SAMOA (September 29 to November 30).

PUBLICATIONS:
Steinfeldt, *The Onderdonks* (1976), 203.
"Texas Seen-Texas Made," *Current Events* (SA), September 25, 1986.
"Exhibit honoring Texas artists opens Sunday," *North San Antonio Times*, September 25, 1986.
"'Texas Seen-Texas Made' opens," *San Antonio Light*, October 5, 1986.

PORTRAIT OF A LADY
ca. 1914, watercolor on ivory, 3⅛" × 2½"
Unsigned

Portrait of a Lady is one of Eleanor's most exquisite miniatures, with its subtle coloring, delicate brushwork, and unusual composition. The flesh tones glow, the hair sparkles with vitality, and the sheer fabric of the dress is handled with sensitivity and finesse. The coiffure and the style of the gown suggest the portrait was done about 1914, when the artist was studying in New York. The painting won the first prize for miniatures in the Ninth Annual Southern States Art League exhibition in 1929.[21]

PROVENANCE:
ca. 1914–1968: Collection of the Onderdonk Family.
1968–1983: Collection of Clyde Ellis.
1983: Purchased by SAMA from Clyde Ellis with Witte Picture Fund.
83–98 P

EXHIBITIONS:
1929: Ninth Annual Exhibition of the Southern States Art League, WMM (April 4 to 30).
1933: Pennsylvania Society of Miniature Painters, Fort Worth Museum of Art (January 28 to February 11).
1933: Pennsylvania Society of Miniature Painters, WMM (February 23 to March 4).
1986: Texas Seen/Texas Made, SAMOA (September 29 to November 30).

PUBLICATIONS:
"Rarely Good Painter of Miniatures in This Young Woman of San Antonio," *San Antonio Express*, July 4, 1915.

MARY
n.d., watercolor on ivory, 2¼" × 2"
Titled and signed on reverse: Mary/E. Onderdonk

Although this miniature is signed and titled on the reverse in Eleanor's handwriting, the subject's identity is a mystery. Her soft features indicate her youthfulness. The warm and vibrant flesh tones are enhanced by the cool gray-blue background and the touch of blue ribbon at the throat. This painting demonstrates the artist's ability to achieve the quality of a full-size portrait in a diminutive space.

PROVENANCE:
1978: The miniature was found in a chest with other miniatures and *objets d'art* in SAMA's vault and was registered as a delayed accession.
78–197 G

EXHIBITIONS:
1929: Ninth Annual Exhibition of the Southern States Art League, WMM (April 4 to 30).
1986: Texas Seen/Texas Made, SAMOA (September 29 to November 30).

21. *Ninth Annual Exhibition of the Southern States Art League* (San Antonio: Pabst Engraving Co., 1929).

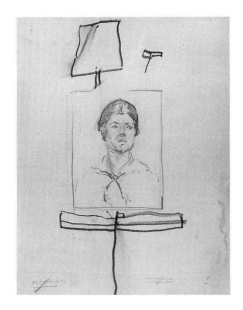

Sketch of "Mary" found in one of Eleanor's sketchbooks, obviously a preliminary drawing for the finished miniature. The sketchbook was given to SAMA by Ethel D. Winn in 1979.

Eleanor Onderdonk in the dining room of her home at 128 West French Place in about 1954. Courtesy of Mary Ann Noonan-Guerra.

Eleanor Onderdonk with her dog, Pepe, in the winter of 1948. Gould-Onderdonk papers. Private collection.

WORKS BY ELEANOR ROGERS ONDERDONK NOT ILLUSTRATED:

IN THE MIRROR (SELF-PORTRAIT)
n.d., watercolor on paper, 7″ × 5½″
Unsigned
Titled across bottom: In the Mirror
67–164 G (14a)
Gift to SAMA by Ofelia Onderdonk.

MUTT AND MY DUCKS
n.d., pencil and ink on paper, 3¾″ × 4″
Initialed lower right: E. O.
Titled across bottom: Mutt and My Ducks
67–164 G (14b)
Gift to SAMA by Ofelia Onderdonk.

OUR HOUSE
n.d., pencil and ink on paper, 3⅝″ × 4″
Unsigned
67–164 G (14c)
Gift to SAMA by Ofelia Onderdonk.

SKETCHES OF DOGS
n.d., ink on paper, 10⅛″ × 6¼″
Unsigned
67–164 G (14d)
Gift to SAMA by Ofelia Onderdonk.

THE MAID IN THE MOON
n.d., watercolor on paper, 4″ × 4″
Unsigned
67–164 G (14e)
Gift to SAMA by Ofelia Onderdonk.

HELLO!
n.d., ink on paper, 3⅛″ × 4¼″
Unsigned
67–164 G (14f)
Gift to SAMA by Ofelia Onderdonk.

PLACE CARD
n.d., watercolor and ink on paper, 6¼″ × 3½″
Unsigned
Inscribed across bottom: Edna Louise Row
67–164 G (14g)
Gift to SAMA by Ofelia Onderdonk.

VALENTINE GREETINGS
n.d., watercolor on paper, 3½″ × 2½″
Signed across bottom: Eleanor R. Onderdonk.
Titled left side: Valentine Greetings
67–164 G (14h)
Gift to SAMA by Ofelia Onderdonk.

RECUERDO
n.d., watercolor on paper, 5¼″ × 3¼″
Unsigned
Titled across bottom: Recuerdo
67–164 G (14i)
Gift to SAMA by Ofelia Onderdonk.

VALENTINE GREETINGS
n.d., watercolor on paper, 5¼″ × 3½″
Unsigned
Titled across bottom: Valentine Greetings
67–164 G (14j)
Gift to SAMA by Ofelia Onderdonk.

SKETCHBOOK
1915, paper with cardboard cover, 7¼″ × 5″
Signed and dated on front cover: Mar. 25, 1915/
Eleanor Onderdonk
79–146 G (1)
Gift to SAMA by Ethel D. Winn.

SKETCHBOOK
1913, paper with cardboard cover, 7¼″ × 5″
Signed and dated on front cover: Nov. 21, 1913/
Eleanor Onderdonk
79–146 G (2)
Gift to SAMA by Ethel D. Winn.

SKETCHBOOK
1901, paper with cardboard cover, 8¼″ × 6½″
Signed and dated inside front cover: Eleanor
Onderdonk/Jan. 5th, 1901
79–146 G (3)
Gift to SAMA by Ethel D. Winn.

ROBERT JENKINS ONDERDONK (1852–1917)

Robert Onderdonk came from a distinguished and cultured Dutch family who first immigrated to America in 1642. Adriaen van der Donck was the most noteworthy of these ancestors and was the first lawyer and historian of New Netherland. His original residence was in Albany, New York, but in 1646 he was allotted a large tract of land that extended from the Hudson to the Bronx River and came to be known as De Jonkheer's Land (the estate of the young lord). The name "Yonkers" gradually evolved from the earlier descriptive term.[1]

The name "van der Donck" was simplified to Onderdonk and, by the early nineteenth century, the family could boast of two Episcopal bishops: Henry Ustick Onderdonk (1798–1858), bishop of Pennsylvania, and his brother Benjamin Treadwell Onderdonk (1791–1861), bishop of New York.[2] Robert's father, Henry Onderdonk, was a well-known educator from New York who taught at St. Timothy's Hall in Catonsville, Maryland, and at Govanstown and in Green Spring Valley. After the Civil War he assumed the position of headmaster at the College of St. James in Washington County, Maryland.[3]

Henry Onderdonk had married Harriet Stevenson Henry of Somerset County, Maryland, in 1849. Robert Jenkins Onderdonk was born of this union on January 16, 1852, at St. Timothy's Hall. Henry and Harriet also had two other sons, Harry and Andrew. Harriet Onderdonk died in 1861, and in 1868 Robert's father married Mary Elizabeth Latrobe, the daughter of Benjamin H. Latrobe, a civil engineer.[4] The renowned architect of the same name was Mary's grandfather.[5] Henry and Mary had two children, Latrobe and Adrian.

With such a background, Robert's early education undoubtedly was scholarly and thorough. He spent his teens at St. James before going to New York to study art.[6] He began his training at the National Academy of Design with Lemuel Everett Wilmarth (1835–1918) as one of his first instructors. In the summer of 1875 the National Academy was forced to close for a limited period because of funding difficulties. A group of students under the guidance of Professor Wilmarth formed a self-governing cooperative class called "The Art Students League," which became one of the most important schools in the country.[7] It is believed Robert was one of the original group.

Robert studied with Walter Shirlaw, William Merritt Chase, and James Carroll Beckwith at the league.[8] Alexander Helwig Wyant (1836–1892) also was one of Robert's instructors, although on an individual and private basis.[9]

Robert's teachers had all studied in Europe and inspired him to do the same, but he lacked the financial wherewithal. When Walter and William Negley, boyhood friends from Hagerstown, Maryland, suggested he visit them in Texas, Robert decided to do so. He planned to spend a year painting portraits of wealthy Texans in order to finance a trip to Europe, although that dream never came true.[10]

Robert was in Texas by 1879. In his copy of *Combats and Conquests of Immortal Heroes* by Charles Merritt Barnes, he made a notation beneath an illustration of the Tunstall homestead, "Where I lived for a year when I came to San Antonio in September, 1879—R. J. O."[11] The large, comfortable rock house belonged to Warwick and Florida Tunstall, whose daughter Ethel (Mrs. Henry Drought) became an outstanding patroness of the arts in San Antonio. She was a child when Robert first knew her, and remained his friend and steadfast supporter throughout the years.[12]

Robert Onderdonk in 1878 or 1879, about the time he moved to Texas. SAMA Historical Photographic Archives, gift of Ofelia Onderdonk.

1. *Encyclopaedia Britannica* (1959), s.v. "Yonkers."
2. Richard J. Koke (Curator of the Museum, The New York Historical Society, New York City) to author (SA), July 16, 1974.
3. Obituary, Baltimore *Sun*, August 19, 1895.
4. Ibid.
5. Paul F. Norton and E. M. Halliday, "Latrobe's America," *American Heritage*, 13 (August 1962): 40.
6. Steinfeldt, *The Onderdonks*, 12.
7. Ibid.
8. Art Students League Microfilm Records, Archives of American Art, Washington Center, 8th and F streets, Washington, D.C.
9. Steinfeldt, *The Onderdonks*, 13.
10. Mrs. Rupert Gresham to author (SA), interview, August 17, 1974.
11. Barnes, *Combats and Conquests*, 17.
12. Steinfeldt, *The Onderdonks*, 13.

Robert Jenkins Onderdonk, about 1883, shown with his portrait of Jessie Belknap. The date and information is on the reverse side of the photograph in Eleanor Onderdonk's handwriting. Private Collection.

Robert evidently found San Antonio's picturesque atmosphere intriguing and stimulating. He made numerous small watercolors and sketches of the local scenery, as well as some diminutive oils on wooden panels or on the tops of old cigar boxes.[13] He also found a charming companion, Emily Gould, who lived across from the Tunstall home. The young couple had much in common, for Emily also came of an old colonial family with distinguished forebears. On April 27, 1881, they were married in St. Mark's Cathedral, in the first wedding held in the newly consecrated church.[14] They had three children: Julian, born in 1882; Eleanor, born in 1884; and Latrobe, born in 1886.[15]

Portrait commissions were few and far between. Robert turned to teaching, for which he was well suited and which was to be his main source of income for most of his life. With his American background in art and his extensive teaching he introduced into Texas new and invigorating art concepts.

In 1886 Robert was instrumental in organizing the first formal art association in the city, the Van Dyke Art Club. Its objective was to establish an art school, an art library, and an art exchange. This group was active for several years, but was replaced in 1894 by one composed only of working artists. The San Antonio Art League grew out of these early efforts and expanded to include all patrons of the arts.[16]

Interest in the arts was growing in San Antonio to the extent that Robert faced competition from numerous other artists. In 1889, at the age of thirty-seven, he decided to try his luck in Dallas. He advertised in newspapers, distributed circulars announcing his presence in that city, and established a school at 721 Elm Street.[17] He participated in the Dallas State Fairs and helped found the Dallas Art Students League, and on February 15, 1893, he was named the instructor for the latter group.[18] During his years in Dallas he also worked doing portrait commissions on consignment. It was a commercial enterprise in which a man named Hulbert employed a number of artists whose work he signed with his own name.[19]

Robert returned to San Antonio around 1896, after the death of his father-in-law Nathan H. Gould. His name again appears in the city directories as an artist with studios in the Alamo Insurance Building. But by November of 1898 he had embarked upon a new business venture, this time in St. Louis, working for china manufacturer Johannes Schumacher. Robert, no novice at decorating china, as he had taught the craft in San Antonio for years, was employed as a painter to design and embellish china tiles. These were fitted together to form large mural-type wall decorations. This job lasted until September 1899, when Robert was approached by the Dallas Fair Association to act as judge and to select paintings for the annual Fair.[20] He served the Fair Association in this capacity until shortly before his death. With this assured income for at least part of the year, he willingly returned to San Antonio.

In 1901 Robert started upon the most ambitious project of his painting career, which has become his most famous work.[21] He was commissioned by the historian James T. DeShields to create a large historical canvas, *The Fall of the Alamo*. It was shown in a number of cities in Texas and in 1904 at the St. Louis World's Fair.[22] It now hangs in the Governor's Mansion in Austin, Texas. Robert also is credited with another heroic painting, *The Surrender of Santa Anna*, which unfortunately was destroyed in a fire.[23]

Robert spent most of his remaining years in San Antonio, with the exception of his trips to select paintings for the Dallas State Fair and a trip to Mexico in 1911.

13. Ibid., 14.
14. Ibid., 14–16; "Thirty-four Years Ago Today–1881," San Antonio Express, April 28, 1915.
15. Steinfeldt, The Onderdonks, 16–17.
16. Garana, "Art Has a Home in S. A.," 62.
17. Robert Onderdonk (Dallas) to wife Emily (SA), February 28, 1889.
18. Original handwritten contract, dated February 15, 1893, signed by Mrs. Sydney Smith, President, Dallas Art Students League. Robert Jenkins Onderdonk file, SAMA Texas Artists Records.
19. Robert Onderdonk (Dallas) to wife Emily (St. James, Maryland), September 7, 1890–November 14, 1890.
20. Robert Onderdonk (St. Louis) to members of his family (SA), November 27, 1898–August 14, 1899. See also Steinfeldt, The Onderdonks, 24–26.
21. Pinckney, Painting in Texas, 207–209.
22. Steinfeldt, The Onderdonks, 28.
23. James T. DeShields (Dallas) to Julian Onderdonk (SA), January 28, 1918.

He also took a short jaunt to Colorado in 1914. His life had assumed a more leisurely pace, and he and his family participated in the social life of San Antonio. He found agreeable companionship with other artists in the Brass Mug Club, the Fifty-two Club, and the "Chili Thirteen."[24]

In 1915 Robert began suffering from discomfort in his jaw, probably cancer, that made even eating difficult. An operation in December 1916 alleviated the condition somewhat, and Robert lived for another six months. He died at his home at 128 West French Place in San Antonio on July 2, 1917.[25]

Robert Onderdonk spent thirty-eight of his sixty-five years in Texas. His influence on the state's art environment during that time cannot be overestimated. American-born and American-trained, he introduced a new dimension to Texas's cultural heritage through his teaching. He was the catalyst in the organization of formal art groups, creating a unity between artists and art patrons that had been lacking. He was quiet and unassuming, and his unflinching determination to continue in his chosen career established a firm basis for the local art scene. Little wonder he is known as the "Dean of Texas's Artists."

The Brass Mug Club of San Antonio, 1914. Left to right, standing: M. Emig; Julian Onderdonk, artist; Ernst Raba, photographer; Theodore Fletcher; Tom Brown, artist; Robert Leo Cotton, artist; and Joe Braun. Seated: Ernest A. Thomas, violin teacher; Robert Onderdonk, artist; José Arpa, artist; Charles Simmang, Jr., steel engraver and medalist; and Alois Braun, musician. SAMA Historical Photographic Archives, gift of an anonymous donor.

An early San Antonio art exhibition, probably in St. Joseph's Catholic Church Hall, about 1900. Ernst Raba is seated in the corner at left. SAMA Historical Photographic Archives, gift of Marjorie Will.

24. Steinfeldt, *The Onderdonks*, 28–30.
25. Ibid., 31.
26. "The Art Students League, Part I," *Archives of American Art Journal* (1973): 2.

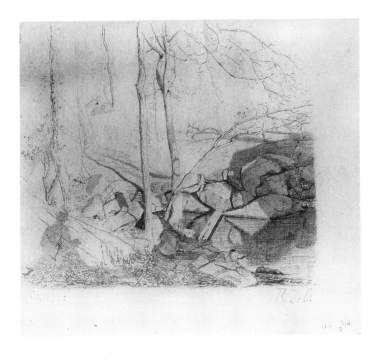

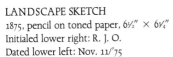

LANDSCAPE SKETCH
1875, pencil on toned paper, 6½" × 6¼"
Initialed lower right: R. J. O.
Dated lower left: Nov. 11/'75

Robert Onderdonk's sketch of a quiet pool
nestled amid stark rocks and leafless trees was
done when he was twenty-three years old. Its
delicate lines and refined treatment express
the young artist's sensitivity to nature, a trait
obvious in much of his work. His own shadow
appears on the left side, a touch so subtle it is
easily overlooked. The sketch could have
been done in Maryland or possibly New York
during his early student years.

PROVENANCE:
1875–ca. 1960: Collection of the Gould-Onderdonk
Family.
ca. 1960: Purchased from Eleanor Onderdonk, the
artist's daughter, by Robert K. Winn.
1970: Gift to SAMA by Robert K. Winn.
70–85 G (22)

EXHIBITIONS:
1970: The Sketches of Robert Onderdonk, WMM
(August 8 to December 1).
1975: The Onderdonks: A Family of Texas Painters,
WMM (January 16 to July 31).
1975: The Onderdonks: A Family of Texas Painters,
Sarah Campbell Blaffer Gallery, University of Houston
(August 30 to November 15).
1979: The American Image: 1875–1978, Center for the
Arts, Corpus Christi State University (March 29 to
April 12).

PUBLICATIONS:
Steinfeldt, The Onderdonks (1976), 35.
The American Image: 1875–1978 (1979): frontispiece.

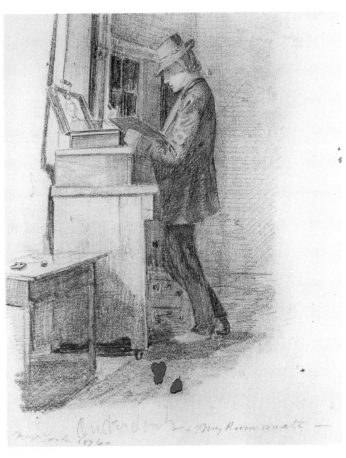

MY ROOM MATE, NEW YORK
1876, pencil on paper, 5⅛" × 4¼"
Signed lower center: Onderdonk
Titled lower right: My Room Mate
Dated lower left: New York, 1876

By 1876 Robert Onderdonk was no longer a
student at the National Academy and had
joined the cadre of young students that
formed the Art Students League. His work
indicates that he was following the edicts
of this new group and sketching directly
from life rather than working in the more
traditional academic manner of drawing from
plaster casts.[26] Robert took advantage of
every opportunity to improve his drafting
skills and sketched his roommate busily
working on a portrait held in the lid of a
paint box. His sketch from a live model
shows his changing technique. The lines are
broader and stronger and are executed with
more confidence.

PROVENANCE:
1876–ca. 1960: Collection of the Gould-Onderdonk
Family.
ca. 1960: Purchased from Eleanor Onderdonk by
Robert K. Winn.
1970: Gift to SAMA by Robert K. Winn.
70–85 G (21)

EXHIBITIONS:
1970: The Sketches of Robert Onderdonk, WMM
(August 8 to December 1).
1975: The Onderdonks: A Family of Texas Painters,
WMM (January 16 to July 31).
1975: The Onderdonks: A Family of Texas Painters,
Sarah Campbell Blaffer Gallery, University of Houston
(August 30 to November 15).

PUBLICATIONS:
Steinfeldt, The Onderdonks (1976), 35.

WILLIAM MERRITT CHASE, INSTRUCTOR
1879, pencil on paper, 8½" × 4¼"
Unsigned

William Merritt Chase was a colorful and
dynamic character and probably enjoyed
posing for students. This sketch provides an
interesting link in Robert's development
from student to the proficient professional
portraitist he became after he moved to
Texas. The drawing is inscribed on the reverse
in Eleanor Onderdonk's handwriting: "A
sketch made by R. J. Onderdonk at
Art Students' League in 1879. Subject:
Wm. Merritt Chase, Instructor."

PROVENANCE:
1879–1964: Collection of the Gould-Onderdonk
Family.
1964: Gift to SAMA by the Estate of Eleanor
Onderdonk.
64–251 G (5)

EXHIBITIONS:
1975: The Onderdonks: A Family of Texas Painters,
WMM (January 16 to July 31).
1975: The Onderdonks: A Family of Texas Painters,
Sarah Campbell Blaffer Gallery, University of Houston
(August 30 to November 15).

PUBLICATIONS:
Utterback, *Early Texas Art* (1968), 53.
Steinfeldt, *The Onderdonks* (1976), 36.

MAN WITH SKETCH PAD
ca. 1877, pencil on paper, 8" × 6½"
Unsigned
Inscribed lower center: Shin
Dated lower left: Feb. 17

Robert did numerous quick sketches of his
painting colleagues during his student days.
An inscription on the reverse in Eleanor
Onderdonk's handwriting states: "By my
father, R. J. Onderdonk, when studying
at the Art Students' League in 1877–78."
Sketches done in five or ten minutes tested
an artist's knowledge of scale and anatomy.
They were excellent exercises in developing
dexterity.

PROVENANCE:
ca. 1877–1967: Collection of the Gould-Onderdonk
Family.
1967: Gift to SAMA by Ofelia Onderdonk, the
daughter-in-law of the artist.
67–164 G (16)

EXHIBITIONS:
1970: The Sketches of Robert Onderdonk, WMM
(August 8 to December 1).

MEXICAN JACÁL
1880, pencil on paper, 5″ × 9″
Initialed, dated, and inscribed lower left: San Antonio,
Tex./July 25, 1880—R. J. O.

When Robert Onderdonk first came to San
Antonio he made many small sketches in and
around the city. The ramshackle Mexican
jacales were one of his favorite subjects. He
later converted many of these into small
paintings and sometimes even duplicated
them.

PROVENANCE:
1880–1967: Collection of the Gould-Onderdonk
Family.
1967: Gift to SAMA by Ofelia Onderdonk.
67-164 G (6q)

SAN PEDRO PARK
1886, watercolor on paper, 6¼″ × 9⅛″
Monogrammed and dated lower left: '86
Inscribed on reverse: San Pedro Park

Robert Onderdonk's small watercolor of the
old stone buildings in San Pedro Park is typical
of his early views of San Antonio. The park
was situated around the headwaters of San
Pedro Springs near downtown San Antonio
and was the city's first municipal gathering
place for picnics, political rallies, agricultural
fairs, and holiday festivities. According to
Cornelia E. Crook's *San Pedro Springs Park: Texas'
Oldest Recreation Area*, the land was leased in
1864 to J. J. Duerler, who converted the area
into an amusement park. He constructed five
small ponds with connecting pathways and
bridges and planted lush tropical foliage
around the natural spring-fed lake.[27]

For several years after Duerler's death in
1874 the park was managed by his heirs but
Frederick Kerble assumed administration in
1882. He added a natural history museum and
a small outdoor zoo.[28]

The building that Onderdonk portrays
in his painting was probably part of this
complex, but its original function is
unknown. It became known as the "Old
Stone Fort," and the slotted fenestrations in
its stone walls are indeed suggestive of a
fortress.[29] This building was one of the first
sites considered for a city museum before
Alfred G. Witte made his bequest to establish
the Witte Memorial Museum in Brackenridge
Park, according to the San Antonio *Express* of
March 14, 1925.

27. Cornelia E. Crook, *San Pedro Springs Park: Texas'
Oldest Recreation Area* (San Antonio: Privately
published, 1967), 48–50.
28. Ibid., 54–58.
29. Ibid., 87–91.

PROVENANCE:
1886–ca. 1965: Collection of the Gould-Onderdonk
Family.
ca. 1965: Collection of Pauline Pinckney.
1991: Purchased from Charles Pinckney, Miss
Pinckney's nephew, with Witte Picture Funds.
91-50 P

THE GRANARY, SAN JOSÉ MISSION
ca. 1895, oil on canvas mounted on panel, 8″ × 11″
Signed lower left: R. J. Onderdonk

The Granary, San José Mission must have been painted by the artist for his own pleasure, as Robert's technique is loose and unrestrained and not as tense and precise as in most of his commissioned pieces. He painted *The Granary* before any restoration work at the mission had been attempted. The view shows the two-storied building with flying buttresses at the side, which had been added to reinforce the walls when a third section was attached to the two sections of the original building, built in 1749. The Granary was the first building purchased and restored by the San Antonio Conservation Society.[30]

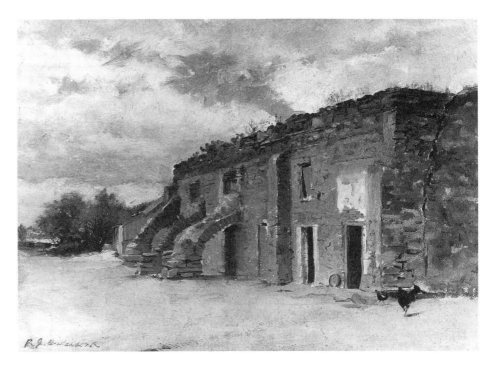

PROVENANCE:
ca. 1895–1938: Collection of the Gould-Onderdonk Family.
1938: Purchased by SAMA from Eleanor Onderdonk with Witte Picture Funds.
38–147 P

EXHIBITIONS:
1936: Centennial Exposition of Early Texas Paintings, WMM (June 1 to August 1). Lent by Eleanor Onderdonk.
1946: Early San Antonio Paintings, WMM (February 24 to March 12).
1964: The Early Scene: San Antonio, WMM (June 7 to August 31).
1966: Echoes of Texas, Museum of the Southwest, Midland (March 1 to April 20).
1975: The Onderdonks: A Family of Texas Painters, WMM (January 16 to July 31).
1984: The Texas Collection, SAMOA (April 13 to August 26).

PUBLICATIONS:
Utterback, *Early Texas Art* (1968), 54.
Steinfeldt, *The Onderdonks* (1976), 66.

MISSION CONCEPCIÓN
n.d., watercolor on paper, 8″ × 11⅛″
Unsigned

Although this painting bears no signature, it was authenticated by Eleanor Onderdonk, the artist's daughter. Numerous similar paintings exist, and Robert no doubt used a photograph for the preliminary drawing of the structure. He varied his subject, however, by changing details in sky, figures, and foliage. This painting was found by the donors in an antique shop in New Orleans. It presumably came from the Col. W. C. Tuttle Estate in San Antonio, as it has Mrs. Tuttle's name on the back.[31]

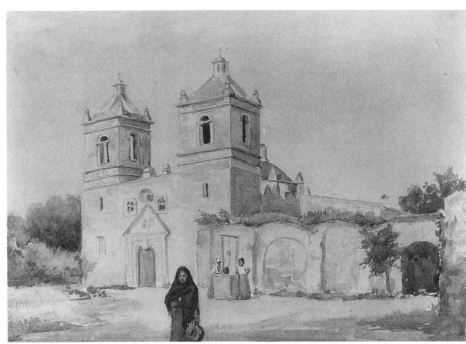

PROVENANCE:
1960: Purchased by Eric Steinfeldt at an antique shop in New Orleans.
1960: Gift to SAMA by Mr. and Mrs. Eric Steinfeldt.
60–180 G

EXHIBITIONS:
1964: The Early Scene: San Antonio, WMM (June 7 to August 31).
1975: The Onderdonks: A Family of Texas Painters, WMM (January 16 to July 31).

1975: The Onderdonks: A Family of Texas Painters, Sarah Campbell Blaffer Gallery, University of Houston (August 30 to November 15).
1986: Texas Seen/Texas Made, SAMOA (September 29 to November 30).

PUBLICATIONS:
Utterback, *Early Texas Art* (1968), 56.
Steinfeldt, *The Onderdonks* (1976), 52, 211.

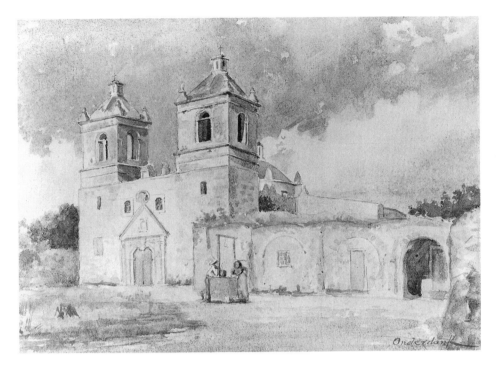

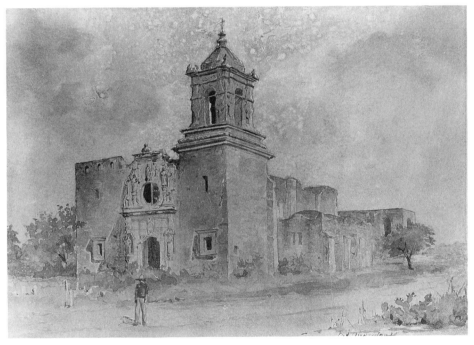

Photograph of Mission San José from the collection of Robert Onderdonk. It is believed Robert Onderdonk used this photograph as a reference for his small watercolor of the mission. SAMA Historical Photographic Archives, gift of Ofelia Onderdonk.

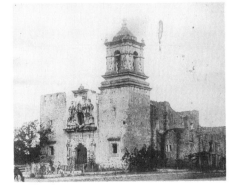

30. Mary Ann Noonan Guerra, *The Missions of San Antonio* (San Antonio: The Alamo Press, 1982), 8.
31. Information supplied by the donors, SAMA Registrar's Records.

CONCEPCIÓN MISSION

n.d., watercolor on watercolor board, 7½″ × 11″
Signed lower right: Onderdonk

This view of Concepción Mission is very much like Robert Onderdonk's other version except for lighter tones and variations in foliage, figures, and sky. Artists found the missions and the Alamo to be popular and saleable subjects, and Robert, like Gentilz, frequently repeated these themes. By using photographs he could work in his studio in inclement weather or when not occupied with a commissioned work.

PROVENANCE:
-1967: Collection of Frances Lee Talbot.
1967: Purchased by SAMA from Frances Lee Talbot with Witte Picture Funds.
67–161 P (2)

EXHIBITIONS:
1975: The Onderdonks: A Family of Texas Painters, WMM (January 16 to July 31).
1975: The Onderdonks: A Family of Texas Painters, Sarah Campbell Blaffer Gallery, University of Houston (August 30 to November 15).

PUBLICATIONS:
Utterback, *Early Texas Art* (1968), 56.
Steinfeldt, *The Onderdonks* (1976), 52.

SAN JOSÉ MISSION

n.d., watercolor on paper, 8″ × 11″
Signed lower right: R. J. Onderdonk

A photograph of Mission San José, found among Robert Onderdonk's papers, obviously was his source for this carefully rendered watercolor. It is not as true a copy of the photo as his versions of Mission Concepción. It shows much freer handling in drawing and less deliberate replication of the photo image and suggests his resistance to slavish duplication.

PROVENANCE:
-1967: Collection of Frances Lee Talbot.
1967: Purchased by SAMA from Frances Lee Talbot with Witte Picture Funds.
67–161 P (3)

EXHIBITIONS:
1975: The Onderdonks: A Family of Texas Painters, WMM (January 16 to July 31).
1975: The Onderdonks: A Family of Texas Painters, Sarah Campbell Blaffer Gallery, University of Houston (August 30 to November 15).

PUBLICATIONS:
Utterback, *Early Texas Art* (1968), 57.
SAMA *Calendar of Events* (March 1976): [3].
Steinfeldt, *The Onderdonks* (1976), 48, 212.

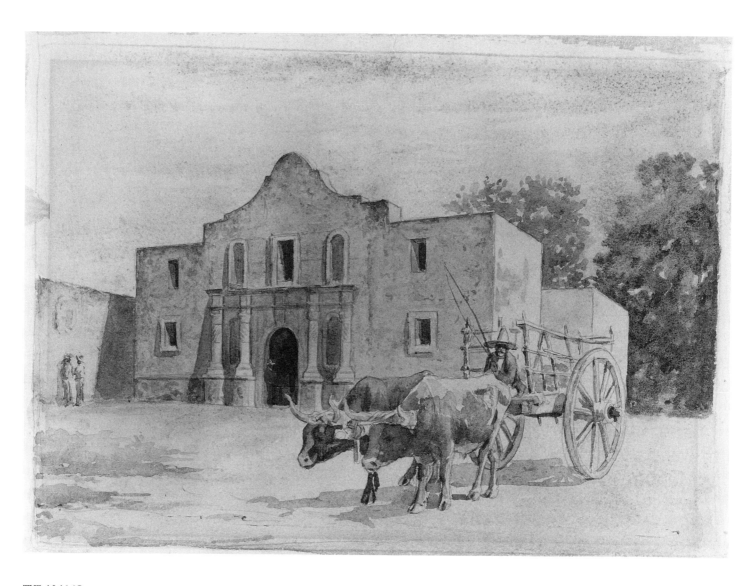

THE ALAMO
n.d., watercolor on watercolor board, 7¼″ × 10¼″
Unsigned (attributed)

Robert Onderdonk's watercolor of the Alamo seems to be based on two photographs as well as on his own familiarity with the subject. The photograph he used for the oxcart was found among his possessions and was placed in the Association's Historical Photographic Archives by Eleanor Onderdonk. It was the same image that Theodore Gentilz used for his *Ox Cart Returning from Town*.

PROVENANCE:
-1967: Collection of Frances Lee Talbot.
1967: Purchased by SAMA from Frances Lee Talbot with Witte Picture Funds.
67–161 P (1)

EXHIBITIONS:
1975: The Onderdonks: A Family of Texas Painters, WMM (January 16 to July 31).
1975: The Onderdonks: A Family of Texas Painters, Sarah Campbell Blaffer Gallery, University of Houston (August 30 to November 15).
1983: Images of Texas, Archer M. Huntington Art Gallery, College of Fine Arts, University of Texas at Austin (February 25 to April 10).
1983: Images of Texas, Traveling Exhibition: Art Museum of South Texas, Corpus Christi (July 1 to August 14). Amarillo Art Center (September 3 to October 30).
1986: Remembering the Alamo: The Development of a Texas Symbol, 1836–1986, WMM (February 23 to October 31).

PUBLICATIONS:
Utterback, *Early Texas Art* (1968), 57.
Steinfeldt, *The Onderdonks* (1976), 53, 209.
Goetzmann and Reese, *Texas Images and Visions* (1983), 69.
Susan Mayer, Arthur Mayer, and Becky Duval Reese, *Texas* (1983), [9].
Becky Duval Reese, "Images of Texas: Myth and Reality Through Art," *The Texas Humanist*, 5 (July/August 1983): 11.

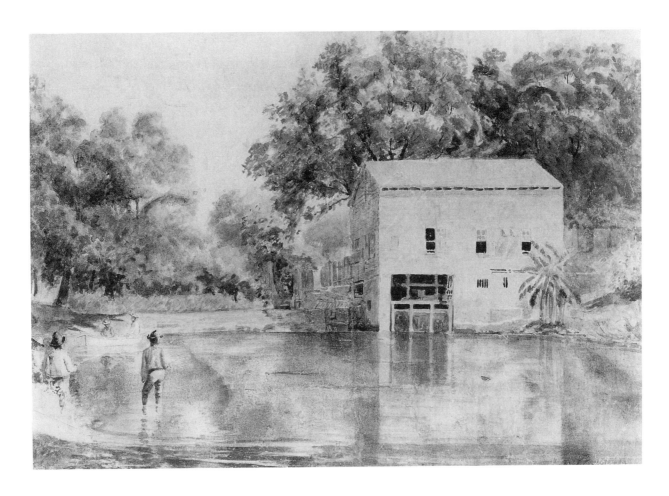

Guenther's Upper Mill, built in 1868 on the San Antonio River at Washington and Beauregard streets. Photograph from the Slide Collection of Albert Steves, Sr., gift of Albert Steves IV.

GUENTHER'S MILL, SAN ANTONIO RIVER
n.d., watercolor on paper, 10⅛" × 14¹⁄₁₆"
Signed lower right: R. J. Onderdonk

Robert Onderdonk's version of this mill, situated on the San Antonio River at Washington and Beauregard streets, suggests the breadth and power of the river at the time. The mill was built in 1868 by Carl Hilmar Guenther, who had come to this country from Germany in 1848. He first traveled through the Midwest, finally settling in Fredericksburg, Texas, where he built his first mill on Live Oak Creek. In 1855, he married seventeen-year-old Dorothea Pape. After a prolonged drought in the area, the Guenthers moved to San Antonio in 1859. The mill that Onderdonk painted used a water turbine for power. With its stone dam and cascading, foaming water, it became a favorite subject for local artists.[32]

PROVENANCE:
-1971: Abacus Antiques, SA.
1971: Purchased by SAMA from Abacus Antiques with Witte Picture Fund.
71–272 P

EXHIBITIONS:
1975: The Onderdonks: A Family of Texas Painters, WMM (January 16 to July 31).
1975: The Onderdonks: A Family of Texas Painters, Sarah Campbell Blaffer Gallery, University of Houston (August 30 to November 15).
1983: Images of Texas, Archer M. Huntington Art Gallery, College of Fine Arts, University of Texas at Austin (February 25 to April 10).
1983: Images of Texas, Traveling Exhibition: Art Museum of South Texas, Corpus Christi (July 1 to August 14). Amarillo Art Center (September 3 to October 30).
1988: The Art and Craft of Early Texas, WMM (April 30 to December 1).

PUBLICATIONS:
Glenn Tucker, "The Onderdonks," San Antonio Light, January 12, 1975.
Steinfeldt, The Onderdonks (1976), 51.
Noonan-Guerra, The Story of the San Antonio River (1978), 20.
Goetzmann and Reese, Texas Images and Visions (1983), 68.

32. [Ernst Schuchard (ed.)], 100th Anniversary, Pioneer Flour Mills, San Antonio, Texas: 1851–1951 (San Antonio: The Naylor Company, 1951), 1–8.

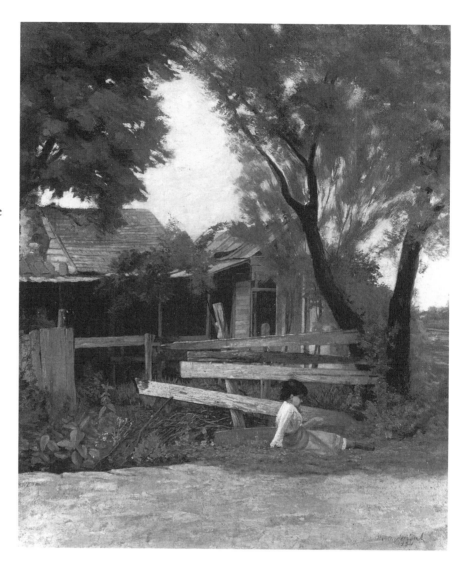

HOUSE AND FIGURE
1884, oil on canvas mounted on panel, 22″ × 18½″
Signed and dated lower right: R. J. Onderdonk/1884

Robert Onderdonk's dexterity with a brush, his feeling for texture and color, and his sense of orderly composition are all apparent in this unpretentious painting. Of all the artists with whom Robert studied, the influence of William Merritt Chase seems most evident in this work. When Robert first came to San Antonio he indulged himself in painting genre scenes in and around the city, and many of these small views are among his most important works.[33] When he painted *House and Figure* he found charm and beauty in a dilapidated hut and a wooden fence overgrown with lush foliage. The figure of the small girl, casually seated in the grass, accents the quiet atmosphere of the abandoned buildings.

PROVENANCE:
1884–ca. 1960: Collection of the Gould-Onderdonk Family.
ca. 1960–1966: Collection of Robert K. Winn.
1966: Gift to SAMA by Robert K. Winn.
66–86 G

EXHIBITIONS:
1975: The Onderdonks: A Family of Texas Painters, WMM (January 16 to July 31).
1975: The Onderdonks: A Family of Texas Painters, Sarah Campbell Blaffer Gallery, University of Houston (August 30 to November 15).
1983: Painting in the South: 1564–1980, Virginia Museum of Fine Arts, Richmond (September 14 to November 27).
1984–1985: Painting in the South: 1564–1980, Traveling Exhibition: Birmingham Museum of Art, Alabama (January 8 to March 4, 1984). National Academy of Design, New York, New York (April 12 to May 27, 1984). Mississippi Museum of Art, Jackson (June 24 to August 26, 1984). J. B. Speed Art Museum, Louisville, Kentucky (September 16 to November 11, 1984). New Orleans Museum of Art, Louisiana (December 9, 1984, to February 3, 1985).
1986: Texas Seen/Texas Made, SAMOA (September 29 to November 30).
1987: Gallery of American Paintings, SAMOA (January 6 to December 31).
1990: Art and Life in Texas in the 1890s, University Art Gallery, University of North Texas, Denton (April 2 to 27).

PUBLICATIONS:
Utterback, *Early Texas Art* (1968), 55.
Schwartz, "Early Texas Art Depicts Era's Action," *Antique Monthly*, 8 (November 1974): 8A.
Delma Guerrero, "Around Town: Special Events," *San Antonio Scene* (January 1975).
"Society to give annual awards in conservation," San Antonio *Express-News*, March 2, 1975.
"Conservation Society Makes Awards," *The Herald* (SA), March 5, 1975.
SAMA *Annual Report, 1974–1975*, 2.
Steinfeldt, *The Onderdonks* (1976), 56.
"Texas Art Void Filled," San Antonio *Light*, March 28, 1976.
Jessie J. Poesch, "Growth and Development of the Old South: 1830 to 1900," in *Painting in the South: 1564–1980* (1983), 263.
J. Gray Sweeney, "The Onderdonks: Robert and Julian," *Southwest Art*, 18 (April 1989): 46.

33. Jessie J. Poesch, "Growth and Development of the Old South: 1830 to 1900," in *Painting in the South: 1564–1980* (Richmond: Virginia Museum of Fine Arts, 1983), 96.

BEACON HILL
1902, oil on academy board, 5½″ × 9¼″
Unsigned (attributed)

Robert Onderdonk executed this oil in such a
free-flowing style that it has the capricious
quality of a watercolor. It may have been
a study sketch for a larger painting, but
the unusual technique suggests it was an
experimental effort by the artist. Even
though he was an accomplished artist,
Onderdonk was also a perennial student and
not averse to testing new painting methods.

PROVENANCE:
-1973: Collection of Gilbert M. Denman, Jr.
1973: Gift to SAMA by Gilbert M. Denman, Jr.
73–69 G (1)

EXHIBITIONS:
1964: The Early Scene: San Antonio, WMM (June 7 to
August 31). Lent by Gilbert M. Denman, Jr.
1975: The Onderdonks: A Family of Texas Painters,
WMM (January 16 to July 31).
1986: Texas Seen/Texas Made, SAMOA (September 29
to November 30).
1990: Looking at the Land: Early Texas Painters,
San Angelo Museum of Fine Arts (February 22 to
March 25).

PUBLICATIONS:
SAMA Annual Report, 1974–1975, 2.
"Conservation Society Makes Awards," The Herald
(SA), March 5, 1975.
Steinfeldt, The Onderdonks (1976), 81.

TWILIGHT, EAST ASHBY PLACE
1903, oil on academy board, 5½″ × 9¼″
Signed lower left: R. J. Onderdonk

The few deft strokes and broad washes that
the artist used in this small canvas evoke a
sense of time and space that seldom occurs in
Robert's more carefully rendered canvases.
Although there is a span of a year between
this work and Beacon Hill, these two views
make interesting companion pieces as they
are so atypical of the artist's usual style.

PROVENANCE:
-1973: Collection of Gilbert M. Denman, Jr.
1973: Gift to SAMA by Gilbert M. Denman, Jr.
73–69 G (2)

EXHIBITIONS:
1964: The Early Scene: San Antonio, WMM (June 7 to
August 31). Lent by Gilbert M. Denman, Jr.
1975: The Onderdonks: A Family of Texas Painters,
WMM (January 16 to July 31).
1986: Texas Seen/Texas Made, SAMOA (September 29
to November 30).

PUBLICATIONS:
"Conservation Society Makes Awards," The Herald
(SA), March 5, 1975.
SAMA Annual Report, 1974–1975, 2.
Steinfeldt, The Onderdonks (1976), 81.

ENGLISH COUNTRY HOUSE
n.d., Opaque and transparent watercolor on paper,
9″ × 15″
Signed on reverse: R. J. Onderdonk

This painting of Francis Smith's home in
England, which Onderdonk presumably did
from a photograph as a sentimental reminder
of Smith's earlier home, is a well-rendered,
almost architectural view of the residence
and clearly defines the artist's ability at linear
perspective. When Smith moved to San
Antonio, he built a similar house which still
stands at 155 Bushnell.[34]

PROVENANCE:
-1980: Collection of Walter Nold Mathis.
1980: Gift to SAMA by Walter Nold Mathis in honor
of Nancy Brown Negley.
80–146 G (2)

EXHIBITIONS:
1982: A Birthday Celebration: Recent Gifts and
Acquisitions, SAMOA (March 1 to May 16).
1986: Texas Seen/Texas Made, SAMOA (September 29
to November 30).

VILLA DE GUADALUPE, POCITO CHAPEL
1911, oil on canvas, 20″ × 16″
Signed lower right: R. J. Onderdonk

In July 1911 Robert and Emily Onderdonk
journeyed to Mexico to visit their son,
Latrobe, who was in business there. Robert
made numerous sketches and paintings in the
country and seemed particularly impressed
with the church at Guadalupe.[35] He
appreciated the story of Guadalupe's
appearance to a young peasant boy, Juan
Diego, and, as evidence, her imprinting her
image on his *tilma* or cloak.[36] Robert wrote
on the back of a postal card of the site: "The
little chapel was erected to the holy peon
who saw the vision of the Virgin which was
reproduced on his *zerapa* [*sic*]. . . . No painter
or scientist has even yet been able to say how
it was done. . . . This wonderful picture . . . is
now framed and placed high up on the altar
of the Cathedral. This Cathedral, to the poor
Mexicans is the most holy of holies. . . ."[37]
Robert's view looks down the steps toward
the rear of the building.

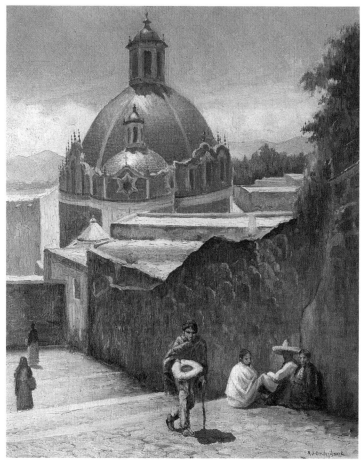

PROVENANCE:
-1974: Collection of Claire Irvin Hasdorf.
1974: Gift to SAMA by the Estate of Claire Irvin
Hasdorf.
74–195 G

EXHIBITIONS:
1928: Onderdonk Memorial Exhibition, WMM
(January 17 to 31). Lent by Miss Tommie Irvin.
Entitled *Steps to Guadalupe.*
1975: The Onderdonks: A Family of Texas Painters,
WMM (January 16 to July 31).

PUBLICATIONS:
"Onderdonk Memorial Collection on View at Witte
Museum," San Antonio *Express*, January 29, 1928.
Steinfeldt, *The Onderdonks* (1976), 88.
Publications of the San Antonio Museum Association (1978): [3].

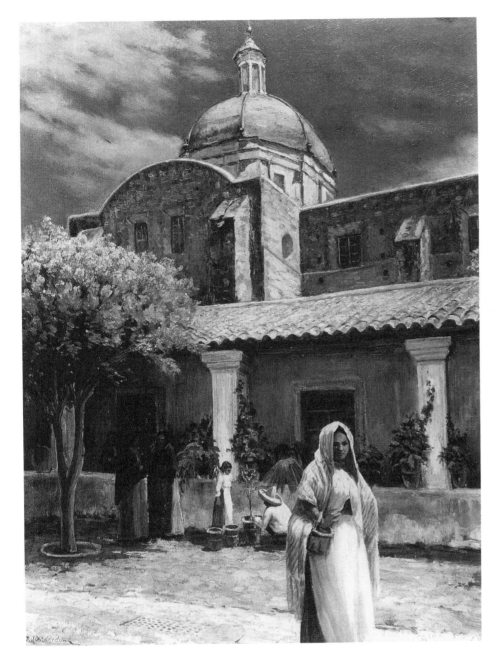

CATHOLIC SISTERS' HOME IN MEXICO
1911, oil on canvas mounted on panel, 24″ × 18″
Signed lower left: R. J. Onderdonk
Titled on reverse of frame: Catholic Sisters' Home
in Mexico

When in Mexico the Onderdonks made
Mexico City their headquarters, but visited
Guadalupe, Cuernavaca, Toluca, and
Xochimilco.[38] Robert took full advantage of
the beautiful country, colorful natives, and
captivating atmosphere. Just exactly where in
Mexico this canvas was painted is not known,
but the artist captured the essence of the lush
foliage with its radiant flowers, the bright red
tile of the roof, and the brilliant indigenous
garb. The experience of using riotous color
must have been a diversion for Robert, and
his Mexican canvases sparkle with light
and vitality.

PROVENANCE:
-1970: Collection of Albert E. Kuehnert.
1970: Gift to SAMA by Albert E. Kuehnert.
70–194 G

EXHIBITIONS:
1975: The Onderdonks: A Family of Texas Painters,
WMM (January 16 to July 31).
1984: The Texas Collection, SAMOA (April 13 to
August 26).

PUBLICATIONS:
Steinfeldt, The Onderdonks (1976), 87.
Les Krantz, The Texas Art Review (1982), 26.

34. Information supplied by the donor, SAMA
 Registrar's Records.
35. Steinfeldt, The Onderdonks, 29.
36. Frances Toor, A Treasury of Mexican Folkways (New
 York: Crown Publishers, 1947; 11th printing, 1967),
 172–178.
37. Notations on back of a postcard of Pocito
 Chapel, signed R. J. O., dated July 1911. R. J.
 Onderdonk file, SAMA Texas Artists Records.
38. Diary of Emily Gould Onderdonk, 1911. Gould-
 Onderdonk papers. Private collection.

PORTRAIT OF THEODOSIA LANE
ca. 1900, oil on canvas, 40″ × 30″
Signed lower right: R. J. Onderdonk

Theodosia Alton Lane, the subject of this portrait, was the daughter of Col. E. Richard Lane and Mary Bartlett (Millett) Lane.[39] By 1895, the Lanes were neighbors of the Onderdonks, residing at 115 West French Place, which no doubt was a factor in their choice of Onderdonk to paint Theodosia's portrait.[40] It successfully conveys the filmy textures of the young lady's dress and her soft skin and silky hair. Robert often used a rose as an accent in his portraits of young women, and in this instance the flower repeats the pink tones in her features. Unfortunately, Theodosia Lane died just months after her portrait was completed.[41]

PROVENANCE:
-1969: Collection of Edward Harllee.
1969: Gift to SAMA by Edward Harllee.
69-4 G

EXHIBITIONS:
1975: The Onderdonks: A Family of Texas Painters, WMM (January 16 to July 31).
1975: The Onderdonks: A Family of Texas Painters, Sarah Campbell Blaffer Gallery, University of Houston (August 30 to November 15).
1986: Texas Seen/Texas Made, SAMOA (September 29 to November 30).
1989–1990: Special Christmas Exhibition, WMM (December 7, 1989, to April 1, 1990).
1990: Art and Life in Texas in the 1890s, University Art Gallery, University of North Texas, Denton (April 2 to 27).

PUBLICATIONS:
Steinfeldt, *The Onderdonks* (1976), 74.
Rosson, "More than Bluebonnets," in *Sentinel* (December 1984): 26.

NUDE
ca. 1906, oil on canvas, 29″ × 39″
Signed lower left: R. J. Onderdonk

There are no other nudes on record known to have been painted by Robert Onderdonk, although he had occasionally done scantily-clad nymphs or discreetly-draped damsels as illustrations or commissions. This canvas was done on consignment for Mrs. Henry Davies Thomson of San Antonio and was copied from a photograph of a similar painting. Although an unusual subject for Robert Onderdonk, it must have revived memories of his Art Students League days, when classes were offered "for the study of the nude and draped model."[42]

PROVENANCE:
ca. 1906–1955: Collection of the Thomson-Barrow Family.
1955: Gift to Robert K. Winn by Mrs. Leonidas Theodore Barrow, Mrs. Thomson's daughter.
1955–1979: Collection of Robert K. Winn.
1979: Gift to SAMA by Ethel D. Winn in memory of her son, Robert K. Winn.
79-147 G

EXHIBITIONS:
1975: The Onderdonks: A Family of Texas Painters, WMM (January 16 to July 31). Lent by Robert K. Winn.
1982: A Birthday Celebration: Recent Gifts and Acquisitions, SAMOA (March 1 to May 16).
1989–1990: Special Christmas Exhibition, WMM (December 7, 1989, to April 1, 1990).

PUBLICATIONS:
Steinfeldt, *The Onderdonks* (1976), 83.

PORTRAIT OF RUTH LIPSCOMB
ca. 1913, oil on canvas, 48″ × 38″
Signed lower left: R. J. Onderdonk
Inscribed on reverse: R. J. Onderdonk, 128 W. French

Many of Robert Onderdonk's portraits are life-size, demonstrating his complete confidence in his ability as a draftsman. His portrait of Ruth Lipscomb is one of his most successful. That she was a particularly beautiful woman is evident in his interpretation of her quiet dignity, serene bearing, and lovely features. Again, the artist uses brilliant red roses to accent the pale golden tones of her dress and shawl and to repeat the warm glowing tones of her features.

Ruth Lipscomb was the daughter of Willoughby W. Lipscomb, a prominent San Antonio financier, and his second wife Jessie O. (Walker) Lipscomb.[43] Ruth Lipscomb, one of four children born to the couple, became Mrs. Rayford W. Alley.[44]

PROVENANCE:
ca. 1913–1977: Collection of the Lipscomb Family.
1977: Gift to SAMA by Louis W. Lipscomb, brother of Ruth Lipscomb.
77–9 G

EXHIBITIONS:
1986: Texas Seen/Texas Made, SAMOA (September 29 to November 30).
1990: Art and Life in Texas in the 1890s, University Art Gallery, University of North Texas, Denton (April 2 to 27).

PUBLICATIONS:
SAMA *Calendar of Events* (September 1986): [1].
"Exhibit honoring Texas artists opens Sunday," *North San Antonio Times*, September 25, 1986.

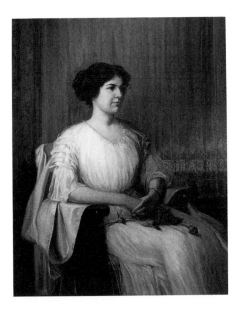

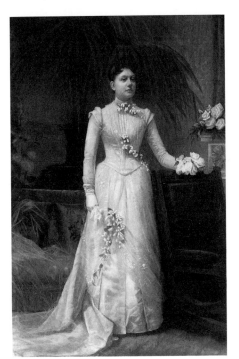

39. Davis and Grobe (eds. and comps.), *The New Encyclopedia of Texas*, s.v. "Colonel E. Richard Lane," 1537.
40. *San Antonio City Directory, 1895–1896*, s.v. "Lane, Ellsberry R."
41. Edward Harllee to Robert K. Winn (SA), February 19, 1969.
42. "The Art Students League, Part I."
43. Davis and Grobe (eds. and comps.), *The New Encyclopedia of Texas*, s.v. "Willoughby W. Lipscomb," 1766.
44. Fenwick, *Who's Who Among the Women of San Antonio and Southwest Texas*, s.v. "Lipscomb, Jessie O."
45. Jerry Bywaters, "Exhibition Honors Artist of 50 Years," *Dallas News*, November 20, 1938.
46. Steinfeldt, *The Onderdonks*, 22. When the book was published, the Robertson heirs recognized the description of the large pastel of their grandmother and made the wise decision to present the painting to SAMA.

PORTRAIT OF
EDNA GEILS SIMPSON ROBERTSON
1890, Pastel on paper mounted on canvas, 72″ × 48″
Signed and dated lower right: Hulbert, '90

When Robert Onderdonk was in Dallas from 1889 to 1895, he worked for a while at the Hulbert Portrait Company, a firm that specialized in family portraiture and employed a number of artists whose works always were signed by Hulbert himself.[45] The portrait of Edna Robertson bears the signature "Hulbert" but was done by Robert Onderdonk, who wrote his wife, "I would like you to see the pastel I am making now for Hulbert. It is a full figure of a bride—I have the dress to work from—I have made a fine thing of it. The bride is not very pretty, but the dress is—white silk draped with tulle. The background is the drawing room decorated for the occasion. It is a show picture altogether."[46]

The pastel indeed is a masterly work in a difficult medium, especially because of its size. It contains characteristics of many of Robert Onderdonk's other works: a dignified handling of the subject, handsome treatment of textures and background, excellent drawing, and the inevitable roses in the bride's hand and in the background. It hung in the Robertsons' Dallas home until given to the Association.

PROVENANCE:
1890–1982: Collection of the Robertson Family.
1982: Gift to SAMA by Elizabeth Harrison Campbell and Harriett Harrison Campbell Clarke in memory of their grandmother, Edna Geils Simpson Robertson, and her three daughters: Edna Geils Robertson Harrison, Harriett Robertson Chancellor, and Martha Fairfax Robertson.
82–112 G

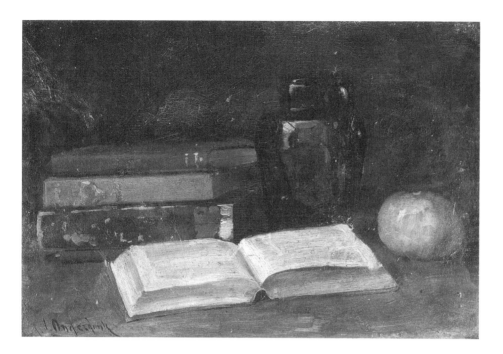

STILL LIFE WITH BOOKS
n.d., oil on canvas mounted on panel, 12″ × 18″
Signed lower left: R. J. Onderdonk

Robert Onderdonk approached the problems
of painting a still life with confidence and
assurance. In *Still Life with Books*, his brushstrokes
are positive and direct and his colors rich and
strong. It has the quality of a painting done
by William Merritt Chase and probably
was done as an exercise for the artist's own
pleasure rather than a commissioned piece. Its
robust and virile character make it stand
out among any group of paintings in an
exhibition.

PROVENANCE:
-1974: Collection of Mr. and Mrs. Liston Zander.
1974: Gift to SAMA by Mr. and Mrs. Liston Zander.
74–213 G

EXHIBITIONS:
1975: The Onderdonks: A Family of Texas Painters,
WMM (January 16 to July 31).
1975: The Onderdonks: A Family of Texas Painters,
Sarah Campbell Blaffer Gallery, University of Houston
(August 30 to November 15).
1986–1988: Capitol Historical Art Loan Program, State
Capitol, Austin (January 30, 1986, to December 19,
1988).
1990: Art and Life in Texas in the 1890s, University Art
Gallery, University of North Texas, Denton (April 2
to 27).

PUBLICATIONS:
Steinfeldt, *The Onderdonks* (1976), 63.

PORTRAIT OF MARJORIE McGOWN
n.d., oil on canvas, 19½″ × 15¼″
Unsigned (attributed)

Marjorie McGown was the daughter of Mr.
and Mrs. Floyd McGown of San Antonio.
Marjorie's father was a distinguished and
influential lawyer with the firm of Denman,
Franklin, and McGown.[47] Like many
prominent people in San Antonio, the
McGowns chose Robert Onderdonk to paint
their daughter's portrait. She was a lovely
child with red-gold hair and piercing blue
eyes, and Robert caught her expression of
mischievous innocence with his facile brush.
Her low-necked white dress with its wide
Bertha collar served to accent the soft flesh
tones and the gleaming tints in her hair.

PROVENANCE:
-1978: Collection of the McGown Family.
1978: Gift to SAMA by Mr. and Mrs. Joseph H.
Sharpley. Mrs. Sharpley is the niece of Marjorie
McGown.
78–768 G

47. Charles G. Norton (ed.), *Men of Affairs of San
Antonio* (San Antonio: San Antonio Newspaper
Artists' Association, 1912), s.v. "Floyd McGown,"
[182].
48. Floy Fontaine Jordan to author (SA), interview,
November 19, 1987.
49. "Gov. Houston's Picture," *The Weekly Alamo
Express*, April 11, 1861. Special advertisements in

the newspapers stated that these homeographic
images were "chemically multiplied" by William
DeRyee and were for sale at Messrs. Pentenrieder
and Blersch and at Iwonski's residence for fifty
cents per copy. How Robert Onderdonk acquired
his copy is a matter of conjecture as it was many
years after they were sold that one came into his
possession.

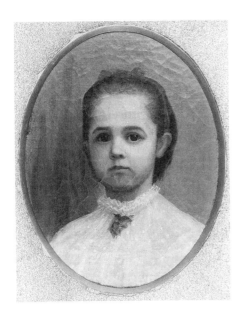

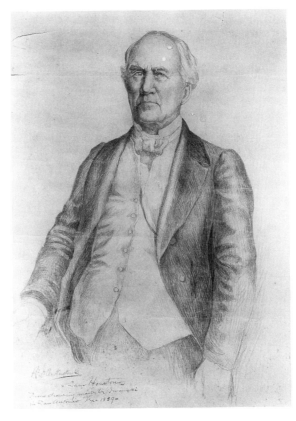

PORTRAIT OF NELLIE EDWARDS
ca. 1880, oil on canvas, 12″ × 9″
Unsigned
Inscribed on reverse: Artist—Robert
Onderdonk—San Antonio, Tx. Painted about 1880.
Model (from tin-type). Nellie Edwards—b. 1853.
d. 5 yr. old.

Nellie Edwards, the sister of Frank Mudge
Edwards (1855–1956), was born in 1853 but
died at the age of five in 1857. Fortunately
the family had a tintype made of her which
Robert Onderdonk used for his sensitive and
delicate portrait.[48] He made the ribbon in
Nellie's hair a soft red, a color he repeated
in the dainty roses at her throat. The frilly
white dress and the touches of rosy color
enhanced the beauty of her soft dark eyes. If
the attributed date of 1880 is fairly accurate,
this is one of the first portraits Robert
painted in Texas.

PROVENANCE:
ca. 1880–1915: Collection of Susan Mudge Edwards
Kearney, grandmother of Floy Fontaine Jordan.
1915–1971: Collection of Floy Edwards Fontaine,
daughter of Susan Mudge Edwards Kearney.
1971–1986: Collection of Floy Fontaine Jordan,
daughter of Floy Edwards Fontaine.
1986: Gift to SAMA by Floy Fontaine Jordan.
86–92 G (1)

EXHIBITIONS:
1986: Texas Seen/Texas Made, SAMOA (September 29
to November 30).
1990: Art and Life in Texas in the 1890s, University Art
Gallery, University of North Texas, Denton (April 2
to 27).

SAM HOUSTON
n.d., pencil on paper, 15¾″ × 11¼″
Signed, titled, and inscribed lower left: R. J.
Onderdonk/Sam Houston/From drawing made by
Iwonski/in San Antonio, Tex. 1859

Robert Onderdonk credited Carl G. von
Iwonski with the original sketch of Sam
Houston from which this drawing was made.
Presumably Onderdonk used one of Iwonski's
homeographic reproductions, one of which
was found among his papers. Issued in 1861,
Iwonski's homeographs of Houston were
advertised in the local newspapers:

> We have been shown a picture of Gen. Sam
> Houston taken from life, during his late speech at
> Austin by Mr. Charles [sic] G. Iwonski of this city
> which we consider the best picture of the old
> hero that we have seen. Taken as it is during the
> most eventful if not the most trying epoch of his
> life, it has unusual interest. The cheapness at which
> this picture is offered places it within the reach
> of all.[49]

PROVENANCE:
ca. 1897–1938: Collection of the Gould-Onderdonk
Family.
1938: Gift to SAMA by Eleanor Onderdonk.
38–138 G (76)

Homeograph of Sam Houston by Carl G. von Iwonski.
Gift to SAMA by Ofelia Onderdonk.

EXHIBITIONS:
1964: The Early Scene: San Antonio, WMM (June 7 to
August 31).
1975: The Onderdonks: A Family of Texas Painters,
WMM (January 16 to July 31).
1979: The American Image: 1875–1978, Center for the
Arts, Corpus Christi State University (March 29 to
April 12).

PUBLICATIONS:
Utterback, Early Texas Art (1968), 53.
"Onderdonk Art on Display," San Antonio Light,
August 3, 1975.
Steinfeldt, The Onderdonks (1976), 82.
Pearson et. al., Texas: The Land and Its People (2nd ed.,
1978), 284.

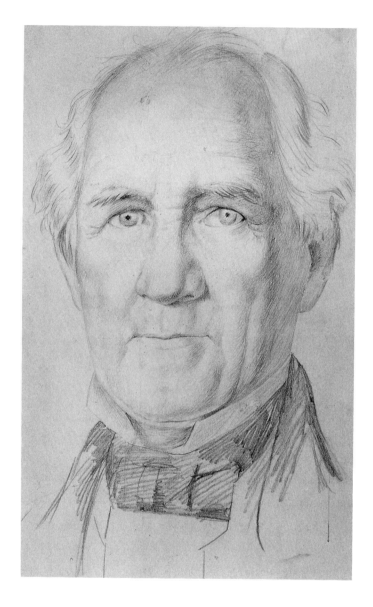

PORTRAIT OF SAM HOUSTON
n.d., pencil on paper, 14¼″ × 9¼″
Unsigned

Another of Robert Onderdonk's drawings of Sam Houston shows him with a remarkably penetrating gaze and austere features. Robert's source for this sketch is unknown, but it must have been a photograph, or possibly a print or reproduction. The artist is presumed to have done these drawings as studies for his heroic painting *The Surrender of Santa Anna*. That painting unfortunately was destroyed in a fire, but a reproduction of it appears in *Combats and Conquests of Immortal Heroes*, by Charles Merritt Barnes.[50] Although Houston faces in the opposite direction in the painting, this sketch no doubt helped Robert capture Houston's character and likeness.

PROVENANCE:
ca. 1897–1967: Collection of the Gould-Onderdonk Family.
1967: Gift to SAMA by Ofelia Onderdonk.
67–164 G (6h)

EXHIBITIONS:
1986: Texas Seen/Texas Made, SAMOA (September 29 to November 30).

50. Steinfeldt, *The Onderdonks*, 28; Barnes, *Combats and Conquests*, 60.
51. Steinfeldt, *The Onderdonks*, 27.
52. Barnes, *Combats and Conquests*, 188.

SKETCH OF DAVY CROCKETT
(for THE FALL OF THE ALAMO)
ca. 1902, pencil on toned paper, 9½″ × 17″
Unsigned

When Robert Onderdonk started work on his historic painting *The Fall of the Alamo*, he made numerous sketches and photographs of men in action which he incorporated into his final version. Everyone in the Onderdonk household became involved, and the story of how they and all their friends were pressed into service as models is one of the family legends.[51] Charles Merritt Barnes credits Frank Mudge Edwards with serving as the model for Davy Crockett.[52] It is a powerful drawing and has more feeling of action and movement than the image in the actual painting, which was completed in 1903.

PROVENANCE:
ca. 1902–1967: Collection of the Gould-Onderdonk Family.
1967: Gift to SAMA by Ofelia Onderdonk.
67–164 G (6k)

EXHIBITIONS:
1975: The Onderdonks: A Family of Texas Painters, WMM (January 16 to July 31).
1975: The Onderdonks: A Family of Texas Painters, Sarah Campbell Blaffer Gallery, University of Houston (August 30 to November 15).

PUBLICATIONS:
Steinfeldt, *The Onderdonks* (1976), 81.

WORKS BY ROBERT JENKINS ONDERDONK
NOT ILLUSTRATED:

THE SEAMSTRESS
ca. 1878, pencil and white chalk on paper,
11⅛″ × 7¼″
Unsigned
79–143 G (1)
Gift to SAMA by Lois Wood Burkhalter.

THE OLD MAN
n.d., pencil and white chalk on toned paper,
10¼″ × 9⅛″
Unsigned
79–143 G (2)
Gift to SAMA by Lois Wood Burkhalter.

LETTER HOME
n.d., pencil and opaque white watercolor on
toned paper, 11″ × 9½″
Unsigned
79–143 G (3)
Gift to SAMA by Lois Wood Burkhalter.

PORTRAIT OF ORAN KIRKPATRICK
n.d., oil on canvas, 30″ × 25″
Signed lower right: R. J. Onderdonk
74–210 G
Gift to SAMA by Mrs. Oran Kirkpatrick.

LADY SPINNING
n.d., oil on canvas, 12½″ × 7¼″
Unsigned
67–164 G (6d)
Gift to SAMA by Ofelia Onderdonk.

LADY WITH TAMBOURINE
n.d., oil on canvas, 12¾″ × 6″
Unsigned
67–164 G (6e)
Gift to SAMA by Ofelia Onderdonk.

WOMEN IN FIELD
n.d., oil on canvas, 7½″ × 11¼″
Unsigned
67–164 G (6f)
Gift to SAMA by Ofelia Onderdonk.

HORN CHAIR
n.d., pen and ink on paper, 7¼″ × 5¼″
Unsigned
67–164 G (6g)
Gift to SAMA by Ofelia Onderdonk.

MISSION CONCEPCIÓN
n.d., pencil on paper, 2½″ × 6″
Unsigned
67–164 G (6i1)
Gift to SAMA by Ofelia Onderdonk.

SAN JOSÉ MISSION
n.d., pencil on paper, 3⅛″ × 5⅛″
Unsigned
67–164 G (6i2)
Gift to SAMA by Ofelia Onderdonk.

MISSION CONCEPCIÓN
n.d., pen and ink on paper, 6¼″ × 10″
Unsigned
67–164 G (6j)
Gift to SAMA by Ofelia Onderdonk.

DEAD SOLDIER (for THE FALL OF THE ALAMO)
ca. 1901, pencil on paper, 7¼″ × 10⅛″
Unsigned
67–164 G (6l)
Gift to SAMA by Ofelia Onderdonk.

CRAZY PHILIP
1897, pencil and ink on paper, 7⅝″ × 6⅝″
Initialed, titled, and dated lower left: R. J. O./Crazy
Philip/San Antonio, Tex./1897
67–164 G (6m)
Gift to SAMA by Ofelia Onderdonk.

THE GONDOLA
n.d., pencil on lined paper, 10¼″ × 7¼″
Unsigned
Color notations overall
67–164 G (6n)
Gift to SAMA by Ofelia Onderdonk.

MRS. ROBERT ONDERDONK
1881 (recto), ink on paper, 9⅛″ × 7″
Initialed and dated lower left: R. J. O./1881
Identified by Eleanor Onderdonk on an
attached note.

MAN IN CHAIR
n.d. (verso), pencil on paper, 9⅛″ × 7″
Initialed and inscribed lower left: R. J. O./A. S. L./
N. Y.
67–164 G (6o)
Gift to SAMA by Ofelia Onderdonk.

LATROBE ONDERDONK
1878, pencil on paper, 8″ × 7″
Titled lower center: Latrobe Onderdonk
Initialed lower right: R. J. O.
Dated and inscribed lower left: Dec. 11, '78/Died 1883,
Age 11
Latrobe Onderdonk was Robert's half brother.
67–164 G (6p)
Gift to SAMA by Ofelia Onderdonk.

TWO HUNTERS
n.d., (Illustration) black-and-white print mounted on
cardboard, 7¼″ × 5¼″
Signed lower left on print: Onderdonk
Documented lower right: Univ. Press
67–164 G (6r)
Gift to SAMA by Ofelia Onderdonk.

MEXICAN GIRL ON A BURRO
n.d., ink and gray wash on paper, 3″ × 3¼″
Unsigned
67–164 G (13a)
Gift to SAMA by Ofelia Onderdonk.

MONKEY SHAVING
n.d., black, brown, and white opaque watercolor
on paper, 5″ × 4½″
Unsigned
67–164 G (13b)
Gift to SAMA by Ofelia Onderdonk.

MEXICAN SOLDIER (for THE FALL OF THE ALAMO)
ca. 1901, pencil on paper, 14″ × 7½″
Unsigned
67–164 G (15)
Gift to SAMA by Ofelia Onderdonk.

WOMAN WITH DOG AND OTHER SKETCHES
ca. 1880, pencil on paper, 14½″ × 11⅛″
Unsigned
Inscribed lower center: About 1880 (in Eleanor
Onderdonk's handwriting)
67–164 G (20)
Gift to SAMA by Ofelia Onderdonk.

SELF-PORTRAIT
n.d., black-and-white opaque watercolor on paper,
3″ × 3″
Unsigned
67–164 G (21)
Gift to SAMA by Ofelia Onderdonk.

MOTHER OF CHRIST
n.d., watercolor on paper, 12½″ × 15″
Signed and inscribed lower left: R. J. Onderdonk/
After August Roth's/Mother of Christ
Inscribed on reverse: This is a watercolor painted by
Robert Onderdonk, father of Julian Onderdonk.
Given to Josephine Spencer Tucker by Miss Mary
Johnston as a wedding present June 26, 1937. Has
value.
85–75 G
Gift to SAMA by Mrs. Robert E. Tucker.

LANDSCAPE WITH TREE
1886, pencil on toned paper, 8″ × 9⅛″
Initialed and dated lower left: R. J. O./April 25, 1886
79–146 G (5)
Gift to SAMA by Ethel D. Winn.

FORT WENTWORTH, STATEN ISLAND
1877, pencil on toned paper, 8⅛″ × 13¼″
Unsigned
Titled and dated lower left: Fort Wentworth/Staten
Island/Apr. 8, 1877
79–146 G (6)
Gift to SAMA by Ethel D. Winn.

SEATED WOMAN
n.d., pencil on toned paper, 7¼″ × 6⅛″
Unsigned
79–146 G (7)
Gift to SAMA by Ethel D. Winn.

THE YOUNG MAN
1878, pencil on toned paper, 11⅛″ × 8″
Initialed lower right: R. J. O.
Dated lower left: May 30th, 1878
79–146 G (8)
Gift to SAMA by Ethel D. Winn.

SEATED WOMAN LEANING FORWARD
n.d., pencil on toned paper, 7½″ × 6¼″
Unsigned
Inscribed lower left: March 18
79–146 G (9)
Gift to SAMA by Ethel D. Winn.

MAN GESTURING
n.d., pencil on paper, 8⅛″ × 6⅛″
Unsigned
Inscribed lower left: Mar. 27
79–146 G (10)
Gift to SAMA by Ethel D. Winn.

THE CASTLE
n.d., pencil and opaque white watercolor on
toned paper, 6½″ × 5½″
Initialed lower left: R. J. O.
79–146 G (11)
Gift to SAMA by Ethel D. Winn.

THE ROCK
1877, pencil and opaque white watercolor on
toned paper, 8″ × 8″
Unsigned
Partially dated lower left:—28/'77
79–146 G (12)
Gift to SAMA by Ethel D. Winn.

THE YOUNG LADY
n.d., pencil on paper, 5⅛″ × 4⅛″
Unsigned
79–146 G (13)
Gift to SAMA by Ethel D. Winn.

DALLAS, CEDAR CREEK
ca. 1890, watercolor on paper mounted on
mat board, 4″ × 6⅛″
Inscribed on reverse in Eleanor Onderdonk's
handwriting: Dallas, Cedar Creek, ca. 1890
79–146 G (14)
Gift to SAMA by Ethel D. Winn.

EASTER MOTIF
n.d., oil on paper, 6¼″ × 5″
Unsigned
79–146 G (15)
Gift to SAMA by Ethel D. Winn.

FEMALE FIGURE
n.d. (recto), pencil on paper, 6½″ × 4″
Unsigned

SEATED MAN
n.d. (verso), pencil on paper, 6½″ × 4″
Unsigned
79–146 G (16)
Gift to SAMA by Ethel D. Winn.

WOMAN IN COSTUME
ca. 1875, pencil and ink on paper, 6½″ × 4¼″
Signed and inscribed on reverse: Robert Jenkins
Onderdonk/Nat. Acad. of Design/N. Y./N. A. D.
79–146 G (17)
Gift to SAMA by Ethel D. Winn.

PELVIC BONE
n.d., ink on paper, 6″ × 4⅛″
Unsigned
79–146 G (18)
Gift to SAMA by Ethel D. Winn.

THIGH BONE
n.d., ink on paper, 6¼″ × 4⅛″
Unsigned
79–146 G (19)
Gift to SAMA by Ethel D. Winn.

THE ANCIENT MARINER
n.d., ink on toned paper, 6″ × 8″
Unsigned
Inscribed across bottom: By thy long grey beard and
glittering eye/It is an ancient mariner/Now where-
fore stopped thou me?/And he stopped one of three
79–146 G (20)
Gift to SAMA by Ethel D. Winn.

PORTRAIT OF A LADY
n.d., pencil on toned paper, 6½″ × 4″
Unsigned
79–146 G (21)
Gift to SAMA by Ethel D. Winn.

MISS SAYERS
n.d., pencil on paper, 5⅝″ × 4½″
Unsigned
Titled across bottom: Miss Sayers
79–146 G (22)
Gift to SAMA by Ethel D. Winn.

FIGURE SKETCHES
n.d. (recto), pencil on paper, 6½″ × 4″
Unsigned

SAM HARRISON
n.d. (verso), pencil on paper, 6½″ × 4″
Titled lower center: Sam Harrison
Unsigned
79–146 G (23)
Gift to SAMA by Ethel D. Winn.

YOUNG GIRL
n.d., pencil on paper, 7″ × 5″
Unsigned
79–146 G (24)
Gift to SAMA by Ethel D. Winn.

FORESHORTENED ARM, ANATOMY STUDY
ca. 1875, pencil on paper, 5¼″ × 7″
Signed across bottom three times: R. J. Onderdonk
Inscribed across bottom: Nat. Acad. of Design/Nat.
Acad. New York
79–146 G (25)
Gift to SAMA by Ethel D. Winn.

STUDY SKETCHES
ca. 1875, pencil on paper, 7½″ × 5″
Unsigned
79–146 G (26)
Gift to SAMA by Ethel D. Winn.

MISS ADAMS
1873, pencil on paper, 8¼″ × 6⅛″
Unsigned
Titled across bottom: Miss Adams
Dated lower left: Jan. 27, '73
79–146 G (27)
Gift to SAMA by Ethel D. Winn.

GIRL READING
n.d., pencil on paper, 9″ × 7″
Unsigned
79–146 G (28)
Gift to SAMA by Ethel D. Winn.

RECLINING FIGURE
ca. 1878, pencil and opaque white watercolor on
toned paper, 6¼″ × 8⅛″
Unsigned
79–146 G (29)
Gift to SAMA by Ethel D. Winn.

FIGURE OF A MAN
ca. 1878, pencil and opaque white watercolor on
toned paper, 8½″ × 5⅛″
Unsigned
79–146 G (30)
Gift to SAMA by Ethel D. Winn.

HOUSE AND TREES
ca. 1890, watercolor on paper, 5″ × 6″
Unsigned
79–146 G (32)
Gift to SAMA by Ethel D. Winn.

SKETCHES OF PEOPLE
n.d., pencil and ink on toned paper, 11″ × 7¼″
Unsigned
79–146 G (33)
Gift to SAMA by Ethel D. Winn.

GIRL IN COSTUME
n.d., pencil on toned paper, 10¼″ × 6¼″
Unsigned
79–146 G (34)
Gift to SAMA by Ethel D. Winn.

FEMALE FIGURE
ca. 1875, pencil and opaque white and yellow
watercolor on toned paper, 11½″ × 6⅛″
Unsigned
79–146 G (35)
Gift to SAMA by Ethel D. Winn.

LADY WITH BIRD
ca. 1880, pencil on toned paper, 12¼″ × 9½″
Signed and inscribed on reverse: Robt. J. Onderdonk/
San Antonio/Bexar Co./Texas
79–146 G (36)
Gift to SAMA by Ethel D. Winn.

THE SHED
ca. 1880, pencil on toned paper, 5″ × 7″
Unsigned
79–146 G (37)
Gift to SAMA by Ethel D. Winn.

LADY WITH HER HAND ON A CHAIR
n.d., pencil on paper, 5¼″ × 3½″
Unsigned
70–85 G (1)
Gift to SAMA by Robert K. Winn.

SEATED LADY
n.d., pencil on paper, 5″ × 3¼″
Unsigned
70–85 G (2)
Gift to SAMA by Robert K. Winn.

MAN WITH STICK
n.d., pencil on paper, 5⅛″ × 5″
Unsigned
70–85 G (3)
Gift to SAMA by Robert K. Winn.

FILLING HIS PIPE
n.d., pencil on paper, 5⅛″ × 3″
Unsigned
70–85 G (4)
Gift to SAMA by Robert K. Winn.

LADY IN PENSIVE POSITION
n.d., pencil on paper, 5⅛″ × 4⅛″
Unsigned
70–85 G (5)
Gift to SAMA by Robert K. Winn.

LADY WITH A BOOK
n.d., pencil on paper, 5″ × 3½″
Unsigned
70–85 G (6)
Gift to SAMA by Robert K. Winn.

MAN WITH GLASS
n.d., pencil on paper, 5⅛″ × 5″
Unsigned
70–85 G (7)
Gift to SAMA by Robert K. Winn.

MAN WITH SHOVEL
n.d., pencil on paper, 5⅛″ × 5″
Unsigned
Inscribed lower left: Feb. 25
70–85 G (8)
Gift to SAMA by Robert K. Winn.

HARD TIMES
1877, pencil on paper, 5¼″ × 3⅛″
Unsigned
Titled lower left: Hard Times
Dated lower right: 1877
70–85 G (9)
Gift to SAMA by Robert K. Winn.

HYDE
n.d., pencil on paper, 8¼″ × 6″
Unsigned
Titled lower center: Hyde
Inscribed lower left: Feb. 11
70–85 G (10)
Gift to SAMA by Robert K. Winn.

GIRL WITH FISHING TACKLE
n.d., pencil on paper, 6¼″ × 5¼″
Unsigned
70–85 G (11)
Gift to SAMA by Robert K. Winn.

LADY WITH BUSTLED DRESS AND HAT
n.d., pencil on paper, 8⅛″ × 6⅛″
Unsigned
70–85 G (12)
Gift to SAMA by Robert K. Winn.

LADY IN A DARK DRESS
n.d., pencil on paper, 8¼″ × 5½″
Unsigned
Inscribed lower left: Feb. 18
70–85 G (13)
Gift to SAMA by Robert K. Winn.

LADY LEANING AGAINST A TREE
n.d., pencil on paper, 8⅛″ × 6″
Unsigned
Inscribed lower left: Feb. 6
70–85 G (14)
Gift to SAMA by Robert K. Winn.

YOUNG LADY WITH A SHAWL
n.d., pencil on paper, 8″ × 6⅛″
Unsigned
70–85 G (15)
Gift to SAMA by Robert K. Winn.

LADY WITH AN UMBRELLA
n.d., pencil on paper, 8⅛″ × 6⅛″
Unsigned
70–85 G (16)
Gift to SAMA by Robert K. Winn.

LADY WITH LOWERED HEAD
n.d., pencil on paper, 8⅛″ × 6½″
Unsigned
70–85 G (17)
Gift to SAMA by Robert K. Winn.

MAN WITH SWAGGER STICK
n.d., pencil on paper, 7½″ × 5½″
Unsigned
70–85 G (18)
Gift to SAMA by Robert K. Winn.

MISS WEIDENMEYER
n.d., pencil on paper, 8⅛″ × 6½″
Unsigned
Titled lower center: Miss Weidenmeyer
Inscribed lower left: Feb. 2
70–85 G (19)
Gift to SAMA by Robert K. Winn.

YOUNG MAN WITH CANE
1877, pencil on paper, 7⅝″ × 5¼″
Unsigned
Dated lower left: Jan. 25/'77
70–85 G (20)
Gift to SAMA by Robert K. Winn.

MAKING TORTILLAS
ca. 1885, pencil and ink wash on paper, 11¼″ × 9″
Unsigned
Titled lower center: Making Tortillas
70–85 G (23)
Gift to SAMA by Robert K. Winn.

ROBERT JULIAN ONDERDONK

When Robert Julian Onderdonk died on October 27, 1922, at the age of forty, Texas lost one of its most productive and promising artists. At that time Julian Onderdonk already had achieved a degree of fame, and he was becoming renowned for his masterly interpretations of the Texas landscape. Had he lived longer he undoubtedly would have made a greater impact in the field of American landscape painting.

Julian was born into an artistically inclined family. His father Robert, a professional artist when he came to Texas from Maryland in 1879, married Emily Wesley Rogers Gould in 1881 in San Antonio, and the couple made Texas their permanent home.[1] The Onderdonks and the Goulds were distinguished families whose heritage included clergymen, statesmen, and educators, dating back to the seventeenth century.[2] Julian, the first child, was born to Emily and Robert on July 30, 1882. His sister Eleanor was born in 1884, and a brother, Latrobe, was born in 1886. The children were reared in a cultured atmosphere amid a devoted and close-knit family, which included Mr. and Mrs. Nathan Gould, Emily's parents.[3]

Julian Onderdonk at his easel, from a photograph by Ernst Raba. SAMA Historical Photographic Archives, gift of an anonymous donor.

Julian was a precocious, strong-willed child, full of energy. These traits, which he never lost, fostered his determination to become an artist. Although many accounts maintain that his father attempted to discourage his artistic career, family records indicate otherwise.[4]

Julian's father was his first art teacher, but by the time Julian was eighteen years old he was anxious to study in the eastern United States. A friend and neighbor, G. Bedell Moore, lent him money to go to New York. In 1901 Julian enrolled in the Art Students League (his father's alma mater), where his first instructor was Kenyon Cox.[5]

During the summer of 1901 Julian attended William Merritt Chase's classes in Shinnecock, Southhampton, Long Island.[6] This proved to be an auspicious decision, since the principles that Chase advocated suited Julian's energetic temperament. He wrote to his parents: "I am very glad you want me to go to the summer school for I was crazy to go for I feel I could do better there than in a blamed old cast room. . . . I long to get out in the open air with my palette in one hand and brush in the other and be able to smear paint over the whole landscape."[7]

Although he studied the work of many painters and also was a student of Frank Vincent DuMond (1865–1951) for a time, Julian's philosophy of painting was most influenced by Chase. Rockwell Kent (1882–1971), another Chase student, succinctly explained the teacher's approach to painting: "Chase was an exponent of the 'plein-air' school. He went to nature, stood before nature, and painted it as his eyes beheld it. And if he didn't kneel before nature, that, as a matter of religion, was his own concern. More interested in 'impressions' of the subject than in the deeper and more labored probing, the work of his students consisted of pictures painted swiftly at one sitting."[8] Julian went far beyond painting pictures "swiftly at one sitting," but he never lost the profound respect for nature that Chase had instilled in him.

Exhausting his funds after the summer at Shinnecock and the following winter term at the Art Students League, Julian started painting to support himself. After he married Gertrude Shipman in June 1902, his formal art education came to a virtual halt.[9] He did take a night course, however, conducted by Robert Henri.[10]

Julian's youth, exuberance, and physical stamina helped him work even harder when he and Gertrude became the parents of a daughter, Adrienne, on September

The Onderdonks, a family portrait taken in 1896, on the occasion of Stephen Gould's fiftieth birthday. Julian Onderdonk stands at the far left, his mother Emily in the center, and his father Robert at the right. Eleanor Onderdonk is seated at the left with uncle Stephen Gould in the center. Mrs. Nathan Gould, the grandmother, is next to Latrobe Onderdonk at the far right. SAMA Historical Photographic Archives, purchased from Mrs. Harry Tunstall.

1. "Thirty-four Years Ago Today—1881," San Antonio Express, April 28, 1915.
2. [Cecilia Steinfeldt], Julian Onderdonk: A Texas Tradition (Amarillo: Amarillo Art Center, 1985), 21.
3. Diaries of Emily Onderdonk, 1891–1903. Gould-Onderdonk papers. Private collection.
4. Steinfeldt, The Onderdonks, 91–93.
5. Forrester-O'Brien, Art and Artists, 169.
6. Ibid.
7. Julian Onderdonk (New York) to "Dear Everybody" (SA), April 16, 1901.
8. Ronald G. Pisano, The Students of William Merritt Chase (Huntington: Hecksher Museum, 1973), 5–6, 7 (quotation).
9. Steinfeldt, The Onderdonks, 96–97.
10. Julian Onderdonk (New York) to "Dear Everybody" (SA), October 27, 1902.
11. Diaries of Emily Onderdonk, 1891–1903.
12. Eleanor Onderdonk (New York) to Emily Onderdonk (SA), June 10, 1906.
13. Diary of Eleanor Onderdonk, 1909.
14. Ibid.
15. Ibid.
16. Albert Curtis, Fabulous San Antonio (San Antonio: The Naylor Company, 1955), 225–226.

13, 1903.[11] In 1906, however, Julian was offered a salaried position to assist in organizing art exhibitions for the Dallas State Fair, a function that his father had performed for many years.[12] This job brought him back to Texas occasionally, and in 1909 he decided to return to San Antonio permanently.[13] Julian was happy to be reunited with his family. His son, Robert Reid, was born on December 9, 1909.[14]

Upon his return Julian immediately began painting the Texas countryside. He and his father went on sketching jaunts together, and Julian, after so many years in New York, was back in his natural element.[15] He diligently applied the principles he had learned from Chase and painted directly from nature. Revealing his love for the Texas landscape, he wrote:

San Antonio offers an inexhaustible field for the artist. Nowhere else are the atmospheric effects more varied or more beautiful. One never tires of watching them. Nowhere else is there such a wealth of color. In the spring, when the wild flowers are in bloom, it is riotous: every tint, every hue, every shade is present in the most lavish profusion, and even in the dead of summer, when one would imagine that any canvas could only convey the impression of intense heat, the possibilities of the landscape are still beyond comprehension. One has only to see it properly to find that everything glows with a wonderful golden tint which is the delight and the despair of all who have ever tried to paint it.[16]

Julian's life became a routine of summers in New York assembling shows for the Dallas State Fair and the rest of the year painting in Texas. His work began to sell locally and as his reputation grew he also showed in galleries throughout the state and in other parts of the country.

Julian's sister Eleanor once stated:

It is evident that Julian was after something which no one else had ever gotten—an interpretation of the Southwest landscape, its essence in form and color so elusive and so subtle that the average person misses the closeness of values in the unity of color, live grey tones that vibrate. And that is where Julian stands preeminent as a painter of Texas landscape: call it atmosphere, if you like; aspect of nature, if you like; but above all recognize forms, in which myriad halftones play. It is impossible to look at any of Julian's paintings and not see the man who looked at nature with wide-open eyes, analyzed, studied and then created. In many of his canvases, Julian uses dramatic contrast—blasts of strong volume, with deep rolling orchestration, far removed from any 'prettiness' which is ascribed by the undiscriminating to my brother's work.[17]

That "prettiness" was ascribed primarily to Julian's scores of bluebonnet land-scapes. They were his most popular and saleable subjects, but he painted them because they appealed to him, not only because they were marketable. He interpreted the essence of oceans of azure-colored flowers in the morning mists, the glaring noonday sun, or in the tender hues of a spring twilight, as no one before him or since. As a consequence he became known as the "Bluebonnet Painter," an appellation he abhorred because of his amateurish imitators, who, for the most part, debased a theme that in Julian's competent hands was poetry in paint. "Bluebonnet Painter" seemed too narrow a classification to express justly Julian's versatility as an artist.[18]

Julian's responsibilities for the Dallas State Fair increased as he started to include the work of western painters as well as eastern artists. During the months he devoted to his own painting, he worked constantly, assiduously producing canvases of greater merit and maturity. Julian never spared himself mentally or physically in any task he undertook. In 1918 he had a short respite from his Dallas Fair obligations because the fair was canceled due to World War I.[19]

Julian came almost to resent the time his Dallas Fair duties occupied. Perhaps he had a presentiment that his days were numbered, and he worked more feverishly than ever. He said: "I want to do big things. I have been working and am still working to do something really worth while. I feel the time will soon come, but I have never been able to put into my painting that which I wish to."[20]

His last paintings, *Dawn in the Hills* and *Autumn Tapestry*, among his finest, were on the way to New York for the annual exhibition of the National Academy of Design for 1922 at the time of his death. Although regulations limited the exhibition to the work of living artists, Julian was accorded the unique honor of having his work accepted because of the unusual circumstances of his death as well as for the excellence of his paintings.[21]

Julian's death was as sudden and unexpected as many of his actions in life. He fell ill in San Antonio and failed to recover from an operation for an intestinal obstruction.[22] His untimely death was doubtless hastened by a cavalier disregard for his own welfare.

Since his early demise, Julian Onderdonk has become a legend. His work, represented in many public and private collections, is still avidly sought and has escalated enormously in value.

Julian's legacy lives on in his emotional, mysterious, and hauntingly beautiful art.

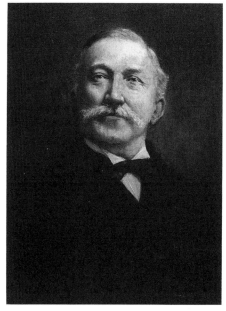

THE OLD MILL
1898, ink on paper, 8½" × 7"
Signed and dated lower left: Julian Onderdonk/
Dec. '98

Sixteen-year-old Julian Onderdonk produced
this pen-and-ink sketch when still a student
of his father's, two years before he went
to New York to study. The sketch shows
remarkable control of space, perspective, and
texture, attributes of the artist's best later
work. Presumably it was a gift to Bettie
Paschal (Sanders).[23]

PROVENANCE:
1898–1956: Collection of Bettie Paschal Sanders.
1956: Gift to SAMA by Bettie Paschal Sanders in
memory of G. R. Sanders, Jr.
56–48 G (5)

EXHIBITIONS:
1961: Early Texas Artists, WMM (Summer).
1975: The Onderdonks: A Family of Texas Painters,
WMM (January 16 to July 31).
1986: Texas Seen/Texas Made, SAMOA (September 29
to November 30).

PUBLICATIONS:
Steinfeldt, *The Onderdonks* (1976), 115.

PORTRAIT OF G. BEDELL MOORE
1905, oil on canvas, 10" × 7½"
Initialed lower left: J. O.
Titled and dated on reverse: Portrait of G. Bedell
Moore/painted from photograph/Apr. 1905, J. O.

The subject of this portrait, Gregory Bedell
Moore, was a successful banker who had large
ranching interests in southwest Texas and was
a noteworthy figure in business circles in San
Antonio.[24] He was the Onderdonks' neighbor
and the person who lent Julian one hundred
dollars with "like amount to follow as
necessities require" so that the young artist
might go to New York to study.[25] Julian
had been in New York almost five years
when he painted Moore's portrait and sent it
to him, no doubt as a token of respect and
gratitude for Moore's interest and generosity.
Although Julian was not particularly skilled in
portraiture, he captured Moore's benevolent
expression and dignified bearing.

PROVENANCE:
1905–1969: Collection of the Moore Family.
1969: Gift to SAMA by G. Bedell Moore, son of the
subject of the portrait.
69–227 G

EXHIBITIONS:
1975: The Onderdonks: A Family of Texas Painters,
WMM (January 16 to July 31).

PUBLICATIONS:
Steinfeldt, *The Onderdonks* (1976), 127.

17. Ibid., 226.
18. Marie Seacord Lilly, "Julian Onderdonk, Painter
of the Southwest," *The Bright Scrawl*, 14 (April
1941): 11.
19. Orpah Dawson Smith (Dallas) to Julian
Onderdonk (SA). This letter is undated but was
in a folder in which Julian kept other
correspondence of 1918.
20. Lilly, "Julian Onderdonk," 11.
21. "Dawn in the Hills Should be Here," San Antonio
Express, December 10, 1923.
22. Steinfeldt, *The Onderdonks*, 111.
23. Bettie Paschal Sanders (Pearsall, Texas) to William
A. Burns (SAMA Director, SA), August 3, 1962.
24. Davis and Grobe (eds. and comps.), *The New
Encyclopedia of Texas*, s.v. "G. Bedell Moore," 1750.
25. Steinfeldt, *The Onderdonks*, 93.

EAST LOYAL FIELD, ARKVILLE, NEW YORK
1908, oil on canvas, 20″ × 30″
Signed lower right: Julian Onderdonk
Titled and dated on reverse: E. Loyal Field/
Arkville, New York, 1908

There was a period in Julian's life when he
was most impressed by the work of George
Inness (1825–1894). He had seen an Inness
exhibit at the Democratic Club in New York
and wrote: "Beautiful things they were,
like poems in color by a man who was
thoroughly in sympathy with nature. One
picture, the 'Harvest Moon,' was one of the
softest, richest things that I have ever seen and
nearly all of his things were that way. . . ." [26]
East Loyal Field, painted in 1908, has soft, rich
autumnal tones suggestive of the work Inness
himself produced in the latter years of his life.

PROVENANCE:
-1975: Collection of Carl C. Phelps.
1975: Purchased by SAMA from Carl C. Phelps with
funds provided by Nancy B. Negley and Gilbert M.
Denman, Jr.
75–144 P

EXHIBITIONS:
1984: The Texas Collection, SAMOA (April 13 to
August 26).

PUBLICATIONS:
SAMA *Calendar of Events* (June 1976): [2].

FALL LANDSCAPE
n.d., oil on canvas, 16″ × 24″
Signed lower right: Julian Onderdonk

Fall Landscape seems to be another of Julian's
canvases inspired by the poetic and dreamlike
style of Inness. The warm, glowing colors
impart the feeling of a quiet autumn sunset
with day slipping into night. It is a sensitive
landscape but lacks the quality that the artist
later put into his more stimulating Texas
landscapes.

PROVENANCE:
-1975: Collection of Mrs. Harry C. Wiess.
1975: Gift to SAMA by Mrs. Harry C. Wiess.
75–76 G (2)

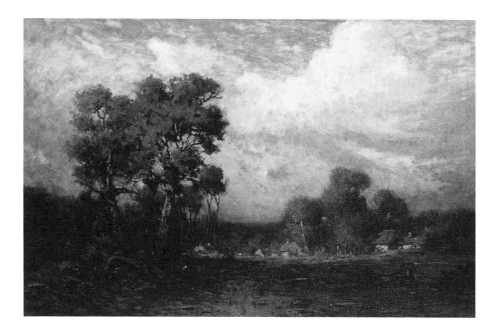

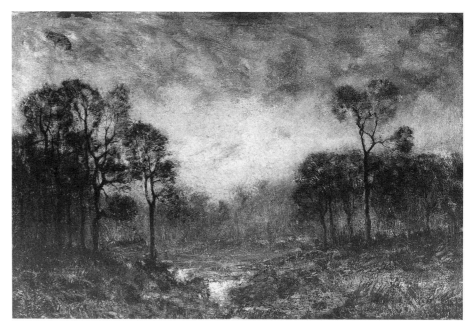

26. "Just Nothing," two journals kept by Julian
 Onderdonk, New York, 1902, Part 2, [20]. Gould-
 Onderdonk papers. Private collection.

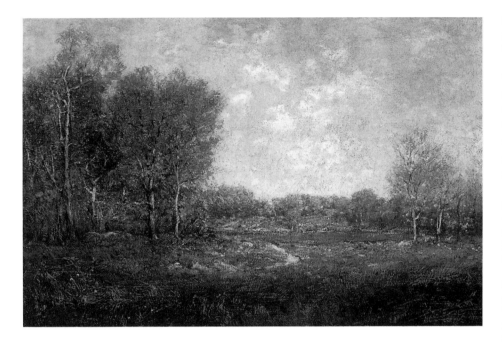

OCTOBER DAY ON STATEN ISLAND
n.d., oil on canvas, 16″ × 24″
Signed lower left: Julian Onderdonk

The influence of George Inness on Julian is apparent in this pleasant canvas with its glow, the delicate handling of the pigment, and the tonal quality. The ruddy tones of fall foliage dissolve against a steel blue sky with the muted, shimmering color intensifying the mood of a dying summer.

PROVENANCE:
-1983: Collection of Joyce J. Booth.
1983: Gift to SAMA by Joyce J. Booth in memory of her parents, Dr. and Mrs. Oscar Hunt Judkins.
83–72 G

EXHIBITIONS:
1983–1985: Witte Museum: Past, Present, and Future, WMM (October 23, 1983, to November 1, 1985).
1986: Texas Seen/Texas Made, SAMOA (September 29 to November 30).

SMOKEY DAY
n.d., oil on wooden panel, 9″ × 12″
Signed lower right: Julian Onderdonk
Titled on reverse: Smokey Day

Even in his small studies Julian skillfully imparts a sense of atmosphere, time, and space. In *Smokey Day* he communicates the hazy quality of a quiet autumn afternoon with subtlety and charm.

PROVENANCE:
-1981: Collection of J. Laurence Sheerin.
1981: Gift to SAMA by J. Laurence Sheerin.
81–168 G (1)

EXHIBITIONS:
1982: A Birthday Celebration: Recent Gifts and Acquisitions, SAMOA (March 1 to May 16).
1984: The Texas Collection, SAMOA (April 13 to August 26).
1986: Texas Seen/Texas Made, SAMOA (September 29 to November 30).

GOLDEN EVENING
n.d., oil on wooden panel, 6″ × 9¼″
Signed lower left: Julian Onderdonk

Golden Evening is a very small painting but
with all the attributes of a large canvas. The
brushstrokes are daring and positive, almost
savage in their intensity. The colors are also
strong with dark trees silhouetted against an
amber sky. The influence of Chase's direct
approach to painting is evident in this quick
sketch.

PROVENANCE:
-1981: Collection of J. Laurence Sheerin.
1981: Gift to SAMA by J. Laurence Sheerin.
81–168 G (5)

EXHIBITIONS:
1982: A Birthday Celebration: Recent Gifts and
Acquisitions, SAMOA (March 1 to May 16).
1984: The Texas Collection, SAMOA (April 13 to
August 26).

SMOKEY AFTERNOON
n.d., oil on academy board, 9″ × 12″
Signed lower right: Julian Onderdonk
Titled on reverse: Smokey Afternoon

Julian's paintings, large or small, showed his
empathy with nature's moods. In *Smokey
Afternoon* the artist captured the sensation of a
late summer day with tender grays, greens,
and soft rose tones. Although this small
painting probably was done in New York,
stylistically it is more closely related to Julian's
Texas landscapes.

PROVENANCE:
-1981: Collection of J. Laurence Sheerin.
1981: Gift to SAMA by J. Laurence Sheerin.
81–168 G (7)

EXHIBITIONS:
1982: A Birthday Celebration: Recent Gifts and
Acquisitions, SAMOA (March 1 to May 16).
1984: The Texas Collection, SAMOA (April 13 to
August 26).
1986: Texas Seen/Texas Made, SAMOA (September 29
to November 30).

AUTUMN AFTERNOON
n.d., oil on academy board, 6″ × 9″
Signed lower right: Julian Onderdonk

Julian Onderdonk could catch the very essence of nature even in his small sketches. In this instance he uses stark trees against a windswept sky with the hills in the distance melting into the background, creating a feeling of desolateness and isolation.

PROVENANCE:
-1981: Collection of J. Laurence Sheerin.
1981: Gift to SAMA by J. Laurence Sheerin.
81–168 G (8)

EXHIBITIONS:
1982: A Birthday Celebration: Recent Gifts and Acquisitions, SAMOA (March 1 to May 16).
1986: Texas Seen/Texas Made, SAMOA (September 29 to November 30).

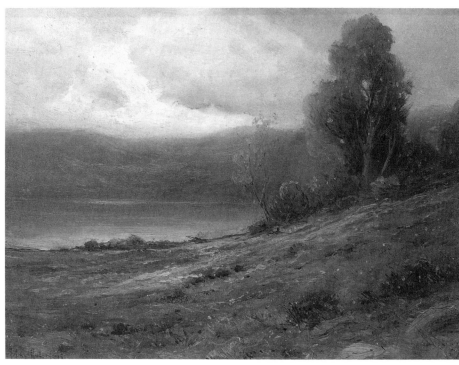

LAKESIDE LANDSCAPE
n.d., oil on academy board, 9″ × 12″
Signed lower left: Julian Onderdonk

Lakeside Landscape is a classic example of a small, intimate Julian Onderdonk painting. He catches the misty, chilly quality of an impending storm with cool gray tones in the clouds and steely hues in the water. The warm tones of late autumn flowers in the foreground enhance the mood.

PROVENANCE:
-1981: Collection of J. Laurence Sheerin.
1981: Gift to SAMA by J. Laurence Sheerin.
81–168 G (2)

EXHIBITIONS:
1982: A Birthday Celebration: Recent Gifts and Acquisitions, SAMOA (March 1 to May 16).
1984: The Texas Collection, SAMOA (April 13 to August 26).

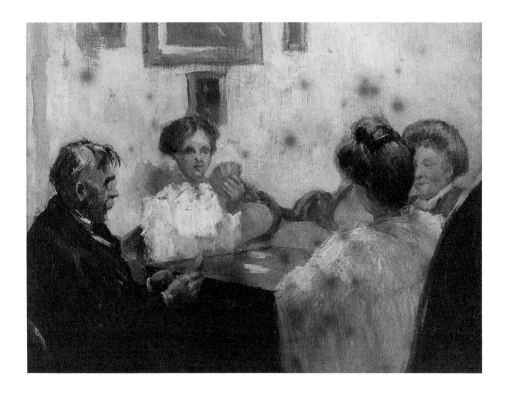

THE FAMILY AT CARDS
1909, oil on wooden panel, 8¼" × 11¼"
Titled, signed, and dated on reverse: The Family at
Cards/by Julian Onderdonk/Nov. 19, 1909

Julian returned to Texas from New York on
November 14, 1909. He enjoyed being home
with his family, and being an enthusiastic and
tireless painter, he painted his relatives at a
game of cards on the evening of November
19. His father Robert is seated at the left and
his sister Eleanor at the far side of the table.
His mother Emily appears across from Robert,
and Julian's wife Gertrude has her back to the
artist.

PROVENANCE:
1909–1976: Collection of the Onderdonk Family.
1976: Purchased by SAMA from Meredith Long
Galleries, Houston, agents for the Estate of Adrienne
Onderdonk, with funds provided by Mrs. Dick Prassel
and the Sarah Campbell Blaffer Foundation, Houston.
76–203 P

EXHIBITIONS:
1941: Landscapes, Portraits, and Still Life by the Late
Julian Onderdonk, San Antonio Junior League Bright
Shawl Galleries (April 15 to May 1). Lent by Eleanor
Onderdonk.
1961: A Century of Art and Life in Texas, DMFA
(April 9 to May 7). Lent by Eleanor Onderdonk.
1975: The Onderdonks: A Family of Texas Painters,
WMM (January 16 to July 31). Lent from the Estate
of Adrienne Onderdonk.

1976: Important American Paintings and Works from
the Estate of Adrienne Onderdonk, Meredith Long
Gallery, Houston (November 18 to December 8).
1979: The American Image: 1875–1978, Center for the
Arts, Corpus Christi State University (March 29 to
April 12).
1985: Julian Onderdonk: A Texas Tradition, Amarillo
Art Center (January 26 to March 17).
1985–1986: Julian Onderdonk: A Texas Tradition,
Traveling Exhibition: Rosenberg Library, Galveston
(April 1 to May 11, 1985). Archer M. Huntington Art
Gallery, University of Texas at Austin (June 15 to
August 15, 1985). D-ART Visual Art Center, Dallas
(September 12 to October 8, 1985). Art Institute
for the Permian Basin, Odessa (November 11 to
December 21, 1985). The Nave Museum, Victoria
(January 6 to February 15, 1986). McAllen
International Museum (March 3 to April 12, 1986).
Museum of Texas Tech University, Lubbock (April 27
to June 7, 1986).

PUBLICATIONS:
"Search under way for Onderdonk paintings," San
Antonio Express-News, August 13, 1972.
Steinfeldt, The Onderdonks (1976), 126.
Mimi Crossley, "Art: East meets West," Houston Post,
November 27, 1976.
SAMA Bi-Annual Report, 1976–1978, 20.
The American Image: 1875–1978 (1979): [3, plate 7].
[Cecilia Steinfeldt], Julian Onderdonk: A Texas Tradition
(1985), 29: plate 40.

27. Gilbert M. Denman, Jr., to Jack R. McGregor
(SAMA Director, SA), December 13, 1978.
28. Diary of Eleanor Onderdonk, 1909.

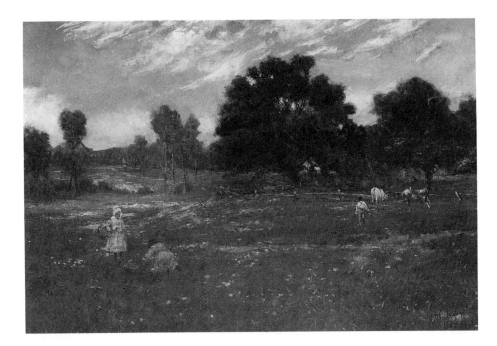

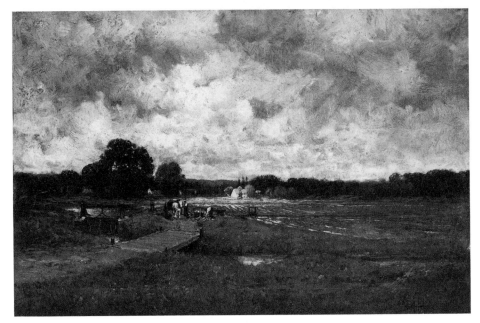

SCENE NEAR SISTERDALE
1909, oil on canvas, 20″ × 30″
Signed and dated lower right: Julian Onderdonk/1909

Julian completed *Scene Near Sisterdale* shortly after returning to Texas from New York. According to the donor, he painted it at the home of Alfred Giles near Sisterdale.[27] Eleanor Onderdonk wrote in her diary that Julian and his brother visited the Giles' ranch on November 26, Latrobe to hunt and Julian to paint.[28] The presence of figures and animals in the painting is somewhat unusual for Julian, but they add charm to a glowing fall landscape.

PROVENANCE:
-1978: Collection of Gilbert M. Denman, Jr.
1978: Gift to SAMA by Gilbert M. Denman, Jr.
78–1265 G

EXHIBITIONS:
1984: The Texas Collection, SAMOA (April 13 to August 26).
1985: Julian Onderdonk: A Texas Tradition, Amarillo Art Center (January 26 to March 17).
1985–1986: Julian Onderdonk: A Texas Tradition, Traveling Exhibition: Rosenberg Library, Galveston (April 1 to May 11, 1985). Archer M. Huntington Gallery, University of Texas at Austin (June 15 to August 15, 1985). D-ART Visual Art Center, Dallas (September 12 to October 8, 1985). Art Institute for the Permian Basin, Odessa (November 11 to December 21, 1985). The Nave Museum, Victoria (January 6 to February 15, 1986). McAllen International Museum (March 3 to April 12, 1986). Museum of Texas Tech University, Lubbock (April 27 to June 7, 1986).
1990: Looking at the Land: Early Texas Painters, San Angelo Museum of Fine Arts (February 22 to March 25).

PUBLICATIONS:
[Steinfeldt], *Julian Onderdonk* (1985), 45: plate 1.

LANDSCAPE NEAR CASTROVILLE
1912, oil on canvas, 16″ × 24″
Signed lower right: Julian Onderdonk

The Texas countryside was Julian's studio. Although he loved the Hill Country near San Antonio and the fields of coreopsis, cactus, or bluebonnets, he was equally at ease painting the flat farmland around Castroville. The vastness of sky and the breadth of the rich land is accentuated by the use of small figures in the middle distance, an example of Chase's influence.

PROVENANCE:
-1973: Collection of Gilbert M. Denman, Jr.
1973: Gift to SAMA by Gilbert M. Denman, Jr.
73–69 G (5)

EXHIBITIONS:
1975: The Onderdonks: A Family of Texas Painters, WMM (January 16 to July 31).
1982: Selections from the Permanent Collection, SAMOA (July 16 to August 29).

1986: Capitol Historical Art Loan Program, State Capitol, Austin (January 30 to September 15).
1986: Texas Seen/Texas Made, SAMOA (September 29 to November 30). Returned to Capitol for exhibition to December 19, 1988.

PUBLICATIONS:
Steinfeldt, *The Onderdonks* (1976), 131.

HUDSON RIVER VIEW
1912, oil on canvas, 18″ × 12″
Unsigned
Dated on reverse: 9/7/12

After Julian returned to Texas in 1909 he
spent several months each year in New York
assembling the art exhibitions for the Dallas
State Fair Association. This canvas was
apparently painted on one of these trips. It
appears to have been done very quickly, as
the brushstrokes are broad and free, but
Julian's inherent sense of spatial relationship
and atmosphere have not been sacrificed.

PROVENANCE:
ca. 1912–1980: Collection of the Strickland Family. The
painting was a gift from Julian Onderdonk to Mrs.
Strickland, the donor's mother.
1967–1980: Extended Loan to SAMA by D. F.
Strickland.
1980: Gift to SAMA by D. F. Strickland.
80–231 G

EXHIBITIONS:
1975: The Onderdonks: A Family of Texas Painters,
WMM (January 16 to July 31).
1982: A Birthday Celebration: Recent Gifts and
Acquisitions, SAMOA (March 1 to May 16).
1982: Selections from the Permanent Collection,
SAMOA (July 16 to August 29).
1984: The Texas Collection, SAMOA (April 13 to
August 26).

PUBLICATIONS:
Steinfeldt, *The Onderdonks* (1976), 130.

BLUEBONNET FIELD
1912, oil on canvas, 20″ × 30″
Signed lower left: Julian Onderdonk

Julian painted many different aspects of Texas bluebonnets; on a hazy morning, in blinding sunshine, or in the dusky tones of twilight. In *Bluebonnet Field* he painted a tract covered with flowers so dense that they appear as a carpet of radiant blue in the intense light. This is Julian at his best, luxuriating in his favorite theme.

PROVENANCE:
ca. 1912–1953: Collection of the Irvin-Gosling Family.
1953: Bequest to SAMA by the Estate of Grace Irvin Gosling. Grace Gosling had inherited the painting from her aunt, "Tommie" Irvin (Sarah Tom Irvin).
53–27 G

EXHIBITIONS:
1966: Echoes of Texas, Museum of the Southwest, Midland (March 1 to April 20).
1970: Special Texas Exhibition, ITC (March 16 to October 8).
1975: The Onderdonks: A Family of Texas Painters, WMM (January 16 to July 31).
1979: The American Image: 1875–1978, Center for the Arts, Corpus Christi State University (March 29 to April 12).

1983: Down Garden Paths: The Floral Environment in American Art, Montclair Art Museum, Montclair, New Jersey (October 1 to November 30).
1983–1984: Down Garden Paths, Traveling Exhibition: Terra Museum of American Art, Evanston, Illinois (December 13, 1983, to February 12, 1984). Henry Art Gallery, Seattle, Washington (March 1 to May 27, 1984).
1985: Julian Onderdonk: A Texas Tradition, Amarillo Art Center (January 26 to March 17).
1985–1986: Julian Onderdonk: A Texas Tradition, Traveling Exhibition: Rosenberg Library, Galveston (April 1 to May 11, 1985). Archer M. Huntington Art Gallery, University of Texas at Austin (June 15 to August 15, 1985). D-ART Visual Art Center, Dallas (September 12 to October 8, 1985). Art Institute for the Permian Basin, Odessa (November 11 to December 21, 1985). The Nave Museum, Victoria (January 6 to February 15, 1986). McAllen International Museum (March 3 to April 12, 1986). Museum of Texas Tech University, Lubbock (April 27 to June 7, 1986).
1986: Texas Seen/Texas Made, SAMOA (September 29 to November 30).
1990: Looking at the Land: Early Texas Painters, San Angelo Museum of Fine Arts (February 22 to March 25).

PUBLICATIONS:
"Onderdonk Exhibit," *The Recorder* (SA), December 31, 1974.
"Onderdonk Exhibit: Texas Art Tribute," *Paseo del Rio Showboat* (SA; January 1975).
SAMA *Calendar of Events* (January 1975): cover.
"Onderdonk Art Show," San Antonio *Light*, January 12, 1975.
"The Onderdonks: San Antonio's art world still under their influence," San Antonio *Express-News*, January 12, 1975.
Steinfeldt, *The Onderdonks* (1976), dust jacket, 154.
"The Onderdonks: A Family of Texas Painters," *Southwestern Art*, 5 (March 1976): 38.
William H. Gerdts, "The Artist's Garden: American Floral Painting, 1850–1915," *Portfolio*, 4 (July/August 1982): 51.
William H. Gerdts, *Down Garden Paths: The Floral Environment in American Art* (1983), 87.
William H. Gerdts, *American Impressionism* (1984), 243.
Steinfeldt, "Blooming Bluebonnets," *Southwest Art*, 14 (April 1985): 62–63.
[Steinfeldt], *Julian Onderdonk* (1985), 53: plate 2.
Betsie Bolger Day, "King of the Bluebonnets," *Texas Homes*, 10 (May 1986): 29.
Susan Hallsten McGarry, "Editor's Perspective," *Southwest Art*, 18 (April 1989): 14.
Gerdts, *Art Across America*, vol. 2 (1990), 119: plate 2.110.

AFTERNOON BACK OF LAUREL HEIGHTS
1913, oil on wooden panel, 8″ × 11″
Signed lower right: Julian Onderdonk
Titled, signed, and dated on reverse: Afternoon
Back of Laurel Heights/San Antonio, Texas/Julian
Onderdonk, 1913

Julian's sensitive appreciation of all growing
things is particularly evident in his treatment
of trees. Slender limbs radiate from sturdy
trunks with attenuated branches reaching
toward radiant Texas skies. Trees are alive
and vibrant, even in his small canvases.

PROVENANCE:
-1958: Collection of Julia Nott Waugh.
1958: Gift to SAMA by the Estate of Julia Nott
Waugh.
58–268 G

EXHIBITIONS:
1941: Landscapes, Portraits, and Still Life by the Late
Julian Onderdonk, San Antonio Junior League Bright
Shawl Galleries (April 15 to May 1). Lent by Julia Nott
Waugh.
1975: The Onderdonks: A Family of Texas Painters,
WMM (January 16 to July 31).
1985: Julian Onderdonk: A Texas Tradition, Amarillo
Art Center (January 26 to March 17).
1985–1986: Julian Onderdonk: A Texas Tradition,
Traveling Exhibition: Rosenberg Library, Galveston
(April 1 to May 11, 1985). Archer M. Huntington Art
Gallery, University of Texas at Austin (June 15 to
August 15, 1985). D-ART Visual Art Center, Dallas
(September 12 to October 8, 1985). Art Institute
for the Permian Basin, Odessa (November 11 to
December 21, 1985). The Nave Museum, Victoria
(January 6 to February 15, 1986). McAllen
International Museum (March 3 to April 12, 1986).
Museum of Texas Tech University, Lubbock (April 27
to June 7, 1986).
1986: Texas Seen/Texas Made, SAMOA (September 29
to November 30).
1990: Looking at the Land: Early Texas Painters,
San Angelo Museum of Fine Arts (February 22 to
March 25).

PUBLICATIONS:
"Society to give annual awards in conservation," San
Antonio Express-News, March 2, 1975.
"Conservation Society Makes Awards," The Herald
(SA), March 5, 1975. SAMA Annual Report, 1974–1975, 2.
Steinfeldt, The Onderdonks (1976), 136.
[Steinfeldt], Julian Onderdonk (1985), 69: plate 37.

THE RIVER (*Opposite page*)
1914, pencil on paper, 5¼″ × 7″
Unsigned
Inscribed and dated across left side: drawn from
memory Jan. 8 1914 before making sketch from
nature

Julian sometimes sketched or painted from
memory, as he noted on this drawing. The
strong, free lines of the trees, the essence of
reflections in the water, and the unrestrained
masses of thick foliage illustrate his under-
standing of nature and command of subject
matter.

PROVENANCE:
1914–1963: Collection of Gertrude and Adrienne
Onderdonk.
1963: Purchased by SAMA from La Sirena, Inc., agents
for Adrienne Onderdonk, with Art Endowment
Funds.
63–80 P (1)

EXHIBITIONS:
1975: The Onderdonks: A Family of Texas Painters,
WMM (January 16 to July 31).

PUBLICATIONS:
Steinfeldt, The Onderdonks (1976), 139.

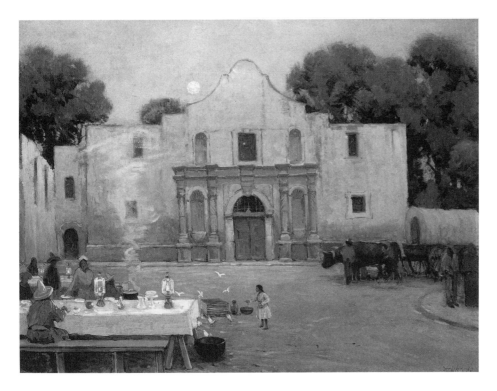

CHILI QUEENS AT THE ALAMO
n.d., oil on canvas mounted on panel, 12″ × 16″
Signed lower right: Julian Onderdonk

Chili stands once were a tradition on the plazas of San Antonio, according to the September 26, 1965, San Antonio *Express-News.* The plazas were used during the day by vendors of vegetables and fruits, but as the sun set, these merchants were replaced by "chili" stands from which spicy chili and other pungent edibles were sold—all flavored with the fiery Mexican chili pepper. *Chili con carne* was the favorite dish, and the Latin ladies who made and dispensed these peppery concoctions became known as "Chili Queens."

When Julian Onderdonk chose to portray this unique custom, he selected the stands on Alamo Plaza at twilight for his subject. The Alamo in the background is bathed in a misty glow of semi-darkness, with colorfully garbed figures in the foreground serving steaming bowls of chili from cloth-covered tables. The glowing Mexican lanterns and the vivid hues of the clothing enhance the silvery pallor of the famous edifice in the background.

The painting is also known as *Christmas at the Alamo*, presumably because it once was used on a Christmas card by the Clegg Company in San Antonio.

PROVENANCE:
-1991: Collection of the William C. Clegg Family.
1991: Purchased by the Rainone Galleries, Inc., Arlington, Texas, from the William C. Clegg Family.
1991: Purchased by SAMA from the Rainone Galleries, Inc., with funds provided by the Lena and Albert Hirschfeld Endowment.
91–54 P

EXHIBITIONS:
1975: The Onderdonks: A Family of Texas Painters, WMM (January 16 to July 31). Lent by Mr. and Mrs. William C. Clegg.

PUBLICATIONS:
"Christmas at the Alamo," Christmas card issued by the Clegg Company (ca. 1938).
History of the Order of the Alamo: 1960–1975 (1975), frontispiece.
Steinfeldt, *The Onderdonks* (1976), 150.
Jacqueline Pontello, "The Alamo: A Mission of Heroes," *Southwest Art*, 15 (February 1986): 70.

BLUEBONNETS
1915, watercolor on watercolor board, 9¼" × 13¼"
Signed and dated lower right: Julian Onderdonk-1915

Julian was best known for his landscapes in oil, but he had exquisite control of the watercolor medium as well. In *Bluebonnets* he achieved the same sense of atmosphere and space as in his canvasses.

PROVENANCE:
-1976: Collection of Helen B. Hunt.
1976: Purchased by SAMA from Helen B. Hunt with funds provided by Nancy B. Negley and Gilbert M. Denman, Jr.
76–53 P

EXHIBITIONS:
1984: The Texas Collection, SAMOA (April 13 to August 26).
1986: Texas Seen/Texas Made, SAMOA (September 29 to November 30).

NEAR SAN ANTONIO
n.d., oil on canvas, 30" × 40"
Signed lower left: Julian Onderdonk

From chalky limestone outcroppings, a common sight near San Antonio, Julian created a poetic painting. In this instance the sun falls on the stark white cliffs, making them glow in the brilliant light. Cloud shadows appear in the foreground and the middle distance, creating tonal variations in the flower-carpeted sweep of the land. These shadows provide a rhythmic composition in an otherwise level landscape.

PROVENANCE:
-1984: Collection of Mr. and Mrs. I. L. Ellwood.
1984: Gift to SAMA by Mr. and Mrs. I. L. Ellwood.
84–103 G

EXHIBITIONS:
1986: Texas Seen/Texas Made, SAMOA (September 29 to November 30).

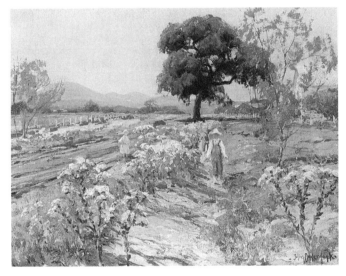

MILKWEED IN BANDERA

1916, oil on canvas, 12½" × 16½"
Signed lower right: Julian Onderdonk
Titled and dated on reverse: Milkweed in Bandera, 1916

Julian's mastery of the oil medium is evident in this landscape. Done with sure, pronounced strokes, the pigment has an unrestrained plastic quality that demonstrates the artist's confidence. The warm pink tones of the earth complement the cool gray-greens of the foliage, and the figures of the children add personality and freshness to the composition.

PROVENANCE:
-1974: Collection of Bishop and Mrs. Everett Jones.
1974: Gift to SAMA by Bishop and Mrs. Everett Jones.
74–133 G

EXHIBITIONS:
1975: The Onderdonks: A Family of Texas Painters, WMM (January 16 to July 31).
1984: The Texas Collection, SAMOA (April 13 to August 26).
1985: Julian Onderdonk: A Texas Tradition, Amarillo Art Center (January 26 to March 17).
1985–1986: Julian Onderdonk: A Texas Tradition, Traveling Exhibition: Rosenberg Library, Galveston (April 1 to May 11, 1985). Archer M. Huntington Art Gallery, University of Texas at Austin (June 15 to August 15, 1985). D-ART Visual Art Center, Dallas (September 12 to October 8, 1985). Art Institute for the Permian Basin, Odessa (November 11 to December 21, 1985). The Nave Museum, Victoria (January 6 to February 15, 1986). McAllen International Museum (March 3 to April 12, 1986). Museum of Texas Tech University, Lubbock (April 27 to June 7, 1986).
1986: Texas Seen/Texas Made, SAMOA (September 29 to November 30).

PUBLICATIONS:
Steinfeldt, *The Onderdonks* (1976), 146.
[Steinfeldt], *Julian Onderdonk* (1985), 58: plate 4.
Dan R. Goddard, "An Artist—and a bluebonnet painter," San Antonio *Express-News*, July 14, 1985.

LATE AFTERNOON SUNLIGHT ON THE BLUEBONNETS

1916, oil on academy board, 6" × 9"
Signed lower left: Julian Onderdonk
Titled, signed, and dated on reverse: Late Afternoon Sunlight on the Bluebonnets North of San Antonio/ Julian Onderdonk, 1916

The size and the unfinished character of this small sketch suggest that the artist intended it as a reference piece for a larger painting. Although small, it is vigorous in its execution and reflects the influence of Chase's philosophy of painting directly from nature.

PROVENANCE:
-1955: Collection of the Halff Family.
1955: Gift to SAMA by Mrs. Henry S. Halff.
55–95 G

EXHIBITIONS:
1975: The Onderdonks: A Family of Texas Painters, WMM (January 16 to July 31).
1984: The Texas Collection, SAMOA (April 13 to August 26).
1986: Texas Seen/Texas Made, SAMOA (September 29 to November 30).

PUBLICATIONS:
Steinfeldt, *The Onderdonks* (1976), 147.

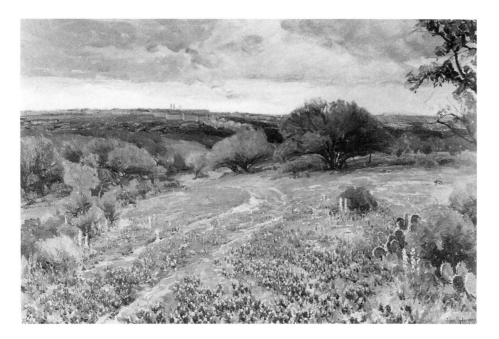

VIEW FROM ALAMO HEIGHTS
1920, pencil on paper, 9″ × 14″
Unsigned
Titled and dated lower edge: view from Alamo
Heights-July 27-1920 from nature

Julian Onderdonk made numerous sketches
to extend his knowledge of nature so that he
could faithfully represent its elements in his
paintings. This view of a landscape near San
Antonio emphasizes dark and light masses
to create a sense of space and atmosphere, at-
tributes always apparent in his finished work.

PROVENANCE:
1920–1963: Collection of the Onderdonk Family.
1963–1979: Collection of the Winn Family.
1979: Gift to SAMA by Ethel D. Winn.
79–146 G (54)

EXHIBITIONS:
1986: Texas Seen/Texas Made, SAMOA (September 29
to November 30).

BLUEBONNET FIELD
n.d., oil on canvas, 20″ × 30″
Signed lower right: Julian Onderdonk

In this rendition of a bluebonnet field other
aspects of the landscape that captivated Julian
appear: a country road, cactus and larkspur,
graceful huisache trees, and even buildings in
the far distance.

PROVENANCE:
-1945: Collection of Mrs. J. S. Lockwood.
1945: Gift to SAMA by Mrs. J. S. Lockwood.
45–30 G

EXHIBITIONS:
1966: Echoes of Texas, Museum of the Southwest,
Midland (March 1 to April 20).
1970: Special Texas Exhibition, ITC (March 16 to
October 8).
1975: The Onderdonks: A Family of Texas Painters,
WMM (January 16 to July 31).
1985: Julian Onderdonk: A Texas Tradition, Amarillo
Art Center (January 26 to March 17).
1985–1986: Julian Onderdonk: A Texas Tradition,
Traveling Exhibition: Rosenberg Library, Galveston
(April 1 to May 11, 1985). Archer M. Huntington Art
Gallery, University of Texas at Austin (June 15 to
August 15, 1985). D-ART Visual Art Center, Dallas
(September 12 to October 8, 1985). Art Institute
for the Permian Basin, Odessa (November 11 to
December 21, 1985). The Nave Museum, Victoria
(January 6 to February 15, 1986). McAllen
International Museum (March 3 to April 12, 1986).
Museum of Texas Tech University, Lubbock (April 27
to June 7, 1986).
1986: Texas Seen/Texas Made, SAMOA (September 29
to November 30).
1990: Art and Life in Texas in the 1890s, University Art
Gallery, University of North Texas, Denton (April 2
to 27).

PUBLICATIONS:
Steinfeldt, *The Onderdonks* (1976), 159.
[Steinfeldt], *Julian Onderdonk* (1985), 41: plate 36.
Reese, Mayer, and Mayer, *Texas* (1987), 39.

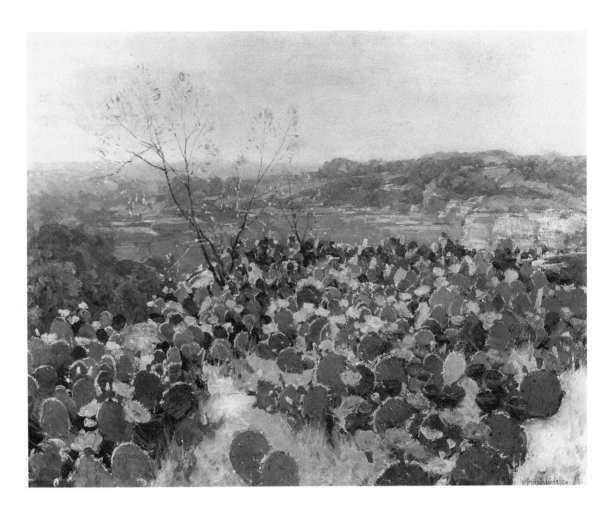

CACTUS FLOWERS
n.d., oil on canvas, 16″ × 20″
Signed lower right: Julian Onderdonk

Although Julian was most famous for his scenes of bluebonnets, he painted the Texas landscape in all of its many phases and with much of its floral splendor. He did numerous paintings of the common cactus plant and usually portrayed it in glorious bloom.

PROVENANCE:
-1972: Collection of the Brown Family.
1972: Gift to SAMA by Mrs. Ernest L. Brown, Sr., and Ernest L. Brown, Jr., in memory of Ernest L. Brown, Sr., and Mrs. Ernest L. Brown, Jr.
72-43 G

EXHIBITIONS:
1975: The Onderdonks: A Family of Texas Painters, WMM (January 16 to July 31).
1979–1980: Contemporary America: 1900–1979, South Texas Artmobile, Eleventh Exhibition (September, 1979, to May, 1980).
1982: Selections from the Permanent Collection, SAMOA (July 16 to August 29).

1983: Images of Texas, Archer M. Huntington Art Gallery, College of Fine Arts, University of Texas at Austin (February 25 to April 10).
1983: Images of Texas, Traveling Exhibition: Art Museum of South Texas, Corpus Christi (July 1 to August 14).
1983: Down Garden Paths: The Floral Environment in American Art, Montclair Art Museum, Montclair, New Jersey (October 1 to November 30).
1983–1984: Down Garden Paths, Traveling Exhibition: Terra Museum of American Art, Evanston, Illinois (December 13, 1983, to February 12, 1984). Henry Art Gallery, Seattle, Washington (March 1 to May 27, 1984).
1985: Julian Onderdonk: A Texas Tradition, Amarillo Art Center (January 26 to March 17).
1985–1986: Julian Onderdonk: A Texas Tradition, Traveling Exhibition: Rosenberg Library, Galveston (April 1 to May 11, 1985). Archer M. Huntington Art Gallery, University of Texas at Austin (June 15 to August 15, 1985). D-ART Visual Art Center, Dallas (September 12 to October 8, 1985). Art Institute for the Permian Basin, Odessa (November 11 to December 21, 1985). The Nave Museum, Victoria

(January 6 to February 15, 1986). McAllen International Museum (March 3 to April 12, 1986). Museum of Texas Tech University, Lubbock (April 27 to June 7, 1986).
1986: Texas Seen/Texas Made, SAMOA (September 29 to November 30).
1990: Art and Life in Texas in the 1890s, University Art Gallery, University of North Texas, Denton (April 2 to 27).

PUBLICATIONS:
SAMA Annual Report, 1974–1975, cover.
Steinfeldt, The Onderdonks (1976), 166.
Contemporary America: 1900–1979 (1979): [2].
"Museum Reinstalls Permanent Collection," Paseo del Rio Showboat (SA; January 1983).
Goetzmann and Reese, Texas Images and Visions (1983), 75.
[Steinfeldt], Julian Onderdonk (1985), 52: plate 3.
Goddard, "An Artist—and a bluebonnet painter," San Antonio Express-News, July 14, 1985.
Sweeney, "The Onderdonks," Southwest Art, 18 (April 1989): 51.

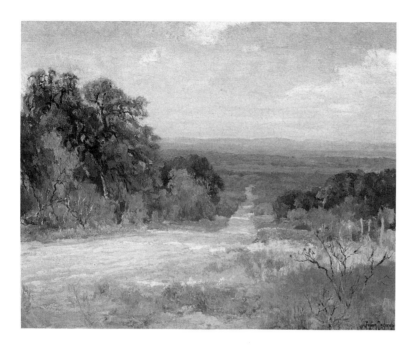

A WHITE ROAD AT LATE AFTERNOON
1921, oil on canvas, 16″ × 20″
Signed lower right: Julian Onderdonk
Titled, signed, and dated on reverse: A White Road
at Late Afternoon/Southwest Texas/Julian
Onderdonk, 1921

Julian's success as a landscape painter was
due in large part to his ability to imbue his
paintings with atmosphere. In this example
one sees the powdery caliche road, the effect
of intense light, and the aura of breathless
stillness, all of which capture the sensation of
a torrid Texas afternoon.

PROVENANCE:
-1976: Collection of Mr. and Mrs. Curtis Vaughan.
1976: Gift to SAMA by Mrs. Curtis Vaughan.
76–207 G

EXHIBITIONS:
ca. 1925: The Canvasses of the Celebrated American
Artist, Julian Onderdonk, The City Federation of
Temple, Texas (December 9 to 30).
1927: Onderdonk Canvasses, City Hall Auditorium,
Abilene (November 19 to 22).
1982: Selections from the Permanent Collection,
SAMOA (July 16 to August 29).
1986: Capitol Historical Art Loan Program, State
Capitol, Austin (January 30 to September 15).
1986: Texas Seen/Texas Made, SAMOA (September 29
to November 30). Returned to Capitol for exhibition
to December 19, 1988.
1990: Looking at the Land: Early Texas Painters,
San Angelo Museum of Fine Arts (February 22 to
March 25).

PUBLICATIONS:
SAMA Bi-Annual Report, 1976–1978, 26.

THE HOUSE NEXT DOOR
1919, pencil on paper, 8″ × 11″
Unsigned
Dated lower left: Jan. 24th/1919

Ordinary vistas assumed beauty and interest
through Julian Onderdonk's eyes. The
imposing "House Next Door" looms in the
background in this sketch, with leafless trees,
a picket fence, and the corner of the artist's
own home in the foreground, all drawn with
sure vigorous strokes. Julian used not only
the point of a pencil but also the side of the
point to achieve variety in texture and tonal
quality.

PROVENANCE:
1919–1963: Collection of Gertrude and Adrienne
Onderdonk.
1963: Purchased by SAMA from La Sirena, Inc., agents
for Adrienne Onderdonk, with Art Endowment
Funds.
63–80 P (2)

EXHIBITIONS:
1975: The Onderdonks: A Family of Texas Painters,
WMM (January 16 to July 31).

PUBLICATIONS:
Steinfeldt, *The Onderdonks* (1976), 162.

The Onderdonk house at 128 West French Place.
SAMA Historical Photographic Archives, gift of Ofelia
Onderdonk.

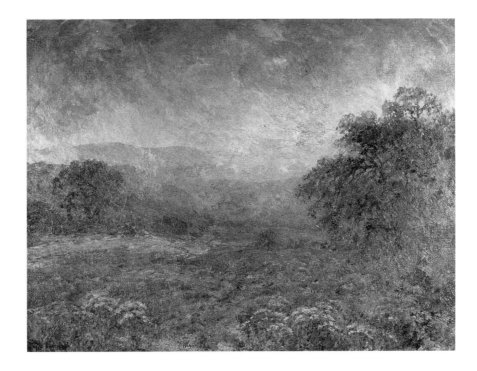

DAWN IN THE HILLS
1922, oil on canvas, 30″ × 40″
Signed lower left: Julian Onderdonk

Dawn in the Hills was Julian's last painting. It is a mystical, fragile, poetic rendition of daybreak on a Texas spring morning. It hovers between the celestial and the real and reveals much of the artist's personality.

Julian Onderdonk's death prompted his friends to launch a campaign to raise funds to purchase *Dawn in the Hills* for the city of San Antonio. Contributions were slow in coming in, and a "blue-bonnet tag day" was organized. On Friday, June 27, 1924, a group of young women assembled in the lobby of the St. Anthony Hotel and were supplied with "tags" and bluebonnet headgear made by the Wolf and Marx Company. They scattered throughout the city and sold their "tags" for twenty-five cents apiece to supplement the fund.[29] Their efforts evidently fell far short of the $10,000 needed to complete the purchase, and solicitations continued for several years. The final goal was reached in 1938, when the Witte Museum Board used accrued interest from the Witte Picture Fund to make the last payment, thus placing the painting in public domain.[30]

29. "Pretty Girls Answer Bluebonnet Tag Day Call," *San Antonio Express*, June 26, 1924.
30. Original Bill of Sale, January 3, 1938, signed by Gertrude, Adrienne, and Robert Reid Onderdonk. SAMA Registrar's Records.

PROVENANCE:
1922–1938: Collection of Gertrude Onderdonk.
1938: Purchased by SAMA from Gertrude Onderdonk with public subscription and Witte Picture Funds. 38–18 P

EXHIBITIONS:
1922: National Academy of Design, New York, New York (November 1 to December 1).
1927: Spring Exhibit of San Antonio Artists, WMM (April 17 to 30). Lent by Gertrude Onderdonk.
1927: Onderdonk Canvasses, City Hall Auditorium, Abilene (November 19 to 22). Lent by Gertrude Onderdonk.
1928: Onderdonk Memorial Exhibition, WMM (January 17 to 31). Lent by Gertrude Onderdonk.
1936: Centennial Exposition of Early Texas Paintings, WMM (June 1 to August 1). Lent by Gertrude Onderdonk.
1938: Dawn in the Hills (formal acceptance), WMM (January 19).
1945: Selections from the Permanent Collection, WMM (June 5 to September 15).
1966: Ethel Drought Gallery of Contemporary Art, WMM (Summer).
1971: Texas Painting and Sculpture: The 20th Century, Pollock Galleries, Owens Art Center, SMU (January 17 to March 7).
1971–1972: Texas Painting and Sculpture, Traveling Exhibition: Witte Confluence Museum, HemisFair Plaza, SA (March 21 to May 2, 1971). University Art Museum, University of Texas at Austin (June 13 to July 18, 1971). Amon Carter Museum of Western Art, Fort Worth (September 16 to November 15, 1971). The Museum, Texas Tech University, Lubbock (January 9 to March 5, 1972).
1975: The Onderdonks: A Family of Texas Painters, WMM (January 16 to July 31).

1983: Painting in the South: 1564–1980, Virginia Museum of Fine Arts, Richmond (September 14 to November 27).
1984–1985: Painting in the South, Traveling Exhibition: Birmingham Museum of Art, Alabama (January 8 to March 4, 1984). National Academy of Design, New York, New York (April 12 to May 27, 1984). Mississippi Museum of Art, Jackson (June 24 to August 26, 1984). J. B. Speed Art Museum, Louisville, Kentucky (September 16 to November 11, 1984). New Orleans Museum of Art, Louisiana (December 9, 1984, to February 3, 1985).
1986: Texas Seen/Texas Made, SAMOA (September 29 to November 15).
1986: Collecting: A Texas Phenomenon, Marion Koogler McNay Art Museum, SA (November 23 to December 24).
1987: Gallery of American Paintings, SAMOA (January 6 to December 31).
1990: Looking at the Land: Early Texas Painters, San Angelo Museum of Fine Arts (February 22 to March 25).

PUBLICATIONS:
Woolford and Quillin, *The Story of the Witte Memorial Museum* (1966), 148.
Texas Painting and Sculpture: The 20th Century (1971), 31.
"The Onderdonks: Major Exhibition of the Great Family," *San Antonio Light*, August 13, 1972.
Steinfeldt, *The Onderdonks* (1976), 167.
Rick Stewart, "Toward a New South," in *Painting in the South* (1983), 108: Figure 44.
Steinfeldt, "Blooming Bluebonnets," *Southwest Art*, 14 (April 1985): 64.
Steinfeldt, "Lone Star Landscapes," M3, SAMA Quarterly, in *San Antonio Monthly*, 5 (July 1986): 23.
Leeper, "The San Antonio Museum of Art," in *Collecting: A Texas Phenomenon* (1986), 55.

WORKS BY ROBERT JULIAN ONDERDONK
NOT ILLUSTRATED:

UNTITLED LANDSCAPE
n.d., oil on canvas, 22½″ × 37½″
Signed lower left: Julian Onderdonk
78–229 G
Gift to SAMA by Nathaniel I. Gray.

BLUEBONNET STUDIES
n.d., pencil on paper, 8½″ × 12¼″
Unsigned
Inscribed over blossom: Old bloom
67–164 G (7A.1)
Gift to SAMA by Ofelia Onderdonk.

BLUEBONNET STUDIES
n.d., pencil on paper, 12¼″ × 8½″
Unsigned
Inscribed on right side: end view, seed pods
67–164 G (7A.2)
Gift to SAMA by Ofelia Onderdonk.

BLUEBONNET STUDIES
n.d., pencil on paper, 8½″ × 12¼″
Unsigned
67–164 G (7A.3)
Gift to SAMA by Ofelia Onderdonk.

BLUEBONNET STUDIES
n.d., pencil on paper, 8½″ × 12¼″
Unsigned
Inscribed over blossoms: old blooms/new blooms
67–164 G (7A.4)
Gift to SAMA by Ofelia Onderdonk.

BLUEBONNET STUDIES
n.d., watercolor and ink on paper, 8½″ × 12¼″
Unsigned
67–164 G (7B.1)
Gift to SAMA by Ofelia Onderdonk.

BLUEBONNET STUDIES
n.d., watercolor on paper, 11″ × 12⅛″
Unsigned
Inscribed upper center: new blooms
67–164 G (7B.2)
Gift to SAMA by Ofelia Onderdonk.

DESIGN FOR MENU WITH BLUEBONNETS
n.d., pencil on paper, 12¼″ × 8½″
Unsigned
Inscribed top center: MKT
Inscribed at center: MENU
67–164 G (7C.1)
Gift to SAMA by Ofelia Onderdonk.

DESIGN FOR MENU WITH BLUEBONNETS
n.d., pencil on paper, 20″ × 15½″
Unsigned
Inscribed top center: MENU
67–164 G (7C.2)
Gift to SAMA by Ofelia Onderdonk.

BLUEBONNET BOOK-END DESIGNS
n.d., pencil, ink, and watercolor on paper, 8½″ × 11″
Unsigned
67–164 G (7D.1)
Gift to SAMA by Ofelia Onderdonk.

BLUEBONNET BOOK-END DESIGNS
n.d., paper stencils, 6¼″ × 6″, and 7″ × 6½″
Unsigned
(7D.2) Inscribed on reverse: Bluebonnet Book-End
(7D.3) Inscribed on reverse: Bluebonnet Book-End
Design
67–164 G (7D.2) and (7D.3)
Gift to SAMA by Ofelia Onderdonk.

CACTUS STUDIES
n.d., pencil on paper, 8½″ × 11″
Unsigned
Inscribed lower left with color notations
67–164 G (7E.1)
Gift to SAMA by Ofelia Onderdonk.

CACTUS STUDIES
n.d., pencil on paper, 8½″ × 11″
Unsigned
Inscribed lower right with color notations
67–164 G (7E.2)
Gift to SAMA by Ofelia Onderdonk.

CACTUS STUDY
n.d., pencil and watercolor on paper, 8½″ × 12½″
Unsigned
67–164 G (7E.3)
Gift to SAMA by Ofelia Onderdonk.

CACTUS STUDY
n.d., watercolor on paper, 9¼″ × 12¼″
Unsigned
67–164 G (7E.4)
Gift to SAMA by Ofelia Onderdonk.

MEXICAN WORKMAN SKETCHES
n.d., pencil on Strathmore paper, 6¼″ × 3½″
Signed upper left: by Julian Onderdonk
67–164 G (7K.1)
Gift to SAMA by Ofelia Onderdonk.

LATE AFTERNOON SUNLIGHT ON THE MEDINA
NEAR BANDERA
n.d. (recto), pencil on lined paper, 2¼″ × 3″
Unsigned
Titled across bottom: Late Afternoon Sunlight
on the Medina near Bandera

UNTITLED LANDSCAPE
n.d. (verso), pencil on lined paper, 2¼″ × 3″
Unsigned
67–164 G (7K.2)
Gift to SAMA by Ofelia Onderdonk.

DESIGN FOR *THE HUISACHE* (San Antonio High
School Magazine)
1903, India ink and opaque watercolor on paper,
23″ × 14½″
Unsigned
67–164 G (7L.1)
Gift to SAMA by Ofelia Onderdonk.

DESIGN FOR *THE HUISACHE*
1904, India ink on paper, 23″ × 14½″
Unsigned
67–164 G (7L.2)
Gift to SAMA by Ofelia Onderdonk.

AUTUMN LANDSCAPE
n.d., oil on wooden panel, 6″ × 9″
Signed lower left: Julian Onderdonk
81–168 G (3)
Gift to SAMA by J. Laurence Sheerin.

AFTERNOON IN THE WOODS
n.d., oil on wooden panel, 6″ × 9″
Signed lower right: Julian Onderdonk
81–168 G (4)
Gift to SAMA by J. Laurence Sheerin.

GOLDEN HOUR
n.d., oil on wooden panel, 7″ × 4″
Signed lower left: Julian Onderdonk
81–168 G (6)
Gift to SAMA by J. Laurence Sheerin.

53rd STREET AT HUDSON RIVER
n.d., oil on academy board, 4½″ × 6″
Signed lower right: Julian Onderdonk
Titled on reverse: 53rd Street at Hudson River
81–168 G (9)
Gift to SAMA by J. Laurence Sheerin.

UNTITLED LANDSCAPE
n.d., oil on academy board, 5″ × 8⅛″
Signed lower right: Julian Onderdonk
82–166 G (1)
Gift to SAMA by D. F. Strickland.

LANDSCAPE WITH WAGON
1899, pencil on paper, 4¼″ × 6⅛″
Signed and dated lower left: Julian Onderdonk/
Feb. 6, 1899
79–146 G (38)
Gift to SAMA by Ethel D. Winn.

MEMORY OF 5th AVENUE
1908, pencil on paper, 10⅝″ × 8¼″
Unsigned
Titled and dated lower left: Memory of 5th Avenue/
1908
79–146 G (39)
Gift to SAMA by Ethel D. Winn.

MESQUITE TREES
1913, pencil on paper, 9″ × 12″
Unsigned
Titled and dated lower left: Mesquite Trees/from
Nature-1913
79–146 G (40)
Gift to SAMA by Ethel D. Winn.

WILLOW TREES
1913, pencil on paper, 8½″ × 11″
Unsigned
Titled lower center: Willow Trees
Dated and inscribed lower right: 1913-from nature
79–146 G (41)
Gift to SAMA by Ethel D. Winn.

CLIFFS IN ROCK QUARRY
1912, pencil on paper, 8⅛″ × 10¼″
Titled and dated lower left: from nature, Cliffs in
Rock Quarry, 1912 79–146 G (42)
Gift to SAMA by Ethel D. Winn.

UPSTREAM FROM BLUFF
1915 (recto), pencil on paper, 9″ × 14″
Unsigned
Titled and dated below sketch: Upstream from Cliffs,
Bandera, Tex./Aug. 1915

CLIFFS AND DRIPPING SPRING ROCK
1915 (verso), pencil on paper, 9″ × 14″
Unsigned
Titled and dated below sketch: Cliffs and Dripping
Spring Rock/Bandera, Tex./Aug. 1915
79–146 G (43)
Gift to SAMA by Ethel D. Winn.

LIVE OAK TREES ON THE OLMOS
1915, carbon pencil on paper, 5½″ × 8½″
Unsigned
Titled right side: Live Oak Trees on the Olmos
at Alamo H'ts./from nature
Dated lower right: Feb. 14, 1915
79–146 G (44)
Gift to SAMA by Ethel D. Winn.

MESQUITE BRUSH
1919, pencil on paper, 4¼″ × 6½″
Unsigned
Titled and dated left side: Mesquite Brush from
New Braunfels/Ave. over L. H. [Laurel Heights]
March 9th, 1919
79–146 G (45)
Gift to SAMA by Ethel D. Winn.

TWILIGHT, BLUEBONNETS
n.d., pencil on paper, 12″ × 8½″
Unsigned
Titled lower center: Twilight, Bluebonnets
79–146 G (46)
Gift to SAMA by Ethel D. Winn.

FIVE YELLOW DAISIES
n.d., opaque watercolor on toned paper, 6″ × 9″
Unsigned
Inscribed around edges with color notations
79–146 G (47)
Gift to SAMA by Ethel D. Winn.

STUDY OF YELLOW DAISIES
n.d., opaque watercolor on toned paper, 6″ × 9″
Unsigned
79–146 G (48)
Gift to SAMA by Ethel D. Winn.

HUISACHE TREES IN WEISE'S LOT
1898, pencil on paper, 4½″ × 6″
Unsigned
Titled and dated lower center: Huisache Trees
in Weise's Lot, 1898
79–146 G (49)
Gift to SAMA by Ethel D. Winn.

TREE
1911, pencil on paper, 4½″ × 7″
Unsigned
Dated lower left: 1911
79–146 G (50)
Gift to SAMA by Ethel D. Winn.

TREES AND STREAM
1897, ink on paper, 5¼″ × 4¼″
Signed and dated lower left: Julian Onderdonk/
Dec. 27, 1897
Inscribed lower right: 15 yrs. old
79–146 G (51)
Gift to SAMA by Ethel D. Winn.

TREE AND FIGURE
1897, pencil on paper, 7¼″ × 5″
Signed and dated lower right: Julian Onderdonk/
June 8, 1897
79–146 G (52)
Gift to SAMA by Ethel D. Winn.

VIEW FROM ALAMO HEIGHTS
1920, pencil on paper, 8¼″ × 13¼″
Unsigned
Titled and dated lower edge: View from Alamo
Heights, July 27, 1920-from nature
79–146 G (54)
Gift to SAMA by Ethel D. Winn.

TREES OVER THE STREAM
n.d., ink on paper, 9″ × 7¼″
Unsigned
79–146 G (55)
Gift to SAMA by Ethel D. Winn.

ROAD TO MEDINA DAM
1919, pencil on paper, 6″ × 8⅛″
Unsigned
Titled and dated on left side: Road to Medina Dam/
Apr. 14th, 1919, Medina River in Background/from
nature
79–146 G (56)
Gift to SAMA by Ethel D. Winn.

LANDSCAPE
1918, pencil on paper, 8½″ × 12½″
Unsigned
Inscribed and dated lower left: Memory, 1918
79–146 G (57)
Gift to SAMA by Ethel D. Winn.

VIEW FROM WASHINGTON'S HEADQUARTERS,
NEWBURGH, NEW YORK
1902, pencil on paper, 4¼″ × 7½″
Unsigned
Titled and dated on bottom: View from
Washington's Headquarters, Newburgh, N.Y., 1902
79–146 G (58)
Gift to SAMA by Ethel D. Winn.

LUPINS ON HILLS
n.d., pencil on paper, 8″ × 10½″
Unsigned
Titled and inscribed on bottom: At Dawn, Lupins on
Hills, with notations
79–146 G (59)
Gift to SAMA by Ethel D. Winn.

BLUEBONNETS
1918, pencil on paper, 8½″ × 12½″
Unsigned
Inscribed and dated on bottom: Memory, 1918,
Bluebonnets, with notations
79–146 G (60)
Gift to SAMA by Ethel D. Winn.

UNTITLED LANDSCAPE
n.d., wash and pastel on paper, 9″ × 12″
Unsigned
79–146 G (61)
Gift to SAMA by Ethel D. Winn.

JONES AVENUE
1920, pencil on paper, 9″ × 12″
Unsigned
Inscribed and dated on bottom: Jones Ave. (Dusty)
view-N.E.-July 21st, 1920-from nature
79–146 G (62)
Gift to SAMA by Ethel D. Winn.

DESK IN OUR ROOM IN NEW YORK
1913, pencil on paper, 10½″ × 7¼″
Unsigned
Inscribed and dated lower right: where we boarded/
Desk in our room in N.Y./1913-from objects
79–146 G (63)
Gift to SAMA by Ethel D. Winn.

BIRD SKETCHES
n.d., pencil on paper, 10½″ × 7½″
Unsigned
Inscribed on edges with color notations
79–146 G (64)
Gift to SAMA by Ethel D. Winn.

BIRD SKETCHES
n.d. (recto), pencil on paper, 10½″ × 7½″
Unsigned
Inscribed on edges with color notations

RED BIRD
n.d. (verso), pencil on paper, 10½″ × 7½″
Unsigned
Inscribed on edges with color notations
79–146 G (65)
Gift to SAMA by Ethel D. Winn.

BOY ON BED
n.d., ink and opaque white watercolor on paper,
3½″ × 5½″
Unsigned
79–146 G (66)
Gift to SAMA by Ethel D. Winn.

ON BOARD THE DOWNY COUCH
1908, ink on paper, 4″ × 6½″
Unsigned
Titled and dated on bottom: On Board the Downy
Couch/March 11, 1908
79–146 G (67)
Gift to SAMA by Ethel D. Winn.

SPIDER WORT
n.d., watercolor on paper, 9″ × 7½″
Signed lower right: J. Onderdonk
Titled lower center: Spider Wort
79–146 G (68)
Gift to SAMA by Ethel D. Winn.

SEASCAPE
ca. 1891, watercolor on watercolor board, 8″ × 16″
Unsigned
Documented on reverse: A picture by Julian
Onderdonk when he was about 9 years old-from him
to me, his teacher, Nora C. Franklin
79–146 G (69)
Gift to SAMA by Ethel D. Winn.

ROCK RUINS
1898, ink on paper, 7⅛″ × 10⅛″
Signed and dated lower left: Julian Onderdonk, '98
79–146 G (70)
Gift to SAMA by Ethel D. Winn.

CLARA CAFFREY PANCOAST

CHILI STAND
n.d., oil on canvas on board, 25″ × 31½″
Signed lower right: C. C. Pancoast

Clara Pancoast was best known for her Texas landscapes, floral paintings, and architectural views. She rarely included figures in her work, but when she executed this scene of the once popular chili stands in San Antonio she used a well-known photograph as her source. She may have done so because the painting probably was made after chili stands had been banished from the streets of San Antonio, in the 1940s. She no doubt had fond recollections of this picturesque local custom and wished to record it in color for posterity.[9]

PROVENANCE:
-1966: Collection of Clara M. Cowsar.
1966: Gift to SAMA by Clara M. Cowsar.
66–69 G

EXHIBITIONS:
1952: Fourth Annual Exhibition of Art by Coppini Academy of Fine Arts, WMM (September 14 to 28).

WORKS BY CLARA CAFFREY PANCOAST
NOT ILLUSTRATED:

BORGLUM STUDIO IN BRACKENRIDGE PARK,
n.d., line etching on toned paper, 5⅞″ × 8¼″
Signed lower right beneath print: C. C. Pancoast
80–112 G (2)
Gift to SAMA by Mr. and Mrs. Eric Steinfeldt.

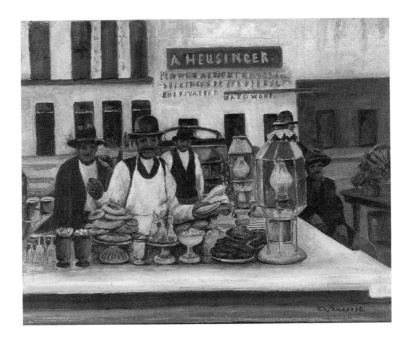

1. Davis and Grobe (eds. and comps.), *The New Encyclopedia of Texas*, s.v. "William Test Pancoast," 573.
2. Fenwick (ed.), *Who's Who Among the Women of San Antonio and Southwest Texas*, s.v. "Pancoast, Clara Caffrey."
3. Davis and Grobe (eds. and comps.), *The New Encyclopedia of Texas*, s.v. "Pancoast."
4. Ibid.
5. "Women in Business," *San Antonio Express*, December 11, 1949.
6. Catalogues and listings, Clara Caffrey Pancoast file, SAMA Texas Artists Records.
7. Ibid.
8. "Last Tribute Set for S. A. Artist, 86," *San Antonio Light*, September 17, 1959.
9. See John L. Davis, *San Antonio: A Historical Portrait* (Austin: The Encino Press, 1978), 90; Sam and Bess Woolford, *The San Antonio Story* (Austin: The Steck Co., 1952), photographic section. The Woolfords attribute the photograph to Harvey Patteson.

Clara Pancoast was a writer by profession and an artist by choice. In spite of the fact that she painted mostly on weekends and vacations, she managed to produce a prodigious number of paintings during her lifetime. She was the daughter of Jefferson Jackson Caffrey and Ann M. (Crow) Caffrey and was the second-youngest of their thirteen children.[1]

Born in Lafayette, Louisiana, Clara was educated at the Home Institute in New Orleans, where she majored in art and music.[2] She married William Test Pancoast in San Antonio on November 17, 1892, and they were the parents of two daughters, Mary Irene and Edith Caffrey.[3]

Just when Clara Pancoast started her journalistic career is uncertain, but she worked for the San Antonio *Express* as head of the women's department for eleven years. Following this, she was society editor of the women's section of the *San Antonio Light* for many years.[4] She was organizer and first president of the Business and Professional Women's Club of San Antonio, which was given official recognition in 1922.[5] She was a member of many organizations: the San Antonio Art League, the Pioneer Club, the Army Civilian Club, the Pan-American Round Table, the Palette and Chisel Club, the Villita Art Gallery, and the Texas Fine Arts Association. The Coppini Academy and the San Antonio Women's Club both made her an honorary life member.[6]

Clara was a regular exhibitor in local, state, and national shows. Considered one of José Arpa's prize students, she also had a number of solo exhibitions, mostly in San Antonio. During the depression, when the Witte Memorial Museum was struggling to keep its doors open, Clara Pancoast was one of the local artists to donate a painting as a prize at a benefit card party for the museum. She always was ready to lend a hand and served as chairman for many events and sometimes acted as judge in competitions.[7]

Clara Caffrey Pancoast died in September 1959, leaving a legacy of hundreds of paintings and prints done locally, in Mexico, and in West Texas.[8]

FRIEDRICH RICHARD PETRI

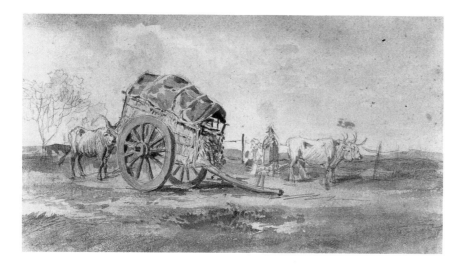

OX CART
n.d., Watercolor and pencil on paper, 4⅝″ × 8⅜6″
Unsigned (attributed)

Much of the story of Richard Petri is told in the biography of Hermann Lungkwitz. As fellow students, brothers-in-law, and early immigrants to Texas, they shared many experiences. As artists, however, their work is quite different, indicating distinct personalities and interests.

Petri's father Heinrich was a prosperous shoemaker in Dresden. Richard was the youngest of six children, all of whom received good educations, with Richard showing an artistic inclination at an early age. In 1838, at the age of fourteen, he entered the Lower Class in the Royal Academy of Fine Arts in Dresden, and his advancement at the academy was rapid.[1] In 1839, having been promoted to Class Two, he studied under Ferdinand Anton Krueger (1795–1857), Karl August Richter (1770–1848), and Ernst Rietschel (1804–1861). He progressed to the Upper Class the following winter and later studied under Julius Hübner (1806–1882) as an *atelier-schüler* (studio student).[2]

During his eleven years at the academy Petri won many awards, including honors in 1841, 1844, 1845, and 1846.[3] Before he left the school at Easter 1849, he was offered a scholarship to study in Italy, with the provision that he return to the academy to teach. He declined, apparently because of poor health.[4]

When Petri came to the United States in 1850, and later to Texas, he brought many of his student sketches with him. They show remarkable skill in draftsmanship and portraiture and a thorough understanding of figure painting. He applied this knowledge to his work in the frontier environment, especially in Fredericksburg, and, besides numerous portraits, did delightful genre scenes of pioneer activities. He also portrayed the local Indians he encountered, mostly Lipans and Comanches, in their colorful costumes, astride their horses or performing daily tasks.[5]

Many of these works are sketches and show a marked deviation from the rigid austerity of student drawings. No longer fettered by inflexible academic rules, Petri was developing a freer style, a maturity in his interpretation of subject matter, a masterly fluidity of line, and a skillful control of technique. Seven years after his immigration to this country, however, Richard Petri died. Whether his continuing poor health was caused by tuberculosis, malaria, or a combination of the two is not clear. In December 1857 he left his sick bed and wandered down to the Pedernales River, possibly thinking to assuage his raging fever in its cold waters. Instead, enfeebled by his illness, Richard Petri drowned.[6] The legacy left in his Texas drawings, watercolors, and paintings enriches the state's art history immeasurably.

When the museum received this small watercolor, it was among a group of wash drawings done by Theodore Gentilz. It was presumed then that this sketch also was done by the Frenchman. Upon closer examination and analytical review of the technical quality, it has been attributed to Richard Petri.[7]

In terms of technique Petri's and Gentilz's styles vary considerably. Gentilz's works are tight and labored, whereas Petri's Texas sketches are free and unrestrained. *Ox Cart's* similarity to Petri's authenticated work is particularly pronounced. The washes in *Ox Cart* have been applied with sure dexterous strokes and a spontaneity lacking in Gentilz's work.[8]

PROVENANCE:
-1964: Collection of the Bartlett Family.
1964: Gift to SAMA by Mrs. Terrell Bartlett.
64–19 G (6)

EXHIBITIONS:
1964: The Early Scene: San Antonio, WMM (June 7 to August 31).
1974–1975: Theodore Gentilz: A Frenchman's View of Early Texas, WMM (November 25, 1974, to March 1, 1975).
1986: Texas Seen/Texas Made, SAMOA (September 29 to November 30).
1988: The Art and Craft of Early Texas, WMM (April 30 to December 1).

PUBLICATIONS:
Utterback, *Early Texas Art* (1968), 18.

1. Newcomb with Carnahan, *German Artist*, 1–5.
2. Ibid., 7–8; McGuire, *Hermann Lungkwitz*, 5.
3. McGuire, *Hermann Lungkwitz*, 5.
4. Newcomb with Carnahan, *German Artist*, 8.
5. Esther Mueller, "Old Fort Martin Scott at Fredericksburg," *Frontier Times*, 14 (August 1937): 466.
6. Newcomb with Carnahan, *German Artist*, 112.
7. Ibid., 25. When compared with a similar view of oxen pulling a *carreta* in Newcomb's book on Petri, the analogy is obvious. That scene was done in San Antonio, as *Ox Cart* may have been.
8. Martha Utterback (Gentilz authority) to author (SA), interview, August 15, 1987. Utterback agreed the watercolor was done by Petri rather than Gentilz.

(1878–1960)

IN THE PATIO
n.d., watercolor on paper, 8½″ × 12½″
Signed lower right: H. D. Pohl
Titled on reverse: In the Patio

This small painting may have been done
in California when Pohl did his views of
the missions there. The meticulous drawing,
the careful attention to detail, and the
absolute control of perspective and values
are reminiscent of the work of Hermann
Lungkwitz and show the influence of Pohl's
European teachers.

PROVENANCE:
-1979: Collection of Robert K. Winn.
1979–1985: Robert K. Winn Folk Art Collection.
1985: Gift to SAMA from the Robert K. Winn Folk
Art Collection.
85–1 G (3881)

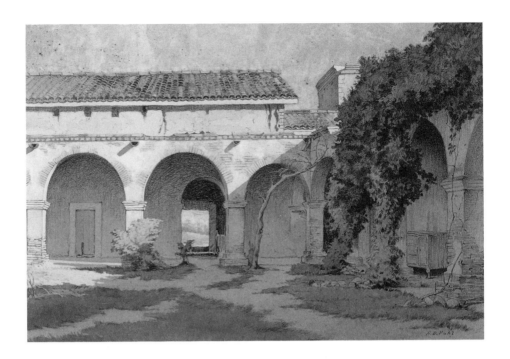

Hugo Pohl was born in Detroit, Michigan, on March 11, 1878. His artistic talent
was discovered early and at the age of eleven he studied with Julius Melchers (1860–
1932), a distinguished painter who had received his education at the Düsseldorf Academy.
Pohl later entered the Detroit Museum of Art where his instructor was Joseph W.
Gies (n.d.), who had studied with Bouguereau and Robert-Fleury in Paris and at the
Royal Academy in Munich.[1]

Pohl furthered his studies in New York, where Kenyon Cox was one of his
tutors, and went on to Paris to become a pupil of Jean-Paul Laurens (1838–1921) at the
Académie Julian. Laurens specialized in grandiose historical murals. These prestigious
instructors all instilled into the young artist an idealistic ideology that remained
throughout his lifetime and was evident in his meticulous painting style and allegorical
subject matter. Hugo Pohl also visited Munich, Amsterdam, and Rome before
returning to America.[2]

After a few years in Detroit, Pohl moved to Chicago. He started showing
his work in American galleries and in 1908 he received a commission from the
International Harvester Company to execute murals for their new building in Chicago.
He devoted eighteen months to these murals, which depicted harvest scenes in
different countries.[3]

In 1918, Pohl decided to tour the West and built a traveling studio on an auto
chassis. His first lengthy stop was in the Rocky Mountains National Park in Colorado,
where he painted all summer. In September he headed southwest and painted
portraits of native Americans, one of his favorite subjects. He spent the winter in
California, where he concentrated on depicting the local missions. Critics considered
the resulting works to be among his best.[4]

Pohl moved to San Antonio in 1924 and constructed a studio in Brackenridge
Park. In 1926 he was commissioned by the city to paint a drop curtain for the newly-
constructed Municipal Auditorium that would picture the founding of San Antonio
by Father Margil in 1718. It was such an enormous curtain that there was no place
in the city in which to paint it, so he leased the Volland scenic studios in St. Louis.

1. Forrester-O'Brien, Art and Artists, 174.
2. Fisk, A History of Texas Artists, 27.
3. Forrester-O'Brien, Art and Artists, 174.
4. Ibid.

When finished, the painting measured thirty-six by seventy-five feet and weighed 5,699 pounds.[5] Unfortunately the curtain was lost in a catastrophic fire that destroyed the interior of the auditorium on January 6, 1979.[6]

On December 28, 1928, Pohl married Minette Teichmueller (1872–?) of New Braunfels. Minette was also an artist. The two often exhibited their works together and established a studio at 622 Avenue E in San Antonio. They were also teachers who influenced many a neophyte artist. They were active in all local art organizations.[7]

In July 1933, Hugo and Minette Pohl had a joint exhibition in the Witte Memorial Museum. Among the works was an allegorical painting by Hugo Pohl titled *The Demons of War*, as well as one of *Mary Magdalen*. His gifted wife, who signed her work "M. Teichmueller," primarily exhibited portraits.[8]

In 1934, Pohl exhibited twenty-nine views of the San Antonio missions in his studio. These included interior as well as exterior scenes and seemed to be a continuation of his interest in the California missions.[9] He did a painting of Colonel William B. Travis that was used for invitations to the Alamo Pilgrimage in 1936 and is now the property of the Alamo.[10]

Pohl continued to teach and paint in his academic style, but slowly faded into obscurity in the wake of more modern trends. He died in his home in Leon Springs, Texas, on July 19, 1960, and was buried in La Grange.[11]

5. Garland Roark, "Founding of San Antonio Fine Painting—State's Largest Too," Houston *Chronicle*, November 30, 1960. Although Pohl was credited with doing extensive research for the project, the result was a highly romanticized and probably inaccurate version of the occasion.

6. Philip Morales, "Arson Probe in Auditorium Fire," San Antonio *Light*, January 7, 1979.

7. Listings and articles, Hugo David Pohl file, SAMA Texas Artists Records.

8. Bess Carroll, "Art Display at Witte Museum," San Antonio *Light*, July 9, 1933.

9. "Pohl Group of Historic Value," San Antonio *Light*, April 29, 1934.

10. "Hugo Pohl Paints Alamo Commander for Pilgrimage Announcement," San Antonio *Express*, February 21, 1936.

11. Obituary, San Antonio *Express*, July 20, 1960.

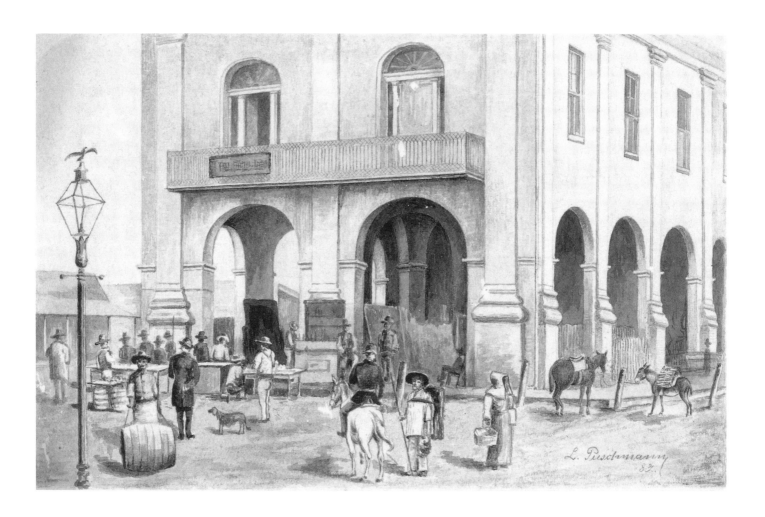

Nothing is known of Ludwig Puschmann except that he is listed in the San Antonio city directories of 1883–1884 and 1885–1886 as an artist with his residence at 311 Elm, at the corner of Fifth Street. In the following year, 1887–1888, only the name of his widow, Antonia, appears. She is recorded as being head milliner at G. B. Frank Company, a dry goods store, with her home at 310 Avenue D.

While living here Puschmann did a portrait of Sam Maverick. A photograph of this painting is in the Daughters of the Republic of Texas Library at the Alamo. Dated 1882, it appears to be a copy of the 1873 portrait of Maverick done by Carl G. von Iwonski (see Carl G. von Iwonski, *Samuel Augustus Maverick*). If other works exist by this fairly competent artist, their whereabouts are unknown.[1]

(Below)
Mounted *carte de visite* of the Market Square in Brownsville prior to 1867 made by R. H. Wallis. SAMA Historical Photographic Archives, gift of Mrs. Edwin Chamberlain.

(Below right)
Unmounted *carte de visite* of the Market House in Brownsville about 1870, showing the gabled roof added after the storm of 1867. SAMA Historical Photographic Archives, gift of Mrs. Edwin Chamberlain.

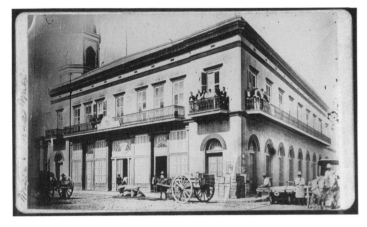 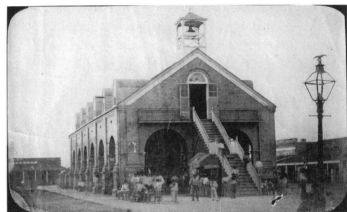

(Opposite page)
MARKET SQUARE, BROWNSVILLE
1883, wash drawing on paper, 5 1/16″ × 7 1/8″
Signed and dated lower right: L. Puschmann/'83
Titled lower center: Market Square, Brownsville

Puschmann used a photograph made prior to 1867 for his very accurate and engaging wash drawing of *Market Square*. The building as pictured was completed in 1853, with the ground floor serving as a public market and the second story for city administrative offices.[2] The structure was so severely damaged by a hurricane on October 7, 1867, that the second floor was removed and replaced with a gabled roof. The building was remodeled in 1912 and again in 1948, but the original walls and arches remained as depicted in the drawing.[3]

The artist recorded everyday activities in the Market Square as well: water vendors roll their barrels along the ground, street peddlers vend their wares from temporary stalls, a horse and burro are tethered to a hitching post, and a bonneted lady trudges home with her purchases in a basket. When Mrs. Edwin Chamberlain presented the drawing to the San Antonio Museum Association, she also gave a number of very early photographs of Brownsville. One of

these, by R. H. Wallis, was used on a *carte de visite* of the same period and shows the Market House with wrought iron balconies at the second level. Another photographic image in the collection, dated 1870, is a view of the remodeled building with the lamppost as depicted in Puschmann's drawing.[4] This type of lighting was installed in 1869 and was still in use in 1883.[5] Therefore, it is possible the artist used more than one photograph to produce his rendition of *Market Square*.

PROVENANCE:
1883–1950: Collection of the Chamberlain Family.
1950: Gift to SAMA by Mrs. Edwin Chamberlain.
50-13 G (44)

EXHIBITIONS:
1964: The Early Scene: San Antonio, WMM (June 7 to August 31).
1986: Texas Seen/Texas Made, SAMOA (September 29 to November 30).

PUBLICATIONS:
Utterback, *Early Texas Art* (1968), 61.

1. Archives of the DRT Library at the Alamo, SA.
2. A. A. Champion (Brownsville) to Martha Utterback (SA), December 6, 1966.
3. Utterback, *Early Texas Art*, 61.
4. SAMA Historical Photographic Archives.
5. Utterback, *Early Texas Art*, 61.

CHARLES FRANKLIN REAUGH

There probably is no other Texas artist about whom so much has been written or who has fallen in and out of favor as often as Frank Reaugh. At this writing Frank Reaugh is back in the limelight, and his sensitive and beguiling pastels and oils of Texas Longhorn cattle, as well as his gentle and poetic landscapes of Texas's Great Plains, are appreciated now as never before.

Frank was born in Morgan County, Illinois, near Jacksonville, on December 29, 1860, the son of George Washington Reaugh and Clarinda Morton (Spilman) Reaugh.[1] Pronounced "Ray," the name may have been derived from Castlereaugh [Castlereagh].[2] At some point Reaugh's first name was shortened to a simple Frank, although his early work was signed C. F. R.[3] His father was a farmer, mechanic, carpenter, and cabinetmaker who taught his son mechanical skills that he later used to make his own patented portable lap easel, picture frames, and other inventions.[4]

Portrait photograph of Frank Reaugh by Ernst Raba, dated 1902. SAMA Historical Photographic Archives, gift of an anonymous donor.

Frank's mother, the daughter of a Presbyterian minister, was a cultured woman and the principal source of the boy's basic education. She taught him botany and zoology and instilled in him a love of nature, an appreciation of music, and an interest in art.[5]

When Frank was nine years old the family moved to Bloomington, Illinois, where his father worked as a carpenter. Before Frank was sixteen the Reaugh family moved in a covered wagon to Terrell, Kaufman County, Texas.[6]

Frank was excited by the scenery on the journey, and his first impressions of Texas remained an inspiration for the rest of his life. In his autobiography he recalled that "in Texas there were motifs in plenty. There were no mountains in sight, but there was illimitable distance, and there were skies that were beautiful, grand or awe-inspiring as the case might be."[7]

Although Frank probably had seen herds of Texas Longhorns in Illinois, he now saw them in their natural element on the vast prairies silhouetted against an infinite celestial expanse. Later he reminisced: "When we came to Texas, fences were unknown. It was in the days of free grass. We could see, from our house near Terrell, just one roof. Cattle were still being driven up the trails. The longhorns were all around us, and I loved to watch them. In an artist's eye, the cattle of those days were handsomer than the ones we see now. They were more slender, active, and intelligent."[8] These great Longhorns, with their proud bearing and agile movements, became his passion, and he painted them with a sympathy and understanding seldom equalled by other artists. He saved the sketches of the cattle he made as a youth before he had art training and before the Longhorn disappeared from the Texas scene, later using them as references for his mature work.[9]

As a young man Frank helped with the chores around the farm and briefly taught public school. In the winter of 1884–1885 Frank Reaugh began his formal academic training at the St. Louis School of Fine Arts. "I wanted to go there because I'd heard about the pictures," he said. While at the school he apparently "studied in the night class from the cast."[10]

When Frank returned to Terrell, he and a group of women of the town, some of whom may have financed his schooling, formed the Frank Reaugh Art Study Club. This group evidently comprised some of his first regular students. He also began to sell some paintings. By 1888 he was able to travel to Europe.[11]

In the winter of 1888–1889 Frank attended the Académie Julian in Paris, where he studied with Jules Lefebvre (1834–1911), Henri-Lucien Doucet (1856–1895), and Jean-Joseph Benjamin-Constant (1845–1902).[12] Like most artists, he haunted the Louvre, where he was captivated by the work of the eighteenth-century portraitist Maurice Quentin de La Tour (1704–1788). La Tour worked almost exclusively in pastel, the medium that was to become Reaugh's favorite. As he later stated, however, "Of all the work I saw abroad, I was most impressed by that of Anton Mauve. . . . " To study more of the work of Mauve (1838–1888), the Dutch landscape and animal painter, he traveled to the Hague.[13]

Reaugh came back to America in May 1889 and never saw Europe again.[14] He had made his first trip to West Texas in 1883 and after his tour in Europe he returned to the area. He started showing his paintings in the Texas State Fair exhibitions in Dallas and in 1905 assisted R. J. Onderdonk in assembling paintings for the show.[15]

In 1890 the Reaugh family bought a house at 110 East Eighth Street in the Oak Cliff area of Dallas. Frank and his father built a studio-workshop in back of the house, a frame structure sheathed with galvanized iron. It was Frank's bachelor quarters as well and soon came to be known as "Old Ironsides."[16] The studio not only provided Frank with working space, it also gave him a place in which to teach. He preferred female students, as he felt they were more alert and were more interested in nature study.[17]

These students formed the nucleus of the groups Frank later took to West Texas during the summers on sketching excursions. Frank had been making annual trips for a number of years, first in a Studebaker hack drawn by horses. By 1916 he had a Ford automobile dubbed the "Tarantula," with a high-wheeled buggy trailer for equipment that was called the "Ant." By 1920 the sketch-trip car was called the "Cicada" and looked like a covered wagon with an engine. As Reaugh did not drive, this conveyance was sometimes piloted by Reveau Bassett (1897–1972), a Reaugh student who later became famous in his own right. Two other Reaugh students who also acted as chauffeurs and later attained fame were Alexander Hogue (1898–) and John Douglass (1906–1969). As the parties grew larger, the "Cicada" was joined by two more Ford cars, the "Spider" and the "Cricket."[18]

Reaugh's reputation as an artist continued to grow. His work was shown in the World's Columbian Exposition in Chicago in 1893 and the Louisiana Purchase Exposition at St. Louis in 1904. He exhibited regularly at the State Fair in Dallas, and occasionally in larger museums throughout the country. Reaugh was particularly proud of two of his students, Reveau Bassett and Edward G. Eisenlohr (1872–1961), who, with Julian Onderdonk and himself, were the first Texas artists whose works were accepted by the National Academy of Design in New York.[19]

In 1929 Frank Reaugh moved to a new studio, "El Sibil" (The Vault), at 122 East Fifth Street in Dallas. It was called El Sibil because it actually contained a vault to store his paintings.[20] In 1976 this structure became a historic landmark with a Texas Historical Marker. The building was used for many years as a creative arts center and is now a photographer's studio.[21]

Reaugh used the vault to store his paintings and monitored the humidity with a leather strap hung inside the door. A touch would tell him whether the atmosphere

1. Roy C. Ledbetter, "Frank Reaugh—Painter of Longhorn Cattle," *The Southwestern Historical Quarterly*, 54 (July 1950): 13.
2. Michael R. Grauer (Canyon, Texas) to author (SA), November 27, 1990.
3. Ibid.
4. Ledbetter, "Frank Reaugh," 13.
5. Ibid.
6. Ibid.
7. J. Evetts Haley, *F. Reaugh: Man and Artist* (El Paso: Carl Hertzog, 1960), [1].
8. Mabel Cranfill, "Frank Reaugh Preserves the Vanishing West," *Holland's, The Magazine of the South*, 48 (April 1929): 9.
9. Alice Bab Stroud and Modena Stroud Dailey, *F. Reaugh: Texas Longhorn Painter* (Dallas: Royal Publishing Company, 1962), 17.
10. Michael R. Grauer, "The Early Career of Frank Reaugh, 1860–1889" (Master's thesis, Meadows School of the Arts, Southern Methodist University, Dallas, 1989), 55.
11. Ibid., 73–76.
12. Ibid.
13. Haley, *F. Reaugh*, [3].
14. Grauer, "The Early Career of Frank Reaugh," 108.
15. Steinfeldt, *The Onderdonks*, 223 n. 103.
16. Stroud and Dailey, *F. Reaugh*, 29.
17. Ibid., 39–42.
18. Ibid., 44–53; Grauer to author, November 27, 1990.
19. Ledbetter, "Frank Reaugh," 17.
20. Ibid.
21. Janet Kutner, "'El Sibil' to be dedicated," *Dallas Morning News*, November 7, 1976; Grauer to author, November 27, 1990.

Texas Longhorns were Frank Reaugh's favorite subjects. Although the creatures were notoriously wild and belligerent, Reaugh often sketched them in their gentler, more complacent moods. This small sketch may have been used for a slightly larger pastel (6½″ × 7″) entitled *Afternoon Nap*, reproduced in *Frank Reaugh: Painter to the Longhorns*.[29] Although the colored portrait is slightly more of a three-quarter view, the placid expression is the same. The pastel depicts a shaggy, white-faced, pink-nosed bovine with a serene and tranquil expression, thick eyelashes shrouding his closed eyes. The name "Mrs. Onderdonk" written across the bottom of the sepia sketch suggests that it was a small gift to Mrs. Robert Onderdonk.

was too damp or too dry, conditions particularly critical to his pastels.[22] He once wrote, "The effective field of pastel as a medium lies somewhat between those of oil and water color; giving the delicacy of the one or the depth and vigor of the other, with some excellent qualities all its own. No other medium can so truthfully give the freshness and bloom of childhood complexion, or the feeling of air in landscape."[23]

Reaugh produced his own pastel crayons and prepared paper for his work. He maintained that "in pastel painting good material is necessary to get the atmospheric clarity and freshness that constitutes its chief charm. The pastels should be firm, and the paper, board or canvas, however it may vary as to fine or rough surface, should have a sharp and firm tooth. Either too much or too little of the binding medium is bad. In the first case it will not take or hold the color, while in the other, if the sand rubs up under [the] work, the color will be muddy and lifeless." He even shaped his crayons hexagonally for easier handling: "Our pastels are made hexagon in form so that they will not roll about as do round ones. Also because this form fits the fingers better."[24]

The man who carefully safeguarded his paintings in a vault also was discreet in their disposal. Although Reaugh sold numerous paintings in his lifetime, he established a board of trustees to handle his work after his death. These trustees included some of his students, including Reveau Bassett, and other close friends.[25] The Panhandle-Plains Historical Museum in Canyon, Texas, was bequeathed his largest collection of 464

22. Stroud and Dailey, *F. Reaugh*, 112.
23. [Frank Reaugh], *Pastel* (Dallas: The Reaugh Studios, 1927), [2]. Jerry Bywaters Collection, SMU.
24. Ibid., [5].
25. Ledbetter, "Frank Reaugh," 25–26.
26. Grauer to author, November 27, 1990. The Panhandle-Plains Historical Museum now owns 541 works by Reaugh and maintains the only permanent exhibit anywhere.
27. Ledbetter, "Frank Reaugh," passim; Grauer to author, November 27, 1990.
28. Frank Reaugh and Clyde Walton Hill, *Prose Sketches: To Accompany the Series of Paintings by Frank Reaugh Entitled, Twenty-Four Hours With the Herd* (Dallas: Frank Reaugh, 1934): [18].
29. *Frank Reaugh: Painter to the Longhorns*, introduction by Donald L. Weismann (College Station: Texas A&M University Press, 1985), 77.
30. [Reaugh], *Pastel*, [6].

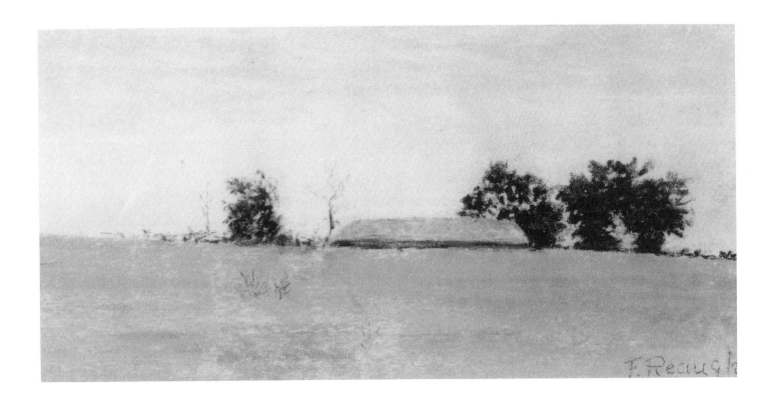

PASTURE, BARN, AND SKY
n.d., Pastel on paper, 4″ × 8″
Signed lower right: F. Reaugh

Frank Reaugh was preoccupied with capturing the vastness of western Texas whether his paintings were large or small. The diminutive proportions of this pastel do not diminish this sensation; they enhance it. He used a base tone of gray for his pastels, saying that "it is neutral and tends to promote harmony of color and an agreeable tone. . . . The inexperienced student is more or less unconscious of the great preponderance of gray in nature."[30] The cool blues and greens in this pastel are typical of his carefully conceived work.

PROVENANCE:
·1986: Collection of Mr. and Mrs. Reveau Bassett.
1986: Collection of Jann and Fred Kline, dealers, SA.
1986: Gift to SAMA by Jann and Fred Kline in honor of Cecilia Steinfeldt.
86–90 G

EXHIBITIONS:
1986: Texas Seen/Texas Made, SAMOA (September 29 to November 30).
1990: Art and Life in Texas in the 1890s, University Art Gallery, University of North Texas, Denton (April 2 to 27).

paintings. Later Judge Hoyet A. Armstrong of Dallas handed down a declaratory judgment ordering Texas Tech University of Lubbock to surrender 217 paintings in their possession to the museum in Canyon, a judgment that to date has not been honored. The Panhandle-Plains Historical Museum considers this a "long-term loan."[26]

The choice of the Canyon Museum to house this important collection was a logical one, for it was at the nearby Palo Duro Canyon and on the surrounding Staked Plains that Reaugh found his greatest inspiration. It was a country Frank Reaugh loved and knew well. The wonderful distances, the intense light, the opalescent coloring, the quiver and glow of the atmosphere, and the witchery of the mirage were subjects that Reaugh transferred to canvas and paper in all their glory.

Reaugh also extended his generosity to the University of Texas, which has acquired a goodly number of his works. The ones he prized most are among them, including a series of seven paintings called *Twenty Four Hours with the Herd* depicting the activities of a herd of Texas Longhorns throughout a day and night. These paintings were given to the university in 1937 but were not formally dedicated to the institution until 1950.[27]

Frank Reaugh died in Dallas on May 6, 1945, leaving in museums and universities a legacy of paintings depicting a vanished era in Texas history. In his own words, he has "passed . . . to the grander heights and fairer plains across the great divide."[28]

HAROLD ARTHUR RONEY

(1899–1936)

Harold Roney was born in Sullivan, Illinois, on November 7, 1899. After serving for a short period in World War I, he attended the Art Institute of Chicago, the Chicago Academy of Fine Arts, and the Glenwood School of Landscape Painting, receiving a thorough academic background in the arts. Later he taught art at a high school in South Bend, Indiana.[1]

In 1925 Roney moved to Houston, Texas, where he worked as a free-lance commercial artist and taught art classes at night in local schools. By 1928, he was in San Antonio, taking an active part in all art affairs in the city as well as the state.[2] In early 1932 Roney was honored with a solo exhibition at the Elisabet Ney Museum in Austin. The exhibition then traveled to the Witte Memorial Museum in March.[3] A welcome addition to San Antonio, he served with Mary Bonner and John Canaday (1907–1980) as a judge for the Local Artists Exhibition in 1933.[4]

Although Roney had adopted Texas as his home and had gained an enviable reputation as a Texas landscapist, he must have felt the need for further instruction. By 1934, he was in Philadelphia studying with John Fulton Folinsbee, NA (1892–1972), and Harry Leith-Ross, NA (1886–?). He also reportedly studied with George Ames Aldrich (1872–1941) and Dawson Dawson-Watson.[5]

While in Philadelphia, Roney was recognized with a one-man show, and shortly after his return to Texas the Business and Professional Women's Club in Austin honored him with an exhibition and formal opening at the State Federation Clubhouse Art Gallery.[6]

Roney painted his earliest Texas landscapes in art colonies in Leon Springs and Kerrville. He liked the Texas Hill Country area so much that in 1943 he purchased fifty acres overlooking the Fredericksburg Road, eleven miles north of San Antonio. Three years later he started to build a house on the site. Materials and labor were still scarce because of World War II, so Roney recruited his wife and a stonemason from the nearby town of Boerne to help him build a cinderblock house. It was reminiscent of homes constructed in frontier Texas; a simple rectangular structure with a ten- by fifty-four-foot porch across the front.[7]

This porch served not only as a room for Roney to paint, but also as a place for him to teach. He also conducted classes in landscape painting for twenty summers at the Ramon Froman School of Art in Cloudcroft, New Mexico.[8]

A member of all local art organizations, Roney also belonged to the American Artists Professional League, the Artists and Craftsmen Associated, the Southern States Art League, and the Texas Fine Arts Association.[9] He was one of two local artists who were included in the 1962 Grand National Exhibition by members of the American Artists Professional League. His work is represented in the collections of the Sullivan Public Library in Illinois; the San Antonio Museum Association; the Austin Public Library; the South Bend Public School in Indiana; and Southwest Texas State University in San Marcos, as well as in many private collections.[10]

Harold Roney died on January 24, 1986, leaving his wife, Aline, and two stepdaughters. Memorial services were conducted by the Reverend Francis Hayward on January 27.[11]

1. Forrester-O'Brien, *Art and Artists*, 186.
2. Ibid.
3. Bess Carroll, "Spring Lives in Museum Exhibit," San Antonio *Light*, March 6, 1932.
4. "Pictures for Exhibition are Picked by Curator," San Antonio *Light*, September 1, 1933.
5. "Tea Marks Opening of Exhibit by Harold Roney, Texas Artist," Austin *American-Statesman*, December 15, 1940.
6. Ibid.
7. June Kilstofte, "House With A View," San Antonio *Express*, February 27, 1949.
8. "Harold Arthur Roney," *North San Antonio Times*, February 13, 1986.
9. Ibid.
10. *Who's Who in American Art: 16th Edition*, s.v. "Roney, Harold Arthur."
11. "Harold Arthur Roney."

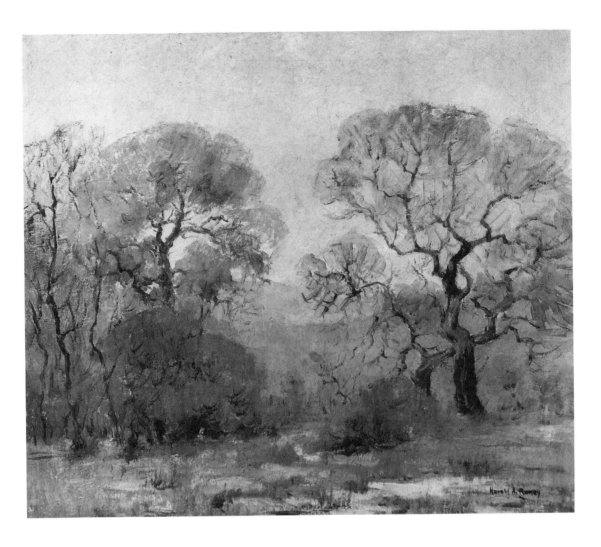

RAINY DAY
n.d., oil on canvas, 24″ × 28″
Signed lower right: Harold A. Roney

Harold Roney captured atmospheric moods in
nature, much like Julian Onderdonk and José
Arpa. Rainy Day has an ethereal quality with
its somber tones and steel-gray sky. It
represents a transitional style in Texas
painting, with less emphasis on realism and
more concern with a semi-abstract, moody
interpretation of nature.

PROVENANCE:
-1933: Collection of the artist.
1933: Purchased by SAMA from the artist with funds
provided by Ruth Coit.
33–6047 P

EXHIBITIONS:
1933: Local Artists Exhibition, WMM (September 3 to
October 1).
1986: Texas Seen/Texas Made, SAMOA (September 29
to November 30).

CHARLES ROSEN, NA

(1878–1950)

Charles Rosen was born in modest circumstances on April 28, 1878, on a farm in Westmoreland County, Pennsylvania, of a Pennsylvania Dutch father and a Scotch-Irish mother. Fine books and paintings were not among his early experiences, and his interest in art dates from a few lessons in drawing before he was sixteen. At that age he opened a photography studio in West Newton, Pennsylvania, and subsequently joined a friend in photography in Salem, Ohio. An inherent aesthetic urge prompted him to study art in New York, where he attended the National Academy of Design as a student of Francis C. Jones (1857–1932) and the New York School of Art under William Merritt Chase and Frank Vincent DuMond. By the time he was twenty he was earning his living as a commercial artist, but he eventually turned to the more challenging field of serious painting.[1]

Rosen won the third Hallgarten prize at the National Academy of Design in 1910 and two years later won the first Hallgarten prize.[2] Awards and honors accumulated rapidly and included the Shaw purchase prize offered by the Salmagundi Club of New York in 1914; honorable mention at the Carnegie Institute in Pittsburgh in 1914; the silver medal at the Panama-Pacific Exposition in San Francisco in 1915; the Inness gold medal of the National Academy of Design in 1916; and the Altman prize of the National Academy of Design in 1916.[3] At age thirty-eight he was elected a full member of the National Academy.[4]

It was about this time that Rosen made the decision to retire to the seclusion of nature to search for a deeper expression. He joined Andrew Dasburg (1887–1979) and Henry Lee McFee at the art colony in Woodstock, New York, and became one of the activists who rebelled against the academic and impressionistic principles associated with the Woodstock school.[5] For nearly ten years he experimented, destroyed, studied, and worked, and succeeded in fashioning his own personal art idiom. Never a complete abstractionist, he used nature, and his paintings developed the power of essentials in an orchestration of line, plane, volume, and color.[6]

By 1925 Rosen was again exhibiting his works and winning more awards, among them the first prize given by the Columbus Art League in 1925 and the Sesnan gold medal awarded by the Pennsylvania Academy of Fine Arts in 1926. His work is represented in many prestigious museums, including the Whitney Museum of American Art in New York City, the Minneapolis Society of Fine Arts, and the Duluth Fine Arts Association, and at the University of Michigan.[7]

Charles Rosen was one of the most distinguished artists to appear on the local scene when he became director of the Witte Museum School of Art in 1940.[8] He was an experienced teacher, having taught at the Art Students League in New York and in Woodstock, and was in charge of the Columbus Gallery of Fine Arts in Columbus, Ohio, for a number of years. A versatile man, he also executed murals for post offices in Beacon and Poughkeepsie, New York, and Palm Beach, Florida, for the Treasury Department.[9]

Rosen was a quiet, mild-mannered man, tolerant, affable, and sympathetic. His students were impressed with the serene strength of his direction and derived mental and spiritual enrichment from working with him.[10] When the Witte Museum School of Art closed its doors because of World War II and Marion McNay established the San Antonio Art Institute, Charles Rosen became the institute's first director. He held this position through 1944.[11] He moved east after retiring and died in 1950.[12]

1. Paul Rodda Cook, "Rosen Pictures at Bright Shawl," San Antonio Express, March 2, 1941; Fielding, Dictionary of American Painters, s.v. "Rosen, Charles."
2. The Third Annual Exhibition of Paintings by American Artists Assembled by the American Federation of Arts, Washington, D.C. (San Antonio: The San Antonio Art League, 1913): 18. It is interesting to note that Charles Rosen's painting, Frozen River; Winter Morning, was included in an exhibition in San Antonio as early as 1913.
3. Fielding, Dictionary of American Painters, s.v. "Rosen, Charles."
4. P. Cook, "Rosen Pictures."
5. Karal Ann Marling, Woodstock: An American Art Colony, 1902–1977 (Poughkeepsie, New York: Vassar College Art Gallery, 1977): n.p.
6. P. Cook, "Rosen Pictures."
7. Fielding, Dictionary of American Painters, s.v. "Rosen, Charles."
8. "New Director of Witte Museum School of Art to Arrive Wednesday," San Antonio Evening News, October 15, 1940.
9. Charles Rosen: Oils and Drawings (San Antonio: Witte Memorial Museum, October 15–November 6, 1940).
10. P. Cook, "Rosen Pictures."
11. Woolford and Quillin, The Story of the Witte Memorial Museum, 122–123.
12. Fielding, Dictionary of American Painters, s.v. "Rosen, Charles."
13. Sigman Byrd, "F. C. Van Duzen to Speak at Witte Sunday," San Antonio Light, February 22, 1942.
14. P. Cook, "Rosen Pictures."

WORKS BY CHARLES ROSEN
NOT ILLUSTRATED:

STILL LIFE
1948, pastel on paper, 16½″ × 14″
Signed lower left: Charles Rosen
Inscribed lower right: To/Betty & Boyer, with/love
and all good wishes/—Charles Rosen
Titled and dated on back: Still Life/1948
90–3 G (2)
Bequest of Elizabeth B. Gonzales (Mrs. Boyer
Gonzales, Jr.).

BEGONIA
n.d., carbon pencil and pastel on paper, 15⅞″ ×
12¾₁₆″
Signed lower left: Charles Rosen

Charles Rosen's drawings show an economy of
line and a masterly use of space and color. He
has said of his own work: "My interest in
most of the subject matter in these drawings
is based to a very large extent upon the
structural interest of the material. By this I
mean—the sequences of line, form and
space, the oppositions of forms and textures
are all so coordinated that the parts seem to
be working together harmoniously toward a
unified and pleasurable experience."[13]

This philosophy is clearly illustrated in
Begonia—a simple plant carelessly staked in an
ordinary pot.

PROVENANCE:
1944–1958: Collection of Robert K. Winn.
1958: Gift to SAMA by Robert K. Winn.
58–417 G (b)

EXHIBITIONS:
1986: Texas Seen/Texas Made, SAMOA (September 29
to November 30).

SUNSET HILL
1944, carbon pencil and pastel on paper,
9½″ × 12¼″
Signed and dated lower left: Charles Rosen—'44

Sunset Hill depicts a scene on the grounds of
the San Antonio Art Institute. It is a typical
Rosen sketch, characterized by well-organized
pattern, interrelated color masses, and clearly
defined design. Done quickly and boldly, the
sure strokes show his mastery of the craft and
illustrate his own personal interpretation of
the subject matter. Rosen's drawings have
been described as being "as far from
photography as graphic art can be."[14]

PROVENANCE:
1944–1958: Collection of Robert K. Winn.
1958: Gift to SAMA by Robert K. Winn.
58–417 G (c)

EXHIBITIONS:
1986: Texas Seen/Texas Made, SAMOA (September 29
to November 30).

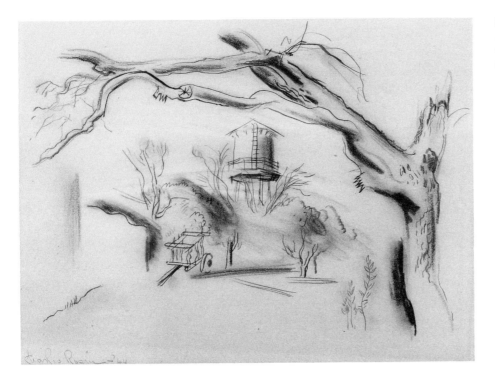

SOLOMAN SALOMAN

Photograph of the stockyards in San Antonio. SAMA Historical Photographic Archives, gift of Mrs. Seth Temple.

THE STOCKYARDS
n.d., oil on canvas, 22" × 30"
Unsigned (attributed)

Simplistic and naive as this painting may be, it illustrates not only an important aspect of the cattle industry, but also a vital phase of San Antonio history. It was painted for George W. Saunders, a lifelong cattleman, who established the Union Stockyards in San Antonio.

George Saunders was the son of Thomas Saunders, who started a cattle ranch in Texas in the 1850s. George Saunders worked on his father's ranch until he left home at seventeen years of age to become a trail driver.[4] In 1880, at the age of twenty-six, he settled in San Antonio. By 1883 he was in the livestock commission business, and eventually started the George W. Saunders Live Stock Commission Company.[5]

A successful man in his field, Saunders undoubtedly cherished the painting of The Stockyards as a reflection of his own accomplishments. An inscription on the back of the canvas describes the scene as livestock left in the yards at the end of the trail by cowhands who had gone into town to celebrate. Stockyard help cared for the cattle until the trail drivers returned. Although the painting technique is crude, the accuracy of the perspective in the corral layout indicates that a photograph was used. In 1985 Mrs. Seth Temple, granddaughter of George Saunders,

presented a photograph which the artist obviously employed for his rendition to the Association from family memorabilia. Although it is unsigned, the heavy brush-strokes, somber colors, and photographic precision suggest that this painting is the work of Soloman Saloman.

This canvas was inherited by Saunders's son-in-law, C. D. Cannon, who also fell heir to the George W. Saunders Live Stock Commission Company. When Cannon closed his office on August 31, 1959, he presented the painting to the San Antonio Museum Association.[6]

PROVENANCE:
-1959: Collection of the Saunders-Cannon Family.
1959: Gift to SAMA by C. D. Cannon.
59–112 G

EXHIBITIONS:
1978–1979: A Survey of Naive Texas Artists, WMM (December 17, 1978, to March 1, 1979).

PUBLICATIONS:
Steinfeldt, "The Folk Art of Frontier Texas," The Magazine Antiques, 114 (December 1978): 1285.
N. Cook, "19th Century Frontier Art," San Antonio Magazine, 13 (January 1979): 31.
Steinfeldt, "Simple Self-Expression," Southwest Art, 10 (September 1980): 62.
Steinfeldt, Texas Folk Art (1981), 84.

1. Loyd Ray Taylor (Dallas) to author (SA), October 1, 1980.
2. A Historical Exhibition: Oil Portraits of Mayors of San Antonio, 1838–1939 (San Antonio: San Antonio Press Club, 1962): 2.
3. William J. Battle, "A Note on the Barker Texas History Center," The Southwestern Historical Quarterly, 59 (April 1956): 499.
4. Davis and Grobe (eds. and comps.), The New Encyclopedia of Texas, s.v. "George W. Saunders," 506.
5. Ibid.
6. C. D. Cannon Gift Contract, SAMA Registrar's Records.
7. Webb, Carroll, and Branda (eds.), The Handbook of Texas, 2, s.v. "Sour Lake, Texas," and "Sour Lake Oil Field."
8. Information provided by the donor, SAMA Registrar's Records.

Soloman Saloman specialized in portraiture, with his known paintings apparently done from photographs. Aesthetically they leave much to be desired, but they are important for their historical content.

Saloman's name appears in the Houston city directories from 1910 through 1920. Although there is little evidence that he had any formal training, he and Robert C. Lehman (n.d.) advertised themselves as portrait artists in 1912.

Saloman may have moved from place to place as commissions demanded, for the 1914 San Antonio city directory lists an S. Saloman. The name occurs again twenty years later as Solly Salomon, artist, residence, 810 West King's Highway. By 1936 his address had changed to 920 Aganier Avenue. Many of his paintings are in San Antonio, Houston, and Dallas.[1]

Saloman painted numerous portraits, now in the possession of the San Antonio Conservation Society, of the city's mayors, as well as of some of the community's prominent citizens.[2] He also did a portrait of Ashbel Smith, currently in the Eugene C. Barker Texas History Center at the University of Texas in Austin.[3]

MR. AND MRS. AMBROSE JACKSON OF
SOUR LAKE, TEXAS
n.d., oil on canvas, 25" × 35"
Signed and inscribed lower right: S. Saloman, Houston, Texas

This double portrait of Mr. and Mrs. Jackson is one of the artist's most effective and pleasing paintings. Probably taken from a snapshot or photograph, it shows a typical Texas couple seated in the yard of their ranch home. The elderly pair seem relaxed, contented, and satisfied with their life.

The Jackson ranch was in Hardin County, near Sour Lake, originally called Sour Lake Springs because of the mineral springs that fed the lake. It also was near the Sour Lake Oil Field, opened in 1901 after the success at the Spindletop Oil Field.[7] The Jacksons were the owners of the Z U brand.[8]

PROVENANCE:
-1969: Collection of the Jackson-Crosbie Family.
1969: Gift to SAMA by Nora Crosbie.
69–134 G

EXHIBITIONS:
1978–1979: A Survey of Naive Texas Artists, WMM (December 17, 1978, to March 1, 1979).
1986: Texas Seen/Texas Made, SAMOA (September 29 to November 30).

PUBLICATIONS:
"Texas Seen-Texas Made," *Current Events*, September 25, 1986.

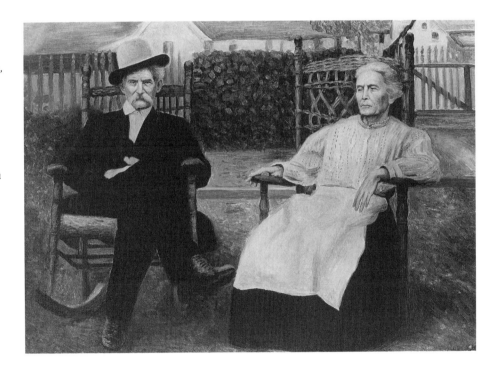

WILLIAM G. M. SAMUEL

Early nineteenth-century Texas attracted people of bold spirit and adventurous character. William G. M. Samuel was such a person. Born in Missouri in 1815, he came to Texas sometime in the late 1830s, shortly after the fall of the Alamo.[1] He served as an Indian fighter with another colorful Texan, "Big Foot" Wallace, and later fought in the Mexican War (1846–1848) with General John E. Wool's Army of the Chihuahua.[2] When hostilities ceased Samuel returned to his home in San Antonio and became a law officer. During the Civil War he was a captain of artillery and was connected with the Quartermaster Department of the Confederate States Army.[3] A description from this time says, "Captain W. G. M. Samuels [sic] in his brilliant uniform and red sash made the rounds of inspecting officer only to find that Frank Huntress, the fireman, always kept everything in fine condition."[4]

After the Civil War Samuel was elected justice of the peace on the Medina and lived at the Garza Crossing, situated a mile from Enoch Jones's "Castle on the Medina." Samuel chose the site because he thought that raiding Indians might cross the river at that point.[5] This was the site of the last big Indian battle fought in that region of the state.

Samuel was also a city marshal in 1852 and a county court commissioner in 1877, and served as a deputy sheriff and notary public from about 1881 until 1900 under Bexar County Sheriffs Thomas F. McCall, Nat Lewis, and John Campbell.[6] During these years he was frequently called upon to act as auctioneer in sheriffs' sales.[7] An obituary called him "one of the best known characters in this city . . . a dead shot and . . . by common consent the bravest man of his day in this section. . . . " He was reputedly an excellent marksman and absolutely fearless.[8]

Although Samuel was a soldier and lawman by profession, he was an artist by choice. With no academic training, he provided valuable visual records of early San Antonio, specifically his four views of the Main Plaza in 1849. Although his views probably were painted for his own pleasure, they were hung in the halls of the second floor of the Bexar County Courthouse.[9] In 1888 a newspaper reported that he had exhibited "two very fine oil paintings" at the First San Antonio International Exposition.[10]

Very little is known about Samuel's personal life. He died on November 7, 1902, in the St. Francis Home for the Aged and was buried in the Confederate Cemetery in San Antonio.[11] His death may have been precipitated by a dose of household ammonia administered as an antidote for a tarantula bite.[12]

1. Utterback, Early Texas Art, 1.
2. Pinckney, Painting in Texas, 30.
3. Utterback, Early Texas Art, 1.
4. "Reminiscences," in History and Guide of San Antonio, Tex. (n.p., n.d. [Published in San Antonio, ca. 1892]): 63.
5. "Rock Mansion, Built 60 Years Ago, Still Stands," Frontier Times, 8 (October 1930): 42–46.
6. Utterback, Early Texas Art, 1.
7. "Paintings of W. G. M. Samuels [sic]," San Antonio Daily Express, May 16, 1900.
8. "The Death of Two Pioneers," San Antonio Daily Express, November 8, 1902.
9. "Paintings of W. G. M. Samuels [sic]."
10. "Out at the Fair," San Antonio Daily Express, November 16, 1888.
11. "The Death of Two Pioneers."
12. Eleanor Onderdonk to Judge Charles Anderson (SA), July 14, 1945.
13. Pinckney, Painting in Texas, 31.
14. Kenneth M. Newman (ed.), The Old Print Shop Portfolio, 33 (n.d.): front cover.
15. Carol Clark, "Charles Deas," in American Frontier Life: Early Western Painting and Prints (New York: Abbeville Press, Publishers, 1987), 60–62.

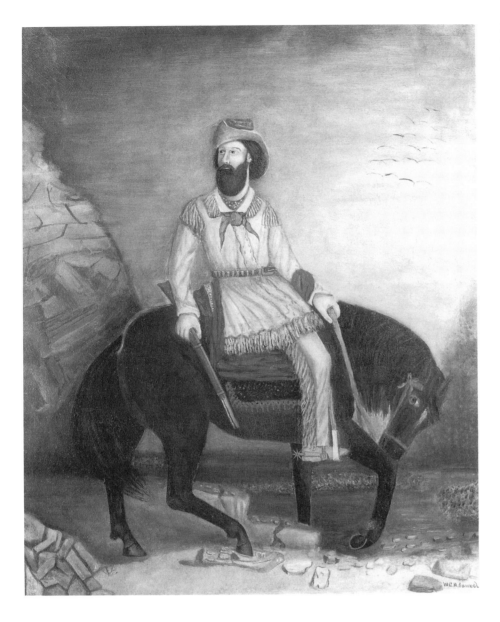

MAN ON HORSEBACK
n.d., oil on canvas, 32½″ × 27¼″
Signed lower right: W. G. M. Samuel

The title Man on Horseback has been arbitrarily applied to this painting. The jet-black hair, the outdoor attire, and the comparatively modest size of the canvas suggest that this may be the self-portrait to which Pauline Pinckney refers in her book Painting in Texas.[13]

Whomever Samuel meant to portray, he obviously was influenced by The Trapper, a well-known portrait of the period by Charles Deas (1818–1867). In about 1855 M. Knoedler issued nationally a colored lithograph of Deas's painting, which Samuel possibly owned since the subject matter surely would have appealed to him.[14] Samuel's version is naive in execution, as are his other paintings, because of his lack of artistic training. Nevertheless his knowledge of frontier apparel is evident. Between his painting and that of Deas are subtle differences, such as the saddle blanket.

Charles Deas produced a number of paintings of this subject with slight variations in detail. Besides The Trapper, there were The Rocky Mountain Man and Long Jacques or Long Jakes.[15]

PROVENANCE:
-1978: Collection of the DRT Library at the Alamo, SA.
1978: Extended Loan to SAMA by the DRT Library.
78–527 L

EXHIBITIONS:
1978–1979: A Survey of Naive Texas Artists, WMM (December 17, 1978, to March 1, 1979).
1979–1980: A Survey of Naive Texas Artists, Traveling Exhibition: The Museum of Fine Arts, Houston (April 11 to May 27, 1979). Laguna Gloria Art Museum, Austin (June 9 to July 23, 1979). Tyler Museum of Art (July 31 to September 9, 1979). Lufkin Historical and Creative Arts Center (September 24 to November 15, 1979). The Art Center, Waco (April 15 to May 30, 1980).
1986: Texas Seen/Texas Made, SAMOA (September 29 to November 30).

PUBLICATIONS:
"Naive Artists," The Daily Texan (Austin), June 7, 1979.
SAMA Ninth Annual Game Dinner Invitation and Program (October 29, 1979): cover.
Steinfeldt, "Simple Self-Expression," Southwest Art, 10 (September 1980): 57.
Steinfeldt, Texas Folk Art (1981), dust jacket, 24.
Willoughby, Texas, Our Texas (1987), 168.

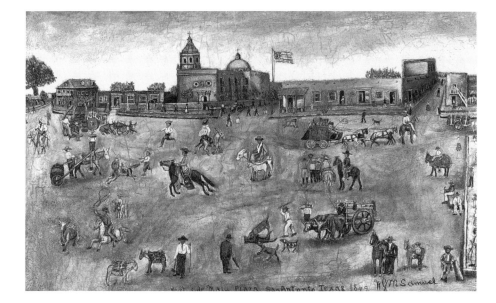

WEST SIDE MAIN PLAZA, SAN ANTONIO,
TEXAS
1849, oil on canvas mounted on panel,
22″ × 36″
Signed lower right: W. G. M. Samuel
Titled and dated lower center: West Side Main
Plaza, San Antonio, Texas, 1849

Samuel's four views of the Main Plaza in San
Antonio are his most important paintings,
not for their aesthetic value, but rather for
their candid visual documentation of the
plaza and the social functions that took place
within it. The west side view shows the
church of San Fernando, the heart of San
Antonio. When the first civilian settlers, the
Canary Islanders, planned the city in the early
eighteenth century, the doorway of the
church was the point from which all streets
radiated.[16]

When Samuel pictured it in 1849, the
plaza was the nucleus of activity within
the small community of San Antonio. A
stagecoach rattles across the square, water
and wood vendors are plying their goods,
a cowboy lassoes a roaming steer, and a
gentleman with an umbrella is witnessing
a dogfight.

PROVENANCE:
-1945: Bexar County.
1945: Extended Loan to SAMA by Bexar County.
72–27 L (3)

EXHIBITIONS:
1946: Early San Antonio Paintings, WMM (February 24
to March 12).
1958: Mission Summer Festival, Mission Concepción,
SA (June 13 to 22).
1964: The Early Scene: San Antonio, WMM (June 7 to
August 31).
1967: Painting in Texas: The Nineteenth Century,
ACMWA (October 5 to November 26).
1967–1968: Painting in Texas: The Nineteenth Century,
The Academic Center, University of Texas at Austin
(December 9, 1967, to January 31, 1968).

1978–1979: A Survey of Naive Texas Artists, WMM
(December 17, 1978, to March 1, 1979).
1979–1980: A Survey of Naive Texas Artists, Traveling
Exhibition: The Museum of Fine Arts, Houston (April
11 to May 27, 1979). Laguna Gloria Art Museum,
Austin (June 9 to July 23, 1979). Tyler Museum of Art
(July 31 to September 9, 1979). Lufkin Historical and
Creative Arts Center (September 24 to November 15,
1979). The Art Center, Waco (April 15 to May 30,
1980).
1986: Texas Seen/Texas Made, SAMOA (September 29
to November 30).
1988: The Art and Craft of Early Texas, WMM (April
30 to December 1).
1988: A Witte Merry Christmas: Tannenbaums to
Tumbleweeds, WMM (December 1 to 30).

PUBLICATIONS:
"Texas in Pictures," The Magazine Antiques, 53 (June
1948): 457.
"Tuesday Lectures at Witte to tell S.A. Story," San
Antonio Express, October 25, 1953.
Fairfax Downey and Paul M. Angle, Texas and the War
with Mexico (1961), 58–59.
Pinckney, Painting in Texas (1967), plate c-3, opposite 28.
Utterback, Early Texas Art (1968), 4.
Remy, "Hispanic-Mexican San Antonio," Southwestern
Historical Quarterly, 71 (April 1968): plate 2.
Kownslar, The Texans (1972), cover, 250–251.
Noonan-Guerra, San Fernando (1977), cover, 44.
Story of the Great American West (1977), 141.
Fehrenbach, The San Antonio Story (1978), 76.
Steinfeldt, "The Folk Art of Frontier Texas," The
Magazine Antiques, 114 (December 1978): 1287.
Pearson et al., Texas: The Land and Its People (2nd ed.,
1978), 378.
Susie Kalil, "Texas Naive," Artweek (May 5, 1979): 8.
Robert Bishop, Folk Painters of America (1979), 224.
Steinfeldt, "Simple Self-Expression," Southwest Art, 10
(September 1980): 56.
Steinfeldt, Texas Folk Art (1981), 21.

Southern Living, The Southern Heritage Company's Coming!
Cookbook (1983), 35.
Holmes, Texas: A Self-Portrait (1983), 34.
Rosson, "More than Bluebonnets," in Sentinel
(December 1984): 27.
Pearson et al., Texas: The Land and Its People (3rd ed.,
1987), dust jacket, 326.
Alice Gordon, Jerry Camarillo Dunn, Jr., and Mel
White, The Smithsonian Guide to Historic America (1990),
42–43.

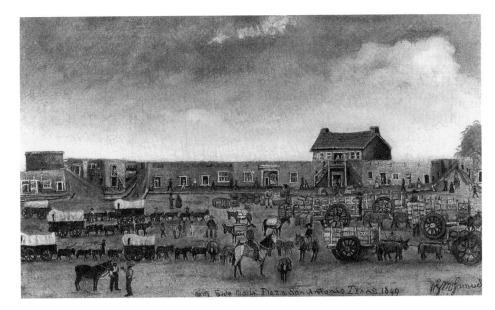

NORTH SIDE MAIN PLAZA, SAN ANTONIO,
TEXAS
1849, oil on canvas mounted on panel,
22⅛" × 36⅛"
Signed lower right: W. G. M. Samuel
Titled and dated lower center: North Side Main
Plaza, San Antonio, Texas, 1849

The north side of the Main Plaza in Samuel's painting shows a two-story structure, the Plaza House, which was built by William Elliott in 1847 and was San Antonio's first genuine hotel. The hotel was the scene of many dramatic events. When Governor Sam Houston was crusading to keep Texas in the Union just before the Civil War, he was cheered by an enthusiastic crowd when he appeared upon the balcony. Ironically, a year later, in 1861, the hotel was the site where General David Emmanuel Twiggs surrendered all federal forces and government stores under his command to the Confederate authorities led by Ben McCulloch. The hotel also served as a stop for stagecoaches bound for San Diego, California.[17]

In this view, however, Samuel illustrated San Antonio's most thriving business at the time, freighting. Oxen first were used to draw these heavy freighting wagons but later were replaced by mules.[18] It is interesting that the artist depicted both mule teams and ox-drawn carts.

The freighting masters had to be fearless, physically rugged, honest, and responsible. They were required to haul all manner of cargo, from staples and stock to luxury items and silver. Teamsters faced appalling obstacles: Indian raids, renegade thieves, rough terrain with little water, wagon breakdowns, and unpredictable Texas weather.[19] Samuel appears to have felt a close kinship with these men, as he filled the painting with his freighting companions.

PROVENANCE:
-1945: Bexar County.
1945: Extended Loan to SAMA by Bexar County.
72–27 L (4)

EXHIBITIONS:
1946: Early San Antonio Paintings, WMM (February 24 to March 12).
1958: Mission Summer Festival, Mission Concepción, SA (June 13 to 22).
1964: The Early Scene: San Antonio, WMM (June 7 to August 31).
1978–1979: A Survey of Naive Texas Artists, WMM (December 17, 1978, to March 1, 1979).
1979–1980: A Survey of Naive Texas Artists, Traveling Exhibition: The Museum of Fine Arts, Houston (April 11 to May 27, 1979). Laguna Gloria Art Museum, Austin (June 9 to July 23, 1979).Tyler Museum of Art (July 31 to September 9, 1979). Lufkin Historical and Creative Arts Center (September 24 to November 15, 1979). The Art Center, Waco (April 15 to May 30, 1980).
1986: Texas Seen/Texas Made, SAMOA (September 29 to November 30).
1988: The Art and Craft of Early Texas, WMM (April 30 to December 1).
1988: A Witte Merry Christmas: Tannenbaums to Tumbleweeds, WMM (December 1 to 30).

PUBLICATIONS:
"Texas in Pictures," The Magazine Antiques, 53 (June 1948): 457.
Utterback, Early Texas Art (1968), 5.
"'Stain' Art at Museum," San Antonio Light, March 24, 1974.
Steinfeldt, "The Folk Art of Frontier Texas," The Magazine Antiques, 114 (December 1978): 1287.
Steinfeldt, Texas Folk Art (1981), 25.

16. John Babcock, "First Zoning Plan for S. A. 200 Years Old," San Antonio Light, August 4, 1938; Lota M. Spell (trans. and ed.), "The Grant and First Survey of the City of San Antonio," Southwestern Historical Quarterly, 66 (July 1962): 73–89.
17. C. Ramsdell, San Antonio (1959), 114–115.

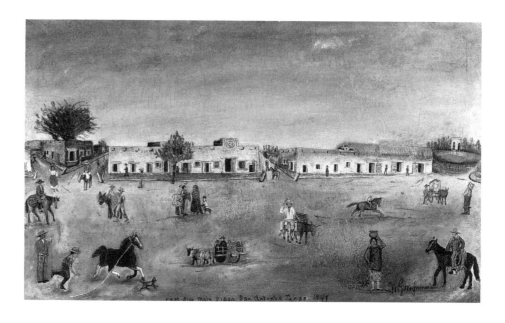

EAST SIDE MAIN PLAZA, SAN ANTONIO,
TEXAS
1849, oil on canvas mounted on panel,
22" × 36"
Signed lower right: W. G. M. Samuel
Titled and dated lower center: East Side Main
Plaza, San Antonio, Texas, 1849

The east side of the Main Plaza in 1849
harbored numerous stores and dwellings. It
had one building with a clock tower. The
seat of local government, it was called the
Casas Reales and housed the small community's
constabulary. Later known as "The Council
House," it was the first courthouse in Texas.[20]

 Samuel also indicated another impor-
tant site on the far right side of his canvas.
"Bowen's Island," actually a bend in the
San Antonio River, was where the town's
first post office stood. The island was named
after John Bowen, one of San Antonio's first
postmasters. There is some confusion about
Bowen's name, since he was born Ralph
William Peacock but had his name changed
to Bowen at the dying request of a half-
brother of that name.[21]

 True to form, the artist dotted the
foreground with San Antonians engaged in
various pursuits and activities.

PROVENANCE:
-1945: Bexar County.
1945: Extended Loan to SAMA by Bexar County.
72–27 L (1)

EXHIBITIONS:
1946: Early San Antonio Paintings, WMM (February 24
to March 12).
1958: Mission Summer Festival, Mission Concepción,
SA (June 13 to 22).
1964: The Early Scene: San Antonio, WMM (June 7 to
August 31).
1967: Painting in Texas: The Nineteenth Century,
ACMWA (October 5 to November 26).

1967–1968: Painting in Texas: The Nineteenth Century,
The Academic Center, University of Texas at Austin
(December 9, 1967, to January 31, 1968).
1978–1979: A Survey of Naive Texas Artists, WMM
(December 17, 1978, to March 1, 1979).
1979–1980: A Survey of Naive Texas Artists , Traveling
Exhibition: The Museum of Fine Arts, Houston (April
11 to May 27, 1979). Laguna Gloria Art Museum,
Austin (June 9 to July 23, 1979). Tyler Museum of Art
(July 31 to September 9, 1979). Lufkin Historical and
Creative Arts Center (September 24 to November 15,
1979). The Art Center, Waco (April 15 to May 30,
1980).
1986: Texas Seen/Texas Made, SAMOA (September 29
to November 30).
1988: The Art and Craft of Early Texas, WMM (April
30 to December 1). 1988: A Witte Merry Christmas:
Tannenbaums to Tumbleweeds, WMM (December 1
to 30).

PUBLICATIONS:
Chabot, *With the Makers of San Antonio* (1937), opposite
142.
Martha Utterback, "Witte Art Activities," *Witte
Quarterly*, 3 (1965): 11.
Pinckney, *Painting in Texas* (1967), 31: plate 11.
Wayne Gard, "Life in the Land of Beginning Again,"
The American West, 5 (May 1968): 47.
Wayne Gard, "Life in the Land of Beginning Again,"
in *The Republic of Texas* (1968), 47.
Utterback, *Early Texas Art* (1968), 2.
Steinfeldt, "The Folk Art of Frontier Texas," *The
Magazine Antiques*, 114 (December 1978): 1286.
Steinfeldt, *Texas Folk Art* (1981), 28.
Paola L. Zinnecker (ed.), *Our Texas* (1985), 63.
James, *The Raven* (1929; reprint, 1990), back endpaper.

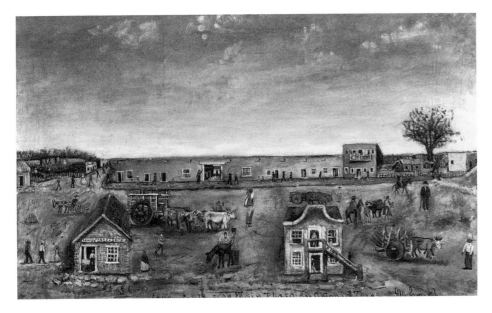

SOUTH SIDE MAIN PLAZA, SAN ANTONIO,
TEXAS
1849, oil on canvas mounted on panel,
21⅛" × 35⅛"
Signed lower right: W. G. M. Samuel
Titled and dated lower center: South Side
Main Plaza, San Antonio, Texas, 1849

In Samuel's view of the south side of the Main Plaza, Bowen's Island again appears, but at the extreme left. The row of simple one-story buildings in the background is relieved by a two-story structure, the Garza House, later the Reed Hotel.[22] The most interesting feature is the presence of two business houses placed prominently in the foreground on the plaza proper. The firm of Lewis and Groesbeck [Groesbeeck] sold dry goods, groceries, and other merchandise and may have kept much of their stock in the long, low building in back. According to a newspaper article, the building in the foreground labeled "Lewis and Groesbeck" once served as the newspaper office of J. P. Newcomb but was burned to the ground in 1861.[23] The two-story building was Bryan Callaghan's store and carried a general stock of merchandise. The outside stairwell suggests that there might have been living quarters on the second level.[24]

Some have wondered if these four views of Main Plaza were executed in 1849 or if they were painted later, from memory and possibly from early photographs or engravings.[25] That Samuel's other paintings bear later dates might lend credence to this hypothesis. Nevertheless, the artist obviously was a keen observer of early San Antonio.

PROVENANCE:
-1945: Bexar County.
1945: Extended Loan to SAMA by Bexar County.
72-27 L (2)

EXHIBITIONS:
1946: Early San Antonio Paintings, WMM (February 24 to March 12).
1958: Mission Summer Festival, Mission Concepción, SA (June 13 to 22).
1964: The Early Scene: San Antonio, WMM (June 7 to August 31).
1978-1979: A Survey of Naive Texas Artists, WMM (December 17, 1978, to March 1, 1979).
1979-1980: A Survey of Naive Texas Artists, Traveling Exhibition: The Museum of Fine Arts, Houston (April 11 to May 27, 1979). Laguna Gloria Art Museum, Austin (June 9 to July 23, 1979). Tyler Museum of Art (July 31 to September 9, 1979). Lufkin Historical and Creative Arts Center (September 24 to November 15, 1979). The Art Center, Waco (April 15 to May 30, 1980).
1986: Texas Seen/Texas Made, SAMOA (September 29 to November 30).
1988: The Art and Craft of Early Texas, WMM (April 30 to December 1).
1988: A Witte Merry Christmas: Tannenbaums to Tumbleweeds, WMM (December 1 to 30).

PUBLICATIONS:
Ward, Cowboys and Cattle Country (1961), 22–23.
Utterback, Early Texas Art (1968), 3.
Kownslar, The Texans (1972), 280–281.
Ginger Dutcher and Esther Curnutt, San Antonio: Reflections of the Last Two Hundred Years (1976), 19.
Fehrenbach, The San Antonio Story (1978), 76.
Steinfeldt, "The Folk Art of Frontier Texas," The Magazine Antiques, 114 (December 1978): 1286.
Steinfeldt, Texas Folk Art (1981), 29.
Steinfeldt, "Texas Folk Art," Antique Review, 14 (September 1988): 25.

18. "Pioneer Freighters," San Antonio Express, August 18, 1935.
19. Helen Raley, "The House of the Tree," San Antonio Express, August 14, 1927.
20. Richard G. Santos, San Antonio de Bexar, 1 de Enero 1836 (San Antonio: Privately published, ca. 1963), [2].
21. Barnes, Combats and Conquests, 202.
22. "Paintings of W. G. M. Samuels [sic]"; Utterback, Early Texas Art, 2.
23. "Paintings of W. G. M. Samuels [sic]."
24. Everett, San Antonio, 26–28.
25. Ibid.

PORTRAIT OF SAM HOUSTON
n.d., oil on canvas, 60¼″ × 41″
Signed lower center: W. G. M. Samuel

Samuel's portrait of Sam Houston, executed
on a grand and majestic scale, indicates his
admiration for this leader. Certainly Houston's
imposing physical bearing, dauntless courage,
reputation as a valiant soldier and leader,
and outstanding role in Texas history would
have appealed to Samuel. Samuel used as a
reference a well-known photograph made in
1856 by Frederick, a New York photographer,
when Houston was a member of the United
States Senate.[26] In the photograph Houston is
attired sedately in a somber shawl. Samuel,
obviously knowing of Houston's penchant
for wearing Indian blankets even while in
Washington, substituted a colorful Mexican
serape.[27] Samuel's painting, naive as it may be,
reflects Houston's description: "Houston stood
six feet six inches in his socks, was of fine
contour, a remarkably well proportioned
man, and of commanding and gallant bearing;
had a large, long head and face and his fine
features were lit up by large eagle-looking
eyes. . . . "[28]

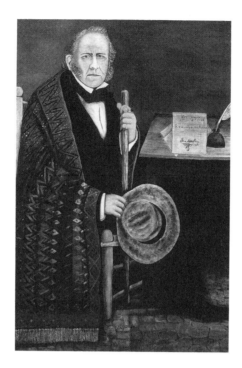
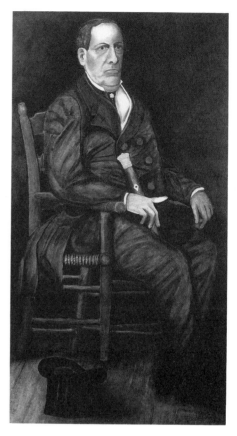

PROVENANCE:
-1977: Collection of A. D. Callahan.
1977: Purchased by SAMA from A. D. Callahan with
Witte Picture and Blaffer Foundation Funds.
77–882 P

EXHIBITIONS:
1978–1979: A Survey of Naive Texas Artists, WMM
(December 17, 1978, to March 1, 1979).
1979–1980: A Survey of Naive Texas Artists, Traveling
Exhibition: The Museum of Fine Arts, Houston (April
11 to May 27, 1979). Laguna Gloria Art Museum,
Austin (June 9 to July 23, 1979). Tyler Museum of Art
(July 31 to September 9, 1979). Lufkin Historical and
Creative Arts Center (September 24 to November 15,
1979).The Art Center, Waco (April 15 to May 30,
1980).
1986: Texas Seen/Texas Made, SAMOA (September 29
to November 30).

PUBLICATIONS:
"Few Can Identify Painting of Mayor During Civil
War," San Antonio Express, March 15, 1935.
Crossley, "Folk Art of the Frontier," *The Magazine of
San Antonio*, 2 (January 1979): 30.
SAMA *Calendar of Events* (November 1981): [2].
Steinfeldt, *Texas Folk Art* (1981), 22.
Steinfeldt, "Texas Folk Art," *Antique Review*, 14
(September 1988): 28.

26. M. James, *The Raven*, frontispiece.
27. Ibid., 136.
28. Ibid., 68.
29. Pease, *They Came to San Antonio*, s.v. "Buquor, Col.
[Paschal] Leo."
30. "Witnessed Last Struggle of the Alamo Patriots,"
San Antonio *Daily Express*, July 19, 1907.
31. Colonel Harry McCorry Henderson, *Colonel Jack
Hays: Texas Ranger* (San Antonio: The Naylor
Company, 1954), 26–27.
32. Pease, *They Came to San Antonio*, s.v. "Buquor."
33. Ibid.; Corner, *San Antonio de Bexar*, 33.
34. Carpenter, *Seventh Census of the United States*, 175.
35. Advertisement, San Antonio *Tri-Weekly Alamo
Express*, February 6, 1861.
36. Pease, *They Came to San Antonio*, s.v. "Buquor."
37. "For Mayor," San Antonio *Semi-Weekly News*,
December 22, 1862.
38. "City Election," San Antonio *Semi-Weekly News*,
December 29, 1862; Pease, *They Came to San Antonio*,
s.v. "Buquor."
39. Pease, *They Came to San Antonio*, s.v. "Buquor."
40. Vinton Lee James, *Frontier and Pioneer Recollections of
Early Days in San Antonio and West Texas* (San
Antonio: Privately published, 1938), 39–40.
41. Walter Prescott Webb, *The Texas Rangers: A
Century of Frontier Defense* (Boston: Houghton Mifflin
Company, 1935), 87.
42. Steinfeldt, *San Antonio Was*, 198.

(*Opposite page*) PORTRAIT OF
MAYOR PASQUAL LEO BUQUOR
1889, oil on canvas, 70″ × 34″
Signed and dated lower right: W. G. M. Samuel/
Nov. 1889

Pasqual Leo Buquor, whose parents had
emigrated from France, was born in New
Orleans in 1821. Buquor came to Texas in 1838
and served in the Cherokee Campaign under
General Thomas Jefferson Rusk. By 1840 he
was in San Antonio as an officer in the
Commissary Department of the United States
Army.[29] One year later he married María
Jesús Delgado. The couple spent their
honeymoon in New Orleans, and upon their
return to San Antonio Buquor resigned from
the army and spent a term as a mail rider.[30]

During the early part of 1841 Buquor
joined a provisional company of Texas
Rangers organized by Colonel Jack Hays. The
small company had been specially formed to
avenge the death of two San Antonio traders
who had been killed by Mexican bandits. On
April 7 the group met a Mexican force under
the command of Captain García and defeated
the Mexicans after a heated battle at close
quarters.[31] For his service to Texas, Buquor
was granted land on Calaveras Creek, about
eight miles east of Mission San José.[32]

Buquor became involved in municipal
affairs, and in 1844 was championing public
education. In 1846 he held the office of city
marshall.[33] In the Bexar County Census of 1850
he was listed as a farmer, worth $6,000, with
four children, two boys and two girls.[34]

Shortly before the Civil War Buquor
advertised himself in the San Antonio news-
papers as a notary public and agent for the
sale and purchase of real estate as well as
justice of the peace. He also transcribed
and translated Spanish "in the shortest
order. . . ."[35] In 1861 he served as alderman
on the City Council until the outbreak of the
Civil War when, as a captain, he organized
a volunteer company. He first was ordered
to Camp Verde but shortly thereafter to
Brownsville. His wife accompanied him on
both assignments.[36]

In December 1862 Buquor, again in San
Antonio, ran successfully for mayor against
Thomas Handee.[37] He assumed office on
January 1, 1863, and held office for two
years.[38] After his term as mayor he returned
to being a notary public and translator and in
1867 was appointed city assessor. He also was
employed as an interpreter in Federal Court.

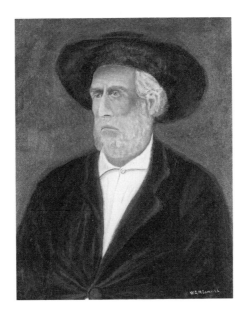

Evidently Buquor lived on his property
outside San Antonio and conducted his busi-
ness on an itinerant basis. In 1891 he retired
permanently to his home in Floresville,
where he died after a long illness in 1901.[39]

Samuel chose to paint a life-size portrait
of Buquor. He depicted a man with stern
features and rugged physique, carefully
attired in formal clothing. The likeness tallies
with Vinton Lee James's description of
Buquor delivering a eulogy for a Confederate
soldier: "Mayor Buquor, a large fleshy,
goodlooking gentleman, who was dressed in
a long-tailed coat and a suit of somber black,
was master of ceremonies. He made an
eloquent speech in a deep, pleasing bass voice
in which he eulogized the dead as having
been a brave soldier who gave his life that his
country might live."[40]

PROVENANCE:
-1977: Collection of A. D. Callahan.
1977: Purchased by SAMA from A. D. Callahan with
Witte Picture and Blaffer Foundation Funds.
77–883 P

EXHIBITIONS:
1978–1979: A Survey of Naive Texas Artists, WMM
(December 17, 1978, to March 1, 1979).

PUBLICATIONS:
"Few Can Identify Painting of Mayor During Civil
War," San Antonio *Express*, March 15, 1935.
SAMA Bi-Annual *Report*, 1976–1978, 68.
Steinfeldt, *Texas Folk Art* (1981), 26.

PORTRAIT OF "BIG FOOT" WALLACE
1899, oil on canvas, 31¼″ × 26¾″
Signed lower right: W. G. M. Samuel
Inscribed on reverse: Devine, Texas/Jany 7, 1899/
Bigfoot Wallace died this morning/at 10 o'clock
am/after an illness/of about one week/He came
to Texas in 1837

William Alexander Anderson Wallace, better
known as "Big Foot," and William Samuel
were friends and kindred spirits. Both served
in the Mexican War and the Confederacy, and
as Indian fighters. There are varying accounts
of how Wallace acquired the sobriquet of
"Big Foot," most of them fostered by Wallace
himself. He was undoubtedly one of Texas's
most colorful characters, and historian Walter
Prescott Webb has said of the man: "His giant
stature and childlike heart, his drollery and
whimsicalness endeared him to the frontier
people. His inexhaustible fund of anecdotes
and a quaint style of narrative, unspoiled by
courses in English composition, made him
welcome by every fireside."[41]

Samuel's *Portrait of "Big Foot" Wallace*,
undoubtedly done out of respect and
admiration for his colleague, may have been
his last artistic effort. The portrait was
apparently based upon a photograph of
Wallace made by A. A. Brack in 1899, even
though the image does not show Wallace
with a beard.[42]

PROVENANCE:
-1945: Bexar County.
1945: Extended Loan to SAMA by Bexar County.
72–27 L (5)

EXHIBITIONS:
1946: Early San Antonio Paintings, WMM (February 24
to March 12).
1964: The Early Scene: San Antonio, WMM (June 7 to
August 31).
1978–1979: A Survey of Naive Texas Artists, WMM
(December 17, 1978, to March 1, 1979).
1979–1980: A Survey of Naive Texas Artists, Traveling
Exhibition: The Museum of Fine Arts, Houston (April
11 to May 27, 1979). Laguna Gloria Art Museum,
Austin (June 9 to July 23, 1979). Tyler Museum of Art
(July 31 to September 9, 1979). Lufkin Historical and
Creative Arts Center (September 24 to November 15,
1979).The Art Center, Waco (April 15 to May 30,
1980).

PUBLICATIONS:
Utterback, *Early Texas Art* (1968), 6.
Paul Rossbach, "Works of Early Texas Artists On
Display at Witte Museum," San Antonio *Light*,
December 3, 1978.
Crossley, "Folk Art of the Frontier," *The Magazine of
San Antonio*, 2 (January 1979): 29.
Steinfeldt, *Texas Folk Art* (1981), 23.

L. SCHLOSS

L. Schloss, who painted the Quien Sabe Ranch scene, was an itinerant artist who traveled around the countryside producing canvases for affluent citizens.[1] He probably specialized in genre scenes of local ranches, judging from the large size and the ambience of the Quien Sabe Ranch painting.

This painting is his only known work, however, and he probably had little training in the academic arts. Nevertheless, he obviously was familiar with cattle, ranch life, and western Texas.

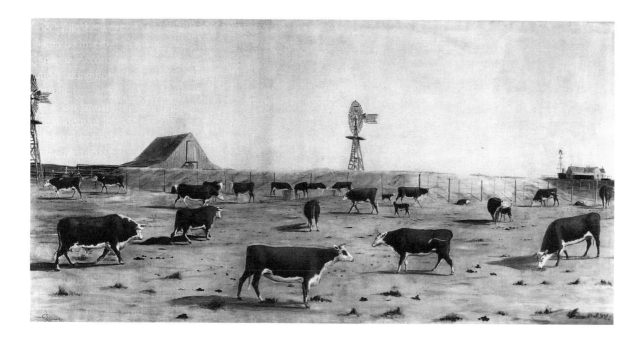

THE QUIEN SABE RANCH
1899, oil on canvas, 43″ × 84½″
Signed and dated lower left: L. Schloss/1899

Although naive in execution, this painting captures the essence of the fervent Texas heat, the vast expanse of a Texas ranch, and the dry and dusty atmosphere of the spacious Texas plains. The Quien Sabe Ranch, in Pecos County in West Texas, was owned by the Halff family, general merchants, of San Antonio. They registered the Quien Sabe brand in 1898. The branding iron was formed of an intermeshed right and left half-circle, and the name "¿Quién Sabe?" (who knows?) is said to derive from a cowboy's answer when asked what to call it. The Halffs ran cattle bearing their mark along the Pecos River until about 1910.[2]

Although the brand does not appear on any of the cattle in the painting, there is no doubt that this was done at the Quien Sabe Ranch. The animals are white-faced Herefords, a strain that was pioneered in the area by the Halffs.[3]

PROVENANCE:
1899–1946: Collection of the Halff Family.
1946: Gift to SAMA by Harry Halff.
46–123 G

EXHIBITIONS:
1947: Painting of the Month, WMM (May).
1978–1979: A Survey of Naive Texas Artists, WMM (December 17, 1978, to March 1, 1979).
1986: The Texas Landscape, 1900–1986, The Museum of Fine Arts, Houston (May 17 to September 7).
1990: Looking at the Land: Early Texas Painters, San Angelo Museum of Fine Arts (February 22 to March 25).

PUBLICATIONS:
Steinfeldt, "Simple Self-Expression," Southwest Art, 10 (September 1980): 60.
Norma Jackson, "'Folk Art'—watercolors on the Brazos," The Daily Texan (SA), December 3, 1981.
Steinfeldt, Texas Folk Art (1981), 83.
Susie Kalil, The Texas Landscape, 1900–1986 (1986), 18.
Steinfeldt, "Texas Folk Art," Antique Review, 14 (September 1988): 25.

1. "Cow Country Painting Displayed at Museum," This Week in San Antonio, May 31, 1947.
2. Webb, Carroll, and Branda (eds.), The Handbook of Texas, 2, s.v. "Quien Sabe Ranch."
3. "Cow Country Painting Displayed at Museum."

Everett Spruce is a true product of the Southwest. He was born on a farm near Conway, Arkansas, and at the age of five moved with his family to another agrarian site in the Ozarks where he lived for twelve years. He began school when he was seven, walking through dense woods and climbing mountains to get to the one-room schoolhouse.[1]

In recalling his early youth, Spruce described how his father took him "to the fields, hunting, fishing, rounding up stock, looking for wild fruit, and so on. Many times I went alone over the country. Discovered the nests of birds, homes of wild animals, strange trees, dramatic storms, swollen streams. So, very early, felt an intimacy with nature that has influenced whatever I have said or want to say in painting." He also said he "Drew continually. Used any material I could find, such as school tablets and slates."[2]

Although Spruce wanted to be an artist even during his high school days in Mulberry, Arkansas, he realized he would have a difficult time getting professional training, since there were five other children in the family and little money for education. Fortunately, however, Texas painter Olin Travis visited the Ozarks while on vacation, probably during the summer of 1925, and requested permission to paint a vista on the Spruce property. Spruce, elated at seeing a real artist at work, showed Travis some of his own drawings of birds, animals, and landscapes. These drawings impressed Travis, and he offered Spruce a scholarship for the next year at the school he had established in 1924, the Dallas Art Institute.[3]

Spruce cleared about twenty-five dollars on his crop that year and went to Dallas in 1926. He was given a job as a janitor in Travis's school but, in his own words, he "nearly starved."[4] Travis was a sympathetic teacher, and although he himself was an Impressionist, he encouraged Spruce to develop his own style. In 1928, Thomas M. Stell, Jr. (1898–1981), a native of Cuero, joined the faculty of the Dallas Art Institute.[5] Stell was an accomplished painter who had studied at the Art Students League and the National Academy of Design, served as mural assistant to Augustus Vincent Tack (1870–1949), and won two successive Prix de Rome competitions at the National Academy. Having just returned from New York, he brought with him a rigorous sense of discipline based on his admiration for the painters of the early Italian Renaissance. Stell's concepts of drawing, his technique, and his knowledge of art history greatly extended Spruce's understanding of painting.[6]

In 1930 Spruce began work in the Dallas Museum of Fine Arts as a general laborer, packing, shipping, and installing exhibitions. Soon he was promoted to doing research, teaching museum classes, and conducting gallery tours. In 1935 he became registrar and assistant to the director. He stated: "All this experience broadened my outlook [and] made me humble toward art. With the exceptions of three summers, my painting was limited to nights and one day a week during these ten years with the museum."[7] In 1935 Spruce married Alice Kramer, a fellow art student. They became the parents of four children, twin girls and two sons.[8]

Although Spruce's painting time was limited in his years in Dallas, he submitted paintings to exhibitions and started winning awards and gaining recognition. He had his first solo exhibition at the Dallas Museum of Fine Arts in 1932. Other solo exhibitions followed, at the Dallas Art Institute in 1933 and at the Joseph Sartor Galleries in 1934. He was one of the artists chosen for the First National Exhibition of American

1. Dorothy C. Miller (ed.), *Americans 1942: 18 Artists from 9 States* (New York: Museum of Modern Art, 1942), 118.
2. Ibid., 119.
3. Gibson Danes, "Everett Spruce: Painter of the Southwest," *American Magazine of Art* (February 1944): 12.
4. Miller, *Americans 1942*, 120.
5. Danes, "Everett Spruce," 13.
6. Ibid.; Stewart, *Lone Star Regionalism*, 186–189.
7. Miller, *Americans 1942*, 121–122.
8. "A Texas Painter," *Paint Rag: Texas Magazine of Art*, 1 (Summer 1953): 17–20.

Art at Rockefeller Center in 1936 and was represented in the Texas section at the Texas Centennial Exposition the same year. In 1937 Spruce became the first Dallas artist to exhibit his work at the Delphic Studios in New York, and the following year he had a larger solo exhibition at the Hudson D. Walker Galleries, a show that received favorable comment in the New York and national art presses. In 1939 his painting *The Hawk* entered the permanent collection of the Museum of Modern Art.[9]

In 1940, at the age of thirty-three, Spruce was invited to become an instructor in the newly formed Department of Art in the College of Fine Arts of the University of Texas at Austin.[10] Always active in local and regional competitions and exhibitions, with more time to paint, his national recognition steadily increased. In 1942 he was one of two Texans selected for an exhibition entitled Americans 1942: 18 Artists from 9 States, shown at the Museum of Modern Art in New York.[11] In 1943 Everett Spruce and Charles Umlauf (1911–), both on the faculty of the art department of the University of Texas at Austin, had a joint exhibition in the Witte Memorial Museum. The same year each of these artists was represented in the famous Artists for Victory show at the Metropolitan Museum in New York.[12] Spruce's painting *Arkansas Landscape, Afternoon*, in the exhibit, later was purchased for the permanent collection of the Phillips Memorial Gallery in Washington, D. C.[13]

In 1945 the Friends of Art of San Antonio purchased Spruce's *Landscape* from the Seventh Texas General Exhibition for the Witte Memorial Museum.[14] In 1946 Spruce had a solo exhibition at the Mortimer Levitt Gallery in New York.[15] The same year a canvas by Spruce merited the title of *Painting of the Year* in the Pepsi-Cola Competition for "Southwest Texas Landscape," and in 1947 he won the Henry Scheidt prize in the Pennsylvania Academy of Fine Arts Exhibition for *Dark Mountain*.[16]

As the years passed the prizes, accolades, purchases, and exhibitions became even more numerous. The Pennsylvania Academy of Fine Arts purchased another Spruce canvas, *Austin Hills*, in 1948.[17] Spruce became chairman of the Department of Art of the University of Texas at Austin from 1949 to 1951.[18] In 1949 he won the Humble Oil and Refining Company purchase prize for the permanent collection of the Dallas Museum of Fine Arts, and in 1950 the Metropolitan Museum of New York purchased *Pigeons on a Roof*.[19]

In 1958 Spruce was chosen as the first artist to be represented in the Blaffer Series of Southwestern Art published by the University of Texas Press. A *Portfolio of Eight Paintings by Everett Spruce* was a handsome volume—seventeen by nineteen inches—designed so that the reproductions could be removed and framed.[20]

The following year a group of Spruce's paintings and drawings was circulated throughout the country under a Ford Foundation grant by the American Federation of Arts. The local showing was at the McNay Art Institute, whose director, John Palmer Leeper, wrote the monograph accompanying the exhibition.[21]

Spruce may be considered the most successful of the "Dallas Nine" (see Charles Taylor Bowling). He is represented in many distinguished museums and institutions in the United States, as well as in Europe, England, and South America. Since his retirement as professor emeritus of the University of Texas at Austin in 1974, he has continued to produce important paintings, and was still working in the late 1980s.[22]

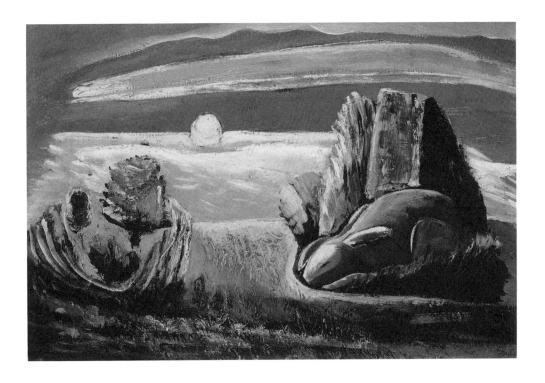

9. Stewart, *Lone Star Regionalism*, 186–187.
10. Miller, *Americans 1942*, 118.
11. "Eighteen Artists From Nine States Reviewed," *The Art Digest* (February 1, 1942): 10. Octavio Medellin, a sculptor, was the other Texas artist represented in the exhibition.
12. "Texas Sculptor and Painter In Joint Art Exhibit," *San Antonio Light*, January 17, 1943.
13. Patricia Peck, "Spruce Canvas Bought From Victory Show," *Dallas News*, April 22, 1943.
14. "Prizes Posted in Texas Art Show," *San Antonio Light*, September 23, 1945. This painting is no longer in SAMA's collection, having been included in the works of art claimed by the San Antonio Art League when they moved to new quarters in the early 1970s.
15. "Holds One-Man Show in N.Y. This Week," *Austin American-Statesman*, December 15, 1946.
16. "Dark Mountain Wins Pennsylvania Prize," *The Daily Texan*, February 9, 1947.
17. "Academy Buys Prof's Painting," *Austin American-Statesman*, March 3, 1948.
18. "Ex-Dallasite To Head U. T. Art Division," *Dallas Morning News*, October 3, 1948.
19. "Pigeons on a Roof Purchased by Metropolitan," *Austin American-Statesman*, February 19, 1950.
20. Donald L. Weismann, "Blaffer Series' First Reaches Lofty Level," *Austin American-Statesman*, October 26, 1958.
21. Donald B. Goodall, "Paintings by Spruce Being Exhibited in S. A.," *Austin American-Statesman*, October 11, 1959.
22. Stewart, *Lone Star Regionalism*, 187.
23. "Sketchbook: Art Curator," *San Antonio Evening News*, June 30, 1948.

SLEEPING RABBIT
ca. 1943, oil on academy board, 10½" × 16"
Signed lower right: E. Spruce

The respect and admiration that Spruce acquired during his youth for all living things is apparent in his painting *Sleeping Rabbit*. One of his earlier works, it defines the direction his painting later attained. It is a much gentler interpretation than his more advanced work because of its quiet tones and serene character. It obviously struck a chord in the heart of another nature lover, Eleanor Onderdonk, for she purchased it from an exhibition in 1943. It was one of her favorite paintings and she shared it with visitors to the Witte Memorial Museum for many years.[23]

PROVENANCE:
1943–1964: Collection of Eleanor Onderdonk.
1964: Inherited by Ofelia Onderdonk from the Estate of Eleanor Onderdonk.
1976: Gift to Mr. and Mrs. Eric Steinfeldt by Ofelia Onderdonk.
1978: Gift to SAMA by Mr. and Mrs. Eric Steinfeldt.
78–640 G

EXHIBITIONS:
1943: Sculpture by Charles Umlauf/Paintings by Everett Spruce, WMM (January 17 to February 7).
1986: Texas Seen/Texas Made, SAMOA (September 29 to November 30).

PUBLICATIONS:
SAMA Bi-Annual Report, 1976–1978, 29.

LANDSCAPE
n.d., oil on Masonite, 16″ × 20″
Signed lower left: E. Spruce

There is a fundamentalism in Spruce's paintings
that gives them a feeling of power and
inevitability. His empathy with nature always
is apparent, even though he distorts the
shapes of trees, rocks, and river beds into
vigorous compositions using a palette of
strong earth tones. *Landscape* is typical of his
earlier work, while he was developing a
unique style which he continued to restate
and refine throughout his career.

PROVENANCE:
-1974: Collection of Mrs. Leal Coates.
1974: Purchased by SAMA from Mrs. Leal Coates with
Witte Picture Funds.
74–26 P

EXHIBITIONS:
1986: Texas Seen/Texas Made, SAMOA (September 29
to November 30).
1990: Looking at the Land: Early Texas Painters,
San Angelo Museum of Fine Arts (February 22 to
March 25).

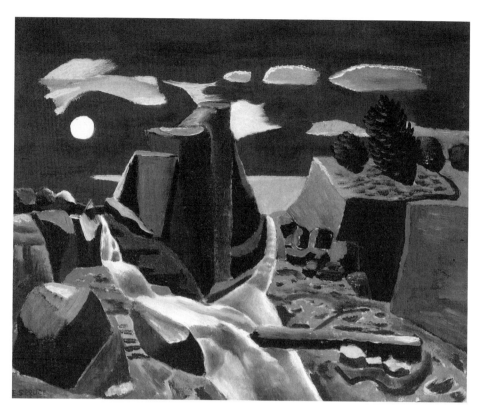

MESA
1944, oil on Masonite, 16″ × 20″
Signed lower left: E. Spruce
Dated on reverse: Oil, '44

Paintings by Spruce with titles such as *West
Texas Mesa*, *Little Mesa*, and *Mesa* appear in
numerous exhibition catalogues. Like all of
his work, this *Mesa* is strong in composition,
bold in technique, and rich in color. In spite
of its vigorous treatment, however, it has
sensitivity, a conscious awareness of the
nature of the terrain and the magnificence
of the landscape that inspired it.

PROVENANCE:
-1976: Purchased by SAMA from Meredith Long and
Company with funds provided by Mrs. R. C. Nelson
in memory of Ellen Schulz Quillin.
76–81 P

EXHIBITIONS:
1986: Texas Seen/Texas Made, SAMOA (September 29
to November 30).
1990: Looking at the Land: Early Texas Painters, San
Angelo Museum of Fine Arts (February 22 to March 25).

PUBLICATIONS:
SAMA *Annual Report*, 1975–1976, 43.

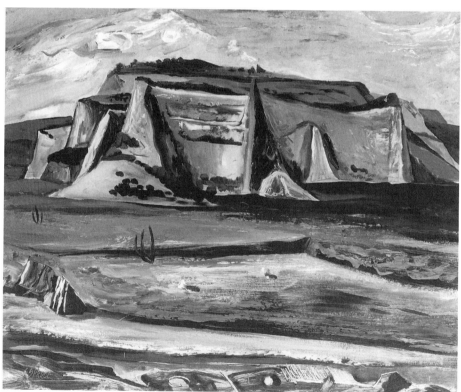

Rolla Taylor about 1930 at his easel painting in the Texas Hill Country. SAMA Historical Photographic Archives, gift of Eric Steinfeldt.

Rolla Taylor was born in Galveston, Texas, on October 31, 1872, the son of Justin C. Taylor, an actor, and Carrie Melissa (Johnson) Taylor, an amateur artist and musician. He attributed his artistic talent to his mother, who allowed him free access to her painting materials and encouraged him in an art career.[1] The family left Galveston when Taylor was a boy because of the severe storms and moved to Houston, then to Cuero, Texas, finally settling in San Antonio when the artist was about eighteen.[2]

Taylor had graduated from the Cuero Institute and sometime in his early life learned shorthand. He was an official court reporter in the district courts of Bexar County for fifty-seven years. Working in the courts led him to study law at night, and he was admitted to the bar in 1932.[3] Taylor earned his bread and butter as a court reporter and applied himself to painting on weekends and during vacations. He studied with José Arpa and was a friend of Julian Onderdonk, and credited them for his interest in scenic painting. He also worked with Arthur W. Best (ca. 1865–1919) in San Francisco and Frederick Fursman (1874–1943) in Michigan.[4]

In 1928 Taylor earned more than $1,000 from the sale of his paintings, which enabled him to travel to Europe. He studied in Paris for three months and toured the principal art galleries on the continent. Besides painting in Texas and other areas of the country, he took frequent trips to Mexico, mainly in the vicinity of Saltillo and Monterrey, and produced some charming canvases of Mexican village life.[5]

Taylor once stated, however, "My favorite subjects are of Texas hills and mountains and bits of dear old 'Santone.'"[6] His paintings of San Antonio are important not for their artistic merit but as memoranda in the chronological history of the city. He recorded sites such as *La Quinta* or *The Old Groesbeeck Home* for posterity and carried on traditions established by earlier painters.

Taylor was a constant supporter of the arts in San Antonio and Texas and exhibited throughout the United States. His work was pleasing and uncontroversial and always was included in local exhibitions. He had two one-man shows in the Witte Memorial Museum, one in 1937 and another in 1953.[7] In 1950 he had a solo exhibition at Incarnate Word College in San Antonio, and Amy Freeman Lee stated: "Mr. Taylor can most accurately be classified as a conservative modern, for while he does not use the highly refined technique of the old masters, he is wholeheartedly a realist, and while he is not adventuresome in any aspect of his work, still, his technique is on the rough-textured, broad-stroked side."[8]

After World War II, when River Art Shows were organized along the banks of the San Antonio River, Taylor consistently won "popularity" awards. In 1967 the Coppini Academy gave him an exhibition and a memorable reception in his honor. He died in 1970.[9]

Although there had long been confusion about Taylor's birth date, in 1970 he freely admitted, "I'm 98! I always lied about my age when I was working. A lot of people lie about their age. But I don't need to lie about it any more."[10]

Besides being a member of many local and state organizations, he was a member of the American Federation of Arts, the Chicago Society of Artists, and the Independent Society of Artists of New York.[11] He also was honored by the Texas State Historical and Landmarks Association for the Texas historical scenes he brought to life in his paintings.[12]

1. Forrester-O'Brien, *Art and Artists*, 203.
2. Gerald Ashford, "Dean of San Antonio Artists," San Antonio *Express-News*, April 5, 1970.
3. Ibid.
4. Fisk, *A History of Texas Artists*, 24.
5. Gale Graham, "Court Reporting His Job, Rolla S. Taylor to Exhibit Paintings," San Antonio *Evening News*, February 9, 1939.
6. Fisk, *A History of Texas Artists*, 24.
7. Catalogues and listings, Rolla Sims Taylor file, SAMA Texas Artists Records.
8. Amy Freeman Lee, "Call Board Reporter," Review for KONO, November 30, 1950. Typescript, Taylor file, SAMA Texas Artists Records.
9. "Rolla Taylor Honoree," San Antonio *Light*, April 16, 1967.
10. Ashford, "Dean of San Antonio Artists."
11. Fisk, *A History of Texas Artists*, 25.
12. "Former court reporter Rolla Taylor dies," San Antonio *Evening News*, July 21, 1970.

LA QUINTA
1918, oil on canvas, 20″ × 29″
Signed, titled, and dated lower right: Rolla S. Taylor/
La Quinta, S. A./1918

Taylor's view of *La Quinta* depicts the rear of
the building. It was one of the most historic
houses in San Antonio before being razed
in 1922 to widen Dwyer Avenue. It was built
in 1761 and named "La Quinta" because it
served as barracks for the Fifth Company of
Spanish soldiers. During the revolt of Mexico
against Spain in the early nineteenth century,
it was the house where the Spanish general
Joaquín de Arredondo imprisoned several
hundred San Antonio women and forced
them to grind corn and make tortillas for his
troops.[13]

The building later served as San
Antonio's first post office under the Republic,
with John Bowen as postmaster. Bowen had
purchased the five-acre site on which the
building stood in a bend in the river and the
area became known as "Bowen's Island."[14]

PROVENANCE:
-1955: Collection of Dr. and Mrs. Garrett P. Robertson.
1955: Gift to SAMA by Mrs. Garrett P. Robertson.
55–109 G

EXHIBITIONS:
1986: Texas Seen/Texas Made, SAMOA (September 29
to November 30).

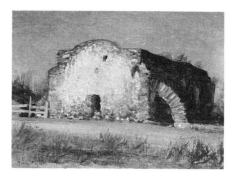

THE GRANARY, SAN JOSÉ MISSION
n.d., oil on canvas board, 10″ × 14″
Signed lower left: Rolla Taylor

Taylor's rendition of the granary at San José
shows the structure in unrestored condition.
It is a pleasant canvas with the warm tones of
the stone emphasized by a brilliant blue
Texas sky. The leafless shrubs that surround
the building suggest it was painted on a
winter day, with sparkling sunlight
accentuating the radiant color.

PROVENANCE:
1980: Gift to SAMA by an anonymous donor.
80–85 G

THE OLD GROESBEECK HOME
1920, oil on canvas, 24″ × 20″
Signed and documented lower left: Rolla Taylor/
San Antonio

The picturesque Groesbeeck Home was
painted by numerous artists, including Robert
Onderdonk. Taylor's version is lively in color
and flooded with sunlight, attributes undoubt-
edly learned from José Arpa. The brushstrokes
are broad and sure with nice textures in the
foliage and stone.

The house was built for Thomas
Howard in the 1840s and was purchased from
him by John D. Groesbeeck a few years later.
Groesbeeck rebuilt and enlarged the house
and terraced the gardens in back with stone
steps leading to the San Antonio River, along
which he planted pinks, petunias, and pansies.
Situated just off the Main Plaza at 138 Dwyer
Avenue, it was torn down in March 1928, the
last of several historic houses to be razed in
the vicinity.[15]

PROVENANCE:
-1953: Collection of Albert Hirschfeld.
1953: Gift to SAMA by Albert Hirschfeld.
53–113 G

EXHIBITIONS:
1986: Texas Seen/Texas Made, SAMOA (September 29
to November 30).

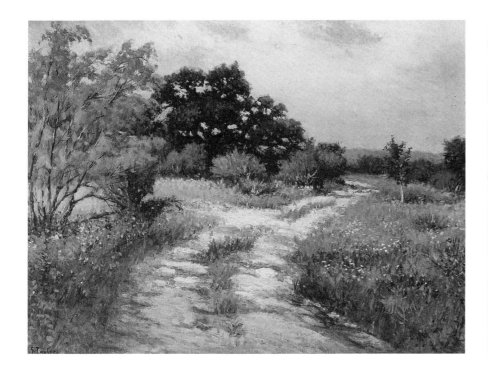

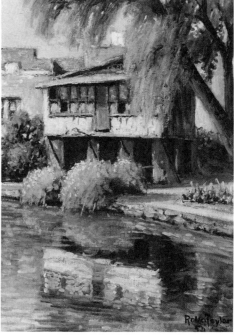

THE OLD TRAIL
n.d., oil on canvas, 16″ × 22″
Signed lower left: R. S. Taylor

SAN ANTONIO RIVER
n.d., oil on canvas, 16″ × 12¼″
Signed lower right: Rolla Taylor/S. A.
Inscribed on reverse: San Antonio River

WORKS BY ROLLA SIMS TAYLOR
NOT ILLUSTRATED:

LA CASITA
n.d., oil on board (cigar box wood panel), 6″ × 10¼″
Signed lower left: R. S. Taylor
Inscribed on reverse: To my friend and confidte
[confidante] with my compliments Apr. 24, 1915 Rolla
S. Taylor/Mrs. D. F. Strickland, Mission, Texas (Mrs.
Strickland was the donor's grandmother).
82–166 G (2)
Gift to SAMA by D. F. Strickland.

Julian Onderdonk's influence is apparent in
Taylor's choice of subject matter for this
canvas. The composition is handled adroitly;
the textures of leaves, grass, shrubs, and rocks
are varied and delicately accented with
scattered flowers. It is a pleasant work that
reflects the Texas countryside in spring-like
glory. But it lacks Onderdonk's feeling for
space, atmosphere, and luminosity.

PROVENANCE:
-1947: Collection of Winifred R. Hamilton.
1947: Gift to SAMA from the Estate of Winifred R.
Hamilton.
47–95 G

EXHIBITIONS:
1950: Rolla Taylor Exhibition, Incarnate Word College,
SA (November 15 to December 8).
1970: Special Texas Exhibition, ITC (March 16 to
October 8).
1986: Texas Seen/Texas Made, SAMOA (September 29
to November 30).
1990: Looking at the Land: Early Texas Painters,
San Angelo Museum of Fine Arts (February 22 to
March 25).

Rolla Taylor's intimate views of sites in San
Antonio provide interesting glimpses into the
city's past. Unfortunately this painting is not
dated but must have been done before the
river was renovated to become a tourist
attraction. Again the artist's colors are lively,
his technique free and bold, and his subject a
favorite San Antonio theme.

PROVENANCE:
-1970: Purchased by Commander and Mrs. Walter Espy
in a local antique shop.
1970–1981: Collection of Commander and Mrs. Walter
Espy.
1981: Gift to SAMA by Jacqueline R. Espy in memory
of her husband, Commander Walter Espy.
81–139 G

EXHIBITIONS:
1982: A Birthday Celebration: Recent Gifts and
Acquisitions, SAMOA (March 1 to May 16).
1986: Texas Seen/Texas Made, SAMOA (September 29
to November 30).

13. "City's First Post Office Being Torn Down in
Effort to 'Modernize' Streets," San Antonio
Express, April 27, 1922; Barnes, Combats and Conquests,
104–108.
14. Noonan-Guerra, The Story of the San Antonio River,
33.
15. "Home Built When Texas Republic to be
Razed," San Antonio Express, March 4, 1928. The
painting is undated, but on a listing of paintings
by Taylor the date has been established as 1920.

IDA HADRA VINES

Ida Hadra Vines was the second child of Dr. Berthold Ernest Hadra and Ida (Weisselberg) Hadra. Her mother died shortly after her birth, and Ida was reared by her aunt Emma, who also became her stepmother.[1]

Little is known of Ida's life history, but she studied art for a year with Robert Onderdonk in San Antonio.[2] She once wrote to Eleanor Onderdonk: "I could never paint as well as my mother, although I managed to become assistant art teacher to Eva Fowler at Kidd-Key College, while I was young. My excuse for boring you with this account of my small talent is that I am proud to be able to write you that my first and one of my most beloved art teachers was your father, R. J. Onderdonk."[3]

Kidd-Key College was in Sherman, Texas, and Eva Fowler (1885–1934) was one of the first instructors to introduce an art history course in a Texas school.[4] Eva Fowler was extremely influential in furthering art interests in the state at the turn of the century.

Exactly how much work Ida produced during her short career is unknown. According to her brother, she gave up painting after her marriage to Phillip Crump Vines on June 17, 1909. The couple had two children, Mary Josephine and Phyllis.[5] While Ida was active artistically she was a member of the Dallas Art Association, the Federation of Dallas Artists, and the Poetry Society of Texas, as well as other art organizations.[6]

Photograph of Berthold Ernest Hadra from which Ida Vines's miniature was taken. SAMA Historical Photographic Archives, gift of Mary Josephine Vines.

PORTRAIT OF BERTHOLD ERNEST HADRA
n.d., watercolor on ivory, 1¼″ × 1½″
Unsigned

When Ida painted this small portrait of her father, probably around 1900, she used a photograph, as did most miniaturists of the day. The picture was by E. F. Eckerskorn, a San Antonio photographer.[7] She not only achieved an excellent likeness, she also demonstrated her competence as a painter.

Originally miniatures were portraits of a reduced size to be carried in a locket, on a pin, or in a small case. They were popular prior to the invention of the camera.[8] The invention of the daguerreotype in the early part of the nineteenth century virtually replaced the art of miniature painting.[9] After a long period of neglect, largely due to the cheaper and more easily available photographs, miniatures finally regained a modest measure of their earlier popularity at the beginning of the twentieth century.

PROVENANCE:
ca. 1900–1969: Collection of the Hadra-Vines Family.
1969: Gift to SAMA by Mary Josephine Vines.
69–102 G (31)

EXHIBITIONS:
1969–1972: Medicine in San Antonio and Texas, WMM (August 1, 1969, to February 30, 1972).
1986: Texas Seen/Texas Made, SAMOA (September 29 to November 30).

PUBLICATIONS:
Cecilia Steinfeldt, "Medicine Men," *Witte Quarterly*, 7 (1969): 13.

1. I. H. Vines, "Two Sisters."
2. Hadra to Onderdonk, June 10, 1936.
3. Mrs. P. C. Vines (Dallas) to Eleanor Onderdonk (SA), June 10, 1936.
4. Fisk, *A History of Texas Artists*, 114–115.
5. Hadra to Onderdonk, June 10, 1936; "Descendants of Anna Maria Naffz."
6. "Descendants of Anna Maria Naffz."
7. Photograph in SAMA Historical Photographic Archives.
8. Van Deren Coke, *The Painter and the Photograph from Delacroix to Warhol* (rev. ed., Albuquerque: University of New Mexico Press, 1972), 21.
9. George C. Williamson and Percy Buckman, *The Art of the Miniature Painter* (New York: Charles Scribner's Sons, 1926), 165.

William Aiken Walker was born on March 25, 1838, in Charleston, South Carolina, the second of three sons of John Falls and Mary Elizabeth (Aiken) Walker. William showed an aptitude for painting at an early age and exhibited at the South Carolina Institute Fair when he was twelve.[1] His subject was a black man lighting his pipe on a dock, with a port scene behind him, themes for which Walker became famous and which he used over and over again.[2]

As a young man, Walker became adept not only in art, but also in opera, music, and literature, interests that remained throughout his lifetime. A handsome man, he was something of a dandy, and developed a lifelong reputation as a natty dresser. At the onset of the Civil War, he joined the Confederate forces and after being wounded was assigned to the Engineer Corps, where he served as a cartographer and draftsman.[3] His work gave him an opportunity to exercise his artistic talents and one of his most unique creations was a set of illuminated playing cards. He painted miniatures of four Southern heroes as kings in his patriotic pack, and the aces were views of war scenes. The queens and jacks were anonymous contributors to the war effort.[4]

After the war Walker became the itinerant artist *extraordinaire* of the growing resort business in the New South. His genre scenes of blacks pursuing their everyday activities in the cotton fields or around their simple cabins were popular with tourists and assured him a steady income and a modest fame. He considered Baltimore his home base but traveled to the resort communities of Arden, North Carolina; Ponce Park, Florida; Cuba; and New Orleans.[5] In 1870 he made a trip to Europe, visiting galleries in France and Germany. Although he reputedly studied in Düsseldorf, there is no substantial evidence to confirm this.[6]

He did, however, spend at least two years in Texas. He painted a very large *View of Galveston Harbor* in 1874, which now hangs in the Rosenberg Library in that city. It is reminiscent of earlier harbor scenes he did of Charleston, Baltimore, and New Orleans.[7] According to a newspaper account the painting accurately represented the waterfront of Galveston Bay in the 1870s. One article also mentioned that "on the water front is a yawl pulled by two men, in the stern of which is a helmsman, who is William A. Walker, the artist, and it was a very good picture of him at that time. . . ."[8] Walker also is listed in the Galveston city directory of 1875–1876 with his residence at the corner of Market and Twenty-first streets.

While in Galveston Walker was associated with other artists: T. D. Jones (1808–1881), a sculptor, and Louis Eyth (1838–ca. 1889), George D. Miles (n.d.) and C. Hoffrichter (n.d.), painters. A newspaper article that discusses these artists, including Walker, states: "A portrait of Father Chambodeu is the latest work of Mr. W. A. Walker. It gives a fair but rather stern likeness, yet this is the result probably of the strong lines in the countenance of the subject. . . ." The report continues: "A small picture entitled 'setttling a difficulty' [*sic*] is a very good specimen of the artist's spirited style in sketch painting. It is just finished and on exhibition."[9]

In 1876 Walker decided to visit San Antonio for a few months. The San Antonio *Daily Express* of June 4, 1876, mentions that "a large Oil Painting, by Mr. Wm. A. Walker, of the 'Second Mission San José,' is now on exhibition at Pentenreider and Co.'s store, where it will remain for a few days." On June 17, 1876, the *Daily Express* reported that "Mr. Walker, the artist, is just finishing painting pictures of Capt. H. B. Adams' beautiful buggy horses. When done, the paintings will be put on exhibition."

1. August P. Trovaili and Roulhac B. Toledano, *William Aiken Walker: Southern Genre Painter* (Baton Rouge: Louisiana State University Press, 1972), 3–14.
2. Ibid., 14: illustration 17.
3. Ibid., 16–18.
4. "A Pack of Rebels: Playing cards by William Aiken Walker," *American Heritage*, 18 (June 1967): 28–29.
5. Poesch, "Growth and Development of the Old South," in *Painting in the South*, 96–97.
6. Trovaili and Toledano, *William Aiken Walker*, 34.
7. Poesch, "Growth and Development of the Old South," in *Painting in the South*, 252: plate 89.
8. "Historical Sketch of the Port of Galveston in 1874," Galveston *Daily News*, September 13, 1908.
9. "What our Artists are Doing," Galveston *Daily News*, December 19, 1874.

On June 6 the San Antonio *Daily Herald* stated that Walker had done a painting of Mission Concepción.[10]

But in October the newspapers announced that "Prof. William A. Walker, who, as an artist and a musician, has, during a stay of several months, ingratiated himself into the general esteem of our people, left the city this morning for his home in Mississippi. We regret to note his departure, especially for the reasons that it deprives the St. Mary's Church Choir of its talented leader, and his many friends of an esteemed companion."[11] There is no evidence that Walker ever returned to Texas.

Walker reverted to his habit of journeying between resort towns, often spending his summers in Baltimore or Charleston and wintering in Florida or New Orleans. In his later years he became a familiar sight in that Southern city. He was tall and lean with a flowing beard and always meticulously dressed. He made a comfortable living by sitting on the corner of Royal and Dumaine streets painting small studies of blacks to sell to tourists. He developed a system of working on a long strip of academy board painting a sky across the top, a ground with cotton fields across the bottom, and superimposing figures of blacks at work in the fields. These rows of people would then be cut into postcard-size portraits ready to be sold.[12]

William Aiken Walker's last sketch was a North Carolina landscape dated October 15, 1920, done when he was eighty-two years old. He became ill three months later, died on January 3, 1921, and was buried at the Magnolia Cemetery.[13] Walker analyzed his own work in a very succinct statement:

> I am like a machine: I paint and repaint these subjects so that many can share the feelings I have for this magnificent world of ours. Art is not only for the artist, it is for all and I shall do my best to see that all can afford it, to the extent that I shall paint and paint and paint until the brush runs dry.[14]

10. "Fine Arts," San Antonio *Daily Herald*, June 6, 1876. The article in full reads: "The admirers of fine pictures should drop into the establishment of Pentenreider's Successor, and inspect a beautiful painting of the Mission Conception [*sic*], from the easel of Prof. Wm. A. Walker. The old mission buildings and their surroundings are portrayed with life-like fidelity, and evince great talent in the artist. We may mention, in this connection, that Mr. Walker's studio is at Mr. Bingham's photographic gallery, where every variety of picture, from life-size oil painting to the ordinary *carte de visite*, can be obtained at prices to suit the times. We had no idea that San Antonio had such facilities until we visited Mr. Bingham's gallery. Both gentlemen understand their business in all its branches, as an inspection of their pictures will demonstrate beyond cavil."
11. "William A. Walker," San Antonio *Daily Express*, October 10, 1876.
12. Trovaili and Toledano, *William Aiken Walker*, 62–63.
13. Ibid., 80.
14. Ibid., 3.
15. Ibid., 100: plates 2, 4.
16. [Harriet Prescott Spofford], "San Antonio de Bexar," *Harpers New Monthly Magazine*, 55 (November 1877): 840–841.
17. Cecilia Steinfeldt, *San Antonio Was*, 19–20.

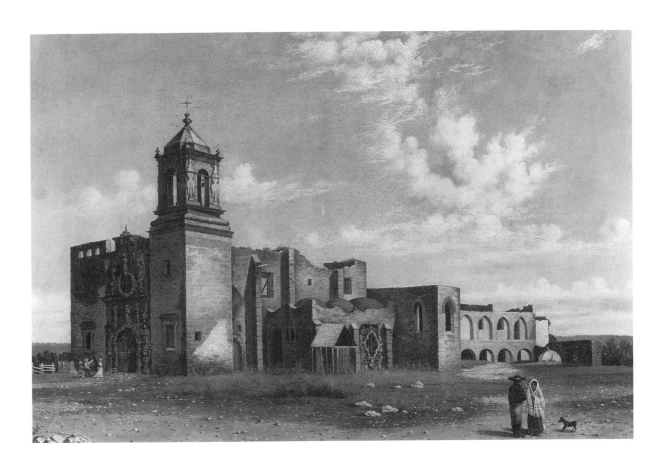

SAN JOSÉ MISSION
1876, oil on canvas, 24½″ × 36½″
Signed and dated lower left: W. A. Walker/1876

Walker's *San José Mission* is an example of his artistic capabilities when he chose to produce a serious canvas. It rivals his large well-painted harbor scenes, his view of St. Finebar's Church in Charleston, the *Levee at New Orleans*, or *The Bombardment at Fort Sumter*.[15] *San José Mission* shows the artist's mastery of draftsmanship, his attention to detail and clear color, and his sense of the dramatic. A small party of tourists admiring the façade of the building is balanced on the right side of the composition by two Mexicans attired in native garb.

Painted much later than Seth Eastman's version (see Seth Eastman, *Mission San José*), Walker's depiction shows the imposing structure in a much more dilapidated condition. Descriptions of the mission at the time corroborate Walker's portrayal of the structure:

The stone, although now lichen-eaten and weather-stained, is the soft cream-colored stone of the district, which is easily wrought, the surface walls frescoed with a diaper of vermilion and blue, of which only faint lines remain. All the lofty façade is a mass of superb sculpture of colossal figures, with cherubs, scrolls, and flowers; similar noble work surrounds one of the exquisitely beautiful windows; but for the rest, the great halls are roofless, the long arcades are crumbling into mounds of dust, and even the fine statuary has been defaced by wanton wretches.[16]

Many artists have depicted the mission in its various stages. Walker's rendition is straightforward and unsentimental, evoking a desolate and abandoned aura. The mission fell into even greater disrepair before restoration was begun in the early twentieth century.[17]

PROVENANCE:
-1978: Fenn Galleries, Ltd., Santa Fe, New Mexico.
1978: Purchased by SAMA from Fenn Galleries, Ltd., with funds provided by The Brown Foundation, Inc., Houston.
78–1282 P

EXHIBITIONS:
1984: The Texas Collection, SAMOA (April 13 to August 26).
1986: Texas Seen/Texas Made, SAMOA (September 29 to November 30).

MARY MOTZ WILLS

Mary Motz Wills was born in Wyetheville, Virginia, on June 6, 1875, the daughter of Mr. and Mrs. Charles Motz. The Motzes moved to Waco, Texas, while still a young couple, and it was there that Mary and her younger sister, Elsie, grew up. It is said that Mary was Elsie's first art instructor. Elsie (1877–?) became a well-known miniaturist and always signed her work Elsie Motz Lowdon.[1]

The artistic fame of Mary Wills rests upon her prodigious number of scientific renderings of wildflowers, particularly those done in Texas. She had training in other artistic fields, however, as she studied at the Art Students League in New York with William Merritt Chase, John Henry Twachtmann (1853–1902), and Frank Vincent DuMond.[2] She may have also attended schools in Boston and Philadelphia and the Pennsylvania School of Industrial Arts.[3]

Mary married Colonel Will Dunbar Wills of the United States Army and accompanied him on his tours of Central and South America. In 1913, while she was recuperating from a serious illness in Panama, her husband began bringing her exotic wildflowers of the area. Mary Wills began executing delicate watercolors of these flowers, attempting to capture their elusive beauty with her brush and paint.[4] Thus she was launched upon a rewarding career.

Some years later, after her husband's untimely death in Maryland, Mary lived for a time in Georgia, but she soon established her permanent residence in Abilene, Texas. Here she concentrated on making a pictorial record of the wildflowers of the state, a project she continued for the rest of her life. Because of her knowledge of the subject, she was in great demand as a lecturer as well.[5]

Ellen Schulz Quillin, herself an accredited botanist, was the first person to recognize the importance of Mary Motz Wills's floral studies.[6] She gave the artist an exhibition in 1935 in conjunction with the annual flower show at the Witte Memorial Museum. Mary Wills visited the city in 1936 for a two-day exhibition at the museum. Also in 1936, 300 of her floral portraits were shown at the Texas Centennial Exposition in Dallas. These later became the property of the Texas Memorial Museum in Austin. In 1943 the Witte Memorial Museum featured flowers she had painted in the Big Bend area of Texas.

In 1955 another collection, from which 105 paintings were purchased by the institution, was shown at the Witte.[7] Wills also had extensive displays at the American Museum of Natural History in New York, the Montgomery Museum in Georgia, and the Mint Museum in Charlotte, North Carolina.[8]

Mary's greatest recognition came in 1961 when the University of Texas Press at Austin published *Roadside Flowers of Texas*, in which 257 of her exquisite paintings were reproduced in vivid color. The lively text describing each plant in detail was written by Howard S. Irwin of the University of Texas Department of Botany and later of the New York Botanical Gardens.[9]

Although Wills's wildflower paintings cannot be considered masterpieces in an artistic sense, they have contributed a unique dimension to the Texas art scene. Many of the examples were endangered species in her day, and some have disappeared entirely since then. As stated in a Witte Memorial Museum Natural History Department report in 1956: "The value is the historical record of the natural beauty of Texas as it was, pre-1930."[10]

Mary Motz Wills died on November 14, 1961, shortly after the publication of *Roadside Flowers of Texas*.[11]

1. Fisk, *A History of Texas Artists*, 154. Information supplied by the Abilene Museum of Fine Arts establishes Mary Motz's birthday as 1875.
2. "100 Paintings Show Flowers," San Antonio *Express*, May 16, 1943.
3. Abilene Museum of Fine Arts Accession Records. Photocopies, Mary Motz Wills file, SAMA Texas Artists Records.
4. Howard S. Irwin, *Roadside Flowers of Texas: Paintings by Mary Motz Wills* (Austin: University of Texas Press, 1961), vii.
5. Ibid.
6. Ibid.
7. Listings and articles, Wills file, SAMA Texas Artists Records.
8. "Flower Paintings Put on Display," San Antonio *Light*, August 21, 1955.
9. "U. T. Presses [sic] 'Roadside Flowers'," *The Daily Texan* (Austin), April 19, 1961.
10. "Witte Memorial Museum Natural History Department Annual Report," 1956–1957. Witte Museum Library.
11. SAMA Natural History Department Records.

Thistle. *Cirsium* sp.
mountain region
arizona.

Mary Motz Wills

THISTLE
n.d., watercolor on paper, 12½″ × 8¼″
Signed lower right: Mary Motz Wills
Titled and documented lower left [Latin names
appear as inscribed on the original paintings and may
not be spelled correctly]: Thistle/*Cirsium* sp./Mountain
region/Arizona

Mary Motz Wills's *Thistle* shows a wildflower
that is native to Arizona but resembles the
bull thistle that grows in Texas. In her
renditions of wildflowers, Mary Wills always
carefully delineated the fine details that
differentiated one species from another.

PROVENANCE:
-1955: Collection of the artist.
1955: Purchased by SAMA from the artist with Witte
Picture Fund.
61–57 P (98)

EXHIBITIONS:
1955: Flower Studies by Mary Motz Wills, WMM
(August 1 to 31).
1980–1981: Wildflower Watercolors, WMM (October
20, 1980, to January 31, 1981).

PUBLICATIONS:
"Wildflower Art on Display," San Antonio *Light*,
November 2, 1980.
SAMA *Calendar of Events* (January 1981): [2].

BROWN IRIS (*Opposite page*)
n.d., watercolor on paper, 14¼″ × 7¼″
Signed lower right: Mary Motz Wills (The "58" in
the lower right corner may be a series number rather
than a date and has been superimposed upon another
number which appears to be "49.")
Titled lower left: Brown Iris/Coast

Irises are among the rarer and more exotic
plants of Texas. Occurring in the eastern part
of the state, they grow in low ground and
swampy areas. Mary Wills imparted the
delicate character of the flower, with its
dainty petals and slender graceful stems and
leaves.

PROVENANCE:
-1955: Collection of the artist.
1955: Purchased by SAMA from the artist with Witte
Picture Fund.
61–57 P (42)

EXHIBITIONS:
1955: Flower Studies by Mary Motz Wills, WMM
(August 1 to 31).

BUSH MORNING GLORY
n.d., watercolor on paper, 16⅞″ × 11¼″
Signed lower right: Mary Motz Wills
Titled and documented lower left: *Impomoea fistulosa*/
Bush Morning Glory

The bush morning glory, a hardy plant, is
most commonly found in the Panhandle
region of Texas.[12] Mary Wills depicted not
only the trumpet-shaped flowers with star-
like centers, but also took care to detail
both closed and opened pods.

PROVENANCE:
-1955: Collection of the artist.
1955: Purchased by SAMA from the artist with Witte
Picture Fund.
61–57 P (30)

EXHIBITIONS:
1955: Flower Studies by Mary Motz Wills, WMM
(August 1 to 31).
1980–1981: Wildflower Watercolors, WMM (October
20, 1980, to January 31, 1981).
1982: Wildflowers of the San Antonio Area, WMM
(March 21 to May 21).

PUBLICATIONS:
"Wildflower Watercolors," San Antonio *Express*,
October 30, 1980.
SAMA *Calendar of Events* (November 1980): [2].

WILD PLUM
n.d., watercolor on paper, 14⅞″ × 8¾″
Signed lower right: Mary Motz Wills
Titled and documented lower left: Wild Plum/*Prunus
rivularis*

The wild plum is also called creek plum or
hog plum and abounds on the Edwards
Plateau and in north Central Texas.[13] Mary
Wills painted the yellowish to red fruit, the
woody bark, and the ovate leaves in minute
detail. A stickler for accuracy, she also added
a smaller branch showing the plant's dainty
flowers as well as a pair of plum beetles with
a notation that they were very similar to
cotton beetles.

PROVENANCE:
-1955: Collection of the artist.
1955: Purchased by SAMA from the artist with Witte
Picture Fund.
61–57 P (20)

EXHIBITIONS:
1955: Flower Studies by Mary Motz Wills, WMM
(August 1 to 31).
1980–1981: Wildflower Watercolors, WMM (October
20, 1980, to January 31, 1981).

(*Opposite page*)
HEMP OR MARIJUANA
n.d., watercolor on paper, 17⅛″ × 14¼″
Signed lower right: Mary Motz Wills
Titled and documented lower left: Hemp-Marihuana-
Hashish/*Cannabis sativa*

Marijuana is obtained from the top leaves and
flowers of the Indian hemp plant, *Cannabis
sativa*, which grows in most parts of the
world.[14] The plant also produces the useful
staple known as hemp, used as a textile
fiber.[15] But when Mary Motz Wills wished to
depict the plant, she had difficulty in locating
a specimen. After five years an anonymous
donor sent her an example by airmail that
she used for her rendition. She included it
with a group of "poisonous plants" in her
exhibits.[16]

PROVENANCE:
-1955: Collection of the artist.
1955: Purchased by SAMA from the artist with Witte
Picture Fund.
61–57 P (31)

EXHIBITIONS:
1940: Mary Motz Wills Wildflowers, West Texas
Chamber of Commerce, Abilene (October 4 to 7).
1955: Flower Studies by Mary Motz Wills, WMM
(August 1 to 31).
1980–1981: Wildflower Watercolors, WMM (October
20, 1980, to January 31, 1981).

12. Irwin, *Roadside Flowers of Texas*, 176.
13. Donovan Stewart Correll and Marshall Conring Johnston, *Manual of the Vascular Plants of Texas* (Renner, Texas: The Texas Research Foundation, 1970), 760.
14. *Encyclopaedia Britannica* (1959), s.v. "Marijuana."
15. Ibid., s.v. "Hemp."
16. "Episcopal Auxiliary Sponsors Exhibit," Abilene *Reporter News*, September 29, 1940. It was Mrs. Wills's intention to educate people to recognize the plant and not to confuse it with similar examples.

WORKS BY MARY MOTZ WILLS
NOT ILLUSTRATED:

PITCHER PLANTS
n.d., watercolor on paper, 22⅛" × 14"
Signed lower right: Mary Motz Wills
Titled lower left: Pitcher plants
61–57 P (1)
Purchased by SAMA from Mary Motz Wills with Witte Picture Fund.

VERBENA
n.d., watercolor on paper, 11½" × 7½"
Unsigned
Titled and documented lower left: Verbena/ *bipinnatifida*/West Texas Ft. Davis
61–57 P (2)
Purchased by SAMA from Mary Motz Wills with Witte Picture Fund.

BUTTERFLY WEED, MILK WEED
n.d., watercolor on paper, 11⁵⁄₁₆" × 7⅞"
Signed lower right: Mary Motz Wills
Titled and documented lower left: Butterfly weed/ Milk weed/*Asclepias tuberosa*
61–57 P (3)
Purchased by SAMA from Mary Motz Wills with Witte Picture Fund.

INDIAN BREAD ROOT, SCURVY PEA
n.d., watercolor on paper, 13⅝" × 12¼"
Signed lower right: Mary Motz Wills
Titled and documented lower left: *Psoralea hypogaea*/ Indian bread root
Inscribed back center: *Psoralea cuspidata*
61–57 P (4)
Purchased by SAMA from Mary Motz Wills with Witte Picture Fund.

BEARD-TONGUE, FALSE FOX GLOVE
1944, watercolor on paper, 17¹⁄₁₆" × 11⅛"
Signed lower right: Mary Motz Wills
Titled, dated, and documented lower left: Beard-tongue/near Dallas-*Penstemon*/April-1944-*Cobaea*/false Fox glove
61–57 P (5)
Purchased by SAMA from Mary Motz Wills with Witte Picture Fund.

WILD PETUNIA
n.d., watercolor on paper, 14¼" × 11½"
Unsigned
Titled and documented top back: Wild Petunia/ *Ruellia occidentalis*
61–57 P (6)
Purchased by SAMA from Mary Motz Wills with Witte Picture Fund.

INDIAN PAINT BRUSH
n.d., watercolor on paper, 11⅝" × 6¼"
Signed lower right: Mary Motz Wills
Titled and documented lower left: *Castilleja latebracteata*/West Texas/Indian Paint Brush
61–57 P (7)
Purchased by SAMA from Mary Motz Wills with Witte Picture Fund.

BULL NETTLE
n.d., watercolor on paper, 14⁹⁄₁₆″ × 11⁷⁄₁₆″
Unsigned
Titled and documented lower left: *Cnidoscolus texanus*/
Bull nettle
61–57 P (8)
Purchased by SAMA from Mary Motz Wills with
Witte Picture Fund.

STAR THISTLE, THISTLE
n.d., watercolor on paper, 15¹⁵⁄₁₆″ × 10⁷⁄₁₆″
Signed lower right: Mary Motz Wills
Titled and documented lower left: Star Thistle/
Centaurea americana
Titled and documented right center side: *Carduus
austrinum*/Thistle
61–57 P (9)
Purchased by SAMA from Mary Motz Wills with
Witte Picture Fund.

BALSAM, SNAKE APPLES
n.d., watercolor on paper, 14⅝″ × 10¾″
Signed lower right: Mary Motz Wills
Titled and documented lower left: *Ibervillea lindheimeri*/
Balsam. Snake apples/August-Abilene
61–57 P (10)
Purchased by SAMA from Mary Motz Wills with
Witte Picture Fund.

TEXAS MOUNTAIN LAUREL
n.d., watercolor on paper, 15⅛″ × 12¹¹⁄₁₆″
Signed lower left: Mary Motz Wills
Titled and documented lower right: Texas Mountain
Laurel/*Sophora secundaflora*
61–57 P (11)
Purchased by SAMA from Mary Motz Wills with
Witte Picture Fund.

WHITE EVENING PRIMROSE
n.d., watercolor on paper, 13″ × 9½″
Signed lower right: Mary Motz Wills
Titled and documented lower left: White Evening
Primrose/*Hartmannia speciosa*
61–57 P (12)
Purchased by SAMA from Mary Motz Wills with
Witte Picture Fund.

BLACK-LOCUST-TREE
n.d., watercolor on paper, 18¼″ × 14⅛″
Signed lower right: Mary Motz Wills
Titled and documented lower left: Black-Locust-Tree/
Robinia pseudoacacia
61–57 P (13)
Purchased by SAMA from Mary Motz Wills with
Witte Picture Fund.

WATER HYACINTH
n.d., watercolor on paper, 14⅛″ × 11½″
Signed lower right: Mary Motz Wills
Titled and documented lower left: *Piaropus crassipes*/
Water Hyacinth
61–57 P (14)
Purchased by SAMA from Mary Motz Wills with
Witte Picture Fund.

CENIZA
n.d., watercolor on paper, 14¹³⁄₁₆″ × 11⅝″
Signed lower right: Mary Motz Wills
Titled and documented lower left: *Leucophyllum
violaceum*/ceniza. senisa/Big Bend Park/Texas/Ceniza/
Senisa
61–57 P (15)
Purchased by SAMA from Mary Motz Wills with
Witte Picture Fund.

BIRD OF PARADISE
n.d., watercolor on paper, 16½″ × 13⅞″
Signed lower right: M. Wills
Titled and documented lower left: *Poinciana*. Bird of
Paradise. *Poinciana gilliesii*/Barba De Chivo/Goat's Beard
61–57 P (16)
Purchased by SAMA from Mary Motz Wills with
Witte Picture Fund.

APACHE-PLUME
n.d., watercolor on paper, 14⁵⁄₁₆″ × 11⅛″
Signed lower right: Mary Motz Wills
Titled and documented lower left: *Fallugia paradoxa*/
Davis Mts.
61–57 P (17)
Purchased by SAMA from Mary Motz Wills with
Witte Picture Fund.

CRAB APPLES
n.d., watercolor on paper, 15⁵⁄₁₆″ × 11″
Unsigned
Titled and documented lower left: Crab apples/*Pyrus
ioensis* var. texana
61–57 P (18)
Purchased by SAMA from Mary Motz Wills with
Witte Picture Fund.

CHEROKEE ROSE
n.d., watercolor on paper, 14⅛″ × 11″
Unsigned
Titled and documented across bottom: *Rosa laevigata*/
origin China. naturalized/in Texas/Cherokee Rose/
East Texas
61–57 P (19)
Purchased by SAMA from Mary Motz Wills with
Witte Picture Fund.

JIMSON WEED, ANGEL'S TRUMPET
n.d., watercolor on paper, 14½″ × 11⁷⁄₁₆″
Signed lower right: Mary Motz Wills
Titled and documented across bottom: *Datura
meteloides*/West Texas/Jimson weed/Angel's Trumpet
61–57 P (21)
Purchased by SAMA from Mary Motz Wills with
Witte Picture Fund.

PURPLE CUTLEAF, NIGHT SHADE
n.d., watercolor on paper, 10¾″ × 8⅝″
Signed lower right: Mary Motz Wills
Titled and documented lower left: *Solanum citrulli-
folium*/Purple cut leaf/night shade
61–57 P (22)
Purchased by SAMA from Mary Motz Wills with
Witte Picture Fund.

PINWHEEL
1940, watercolor on paper, 14″ × 11½″
Signed lower right: Mary Motz Wills
Titled and documented across bottom: Canyon at
Chisos Mts. August/*Macrosiphonia macrosiphon*/Big Bend
Park/Pinwheel
Dated top back: Aug-1940
61–57 P (23)
Purchased by SAMA from Mary Motz Wills with
Witte Picture Fund.

MARGIL, WILD SARSAPARILLA
n.d., watercolor on paper, 15¹⁵⁄₁₆″ × 11¹¹⁄₁₆″
Signed lower right: Mary Motz Wills
Titled and documented lower left: *Cebatha carolina*/
Margil/Wild Sarsaparilla
61–57 P (24)
Purchased by SAMA from Mary Motz Wills with
Witte Picture Fund.

PINK PRICKLY POPPY
n.d., watercolor on paper, 13⁵⁄₁₆″ × 10¹³⁄₁₆″
Signed lower center: M. Wills
Titled and documented lower left: Pink prickly
poppy/*Argemone rosea*
61–57 P (25)
Purchased by SAMA from Mary Motz Wills with
Witte Picture Fund.

BULL THISTLE, PINEAPPLE THISTLE
n.d., watercolor on paper, 18¼″ × 13¹³⁄₁₆″
Signed lower right: Mary Motz Wills
Titled and documented lower left: Bull thistle/
Pineapple thistle/*Cirsium horridulum*
61–57 P (26)
Purchased by SAMA from Mary Motz Wills with
Witte Picture Fund.

WILD CHINABERRY, SOAPBERRY
n.d., watercolor on paper, 13¼″ × 10¼″
Signed lower right: Mary Motz Wills
Titled and documented across bottom: *Sapindus
drummondii*/Wild Chinaberry-Texas/Tree, soapberry
61–57 P (27)
Purchased by SAMA from Mary Motz Wills with
Witte Picture Fund.

SPANISH BUCKEYE, EAST TEXAS BUCKEYE
n.d., watercolor on paper, 15⅞″ × 11½″
Signed lower right: Mary Motz Wills
Titled and documented lower left: Spanish buckeye/
Ungnadia speciosa/Buckeye So. E. Texas/East Texas
Buckeye/Dr. Ray
61–57 P (28)
Purchased by SAMA from Mary Motz Wills with
Witte Picture Fund.

MILK WEED
n.d., watercolor on paper, 15″ × 11¼″
Signed lower right: Mary Motz Wills
Titled and documented lower left: Milk weed/
Mid-West/*asclepias*
61–57 P (29)
Purchased by SAMA from Mary Motz Wills with
Witte Picture Fund.

SMALL WHITE FOX GLOVE
n.d., watercolor on paper, 14¼" × 7⁷⁄₁₆"
Signed lower right: Mary Motz Wills
Titled and documented lower left: *Pentstemon tubiflorus*/
Small white Fox Glove/*Penstemon*
61–57 P (32)
Purchased by SAMA from Mary Motz Wills with
Witte Picture Fund.

THIMBLE PLANTS, NIGGER HEADS
n.d., watercolor on paper, 13⅛" × 8½"
Signed lower right: Mary Motz Wills
Titled and documented lower left: Thimble plants/
nigger heads/*Ratibida columnaris*
61–57 P (33)
Purchased by SAMA from Mary Motz Wills with
Witte Picture Fund.

FOX GRAPE
n.d., watercolor on paper, 14⁷⁄₁₆" × 10¹³⁄₁₆"
Signed lower right: Mary Motz Wills
Titled and documented lower left: *Vitis arizonica*/
Fox Grape [?]
61–57 P (34)
Purchased by SAMA from Mary Motz Wills with
Witte Picture Fund.

WILD HYACINTH
n.d., watercolor on paper, 13⅛" × 7⅛"
Signed lower right: Mary Motz Wills
Titled and documented lower left: *Quamassia
hyacinthina*/Wild Hyacinth/Central Texas
61–57 P (35)
Purchased by SAMA from Mary Motz Wills with
Witte Picture Fund.

GUM PLANT, STICKYHEAD
n.d., watercolor on paper, 11⅛" × 7⁷⁄₁₆"
Signed lower right: Mary Motz Wills
Titled and documented lower left: Gum plant.
Stickyhead/*Grindelia inuloides*
61–57 P (36)
Purchased by SAMA from Mary Motz Wills with
Witte Picture Fund.

FERN
1944, watercolor on paper, 10⁹⁄₁₆" × 9¹¹⁄₁₆"
Signed lower right: Mary Motz Wills
Titled, dated, and documented lower left: Fern/
Ft. Davis/Aug-1944
61–57 P (37)
Purchased by SAMA from Mary Motz Wills with
Witte Picture Fund.

GOLDEN CORYDALIS, SCRAMBLED EGGS
n.d., watercolor on paper, 11⁹⁄₁₆" × 8¹³⁄₁₆"
Signed lower right: Mary Motz Wills
Titled and documented lower left: Golden Corydalis/
Capnoides curvisiliquum/scrambled eggs
61–57 P (38)
Purchased by SAMA from Mary Motz Wills with
Witte Picture Fund.

RUBBER PLANT
n.d., watercolor on paper, 10⅛" × 5⅛"
Unsigned
Titled and documented lower left: Rubber Plant/
Jatropha spathulata/Texas
61–57 P (39)
Purchased by SAMA from Mary Motz Wills with
Witte Picture Fund.

WINE CUPS
1944, watercolor on paper, 16⁹⁄₁₆" × 12½"
Signed lower right: Mary Motz Wills
Titled, dated, and documented lower left: *Callirhöe
digitata*/Wine cups/April-1944/Dallas
61–57 P (40)
Purchased by SAMA from Mary Motz Wills with
Witte Picture Fund.

PINK MARSH MALLOW
n.d., watercolor on paper, 14⁷⁄₁₆" × 11⅛"
Signed lower right: Mary Motz Wills
Titled lower left: Pink Marsh Mallow
61–57 P (41)
Purchased by SAMA from Mary Motz Wills with
Witte Picture Fund.

TEXAS BLUE BELLS
n.d., watercolor on paper, 14⁹⁄₁₆" × 13¹³⁄₁₆"
Signed lower right: Mary Motz Wills
Titled and documented lower left: Texas blue bells/
Eustoma russellianum/Gentian Family
61–57 P (43)
Purchased by SAMA from Mary Motz Wills with
Witte Picture Fund.

HORSEMINT
n.d., watercolor on paper, 13¼" × 7¼"
Signed center bottom: Mary Motz Wills
Titled lower left: Horsemint
61–57 P (44)
Purchased by SAMA from Mary Motz Wills with
Witte Picture Fund.

SNAKE APPLE
n.d., watercolor on paper, 15⅛" × 9⅛"
Unsigned
Titled top back: Snake apple
61–57 P (45)
Purchased by SAMA from Mary Motz Wills with
Witte Picture Fund.

STICK LEAF, GOOD MOTHER, "MALA MUJER"
n.d., watercolor on paper, 14¼" × 12¼"
Signed lower right: M. Wills
Titled and documented lower left: Stick leaf. Good
Mother. "mala mujer"/*Mentzelia albescens*/West Texas
61–57 P (46)
Purchased by SAMA from Mary Motz Wills with
Witte Picture Fund.

ROSE MALLOW
n.d., watercolor on paper, 12⅛" × 7¼"
Unsigned
Titled and documented lower right: *Pavonia lasiopetala*/
Rose Mallow
61–57 P (47)
Purchased by SAMA from Mary Motz Wills with
Witte Picture Fund.

SOUTHERN ANEMONE, WIND FLOWER
1943, watercolor on paper, 11¼" × 7¼"
Signed lower right: Mary Motz Wills
Titled, dated, and documented lower left: *Anemone
decapetala*/Anemone-Abilene Tex/Feb. 28th 1943/
March
Titled top back: Southern Anemone/or wind flower
61–57 P (48)
Purchased by SAMA from Mary Motz Wills with
Witte Picture Fund.

GREEN VIOLETS, BABY SLIPPERS
n.d., watercolor on paper, 11½" × 5⅛"
Signed lower right: Mary Motz Wills
Titled and documented lower left: Green Violets/
Baby Slippers/*Calceolaria verticillata*/Texas--May
61–57 P (49)
Purchased by SAMA from Mary Motz Wills with
Witte Picture Fund.

TEXAS "CHAPARRAL," BRASIL, BLUEWOOD
n.d., watercolor on paper, 11⅛" × 8⅝"
Unsigned
Titled and documented lower left: *Condalia obovata*/
Texas "chaparral"/San Ant. to Dallas/Brasil. Bluewood
61–57 P (50)
Purchased by SAMA from Mary Motz Wills with
Witte Picture Fund.

VERBENA
n.d., watercolor on paper, 10⅝" × 7½"
Signed lower right: Mary Motz Wills
Titled and documented lower left: Verbena/*Verbena
bipinnatifida*
61–57 P (51)
Purchased by SAMA from Mary Motz Wills with
Witte Picture Fund.

MILK WEED
n.d., watercolor on paper, 11¼" × 8¼"
Signed lower right: Mary Motz Wills
Titled and documented across bottom: Milk weed/
Asclepias sp.
61–57 P (52)
Purchased by SAMA from Mary Motz Wills with
Witte Picture Fund.

WHITE BINDWEED, PURPLE THROAT BINDWEED
n.d., watercolor on paper, 11⅛" × 7¼"
Signed lower right: Mary Motz Wills
Titled and documented lower left: White Bindweed-
Con. spithamaens/Purple Throat bindweed/*Convolvulus
sepium*
61–57 P (53)
Purchased by SAMA from Mary Motz Wills with
Witte Picture Fund.

PENSTEMON
n.d., watercolor on paper, 20⅛" × 9"
Signed lower right: Mary Motz Wills
Titled and documented lower left: *Pentstemon*-Phantom
Hill/N. West Texas/near Abilene
61–57 P (54)
Purchased by SAMA from Mary Motz Wills with
Witte Picture Fund.

YELLOW STANDING CYPRESS
n.d., watercolor on paper, 20½″ × 11½″
Signed lower right: Mary Motz Wills
Titled and documented lower left: Yellow standing
cypress/Gilia rubra var. (?)
61–57 P (55)
Purchased by SAMA from Mary Motz Wills with
Witte Picture Fund.

WHITE GILIA
n.d., watercolor on paper, 12″ × 8⅞″
Signed lower right: Mary Motz Wills
Titled and documented lower left: White Gilia/Gilia
longiflora
61–57 P (56)
Purchased by SAMA from Mary Motz Wills with
Witte Picture Fund.

CURLY DOCK
n.d., watercolor on paper, 20⁷⁄₁₆″ × 13⅛″
Unsigned
Titled and documented lower left: Curly Dock/Rumex
hymenosepalus
61–57 P (57)
Purchased by SAMA from Mary Motz Wills with
Witte Picture Fund.

WATER LILY
n.d., watercolor on paper, 13¹¹⁄₁₆″ × 11¹⁄₁₆″
Signed lower right: Mary Motz Wills
Titled and documented lower left: Water Lily/Castalia
elegans
61–57 P (58)
Purchased by SAMA from Mary Motz Wills with
Witte Picture Fund.

BLUE CURLS
n.d., watercolor on paper, 11⅝″ × 6⅞″
Signed lower right: Mary Motz Wills
Documented top back: Phacelia congesta
61–57 P (59)
Purchased by SAMA from Mary Motz Wills with
Witte Picture Fund.

MALLOW, WILD HOLLYHOCK
1940, watercolor on paper, 11″ × 6¼″
Unsigned
Titled and documented across bottom: Mallow/
Wild Hollyhock/Sphaeralcea cuspidata (angustifolia)
Documented and dated top back: Fort Davis/
August 1940
61–57 P (60)
Purchased by SAMA from Mary Motz Wills with
Witte Picture Fund.

LARGE SKULLCAP
n.d., watercolor on paper, 11″ × 7⅛″
Signed lower right: Mary Motz Wills
Titled and documented lower left: Large Skullcap/
Brazoria scutellarioides
61–57 P (61)
Purchased by SAMA from Mary Motz Wills with
Witte Picture Fund.

MILK WEED
n.d., watercolor on paper, 13¾″ × 8⅝″
Signed lower right: Mary Motz Wills
Titled and documented lower left: Asclepias lindheimeri/
Milk weed/West Texas
61–57 P (62)
Purchased by SAMA from Mary Motz Wills with
Witte Picture Fund.

MEXICAN APPLE
n.d., watercolor on paper, 9¼″ × 6⅝″
Signed lower right: Mary Motz Wills
Titled and documented lower left: Mexican apple/
Malvaviscus drummondii
61–57 P (63)
Purchased by SAMA from Mary Motz Wills with
Witte Picture Fund.

PINK MIMOSA
n.d., watercolor on paper, 11″ × 9″
Unsigned
Titled and documented lower left: Pink Mimosa/
Mimosa fragrans
61–57 P (64)
Purchased by SAMA from Mary Motz Wills with
Witte Picture Fund.

MEXICAN PERSIMMONS, CHAPOTE POSSOM PLUMS
n.d., watercolor on paper, 11½″ × 8⅛″
Unsigned
Titled and documented across bottom: Brayodendron
texanum/Mexican persimmons/San Antonio August-July
Titled top back: Mexican persimmon-Brayodendron
texanum/chapote Possom Plums
61–57 P (65)
Purchased by SAMA from Mary Motz Wills with
Witte Picture Fund.

STANDING CYPRESS, TEXAS STAR, INDIAN PLUME
n.d., watercolor on paper, 21¹¹⁄₁₆″ × 13¹¹⁄₁₆″
Signed lower right: Mary Wills
Titled and documented lower left: Gilia rubra/
Standing Cypress/Texas Star
Titled and documented top back: Standing Cypress-
Indian plume/Gilia rubra
61–57 P (66)
Purchased by SAMA from Mary Motz Wills with
Witte Picture Fund.

RAIN LILY
n.d., watercolor on paper, 12⁷⁄₁₆″ × 7¹¹⁄₁₆″
Signed lower right: Mary Motz Wills
Titled and documented lower left: Cooperia drummondii/
Rain Lily
61–57 P (67)
Purchased by SAMA from Mary Motz Wills with
Witte Picture Fund.

OCOTILLO, JACOB'S STAFF
n.d., watercolor on paper, 13¾″ × 7⅞″
Signed lower right: Mary Motz Wills
Titled and documented lower left: Fouquieria splendens/
Ocotillo/Jacob's Staff
61–57 P (68)
Purchased by SAMA from Mary Motz Wills with
Witte Picture Fund.

YELLOW EVENING PRIMROSE, FLUTTER-MILL
n.d., watercolor on paper, 14¼″ × 10″
Unsigned
Titled and documented center back: Oenothera
missouriensis/near Abilene
61–57 P (69)
Purchased by SAMA from Mary Motz Wills with
Witte Picture Fund.

TEXAS BLAZING STAR, GAY FEATHER
n.d., watercolor on paper, 15¹³⁄₁₆″ × 11¼″
Signed lower right: Mary Motz Wills
Titled lower left: Texas Blazing Star
Titled and documented top back: Liatris punctata/
Blazing Star/Gay feather-Colic Root
61–57 P (70)
Purchased by SAMA from Mary Motz Wills with
Witte Picture Fund.

NIGHT BLOOMING CEREUS, MEXICAN CEREUS
1940, watercolor on paper, 14⅛″ × 13³⁄₁₆″
Unsigned
Titled, dated, and documented lower left: Night
blooming Cereus/Arizona May-1940/Imported from
Mexico/Mexican Cereus
61–57 P (71)
Purchased by SAMA from Mary Motz Wills with
Witte Picture Fund.

SMOOTH SUMAC, WINGED SUMAC
n.d., watercolor on paper, 12½″ × 10⁷⁄₁₆″
Signed lower right: Mary Motz Wills
Titled and documented lower left: Smooth Sumac/
Rhus glabra/Winged Sumac/Rhus copallina
61–57 P (72)
Purchased by SAMA from Mary Motz Wills with
Witte Picture Fund.

PURPLE CONE FLOWER
1944, watercolor on paper, 13″ × 9¹⁵⁄₁₆″
Signed lower right: Mary Motz Wills
Titled and documented lower left: Echinacea
angustifolia/Purple Cone flower/Dallas
Documented and dated top back: at Dallas 1944
61–57 P (73)
Purchased by SAMA from Mary Motz Wills with
Witte Picture Fund.

ANGEL'S TRUMPETS, FLAME FLOWER
n.d., watercolor on paper, 10⅝″ × 7⅛″
Signed lower left: Mary Motz Wills
Titled lower left: Angel's Trumpets
Titled and documented lower right: Flame flower/
Talinum lineare
Titled and documented top back left: Acleisanthes
longilora/Angels' Trumpets
61–57 P (74)
Purchased by SAMA from Mary Motz Wills with
Witte Picture Fund.

WHITE MEXICAN POPPY, MEXICAN THISTLE
n.d., watercolor on paper, 14⅛″ × 9″
Unsigned
Titled and documented lower left: *Argemone alba*/
White Mexican poppy
Titled top back: Mexican poppy-Mexican thistle
61–57 P (75)
Purchased by SAMA from Mary Motz Wills with
Witte Picture Fund.

WINE CUPS
n.d., watercolor on paper, 14⁹⁄₁₆″ × 11½″
Signed lower center: Mary Motz Wills
Titled lower left: Wine cups
Documented lower right: *Callirhöe involucrata* (pink and
white/forms)/Albany, Texas
61–57 P (76)
Purchased by SAMA from Mary Motz Wills with
Witte Picture Fund.

INDIAN PAINTBRUSH
n.d., watercolor on paper, 11¼″ × 7″
Signed lower right: M. Wills
Titled and documented lower left: Indian Paintbrush/
Castilleja individa
61–57 P (77)
Purchased by SAMA from Mary Motz Wills with
Witte Picture Fund.

CARDINAL FLOWER
n.d., watercolor on paper 12⅛″ × 6⅞″
Signed lower right: Mary Motz Wills
Titled and documented lower left: *Lobelia cardinalis*/
Cardinal Flower
61–57 P (78)
Purchased by SAMA from Mary Motz Wills with
Witte Picture Fund.

CONE FLOWER
n.d., watercolor on paper, 14⅛″ × 12″
Signed lower right: Mary Motz Wills
Documented lower right: West Texas/*Rudbeckia
laciniata*
61–57 P (79)
Purchased by SAMA from Mary Motz Wills with
Witte Picture Fund.

WILD IRIS
n.d., watercolor on paper, 14″ × 8¹¹⁄₁₆″
Signed lower right: Mary Motz Wills
Titled and documented lower left: Wild Iris/
Iris carolinianum/Iris-Coastal
61–57 P (80)
Purchased by SAMA from Mary Motz Wills with
Witte Picture Fund.

DEVIL'S HORNS, UNICORN PLANT
n.d., watercolor on paper, 14″ × 13¹⁄₁₆″
Signed lower right: Mary Motz Wills
Titled, documented, and dated lower left: Unicorn
plant/Devil's Horns/Davis Mountains/August/*Martynia
fragrans*
61–57 P (81)
Purchased by SAMA from Mary Motz Wills with
Witte Picture Fund.

DEVIL'S HORNS, UNICORN PLANT
n.d., watercolor on paper, 12¼″ × 9″
Signed lower right: Mary Motz Wills
Titled and documented lower left: Devil's horns/
Martynia fragrans/unicorn plant
61–57 P (82)
Purchased by SAMA from Mary Motz Wills with
Witte Picture Fund.

YELLOW NIGHT SHADE, BUFFALO BUR
n.d., watercolor on paper, 10¼″ × 7¼″
Signed lower right: Mary Motz Wills
Titled and documented across bottom: Yellow night
shade/*Solanum rostratum*/Buffalo Bur
61–57 P (83)
Purchased by SAMA from Mary Motz Wills with
Witte Picture Fund.

BALL MOSS
n.d., watercolor on paper, 10⅛″ × 9¼″
Signed lower right: Mary Motz Wills
Titled and documented lower left: Ball Moss/
Tillandsia-recurvata
61–57 P (84)
Purchased by SAMA from Mary Motz Wills with
Witte Picture Fund.

WILD HONEYSUCKLE
n.d., watercolor on paper, 13¾″ × 7¼″
Unsigned
Documented center back: (left) *Gaura suffulta*/(right)
Gaura brachycarpa
61–57 P (85)
Purchased by SAMA from Mary Motz Wills with
Witte Picture Fund.

RAGWORT
n.d., watercolor on paper, 13⅛″ × 8⅛″
Signed lower right: Mary Motz Wills
Titled and documented lower left: *Senecio filifolius*/
Ragwort
61–57 P (86)
Purchased by SAMA from Mary Motz Wills with
Witte Picture Fund.

LATE ASTER
n.d., watercolor on paper, 11⁷⁄₁₆″ × 7⅛″
Signed lower right: Mary Motz Wills
Titled lower left: Late aster
61–57 P (87)
Purchased by SAMA from Mary Motz Wills with
Witte Picture Fund.

LOCO WEED
n.d., watercolor on paper, 15⅛″ × 11⅛″
Signed lower right: Mary Motz Wills
Titled and documented lower left: *Oxytropis lambertii*/
Loco weed
Documented top back: near Abilene/April
61–57 P (88)
Purchased by SAMA from Mary Motz Wills with
Witte Picture Fund.

STANDING PRIMROSE
n.d., watercolor on paper, 17″ × 11⅛″
Unsigned
Titled and documented lower right: Standing
primrose/*Oenotera* sp.
61–57 P (89)
Purchased by SAMA from Mary Motz Wills with
Witte Picture Fund.

ACTINEA DAISY
n.d., watercolor on paper, 12¼″ × 7⅛″
Signed lower right: Mary Motz Wills
Titled and documented lower left: Actinea Daisy/
Fort Davis
61–57 P (90)
Purchased by SAMA from Mary Motz Wills with
Witte Picture Fund.

TEXAS BLUE STAR
n.d., watercolor on paper, 8″ × 5″
Signed lower right: Mary Motz Wills
Titled and documented bottom back: Texas Blue
Star/*Amsonia texana*
61–57 P (91)
Purchased by SAMA from Mary Motz Wills with
Witte Picture Fund.

HORSE MINT, RED BERGAMOT
n.d., watercolor on paper, 11″ × 6½″
Signed lower right: Mary Motz Wills
Titled and documented lower left: Red Bergamot/
horse mint/*Monarda didyma*
61–57 P (92)
Purchased by SAMA from Mary Motz Wills with
Witte Picture Fund.

YELLOW DAISY
n.d., watercolor on paper, 11⅛″ × 5¹⁵⁄₁₆″
Signed lower right: Mary Motz Wills
Documented top back: *Tetraneuris scaposa*
61–57 P (93)
Purchased by SAMA from Mary Motz Wills with
Witte Picture Fund.

PARTRIDGE PEA
n.d., watercolor on paper, 9¹³⁄₁₆″ × 6½″
Signed lower right: Mary Motz Wills
Titled and documented lower left: Partridge Pea/
Camaecrista/*cinerea*
61–57 P (94)
Purchased by SAMA from Mary Motz Wills with
Witte Picture Fund.

WHITE WINGS, WHITE MILKWORT
n.d., watercolor on paper, 11¾″ × 7¼″
Signed lower right: Mary Motz Wills
Titled, dated, and documented lower left: White
wings/White milkwort/*Polygala alba*/near Abilene-
May 7
61–57 P (95)
Purchased by SAMA from Mary Motz Wills with
Witte Picture Fund.

PAPER DAISY, PRAIRIE ZINNIA
n.d., watercolor on paper, 7¼" × 7⁷⁄₁₆"
Signed lower right: Mary Motz Wills
Titled and documented lower left: Paper Daisy/
West Texas/Davis Mt/*Crossina grandiflora*
Titled lower left back: Prairie Zinnia
61–57 P (96)
Purchased by SAMA from Mary Motz Wills with
Witte Picture Fund.

SWEET BUSH
n.d., watercolor on paper, 14⅛" × 9¼"
Signed lower center: Mary Motz Wills
Titled and documented across bottom: *Aloysia
ligustrina*/Sweet Bush/Ft. Davis
61–57 P (97)
Purchased by SAMA from Mary Motz Wills with
Witte Picture Fund.

WILD ROSE, PASTURE ROSE
n.d., watercolor on paper, 10¼" × 6⅝"
Signed lower right: Mary Motz Wills
Titled and documented lower left: Wild Rose/*Rosa
sp.*/Pasture Rose
61–57 P (99)
Purchased by SAMA from Mary Motz Wills with
Witte Picture Fund.

RED YUCCA, PINKTORIA
n.d., watercolor on paper, 14¼" × 8⅜"
Signed lower right: Mary Motz Wills
Titled and documented lower left: Red/Yucca/
Pinktoria
61–57 P (100)
Purchased by SAMA from Mary Motz Wills with
Witte Picture Fund.

THELESPERMA
n.d., watercolor on paper, 11⅛" × 7⅛"
Signed lower right: Mary Motz Wills
Documented lower left: *Thelesperma/Thelesperma
subsimpliciolium*/closely related to Coreopsis
61–57 P (101)
Purchased by SAMA from Mary Motz Wills with
Witte Picture Fund.

YELLOW FLUTTER MILL
n.d., watercolor on paper, 13¼" × 8¼"
Unsigned
61–57 P (102)
Purchased by SAMA from Mary Motz Wills with
Witte Picture Fund.

TEXAS STAR
n.d., watercolor on paper, 11⅛" × 6⅛"
Signed lower right: Mary Motz Wills
Titled and documented across bottom: near Abilene
Tex/Texas Star [?]/*Erythraea calycosa*
61–57 P (103)
Purchased by SAMA from Mary Motz Wills with
Witte Picture Fund.

BLUE SALVIA, BLUE SAGE
n.d., watercolor on paper, 11⅛" × 7⁹⁄₁₆"
Unsigned
Titled and documented across bottom: Blue Salvia/
Blue Sage/*Salvia farinacea*/Blue sage/*Salviastrum/texanum*
61–57 P (104)
Purchased by SAMA from Mary Motz Wills with
Witte Picture Fund.

PURPLE WATER HYACINTH
1937, watercolor on paper, 14¹⁵⁄₁₆" × 11¹¹⁄₁₆"
Signed lower right: Mary Motz Wills
Dated and titled upper left back: Aug. 22, 1937/
Erchhoma sp.
61–57 P (105)
Purchased by SAMA from Mary Motz Wills with
Witte Picture Fund.

Robert Wood was born on March 24, 1889, in Sandgate, England, a small town on the Kentish Coast near the white cliffs of Dover. He was the son of W. J. Wood, also a painter, and was encouraged by his father to pursue a career in art. At the age of twelve, Robert was enrolled in an art school in nearby Folkestone and later may also have attended the South Kensington School of Art.[1]

Robert Wood came to America in 1910 to explore the country and to ply his craft. He found little lucrative work as an artist and was forced to take any job available. He became a "hobo artist" traveling the country by hopping freight cars, sketching and painting wherever he went.[2]

In 1912 Wood was in Florida, where he met Eyssel del Wagoner, who became his first wife. She shared her husband's adventurous spirit and by the time their first child, Florence Adeline, was born in 1913, they had moved to St. Johns, Ohio. Shortly thereafter, they moved to Seattle, Washington, where a son, John Robert, was born in 1919.[3]

The son's health was of great concern to the family, and they hopscotched across the country to find a salubrious climate, trying California, Oregon, Missouri, Kansas, and elsewhere. They traveled in a touring car, camping out for the most part. Wherever they stopped, Robert Wood would paint and sell enough canvases for them to survive.[4]

Their odyssey found them along the Texas Gulf Coast in 1924. Robert Wood was a skillful painter and had developed an act in which he created paintings in a matter of minutes on stage and in store windows. When the family came to San Antonio sometime in 1924, he continued to paint "buckeye" pictures in a window in his downtown studio.[5] The colorful city seemed to suit Robert's temperament very well; he lived there and in the neighboring Hill Country until 1941.

In 1925 the Woods divorced, with Robert retaining full custody of the children.[6] Robert continued his serious painting career, studying with José Arpa, who also became a close friend.[7] Wood's painting style reflects Arpa's influence with its competent interpretation of nature but does not quite equal Arpa's mastery of brilliant sunshine and the play of light and shadow.

Wood was active in local art organizations and exhibited regularly in regional shows. He was a member of the Coppini Academy, a consistent exhibitor in its shows, and one of its staunch supporters.[8] Although there is little evidence that Wood ever did much teaching, he is credited with encouraging Porfirio Salinas (1910–1973), who also became a Texas landscapist.[9]

In 1932 Robert Wood moved to a rustic house on the Scenic Loop Road near the community of Helotes. He reveled in the picturesque Texas Hill Country and produced hundreds of pleasant and popular Texas landscapes. During this era of prolific output he sometimes signed his canvases with the pseudonyms "G. Day" (for "Good Day") or "Trebor" (Robert in reverse).[10]

Wood married Tula Murphy during his stay in Texas, and in 1941 they moved to California. The couple first chose the Monterey Peninsula for a home but lived in other sites in the state before Robert decided to spend some time in the Woodstock Art Colony in New York. They returned to California in the early 1950s and were divorced in 1952. He later married Caryl Price, one of his art students.[11]

1. Doris Ostrander Dawdy, Artists of the American West, A Biographical Dictionary: Artists Born Before 1900, 3 (Chicago: Swallow Press, 1981), s.v. "Wood, Robert"; Violet Sigoloff Flume, The Last Mountain: The Life of Robert Wood (Brookline Village, Massachusetts: Branden Press, 1983), 6.
2. Glenn Tucker, "Art Scene," San Antonio Light, March 25, 1979.
3. Flume, The Last Mountain, 11–14.
4. Ibid, 15–19.
5. Ibid., 21.
6. Ibid., 25.
7. Tucker, "Art Scene."
8. Catalogues and listings, Robert William Wood file, SAMA Texas Artists Records.
9. Ruth Goddard, Porfirio Salinas, with an introduction by Dewey Bradford (Austin: Rock House Press, 1975), 25.
10. Flume, The Last Mountain; William Elton Green (SAMA Associate Curator of History) to author (SA), interview, August 14, 1984.
11. Flume, The Last Mountain, 35–41.

With the exception of painting excursions, Robert and Caryl remained in California, moving from place to place, ultimately settling in Bishop, a small town snuggled in the Sierra Madre mountains near the Nevada border. Robert Wood died there on March 15, 1979, just nine days shy of his ninetieth birthday.[12]

Robert Wood was an exceedingly successful painter in his day, and since his death his paintings have escalated in value. His prodigious output has not decreased their desirability, and his work is being sought as eagerly as Julian Onderdonk's or José Arpa's. To him life was a continuing challenge, and he was fond of saying, "No matter how many mountains you climb in your life, there is always one more facing you."[13]

SPRINGTIME
1953, oil on canvas, 24″ × 36″
Signed and dated lower left: Robert Wood, '53

Robert Wood painted *Springtime* while living in California. He had a remarkable visual memory and carried scenes in his head which he translated to canvas whenever he wished.[14] Possibly *Springtime* was such a creation, as it is a typical Texas landscape. The foreground is a sea of blue flowers dotted with white poppies, the trees appear to be Texas live oaks, and the sprawling hills in the distance suggest the Texas Hill Country. It has a definite aura of springtime with its delicate tonality, luscious growth, and fleecy clouds. It is a capable painting done in the traditional manner to which Wood adhered throughout his career.

PROVENANCE:
1955: Purchased by H. L. Winfield, father of Mrs. Asher R. McComb. Winfield was president of the Pecos County State Bank in Fort Stockton, Texas, where the painting hung until his death in 1957.
1957: Inherited by Dr. and Mrs. Asher R. McComb.
1981: Gift to SAMA by Dr. and Mrs. Asher R. McComb.
81–169 G

EXHIBITIONS:
1982: A Birthday Celebration: Recent Gifts and Acquisitions, SAMOA (March 1 to May 16).
1986: Texas Seen/Texas Made, SAMOA (September 29 to November 30).
1990: Looking at the Land: Early Texas Painters, San Angelo Museum of Fine Arts (February 22 to March 25).

12. Tucker, "Art Scene"; "Noted painter dies," San Antonio *Express*, March 16, 1979.
13. Flume, *The Last Mountain*, 2.
14. Ibid., 37.

1. Glen E. Lich, *The German Texans* (San Antonio: University of Texas Institute of Texan Cultures at San Antonio, 1981), 140; "The Wueste Family." Undated photocopied typescript, Louise Heuser Wueste file, SAMA Texas Artists Records (from Mrs. Kenneth C. Nichols).

2. Elsbeth Heuser, "Our Ancestors" (written in Hameln, Germany, 1952): 3. Photocopied typescript, Wueste file, SAMA Texas Artists Records.

3. Mary Staffel Elmendorf, "Our Ancestors" (written in San Antonio, 1955): 2, 7. Photocopied typescript, Wueste file, SAMA Texas Artists Records.

4. Ingeborg Wittichen, *Oberbergische Malerinnen: des 19. Jahrhunderts aus der Familie Jügel/Heuser* (Celle, West Germany: Cellesche Zeitung, Schweiger & Pick Verlag for the Museum des Oberbergischen Landes auf Schloss Homburg, 1980), 11.

5. "The Wueste Family."

6. Wittichen, *Oberbergische Malerinnen*, 11. Mary Elmendorf made a more blunt statement: "[He] caught the prevailing epidemic and died."

7. James Patrick McGuire, "Views of Texas: German Artists on the Frontier in the Mid-Nineteenth Century," in *German Culture in Texas: A Free Earth; Essays from the 1978 Southwest Symposium*, eds. Glen E. Lich and Dona B. Reeves (Boston: Twayne Publishers, 1980), 131.

8. Ibid.

9. Wittichen, *Oberbergische Malerinnen*, 11; Utterback, *Early Texas Art*, 46. Many years later in a letter Louise remembered her student days with nostalgia: "I may assure you that the happiest time of my life were the five years I spent with you at Dusseldorf and which I still remember with pleasure." Louise Wueste (SA) to her relatives in Germany, April 25, 1869.

10. "The Wueste Family."

11. "Diary of Adeline Wueste Staffel."

12. Elmendorf, "Our Ancestors," passim.

13. E. Geue, *New Homes in a New Land*, 49. This is substantiated in the short biography written in German by Ingeborg Wittichen, a Heuser descendant.

14. Wittichen, *Oberbergische Malerinnen*, 11.

Louise Heuser Wueste [Wüste], the first important woman artist to appear on the Texas scene, was born on June 6, 1805, in Gummersbach, Germany, the eldest daughter of Daniel and Louise (Jügel) Heuser.[1] One family account maintains that Louise was a twin but that her brother died at birth.[2] Her family was a distinguished and prosperous one that could boast of numerous talented artists and musicians. As a consequence Louise's childhood was spent in pleasant surroundings and a cultured atmosphere.

Louise's father was a successful merchant who dealt in wines, dyes, paints, and gunpowder. As an importer as well as a manufacturer, he once cornered the indigo market in Germany. His company is credited with developing a new dye from indigo, Prussian blue, a brilliant color familiar to all artists.[3]

Besides Louise, the Heusers had five other children. The children spent many happy hours at the home of their uncle, Carl Jügel, in Frankfurt, where they met many interesting and entertaining young men and women. But it was in her own home in Gummersbach that Louise made the acquaintance of a handsome young physician, Peter Wilhelm Leopold Wueste, from Hülsenbusch. He often visited the home of Daniel Heuser, and the two young people fell in love. They became engaged in the spring of 1823, and were married on January 16, 1824.[4]

The couple had three children: Emma, born on March 3, 1827; Adeline, born on August 11, 1828; and Daniel, born on May 29, 1830.[5] When the children were still infants, Dr. Wueste met an untimely end, having contracted typhoid fever from infected patients. He was only thirty-seven years old.[6] The distraught Louise, with her small brood, returned to her parents' home to live and to further her art career.[7]

Two of Louise's sisters had married prominent German artists: Ida Heuser married Karl-Friedrich Lessing (1808–1880), and Alwine was wedded to Adolph Schröedter (1805–1875).[8] These distinguished gentlemen encouraged Louise and helped her with her painting. She went on to study at the academy in Düsseldorf where she was greatly influenced by Friedrich Böser (1809–1881), a fashionable portrait painter of the period, and possibly by Karl Ferdinand Sohn (1805–1867).[9]

Louise's life in Germany must have been agreeable and pleasant for the most part. Her daughters were married, Emma to Carl Ferdinand Schlickum and Adeline to Heino Staffel.[10] In 1852 Adeline and Heino, accompanied by their small son Eugene and Heino's brother August, immigrated to Texas. Adeline kept a diary for her mother in which she described the ordeals encountered on the long sea journey and the trials and tribulations that faced them in their new home.[11] Discouraging as some of her tales were, there was also a definite sense of hopefulness for the future, and by 1854 Emma and her husband followed the Staffels to Texas. Daniel Wueste joined them, and although they all eventually went their separate ways, they shared San Antonio as a base.[12]

Even though most accounts maintain that Louise Wueste followed her children to Texas in 1857, her name first appears on a ship's list in 1859, on the sailing ship *Weser*.[13] Louise first stayed with her daughter Adeline in San Antonio, and later visited Adeline when she had moved to Pleasanton. Not wanting to be a burden on her family, she decided to apply her artistic talents primarily in the field of portraiture.[14] Already in her mid-fifties and in surroundings that were a far cry from the cultured environment she had known in Germany, her lot was not an easy one. But

by 1860 she had established a studio at No. 18 in the French Building in San Antonio and advertised in a local newspaper offering "the services of her art training in taking likenesses in oil or drawing, as well as to give lessons in every branch of art. . . ."[15] She painted one of her most successful portraits, of nineteen-year-old Sarah Riddle Eagar, one of San Antonio's most beautiful belles, in 1861.[16]

Louise Wueste worked at the same time that Carl G. von Iwonski, Hermann Lungkwitz, and Theodore Gentilz were active in San Antonio, but there is no evidence that she knew them well. A photograph of her with palette in hand, however, has been attributed to Lungkwitz.[17]

The hardships imposed by the Civil War evidently forced Louise to flee to Piedras Negras, Mexico, to be with her son Daniel, who was in business there. In 1863, she wrote to her daughter Emma:

> I have had very little—or no work—and am glad that I can be of service here, and not like an unnecessary piece of furniture shoved about in the world. Painting is a queer art here in America where only commerce is recognized. . . . Here we live in mud houses with dirt floors and straw roofs even without windows but what of it! If only conditions will not change for the worse. At present there are no commissions to be had here for an artist. Only Daniel has much work to do and we see him only at meal time.[18]

Several months later Louise was back in San Antonio, again writing to her daughter Emma. She lamented the adversities that everyone was enduring because of the war but did refer to an earlier period when her painting had fared a little better: "I have been getting along nicely, had much work [painting], made money, and saved some for hard times which are now here and devour my savings. . . . My art as you can surmise now brings me small returns and I wish daily to be far away where I could better practice it."[19]

In September 1865 Louise decided to join Emma in New Orleans. She got as far as Galveston before learning that Emma had moved to Brownsville. Undaunted, Louise made the best of the situation and lodged for a short time with a cigar merchant named Baer and his family in Galveston, where she gave painting lessons until she was able to return to San Antonio.[20]

Just when Louise returned to San Antonio is not clear, but the growing community undoubtedly provided her with opportunities to pursue her art career. She maintained various studios at different times. Besides the atelier in the French Building, she painted and taught art classes at 511 Villita Street in a pleasant house of stuccoed and painted limestone built by Colonel Jeremiah Y. Dashiell. Its spacious upper floor had a veranda across the front. It was built on a site that sloped down to the river in back. A full-story basement beneath the upper level opened onto a rear garden that provided Louise some respite from the sultry Texas heat.[21] There also is evidence that she taught sewing and, possibly, drawing at the German-English School on South Alamo Street in the district known as La Villita.[22]

Between 1865 and 1869, Louise occasionally visited her son, who had moved to Eagle Pass. In 1869 she wrote to her sisters in Germany: "You know I was with Daniel at Eagle Pass. He has settled there and owns a large house with a garden and sufficient business and wanted me to stay with him but unfortunately the climate does not agree with me as I am still suffering from my eyes. I was obliged to consult a good

physician here (Doctor Herff), a famous San Antonio Dr. who came with the German immigrants. . . ."[23] Failing eyesight must have been a heavy cross for Louise to bear, and although her references to her debility are vague and undefined, the ministrations of the noted pioneer Dr. Ferdinand Herff evidently helped her. For in the same letter she stated: "Later on, when my eyes will be better, I hope to take to painting again. As yet I was not allowed to paint, which I regret very much. I cannot make you feel how afraid I was that I might go blind!"[24]

Certainly Louise's eyesight and spirits were improving, for another paragraph in the same letter reads: "Just now I am looking through the door at the wonderful green, which, this year is so lush. We had a great deal of rain, which means abundance in Texas. Everybody rejoices at the amount of fruit and flowers I have never seen the like since I have been here. There are roses so beautiful and aromatic and so many of them that you will see them in every house and garden—indeed it is a beautiful year."[25]

During the next few years she alternated between Eagle Pass and San Antonio. The Texas heat, from which she suffered so greatly, was made more bearable in August 1874 when she accompanied the Staffels to a farm on the Bandera Road belonging to a Mr. Müller. She relished the higher, drier climate on the farm and "had an enjoyable time."[26]

On September 14, 1874, Louise started her last journey to Daniel's home in Eagle Pass. She disregarded a boil on her back, an inflammatory condition to which she was prone. The eight-day carriage ride over rough roads, the heat, and her advancing age created a situation that culminated in a fatal illness. Daniel wrote: "[She] arrived here eight days ago mortally ill. The boil [a carbuncle] had spread over her entire back and she could not get out of the carriage and I had to carry her into the house."[27]

Louise Wueste died on September 25, 1874. A courageous and valiant lady, as well as a talented painter, she was laid to rest in the Military Cemetery in Eagle Pass.[28]

15. Advertisement, San Antonio Daily Herald, May 8, 1860.
16. Pinckney, Painting in Texas, 120.
17. Charles Ramsdell, "Kunst und Kaffeeklatsch," San Antonio Express, February 20, 1949.
18. Louise Wueste (Piedras Negras) to Emma [Schlickum] (New Orleans), April 29, 1863.
19. Louise Wueste (SA) to Emma [Schlickum] (New Orleans), January 24, 1864.
20. McGuire, "Views of Texas," in German Culture in Texas, eds. Lich and Reeves, 133. In all of her letters Louise lamented the Texas heat and how it troubled her. McGuire quotes, "I have again felt in Staffel's home [in San Antonio] how little I can stand any exertion in this hot climate. . . ." The Texas heat aggravated an infectious condition to which Louise was prone and which eventually was responsible for her death.
21. Utterback, Early Texas Art, 46; Goeldner (comp.), Texas Catalog (TEX-3169).
22. McGuire, "Views of Texas," in German Culture in Texas, eds. Lich and Reeves, 132.
23. Louise Wueste (SA) to her relatives in Germany, April 25, 1869.
24. Ibid. Although Louise makes no reference to cataracts causing her condition, it is possible Dr. Herff performed this type of operation. Cataract surgery was one of the ophthalmic skills he learned in Germany and when he practiced in Texas, there are numerous testimonials to his successful cataract operations. See Ferdinand Peter Herff, The Doctors Herff: A Three-Generation Memoir, ed. Laura Barber (San Antonio: Trinity University Press, 1973).
25. Ibid.
26. Louise Wueste (SA) to Emma [Schlickum] (Austin), August 15, 1874.
27. Daniel Wueste (Eagle Pass) to Emma [Schlickum] (Austin), September 25, 1874.
28. Ibid.

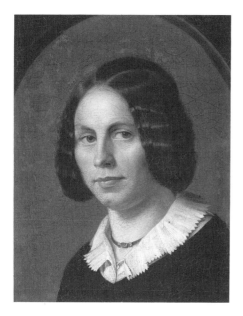

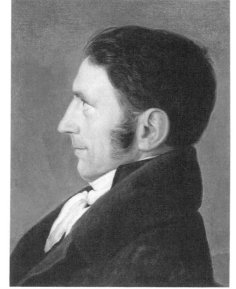

SELF-PORTRAIT
n.d., oil on canvas, 14½″ × 11¼″
Unsigned

Louise Wueste's self-portrait reveals features
that are strong, dignified, gracious, and
composed. She undoubtedly painted it in
Germany while a young woman, as it reflects
the idealistic, romantic style she adopted
under the guidance of her German
instructors. A modest woman, she seldom
signed her paintings in full, preferring to
monogram them with a discreet "L. W."
Unfortunately, she also avoided dating her
work, making a definitive chronology
difficult. This painting and the painting of
her husband are gifts from one of her direct
descendants, Gertrude Wueste Gardner.

PROVENANCE:
ca. 1835–1984: Collection of the Wueste Family.
1984: Bequest to SAMA by the Estate of Gertrude
Wueste Gardner.
84–95 G (1)

EXHIBITIONS:
1986: Texas Seen/Texas Made, SAMOA (September 29
to November 30).

PUBLICATIONS:
Ingeborg Wittichen, *Oberbergische Malerinnen: des 19.
Jahrhunderts aus der Familie Jügel/Heuser* (1980), 24.

PORTRAIT OF
DR. PETER WILHELM LEOPOLD WUESTE
n.d., oil on canvas, 14½″ × 11¼″
Unsigned

In her portrait of Peter Wueste, Louise
Wueste captured his distinguished features
and dignified bearing. This portrait and her
own self-portrait seemed to have been
painted as a matching pair. Wueste is attired
in the elegant but subdued fashion of the late
Empire period. His coat has a high collar, his
throat is wrapped with a standing stock and
flowing cravat, and his face is adorned with
stylish sideburns. The mode of dress in both
portraits denotes persons of consequence and
respectability.

PROVENANCE:
ca. 1835–1984: Collection of the Wueste Family.
1984: Bequest to SAMA by the Estate of Gertrude
Wueste Gardner.
84–95 G (2)

EXHIBITIONS:
1986: Texas Seen/Texas Made, SAMOA (September 29
to November 30).

PUBLICATIONS:
Armin Elmendorf, A *Texan Remembers* (1974), [12].

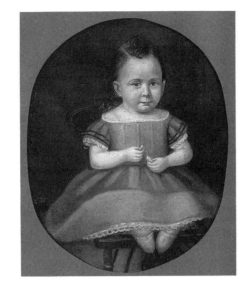

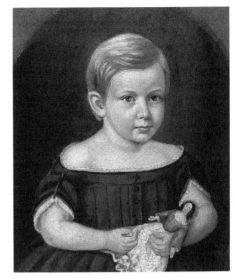

KARL GRAEBNER
1862, oil on canvas, 12¼″ × 10½″
Initialed lower left: L. W.
Inscribed in German on stretchers: Painted December 1 1862 by Mrs. Wüscht [?]/Karl Gräbner born 3 September 1861/His father, Heinrich Gräbner, born Heilbronn, on the Neckar, Kingdom of Würt[t]emberg/Heinrich Gräbner, son of Friedrich Gräbner, master soap manufacturer from Heilbronn/ Friedrich Gräbner born in Durlach [?] in the Grand Duchy of [illegible; presumed to read Baden]

Fortunately, this child is identified by name as Karl Graebner, born on September 3, 1861. The artist's name and the date of the painting (December 1, 1862) also appear on the inscription on the stretcher strips to which the canvas is attached.[29] The dress is very similar to the one worn by the subject in *Child with Doll.* Although the heads in Louise Wueste's portraits always are drawn with competence, sometimes the rest of the figure displays a certain naiveté in draftsmanship, a trait apparent in this painting.

Karl Graebner, later known as Charles, served as president and general manager of Duerler's Confectionery business but retired in 1923 to devote more time to his real estate interests and his many civic enterprises.[30] This portrait is particularly important to The Texas Collection, because Graebner was the second president of the San Antonio Museum Association (1924–1926) and was on the program at the opening ceremonies of the Witte Memorial Museum.[31]

PROVENANCE:
1862–1958: Collection of the Graebner Family.
1958: Gift to SAMA by Bertha Graebner.
58–401 G

EXHIBITIONS:
1960: Paintings from the San Antonio Museum Association, The Argyle Hotel, SA (April 16 to June 30).
1964: The Early Scene: San Antonio, WMM (June 7 to August 31).
1986: Texas Seen/Texas Made, SAMOA (September 29 to November 30).

PUBLICATIONS:
Utterback, *Early Texas Art* (1968), 47.

CHILD WITH DOLL
ca. 1860, oil on canvas, 11″ × 9¼″
Initialed lower right: L. W.

Unfortunately the identity of this child is unknown. Louise Wueste did many portraits of children, including family members. This young person could be either a girl or a boy, for the styles of dress for infants at the time were virtually identical. The presence of a doll in the child's arms might suggest a girl, but even scarce playthings were interchangeable between the sexes in a frontier society.

PROVENANCE:
-1986: Collection of the Seeligson Family.
1986: Gift to SAMA by Mrs. Arthur A. Seeligson, Sr., in honor of Cecilia Steinfeldt.
86–85 G

EXHIBITIONS:
1986: Texas Seen/Texas Made, SAMOA (September 29 to November 30).

WORKS BY LOUISE HEUSER WUESTE
NOT ILLUSTRATED:

PORTRAIT OF ELIZABETH MENEFEE RIDDLE
n.d., oil on canvas, 25″ × 21″
Initialed lower center: L. W.
Presented to SAMA by Mr. and Mrs. David Carter in memory of Sarah Elizabeth Riddle.
88–21 T

29. Utterback, *Early Texas Art,* 46.
30. Davis and Grobe (eds. and comps.), *The New Encyclopedia of Texas,* s.v. "Charles Graebner," 421.
31. Woolford and Quillin, *The Story of the Witte Memorial Museum,* 359; "Museum to be opened Friday," San Antonio *Express,* October 3, 1926.

ANONYMOUS

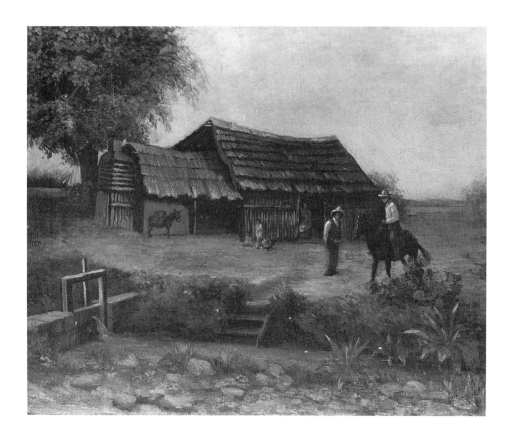

HEAD OF THE SAN ANTONIO RIVER IN 1850
n.d., oil on canvas, 22″ × 27″
Anonymous

This painting is somewhat of a mystery. The title, *Head of the San Antonio River in 1850*, is pencilled across the top of the stretcher on the reverse. This is a questionable title for several reasons. The stretcher, or strainer, does not seem to be original, since the canvas is actually larger and turned over the stretcher all around. The scene does not fit any verbal description or illustration of the headwaters of the river as it would have appeared in 1850. Furthermore, it is doubtful that the painting was done as early as 1850 because no known artists working in the area at that time painted in this style.

Nevertheless, the Mexican *jacál*, or hut, is faithful to versions of the type of structure found in San Antonio at the time. It is of palisaded construction with small logs placed vertically and staked into the ground, rather than laid horizontally as in a log cabin. Also, the roof is of thatched *tule*, a reed that once grew abundantly along the banks of the San Antonio River.[1]

Although the canvas is in unrestored condition, there is a definite painting quality in the sure brushstrokes throughout. Good draftsmanship is evident in the figures, the perspective in the house, and the spatial relationship of the objects in the landscape. The anonymous artist's technique shows influence of the American school, rather than the more restrained European style so characteristic of Texas painters of the mid-nineteenth century.

One hypothesis is that it may be an early painting by Robert Onderdonk (1852–1917), who came to Texas in 1879. When he first arrived in San Antonio, he was charmed with the quaintness and picturesque atmosphere of the town and made numerous sketches and paintings of sites and scenes in the area.[2] This theory could be plausible since his daughter Eleanor, art curator of the Witte Memorial Museum from 1927 until 1958, frequently brought items to the museum for use without making proper records. Moreover, the painting displays characteristics of Robert Onderdonk's work.

PROVENANCE:
·1973: The painting was removed from the Pioneer Log Cabin when the historic houses on the Witte Memorial Museum's grounds were renovated to accommodate examples in the Early Texas Furniture and Decorative Arts exhibition. It was entered into the permanent collection and recorded as a delayed accession.
73–112 G

EXHIBITIONS:
1973: Pioneer Log Cabin, WMM.

1. Frederick Law Olmsted, *A Journey Through Texas; Or, A Saddle-Trip on the Southwestern Frontier: With a Statistical Appendix* (New York: Dix, Edwards & Co., 1857), 149.
2. Cecilia Steinfeldt, *The Onderdonks: A Family of Texas Painters* (San Antonio: Published for the San Antonio Museum Association by Trinity University Press, 1976), 11–17.

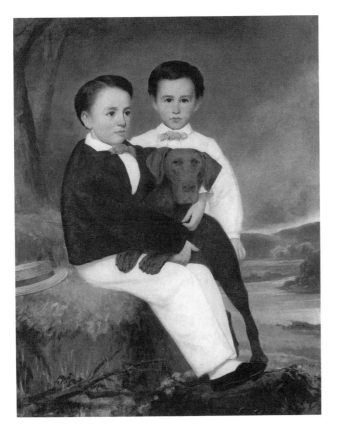

THE McDONALD BROTHERS AND THEIR DOG
n.d., oil on canvas, 53″ × 41″
Anonymous

During the nineteenth century itinerant painters roamed the Texas countryside recording likenesses of prosperous citizens and their families. They painted much in the same manner that limners had worked a century earlier in the eastern United States. In mid-nineteenth-century Texas, however, they must have been in direct competition with the much less expensive and more prolific art of the daguerreotypist and photographer.

The careful treatment of the figures in this painting, plus the flattering portrayal of the children's features, suggest an artist of modest training. The rendition of the dog, however, shows a deficiency of skilled drafts-manship in the lack of three-dimensional quality. The background is pleasant none-theless and indicates a degree of competence. The painting is reminiscent of famous portraiture of the eighteenth and early nineteenth centuries.

The legend attached to this canvas maintains it was the work of an anonymous artist who traveled throughout the state of Texas in a covered wagon. As boys, the McDonald brothers lived east of Austin on the Colorado River, which is seen in the background. The dog, probably their favorite pet, is referred to as a "blue tick" hound.[1] The use of pets in portraits of children was a popular theme frequently used by artists, especially during the Victorian period.

PROVENANCE:
–ca. 1970: Collection of the McDonald Family.
1970–1978: Collection of Willis Reid.
1978: Purchased by SAMA from Willis Reid, Cleburne, Texas, with funds provided by Arthur's Restaurant and The Annual Gift Appeal. The painting was a gift to Reid from Mrs. McDonald, also of Cleburne, who had married one of the boys depicted in the painting.
78–1281 P

EXHIBITIONS:
1978–1979: A Survey of Naive Texas Artists, WMM (December 17, 1978, to March 1, 1979).
1979–1980: A Survey of Naive Texas Artists, Traveling Exhibition: The Museum of Fine Arts, Houston (April 11 to May 27, 1979). Laguna Gloria Art Museum, Austin (June 9 to July 23, 1979). Tyler Museum of Art (July 31 to September 9, 1979). Lufkin Historical and Creative Arts Center (September 24 to November 15, 1979). The Art Center, Waco (April 15 to May 30, 1980).
1986: Texas Seen/Texas Made, SAMOA (September 29 to November 30).

PUBLICATIONS:
Cecilia Steinfeldt, "Simple Self-Expression: A Survey of Naive Painters from The Lone Star State," *Southwest Art*, 10 (September 1980): 57.
Cecilia Steinfeldt, *Texas Folk Art: One Hundred Fifty Years of the Southwestern Tradition* (Austin: Published for San Antonio Museum Association by Texas Monthly Press, 1981), 56.
Cecilia Steinfeldt, "Texas Folk Art: The San Antonio Museum Association's Collection," *Antique Review*, 14 (September 1988): 25.

1. Willis Reid to author (Cleburne, Texas), interview, May 4, 1978.

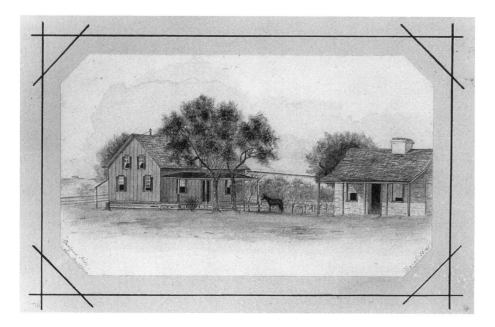

OAKLAND HILL, SAN ANTONIO
1883, watercolor on paper, 6¼" × 10⅛"
Anonymous
Titled lower left: Oakland Hill, San Antonio
Dated lower right: March 23, 1883

The name "Louise," on the back of the stretcher strip of *Oakland Hill, San Antonio.*

This small painting has notable historical merit as a visual record of a view in San Antonio during the last quarter of the nineteenth century. The careful rendering of two types of residential structures—one wooden clapboard, the other probably cut limestone—portrays the modest living conditions of the period. Few photographers recorded this aspect of San Antonio; photographers and artists of the period preferred the picturesque, the colorful Mexican scenes, and the missions and parks.

Just where Oakland Hill was in San Antonio has not been established definitely, but the city directory of 1885–1886 asserts that Oakland Street began at the west side of the San Antonio River and extended southwest to Romana Street. This is probably the site depicted in the painting. An 1886 bird's-eye-view map of San Antonio shows small structures on Oakland Street that very well could be these two diminutive houses.[1]

The meticulous brushstrokes and attention to detail suggest that the watercolor may have been done by a student of Theodore Gentilz (1819–1906). This tentative assertion is enhanced by the name that appears in scribbled pencil on the back of the original stretcher. The first name is

clearly "Louise," but the surname is illegible. Louise Frétellière (1856–1940) was a student of Gentilz, as well as his niece, and a comparison of their works shows similarities. It is possible this is a painting by Louise Frétellière.

PROVENANCE:
1975: Purchased by SAMA from John Bihler and Henry Coger, dealers, of Ashley Falls, Massachusetts, with Endowment Funds.
75–215 P

EXHIBITIONS:
1978–1979: A Survey of Naive Texas Artists, WMM (December 17, 1978, to March 1, 1979).
1979–1980: A Survey of Naive Texas Artists, Traveling Exhibition: The Museum of Fine Arts, Houston (April 11 to May 27, 1979). Laguna Gloria Art Museum, Austin (June 9 to July 23, 1979). Tyler Museum of Art (July 31 to September 9, 1979). Lufkin Historical and Creative Arts Center (September 24 to November 15, 1979). The Art Center, Waco (April 15 to May 30, 1980).
1986: Texas Seen/Texas Made, SAMOA (September 29 to November 30).
1988: The Art and Craft of Early Texas, WMM (April 30 to December 1).

PUBLICATIONS:
Steinfeldt, *Texas Folk Art* (1981), 53.

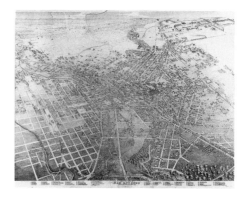

Bird's Eye View of San Antonio, Bexar Co., Texas, 1886. Looking North East, by Augustus Koch. SAMA Map Collection, gift of Mrs. Albert Steves III, in 1978.

1. Augustus Koch, *Bird's Eye View of San Antonio, Bexar Co., Texas, 1886. Looking North East,* SAMA Map Collection.

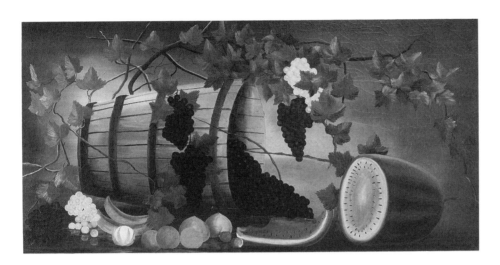

STILL LIFE WITH GRAPES
n.d., oil on canvas, 35″ × 70″
Anonymous

When this picture was acquired by Robert K. Winn of San Antonio at a Junior League rummage sale, he made inquiries to determine its origin. Salespersons told him it once graced a bar in Castroville, a small Alsatian community near San Antonio.[1] The size and shape of this particular canvas substantiates this hypothesis, as does the fact that grapes and fruit were used as subject matter, the essence of the wines and liqueurs that would be served in a drinking establishment.

The paint is thin and used sparingly overall, suggesting not only timidity by the artist, but an unfamiliarity with the medium. The draftsmanship is straightforward, however, and a fairly competent three-dimensional quality was achieved with the use of light and shade. This type of painting could have been influenced by the popular chromolithographs or other prints of the late Victorian period. An incongruous note, not necessarily intentional, is the juxtaposition of dark and light grapes springing from the same vine. The pale green grapes nestled in the dark foliage surrounded with somber tones successfully attract the viewer's eye and swing attention around the canvas. This may have been intentional, but with untrained painters this usually occurs naturally because of their innate sense of color and design.

Rudolph Mueller is the only known painter who worked in the Castroville area during the same time period. Although a number of Mueller's paintings were displayed in Castrovillian barrooms, the style of this painting with its delicate handling and attenuated painting technique, however, precludes attribution to Mueller, whose style was far more vigorous and powerful with heavier brushstrokes.

Naive or untrained artists frequently do not sign their paintings, probably not due to modesty but because their paintings are so personal. They usually create to please themselves, or possibly to decorate their homes or as gifts to friends. A signature seems superfluous.

EXHIBITIONS:
1978–1979: A Survey of Naive Texas Artists, WMM (December 17, 1978, to March 1, 1979).
1979–1980: A Survey of Naive Texas Artists, Traveling Exhibition: The Museum of Fine Arts, Houston (April 11 to May 27, 1979). Laguna Gloria Art Museum, Austin (June 9 to July 23, 1979). Tyler Museum of Art (July 31 to September 9, 1979). Lufkin Historical and Creative Arts Center (September 24 to November 15, 1979). The Art Center, Waco (April 15 to May 30, 1980).
1986: Texas Seen/Texas Made, SAMOA (September 29 to November 30).
1988: The Art and Craft of Early Texas, WMM (April 30 to December 1).
1988: A Witte Merry Christmas: Tannenbaums to Tumbleweeds, WMM (December 1 to 30).

PUBLICATIONS:
Steinfeldt, *Texas Folk Art* (1981), 73.
Steinfeldt, "Texas Folk Art," *Antique Review*, 14 (September 1988): 26.

PROVENANCE:
ca. 1965–1977: Collection of Robert K. Winn.
1977: Gift to SAMA by Robert K. Winn.
77-45 G

1. Robert K. Winn to author (SA), interview, May 5, 1977.

PORTRAIT OF MR. EDWARD D. SIDBURY
ca. 1875, oil on canvas, 27″ × 22″
Anonymous

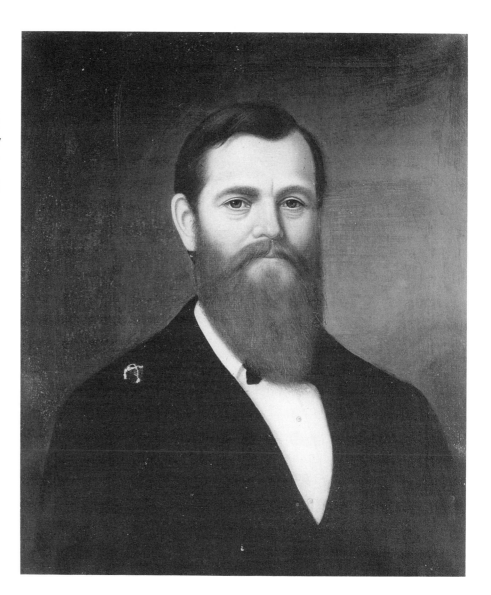

Edward D. Sidbury, born in 1838, was reared and educated in Wilmington, North Carolina. In 1862 he entered the Confederate army and served until the cessation of hostilities. Shortly after the war Sidbury visited the West Indies, but by 1867 he was bound for Corpus Christi, Texas, on the steamer *Young America*. A skillful mechanic, he worked at his trade until 1870, when he invested in the booming lumber business. According to existing records, his undertaking flourished and he amassed a fortune.[1]

On January 29, 1875, Sidbury married the widow of John Wesley Scott, a rancher who had been the victim of the yellow fever epidemic of 1867. Family tradition maintains that Sidbury had his portrait and that of his wife painted shortly after their marriage to hang in their new mansion, which overlooked the Corpus Christi Bay.[2] Sidbury died six years later, on August 17, 1881, at the age of forty-three, in Hot Springs, Arkansas.[3] His remains were transported by train to Galveston and on to Corpus Christi on the ship *Aransas*.[4]

When compared to his photograph, Sidbury's portrait is an excellent likeness. It is scrupulously painted with carefully applied brushstrokes and, although the paint is thin on the canvas, the technique is not labored, attesting to the anonymous portraitist's ability. In 1875, the approximate date of this canvas, the splashy bold style of Henri, Chase, and John Singer Sargent (1856–1925) was not yet universally admired. Most people who sat for their portraits at the time preferred a conservative approach and selected artists who adhered to a much more restrained and traditional method of painting.

PROVENANCE:
ca. 1875–1960: Collection of the Sidbury Family.
1960: Gift to SAMA by Margaret B. Passwaters in memory of Mrs. Sidbury Bingham Craig.
60–39 G (1)

EXHIBITIONS:
1960: Paintings from the San Antonio Museum Association, The Argyle Hotel, SA (April 16 to June 30).
1961–1973: Texas History Hall, WMM.

1. L. E. Daniell, *Personnel of the Texas State Government: with Sketches of Representative Men of Texas* (San Antonio: Maverick Printing House, 1892), s.v. "Edward D. Sidbury," 529.
2. Information provided by the donors, SAMA Registrar's Records.
3. Daniell, *Personnel of the Texas State Government*, s.v. "Mrs. Charlotte M. Sidbury," 531.
4. "At Half-Mast," Galveston *Daily News*, August 20, 1881. Sidbury's own schooners, the E. D. *Sidbury* and the *Henrietta*, floated their colors at half-mast in Galveston on August 19 as a mark of respect.

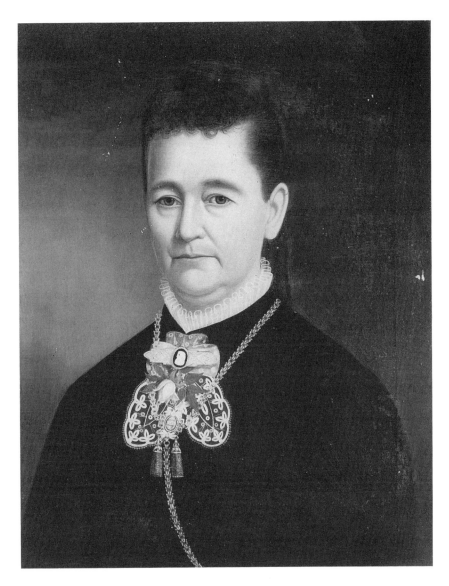

PORTRAIT OF MRS. EDWARD D. SIDBURY
ca. 1875, oil on canvas, 27″ × 22″
Anonymous

Mrs. Edward D. Sidbury's portrait is a nice
complement to the painting of her husband.
Although both portraits are somewhat
somber in mood, Mrs. Sidbury's is livelier due
to the frilly adornment at collar and throat.
The delicate lace jabot, pink rose, brooches,
and gold chain provide welcome relief from
the austere tones of dress and background.
The details are executed with consummate
skill and indicate an artist of considerable
talent. Although neither portrait is signed,
there is a remote possibility that they are
the work of Eugenie Lavender (1817–1898),
who was active in the Corpus Christi area
at the time.

Mrs. Sidbury was born Charlotte
Matilda Cook on August 2, 1830, in North
Carolina. Her father was a pioneer Methodist
minister who came to Texas with Robertson's
colony and located in Burleson County. She
married John Wesley Scott in 1848, and the
couple had two children, Mary Margaret Ann
and James Ferguson. After Scott's death in
1867, his wife managed his extensive ranch
lands.[1] Upon the death of Sidbury, her second
husband, she was no novice in the field of
administration. She assumed control of
Sidbury's lumber business, with branches in
Alice, San Diego, and Laredo. She also became
director and stockholder of the Corpus
Christi National Bank.[2] When Mrs. Sidbury
died in Corpus Christi on November 12,
1904, at seventy-four, she had developed a
reputation as a very civic-minded person as
well as an astute businesswoman. Although
active in what then was primarily a man's
world, she also was noted for her interest in
needlework and quilt- and rug-making, and
for being a fine cook.[3]

PROVENANCE:
ca. 1875–1960: Collection of the Sidbury Family.
1960: Gift to SAMA by Margaret B. Passwaters in
memory of Mrs. Sidbury Bingham Craig.
60–39 G (2)

EXHIBITIONS:
1960: Paintings from the San Antonio Museum
Association, The Argyle Hotel, SA (April 16 to
June 30).
1961–1973: Texas History Hall, WMM.

1. Genealogical and biographical account of the
 Ancestors of James Ferguson Scott and Mary
 Margaret Ann Scott Savage, in *Pathfinders of Texas* by
 Mrs. Frank de Garme, 1951. Photocopied
 typescript provided by the donors when the
 portraits were donated to SAMA. Edward D.
 Sidbury file, SAMA Texas Artist Records.
2. Daniell, *Personnel of the Texas State Government*, s.v.
 "Mrs. Charlotte M. Sidbury," 531.
3. Ibid.; Genealogical and biographical account.

THE TEMPTATION OF THE HERMIT
early 20th century (?), oil on domestic oil cloth,
68″ × 44″
Anonymous

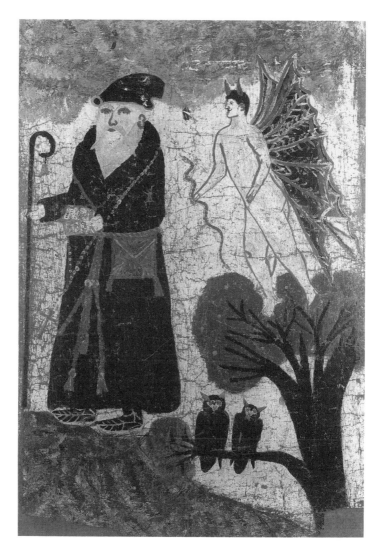

This painting has been arbitrarily dated as early twentieth century, but it could be several decades older based on two things. Both its companion piece, *St. Michael Vanquishing the Devil*, and this painting were in worn and used condition when found in 1929. Also, an article written in 1934 referred to them as being "very old."[1] Regardless of their age they are simple statements made by an untrained painter in a forceful and forthright manner.

Both of the paintings were banners used in the religious play, *Los Pastores* (*The Shepherds*), a traditional pageant performed in San Antonio during the Christmas season. The play represents the pilgrimage of the shepherds to Bethlehem in search of the Christ Child, and the efforts of Satan and his attendant devils to divert the shepherds from their destination. Such a performance originated in Europe during the Middle Ages to acquaint an illiterate society with the Bible story. The custom of performing religious plays was brought to the New World by the Franciscan friars, eventually finding its way to Texas with the early missionaries. When the missions were secularized in the late eighteenth century, the devout early Mexican Texans took the plays to their homes.[2] They established the tradition of presenting them in the streets and yards of San Antonio, a rite that is encouraged by the San Antonio Conservation Society today.

In *Temptation of the Hermit*, the artist has portrayed one of the comic characters of the play. The hermit customarily is clad in a rough gown with a homemade wig of cord. Sometimes his rosary is made from old spools and his staff is a simple, straight stick of wood. He is shown being tempted by the devil, who is promising him a shepherd's daughter for a wife if he ceases seeking the Christ Child.[3] The figures in the painting are static and rigid, but the sure broad strokes of the anonymous artist's brush dramatize the incident. Although there is no attempt to put the figures in proper perspective, the painting has a spatial quality nevertheless. The tree, much smaller than the important image of the hermit, conveys a sense of distance and space.

PROVENANCE:
-1929: Collection of Sr. Gertrudes Alonzo.
1929: Purchased from Sr. Gertrudes Alonzo by the San Antonio Conservation Society.
1929: Gift to SAMA by the San Antonio Conservation Society.
29–3969 G (1)

EXHIBITIONS:
1951–1960: Latin-American Gallery, WMM.
1978–1979: A Survey of Naive Texas Artists, WMM (December 17, 1978, to March 1, 1979).
1979–1980: A Survey of Naive Texas Artists, Traveling Exhibition: The Museum of Fine Arts, Houston (April 11 to May 27, 1979). Laguna Gloria Art Museum, Austin (June 9 to July 23, 1979). Tyler Museum of Art (July 31 to September 9, 1979). Lufkin Historical and Creative Arts Center (September 24 to November 15, 1979). The Art Center, Waco (April 15 to May 30, 1980).
1986: Art Among Us, SAMOA (April 27 to June 15).

PUBLICATIONS:
Eleanor Onderdonk, "Los Pastores," *Southwester*, 1 (December 1935): 3.
Woolford and Quillin, *The Story of the Witte Memorial Museum* (1966), 223.
"Witte Museum Spotlights 'Naive' Artists of Texas," *Paseo del Rio Showboat* (SA), December 1978.
Cecilia Steinfeldt, "The Folk Art of Frontier Texas," *The Magazine Antiques*, 114 (December 1978): 1280.
Mimi Crossley, "Folk Art of the Frontier: A Survey of Naive Texas Art," *The Magazine of San Antonio*, 2 (January 1979): 29.
Steinfeldt, "Simple Self-Expression," *Southwest Art*, 10 (September 1980): 60.
Steinfeldt, *Texas Folk Art* (1981), 81.

1. Molly Heilman, "Los Pastores at Witte Sunday," San Antonio *Light*, December 23, 1934.
2. Dorothy Hirshfield, "Los Pastores," *Theatre Arts Monthly*, 12 (December 1928): 903–911.
3. Ibid.

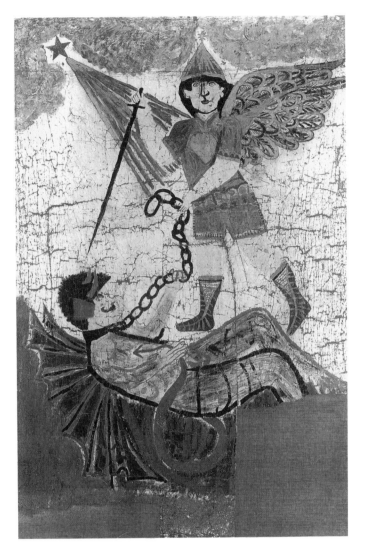

ST. MICHAEL VANQUISHING THE DEVIL
early 20th century (?), oil on domestic oil cloth,
68″ × 44″
Anonymous

St. Michael, the most important of the archangels, plays a vital role in the simple story of *Los Pastores*. It is he who announces the birth of Christ to the shepherds and who vanquishes the devil before the shepherds can proceed on their journey.[1] The anonymous artist painted the scene using the same bold treatment as that of the hermit: vigorous brushstrokes; broad, flat, space-filled areas; and a sense of movement achieved with placement of the figures.

Here St. Michael has a kindly, if stern, expression, and the devil's malevolent character is evident in the evil gleam in his eye. Although the artist shows little skill in drawing, both canvases assert devoutness in their straightforward and honest presentations.

A comparison with religious paintings produced in New Mexico by converted native Americans shows striking similarities in style. Presumably the development of this form had no Spanish or European influence on the interpretation of pious themes by native Americans, who made clear, resolute paintings and carvings of familiar reverential subjects in a simple dynamic manner.

PROVENANCE:
-1929: Collection of Sr. Gertrudes Alonzo.
1929: Purchased from Sr. Gertrudes Alonzo by the San Antonio Conservation Society.
1929: Gift to SAMA by the San Antonio Conservation Society.
29–3969 G (2)

EXHIBITIONS:
1951–1960: Latin-American Gallery, WMM.
1978–1979: A Survey of Naive Texas Artists, WMM (December 17, 1978, to March 1, 1979).
1979–1980: A Survey of Naive Texas Artists, Traveling Exhibition: The Museum of Fine Arts, Houston (April 11 to May 27, 1979). Laguna Gloria Art Museum, Austin (June 9 to July 23, 1979). Tyler Museum of Art (July 31 to September 9, 1979). Lufkin Historical and Creative Arts Center (September 24 to November 15, 1979). The Art Center, Waco (April 15 to May 30, 1980).
1986: Art Among Us, SAMOA (April 27 to June 15).

PUBLICATIONS:
Onderdonk, "Los Pastores," *Southwester*, 1 (December 1935): 3.
Woolford and Quillin, *The Story of the Witte Memorial Museum* (1966), 223.
Steinfeldt, "The Folk Art of Frontier Texas," *The Magazine Antiques*, 114 (December 1978): 1280.
SAMA *Calendar of Events* (December 1978): cover.
Lonn Taylor, "Images: Naive Art," *Vision*, 3 (March 1980): 19.
Steinfeldt, *Texas Folk Art* (1981), 80.
Steinfeldt, "Texas Folk Art," *Antique Review*, 14 (September 1988): 30.

1. "America's Oldest Play Has Christmas Plot," San Antonio *Express*, December 21, 1913.

Books and Exhibition Catalogues

*indicates exhibition catalogues

*Ahlborn, Richard E., ed. Man Made Mobile: Early Saddles of Western North America. Smithsonian Studies in History and Technology, no. 89. Washington, D.C.: Smithsonian Institution Press, 1980.

*The American Image: 1875–1978. Corpus Christi: Corpus Christi State University, 1979.

Anderson, Adrian N., and Ralph A. Wooster. Texas and Texans. Rev. ed. Austin: Steck-Vaughn Co., 1978.

Barnes, Charles Merritt. Combats and Conquests of Immortal Heroes: Sung in Song and Told in Story. San Antonio: Guessaz and Ferlet Co., 1910.

Bartlett, John Russell. Personal Narrative of Explorations and Incidents in Texas, New Mexico, California, Sonora, and Chihuahua: Connected with the United States and Mexican Boundary Commission During the Years 1850, '51, '52 and '53. 2 vols. New York: D. Appleton and Co., 1854. Reprint. Chicago: Rio Grande Press, 1965.

Bénézit, Emmanuel. Dictionnaire Critique et Documentaire des Peintres, Sculpteurs, Dessinateurs et Graveurs. 8 vols. Paris: Libraire Gründ, 1966.

Berlandier, Jean Louis. The Indians of Texas in 1830. Edited and introduced by John C. Ewers. Washington, D.C.: Smithsonian Institution Press, 1969.

Biesele, Rudolph Leopold. The History of the German Settlements in Texas: 1831–1861. Austin: Von Boeckmann-Jones, 1930.

Bishop, Robert. Folk Painters of America. New York: E. P. Dutton, 1979.

*Boyer Gonzales, The Painter: A Retrospective Exhibition, 1930 to the Present. Index of Art in the Pacific Northwest, no. 13. Seattle: Henry Art Gallery, University of Washington, 1979.

Bracht, Viktor. Texas in 1848. Translated from the German by Charles Frank Schmidt. San Antonio: Naylor Printing Co., 1931.

Bracken, Dorothy Kendall, and Maurine Whorton Redway. Early Texas Homes. Dallas: Southern Methodist University Press, 1956.

Brown, John Henry. "Thomas Gonzales, Galveston." In Indian Wars and Pioneers of Texas. Austin: L. E. Daniell, n.d.

Burkhalter, Lois. A Seth Eastman Sketchbook, 1848–1849. Austin: University of Texas Press for the Marion Koogler McNay Art Institute, San Antonio, 1961.

Burkholder, Mary V. The King William Area: A History and Guide to the Houses. San Antonio: King William Association, 1973.

Bushnell, David I., Jr. Seth Eastman: The Master Painter of the North American Indian. Smithsonian Miscellaneous Collections, vol. 87, no. 3. Washington, D.C.: Smithsonian Institution, April 11, 1932.

*Bywaters, Jerry. Otis Dozier: Growth and Maturity of a Texas Artist. Dallas: Dallas Museum of Fine Arts, 1956.

*———. A Century of Art and Life in Texas. Dallas: Dallas Museum of Fine Arts, 1961.

*———. Seventy-Five Years of Art in Dallas: The History of the Dallas Art Association and the Dallas Museum of Fine Arts. Dallas: Dallas Museum of Fine Arts, 1978.

Calvert, Robert A., and Arnoldo De León. The History of Texas. Arlington Heights, Ill.: Harlan Davidson, 1990.

Carpenter, Mrs. V. K. Seventh Census of the United States: 1850 Census, Bexar County, Texas. Fort Worth: American Reference Publishers, 1969.

*Catalogue of the Exhibition of Paintings, Sculptures, Graphic Arts. Centennial Exposition Department of Fine Arts. Dallas: Dallas Museum of Fine Arts, June 6 to November 29, 1936.

*[Chabot, Frederick C.] Yanaguana Society Catalogue of a Loan Exhibition of Old San Antonio Paintings. San Antonio: Yanaguana Society, 1933.

———. With the Makers of San Antonio: Genealogies of the Early Latin, Anglo-American, and German Families With Occasional Biographies, Each Group Being Prefaced With a Brief Historical Sketch and Illustrations. San Antonio: Artes Gráficas, 1937.

*Charles Rosen: Oils and Drawings. San Antonio: Witte Memorial Museum, 1940.

Clark, Carol. "Charles Deas." In American Frontier Life: Early Western Painting and Prints. New York: Abbeville Press, Publishers, 1987.

Coke, Van Deren. The Painter and the Photograph from Delacroix to Warhol. Rev. ed. Albuquerque: University of New Mexico Press, 1972.

*Contemporary America: 1900–1979. Corpus Christi: James R. Dougherty, Jr. Foundation and Corpus Christi State University, 1979.

Coppini, Pompeo. From Dawn to Sunset. San Antonio: Naylor Co., 1949.

Corner, William, comp. and ed. San Antonio de Bexar: A Guide and History. San Antonio: Bainbridge and Corner, 1890.

Correll, Donovan Stewart, and Marshall Conring Johnston. Manual of the Vascular Plants of Texas. Renner, Tex.: Texas Research Foundation, 1970.

Crook, Cornelia E. San Pedro Springs Park: Texas' Oldest Recreation Area. San Antonio: Privately published, 1967.

Cruz, Gilbert R. Let There Be Towns: Spanish Municipal Origins in the American Southwest, 1610–1810. College Station: Texas A&M University Press, 1988.

Curtis, Albert. Fabulous San Antonio. San Antonio: Naylor Co., 1955.

"Daniel Sullivan." Reprint from National Cyclopaedia of American Biography. New York: James T. White and Co., 1935.

Daniell, L. E. Types of Successful Men of Texas. Austin: Privately published, 1890. Photocopy, Ida Hadra Vines file, SAMA Texas Artists Records.

———. Personnel of the Texas State Government: With Sketches of Representative Men of Texas. San Antonio: Maverick Printing House, 1892.

The Daughters of the Republic of Texas, comps. The Alamo Long Barrack Museum. Dallas: Taylor Publishing Co., 1986.

Davis, Ellis A., and Edwin A. Grobe, eds. and comps. The New Encyclopedia of Texas. 4 vols. Dallas: Texas Development Bureau, [ca. 1928].

Davis, John L. San Antonio: A Historical Portrait. Austin: Encino Press, 1978.

———. The Danish Texans. San Antonio: University of Texas Institute of Texan Cultures at San Antonio, 1979.

Dawdy, Doris Ostrander. *Artists of the American West: A Biographical Dictionary.* 3 vols. Chicago: Swallow Press, 1974–1981.

Downey, Fairfax, and Paul M. Angle. *Texas and the War with Mexico.* New York: American Heritage Publishing Co., 1961.

Droste, Mary Elizabeth. "About the Author." In Emily Edwards, *F. Giraud and San Antonio.* San Antonio: Southwest Craft Center, 1985.

Dutcher, Ginger, and Esther Curnutt. *San Antonio: Reflections of the Last Two Hundred Years.* San Antonio: San Antonio Board of Realtors, 1976.

Edwards, Emily. "In San Antonio at the Turn of the Century." In *Stones, Bells, Lighted Candles: Personal Memories of the Old Ursuline Academy in San Antonio at the Turn of the Century.* San Antonio: Daughters of the Republic of Texas Library, 1981.

———. *F. Giraud and San Antonio.* San Antonio: Southwest Craft Center, 1985.

Elmendorf, Armin. *A Texan Remembers: A Bit of Biography and Some Incidents in the History of the Elmendorf and Staffel Families of San Antonio, Texas, as Recorded for his Grandchildren by Armin Elmendorf in 1974.* Portola Valley, Calif.: Privately published, 1974.

Encyclopaedia Britannica. 1959 ed. Chicago: William Benton, 1959.

Everett, Donald E. *San Antonio: The Flavor of Its Past, 1845–1898.* San Antonio: Trinity University Press, 1975.

Falk, Peter Hastings, ed. *Who Was Who in American Art.* Compiled from the Original Thirty-Four Volumes of *American Art Annual: Who's Who in Art. Biographies of American Artists Active from 1898–1947.* Madison, Conn.: Sound View Press, 1985.

Fehrenbach, T. R. *The San Antonio Story: A Pictorial and Entertaining Commentary on the Growth and Development of San Antonio, Texas.* Tulsa: Continental Heritage, 1978.

Fenwick, Marin B., ed. *Who's Who Among the Women of San Antonio and Southwest Texas: A Blue Book and Directory and Year Book of the Women's Organizations.* San Antonio: Marin B. Fenwick, 1917.

Fielding, Mantle. *Dictionary of American Painters, Sculptors, and Engravers.* Rev. ed., edited by Glen P. Opitz. Poughkeepsie, N.Y.: Apollo Books, 1983.

Fisk, Frances Battaile. *A History of Texas Artists and Sculptors.* Abilene, Tex.: Privately published, 1928.

Flume, Violet Sigoloff. *The Last Mountain: The Life of Robert Wood.* Brookline Village, Mass.: Branden Press, 1983.

Forrester-O'Brien, Esse. *Art and Artists of Texas.* Dallas: Tardy Publishing Co., 1935.

Frank Reaugh: Painter to the Longhorns. Introduction by Donald L. Weismann. College Station: Texas A&M University Press, 1985.

Galveston City Directories. Rosenberg Library, Galveston, Texas. Microfilm.

Garana, Sister Miriam. "Art Has a Home in S. A." In *San Antonio: A History for Tomorrow,* edited by Sam Woolford. San Antonio: Naylor Co., 1963.

Gard, Wayne. "Life in the Land of Beginning Again." In *The Republic of Texas.* Palo Alto, Calif.: American West Publishing Co. and Texas State Historical Association, 1968.

Geiser, Samuel Wood. *Horticulture and Horticulturists in Early Texas.* Dallas: Southern Methodist University, 1945.

George, Mary Carolyn Hollers. *Mary Bonner: Impressions of a Printmaker.* San Antonio: Trinity University Press, 1982.

*Gerdts, William H. *Down Garden Paths: The Floral Environment in American Art.* London: Associated University Presses, 1983.

———. *American Impressionism.* New York: Abbeville Press, 1984.

———. *Art Across America: Two Centuries of Regional Painting, 1710–1920.* 3 vols. New York: Abbeville Press, Publishers, 1990.

Geue, Chester W., and Ethel H. Geue, eds. and comps. *A New Land Beckoned: German Immigration to Texas, 1844–1847.* 2nd rev. ed. Waco: Texian Press, 1972.

Geue, Ethel Hander. *New Homes In a New Land: German Immigration to Texas, 1847–1861.* Waco: Texian Press, 1970.

*[Gillham, Margaret]. *Gutzon Borglum (1867–1941): Before Mount Rushmore.* Corpus Christi: Art Museum of South Texas, 1990.

Gittinger, Ted, Connie Rihn, Roberta Haby, and Charlene Snavely, authors and comps. *St. Louis Church, Castroville: A History of the Catholic Church in Castroville, Texas.* Castroville: St. Louis Catholic Church, 1973.

* *Go West Young Man: An Exhibition of Early Western Paintings and Lithographs.* San Antonio: Marion Koogler McNay Art Institute, 1960.

Goddard, Ruth. *Porfirio Salinas.* With an Introduction by Dewey Bradford. Austin: Rock House Press, 1975.

Goeldner, Paul, comp. *Texas Catalog: Historic American Buildings Survey. A List of Measured Drawings, Photographs, and Written Documentation in the Survey-1974.* Edited by Lucy Pope Wheeler and S. Allen Chambers, Jr. San Antonio: Trinity University Press, 1975.

Goetzmann, William H., and Joseph C. Porter. *The West as Romantic Horizon.* With Artists' Biographies by David C. Hunt. Omaha: Joslyn Art Museum, 1981.

*Goetzmann, William H., and Becky Duval Reese. *Texas Images and Visions.* Austin: Archer M. Huntington Art Gallery, University of Texas, 1983.

Goetzmann, William H., and William N. Goetzmann. *The West of the Imagination.* New York: W. W. Norton and Co., 1986.

Gordon, Alice, Jerry Camarillo Dunn, Jr., and Mel White. *The Smithsonian Guide to Historic America: Texas & the Arkansas River Valley.* New York: Stewart, Tabori and Chang, 1990.

Gould, Stephen. *The Alamo City Guide: San Antonio, Texas.* New York: McGowan and Slipper, 1882.

Green, Rena Maverick, ed. *Samuel Maverick, Texan: 1803–1870. A Collection of Letters, Journals and Memoirs.* San Antonio: Privately published, 1952.

Groce, George C., and David H. Wallace. *New-York Historical Society's Dictionary of Artists in America, 1564–1860.* New Haven: Yale University Press; London: Oxford Press, 1957.

Guerra, Mary Ann [Noonan-Guerra]. *San Fernando: Heart of San Antonio.* San Antonio: Archdiocese of San Antonio, 1977.

[———]. *The Story of the San Antonio River.* San Antonio: San Antonio River Authority, 1978.

[———]. *An Alamo Album.* New rev. ed. San Antonio: Privately published, 1979.

———. *The Missions of San Antonio.* San Antonio: Alamo Press, 1982.

———. *The San Antonio River.* 1st rev. ed. San Antonio: Alamo Press, 1987.

———. *The History of San Antonio's Market Square.* San Antonio: Alamo Press, 1988.

Haas, Oscar. *History of New Braunfels and Comal County, Texas: 1844–1946.* Austin: Steck Co., 1968.

Habig, Marion A., O.F.M. *San Antonio's Mission San José: State and National Historic Site, 1720–1968.* San Antonio: Naylor Co., 1968.

Hagner, Lillie May. *Alluring San Antonio: Through the Eyes of an Artist.* San Antonio: Privately published, 1947.

Hale, Leon. *Texas Out Back.* Austin: Madrona Press, 1973.

Haley, J. Evetts. *F. Reaugh: Man and Artist.* El Paso: Carl Hertzog, 1960.

Havlice, Patricia Pate. *Index to Artistic Biography,* First Supplement. Metuchen, N.J.: Scarecrow Press, 1981.

Henderson, Colonel Harry McCorry. *Colonel Jack Hays: Texas Ranger.* San Antonio: Naylor Co., 1954.

Herff, Ferdinand Peter. *The Doctors Herff: A Three-Generation Memoir.* Edited by Laura Barber. San Antonio: Trinity University Press, 1973.

Heusinger, Edward W., F.R.G.S. *The Heusinger Family in Texas.* San Antonio: Standard Printing Co., 1945.

———. *A Chronology of Events in San Antonio: Being a Concise History of the City Year by Year From the Beginning of Its Establishment to the End of the First Half of the Twentieth Century.* San Antonio: Standard Printing Co., 1951.

* *A Historical Exhibition: Oil Portraits of Mayors of San Antonio, 1838–1939.* San Antonio: San Antonio Press Club, 1962.

History and Guide of San Antonio, Tex. N.p., n.d. [ca. 1892].

History of the Order of the Alamo: 1960–1975. San Antonio: Order of the Alamo, 1975.

Holmes, Jon. *Texas: A Self-Portrait.* New York: Harry N. Abrams, 1983.

* *Horse and Rider.* Fort Worth: Amon Carter Foundation, 1957.

Houston City Directories. Rosenberg Library, Galveston, Texas.

Irwin, Howard S. *Roadside Flowers of Texas: Paintings by Mary Motz Wills.* Austin: University of Texas Press, 1961.

James, Marquis. *The Raven: A Biography of Sam Houston.* New York: Blue Ribbon Books, 1929.

———. *The Raven: A Biography of Sam Houston.* With an Introduction by Robert M. Utley. Illustrations for this edition selected by Joan Paterson Kerr. New York City: Blue Ribbon Books, 1929. Reprint. New York: Book-of-the-Month Club, 1990.

James, Vinton Lee. *Frontier and Pioneer Recollections of Early Days in San Antonio and West Texas.* San Antonio: Privately published, 1938.

Johnson, LeRoy, Jr., ed. *Proceedings, Texana I: The Frontier.* The Proceedings of a Humanities Forum Held at Round Top, Texas, May 1–3, 1980. Sponsored by the Texas Historical Commission, the Texas Historical Foundation, the Texas Pioneer Arts Foundation, the Texas Committee for the Humanities, and the National Endowment for the Humanities. Austin: Texas Historical Commission, 1983.

*Kalil, Susie. *The Texas Landscape, 1900–1986.* Houston: Houston Museum of Fine Arts, 1986.

Katz, Susanna R., and Anne A. Fox. *Archaeological and Historical Assessment of Brackenridge Park, City of San Antonio, Texas.* Archaeological Survey Report, no. 33. San Antonio: Center for Archaeological Research, University of Texas at San Antonio, 1979.

Keating, Mary Aubrey. *San Antonio: Interesting Places in San Antonio and Where to Find Them.* [San Antonio: N.p., 1935].

Kendall, Dorothy Steinbomer, and Carmen Perry. *Gentilz: Artist of the Old Southwest, Drawings and Paintings by Theodore Gentilz.* Austin: University of Texas Press, 1974.

Kinzinger, [Edmund Daniel]. *Landscape Course Catalogues, 1936 and 1937.* Jerry Bywaters Collection on Art of the Southwest, DeGolyer Library, Southern Methodist University, Dallas. (Hereafter referred to as Jerry Bywaters Collection, SMU.)

Kownslar, Allan O. *The Texans: Their Land and History.* New York: American Heritage Publishing Co., 1972.

Krantz, Les. *The Texas Art Review.* Houston: Gulf Publishing Co. and Krantz Co., 1982.

Lavender, David. *The American Heritage History of the Great West.* New York: American Heritage Publishing Co., 1965.

*Lee, Amy Freeman. *Xavier Gonzalez: A Gift of Compassion to the Confluence of Cultures.* San Antonio: Witte Memorial Museum, 1968.

*Leeper, John Palmer. "The San Antonio Museum of Art." In *Collecting: A Texas Phenomenon.* San Antonio: Marion Koogler McNay Art Museum, 1986.

Lich, Glen E., and Dona B. Reeves, eds. *German Culture in Texas: A Free Earth; Essays from the 1978 Southwest Symposium.* Boston: Twayne Publishers, A Division of G. K. Hall and Co., 1980.

Lich, Glen E. *The German Texans.* San Antonio: University of Texas Institute of Texan Cultures at San Antonio, 1981.

Lochbaum, Jerry, ed. *Old San Antonio: History in Pictures.* San Antonio: Express Publishing Co., 1965. Rev. ed. 1968.

Lord, Walter. "Myths and Realities of the Alamo." In *The Republic of Texas.* Palo Alto, Calif.: American West Publishing Co. and Texas State Historical Association, 1968.

*McDermott, John Francis. *The Art of Seth Eastman: A Traveling Exhibition of Paintings and Drawings.* Washington, D.C.: Smithsonian Institution, 1959.
———. *Seth Eastman: Pictorial Historian of the Indian.* Norman: University of Oklahoma Press, 1961.
———. *Seth Eastman's Mississippi: A Lost Portfolio Recovered.* Urbana: University of Illinois Press, 1973.

[McGuire, James Patrick]. *The French Texans.* San Antonio: University of Texas Institute of Texan Cultures at San Antonio, 1973.

———. *Iwonski in Texas: Painter and Citizen.* San Antonio: Published by the San Antonio Museum Association with the cooperation of the University of Texas at San Antonio Institute of Texan Cultures, 1976.
———. "Views of Texas: German Artists on the Frontier in the Mid-Nineteenth Century." In *German Culture in Texas: A Free Earth; Essays from the 1978 Southwest Symposium,* edited by Glen E. Lich and Dona B. Reeves. Boston: Twayne Publishers, A Division of G. K. Hall and Co., 1980.
———. *Hermann Lungkwitz: Romantic Landscapist on the Texas Frontier.* Austin: University of Texas Press for the University of Texas Institute of Texan Cultures at San Antonio, 1983.

Marks, Paula Mitchell. *Turn Your Eyes Toward Texas: Pioneers Sam and Mary Maverick.* College Station: Texas A&M University Press, 1989.

*Marling, Karal Ann. *Woodstock: An American Art Colony, 1902–1977.* Poughkeepsie, N.Y.: Vassar College Art Gallery, 1977.

Mayer, Susan [M.], Arthur [J.] Mayer, and Becky Duval Reese. *Texas.* Austin: Archer M. Huntington Art Gallery, College of Fine Arts, University of Texas at Austin, 1983.

*Miller, Dorothy C., ed. *Americans 1942: 18 Artists from 9 States.* New York: Museum of Modern Art, 1942.

Mount Rushmore National Memorial. Chicago: Mount Rushmore National Memorial Commission, 1930.

New International Encyclopedia of Art. New York: Greystone Press, 1967.

Newcomb, William W., Jr., with Mary S. Carnahan. *German Artist on the Texas Frontier: Friedrich Richard Petri.* Austin: University of Texas Press with the Texas Memorial Museum, 1978.

* *Ninth Annual Exhibition of the Southern States Art League.* San Antonio: Pabst Engraving Co., 1929.

Nixon, Pat Ireland, M.D. *A Century of Medicine in San Antonio: The Story of Medicine in Bexar County, Texas.* San Antonio: Privately published, 1936.

Norton, Charles G., ed. *Men of Affairs of San Antonio.* San Antonio: San Antonio Newspaper Artists' Association, 1912.

Olmsted, Frederick Law. *A Journey Through Texas; Or, A Saddle-Trip on the Southwestern Frontier: With a Statistical Appendix.* New York: Dix, Edwards and Co., 1857.

* *Paintings and Prints by Edmund Daniel Kinzinger.* San Antonio: Witte Memorial Museum, October 8 to 31, 1944.

Pearson, Jim B., Ben H. Proctor, and William B. Conroy. *Texas: The Land and Its People.* Edited by Barbara J. Stockley. Dallas: Hendrick-Long Publishing Co., 1972. 2nd ed., 1978. 3rd ed., 1987.

Pearson, Ralph M. *The Modern Renaissance in the U.S.A: Critical Appreciation Course II.* Nyack, N.Y.: Ralph M. Pearson's Design Workshop Courses by Mail, 1950.

* *Picturesque Images from Taos and Santa Fe.* Denver: Denver Art Museum, 1974.

Pinckney, Pauline A. *Painting in Texas: The Nineteenth Century.* Austin: Published for the Amon Carter Museum of Western Art, Fort Worth, by the University of Texas Press, 1967.

Pisano, Ronald G. *The Students of William Merritt Chase.* Huntington, N.Y.: Hecksher Museum, 1973.

Poesch, Jessie J. "Growth and Development of the Old South: 1830 to 1900." In *Painting in the South: 1564–1980.* Richmond: Virginia Museum of Fine Arts, 1983.

Price, Willadene. *Gutzon Borglum: Artist and Patriot.* N.p., 1972.

Raba, Ernest A., J.D., LL.D. *The St. Mary's University School of Law: A Personal History.* San Antonio: St. Mary's University School of Law, [1981].

Ramsdell, Charles. *San Antonio: A Historical and Pictorial Guide.* Austin: University of Texas Press, 1959.
———. *San Antonio: A Historical and Pictorial Guide.* Rev. ed. by Carmen Perry. Austin: University of Texas Press, 1976.

Ransleben, Guido. *A Hundred Years of Comfort in Texas: A Centennial History.* San Antonio: Naylor Co., 1954.

[Reaugh, Frank]. *Pastel.* Dallas: Reaugh Studios, 1927. Jerry Bywaters Collection, SMU.

*Reaugh, Frank, and Clyde Walton Hill. *Prose Sketches: To Accompany the Series of Paintings by Frank Reaugh Entitled, Twenty-Four Hours with the Herd.* Dallas: Frank Reaugh, 1934.

Reese, Becky Duval, Susan M. Mayer, and Arthur J. Mayer. *Texas.* Austin: Trillium Press for the Archer M. Huntington Art Gallery, University of Texas at Austin, 1987.

Reese, James V., and Lorrin Kennamer. *Texas, Land of Contrast: Its History and Geography.* Austin: W. S. Benson and Co., 1972. Rev. ed., 1978.

Reilly, J. S. *San Antonio: Past, Present, and Future.* San Antonio: J. S. Reilly, [ca. 1885].

Richardson, E. P. *A Short History of Painting in America: The Story of 450 Years.* New York: Thomas Y. Crowell Co., 1963.

Robinson, Frank T. *Living New England Artists.* Facsimile reprint. New York: Garland Publishing Co., 1977.

Rollings, Willard H. *The Comanche.* New York: Chelsea House Publishers, 1989.

Rubin, Cynthia Elyce, ed. *Southern Folk Art.* Birmingham: Oxmoor House, 1985.

Samuels, Peggy and Harold. *The Illustrated Biographical Encyclopedia of Artists of the American West.* New York: Doubleday and Co., 1976.

San Antonio City Directories. San Antonio Public Library. Microfilm.

Santleben, August. *A Texas Pioneer: Early Staging and Overland Freighting on the Frontiers of Texas and Mexico.* Edited by I. D. Affleck. New York and Washington: The Neale Publishing Co., 1910. A complete facsimile from the press of W. M. Morrison, Waco, Tx., 1967.

Santos, Richard G. *San Antonio de Bexar, 1 de Enero, 1836.* San Antonio: Privately published, [ca. 1963].

[Schuchard, Ernst, ed.]. *100th Anniversary, Pioneer Flour Mills, San Antonio, Texas: 1851–1951.* San Antonio: Naylor Co., 1951.

Schmitz, Joseph W. "Mission Concepción." Reprint from *Six Missions of Texas.* Waco: Texian Press, 1965.

* *Sculpture by Charles Umlauf/Paintings by Everett Spruce.* San Antonio: Witte Memorial Museum, 1943.

Southern Living. *The Southern Heritage Company's Coming! Cookbook.* Birmingham: Oxmoor House, 1983.

The Spanish Texans. San Antonio: University of Texas Institute of Texan Cultures at San Antonio, 1972.

Steen, Ralph W., and Frances Donecker. *Texas: Our Heritage.* Austin: Steck Co., Publishers, 1962.

Steinfeldt, Cecilia, and Donald Lewis Stover. *Early Texas Furniture and Decorative Arts.* San Antonio: Trinity University Press for the San Antonio Museum Association, 1973.

Steinfeldt, Cecilia. *The Onderdonks: A Family of Texas Painters*. San Antonio: Published for the San Antonio Museum Association by Trinity University Press, 1976.

————. *San Antonio Was: Seen Through a Magic Lantern. Views from the Slide Collection of Albert Steves, Sr.* San Antonio: San Antonio Museum Association, 1978.

————. *Texas Folk Art: One Hundred Fifty Years of the Southwestern Tradition*. Austin: Published for the San Antonio Museum Association by Texas Monthly Press, 1981.

*[————]. *Julian Onderdonk: A Texas Tradition*. Amarillo: Amarillo Art Center, 1985.

Stewart, Rick, "Toward a New South: The Regionalist Approach, 1900 to 1950." In *Painting in the South: 1564–1980*. Richmond: Virginia Museum of Fine Arts, 1983.

————. *Lone Star Regionalism: The Dallas Nine and Their Circle, 1928–1945*. Austin: Texas Monthly Press for the Dallas Museum of Art, 1985.

Story of the Great American West. Pleasantville, N.Y.: Reader's Digest Association, 1977.

Stroud, Alice Bab, and Modena Stroud Dailey. *F. Reaugh: Texas Longhorn Painter*. Dallas: Royal Publishing Co., 1962.

Taft, Robert. *Artists and Illustrators of the Old West: 1850–1900*. New York: Charles Scribners' Sons, 1953.

Taylor, Lonn, and David B. Warren. *Texas Furniture: The Cabinetmakers and Their Work, 1840–1880*. Austin: University of Texas Press, 1975.

* *Texas Centennial Exposition*. Dallas: Dallas Museum of Fine Arts, 1936.

* *Texas Coast Fair Art Catalogue, 1896, Dickinson, Nov. 10 to 14 Inclusive*. Dickinson, Tex.: Privately published, 1896. Harris County Heritage Society Archives, Houston.

* *Texas Painting and Sculpture: The 20th Century*. Dallas: Brodnax Printing Co., 1971.

* *The Third Annual Exhibition of Paintings by American Artists Assembled by the American Federation of Arts, Washington, D.C.* San Antonio: San Antonio Art League, 1913.

Thomas, W. Stephen. *Fort Davis and the Texas Frontier: Paintings by Captain Arthur T. Lee, Eighth U.S. Infantry*. College Station: Published for the Amon Carter Museum of Western Art, Fort Worth, by Texas A&M University Press, 1976.

Time-Life Books. *The Spanish West*. By the editors of Time-Life Books. New York: Time-Life Books, 1976.

* Todd, Emily L. *Frank Freed: People and Places*. Houston: Contemporary Arts Museum, 1983.

Toor, Frances. *A Treasury of Mexican Folkways*. New York: Crown Publishers, 1947. 11th printing, 1967.

Trovaili, August P., and Roulhac B. Toledano. *William Aiken Walker: Southern Genre Painter*. Baton Rouge: Louisiana State University Press, 1972.

Tyler, Ron. *Pecos to the Rio Grande: Interpretations of Far West Texas by Eighteen Artists*. College Station: Texas A&M University Press, 1983.

————. *Views of Texas, 1852–1856: Watercolors by Sarah Ann Lillie Hardinge Together with a Journal of Her Departure from Texas*. Fort Worth: Amon Carter Museum, 1988.

————, ed. *Prints of the American West: Papers Presented at the Ninth Annual North American Print Conference*. Fort Worth: Amon Carter Museum, 1983.

Tyler, Ron, Carol Clark, Linda Ayres, Warder H. Cadbury, Herman J. Viola, and Bernard Reilly. *American Frontier Life: Early Western Painting and Prints*. Introduction by Peter Hassrick. New York: Abbeville Press, Publishers, 1987.

Urban Texas Tomorrow: Report of the Texas Assembly on the State and Urban Crisis with Historical Illustrations. Arlington: Institute of Urban Studies, University of Texas at Arlington, 1970.

Utterback, Martha. *Early Texas Art in the Witte Museum*. San Antonio: Witte Memorial Museum, 1968.

* *Van Dyke Art Club Second Annual Exhibition*. San Antonio: Light Printing House, 1888.

Ward, Don. *Cowboys and Cattle Country*. New York: American Heritage Publishing Co., 1961.

Waugh, Julia Nott. *Castro-Ville and Henry Castro, Empresario*. San Antonio: Standard Printing Co., 1934.

Webb, Walter Prescott. *The Texas Rangers: A Century of Frontier Defense*. Boston: Houghton Mifflin Co., 1935.

Webb, Walter Prescott, H. Bailey Carroll, and Eldon Stephen Branda, eds. *The Handbook of Texas*. 3 vols. Austin: Texas State Historical Association, 1952, 1976.

Welch, June Rayfield. *Texas: New Perspectives*. Editorial Consultant, Ann Fears Crawford. Austin: Steck-Vaughan Co., 1972.

Weniger, Del. *The Explorers' Texas: The Lands and Waters*. 1st ed. Austin: Eakin Press, 1984.

* *The Westgate Gallery of Wayman Adams Paintings*. N.p., n.d.

Who's Who in America: Biographical Dictionary of Notable Living Men and Women of the United States, 1924–1925. Vol. 13. Chicago: A. N. Marquis and Co., 1925.

Who's Who in American Art. Edited by Dorothy P. Gilbert. New York: R. R. Bowker Co., 1956.

Who's Who in American Art: 16th Edition. Edited by Jacques Cattrell Press. New York: R. R. Bowker Co., 1984.

Wiggins, Gary. *Dance & Brothers: Texas Gunmakers of the Confederacy*. Edited and designed by Stephen Willim Sylvia. Orange, Va.: Moss Publications, 1986.

Williamson, George C., and Percy Buckman. *The Art of the Miniature Painter*. New York: Charles Scribner's Sons, 1926.

Willoughby, Larry. *Texas, Our Texas*. Austin: Learned and Tested, 1987.

* Wilmerding, John. *The Waters of America: 19th-Century American Paintings of Rivers, Streams, Lakes, and Waterfalls*. New Orleans: Historic New Orleans Collection, 1984.

Wittichen, Ingeborg. *Oberbergische Malerinnen: des 19. Jahrhunderts aus der Familie Jügel/Heuser*. Celle, West Germany: Cellesche Zeitung, Schweiger and Pick Verlag for the Museum des Oberbergischen Landes auf Schloss Homburg, 1980. Photocopy, Louise Wueste file, SAMA Texas Artists Records.

Woolford, Bess Carroll, and Ellen Schulz Quillin. *The Story of the Witte Memorial Museum: 1922–1960*. San Antonio: San Antonio Museum Association, 1966.

Woolford, Sam and Bess. *The San Antonio Story*. Austin: Steck Co., 1952.

Zinnecker, Paola L., ed. *Our Texas*. Grand Rapids, Mich.: Gateway Press, 1985.

Periodicals

"Among Our Local Artists: Hohnstedt, the Artist and the Man." *San Antonio Home and Club*, 3 (September 1932): n.p. Photocopy, Peter Lanz Hohnstedt file. SAMA Texas Artists Records.

"Antique Show." *Houston Downtown Magazine* (November 26, 1984): 5.

"The Art Students League, Part I." *Archives of American Art Journal* (1973): 2.

Battle, William J. "A Note on the Barker Texas History Center." *Southwestern Historical Quarterly*, 59 (April 1956): 498–501.

Borden, Penelope. "Mary Bonner, Etcher of Texas Cowboys." *Holland's, The Magazine of the South*, 47 (June 1928): 16–17.

"Borglum and His Work." *Southern California Magazine*, 4 (December 1895): 34–37.

Boston Museum of Fine Arts Bulletin, 23 (n.d.). Photocopy, Thomas Allen file. SAMA Texas Artists Records.

Brown, Joan Sayers. "Henry Clay's Silver." *The Magazine Antiques*, 120 (July 1981): 172–177.

The Bulletin of the Museum of Fine Arts of Houston, Texas, 6 (Winter 1944): [6].

Burns, William A. "The Witte Memorial and Confluence Museums." *Witte Quarterly*, 7, no. 4 (1969): 1–69.

"A Charming Primitive Oil Painting." *People* (University of Texas Institute of Texan Cultures at San Antonio), 4 (September-October 1974): 8.

Cook, Nancy. "19th Century Frontier Art: Texas as Seen through the Eyes of Untrained Artists." *San Antonio Magazine*, 13 (January 1979): 30–31.

Cook, Roger Allen. "Sunken Garden Art Colony." *The Southern Artist*, 2 (June 1955): 11–14.

"Cow Country Painting Displayed at Museum." *This Week in San Antonio*, May 31, 1947. Photocopied clipping. Witte Museum Press Records.

Cranfill, Mabel. "Frank Reaugh Preserves the Vanishing West." *Holland's, The Magazine of the South*, 48 (April 1929): 9, 85–90.

Crossley, Mimi. "Folk Art of the Frontier: A Survey of Naive Texas Art." *The Magazine of San Antonio*, 2 (January 1979): 28–30.

Danes, Gibson. "Everett Spruce: Painter of the Southwest." *American Magazine of Art* (February 1944): 12–15.

Day, Betsie Bolger. "King of the Bluebonnets." *Texas Homes*, 10 (May 1986): 29–34.

"December Scene at Witte." *San Antonio Scene* (December 1974). Clipping. Witte Museum Press Records.

dos Passos, John. "Builders for a Golden Age." *American Heritage*, 10 (August 1959): 65–77.

"Eighteen Artists from Nine States Reviewed." *The Art Digest* (February 1, 1942): 10.

El-Beheri, Mary Mathis, and Susan Clayton. "High School Students Research History of German-English School in San Antonio." *Die Unterrichtspraxis*, 8 (Fall 1975): 62–66.

Fabri, Ralph. "Xavier Gonzalez: Artist of Many Talents." *Today's Art*, 14 (August 1966): 6–8.

Fenstermaker, Mary. "A Conversation with Emily Edwards." *San Antonio Conservation Society Newsletter*, 17 (February/March 1980): 1–4; (April 1980): 3–7.

Freed, Eleanor. "Frank Freed's Visual Reflections on the Human Comedy." *Forum* (University of Houston), 2 (Spring 1973): 22–32.

Freed, Frank. "Artist on Art." *Southwest Art*, 2 (March 1972): 34. Reprint, Frank Freed file. SAMA Texas Artists Records.

"Freshness and Assurance Mark Dallas Show." *The Art Digest*, 6 (May 1, 1932). Clipping, Otis Dozier file. SAMA Texas Artists Records.

Frétellière, H. T. "San Antonio de Bexar, Half a Century Ago: The Reminiscence of a Castro Colonist." Translated from the original Spanish. *The Texas Magazine*, 5 (March 1912): 54–61.

Gard, Wayne. "Life in the Land of Beginning Again." *The American West*, 5 (May 1968): 42–49.

Gerdts, William H. "The Artist's Garden: American Floral Painting, 1850–1915." *Portfolio: The Magazine of the Fine Arts*, 4 (July/August 1982): 44–51.

Gideon, Samuel E. "Two Pioneer Artists in Texas." *American Magazine of Art* (September 1918). Typescript, Karl Friedrich Hermann Lungkwitz file. SAMA Texas Artists Records.

"Glory of the Morning." *The Pioneer Magazine*, 7 (April 1927): 5, 12.

Guerrero, Delma. "Around Town: Special Events." *San Antonio Scene* (January 1975). Clipping. Witte Museum Press Records.

Haley, J. Evetts. "F. Reaugh: Man and Artist." *The Shamrock* (Summer 1960): 8–12. Photocopy. Jerry Bywaters Collection, SMU.

Hirshfield, Dorothy. "Los Pastores." *Theatre Arts Monthly*, 12 (December 1928): 903–911.

Holley, Mary Austin. "The Texas Diary: 1835–38." Introduction and Notes by J. P. Bryan. *Texas Quarterly*, 8 (Summer 1965): 7–120.

Kalil, Susie. "Texas Naive." *Artweek* (May 5, 1979).

Keltner, Carmen. "Painting in Texas Began with the Arrival of U.S. Immigrants." *Houston Downtown Magazine* (November 26, 1984): 7–15.

Ketchum, Richard M. "The Case of the Missing Portrait." *American Heritage*, 9 (April 1958): 62–64, 85.

[King, Edward]. "Glimpses of Texas—1: A Visit to San Antonio." *Scribner's Monthly, An Illustrated Magazine for the People*, 7 (January 1874): 302–330.

"King of the Bluebonnets." *Texas Homes* (May 1986): 29. Clipping, Julian Onderdonk file. SAMA Texas Artists Records.

Ledbetter, Roy C. "Frank Reaugh—Painter of Longhorn Cattle." *Southwestern Historical Quarterly*, 54 (July 1950): 13–26.

Lilly, Marie Seacord. "Julian Onderdonk, Painter of the Southwest." *The Bright Scrawl*, 14 (April 1941): 11, 17.

Lord, Walter. "Myths and Realities of the Alamo." *The American West*, 5 (May 1968): 18–25.

McDermott, John Francis. "The Discovery of a Lost Charles Deas Painting." *The American West* (December 1980): 22. Photocopy, Charles Deas file. Amon Carter Museum, Fort Worth.

———. "Charles Deas Portrait of a Mountain Man: A Mystery in Western Art." *Gateway Heritage* (Spring 1981): 2. Photocopy, Charles Deas file. Amon Carter Museum, Fort Worth.

McGarry, Susan Hallsten. "Editor's Perspective." *Southwest Art*, 18 (April 1989): 14.

McGregor, Roberta, and Fred Valdez, Jr. "The Lower Pecos River Indian Art." *Heritage: A Publication of the Texas Historical Foundation*, 3 (Spring 1986): 30–31.

Miller, Inez. "Wayman Adams: The Man From Indiana." Reprint from *The Texas Artist Now*, n.d., n.p. Photocopy, Wayman Adams file. Amon Carter Museum, Fort Worth.

Mueller, Esther. "Old Fort Martin Scott at Fredericksburg." *Frontier Times*, 14 (August 1937): 463–470.

[Murry, Ellen N.]. "'Au Texas': The Art of Theodore Gentilz." *Star of The Republic Museum Notes*, 10 (Summer 1986): n.p.

Newman, Kenneth M., ed. *The Old Print Shop Portfolio*, 33 (n.d.).

Norton, Paul F., and E. M. Halliday. "Latrobe's America." *American Heritage*, 13 (August 1962): 32–56.

Obrecht, John. "The SAMA Saga: Six Decades with the San Antonio Museum Association." *M3, SAMA Quarterly*, in *San Antonio Monthly*, 5 (July 1986): 9–15, 27.

———. "Fantasy Flight." *M3, SAMA Quarterly*, in *San Antonio Monthly*, 6 (October 1986): 9.

Onderdonk, Eleanor. "Los Pastores." *Southwester*, 1 (December 1935): 3–4.

"The Onderdonks: A Family of Texas Painters." *Southwestern Art*, 5 (March 1976): 32–43.

"A Pack of Rebels: Playing Cards by William Aiken Walker." *American Heritage*, 18 (June 1967): 28–29.

Review of "Painting in Texas: The Nineteenth Century." In *Southwestern Art*, 2 (March 1968): 58–61.

Pontello, Jacqueline. "The Alamo: A Mission of Heroes." *Southwest Art*, 15 (February 1986): 68–77.

Raley, Helen. Texas Wild-Flower Art Exhibit." *Holland's, The Magazine of the South*, 46 (July 1927): 5, 49.

Reese, Becky Duval. "Images of Texas: Myth and Reality Through Art." *The Texas Humanist*, 5 (July/August 1983): 8–11.

"Reminiscences of One of the Boys of '60." *The Passing Show*, 1 (November 2, 1907): [2–3].

Remy, Caroline. "Hispanic-Mexican San Antonio: 1836–1861." *Southwestern Historical Quarterly*, 71 (April 1968): 564–570.

"Rock Mansion, Built 60 Years Ago, Still Stands." *Frontier Times*, 8 (October 1930): 42–46.

Rosson, Joe. "More than Bluebonnets . . . Texas Art." *Sentinel: Star of the Republic Antiques Show* (December 1984): 24–27.

"San Antonio Gets Four Eastman Paintings." *The Art Digest*, 8 (September 1, 1934): 17.

"The San Antonio Museum Association Exhibits." *San Antonio Monthly*, 5 (September 1986): 19; 6 (October 1986): 38.

Schmitz, Joseph W. "The Beginnings of the Society of Mary in Texas, 1852–1866." Reprint from *Mid-America*, 25, n.s. 14, no. 1 (n.d.).

Schwartz, Marvin D. "Early Texas Art Depicts Era's Action." *Antique Monthly*, 8 (November 1974): 1A, 8A.

Southwestern Historical Quarterly, 94 (January 1991): front cover.

"Southwest Painter." *Time*, 68 (December 17, 1956): 82.

Spell, Lota M., trans. and ed. "The Grant and First Survey of the City of San Antonio." *Southwestern Historical Quarterly*, 66 (July 1962): 73–89.

[Spofford, Harriet Prescott]. "San Antonio de Bexar." *Harper's New Monthly Magazine*, 55 (November 1877): 831–850.

Steinfeldt, Cecilia. "Medicine Men." *Witte Quarterly*, 7, no. 3 (1969): 4–29.

———. "The Folk Art of Frontier Texas." *The Magazine Antiques*, 114 (December 1978): 1280–1289.

———. "Simple Self-Expression: A Survey of Naive Painters from The Lone Star State." *Southwest Art*, 10 (September 1980): 56–65.

———. "Blooming Bluebonnets: A Texas Tradition." *Southwest Art*, 14 (April 1985): 62–69.

———. "Lone Star Landscapes: Early Texas Seen through Artists' Eyes." *M3, SAMA Quarterly*, in *San Antonio Monthly*, 5 (July 1986): 20–25.

———. "Wayman Adams: Portraitist of High Society." *M3, SAMA Quarterly*, in *San Antonio Monthly*, 6 (October 1986): 10.

———. "Texas Folk Art: The San Antonio Museum Association's Collection." *Antique Review*, 14 (September 1988): 25–30.

Sweeney, J. Gray. "The Onderdonks: Robert and Julian." *Southwest Art*, 18 (April 1989): 45–63, 128.

Taylor, Lonn. "Images: Naive Art." *Vision*, 3 (March 1980): 18–19.

"The Texas Arts: Oldster's Art." *Texas Week*, 1 (December 14, 1946): 18–20.

"Texas in Pictures." *The Magazine Antiques*, 53 (June 1948): 453–459.

"A Texas Painter." *Paint Rag: Texas Magazine of Art*, 1 (Summer 1953): 17–20, 28.

Utterback, Martha. "Additions to the Early Texas Collection." *Witte Quarterly*, 3, no. 2 (1965): 4–15.

———. "Witte Art Activities." *Witte Quarterly*, 3, no. 4 (1965): 11–16.

———. "Gentilz Note Paper." *Witte Quarterly*, 5, no. 4 (1967): 17.

"The Vanished Texas of Theodore Gentilz." *American Heritage*, 25 (October 1974): 18–27.

Vines, Mary Jo. "A Pioneer Poet of Texas." *The American-German Review*, 14 (June 1948): 28–31.

Wright, Lucy Runnels. "A Woman Extraordinary." *The Texas Outlook*, 21 (May 1937): 28–29.

Unpublished Sources

Albrecht, Theodore John. "German Singing Societies in Texas." Ph.D. diss., North Texas State University, Denton, 1975.

Allen, Thomas. Undated biographical typescript. Thomas Allen file. SAMA Texas Artists Records.

Becker, Erretta G. "A Miniature History of the San Antonio Art League, 1942." Photocopied typescript. San Antonio Art League file. SAMA Texas Artists Records.

"The Borglum Studio." Undated photocopied typescript. Gutzon Borglum file. SAMA Texas Artists Records.

Borromeo, Sister. "Biography of Mrs. Charles Lavender, Artist." [1928]. Typescript. La Retama Public Library Archives, Corpus Christi, Texas.

Cameron, Minnie B., Librarian, San Antonio Public Library. Undated Thomas Allen biographical typescript. San Antonio Public Library Archives.

Carraro, Francine. "Painters of the Southwest Landscape: Otis Dozier, William Lester, Everett Spruce." M.F.A. thesis, Southern Methodist University, Dallas, 1976.

Chabot, Frederick C. Photographic Album #2. SAMA Historical Photographic Archives.

Dallas Art Students League Contract, February 15, 1893, signed by Mrs. Sydney Smith, President. Robert Onderdonk file. SAMA Texas Artists Records.

Davidson, Kathryn, and Elizabeth Glassman. "C. A. A. Dellschau, A Visual Journal." 1977. Typescript. Menil Foundation Archives, Houston.

"Dawson-Watson, Dawson." Undated biographical typescript. Dawson Dawson-Watson file. SAMA Texas Artists Records.

de Garme, Mrs. Frank. Genealogical and Biographical Account of the Ancestors of James Ferguson Scott and Mary Margaret Ann Scott Savage as Taken from *Pathfinders of Texas*, 1951. Photocopied typescript. Edward D. Sidbury file. SAMA Texas Artists Records.

"Descendants of Anna Maria Naffz, Daughter of Heinrich, and Sister of Carl Heinrich Naffz of Mainberheim, Bavaria." Undated photocopied biographical typescript. Ida Weisselberg Hadra file. SAMA Texas Artists Records.

Elmendorf, Mary Staffel. "Our Ancestors." Written in San Antonio, 1955. Photocopied typescript. Louise Wueste file. SAMA Texas Artists Records.

Freed, Eleanor. "Frank Freed." Undated biographical resumé. Photocopied typescript. Frank Freed file. SAMA Texas Artists Records.

"Gallagher, Peter." Undated photocopied biographical typescript. Peter Gallagher file. SAMA Texas History Records.

Gentilz, Theodore. *Bridge Over the San Antonio River.* Original Bill of Sale, July 16, 1945, signed by V. J. Rose. SAMA Registrar's Records.

———. Original cover design for *Méthode Électique de la Perspective du Dessinateur et du Peintre Ouvrage Élémentaire Complet Contenand plus [?] 600 Figures Par T. Gentilz Lauréat de l'Ecole Nationale de Mathématique et de Dessin, de Paris,* undated. Archives of the DRT Library at the Alamo, SA.

Gonzales, Boyer, Jr. "Transcription of a Tape-recorded Interview with Boyer Gonzales [Jr.], at the Artist's Home in Seattle, Washington, November 26, 1984, Barbara Johns, Interviewer." Photocopied typescript. Boyer Gonzales, Sr., file. SAMA Texas Artists Records.

Gonzales, Boyer, Sr. Undated biographical typescript. Boyer Gonzales, Sr., file. SAMA Texas Artists Records.

———. Diary, 1892. Typescript. Rosenberg Library, Galveston.

———. Photocopied handwritten note, 1912. Boyer Gonzales, Sr., file. SAMA Texas Artists Records.

Gonzales, Eleanor. Diary, 1908. Typescript. Rosenberg Library, Galveston.

Gould-Onderdonk Papers. Private collection.

Grauer, Michael R. "The Early Career of Frank Reaugh, 1860–1889." Master's thesis, Meadows School of the Arts, Southern Methodist University, Dallas, 1989.

"Harry Anthony De Young Summer Painting Class in Monterrey, Mexico" [1934?]. Typescript announcement. Harry Anthony De Young file. SAMA Texas Artists Records.

Heuser, Elsbeth. "Our Ancestors." Written in Hameln, Germany, 1952. Photocopied typescript. Louise Wueste file. SAMA Texas Artists Records.

"Hohnstedt, Peter L." Undated biographical typescript. Peter Lanz Hohnstedt file. SAMA Texas Artists Records.

King, Stewart. "Little Known Facts About Our Parks." Paper delivered at the President's Council by Stewart King, Superintendent of Parks, San Antonio, February 6, 1950. Photocopied typescript. John C. Filippone file. SAMA Texas Artists Records.

Lee, Amy Freeman. "Call Board Reporter." Review for KONO, November 30, 1950. Typescript. Rolla S. Taylor file. SAMA Texas Artists Records.

McDowell, Catherine. "San Antonio's River." Paper delivered at a meeting of the San Antonio Conservation Society, San Antonio, October 23, 1974. Photocopied typescript. San Antonio River file (under Mills). SAMA Texas Artists Records.

"Monier, John C." Undated biographical typescript. John C. Monier file. SAMA Texas History Records.

Navarro, P. G. "Dellschau's Aeros." 1979. Manuscript. Property of the author.

Onderdonk, Eleanor. Diaries and Correspondence, 1904–1910. Gould-Onderdonk Papers. Private collection.

Onderdonk, Emily. Ledger, "Baby Days, 1884." Gould-Onderdonk Papers. Private collection.

———. Diaries, 1891–1903, 1911. Photocopied typescripts. Gould-Onderdonk Papers. Private collection.

———. Diary, July 15, 1913. Gould-Onderdonk Papers. Private collection.

Onderdonk, Julian. "Just Nothing." Two Journals, New York, 1902. Gould-Onderdonk Papers. Private collection.

Onderdonk, Julian. *Dawn in the Hills.* Original Bill of Sale, January 3, 1938, signed by Gertrude, Adrienne, and Robert Reid Onderdonk. SAMA Registrar's Records.

Pease, S. W. "They Came to San Antonio: 1794–1865." Undated photocopied typescript. SAMA Texas History Records.

Remy, Caroline. "Biographical Sketches of Fifteen Texas Artists." June 1966. Photocopied typescript. SAMA Texas Artists Records.

"Second Annual Davis Mountain Summer Painting Camp" (1932). Typescript announcement. Harry Anthony De Young file. SAMA Texas Artists Records.

Staffel, Adeline Wueste. "Diary of Adeline Wueste Staffel." Translated by Mrs. Heino Staffel, San Antonio, Texas, 1852. Photocopied typescript. Louise Wueste file. SAMA Texas Artists Records.

Texas Census (Bexar County Archives, San Antonio, 1870). Microfilm Roll #1575.

"A Thumbnail Sketch of the Zimmerscheidt, Leyendecker and Brune Family." Undated photocopied typescript. Louis Hoppe file. SAMA Texas Artists Records.

Utterback, Martha. "Xavier Gonzalez Biography." Undated typescript. Xavier Gonzalez file. SAMA Texas Artists Records.

Vines, Ida Hadra. "Two Sisters in Early Texas." Undated typescript. Ida Weisselberg Hadra file. SAMA Texas Artists Records.

Wagner, Frank. "Wm. DeRyee of Corpus Christi: A Biographical Sketch." Undated photocopied typescript. William DeRyee file. SAMA Texas Artists Records.

Ward, James, and P. G. Navarro. "The Riddle of Dellschau and His Esoteric Books." Undated photocopied typescript. C. A. A. Dellschau file. SAMA Texas Artists Records.

———. "Dellschau: The Enigmatic Man." Undated photocopied typescript. C. A. A. Dellschau file. SAMA Texas Artists Records.

Witte, Alfred G. Bequest, June 6, A.D. 1921. Typescript. SAMA Registrar's Records.

"Witte Memorial Museum Art Department Annual Reports," 1936, 1942, 1953–1954. Witte Museum Library, San Antonio.

"Witte Memorial Museum Natural History Department Annual Report," 1956–1957. Witte Museum Library, San Antonio.

"The Wueste Family." Undated photocopied typescript. Louise Wueste file. SAMA Texas Artists Records.

Letters

Allen, Eleanor W. (Princeton, Mass.), to Minnie B. Cameron (San Antonio), October 16, 1935. San Antonio Public Library Archives.

———— (Boston), to Eleanor Onderdonk (San Antonio), February 13, 1936, with attached biographical information. Thomas Allen file. SAMA Texas Artists Records.

Britton, Lillian E. (San Antonio), to author (San Antonio), April 23, 1982. Louis Hoppe file. SAMA Texas Artists Records.

Champion, A. A. (Brownsville), to Martha Utterback (San Antonio), December 6, 1966. Ludwig Puschmann file. SAMA Texas Artists Records.

Cherry, E. Richardson (Houston), to Ellen S. Quillin (San Antonio), n.d. E. Richardson Cherry file. SAMA Texas Artists Records.

Dawson-Watson, Dawson (St. Louis), to Julian Onderdonk (San Antonio), September 11, 1921. Photocopy. Julian Onderdonk file. SAMA Texas Artists Records.

Denman, Gilbert M., Jr. (San Antonio), to Jack R. McGregor (SAMA Director, San Antonio), December 13, 1978. SAMA Registrar's Records.

DeShields, James T. (Dallas), to Julian Onderdonk (San Antonio), January 28, 1918. Gould-Onderdonk Papers. Private collection.

Gerdts, William A. (New York), to author (San Antonio), February 3, 1987. George Comegys file. SAMA Texas Artists Records.

Gonzales, Bettie (Seattle), to author (San Antonio), July 28, 1987. Boyer Gonzales, Jr., file. SAMA Texas Artists Records.

Gonzalez, Xavier (New York), to Martha Utterback (San Antonio), n.d. Xavier Gonzalez file. SAMA Texas Artists Records.

Grauer, Michael R. (Canyon, Tex.), to author (San Antonio), November 27, 1990.

Green, William Elton (San Antonio), to George L. McKenna (Kansas City, Mo.), June 6, 1983. Photocopy. Albert Fahrenberg, Sr., file. SAMA Texas Artists Records.

Hadra, J. M. (Dallas), to Eleanor Onderdonk (San Antonio), June 2 and June 10, 1936. Ida Weisselberg Hadra file. SAMA Texas Artists Records.

Harllee, Edward (San Antonio), to Robert K. Winn (San Antonio), February 19, 1969. SAMA Registrar's Records.

Hawes, Charles H. (Associate Director, Museum of Fine Arts, Boston), to Mattie Austin Hatcher (Archivist, University of Texas, Austin), September 20, 1932. Photocopy. Thomas Allen file. Eugene C. Barker Texas History Center, University of Texas at Austin.

Hiller, Robert (Stuttgart, Germany), to editor, *The Magazine Antiques*, January 27, 1979. Rudolph Mueller file. SAMA Texas Artists Records.

Jordan, Floy Fontaine (Cotulla, Tex.), to author (San Antonio), December 6, 1978. Frank Edwards file. SAMA Texas Artists Records.

Kinzinger, Edmund (Waco), to Jerry Bywaters (Dallas), October 10, 1946; September 23 and 24, 1947. Edmund Kinzinger file. Jerry Bywaters Collection, SMU.

———— (Delevan, Wis.), to Jerry Bywaters (Dallas), March 25, 1958. Jerry Bywaters Collection, SMU.

Kinzinger, Mary (Larboro, N.C.), to Dr. Richard Gasser (Fort Worth), May 23, 1973. Jerry Bywaters Collection, SMU.

Koke, Richard J. (New York), to author (San Antonio), July 16, 1974. Robert Onderdonk file. SAMA Texas Artists Records.

Lawler, Ruth Curry (Castroville, Tex.), to author (San Antonio), April 20, 1978. Rudolph Mueller file. SAMA Texas Artists Records.

Layne, Frances (Dallas), to author (San Antonio), June 29, 1986. Charles T. Bowling file. SAMA Texas Artists Records.

Marucheau, Henry (Paris, France), to Erna Schelper (San Antonio), May 8, 1909. Edward Grenet file. SAMA Texas Artists Records.

Onderdonk, Eleanor (New York), to Emily Onderdonk (San Antonio), June 10, 1906. Gould-Onderdonk Papers. Private collection.

———— (San Antonio), to Sarah Scott McKellar (Mexico), November 23, 1927. Eleanor Onderdonk file. SAMA Texas Artists Records.

———— (San Antonio), to Judge Charles Anderson (San Antonio), July 14, 1945. W. G. M. Samuel file. SAMA Texas Artists Records.

———— (San Antonio), to Genevieve Hitt (Front Royal, Va.), October 23, 1952. Eleanor Onderdonk file. SAMA Texas Artists Records.

———— (San Antonio), to Marion Gibbs Caphton (Harrisburg, Pa.), January 4, 1962. Eleanor Onderdonk file. SAMA Texas Artists Records.

Onderdonk, Julian (New York), to "Dear Everybody" (San Antonio), April 16, 1901, and October 27, 1902. Gould-Onderdonk Papers. Private collection.

Onderdonk, Robert (Dallas), to Emily Onderdonk (San Antonio), February 28, 1889. Gould-Onderdonk Papers. Private collection.

———— (Dallas), to Emily Onderdonk (St. James, Md.), September 7, 1890 to November 14, 1890. Gould-Onderdonk Papers. Private collection.

———— (St. Louis), to Emily Onderdonk (San Antonio), January 29, 1899. Gould-Onderdonk Papers. Private collection.

———— (St. Louis), to members of his family (San Antonio), November 27, 1898 to August 14, 1899. Gould-Onderdonk Papers. Private collection.

Paine, Joseph Polley (San Antonio), to Eleanor Onderdonk (San Antonio), May 10, 1953. Eleanor Onderdonk file. SAMA Texas Artists Records.

Petteys, Mrs. Robert (Denver), to Claudia Eckstein (San Antonio), December 5, 1978. E. Richardson Cherry file. SAMA Texas Artists Records.

Sanders, Bettie Paschal (Pearsall, Tex.), to William A. Burns (SAMA Director, San Antonio), August 3, 1962. Julian Onderdonk file. SAMA Texas Artists Records.

Smith, Orpah Dawson (Dallas), to Julian Onderdonk (San Antonio), ca. 1918. Gould-Onderdonk Papers. Private collection.

Steinfeldt, John M. (Paris, France), to Mrs. John M. Steinfeldt (San Antonio), July 6, 1909. Special Collections, Steinfeldt Collection. John Peace Library, University of Texas at San Antonio.

Taylor, Loyd Ray (Dallas), to author (San Antonio), October 1, 1980. Solomon Saloman file. SAMA Texas Artists Records.

Vines, Mrs. P. C. (Dallas), to Eleanor Onderdonk (San Antonio), June 10, 1936.

Wueste, Daniel (Eagle Pass), to Emma [Schlickum] (Austin), September 25, 1874. Photocopied typescript. Louise Wueste file. SAMA Texas Artists Records.

Wueste, Louise (Piedras Negras), to Emma [Schlickum] (New Orleans), April 29, 1863. Photocopied typescript. Louise Wueste file. SAMA Texas Artists Records.

———— (San Antonio), to Emma [Schlickum] (New Orleans), January 24, 1864. Photocopied typescript. Louise Wueste file. SAMA Texas Artists Records.

———— (San Antonio), to her relatives in Germany, April 25, 1869. Photocopied typescript. Louise Wueste file. SAMA Texas Artists Records.

———— (San Antonio), to Emma [Schlickum] (Austin), August 15, 1874. Louise Wueste file. German Section, University of Texas Institute of Texan Cultures at San Antonio.

Interviews with Author

Denman, Gilbert M., Jr., San Antonio, September 5, 1981.

Fitzsimon, Bernard, Castroville, Tex., June 2, 1978.

Freed, Eleanor, Houston, September 16, 1986.

Gibson, Elizabeth Conroy, San Antonio, May 14, 1985.

Gonzales, Boyer, Jr., Seattle, Wash., August 20, 1984.

Green, William Elton, San Antonio, August 14, 1984; March 2, 1991.

Gresham, Mrs. Rupert, San Antonio, August 17, 1974.

Jordan, Floy Fontaine, San Antonio, December 22, 1986; February 2 and November 19, 1987.

Kerr, Sara, San Antonio, February 2, 1987.

McGregor, Roberta, San Antonio, March 21, 1986.

McGuire, James Patrick, San Antonio, August 21 and September 2, 1987; April 15, 1988.

McMillan, Mrs. W. B., San Antonio, May 9, 1985.

Reid, Willis, Cleburne, Tex., May 4, 1978.

Utterback, Martha, San Antonio, August 15, 1987.

Washichek, Laura Vollrath, San Antonio, May 24, 1978.

Winn, Robert K., San Antonio, May 5, 1977.

Newspapers

Abilene *Reporter News*, September 29, 1940.
Austin *American-Statesman*, December 15, 1940;
 December 15, 1946; March 3, 1948; February 19,
 1950; September 23, 1955; October 26, 1958; April 8
 and October 11, 1959; August 14, 1966; March 22,
 1970.
Austin *Daily Democratic Statesman*, November 18, 1876;
 April 26, 1882.
Baltimore *Sun*, August 19, 1895.
Christian Science Monitor, November 13, 1926.
Citizen Marquee (Austin), June 15, 1979.
Current Events (San Antonio), September 25, 1986.
The Daily Texan (Austin), February 9, 1947; April 4 and
 19, 1961; June 7, 1979; December 3, 1981.
Dallas *News*, November 20, 1938; March 7, 1941; April
 22, 1943; December 18, 1956.
Dallas *Morning News*, July 17, 1938; October 3, 1948;
 February 12, 1960; November 7, 1976.
Dallas *Times Herald*, February 5, 1967.
Eagle Lake *Headlight*, May 28, 1981.
The 4-County News Bulletin (Castroville), January 1, 1979.
Galveston *Daily News*, December 19, 1874; August 20,
 1881; July 22, 1903; September 13, 1908.
Galveston *Tribune*, January 18, 1916.
The Herald (San Antonio), March 5, 1975.
Hondo *Anvil Herald*, December 18, 1953.
Houston *Chronicle*, May 18, 1947; October 31, 1954;
 November 30, 1960; August 17, 1972; October 12,
 1977; April 15, 1979.
Houston *Post*, March 5, 1950; October 31, 1954;
 February 24, 1972; November 27, 1976; December
 15, 1978.
New Braunfels *Herald*, May 14, 1975; September 9,
 1976.
North San Antonio Times, December 12, 1974; February
 19, 1981; December 22, 1983; February 13,
 September 25, and November 6, 1986.
Paseo del Rio Showboat (San Antonio), December 1974;
 January 1975; August 1976; December 1978; January
 1983; August 1984; October 1986.
The Recorder (San Antonio), December 31, 1974.
St. Louis *Republic*, February 28, 1897.
San Antonio *Daily Express*, February 12, February 26,
 June 4, June 17, August 9, and October 10, 1876;
 August 2, 1878; September 20, 1881; April 9,
 November 16, and December 1, 1888; May 16,
 1900; November 8, 1902; June 12, 1903; April 13
 and July 19, 1907.
San Antonio *Daily Herald*, February 9, 1859; May 8,
 1860; February 19, 1871; May 22 and July 17, 1875;
 June 6, 1876.
San Antonio *Evening News*, February 17, 1928; February
 9, 1939; October 15, 1940; November 11, 1945; June
 30, 1948; May 28 and December 12, 1953; July 21,
 1970.
San Antonio *Express*, August 15, 1895; November 8,
 1902; December 21, 1913; April 28 and July 4, 1915;
 January 30, 1917; April 8 and 27, 1922; December
 10, 1923; June 26, 1924; January 25 and March 14,
 1925; October 3 and December 5, 1926; February
 20, August 14, and October 9, 1927; January 8,

January 29, and March 4, 1928; February 24, 1929;
 February 16, 1930; September 27, 1931; November
 30, 1932; January 15 and October 15, 1933; January 6,
 March 7, April 29, August 4 and 5, and September
 5, 1934; March 15 and 31, May 23, June 28, August
 18 and 28, November 10, and December 31, 1935;
 February 13 and 21, April 26, May 1, November 8,
 and December 27, 1936; April 10 and 24, May 1
 and 12, 1938; May 21, July 22, and September 5,
 1939; March 2, 1941; May 16, 1943; November 17,
 1944; May 9 and July 11, 1948; February 20 and 27,
 and December 11, 1949; January 29, 1950; April 22
 and September 23, 1951; June 29, and October 10
 and 17, 1952; March 1, May 24, October 25, and
 December 13, 1953; May 24 and June 19, 1955;
 January 18, 1956; July 20, 1960; November 25 and
 December 19, 1974; September 19 and November
 4, 1976; October 12, 1978; March 16, 1979; October
 30, 1980.
San Antonio *Express-News*, September 26, 1965; April 5,
 1970; September 12, 1971; August 13, 1972; De-
 cember 15, 1973; October 19, November 25, and
 December 19, 1974; January 12, February 16, and
 March 2, 1975; September 19, 1976; October 16,
 1977; July 14, 1985; October 5, 1986; May 27, 1988;
 December 16, 1990.
San Antonio *Light*, July 17, 1927; February 22, 1929;
 March 6, May 22, and November 27, 1932; March
 5, July 9, September 1, September 17, November
 26, and December 17, 1933; February 18, April 8
 and 29, and December 23, 1934; January 27,
 February 1, May 23 and November 17, 1935; March
 29, April 26, May 1, and December 16, 1936;
 August 4 and December 18, 1938; February 19 and
 October 20, 1940; February 22 and May 1, 1942;
 January 17, 1943; September 23 and November 11,
 1945; February 17, 24, and 27, and November 24,
 1946; September 9 and December 12, 1951; August
 22, 1954; May 24 and August 21, 1955; June 24, 1956;
 January 1, 1957; September 17, 1959; August 10,
 1963; November 12, 1964; April 16, 1967; October
 26, 1969; August 13, 1972; May 5, 1973; March 24,
 April 14, September 1 and 8, October 27, Novem-
 ber 1, and December 1 and 29, 1974; January 12,
 April 27, and August 3, 1975; March 28, 1976;
 November 26 and December 3, 1978; January 7
 and March 25, 1979; February 17 and November 2,
 1980; March 1, 1981; October 5, 1986; July 30 and
 August 30, 1987.
San Antonio *Semi-Weekly News*, December 22 and 29,
 1862; May 21, 1863.
San Antonio *Tri-Weekly Alamo Express*, February 6, 1861.
The Southern Messenger (San Antonio), October 14, 1926.
Uvalde *Leader News*, January 19, 1956.
Waco *Tribune-Herald*, January 13, 1963.
The Weekly Alamo Express, April 11, 1861.
West Side Sun (San Antonio), May 9, 1985.

Maps

[Gentilz, Theodore]. *Castro's Colony/Bexar District*. Hand-
 drawn plat map. SAMA Map Collection.
Koch, Augustus. *Bird's Eye View of San Antonio, Bexar Co.,
 Texas, 1886. Looking North East*. SAMA Map
 Collection.
Steinfeldt, Eric. "San Antonio de Bexar, 1 de Enero,
 1836." Centerfold in *San Antonio de Bexar, 1 de Enero,
 1836*, by Richard G. Santos. San Antonio: Privately
 published, [ca. 1963].

Posters, Advertisements, and Invitations

Celebrating the Republic of Texas. Arby's Restaurant
 advertisement. 1980.
"Christmas at the Alamo." Christmas card issued by
 the Clegg Company. Ca. 1938.
HRW [Holt, Rinehart and Winston] *Time Line*.
 Classroom supplement posters. Austin: Holt,
 Rinehart and Winston, 1989.
Publications of the San Antonio Museum Association. 1978.
 Catalogue.
San Angelo Preview Reception Invitation for the
 exhibition, Looking at the Land: Early Texas
 Painters. 1990.
SAMA Annual Christmas Party Invitation. 1978.
SAMA Ninth Annual Game Dinner Invitation and
 Program. 1979.
Sesquicentennial Almanac. Calendar. Texas: Under Six
 Flags, 1836-1986. Sun City, Ariz.: Gene Fowler and
 Friends, 1986.
Witte Museum Brochure, San Antonio. 1961.

San Antonio Museum Association Publications

SAMA *Annual Report: 1974–1975, 1975–1976*.
SAMA *Bi-Annual Report, 1976–1978*.
SAMA *Calendar of Events*: December 1974; January 1975;
 May 1975; March 1976; June 1976; November 1978;
 December 1978; February 1979; June 1979;
 November 1980; January 1981; November 1981;
 September 1986; October 1986.
*Witte Memorial Museum: First Annual Report of the Director
 and Board of Trustees to the City of San Antonio* (San
 Antonio: Witte Memorial Museum, 1927).

INDEX